Envisioning Christ on the Cross

Envisioning Christ on the Cross: Ireland and the Early Medieval West

Juliet Mullins, Jenifer Ní Ghrádaigh
& Richard Hawtree

EDITORS

FOUR COURTS PRESS

Typeset in 11pt on 14pt AGaramondPro by
Carrigboy Typesetting Services for
FOUR COURTS PRESS LTD
7 Malpas Street, Dublin 8, Ireland
www.fourcourtspress.ie
and in North America for
FOUR COURTS PRESS
c/o ISBS, 920 N.E. 58th Avenue, Suite 300, Portland, OR 97213.

A catalogue record for this title is available
from the British Library.

ISBN 978–1–84682–387–9

SPECIAL ACKNOWLEDGMENT

Published with the aid of an Irish Research Council for the Humanities and Social Sciences
grant in Religious and Theological Studies.

Printed in Spain
by Castuera, Pamplona

Contents

Illustrations

Figures

Abbreviations

abb.	Abbildung ('figure')
ACW	*Ancient Christian Writers* (Mahwah, NJ, 1872–)
AntL	Antiphonary of León, ed. Louis Brou & José Vives, *Antifonario visigótico mozárabe de la catedral de León*, Monumenta Hispaniae sacra. Serie liturgica, V,1 (Barcelona & Madrid, 1959)
BL	British Library, London
BN	Bibliothèque Nationale, Paris
cat.	catalogue
CCCM	*Corpus Christianorum Continuatio Mediaevalis* (Turnhout, 1966–)
CCSL	*Corpus Christianorum Series Latina* (Turnhout, 1954–)
CELT	Corpus of Electronic Texts
CSEL	*Corpus Scriptorum Ecclesiasticorum Latinorum* (Vienna, 1866–)
d.	died/died in
D.	depth
diam.	diameter
EDXRF	energy dispersive x-ray fluorescence
Ep.	Epistola/epistolae
fo.	folio
GaGo	*Missale Gothicum*, ed. L. Mohlberg (Rome, 1961)
GeV	Old Gelasian Sacramentary, ed. L. Mohlberg, *Liber sacramentorum Romanae aeclesiae ordinis anni circuli (Cod. Vat. Reg. Lat. 316/Paris Bibl. Nat. 7193, 41/56)* (Rome, 1960)
H.	height
IRCHSS	Irish Research Council for the Humanities and Social Sciences
JECS	*Journal of Early Christian Studies* (Baltimore, 1993–)
JRSAI	*Journal of the Royal Society of Antiquaries of Ireland* (Dublin, 1849–)
JWCI	*Journal of the Warburg and Courtauld Institutes*
LO	*Liber Ordinum Episcopal (Cod. Silos, Arch. Monástico, 4)*, ed. José Janini, Studia Silensia, 15 (Burgos, 1991)
MGH	*Monumenta Germaniae Historica* (Berlin, 1826–1948; Munich, 1949–)

MNAC	Museu Nacional d'Art de Catalunya
MS	manuscript
n.s.	new series
NMI	National Museum of Ireland
NPNCF	*Nicene and Post-Nicene Christian Fathers* (New York, 1887–92; Oxford, 1890–1900)
NPNF	*Nicene and Post-Nicene Fathers* (Edinburgh and New York, 1886–1900)
OPD	*Opificio delle Pietre Dure*
OR	Ordo romanus, ed. M. Andrieu, *Les ordines Romani du haut moyen âge*, 1–5 (Louvain, 1931–61)
P&H	*The passions and homilies from the Leabhar Breac*, ed. and trans. Robert Atkinson, Todd Lecture Series, 2 (Dublin, 1887)
pers. comm.	personal communication
PG	*Patrologiae Cursus Completus*, Series Graeca, ed. Jacques-Paul Migne, 162 vols (Paris, 1857–66)
PL	*Patrologiae Cursus Completus*, Series Latina, ed. Jacques-Paul Migne, 221 vols (Paris, 1844–64)
PRIA	*Proceedings of the Royal Irish Academy*
RAH	Real Academia de la Historia, Madrid
RIA	Royal Irish Academy
s.a.	*sub anno*
SC	*Sources chrétiennes* (Paris, 1941–)
ser.	series
SOSA	Support of Scholarly Activities
Tr.	Leo Magnus, *Tractatus*, ed. Antoine Chavasse (Turnhout, 1973)
trans.	translated by/translation
W.	width
Xrf	x-ray fluorescence

Contributors and editors

CONTRIBUTORS

Prof. Michele Bacci, University of Fribourg

Dr Elizabeth Boyle, University of Cambridge

Dr Jordi Camps i Sòria, Museu Nacional d'Art de Catalunya

Prof. Celia Chazelle, College of New Jersey

Dr Katharina Christa Schüppel, Leipzig University

Dr César García de Castro Valdés, Patrimonio Cultural del Principado de Asturias

Dr Felicity Harley McGowan, University of Melbourne

Dr Beatrice Kitzinger, Stanford University

Dr John Munns, University of Cambridge

Dr Griffin Murray, University College Cork

Prof. Carol Neuman de Vegvar, Ohio Wesleyan University

Dr Jennifer O'Reilly, University College Cork

Prof. Elizabeth C. Parker, Fordham University

Dr Louis van Tongeren, Tilburg University

EDITORS

Dr Richard Hawtree, University College Cork

Dr Juliet Mullins, University College Cork

Dr Jenifer Ní Ghrádaigh, University of Sheffield

Acknowledgments

This collection derives from a conference held under the auspices of the IRCHSS-funded project 'Christ on the Cross: Representations of the Passion in Early Medieval Ireland' and the editors would like to acknowledge here the support provided by this funding body. Further assistance and financial support was provided by Bord Fáilte, and by University College Cork, specifically the following disciplines and schools: Classics, Early and Medieval Irish, English, History, History of Art, and Hispanic Studies. Maeve Barry and Anne Fitzgerald rivaled each other in the expertise and speed with which they resolved the administrative issues that such an international conference inevitably produced, and allowed the convenors to focus on the academic content – we cannot thank them enough! Colleagues provided advice, encouragement and inspiration and we would particularly like to express our gratitude to Flavio Boggi, Máire Herbert, Małgorzata Krasnodębska-D'Aughton, Kirsty March, Éamonn Ó Carragáin, Jennifer O'Reilly and last, but never least, David Woods. The gathering together of essays from scholars across Europe inevitably led to some language difficulties, and our thanks are especially due to Jacco Thijssen for his graceful translations from Dutch. All our contributors, and our editors at Four Courts Press have made the publication of this book a far easier endeavour than it might otherwise have been. Finally, we could not have achieved this without the help, patience and generous support of our families.

Introduction

The Ruthwell Cross is an eighth-century stone cross that once stood in the Anglo-Saxon kingdom of Northumbria but is now preserved in the church in Ruthwell, Scotland. Upon it is inscribed in runes the remains of a poem, a version of which survives in a tenth-century Anglo-Saxon manuscript that made its way some time before the twelfth century to Vercelli in northern Italy. The poem, known to modern scholars as *The Dream of the Rood*, is a vision in which a dreamer encounters the cross in many guises: as an instrument of torture, the blood-stained token of Christ's humanity, and the jewel-encrusted symbol that appears at the day of Judgment as witness to Christ in divine form. The poem and the stone cross upon which it is inscribed represent just two of the many facets of vision in medieval culture (the private dream vision and the physical monument upon which believers publically gaze), and illustrate the many powerful ways in which the crucifixion might be conceptualized. The transmission of the manuscript further acts as a reminder of the universal significance of the crucifixion across the Christian world and the central place that the cross holds in the liturgy, architecture, texts and art of medieval Europe.

And yet, despite the universality of the cross as symbol and sign in various media throughout the early medieval West, remarkably few representations of the Passion survive from before the eighth century, and in this the Ruthwell Cross is no exception.[1] Whereas the Vercelli poem confidently proclaims that 'Christ was on the cross' (*Crist wæs on rode*), and the runes inscribed upon the cross assert that 'Christ was on the cross. Yet the brave came there from afar to their lord' (*Krist wæs on rodi. Hweþræ þer fusæ fearran kwomu æþþilæ til anum*),[2] an image of the crucifixion was not added to the base of the Ruthwell Cross until a later date.[3] The

1 See Harley McGowan and O'Reilly, this volume. **2** *The Dream of the Rood*, ed. Michael Swanton (Exeter, 1987), l. 56. The date of the runic inscriptions remains the cause of some controversy, with scholars such as Patrick Conner arguing that they were added as late as the tenth century. See Patrick W. Conner, 'The Ruthwell monument runic poem in a tenth-century context', *Review of English Studies* (2007), 1–27; Alfred Bammesberger, 'Two archaic forms in the Ruthwell Cross inscription', *English Studies*, 75:2 (1994), 97–103; idem, 'Die Runeninschrift auf dem Ruthwellkreuz', *Anglia*, 121 (2003), 265–73. **3** The crucifixion panel on the Ruthwell Cross is particularly badly damaged,

apparent disjunction between monument and text has often been attributed to the far-reaching effects of iconoclasm and a fear among the faithful of depicting the divine in suffering human form; whatever its source, the impact upon modern scholarship has been marked.[4] Although it is apparent that much of the art of the early medieval period is not so much a replication of the visible natural world as an expression and exploration of the spiritual as conveyed in the written and spoken word, scholars have been slow to examine image and text in parallel. Instead, the two are often examined in a source-secondary relationship that enforces a hierarchy that would have had little relevance to the medieval viewer, or in isolation and within the close confines of academic disciplines. The legacy of these approaches has been largely negative, particularly for the more abstract Insular art, but also for those texts that must have been produced with a limited audience in mind and might seem far removed from the public monuments to medieval spirituality that defined the contemporary landscape. Without an appreciation of the medieval liturgical *praxis* and theological speculation with which they engage, sophisticated artworks such as the Durham Gospels, the Blythburgh Tablet or the Glendalough Cross might seem simplistic and naïve, and at a far remove from important Continental works such as the Maskell Passion Ivories, the *Volto Santo* and the Catalan majestats ('Majesties').[5] And without an awareness of the theological complexities examined in the Asturian crosses, the Irish high crosses or the English *Gnadenstuhl*, the impact of works by scholars such as Eriugena, Echtgus Úa Cúanáin and Hrabanus Maurus is far from clear.[6] One of the aims of this volume is, therefore, to offer a reassessment of early medieval depictions of the crucifixion in both image and text, and to re-examine the veneration of Christ's salvific sacrifice across regional, chronological, methodological and disciplinary divides.

The contributors to this volume have focused upon the presentation of the body of Christ on the cross in medieval art and literature from the fifth to the

but Éamonn Ó Carragáin has discussed the reconstruction in *Ritual and the rood: liturgical images and the Old English poems of the Dream of the Rood tradition* (Toronto and London, 2005), pp 12–32; the crucifixion panel specifically is discussed in greater detail at pp 109, 211–13. Ó Carragáin suggests that the crucifixion panel was not added until at least a generation after the original construction, at which time a devotional crucifixion was added 'with a naked figure of Christ, his head inclined to the right in the new style of the late eighth century' (pp 211–13). **4** See, for example, Michael W. Herren and Shirley Ann Brown, *Christ in Celtic Christianity: Britain and Ireland from the fifth to the tenth century* (Woodbridge, 2002). For a review of Herren and Brown, see Gilbert Markús, 'Pelagianism and the "Common Celtic Church"', *Innes Review*, 56:2 (2005), 165–213. **5** The Durham Gospels and Blythburgh Tablet are discussed below by O'Reilly and Neuman de Vegvar; the Maskell Passion Ivories, the *Volto Santo* and the Catalan majestats are the subject of the contributions by Harley McGowan, Bacci and Camps i Sòria. **6** For the Asturian crosses, the Irish high crosses and the English *Gnadenstuhl*, see the essays below by García de Castro Valdés, Ní Ghrádaigh and Munns respectively; for studies of Eriugena, Echtgus Úa Cúanáin and Carolingian writers such as Hrabanus Maurus, see the essays by Hawtree, Boyle and Chazelle, this volume.

twelfth century, in works produced in Ireland and neighbouring regions.[7] The contributions extend temporally and geographically from the late antique liturgical and material culture of Rome to the Romanesque depictions of the crucifixion emerging from twelfth-century Ireland. The title of the volume invokes the concept of vision, which the various essays address in its many aspects; but throughout there is an attempt to engage with the viewer as a participating spiritual subject as well as the object as a specific artist's vision of Christ. This book's title also hints at the diversity of disciplinary perspectives with which the different scholars engage, and the simultaneous universality of the crucifixion and cross. The centrality of the cross within Christian theology, ritual and worship should not blind us to its dynamism and multivalence as an artefact, symbol and sign. For, as this collection of essays demonstrates, Christ is envisioned upon the cross in ways that are often dynamic, radical and innovative. The cross is the most potent of all objects in early medieval culture: it is a strikingly simple image in structural terms, yet its significance is profound. Each of the essays engages with the paradoxes of the crucifixion, adopting approaches that are always sensitive to the simplicity and centrality of the sign of the cross, but which at the same time reflect on multiple levels the complexity with which the medieval world envisioned the defining moment in Christian history and theology when Christ was crucified.

Through the various approaches adopted in the individual essays, *Envisioning Christ on the Cross* explores two fundamental aspects of the crucifixion, reflected in the division of this volume into two sections: 'God hanging from a cross' and 'Contemplate the wounds of the Crucified'. The first concerns the mystery of God's revelation of his divinity upon the cross, so vividly evoked in the words of Gregory Nazianzen who, although he was an Eastern theologian, reflects in his thinking a number of preoccupations common to both East and West:

> Many indeed are the wondrous happenings of that time: God hanging from a cross, the sun made dark and again flaming out; for it was fitting that creation should mourn with its creator. The temple veil rent, blood and water flowing from his side: the one as from a man, the other as from what was above man; the earth shaken, the rocks shattered … Yet no one of them can be compared to the miracle of my salvation. A few drops of blood renew the whole world …[8]

7 Contributors offered their papers at a conference held in University College Cork, Ireland, in March 2010 entitled '*Croch saithir*: envisioning Christ on the cross in the early medieval West', as part of an Irish Research Council for the Humanities and Social Sciences-funded research project entitled 'Christ on the cross: textual and material representations of the Passion in early medieval Ireland (*c.*800–1200)'. For further details of the project, see www.christonthecross.org. **8** Gregory Nazienzen, *Oration XLI: on Pentecost* in *NPNF*, 2, trans. Philip Schaff (Edinburgh, 1896), p. 378.

As Nazianzen's passage indicates, the crucifixion represents a defining moment in the history of Christian salvation, which has implications for all creation and is marked by various natural and supernatural signs. The Eastern theologian acknowledges the paradox of 'God hanging from a cross', the scandal of which is frequently acknowledged by St Paul in his letters to the early church, yet is at pains to reiterate the distinction between creation and creator. Refuting those heretics that claim that the Son is secondary to the Father or less than one with him, Nazianzen emphasizes divine intervention in human history at this very point: the prophecies of the past are fulfilled when the temple veil is rent, and the salvation of mankind in the future is ensured through the blood that Christ shed, 'the one as from a man, the other as from what was above man'.

The blood of Christ is also a prominent feature of a second aspect examined in this volume, 'Contemplate the wounds of the Crucified'. Here, the wounds of Christ are a sign of his suffering humanity as depicted in the tradition of affective piety, so frequently associated with Anselm of Canterbury and Bernard of Clairvaux. This is not to suggest that an emotional response was undesired in works of the first millennium, or that later works rejected the theological, doctrinal and aesthetic traditions established and often questioned by their forebears. Indeed, the second unifying element in this collection is strikingly expressed by St Augustine:

> That very thing which the proud deride in him, see how beautiful it is. By your interior illumination contemplate the wounds of the Crucified, the scars of the risen one, the blood of the dying one, the ransom of the believer, the price paid by the Redeemer.
>
> Consider how much these things are worth. Weigh them in the scale of charity.[9]

Here we encounter an early and confident advocacy of affective devotion: the believer is to engage with the crucified Christ through his or her 'interior illumination' or 'inner eyes' (*internis luminibus*) and by looking inwards to understand and perceive the exterior vision of a wounded Christ. As a result of this introspection, it is not in this case salvation that is the theologian's concern, but works and charity in conjunction with thought and consideration (demanded by the imperative *cogitate*) that are required. Augustine not only engages with the concept of the suffering and torture of the Passion (the 'cross of travail' or *croch*

9 *Illud ipsum quod in eo derident superbi, inspicite quam pulchrum sit: internis luminibus inspicite vulnera pendentis, cicatrices resurgentis, sanguinem morientis, pretium credentis, commercium redimentis. Haec quanti valeant cogitate, haec in statera charitatis appendite.* Augustine, *De santa virginitate*, chs 54–5, in *PL*, 40, col. 428; trans. from St Augustine, *Treatises on marriage and other subjects*, trans. Roy J. Deferrari (New York, 1955), p. 210.

saithir commemorated in the ninth-century Irish Stowe Missal) but also impresses upon his audience the necessity of an appropriate intellectual response.

Augustine's treatise demonstrates from an early date the importance of the humanity of Christ and the emotional effect that his suffering should have upon believers. That affective devotion and a mode of spirituality that transforms the viewer from passive witness to active participant in 'felt prayer' was not an innovation of the eleventh century but had antecedents in earlier devotional processes has been acknowledged in a number of fields.[10] In these works, the transition between non-affective and affective devotion is often defined as a movement from a 'fear-based' piety to one that is 'love-based', and within the context of the Passion, a triumphant, awe-inspiring Christ is replaced by a more compassionate, human figure whose sufferings elicit an empathetic response. Although it is not until the twelfth century and later that the highly charged depiction of 'the man of sorrows' appears, and it is certainly true that the triumph of the crucifixion is the primary concern of early medieval depictions of Christ upon the cross, to draw too sharp a line between the period before the eleventh century and after is, as the continuities witnessed across this collection demonstrate, misleading. So, for example, in one of the earliest accounts of an image of the crucifixion, in her journal of the pilgrimage that she undertook to the Holy Land, the Spanish pilgrim Egeria describes the ecstasy that the vision of Christ provokes.[11]

In the study of most regions in early medieval Europe, when affective responses such as Egeria describes are encountered in the record, they are usually marginalized or sidelined in favour of a dominant narrative that focuses upon the triumphant, glorified and public features of the crucifixion, and not without reason. For this is the prevailing image that is encountered and – as many of the contributions that follow demonstrate – one of great complexity that could be adapted and acculturated to suit the cultural context in which it appears. In Ireland, and elsewhere in what has been given the misleading label of the 'Celtic Church', by contrast, a personal and emotional spirituality has been sought at the expense of the dominant, institutional majority culture.[12] Since the eighteenth

10 It is perhaps hardly surprising that it is in Anglo-Saxon England, which produced mystical texts such as the *Dream of the Rood*, described above, that early examples of affective devotion beyond the monastery walls have been charted: see, for instance, Allen Frantzen, 'Spirituality and devotion in the Anglo-Saxon penitentials', *Essays in Medieval Studies*, 22 (2005),117–28; Scott DeGregorio, 'Affective spirituality: theory and practice in Bede and Alfred the Great', *Medieval Studies*, 22 (2005), 129–39. **11** *Egérie: Journal de voyage et lettre sur la Bse. Egérie*, ed. P. Maravel and M. Diaz y Diaz, *SC*, 296 (Paris, 1982); John Wilkinson, *Egeria's Travels* (3rd ed., Warminster, 1999). St Paula also visited the holy places and, writing approximately twenty years later, Jerome describes the emotional response that the sight of the site of Christ's last days elicits in her: Jerome, *Ep.* 46:13, *PL*, 22:490–1; *Jerome: Letters and selected works*, trans. W.H. Fremantle, *NPNF*, 6 (Peabody, 1996). **12** The existence of a Celtic Church has been questioned by, among others, Kathleen Hughes, 'The Celtic Church: is this a valid concept', *Cambrian Medieval Celtic Studies* (1981), 1–20; Wendy Davies, 'The

century, romantic interpretations, reinterpretations and misinterpretations of early medieval poetry written in the Celtic vernaculars have fuelled the construction of an image of the mystical Celt whose devotions were marked by affective piety and 'felt prayer', and who also had a special affinity with the natural world. This image of Celtic monks, far removed from the rest of the world, who were – in the words of Matthew Arnold (1822–88), one of the more prominent early champions of 'Celtic Christianity' – 'keenly sensitive to joy and sorrow' is found also in academic circles, where it continues to be used to emphasize the particularity, difference and isolation of the church in these regions.[13] Thus, Eleanor Hull, an early Irish scholar and co-founder of the Irish Texts Society, was able to write of the 'deep religious feeling of the Celtic mind, with its far-stretching hands groping towards the mysterious and the infinite' and, indeed, to contrast this image of the Celtic mind with the apparently cold-hearted religiosity of Bernard of Clairvaux:

> St Bernard walking round the Lake of Geneva, unconscious of its presence and blind to its loveliness, is a fit symbol of the tendency of the religious mind in the Middle Ages. Sin and repentance, the fall and redemption, hell and heaven, occupied the religious man's every thought; beside such weighty themes the outward life became almost negligible. If he dared to turn his mind towards it at all, it was in order to extract from it some warning of peril, or some allegory of things divine.
>
> But the Irish monk showed no such inclination, suffered no such terrors. His joy in nature grew with his loving association with her moods. He refused to mingle the idea of evil with what God had made so good. If he sought for symbols, he found only symbols of purity and holiness.[14]

The innocence and naivety attributed to the Irish monk by supporters and scholars of Irish religious writings has created a remarkably damaging legacy that has written the importance of *romanitas* and the Continental influence upon early Irish Christianity out of the historical record.[15] The contrast it establishes between St Bernard, on the one hand, as a symbol of 'the religious mind in the Middle Ages' and the Irish monk, on the other, as the Other, is reductive in a number of

myth of the Celtic Church' in Nancy Edwards and Alan Lane (eds), *The early church in Wales and the West* (Oxford, 1992), pp 12–21. The concept of 'Celtic Christianity' is challenged by Donald E. Meek, *The quest for Celtic Christianity* (Edinburgh, 2000). **13** Matthew Arnold, *The study of Celtic literature* (London, 1900), p. 84; cited in Meek, *The quest for Celtic Christianity*, p. 49. **14** *The poem-book of the Gael*, ed. Eleanor Hull (London, 1912), pp xxxvi, xx. **15** Hull's focus upon sin and repentance as a feature of Continental piety is telling, however, not only because of the large corpus of Irish penitentials and other literature concerned with sin and the end of things, but also because a concern with penance and sin has been recognized by a number of scholars as being of vital importance in the development of affective piety. Allen Frantzen, for instance, has argued in his 'Spirituality and devotion in the Anglo-Saxon penitentials' for the role of sin in establishing a sense

ways. For not only does it suggest that the symbolism of Irish monasticism was pure, holy, simple and naïve, but it also offers an utterly inadequate image of the Middle Ages as a whole, for which the (misinterpreted) spirituality of St Bernard alone is offered as a representative. The contributions offered in this volume examine depictions of the crucifixion from Ireland and also from Anglo-Saxon England, Brittany, Carolingian Francia, Spain and Italy, not in any attempt to homogenize the European experience, but rather to demonstrate how an integrated response to the Passion might further academic debate in a number of related fields. Although divided into two parts in roughly chronological order, there is no search for a singular trajectory in the development of depictions of Christ upon the cross across either time or place, but instead an acknowledgment of continuities amid change. From the various and quite different images of the crucified Christ discussed in image and text, we witness engagement in a complex discourse that spans the medieval period and beyond, and goes to the very heart of what it means to be a Christian and to the very essence of Christianity.

The quotation from Gregory Nazianzen's treatise above celebrates with wonder the salvation that the crucifixion effects, while all the time aware that God is hanging on a cross. Those standing by witness the demise of Christ's physical body, but in the commemoration of this event, enacted on Good Friday in churches throughout the West and recalled in the celebration of the Eucharist, the salvation of sinners is simultaneously called to mind. Death and life are brought together through Christ's sacrifice in an act that, while now familiar, evoked profound unease among early Christian communities and provoked scorn and condemnation among their opponents. It is the attempt of these early Christians to realign the crucifixion with contemporary artistic and aesthetic modes of expression that is the subject of Felicity Harley McGowan's essay, which considers the ways in which Christians arrived at an explicit iconography of the death of their Saviour. Harley McGowan discusses two crucifixions produced in Rome between AD420 and 430. The first appears as part of a cycle of scenes carved across four ivory panels and is especially suitable for private devotion, while the second, the famous representation on the wooden doors of the church of Santa Sabina, occupies a very public position. The different approaches adopted in public and private devotions form a recurring focus of interest throughout these essays.

In the essays by Louis van Tongeren and Celia Chazelle, for example, the public celebration of the Mass is considered as these authors move to examine in further detail the 'few drops of blood' described by Nazianzen, and the importance

of self, which through the very private process of penance is channeled towards first guilt then contrition, and finally understanding and repentance. In the penitentials, weeping is intended to elicit feelings of guilt, which in turn elicit mercy from the confessor: 'Contrition is not something that happens to the penitent but is rather an affect he or she creates, as the focus on humility and on the weeping voice suggests' (122).

of the Eucharist and Mass to medieval readings of the crucifixion (a theme picked up by Boyle and Parker in the second section). Van Tongeren traces the Western veneration of the cross on Good Friday from the fourth to the tenth century, bringing out aspects of its diversity while at the same time illustrating a gradual development towards liturgical uniformity. The Eucharist is treated further by Chazelle, who is concerned with the rituals of eating and drinking, and the influence Carolingian imperial and clerical authority exerted upon popular conceptions of the Mass. As Chazelle's work demonstrates, any attempt to standardize and homogenize the Mass was thwarted by the practical realities faced by believers on the ground, each of whom brought their own cultural needs and expectations to the private and public celebration of Christ's sacrifice. Carolingian readings of the crucifixion form the starting point for Richard Hawtree's contribution, in which he views Eriugena's striking imagery of the cross in relation to the theological complexities of the Insular commentary tradition. Hawtree's work brings together Continental and Insular readings of the Passion as he contends that Eriugena's poem is as much a summation of Insular theological values as an attempt to champion the most recent Carolingian ideals.

A number of essays in *Envisioning Christ on the Cross* explore the intersection between image and text. So, for example, Kitzinger considers the way in which a manuscript diptych coordinates content with composition so as to emphasize the union of history and liturgy, and the role of the Church in the continuation of both. In another essay devoted to manuscript illustration, O'Reilly examines the importance of sight and the gaze to the image of Christ and his physical presence upon the cross. The theme of presence and absence, the hidden and the revealed, is taken up by Neuman de Vegvar in her analysis of the Blythburgh Tablet, an ivory artefact that she argues functioned as part of a liturgical diptych, with five rivets to represent the wounds of Christ. It is suggested that the Blythburgh Tablet ties into a long tradition of the crucifixion as a focus for meditation, prompting reflection upon the reality of Christ's suffering, even when his *corpus* is not present. The absence of the body of Christ and depictions of the crucifixion as opposed to the cross in the Asturian kingdom are examined by García de Castro Valdés. Here, the estrangement of Spanish iconographic traditions from crucifixion iconography is accounted for not by reference to Adoptionism or Arianism as has previously been suggested, but rather by the importance of the cross as an intercessory and apotropaic sign that presages the *parousia* and the Last Judgment.

In the second section of this volume, the authors continue to engage with issues examined in the first, but the works with which they are concerned were constructed, commissioned or composed to demonstrate a more explicit engagement with the affective potential of the crucifixion and the effect of considering the wounds of Christ. Boyle considers the Eucharist within the context of the

works of the Irish poet Echtgus Úa Cúanáin, and argues that Echtgus was familiar not only with the theological writings of Paschasius Radbertus but also with the works of the Anglo-Norman Lanfranc and should be viewed within the wider context of contemporary English and Continental Christology. Her work thus provides a textual complement to the later essay by Munns, in which Anglo-Norman art is related to theological doctrine. Using the writings of Anselm, and the diocesan context of the dedication of Norwich Cathedral in 1096, Munns probes the sophisticated Trinitarian theology revealed in the wall paintings at the church of St Mary, Houghton-on-the-Hill, Norfolk, which he re-dates to the period *c.*1091–1100.

The importance of viewing Insular material within the context of Continental works is argued by a number of contributors, including Mullins in her examination of *imitatio Christi* in the Middle Irish passions and homilies preserved in the fifteenth-century Leabhar Breac. This manuscript opens with an account of a *Passio imaginis*, which, in the words of Augustine, encourages its reader/audience to ponder the fact that, upon the cross, Christ's 'whole body is displayed for your redemption'. The *Passio imaginis* forms a notable thematic link with the work of Bacci on the *Volto Santo* image and Camps' essay on the Catalan majestats, and functions to underline the importance of the fruitful contact between art historians and textual scholars that this publication promotes. As in the material presented in the first section of the book, the crucifixion is viewed as a victory, and often aligned, as both Bacci and Camps demonstrate, with earthly victories (over the Iconoclasts in the East, for example). At the same time, the images inspired by the *Volto Santo* draw the gaze of those looking on not only outwards to the appearance of Christ upon the cross, but also inwards to their own souls and salvation.

Murray and Ní Ghrádaigh offer essays devoted to Irish material that complement the Continental perspective offered by Bacci and Camps, again demonstrating the importance that material culture bears for a broader understanding of theology, ritual and function. Ní Ghrádaigh explores those aspects of twelfth-century Irish crucifixion iconography that situate the Irish tradition firmly within a Romanesque stylistic context. Murray's essay offers a focused examination of eight crucifixion plaques, which he suggests were originally attached to large wood and metal altar crosses, and reassesses the criteria by which they have been grouped. By positing such a function for these objects, Murray's essay gestures towards the wider liturgical context of crucifixion iconography, a subject approached in Bacci's essay and in a number of subsequent contributions.

Schüppel, for example, considers the liturgical and paraliturgical uses of medieval painted crosses in the Italian peninsula from the twelfth century. Like Murray, she is interested in 'decentralization' and her essay directs scholarly

attention away from the famous productions of the Umbro-Tuscan school towards striking examples of *croci dipinte* from southern Italy. Parker also explores the liturgical context of a 'suffering' Christ, as depicted through the sculptural artistry of Antelami's Parma Deposition. By comparing the early medieval commentary of Amalarius of Metz with the single surviving fifteenth-century witness to the Parma rite, the *Ordinarium Ecclesiae Parmensis*, Parker reconstructs the liturgical context for this important twelfth-century sculpture and emphasizes once again the central relationship between image and text.

The Passion, as its name indicates, focuses upon the suffering of Christ and his humanity; at the same time, believers are invited to look forward with hope to the resurrection, when the divinity of Christ and his victory over death will be revealed. This dual vision is reflected in the complex early medieval representations of Christ on the cross. Throughout *Envisioning Christ on the Cross*, the contributors concentrate upon the dynamic relationship between the image of Christ upon the cross and the textual traditions – liturgical, theological and poetic – that transmitted such a rich diversity of approaches to the crucifixion throughout the early medieval West. Amid such variety, this volume shows that those responsible for the textual and material culture of the Middle Ages never forgot the importance of Christ's sacrifice and its paradoxical relationship with his divine triumph. Out of this awareness, writers and artists from Cork to Parma and beyond shaped a theological debate that remains central to the Western intellectual experience and continues to inspire devotional reflections centred upon the vision of Christ upon the cross.

PART I

God hanging from a cross

The Maskell Passion Ivories and Greco-Roman art: notes on the iconography of crucifixion

FELICITY HARLEY MCGOWAN

The execution of Jesus of Nazareth in the first century AD lies at the heart of the Christian faith; and the instrument of his death, the cross, remains the pivotal and universally recognized symbol of the Christian church.[1] Yet in stark contrast to this theological and visual centrality, images of Jesus' death are conspicuously rare prior to the sixth century and seem not to have formed a visual focus for Christians in late antiquity.[2]

In this essay, I will briefly examine the earliest known depiction of the crucifixion in a narrative context – that is, the first known representation of Jesus affixed to a cross that occurs as part of a pictorial narration of his arrest, death and resurrection. This image appears within a Passion narrative illustrated across a series of four ivory panels that are known collectively as the Maskell Passion Ivories. Produced around AD420–30, possibly in Rome, the panels are carved in

1 My thanks are due to the conference organizers for the kind invitation to speak; David Woods and the Department of Classics at University College Cork for sponsoring my participation; Christopher Entwistle for facilitating my ongoing work on the Maskell Passion Ivories at the British Museum; and Andrew McGowan for his comments on this essay. Although it presents aspects of research in progress, the essay is dedicated to Professors Elizabeth McGrath and Charles Hope, who inspired my interest in the survival of the Classical tradition and who both retired from their positions at the Warburg Institute in the year in which this paper was presented. **2** A fact noted by art historians and theologians alike: including Massey H. Shepherd Jr, 'Christology: a central problem of early Christian theology and art' in Kurt Weitzmann (ed.), *Age of spirituality: a symposium* (New York, 1980), p. 112; Anna Kartsonis, *Anastasis: the making of an image* (Princeton, 1986), pp 33–9; Robin Jensen, *Understanding Christian art* (London, 2000), pp 130–55. See also Felicity Harley, 'Images of the crucifixion in late antiquity: the testimony of engraved gems' (PhD, University of Adelaide, 2001), the conclusions of which are summarized in Felicity Harley, 'The Constanza Gem and the development of crucifixion iconography in late antiquity' in Chris Entwistle and Noel Adams (eds), *Gems of heaven: recent research on engraved gemstones in late antiquity, AD200–600* (London, 2011). A

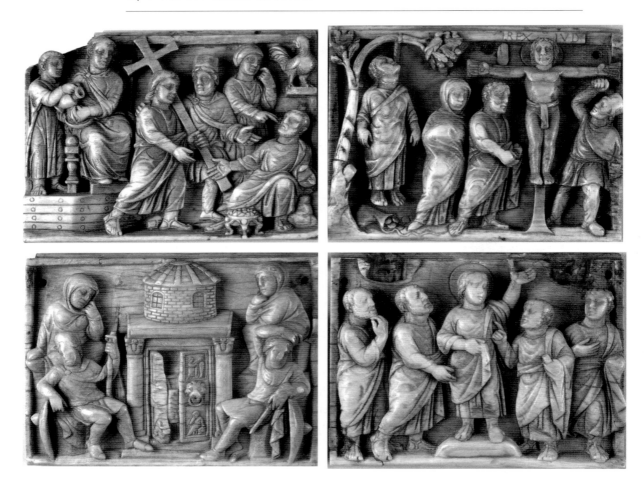

1.1 Maskell Passion Ivories: four ivory plaques with the Passion and resurrection of Christ. Rome(?), c.AD420–30. Each panel measures approximately 7.5 by 9.8cm. British Museum: Department of Prehistory and Europe, MME 1856.06–23.4–7. From the collection of William Maskell (© image courtesy of the Trustees of the British Museum).

high relief with a cycle of seven episodes from Jesus' Passion (fig. 1.1).[3] The narrative begins on the first panel with Pilate washing his hands, Jesus carrying his own cross, and the denial of Peter. The second panel depicts the suicide of Judas alongside Jesus' crucifixion. The third panel features the women at the empty tomb; and the fourth illustrates the appearance of the risen Jesus to his disciples, incorporating the doubting of Thomas. The scene of the crucifixion as illustrated on the second panel within this cycle is an historically important image in its own right (fig. 1.2); nonetheless, in this visual context, it forms an integral part of what is a highly sophisticated interpretation of Jesus' death and resurrection.

forthcoming monograph will treat the subject in detail. **3** British Museum, MME 1856:06–23:4–7. From the collection of William Maskell (1814–90). Ormond Maddock Dalton, *Catalogue of the ivory carvings of the Christian era* (London, 1909), pp xvii, xviii. For bibliographies, see Dalton, *Catalogue of early Christian antiquities and objects from the Christian East in the Department of British and mediaeval antiquities and ethnography of the British Museum* (London, 1901), cat. no. 291, pp 49–50; and Felicity Harley in *Picturing the Bible: the earliest Christian art*, ed. Jeffrey Spier (New Haven, CT, 2007), cat. no. 57, pp 229–32.

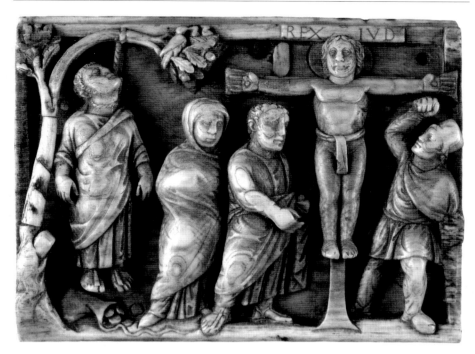

1.2 Suicide of Judas and crucifixion of Jesus: the Maskell Passion Ivories: second panel (© image courtesy of the Trustees of the British Museum).

I will be concerned here to observe ways in which the artist's use of visual tropes from Greco-Roman art facilitated both the visual narration of the crucifixion, faithful to details recorded in the Gospel accounts, and an interpretation of that event coherent with contemporary thought regarding the crucifixion and resurrection as a triumph.

THE MASKELL PASSION IVORIES

The consistent size, shape and structure of the four rectangular panels indicate that although now separated, they originally served as the sides of a small square casket. Each measures approximately 7.5 by 9.8cm, has a groove along its bottom edge to enable insertion into a base, and is rebated at the top to receive a lid. Although the lid, along with the base, is now lost, semi-circular excisions near the upper edge of the fourth (back) panel suggest that it was originally attached by two hinges, while marks near the top of the second (front) panel suggest that it was secured by a latch. In form and function, this reconstructed casket can be compared to those surviving intact in Brescia[4]

4 The Brescia Casket, provenance unknown: AD380s, northern Italian(?), ivory. H. 21.2cm, with lid 24.7cm; W. 31.6cm; D. 22cm. Brescia, Museo Cristiano, inv. avorio 1. Catherine Brown Tkacz, *The key to the Brescia Casket: typology and the early Christian imagination* (Paris and South Bend, IN, 2001), with discussion of the date p. 19, nn 1, 2. See also Bente Kiilerich, *Late fourth-century classicism in the plastic arts: studies in the so-called Theodosian Renaissance* (Odense, 1993), pp 220–1.

and Venice.[5] Like those caskets, dating from the late fourth and early/mid-fifth centuries respectively, it is likely to have contained sanctified matter related to and used in a liturgical context: a relic (perhaps relating to the Passion, in view of the subject matter), or a portion of the consecrated host.[6] As Elsner has highlighted, such boxes were small enough to be handled by a single person, so that the chief face to be viewed was the top, the lid.[7] This point has an important bearing on the understanding of the iconographic programme across the Maskell Ivories and I raise it not to hypothesize here about the likely subject that featured on the now-lost lid,[8] but to emphasize the unified relationship of the narrative sequence that unfolded across the side panels of the original casket.

Although nothing specific is known about the provenance of the reliefs, various scholars have noted the classicizing style on which they draw, including the rendering of drapery, the gestures, and strong modelling of the human form in the depiction of Jesus' crucified body.[9] Both this style and the technical standard have seen the panels firmly aligned with ivory diptychs commissioned in the late fourth and early fifth centuries by the wealthy Roman senatorial classes[10] to commemorate both private events (such as marriages or deaths)[11] and public events (primarily appointments to the position of consul).[12] These diptychs are often inscribed with the names of those who commissioned them, and can be assigned a specific centre of production on account of historical data in addition to stylistic evidence.[13] They thereby provide an important chronological frame-work within which to date Christian ivories, and suggest possible places of manufacture. Indeed, on account of such comparisons with datable ivories produced in Roman ateliers, the Maskell Ivories are customarily dated around

5 The Pola Casket, discovered at Samagher (near Pola, Croatia): *c.*AD450(?), Rome(?), ivory. H. (with lid and feet) 18.5cm; W. 20.5cm; D. 16.1cm. Venice, Museo Archeologico, inv. avorio 279/52. Davide Longhi, *La capsella eburnea di Samagher: iconografia e committenza* (Ravenna, 2006). **6** Dalton, *Catalogue of the ivory*, pp xxii–xxiii. **7** Jaś Elsner, 'Framing the objects we study: three boxes from late Roman Italy', *JWCI*, 71 (2008), 21–38 at 31. **8** Frederick Gerke's theory that the ascension, or a scene of Jesus as ruler of the universe (such as a *Maiestas Domini*, or the *traditio legis* as on the lid of the Pola Casket) might have appeared on the missing casket lid, remains attractive and is worthy of further consideration in the context of a broader examination of the series as a whole: 'Die Zeitbestimmung der Passionssarkophage', *Archaeologiai Ertesito*, 52 (1940), 46. **9** Including Eduard Dobbert, 'Sitzungen der archäolischen Gesellschaft in Berlin: Sitzung vom 2. Mai', *Archäologische Zeitung*, 34 (1876), 42, and Ernst Kitzinger, *Byzantine art in the making* (Cambridge, MA, 1995), pp 47–8, who notes that the artist 'clearly was rooted' in the classicizing style manifest in ivories produced in the West *c.*400, but that the ivories present a changing style in which the figures are 'heavier'. **10** For example, Liselotte Kötzsche in Kurt Weitzmann (ed.), *Age of spirituality: late antique and early Christian art, third to seventh century: catalogue* (New York, 1979), cat. no. 452, p. 503. Kiilerich refutes this alignment: *Late fourth-century classicism*, pp 158–9. **11** For example, the Nicomachorum–Symmachorum diptych, interpreted as commemorating a marriage, but possibly a death: Kiilerich, *Late fourth-century classicism*, pp 144–9. **12** Richard Delbrueck, *Dittici Consolari Tardoantichi* (Bari, 2009), with chronological table, pp 163–7; Kiilerich, *Late fourth-century classicism*, pp 136–59. **13** Kiilerich, *Late fourth-century classicism*, p. 209.

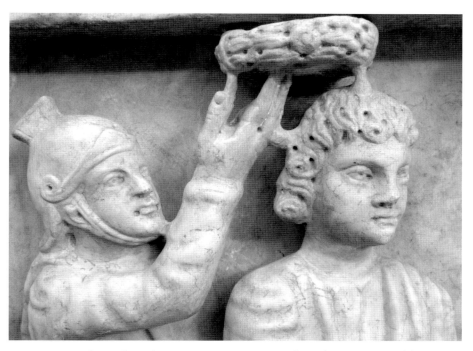

1.3 Jesus being crowned with 'thorns': detail from a Sarcophagus with scenes of the Passion. Roman, c. 350. Marble. Musei Vaticani: Museo Pio Cristiano, inv. 31525 (photograph by the author).

AD420–30 and attributed to a Western centre of production, possibly Rome, although the lack of certainty should be noted.[14]

Features of the Maskell Ivories can be related to the widespread emergence across the late fourth and early fifth century of a range of classicizing styles in both Christian and pagan art that involved the adoption of stylistic formulae or formal properties of the classical language.[15] Artists working in different ateliers in different regions in the empire – from Rome to Milan, Alexandria and Constantinople – catered to commissions from Christians as well as others, and so drew on common artistic sources in the service of scenes connected both with the Gospels and with traditional Roman religion.[16] As will be noted below, while the iconographic language utilized across the Maskell Passion Ivories betrays the artist's facility with Greco-Roman visual tropes, the shorter and stockier characteristics of the figures is just one indication that the panels represent what Kiilerich has seen

14 Kötzsche in *Age of spirituality: catalogue*, pp 502–4; Harley in *Picturing the Bible*, p. 229. In the absence of inscriptions, style is an essential tool in dating Christian ivories: Kiilerich, *Late fourth-century classicism*, pp 158–9. In some cases, such scientific methods as radiocarbon analysis have been used: Paul Williamson, 'On the date of the Symmachi Panel and the so-called Grado Chari Ivories' in Chris Entwistle (ed.), *Through a glass brightly* (Oxford, 2003), pp 47–50. 15 Kiilerich, *Late fourth-century classicism*, pp 190–1. While the term 'pagan' is problematic, it is used in this essay for convenience. A short précis of objections to the label is given by Neil McLynn, 'Pagans in a Christian empire' in Philip Rousseau (ed.), *A companion to late antiquity* (Maldon, 2009), p. 573. 16 Style thus transcends religious distinctions at this period: Kiilerich, *Late fourth-century classicism*, pp 191, 217.

as a tapering away of the classical impulse that had been at its height in Rome in the late fourth century.[17]

PASSION ICONOGRAPHY IN LATE ANTIQUE ART

While the story of Jesus' death and resurrection came to have pre-eminence in Christian art after the sixth century, the earliest Christian images centred on salvation, deliverance from death and the hope in resurrection to new life that belief in Christ promised. This is shown in the first distinctly Christian images as they began to appear around AD200,[18] through to the fourth century when a wider range of episodes from Jesus' life, including his Passion, began to be illustrated.[19] The new subjects remained faithful to the focus on deliverance and triumph, sometimes by adopting and adapting classical models for the representation of victory and power, including key elements of contemporary imperial iconography.[20] So the first event of the Passion, Jesus' entry into Jerusalem (Mk 11:1–11), could be modelled iconographically and thematically on depictions of the emperor's ceremonial entry into the city in late antiquity, the divine power of Christ thereby equated with that of the emperor.[21] Likewise, Jesus' humiliating crowning with thorns (Mk 15:16–17 and parallels) could be transformed into a ceremonial one (fig. 1.3) through appropriation of imperial iconography in which the corona civica indicated the supreme rule of a Roman emperor (fig. 1.4).[22] As Samuel Brandon thus observed, it is not so much the rarity of references to the Passion of Christ in the earliest Christian art that is striking, as 'its curious transformation': Christ is not the suffering figure so vividly described in the Gospels, but a serene Greco-Roman hero.[23]

17 The ivories can thus be associated with the gradual decline in artistic standards following the sack of Rome in 410: on this change, see Kiilerich, *Late fourth-century classicism*, pp 194–5. **18** No securely datable and recognizably Christian art survives from before this time, and archaeological and literary evidence that might furnish a clearer understanding of the origins and nascent development of specifically Christian images is scarce: *Picturing the Bible*, pp 1–23, esp. pp 4–6 (Jeffrey Spier), 51–63 (Mary Charles Murray). **19** Felicity Harley, 'The narration of Christ's Passion in early Christian art' in John Burke, with Ursula Betka, Penelope Buckley, Kathleen Hay, Roger Scott and Andrew Stephenson (eds), *Byzantine narrative: papers in honour of Roger Scott* (Melbourne, 2006), pp 221–32. **20** Johannes G. Deckers in *Picturing the Bible*, pp 105–6 **21** Deckers, *Picturing the Bible*, p. 105. A fine and well-known example occurs on the marble sarcophagus of Junius Bassus, Rome, *c.*AD359, Vatican Museums, Museo Historico e Artistico: Elizabeth Struthers Malbon, *The iconography of the sarcophagus of Junius Bassus* (Princeton, NJ, 1990), pp 53–4, fig. 43. **22** See the crowning of Augustus in the upper register of the Gemma Augustea: after AD10, Roman, two-layered onyx, H. 19cm. Kunsthistorisches Museum, Vienna, inv. no. IX A79. The oak wreath, traditionally associated with military feats, was transformed into a crown with royal associations: Paul Zanker, *The power of images in the age of Augustus*, trans. Alan Shapiro (Ann Arbor, MI, 1988), pp 92–4. **23** Samuel G.F. Brandon, 'Christ in verbal and depicted imagery' in Jacob Neusner (ed.), *Christianity, Judaism and other Greco-Roman cults: studies for Morton Smith at sixty, pt 2: early Christianity* (Leiden, 1975), pp 169–70.

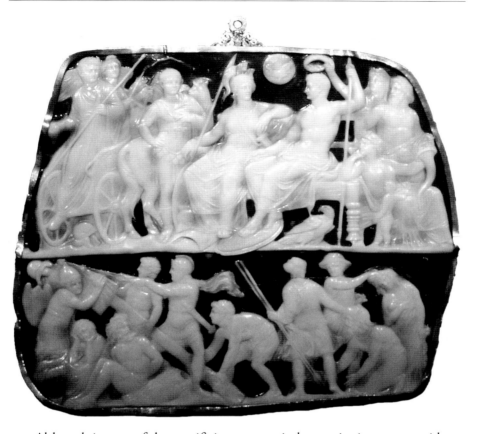

1.4 Gemma Augustea. Roman, after AD10 (seventeenth-century setting). Low relief cameo, two-layered Arabian onyx stone, H. 19cm. Kunsthistorisches Museum, Vienna, AS inv. no. IX A 79 (photograph by Gryffindor, Wikimedia Commons User).

Although images of the crucifixion are rare in late antiquity, extant evidence suggests that, as early as the third century, attempts were made in different parts of the empire to illustrate and express visually its interpretation as a triumph.[24] On engraved gems in the fourth century, this took the form of experimentation with the depiction of the veneration of the cross, highly popular on contemporary sarcophagi and itself an adaptation of iconographic precedents for the representation of the emperor amid his retinue.[25] Such iconography emphasized Christ's authority: the crucified and risen Jesus, standing unmoved against the cross in the midst of a highly symmetrical procession of apostles, receives the ceremonial adoration of the apostles in heaven. In this way, early experimentation with the depiction of the crucifixion focused on Christ's victory after the resurrection and had broader eschatological implications rather than merely referring to the historical event.

24 For the evidence, including engraved gems, and its interpretation, see Harley, 'The Constanza Gem', passim. The early date was raised as early as 1964 by Philippe Derchain, 'Die älteste Darstellung des Gekreuzigten auf einer magischen Gemme des 3. (?) Jahrhunderts' in *Christentum am Nil* (Recklinghausen, 1964), pp 109–13. See now Jeffrey Spier, *Late antique and early Christian gems* (Wiesbaden, 2007), pp 73–5. 25 Marion Lawrence, 'Columnar sarcophagi in the late West:

The Maskell Passion Ivories show that in the following century, classical precedents remained integral in the visual interpretation and presentation of the crucifixion as a triumph. Lieslotte Kötzsche has demonstrated the acquaintance with and ease in drawing on classical types for the representation of Christian stories regarding the depiction of the mourning women at the empty tomb on the third panel in the series.[26] Indeed, as a whole, the cycle of the Passion as it is depicted across the four ivories is peppered with pictorial types drawn from an established classical iconography, making evident the carver's familiarity with the pictorial conventions of antiquity and the ongoing visual currency of these types – given that the impact of the symbolism utilized in this Christian context would be heightened by the viewer's own recognition of their meaning in a classical context.[27] Here it will suffice to examine several iconographic precedents key to the presentation of the crucifixion scene.

THE ICONOGRAPHY OF THE CRUCIFIXION PANEL

The image of the crucifixion included on the second panel in the Maskell series is the first of only two representations of the subject to survive from the fifth century. The second, slightly later, depiction survives within the large cycle of scenes from the Old and New Testaments carved on the wooden panels affixed to the doors of the church of Santa Sabina in Rome, dated around 432.[28] The ivory panel's iconography is similar to that image, and to the fourth-century versions preserved on engraved gems, in the representation of Jesus alive, naked and vigorously upright. However, there are also fundamental compositional differences. For example, the Maskell depiction is unique in late antiquity in its immediate contrast of Jesus' death with that of Judas, and in the presentation of certain details ostensibly pertaining to narrative but having a symbolic function, such as Judas' purse, the oak tree from which he hangs and the clothing of the Roman soldier.

ateliers, chronology and style', *Art Bulletin*, 14:2 (1932), 112–15; Guntram Koch, *Frühchristliche Sarkophage* (Munich, 2000), pp 315–16. **26** Lieselotte Kötzsche, 'Die trauernden Frauen: Zum Londoner Passionskästchen' in David Buckton and T.A. Heslop (eds), *Studies in medieval art and architecture presented to Peter Lasko* (Stroud, 1994), pp 80–90. The cock on the first panel may also represent an adaptation of pagan iconography: Alexander Coburn Soper, 'The Latin style on Christian sarcophagi of the fourth century', *Art Bulletin*, 19:2 (1937), 199, n. 142. **27** I hope to examine this further in a forthcoming study. See Ruth Leader-Newby, 'Personifications and *paideia* in late antique mosaics from the Greek East', *Personification in the Greek world: from antiquity to Byzantium* (Aldershot, 2005), pp 231–46, who proposes a kind of 'visual literacy' in late antiquity with regard to pictorial conventions of classical art, arguing that *paideia* may have 'provided implicit training in ways of looking at and interacting with art', p. 236. **28** Gisela Jeremias, *Die Holztür der Basilika S. Sabina in Rom* (Tübingen, 1980), pp 60–3, pl. 52; Jean-Michel Spieser, 'Le programme iconographique des portes de Sainte-Sabine', *Journal des Savants* (janvier–juin 1991), 47–81. For the date, see Hugo Brandenburg, *Ancient churches of Rome* (Turnhout, 2005), p. 167.

Reading the scene from left to right, the viewer's eye is immediately drawn into the crucifixion narrative by the arching shape of a gnarled and leafy oak tree,[29] which reaches over into the composition to form a canopy for the dead body of Judas hanging from its branch, and a home for a bird and its young, nesting in the foliage. Judas' neck is broken in the noose, the dead weight of his head causing it to roll backward and his eyes to close. His limbs hang limply. Beneath his feet, Judas' coin purse is seen to have fallen to the ground where it disgorges the silver coins paid to him for his betrayal of Jesus to the chief priest (Mt 26:14–16).[30] Although Judas was the holder of the common purse (Jn 12:4–6, 13:29), the coins and pictorial context clearly indicate that this detail should be read as a symbol of both avarice and betrayal, qualities that led to his suicide.[31] A woman and a man process away from the tree, towards the cross; from Jn 19:25–7, we take them to be Jesus' mother, Mary, and his beloved disciple John.

Mary and John approach Jesus slowly, a pair bound in their shared mourning, with eyes cast down and averted from the cross. The figure of Jesus upon that cross is alive, having open eyes, a muscular and taut physique, with feet voluntarily and firmly flexed upwards without the support of a *suppedaneum*. Jesus' body, thus radiating energy, is in stark contrast with that of Judas, whose lifeless limbs hang beneath his subsequently shapeless tunic, his own feet drooping. Over Jesus' head is inscribed REX IUD(aeorum), 'King of the Jews' (Mk 15:26). At the far right of the scene, in a fine example of the carver's technical dexterity, a soldier lunges vigorously into the foreground in order to pierce Jesus' side with a lance (Jn 19: 34–5). As a result of the high relief, and fineness of detail, the lance is now broken; however, the stump of the weapon can be seen in the soldier's fist, and the wound it made can be seen in Christ's side.

Undoubtedly, although placed off-centre, the focus of the crucifixion scene is the figure of Jesus, presented in a conspicuously open and powerful posture – with limbs unfurled against the cross beams. Aside from this visually striking pose, various compositional elements conspire to draw our gaze directly to the cross. The contrasting diagonal lines created by the downcast eyes of Mary and John, and the upturned face of the soldier is one example, highlighting the intensity with which Jesus stares unblinkingly out of the image. Another contrast is that of motion: between the restrained walking pace of the mourners, and the violent action of the soldier. Indeed, the manner with which the artist handles Jesus and his cross within the scene, inserting it into this carefully constructed composition, deter-mines the success with which the notion of triumph is conveyed even before the

29 From the mid-vein and lobed shape of the broad, thin and flat leaves, plus the presence of acorns, this can be taken to be an oak. **30** Matthew refers specifically to thirty pieces of silver as the sum given by the chief priests; Luke (22:1–6) refers only to money. See also Mt 27:6–9. **31** Such a bag (larger) appears on the back middle panel of the Brescia Casket, where it aids the identification of that scene as the judgment of Peter over Ananias and Sapphira (Acts 5:1–11): for the scene, see

viewer moves onto the resurrection scenes. We know that Jesus has defeated death before the empty tomb is shown.

In the representation of Mary veiled, wrapped tightly in her *maphorion*, the artist makes use of a recognizable pictorial tradition in ancient funerary art for the depiction of one in mourning: with head bowed, eyes downcast, physically turned in on herself, and having a measured gait (fig. 1.2).[32] The figure of John also replicates this type with respect to the downward gaze, and the angle and alignment of the right leg and foot, which, like that of Mary, is shown to trail gracefully behind him. This latter device acts to further slow the pace and distinguishes John's posture from that adopted by Jesus on the first panel (carrying the cross), and from the disciple on Jesus' right on the final panel (approaching the risen Jesus), whose actions are more energetic. In addition, we can observe that John's right palm is closed, which helps to mark him out in this scene as a figure of reflection, full of introspection as befits one in mourning.[33]

The vigorous act of the Roman soldier at the far right of the scene contrasts physically and theologically with the sorrowful introspection of Mary and John. By his act, he treats Jesus as a human criminal; in comparison, Mary and John may mourn his death, but they also honour his divinity. These distinctions further accentuate the dominance of the athletic figure of Jesus, unmoved by the action of the soldier beside him, and placed high up on the cross – raised into a higher pictorial space, and thus into a higher symbolic realm, than any other figure on this panel.

The soldier's pose can be readily compared with classical models in imperial as well as private funerary art for the depiction both of soldiers and of mythical heroes enacting deeds of violence. A fine comparison occurs on the Gemma Augustea, the large cameo dating from the last years of Augustus (fig. 1.4). In the left-hand corner of the lower register, a Roman soldier is depicted lunging into the foreground as he steps around not the victorious cross of Christ, but its pictorial antecedent in Greco-Roman art: an imperial victory trophy.[34] Various imperial monuments, including the Column of Trajan, illustrate the range of iconographic

Tkacz, *The key to the Brescia Casket*, p. 223. **32** For stock poses of mourning women in funeral procession, the so-called 'Mourning women' sarcophagus, *c.*350BC, in the Istanbul Archaeological Museum, furnishes numerous examples: Martha E. Weller, 'The procession on the Sarcophagus of the mourning women', *California Studies in Classical Antiquity*, 3 (1970), 219–27; Robert Fleischer, *Der Klagefrauensarkophag aus Sidon* (Tübingen, 1983). On the influence of earlier pictorial traditions on the representation of women in distress or mourning in early Christian art, see Nurith Kenaan-Kedar, 'The new images of women in early Christian art', *Assaph*, 2 (1996), 83–92. **33** As opposed to excessive displays of mourning, such as were discouraged by John Chrysostom in the late fourth century: *Homily on First Corinthians* 28:3 (*PG*, 61, 235); Jaclyn L. Maxwell, *Christianization and communication in late antiquity* (Cambridge, 2006), pp 160, 81–2. **34** Gemma Augustea. The literature is extensive; however, regarding imperial symbolism and Augustan art, see J. Pollini, 'The Gemma Augustea: ideology, rhetorical imagery and the creation of a dynastic narrative' in Peter

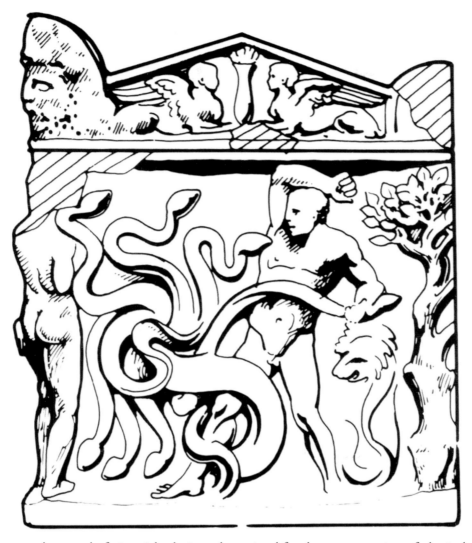

1.5 Hercules attacking the Lernian Hydra: right short side of a Sarcophagus with the Labours of Hercules. Roman, AD150–170/80. Proconnesian marble (chest), carrara marble (lid). British Museum, inv. GR 1878.8–20.160 (image courtesy of Susan Bird, British Museum).

precedents and of pictorial solutions that existed for the representation of physical actions in historical battles.[35] The same movement is seen in a private funerary context, struck by the figure of Hercules attacking the Lernian Hydra on the right short side of a late second-century Roman sarcophagus in the British Museum (fig. 1.5): just as the soldier steps around from behind the cross on the ivory, leaning onto his left leg while lifting his right arm to raise and thrust the lance, around which his fist is wrapped, so the young and beardless hero Hercules steps around the Hydra and raises his right arm with clenched fist.[36]

Holliday (ed.), *Narrative and event in ancient art* (Cambridge, 1993), pp 258–98. **35** Salvatore Settis, *La Colonna Traiana* (Torino, 1988). **36** Frieze sarcophagus depicting the Labours of Hercules: AD150–70/80, Roman, Proconnesian marble (chest) and Carrara marble (lid). L. 227cm;

While the soldier strikes a pictorial type familiar for the representation of a violent deed, and while Mary and John have a powerful resonance for the viewer as Romans in conventional postures of mourning, in the Christian pictorial and narrative context these figures take on specific identities. The soldier who pierces Christ's side is not just any athletically able Roman soldier: he is the one who witnesses Jesus' death. Moreover, wearing the short cylindrical hat (*pileus*), he is marked as a member of the Roman military elite. Beat Brenk has argued that the *pileus* was specifically worn by those officers who had a role in the persecution of Christians; hence in early Christian iconography, it was not merely symbolic of a soldier's role, but was intended to have a broader didactic function about the history of Christians.[37] Similarly, while the mourning couple imbue the scene most effectively with profound emotion, these are no ordinary mourners: the woman is the mother of the crucified, and the man is the disciple Jesus loved. The artist thus incorporates pagan visual tropes and explicitly Christian content: the pre-existing iconographic forms are recognizable to the viewer as stock symbols of violence or mourning and yet, simultaneously, have recognizable Christian identities.[38]

For the figure of Judas, iconographic precedents are more complex to isolate.[39] With no extant examples in Greco-Roman art of suicide by hanging, the artist might be assumed to rely more heavily on biblical textual details.[40] The two accounts in the New Testament present contrasting versions of how Judas died. Perhaps the earliest is that in the Gospel of Matthew (27:3–5), which records that Judas hangs himself and implies that this was a result of his remorse. In the other, probably later, account (Acts 1:16–20), Judas dies after a violent fall. While it is doubtful whether either version contains historically reliable detail,[41] on the few occasions that the subject was illustrated in Christian art before the sixth century, the hanging version appears in all instances: in a short narrative of the Passion on a Roman sarcophagus in Arles (second third of the fourth century);[42] on a back

H. 97cm; D. 82cm. London, British Museum, inv. GR 1878:8–20:160. It is said to have been found in the ruins of an ancient tomb near the Via Appia, Rome. Susan Walker, *Catalogue of Roman sarcophagi in the British Museum* (London, 1990), pp 22–3, pl. 6 (15a–c), fig. 4E2. Peter Jongste, *The twelve labours of Hercules on Roman sarcophagi* (Rome, 1992), no. B3, pp 48–52 – with photographic reproduction of the front of the sarcophagus at fig. 9, and of the right short side at fig. 10. **37** Beat Brenk, 'The imperial heritage of early Christian art' in *Age of spirituality: a symposium*, p. 40 **38** I take this point from Kenaan-Kedar, 'The new images of women', p. 86, where she discusses depictions of the holy women at the tomb on early Christian ivories. **39** I provided preliminary findings of an ongoing study of the iconography of Judas' suicide in late antiquity as a plenary paper at the sixth annual conference of the Australian Early Medieval Association, Monash University, 1 Oct. 2009: 'Hanging by a thread: Judas' suicide in early medieval art'. **40** While suicide by hanging is not uncommon in Greek myth, in reality it was regarded with contempt, particularly in the Roman world. I have yet to find an example in Greco-Roman visual art. The authoritative study of ancient suicide is Anton J.L. van Hooff, *From autothanasia to suicide: self-killing in classical antiquity* (London and New York, 1990), with discussion of self-hanging pp 64–72. **41** J. Rendel Harris, 'Did Judas really commit suicide?', *American Journal of Theology*, 4 (1990), 490–513. **42** Brigitte

1.6 Woman seated in mourning beside tomb: left short side of a Sarcophagus with Myth of Meleager. Roman, AD160–70, marble. From the collection of Sir John Dashwood, West Wycombe Park, Buckinghamshire (image courtesy of the Warburg Institute, Photographic Collection).

panel of the ivory Brescia Casket (c.380s);[43] and the most detailed instance, this Maskell crucifixion panel.[44] The representations on the Brescia Casket and Maskell Ivories both adhere to a specific iconographic type: Judas fully clothed in a tunic and toga, his limbs falling lifelessly, a rope tied around his neck, suspended from the branch of a tree, the branch arching over due to his dead weight.[45]

While the artist of the Maskell Ivories is clearly familiar with an established iconographic convention for the depiction of Judas' death, certain elaborations are made to the scene that enable a refinement of the interpretation of the event. Most notable are the addition of the purse at Judas' feet, and the inclusion of a bird and its young nesting in the oak tree. As noted above, the coin purse functions as a symbol of Judas' betrayal. The tree with its bird and nest, however, is a more

Christern-Briesenick, *Repertorium der Christlich-Antiken Sarkophage, bd III: Frankreich, Algerien, Tunesien* (Mainz am Rhein, 2003), no. 42, pp 29–31, taf. 15,3–5. Only fragments of the original frieze survive, and not enough to speak with specificity about the original Judas iconography. **43** Tkacz, *The key to the Brescia Casket*, p. 41. **44** The suicide is also mentioned by the Spanish poet Prudentius (b. 348) in his *Dittochaeon* (39), c.AD400. Containing forty-eight quatrains that may have been intended as captions for a cycle of illustrations, the work may testify to the depiction of the subject in other visual contexts in the late fourth/early fifth century. For the dating of the work, and an analysis of each quatrain (with iconographical description): Renate Pillinger, *Die Tituli Historiarum oder das sogenannte Dittochaeon des Prudentius* (Vienna, 1980). **45** While there are no acorns, the flat leaves of Judas' tree as depicted on the Brescia Casket appear to have the mid-vein and lobed margin of oak leaves, as carved more clearly, with accompanying fruit, on the Maskell

interesting and complex feature, and as with the mourning figures and the soldier, is a recognizable classical symbol brought into this narrative context and thereby infusing it with particular meaning. For, as well as being integral to the narrative, being the means by which Matthew's version of Judas' death could be illustrated, the tree-bird motif had an important role in Greco-Roman funerary symbolism: when placed around a tomb, the two symbols together referred to the life of the deceased's soul after death (fig. 1.6).[46] Normally, the figure of a woman seated or standing in a posture of mourning would also be shown beside the tomb. The artist of the Maskell Ivories has used the pictorial device of the woman-tomb as the core elements of a depiction of Christ's resurrection from the dead on the third panel in the series; the tree has been extracted from that device and placed into the crucifixion scene, where it now symbolizes the new life specifically secured for the Christian by the death of Jesus. Moreover, the allusion to defeat of death is emphasized in the variety of tree chosen for depiction: oak, commonly associated with victory in the Roman world.[47]

The appearance of the tree-bird motif alone,[48] or as one in a medley of symbols that collectively expressed hope in the salvation provided by Christ,[49] indicates that in its own right it was a powerful symbol of new life in the late Roman period, recognizable as such to pagans and Christians alike from Greco-Roman funerary art. That it retained this currency in an early Christian narrative context, sometimes without the bird, is witnessed in the pictorial narration of the death of characters from the New Testament, including that of Lazarus.[50] In the late fourth and early fifth century, it appears behind Jesus' own tomb in several

relief. On the symbolism of the oak tree, see further n. 47. **46** On the right short side of a Roman 'Meleager' sarcophagus, the bird stands on the roof of the tomb, with the tree to the right: West Wycombe Park, Buckinghamshire, published in Guntram Koch, *Die antiken Sarkophagreliefs. Bd. 12, Die mythologischen Sarkophage. T6, Meleager* (Berlin, 1975), no. 74, p. 107, and taf. 79. See also the second-century marble sarcophagus in the Vatican, where the bird is in the tree: Musei Vaticani, Museo Gregoriano Profano, inv. 10437. Paul Zanker and Björn Christian Ewald, *Mit Mythen leben: Die Bilderwelt der römischen Sarkophage* (Munich, 2004), pp 357–9, and for the detail abb. 30, p. 45. **47** Georg Daltrop argued that in the representation of the Entry into Jerusalem on the sarcophagus of Junius Bassus, the artist made specific symbolic allusion to Christ's triumph by including an oak tree: 'Anpassung eines Relieffragmentes an den Deckel des Iunius Bassus Sarkophages', *Rendiconti della Pontificia Accademia Romana di Archeologia*, 51–2 (1978–80), 164–5; as discussed by Malbon, *The iconography of the sarcophagus of Junius Bassus*, p. 54, who highlights the symbolic meaning of the scene on the sarcophagus, as a representation of the entry into the heavenly Jerusalem, pp 53–4. **48** A Roman gem engraved with the symbol of a bird in a tree, dating from the second or early third century, indicates that the image could appear alone, and in everyday contexts. Spier, *Late antique*, p. 175, no. X49 – who sees no reason to think that the image in this context is Christian. **49** Engraved gem with Good Shepherd and other symbols of salvation, late third century. Eastern Mediterranean (said to be from Sicily), carnelian, 1.3 by 1.5cm. Walters Art Museum, Baltimore. *Picturing the Bible*, cat. no. 23, pp 192–3. **50** Medallion with Raising of Lazarus: late fourth century. Rome, gold glass, maximum diam. 10cm. Vatican Museums, inv. 60705: *Picturing the Bible*, cat. no. 50, p. 222 and fig. 50, p. 223.

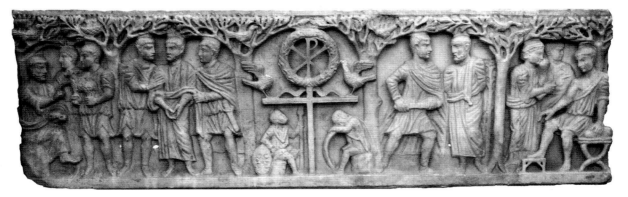

1.7 Passion 'Tree'
Sarcophagus. Roman,
c. AD325–50. Musei
Vaticani: Museo Pio
Cristiano, inv. 28591
(photograph by the
author).

important early representations on ivory reliefs of the women at the empty sepulchre.[51]

The tree-bird motif has further important Christian precedents in a resurrection context with paradisiacal symbolism: across a group of Roman columnar 'Passion' sarcophagi produced from the mid-fourth up to the early fifth century.[52] As an early example of this group attests (fig. 1.7),[53] the trunks and foliate branches of the trees were used to replace columns in order to divide the front of the sarcophagus into niches; and in certain instances, the trees are clearly oaks.[54] On the front of the example now in the Vatican, the pivotal symbol of the triumphal cross in the central niche worked with the tree motifs to unify the episodes from the Old and New Testaments depicted in the niches, and thereby articulate a broad theme of sacrifice and deliverance: Cain and Abel, Peter arrested, Paul martyred and Job. The chi-rho monogram surmounting the cross is encircled by a victory wreath bearing berries, at which the birds seated on the arms of the cross peck. Corresponding birds sit in the trees overhead and feed their young.[55]

51 Ivory plaque illustrating the women at the tomb and ascension: 18.7 by 11.6cm. Munich, Bayerische Nationalmuseum, MA157. Kiilerich, *Late fourth-century classicism*, pp 155–7, fig. 85, suggests a Constantinopolitan provenance and late fourth-century date. Also, ivory plaque in Milan illustrating the women at the tomb: 30.7 by 13.4cm. Milan, Castello Sforzesco, avori no. 9. From the Trivulzio collection. Kiilerich, *Late fourth-century classicism*, pp 154–5, fig. 86, and p. 157 comparing the panel with that in Munich. On the basis of figure style, Kiilerich suggests Milan as a place of production, p. 157. Although not referring to the pagan origin, Erik Thunø argues that the tree on this relief is used to indicate that the tomb is 'life-giving': *Image and relic: mediating the sacred in early medieval Rome* (Rome, 2002), pp 98–100. **52** Lawrence, 'Columnar', 171–3. **53** Passion Sarcophagus, *c.*AD325–50, Roman, marble, Vatican Museums, Museo Pio Cristiano inv. 28591. Koch, *Frühchristliche*, p. 45, no. 58, illustrated p. 47, abb. 17:1. See also the example in Arles, abb. 17:2. On the type, which is seen to be a variant on the earlier columnar sarcophagi, see Marion Lawrence 'City-Gate Sarcophagi', *Art Bulletin*, 10:1 (1927), 1–45 at 5, n. 8; Lawrence, 'Columnar', Type VII. Nr 72, p. 171, fig. 64 (who considers the Vatican example to be an early member of this group). **54** As close inspection of the leaves on the example in the Musée du Louvre indicates (inv. Ma2981). François Baratte and Catherine Metzger, *Catalogue des sarcophages en pierre d'époques romaine et paléochrétienne* (Paris, 1985), no. 211, pp 311–12; Lawrence, 'Columnar', no. 73, p. 172; and Koch, 'Frühchristliche', p. 45, fig. 72. **55** These may be oak: the leaves of the trees arching

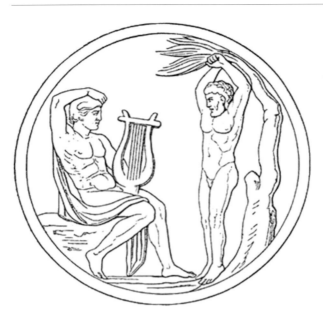

1.8 Oscillum with Apollo and Marsyas hanging from a palm tree. Roman, first century AD. Parian marble, diam. 30cm. Dresden, Staatliche Kunst-sammlung ZV 481 (line drawing from *Meyers Großes Konversations-Lexikon* (Leipzig, 1902–8; 6th ed., vol. 13 (1906)), p. 361).

The addition of fillets beneath the wreath points to its transformation into a kind of crown. It is the symbolism of new life and fertility carried across this sarcophagus to underscore the theme of triumph that can be seen to be taken up on the Maskell crucifixion panel – the oak tree with its nesting birds not simply adopted to frame a Passion episode and imbue it with the same rich symbolism of paradise, but also functioning as a key component of the narrative. This is a clever utilization and adaptation of iconographic precedent.

For the representation of a figure committing suicide by hanging, roughly commensurate models might be sourced in mythology. Depictions of the satyr Marsyas tied to and hanging from a tree, as punishment after his failed challenge of Apollo to a music contest, were widespread in Roman funerary art,[56] and other private as well as civic contexts.[57] Despite obvious differences – nudity and the positioning of the head and arms – the pictorial rudiments for the representation of Judas hanging can be identified (fig. 1.8): the gnarled tree arching under the weight of the figure, the placement of the legs hanging together side by side, and the flaccid feet.

Aside from providing a well-known model that offered a solution to some of the compositional practicalities of depicting a hanging figure, there are striking

directly over the wreath certainly have lobed margins, however, those across most of the sarcophagus are in a poor state of preservation and only a mid-vein is discernable (with some round fruits). **56** Beyond sarcophagi, it appears on a drinking bowl found placed on the chest of a corpse in a sarcophagus: second half of fourth century, Cologne, glass, diam. 23.8–24.5cm. Bonn, Rheinisches Landesmuseum, 42:0076:01. William Childs in *Age of spirituality: catalogue*, no. 113, p. 136. **57** Anne Weis, *The hanging Marsyas and its copies: Roman innovations in a Hellenistic sculptural*

thematic connections between the Marsyas myth and Matthew's version of Judas' suicide, making the adaptation of the iconography into a Christian context all the more plausible – and ingenious. As an important moral *exemplum*, the Marsyas story was broadly diffused across social classes in the Roman imperial period and depicted on larger monuments as well in the minor arts, as a marble *oscillum* (a disk that could be suspended from a tree or architrave of the portico of a building) in Dresden illustrates (fig. 1.8).[58] Yet, in late antiquity, the hanging of Marsyas is found mostly on objects associated with the pagan nobility, including high-quality sepulchral monuments, mosaic, glass, silver plate and statuary. Accordingly, Anne Weis argues that the image may have become associated with traditional classical *paideia*.[59] Thus, it is likely to have been known to wealthy and learned Christian patrons able to commission art, including complex sarcophagi and such luxury items as the Brescia Casket or Maskell Ivories. Allusions to the myth in late antique poetry and minor arts continued to emphasize the contest and 'the hubris, impiety or sheer foolishness of a lesser creature who set himself up against his superior'.[60] Knowledge of this thematic link might conceivably have imbued the image with a particular, tragic, resonance for those educated in the pagan cultural heritage.

At a formal level, the hanging-Marsyas iconography might also have provided a model for the depiction of Jesus affixed to the cross. Although Jesus' body radiates energy, in contrast to Marsyas' body, out of which the energy drains, similarities can be noted in the treatment of the naked form, such as in the perfect alignment of the chest and legs (themselves placed carefully side by side). Yet, even if such a visual precedent had aided the formulation of an iconography representing the naked figure of Jesus attached to the cross, there are other iconographic stimuli from earlier Greco-Roman art that can be seen to assist in the pictorialization of this event.

The powerful formal contrast drawn between the bodies of Jesus and Judas expresses a very particular tragedy that viewers familiar with the Gospels would have understood well, but which even an uninformed viewer would discern from the iconography. Already Jesus' actual death is subordinated to the theme of victory, which is developed more profoundly in the following two panels. He is presented not as a victim, subjected to a gruesome execution by the Roman state, but as defiant, voluntarily submitting to his father's will; and although he endures death (note the nails in his palms), he overcomes it. Yet it is not simply posture

tradition (Rome, 1992). **58** Roman Oscillum, diam. 30cm. Parian marble. Weis, *The hanging Marsyas*, no. 23, p. 226, fig. 82. On *oscilla*, see Rabun Taylor, 'Roman oscilla: an assessment', *RES: Anthropology and Aesthetics*, 48 (2005), 83–105. **59** On the relationship of the Marsyas image to this notion of culture or education, see Weis, *The hanging Marsyas*, pp 121–2. Further on this, as Weis notes (p. 122, n. 602): Deriksen M. Brinkerhoff, *A collection of sculpture in classical and early Christian Antioch* (New York, 1970), pp 53–62. **60** Weis, *The hanging Marsyas*, pp 119–20.

1.9 Sarcophagus with Myth of Icarus. Roman, third century AD, marble. Messina, Museo Regionale, inv. no. 1687/A 223 (image courtesy of the Museo Regionale di Messina).

and facial intensity that gives rise to the sense of Jesus' vigour. The artist uses the protagonist's muscular body as a vehicle for the expression of his defeat of death. Wearing only the very narrow loincloth (*subligaculum*) in which some slaves and victims of crucifixion were killed, this is nonetheless the divine or athletic, heroic display of nudity that was understood in the Greco-Roman world as a mark of superior status.[61]

In this use of nudity, an intriguing parallel can be found in the depiction of Icarus. Within a linear narrative on a second-century Roman sarcophagus in Messina, Icarus appears as a youthful, naked hero prior to his 'fall' (fig. 1.9). Four episodes of his life are illustrated, the most prominent, placed right of centre, depicting him with wings unfurled, his arms outstretched beneath them, with wrists broken as though affixed to the feathers.[62] In its frontal presentation, beautifully balanced in pose and proportion, the muscular body, arms languidly outstretched, presents several key elements also present in crucifixion iconography prior to the fifth century. This nudity is certainly comparable to that used in the depiction of Christ crucified yet adored in heaven on fourth-century engraved gems.

Although the Gospels do not state the fact of Jesus' nudity, it was believed in the early Christian period that he was crucified naked, primarily because of the report that the soldiers cast lots for his garments while he was on the cross (Mt 27:35, Jn 19:23–4). Only later, in the apocryphal fourth-century *Acts of Pilate*, surviving in the *Gospel of Nicodemus* and drawing on the Lukan crucifixion

61 Cecil Smith made this connection when discussing the nudity of Jesus on the Constanza gem in the British Museum: 'The crucifixion on a Greek gem', *Annual of the British School at Athens*, 3 (1896/7), 201–6. **62** Sarcophagus with Myth of Icarus: third century, Roman, white marble, H. 78 by L. 209cm. Messina, Museo Regionale, inv. no. 1687/A 223). Vincenzo Tusa, *I Sarcofagi Romani in Sicilia* (Rome, 1995), cat. 39, p. 39, tav. LII. My sincere thanks to Roberto Cobianchi, University of Messina, for conversation about the sarcophagus; and Caterina di Giacomo, Museo Regionale di Messina, for generous assistance in making a photograph available.

narrative, is it specified that the soldiers stripped Jesus and re-clothed him in a linen cloth.[63]

To be stripped in public was shameful, associated with the display of slaves for purchase or the treatment of condemned criminals; yet individuals described as 'stripped' (*nudus*) in ancient sources most probably retained an undergarment, the *perizoma*.[64] Thus, on a fragmentary third-century AD marble relief from Smyrna, now in the Ashmolean Museum, pairs of prisoners wearing loincloths are shown roped together at the neck, being led by attendants wearing trousers, tunics and helmets.[65] However, on the basis of this evidence and the testimony of the Gospel Passion narratives to the division of Jesus' garments, it would be misleading to interpret iconography as merely reflecting what appear to be both narrative and historical connections, especially if it were used to underscore the misplaced notion that the rarity of images of the crucifixion in late antiquity is due predominantly to the shame associated with this form of execution in the Roman world.[66]

Just as many contrasts between defeated and victor had been effected in Roman art,[67] so were the important differentiations between the use of nudity in Roman society translated into visual contexts.[68] This might be illustrated in a comparison between a depiction of nude slaves and a nude emperor on the same object. In the lower register of the Gemma Augustea, for example (fig. 1.4), two male barbarian prisoners are distinguished from the Roman soldiers, and from the deities and the emperor himself in the upper register, not simply by their bare chests but by their posture and demeanour: one prisoner is shackled, with arms tied behind his back; the other is kneeling in submission. The nudity of these clearly defeated barbarians directly contrasts the representation of Augustus in the upper register. Nude, except for a hip-mantle, the victorious emperor is enthroned, crowned with the *corona civica*, and holds the *lituus* (augural staff) and sceptre.[69] His nudity corresponds with his power; their nudity with defeat. The same distinction can be observed on the marble disk in Dresden (fig. 1.8), between the victor Apollo and the tragic Marsyas. According to this differentiation (albeit briefly articulated), the use of nudity in the context of the Maskell crucifixion ivory is calculated to align Jesus not with criminals, but with the heroes of Greco-Roman myth, with divinities and figures of public prominence.

63 *New Testament Apocrypha*, compiled by Edgar Hennecke, ed. W. Schneemelcher; Eng. trans. ed. R.McL. Wilson (London, 1963–5), i (1963), p. 459. **64** Christopher Hallett, *The Roman nude: heroic portrait statuary, 200BC–AD300* (Oxford, 2005), p. 61. **65** *Gladiators and Caesars: the power of spectacle in Ancient Rome*, ed. Eckart Köhne and Cornelia Ewigleben (Berkeley and Los Angeles, CA, 2000). Wild beasts are depicted at the bottom of the relief. Bradley posits that the nude figures may be prisoners of war, 'On captives', 300, n. 4. **66** As recently emphasized by Allyson Sheckler and Mary Winn Leith, 'The crucifixion conundrum and the Santa Sabina Doors', *Harvard Theological Review*, 103 (2010), 67–88. **67** Bradley discusses numerous examples: 'On captives', passim. **68** Hallett, 'The Roman nude', passim and conclusions, pp 100–1. The tradition of nudity lasts until Constantine and a little beyond. **69** See the description by Hallett, 'The Roman nude',

Within the crucifixion scene depicted in the Passion cycle on the Maskell Ivories, the nudity of Jesus should be regarded in symbolic terms, indicating Christ's heroism, as opposed to narrative terms, referring merely to his stripping and thus humiliation. Aside from the attribution of a nimbus to confirm his divinity,[70] this interpretation is affirmed by the fact that by the fourth century, the idea of Jesus' very public nudity on the cross had approximated an heroic significance in theology. Cyril of Jerusalem describes the process of the stripping as Christ 'throwing off the cosmic powers and authorities like a garment and publicly upon the cross leading them in his triumphal procession'.[71]

CONCLUSION

Despite the carver's close attention to details in the crucifixion panel, it must be emphasized that its focus, and indeed the concern of the series as a whole, lies beyond literal depictions of textual particulars. For, in the representation of Jesus as youthful, serenely carrying his cross (panel 1), defiant in the face of execution (panel 2), forcefully absent from the tomb (panel 3), and finally as a potent figure of leadership amid the disciples and in the face of sceptics (panel 4), there is a strong theological statement regarding Christ's triumph and his divinity. Even the cross that he carries on panel one, and on which he is crucified on panel two, would have been recognized as victorious in form: with its flared ends, it can be compared with processional or triumphal crosses pictured on fourth-century 'Passion' sarcophagi,[72] and in representations of the adoration of the cross in a variety of media from the fifth century.[73]

Thus, although the artist has included four pre-crucifixion scenes in the representation of the Passion across the Maskell Ivories, as well as the execution itself, and incorporated narrative details (the *titulus* above Jesus' head, for example), the emphasis in this cycle is not on the specifics of the trial and death of Jesus, but on the revelation of his divinity and the subsequent defeat of death as demonstrated in his resurrection. This is seen most obviously in the fact that the trial and crucifixion, depicted across two panels, are presented alongside two post-

164; and Karl Galinsky, *Augustan culture: an interpretive introduction* (Princeton, NJ, 1996), pp 120, 121. **70** This detail is incised, rather than carved in high relief, causing some speculation as to whether it is a later addition (for example, Dalton, *Catalogue of the ivory*, p. 5). It is possible the artist added it after carving: leaving technical issues to one side, since a nimbus is not used for Jesus on the first panel, but is on the second and fourth, it is also possible to conclude that the attribute is used to denote that Jesus' divinity is not revealed until the defeat of the cross and in the resurrection. **71** Cyril of Jerusalem, *Mystagogae*, 2:2, in *The works of St Cyril of Jerusalem*, trans. Leo P. McCauley and Anthony A. Stephenson (Washington, DC, 1970), ii, p. 161. **72** Marion Lawrence, 'City-Gate Sarcophagi' picturing the cross carried by Peter on various sarcophagi, by Christ (fig. 40), and forming part of the *crux invicta* on certain star-and-wreath sarcophagi (fig. 37). **73** Including in

resurrection scenes across the next two panels, affirming that the themes of death and resurrection should be understood as intertwined – as cause and effect.

The focus of the final two panels on the resurrection together bear witness to the fact that the series in its entirety is specifically concerned with the historical fact of Jesus' triumph over death in the resurrection, and the revelation of his divinity. The scenes of death – Judas' suicide and Jesus' crucifixion – are pivotal in the articulation of these intertwined themes. If we recall that the cycles of Christian images produced to decorate tombs and funerary monuments prior to the fifth century expressed a profound hope in eternal salvation,[74] it is possible to appreciate the extent to which the Maskell Passion Ivories continue and build on a characteristic early Christian thematic emphasis in art, rather than presenting a radical departure from it. So, while the crucifixion as it is illustrated in this visual context might survive as a very rare example of the literal pictorialization of the death of Jesus in the early Christian period, it also continues the early Christian focus on hope in resurrection to eternal life, offering a more didactic exploration of this theme than had been achieved in the previous century.

The image of the crucifixion on the Maskell Passion Ivories thus preserves vital information about the way early Christians experimented with the formulation of a visual language to suit a particular didactic interest: that is, an interest in the power of Jesus in defeating death. This visual language is carefully constructed to communicate with an audience intimately acquainted with the textual descriptions of Jesus' death, conversant with the complexities of Christian theology and familiar with the visual tropes of Greco-Roman funerary art as they were employed in the private sphere.

Probing the components of this language, we find that the appropriation of these tropes in early Christian art facilitated a high degree of innovation and experimentation with the narration of a well-known biblical story as artists, and their clients, constructed a narrative scene to convey a very particular message. And, happily, this primary interest in power and triumph was congruent with the major thematic thrust of Christian funerary art across the third and fourth centuries: deliverance from death. Thus, it was not the fact of death that was principally recalled in funerary art of this period, but instances of deliverance from death. It is this thrust that had a critical impact on the formulation of crucifixion iconography in the early church, and helps us better understand why the image of the crucifixion emerged as it did.

the apse in the representation of St Peter's shrine at Old St Peter's as on the back of the Pola Casket: Longhi tav. X a (detail), with parallels on other media across the fifth and sixth centuries, tav. XI a–g. For the history of the liturgy surrounding the adoration of the cross in Rome, see Van Tongeren, this volume. **74** Felicity Harley McGowan, 'Death is swallowed up in victory: scenes of death in early Christian art and the emergence of crucifixion iconography', *Cultural Studies Review (special issue,* 'The death scene: perspectives on mortality'), 17:1 (March 2011), 101–24.

Imagining the cross on Good Friday: rubric, ritual and relic in early medieval Roman, Gallican and Hispanic liturgical traditions

LOUIS VAN TONGEREN[1]

INTRODUCTION

The roots of the cult of the cross lie in Jerusalem and go back to the alleged finding of the true cross around 325 by Helena, the mother of Emperor Constantine the Great.[2] Driven by Helena's recovery of the cross and the subsequent dissemination of cross relics, the fourth century witnessed the emergence of several rituals and feasts concerning the cross, feasts that spread from Jerusalem first to the East and then to the West, where they were subject to constant development.[3] The feasts of the cross are unique in the Christian calendar for being dedicated not to saints or events in the life of Christ, but to an inanimate

1 Translated by Jacco Thijssen, Juliet Mullins and Richard Hawtree. 2 See Louis van Tongeren, *Exaltation of the cross: toward the origins of the feast of the cross and the meaning of the cross in early medieval liturgy* (Leuven, Paris and Sterling, VA, 2000), pp 1–4, 17–39; Barbara Baert: *A heritage of holy wood: the legend of the True Cross in text and image*, trans. Lee Preedy (Leiden and Boston, 2004), pp 15–53. 3 Van Tongeren, *Exaltation of the cross*; idem, 'Vom Kreuzritus zur Kreuzestheologie: Die Entstehungsgeschichte des Festes der Kreuzerhöhung und seine erste Ausbreitung im Westen', *Ephemerides Liturgicae*, 112 (1998), 216–45; idem, 'A sign of resurrection on Good Friday: the role of the people in the Good Friday liturgy until *c.*1000AD and the meaning of the cross' in Charles Caspers and Marc Schneiders (eds), *Omnes circumadstantes: contributions towards a history of the role of the people in the liturgy* (Kampen, 1990), pp 101–19; idem, 'The cult of the cross in late antiquity and the Middle Ages: a concise survey of its origins and development', *Römisches Jahrbuch der Bibliotheca Hertziana*, 38 (2007/2008), 59–75; idem, '*Crux mihi certa salus*: the cult and the veneration of the cross in early medieval Europe' in F.J. Fernández Conde and C. García de Castro Valdés (eds), *Poder y simbología en Europa: Siglos VIII–X* (Gijon and Oviedo, 2009), pp 349–69; Hansjörg auf der Maur, *Feiern im Rhythmus der Zeit* 1, *Herrenfeste in Woche und Jahr* (Regensburg, 1983), pp 78–9, 107–13; Martin Klöckener, 'Die "Feier vom Leiden und Sterben Jesu Christi" am

object. These feasts include the Exaltation of the Cross, celebrated on 14 September, and the Invention of the Cross, commemorated on 3 May. This essay explores a third manifestation of the cult of the cross in early medieval Europe: its veneration as enacted in the liturgical celebrations of Good Friday. Liturgical rituals comprise an interaction between words and actions: not only is there prayer, song and reading from the Bible, but rituals are enacted as well. The liturgical performance becomes physical through word and deed.[4] This study will therefore focus on the close relationship between rubric and ritual in the Good Friday liturgy, using the oldest surviving material in liturgical writings. It will provide a description of the earliest liturgies for Good Friday and the liturgical affiliations of the cross in the different regions described, followed by an analysis of the role of the cross in these ceremonies and the impact that the relics had upon the performance of the Good Friday rituals. These writings represent three distinct indigenous liturgical families or traditions: the Roman, the Gallican and the Hispanic. Since the origin of the cult of the cross lies in Jerusalem, the manner in which the cross was honoured there on Good Friday in the fourth century will provide our starting point.

JERUSALEM: LATE FOURTH CENTURY

In the journal recounting her travels to the Holy Land *c.*380–5, the Spanish pilgrim Egeria describes the Jerusalem liturgy in detail.[5] For the celebration of Easter, the Gospel accounts are followed closely and the commemoration of the last days of Jesus' life celebrated at the historical places and times mentioned. Easter is no longer a single celebration of suffering, death and resurrection, but is instead a complex feast spread out over a number of days, during the course of which the historical events of the first Paschal feast are recollected and dramatized.[6] On Good Friday, according to Egeria's account, the faithful travel to various locations in and outside the city, where biblical passages related to the specific place are read and people pray and sing. The process that Egeria here describes is a clear and very public display of affective piety: through their tears and sorrow, believers share in Jesus' sufferings. Of particular interest is a veneration of the cross that takes place between the second and the sixth hours (8.00–12.00). Egeria's account may be summarized as follows:[7] in the small chapel situated between Golgotha and the Martyrium basilica, the bishop is seated and a table is put before

Karfreitag', *Liturgisches Jahrbuch*, 41 (1991), 210–51 at 212–20. **4** For other studies of the importance of performance to the commemoration of the Passion, see Mullins, Bacci and Parker, this volume. **5** Egeria, *Itinerarium*, in *Egeria's travels to the Holy Land*, trans. John Wilkinson (Warminster, 1981). **6** Klöckener, 'Die "Feier vom Leiden und Sterben Jesu Christi" am Karfreitag', 212–20. **7** Egeria, *Itinerarium*, 36:5–37:3, pp 136–7.

him. Surrounded by deacons, the wood of the cross is taken from a silver box lined with gold and laid on the table together with the *titulus*. One by one, the faithful pass this table and venerate the cross: each person bows in front of the table before touching both cross and *titulus*, first with his or her forehead and then with his or her eyes, and then he or she kisses the cross. Having honoured the cross, believers approach the deacon, who holds out for veneration the ring of Solomon and the horn with which the kings were anointed. Finally, they leave the chapel through a different door from that through which they entered. We are told that since a part of the relic had once been stolen by someone who had bitten off a piece, the deacons remain watchful throughout.

Egeria's description constitutes the oldest surviving evidence of the veneration of the relic of the cross. The Good Friday rituals previously had been restricted to a service of the Word, but the presence of a cross relic made the addition of this new celebration both possible and desirable. In comparison with the other gatherings she describes, which have a strong collective character, Egeria gives the impression that this cross ritual constituted a private expression of piety rather than a communal celebration of the liturgy.[8] The presence of the bishop, who encourages the faithful to take part and is himself prominent in the celebrations described, suggests that this was perceived as a liturgical gathering rather than an act of individual devotion. Yet nothing is said of reading, praying or singing collectively and the cross relic is touched and kissed by individual believers in an act of veneration that cannot be performed collectively. Moreover, the ritual takes place in a small space that is not suitable for a large congregation. This suggests that the topographical reality of Golgotha as the historical place of the cross and the crucifixion was more important than the space required for the staging of a large collective ritual.

DIFFERENT TRADITIONS IN ROME

The presence of a cross relic was an important precondition for the emergence of the veneration of the cross on Good Friday in Jerusalem. Once the cross had been 'found', cross relics were soon disseminated to other places and by the fourth century such relics were available in both the East and the West.[9] But the spread of these relics did not immediately give rise to a public cult of the cross outside of Jerusulem: a public ritual around the cross relic is not found in the East until the sixth century,[10]

8 A.-M. Plum, *Adoratio Crucis in Ritus und Gesang: die Verehrung des Kreuzes in liturgischer Feier und in zehn exemplarischen Passionsliedern* (Tübingen and Basel, 2006), p. 20. **9** A. Frolow, *La relique de la vraie croix: recherches sur le développement d'un culte* (Paris, 1961); Van Tongeren, *Exaltation of the cross*, pp 20–3, 55–6; idem, '*Crux mihi certa salus*', pp 355–7. **10** Van Tongeren, *Exaltation of the cross*, pp 36–9.

and does not appear in the West until the seventh century.[11] Nevertheless, from the second half of the fourth century onwards, individual devotion associated with a cross relic is attested in the form of amulets or similar personal objects in both the East and the West.[12]

It was around AD630 that a cross ritual was introduced in Rome, at the feast of Cornelius and Cyprian on 14 September, the later feast of the Exaltation of the Cross;[13] sources from several decades later also mention a cross ritual on Good Friday.[14] This means that approximately three centuries after the description of the liturgical practice in Jerusalem by Egeria, a cross ritual had become part of the celebration of Good Friday in Rome. Until approximately the end of the seventh century, the liturgy of Good Friday as celebrated in Rome consisted of a liturgy of the Word with the scriptural readings, ending with a series of solemn orations, and the prayer of the faithful.[15] Around the turn of the eighth century, two elements were added from the East:[16] a veneration of the cross and a communion rite. By that time, there were two liturgical practices with two types of celebrations in coexistence, one related to the papal liturgy and the other to the presbyteral liturgy in the titular churches of the city.

The papal liturgy

The papal liturgy described in *Ordo Romanus* (OR) 23[17] is celebrated as a stational liturgy that begins at the eighth hour (14.00) with an elaborate procession from St John in the Lateran to the church of S. Croce in Hierusalem, during which Psalm

11 See Van Tongeren, *Exaltation of the cross*, pp 41–68; idem, 'The cult of the cross'; idem, '*Crux mihi certa salus*'. According to H. Klein, *Byzanz, der Westen und das 'wahre' Kreuz: die Geschichte einer Reliquie und ihrer künstlerischen Fassung in Byzanz und im Abendland* (Wiesbaden, 2004), p. 77, cross relics were not directly used during rituals because originally they were not available to be used freely but were locked up in altars. **12** F. Dölger, 'Das Anhängekreuzchen der hl. Makrina und ihr Ring mit der Kreuzpartikel. Ein Beitrag zur religiösen Volkskunde des 4.Jahrhundertsnach der *Vita Macrinae* des Gregor von Nyssa', *Antike und Christentum*, 3 (1932), 81–116; Frolow, *La relique de la vraie croix*; idem, 'Le culte de la relique de la vraie Croix à la fin du VIe et au début du VIIe siècles', *Byzantinoslavica*, 22 (1961), 320–39. For the earliest examples of material depictions of the crucifixion, see Harley McGowan, this volume; for gems specifically, see n. 24. For detailed discussion of the sixth-century *ampullae* that were mass-produced for pilgrims to Jerusalem, see O'Reilly, this volume, p. 53. **13** Van Tongeren, *Exaltation of the cross*, pp 49–59. **14** It is quite probable that there were relics of the cross in Rome in the fourth century, and certainly by the fifth; see Van Tongeren, *Exaltation of the cross*, pp 55–6; see also Sible de Blaauw, 'Jerusalem in Rome and the cult of the cross' in Renate L. Colella, Meredith J. Gill, Lawrence A. Jenkens and Petra Lamers (eds), *Pratum Romanum: Richard Krautheimer zum 100. Geburtstag* (Wiesbaden, 1997), pp 55–73. **15** Auf der Maur, *Feiern im Rhythmus der Zeit* 1, p. 108. **16** In relation to the influence of the East on the liturgy of Good Friday in Rome, see Klöckener, 'Die "Feier vom Leiden und Sterben Jesu Christi" am Karfreitag', 224. **17** OR 23, 9–22, in *Les ordines romani du haut Moyen Age*, 3, ed. Michel Andrieu (Louvain, 1951), pp 270–2. According to Andrieu (p. 266), OR 23 dates from the first half of the eighth century; Antoine Chavasse, *Le sacramentaire gélasien (Vaticanus Reginensis 316): Sacramentaire presbytéral en usage dans les titres romains au VIIe siècle* (Tournai, 1958), p. 96, however,

119 (*Beati immaculati*) is sung, probably with the antiphon *Ecce lignum crucis in quo salus mundi pependit. Venite adoremus.*[18] During the procession, the relic of the cross is carried in a very specific manner: the archdeacon, led by two clerics with burning torches, holds the left hand of the pope, who himself carries a censer in his right hand; another deacon walks behind the pope supporting the gold cross reliquary set with precious stones upon the pope's shoulders. The arrangement of this procession indicates an Eastern influence and is a reminder of the 'way of the cross', with the pope, with the cross on his shoulders, representing Jesus and the deacon representing Simon of Cyrene, who comes to his aid.[19] The pope and his retinue complete this journey barefoot.[20] Having entered the church of S. Croce in Hierusalem, the box containing the relic is placed on the altar and opened by the pope. Then he prostrates himself in prayer before the altar and thus before the cross. Subsequently, he is the first person to venerate the cross with a kiss, followed by the rest of the clergy in hierarchical order. After that, the people are offered the opportunity to venerate the relic of the cross, first the men, then the women.[21] In the meantime, the liturgy of the Word has begun immediately following the veneration of the cross by the pope. At the end of the service, the people are given the opportunity to take communion. The pope and the deacons explicitly do not participate, but return to St John in the Lateran singing Psalm 119 again as they go.

The liturgy of the Word that takes place during the veneration of the cross in this papal liturgy does not allude to the cross explicitly, but suffering, death and resurrection are presented together as Paschal Unity (*Gesamtpascha*).[22] The texts read include mention of the resurrection on the third day (Hos 6), a prophecy referring to Christ's crucifixion (Hab 3), and the Passover sacrifice (Deut 16).[23] In

dates this *Ordo* to just before the end of the seventh century. **18** Patrick Regan, 'Veneration of the cross', *Worship*, 52 (1978), 2–13 at 4. See also Herman Schmidt, *Hebdomada sancta*, 2 (Rome, 1957), p. 793 and S. Janeras, *Le Vendredi-Saint dans la tradition liturgique byzantine: structure et histoire de ses offices* (Rome, 1988), p. 288. **19** See Klöckener, 'Die "Feier vom Leiden und Sterben Jesu Christi" am Karfreitag', 221; Anton Baumstark, *Liturgie comparée: principes et méthodes pour l'étude historique des liturgies chrétiennes* (Chevetogne, 1953), pp 158–9; Janeras, *Le Vendredi-Saint dans la tradition liturgique byzantine*, pp 287–8. **20** Going barefooted is an ancient but not specifically Christian custom that expresses sorrow, self-abasement and respect as well as penance. In this case, it seems to underline the aspect of penance as practised during penitential processions in Rome, during which the people went barefoot: see G. Römer, 'Die Liturgie des Karfreitags', *Zeitschrift für katholische Theologie*, 77 (1955), 39–93, esp. 78–9; Plum, *Adoratio Crucis in Ritus und Gesang*, p. 94. **21** Römer, 'Die Liturgie des Karfreitags', 51, interprets this kissing of the cross as a greeting of the cross that replaces the usual kissing of the altar as a greeting of Christ at the start of the celebration. On Good Friday, not only the celebrant but also the assistants and the people greet the cross, as they usually do when they greet the altar with a kiss. Indeed, OR 23 reads *osculare* and not *adorare* at this point. Later, this occurs in OR 24, 30, which reads *adorare*; see p. 41, 'a rearrangement', below. **22** See Auf der Maur, *Feiern im Rhythmus der Zeit* 1, p. 109. **23** The use of Deut 16 in OR 23 as a reading for Good Friday is unique: this reading does not appear in other, later sources. In the Jewish Passover and early Christian Easter celebrations, Deut 16 is known in addition to Ex 12: see Raniero Cantalamessa, *La Pâque dans l'Eglise ancienne* (Bern, Frankfurt an Main and Las Vegas,

addition, Psalm 91 is sung, the thirteenth verse of which is traditionally inter-preted as a prophecy of Christ's victory over death and the powers of the devil.[24] After the singing of this psalm, the barefoot deacon reads the Passion according to John. Through this liturgy of the Word, cross and resurrection, Good Friday and Easter are strikingly juxtaposed and the unity of the early Christian Easter celebration remembered and preserved. From a ritual perspective, however, it is the cross that is pre-eminent: the procession and veneration of the cross during the liturgy of the Word accentuate the dominant place of the cross relic. Moreover, the dramatic form of the procession, which re-enacts the historic path of the cross to Calvary, explicitly places the cross within the perspective of Jesus' suffering and death.

At the end of this liturgy, OR 23 provides the opportunity for the faithful to take communion. There are two choices: at the end of the celebration, one may take the bread for communion in the church of S. Croce or one can go to one of the other titular churches in the city and receive both the bread and the wine.[25]

The presbyteral liturgy

In the titular churches, the liturgy intended for the faithful of the city was celebrated in a somewhat different way. In the first instance, it was not led by the pope but by a priest. This presbyteral liturgy, as described in the Old Gelasian Sacramentary (GeV) and dating from just before the end of the seventh century,[26] starts at the ninth hour (15.00) and does not include a procession. The cross is placed on the altar without any ceremony before the liturgy begins. The priest and his retinue enter the church in silence. They halt before the altar, in front of the exhibited cross, and the priest asks to pray, in response to which an oration is said. A liturgy of the Word follows, with the same number of readings and hymns as in the papal liturgy; which texts were read and sung is not mentioned, but they were probably the same in both instances. A novelty that distinguishes this from the papal liturgy is the fact that in the presbyteral liturgy of the city churches, two prayers are adopted in the liturgy of the Word. Both prayers express the healing consequences of Jesus' death on the cross.[27] The first prayer (GeV, 396) connects the crucifixion with the resurrection: on the cross, Jesus has recompensed Judas and the Good Thief appropriately; at the same time, through his death on the cross the ancient error (*vetustatis error*) is redeemed by the mercy of the

1980), p. 216; see Klöckener, 'Die "Feier vom Leiden und Sterben Jesu Christi" am Karfreitag', 221. **24** Auf der Maur, *Feiern im Rhythmus der Zeit* 1, p. 109. **25** Chavasse, *Le sacramentaire gélasien*, p. 90. **26** GeV, 395–418, in *Liber sacramentorum Romanae aeclesiae ordinis anni circuli*, ed. Leo Cunibert Mohlberg (Rome, 1960), pp 64–7. Dating according to Chavasse, *Le sacramentaire gélasien*, p. 96. **27** For both orations, see Gerard Lukken, *Original Sin in the Roman liturgy: research into the theology of Original Sin in the Roman sacramentaria and the early baptismal liturgy* (Leiden, 1973),

resurrection. The second *oratio* (GeV, 398) is based on Paul's teaching on death and on the first and second Adam in Rom 5:12ff and 1 Cor 15:44b–49. Through the crucifixion, mankind is delivered and freed from the earthly, mortal existence that is the consequence of original sin (*peccatum vetus*). The emphasis in the prayers lies on the freeing of the first man, who is in need of redemption because of sin, achieved through the cross. It is resurrection and redemption that are the dominant themes of this liturgy, rather than the suffering and sacrifice emphasized in the papal procession.

After the solemn orations with which the liturgy of the Word ends, the consecrated bread and wine are placed on the altar and the cross is venerated and kissed by the priest alone before the altar. Then preparations are made for communion, after which everyone present venerates the cross and takes communion. This part of the celebration shows several remarkable differences in comparison to the papal liturgy: the veneration of the cross has not yet been elaborated ritually, does not coincide with the liturgy of the Word, nor is it combined with a communion rite.

Both the papal liturgy and the liturgy in the titular churches show that in Rome around 700 the commemoration of Good Friday did not involve a fully developed celebration. The liturgy of the Word is the oldest element and forms a complete whole, but the added elements are not linked to it in a balanced way. The fact that the veneration of the cross by the people in the papal liturgy coincides with the liturgy of the Word indicates a liturgy in development. These two distinct elements take place simultaneously and are in no way connected. The liturgy of the Word to which the celebration of Good Friday in Rome was originally restricted is combined with the veneration of the cross, which had possibly originated earlier as a separate form of private devotion outside a liturgical setting.[28] The lack of specific hymns and prayers for the veneration of the cross could indicate that this veneration of the cross had not grown into a full public ritual when it first became part of the papal liturgy. Moreover, the option to take communion at the end of the celebration seems a loose addition. In the titular churches, on the other hand, the liturgy of the Word is a separate section, but the veneration of the cross and the communion rite are combined. This lack of balance and coherence indicates the recent introduction of both the ritual of the cross and the communion. A comparison of these two liturgies demonstrates that they are complementary. In the titular churches, the service began at the ninth hour (15.00). It seems likely that this was also the case for the papal liturgy,

pp 127–9, 355, 365. **28** Plum, *Adoratio Crucis in Ritus und Gesang*, p. 95. It is quite possible that there was an even older practice, dating back to the fifth century. In that case, the first description of the papal liturgy with the cross ritual on Good Friday in OR 23 is probably a modified version of an older ritual that took place in the basilica Hierusalem: see De Blaauw, 'Jerusalem in Rome and the cult of the cross'; see also Van Tongeren, '*Crux mihi certa salus*', 361–2.

because the procession started one hour earlier, at the eighth hour (14.00), so that the celebration in S. Croce could also start at around 15.00;[29] those who wished to celebrate the liturgy in their own titular church therefore had the opportunity to watch the procession with the relic of the cross first.

A rearrangement

Several decades later, according to OR 24, which dates from about the middle of the eighth century, there were two services on Good Friday.[30] First, there was the liturgy of the Word, in which every priest, the whole clergy, the people and the pope or his representative participated. This service was moved to the third hour (9.00) and took place in one of the titular churches in the city. Then, in the evening, during vespers, the veneration of the cross and the communion rite were celebrated in all churches of the city. But again, the same liturgy of the Word was held first. A comparison between the papal and the presbyteral liturgies described above reveals that this liturgy of the Word exhibits only minor variations. The fundamental structure is in each case the same; the only addition being Psalm 140, which is presented as an alternative to Psalm 91.[31]

After the liturgy of the Word, the cross was held by two acolytes at some distance from the altar and it was venerated in hierarchical order by the clergy and the people. According to the description in OR 24, the cross is honoured with a kiss, but it is likely that the clergy also lay prostrate on the ground in prayer (*prostratio*) because, before the veneration of the cross, a prayer-cloth (*oratorium*) was laid in front of the cross.[32] Furthermore, the veneration of the cross was now accompanied by a hymn for the first time, as well as Psalm 119 and the antiphon *Ecce lignum crucis*.

OR 24 shows that the liturgy of Good Friday was rearranged over a short period of time and that the veneration of the cross evolved accordingly. The papal liturgy in the morning was no longer accompanied by a procession with the relic, but involved a liturgy of the Word only, without the veneration of the cross. The veneration of the cross that takes place in separate churches in the evening has become an independent part of the celebration with a more developed ritual framework.

29 The reasons behind the ninth hour as the starting time suggested by Auf der Maur, *Feiern im Rhythmus der Zeit*, 1 (p. 108), are that no liturgical actions begin before the ninth hour on fast days, and that the ninth hour was the dying hour of the Lord (Mt 27:46). **30** OR 24, 22–39, pp 291–4. **31** Apart from these psalms, only texts from the Canticle of Habakkuk and a reference to the Passion according to John are mentioned. The other readings and the prayers are referred to without direct mention of the appropriate texts. There is, however, reference to a sacramentary, probably the Old Gelasian, which mentions two prayers. **32** OR 24, 30. See Römer, 'Die Liturgie des Karfreitags', 49–50.

THE GALLICAN LITURGY

Like the oldest layers of the liturgy in the city of Rome, the Gallican liturgy does not include any evidence for the veneration of the cross on Good Friday. Even so, there was, according to the *Gallicanum Vetus* (*GaV*), a liturgy of the Word the form, construction and texts of which reflect the liturgical practice in Rome *c.*700.[33] The surviving liturgical sources, especially the (fragments of) lectionaries and prayer collections, provide information concerning the liturgy of Good Friday, but in order to get a picture of the meaning ascribed to the cross in these celebrations, we are principally reliant upon the surviving collections of prayers alone, which, because of their time indications (for example, *oratio ad sextam*), were probably intended for various hours of prayer.[34] The readings mentioned in the lectionaries are concerned with Jesus' suffering and death and the prefigurations of his Passion rather than with the cross per se. A number of the prayers, particularly those preserved in the collection *GaV* 115–18, represent a typically Gallican style of prayer. This Gallican mode of prayer differs emphatically from the Roman one, which dominated the liturgy of the West in that Roman prayers are typically compact and consist of crisp, rhythmically ordered formulae that express theological content at a high level of abstraction; they are texts that are modelled on settled underlying templates.[35] In contrast, the prayers in the Gallican (and also the Hispanic) sources are usually full of metaphor, effusive, lyric in tone and content, and narrative in nature; they develop themes and motifs elaborately, richly engaging in associations from Scripture while doing so. This often means that these prayers are of considerable length. Without analysing the prayers in detail here, it can be indicated briefly how the cross is imagined in them.

The central theme of the Gallican prayers is the redemption that Christ achieved on the cross for the benefit of humankind. The crucifixion has a healing meaning because God was involved; after all, he has accepted Jesus' death (called

33 *GaV* 92–111, in *Missale* Gallicanum Vetus, ed. Leo Cunibert Mohlberg (Rome, 1958), pp 27–29. The only variation is the use of Ex 12 where in the papal liturgy Deut 16 is read: see n. 23. Because of the aforementioned similarity, and since the other texts for Good Friday in the Gallican sources can be separated from the texts of the liturgy of the Word both stylistically as well as content-wise, the possibility cannot be ruled out that the liturgy of the Word in the *GallicanumVetus* is taken from Roman sources. 34 The following prayers referring to Good Friday are in the form found in the '*Orationes in biduana*' from the *Missale Gothicum* (*GaGo*) and the *GallicanumVetus*: *GaGo*, 215–18 in *Missale Gothicum*, ed. E. Rose (Turnhout, 2005), pp 433–4, and *GaV* 112–14 and *GaV* 115–18, in *Missale* Gallicanum Vetus, pp 29–32. The prayers *GaGo*, 215–17 are identical to *GaV* 112–14, whereas *GaGo*, 218, which is also found in the Roman sources (= GeV, 396; see pp 39–40, 'the presbyterial liturgy', above), is identical to *GaV* 93. The possibility that we are dealing with a Roman oration here cannot be excluded. This also holds for *GaGo*, 216 = *GaV* 113; see Van Tongeren, *Exaltation of the cross*, pp 98–9, n. 67. These two prayers are, therefore, not considered further here. 35 See A. Bastiaensen, *Ere wie ere toekomt: Over ontstaan en vroege ontwikkeling van de Latijnse liturgie* (Nijmegen, 2006).

his blood – *GaV* 114). But the divinity of Jesus himself also plays an important role. He is the wisdom and Word of God and shares in the divinity of the Father. As Son, he is God, outside whom and without whom nothing exists. At the same time, he is equal to man because of man. From this double nature, Christ brings – through his suffering and death – healing for man, as described through several antithetical notions: his suffering is our freedom, his death is our life, his cross is our redemption and his wound is our salvation (*GaV* 116). Christ is explicitly referred to as God (*Christi deus, Adonae magne, uirtus aeterna, deus*), whose cross is to our benefit, whose suffering is healing, and whose blood that flowed on the cross leads man to salvation (*GaV* 117).

The healing nature of Christ's death on the cross is focused upon the removal of sins and the elimination of the devil and the adulterous tyrant (*GaV* 114; 117). An appeal is made to Genesis 3, the account of the Fall, as a result of which, man is stained from birth so that he is propelled towards the devil and has been touched by death (*GaV* 114; 117). The death and wounds to which man is subjected because of this ancient wrong (*antiqua praeuaricatio* – *GaV* 118) are transformed by Christ's wounds and death on the cross (*GaV* 117; 118). Because Jesus himself is without sin, and because he has been offered as a spotless lamb, he can take our sins upon himself and destroy them (see Jn 1:29) (*GaV* 115). His death takes away sin because our sins have been nailed with him to the cross. And as the cross refers to Jesus' death, so, too, the blood is a metaphor for his atoning death. The blood that flowed at the crucifixion has a cleansing signification: it washes away sin (*GaV* 117).

A second focus of the redeeming death on the cross places Jesus' death in the perspective of a life with God. By being crucified with Jesus, one shares in the life of Jesus and wishes to be united with him and with the Father (*GaV* 116; 117). The liberation that has been established by the crucifixion provokes the longing to live under Christ's rule and sovereignty. The freedom, the life, the redemption and the salvation that Christ has offered man in his suffering and death, in his cross and his wounds, are descriptions of what it means to be elevated to the Father and thus refer to a life in the company of God (*GaV* 116).

Jesus' suffering and death are referred to in all these prayers in such a way that the commemoration of the historical event remains central. The redemption is revealed from the perspective of the crucifixion without any reference to the resurrection or the second coming; Good Friday has been separated from Easter and is not a part of the *Gesamtpascha*. The historical event is explicitly emphasized in the prayer intended for the second hour, at which time Jesus' arrest is recalled (*GaV* 115). The prayer for the ninth hour has a similarly historical focus (*GaV* 118). This prayer, offered at three in the afternoon, follows the tradition that Jesus died on the cross at that hour. The prayer recalls how the humiliation, the

suffering and the death that Jesus had to undergo at the end of his life mark a
healing victory. That is why at this historic moment the liturgy does not express
the negative and the painful; instead, the euphoric commemoration of this violent
but vital death is central.

Christ's crucifixion and death on the cross are discussed at length in these
orations, but the cross itself occupies a less exalted place. Attention is turned
primarily towards the events upon the cross and the one who died upon it. This is
not to say that the cross is neglected. The cross gains certain qualities that are
derived from what it established: the cross is our redemption; by its power the
cross in us is victorious over the world; the cross is a trophy (*GaV* 116; 117; 118).

THE HISPANIC LITURGY

According to the surviving sources, the indigenous early medieval liturgy on the
Iberian Peninsula and in Septimania (Southern Gallia) consisted of three
celebrations on Good Friday: Matins, Terce and None.[36] Across all three, the
celebration of Good Friday is driven by the remembrance of Jesus' suffering and
death. Within that, two particular points of emphasis have been added: a
veneration of the cross during the office of Terce and the so-called *indulgentia* rite,
a celebration of penance and reconciliation, during the office of None. The cross
is venerated not only during Terce, however, but also as part of the celebrations of
None. Then, too, the cross is alluded to in several texts, while the introductory
rubric for None explicitly concerns the cross. The cross and the reconciliation that
it offers (as celebrated in the *indulgentia* rite) form the two foci of attention of
Good Friday; within the rituals of Terce and None respectively, each has been
elaborated upon individually, while at the same time they are intertwined as
themes in both hours. In order to sketch the meaning and the presentation of the
cross on Good Friday in the Hispanic liturgy, I first present the ritual performance
of the cross, after which I deal with the liturgical texts.

The ritual performance

According to the most important sources, the Antiphonary of León (AntL) and
the *Liber Ordinum* (*LO*), the Hispanic ritual of the veneration of the cross

36 For a more detailed description and an analysis of some of the liturgical texts, see Louis van
Tongeren, 'La vénération de la croix: Le vendredi saint dans la liturgie Hispanique', *Questions
liturgiques: Studies in liturgy*, 80 (1999), 106–31. I have based this description and analysis on the
Antiphonary of León with the hymns for Mass and the cathedral office for Sundays and feast days
found in *Antifonario visigótico mozárabe de la catedral de León*, ed. Louis Brou and José Vives
(Barcelona and Madrid, 1959), pp 268–77, and the *Liber Ordinum*, which is comparable with the
Roman Ritual and Pontifical and in which text material for the celebration of the sacraments and for

celebrated during Terce can be described as follows.[37] At the third hour, the wood of the holy cross is placed on a dish on the altar in the cathedral. After the Gospel,[38] the deacon lifts up the dish with the wood of the cross and takes it to the Church of the Cross while three antiphons are sung. Having arrived at the Church of the Cross, the cross is venerated with a kiss by the bishop, priest, clergy and all the faithful, following which everyone sits down and continues to sing while the cross is put away safely in the treasury. The *LO* makes subtle distinctions in a number of places in this description. Not only is the wood of the holy cross mentioned (*lignum sanctae crucis*), but the precious relic of the cross is also referred to: namely, a golden cross which holds relics (*crux aurea cum reliquiis clausa*). Moreover, according to the *LO*, after Terce there is again a procession, this time in the opposite direction, although not everyone takes part. The clergy alone take the cross from the Church of the Cross back to the treasury of the cathedral, all the while singing psalms.

The brief descriptions offered in these rubrics are evidence that the cross played a central role in the Hispanic liturgy during Terce. The whole celebration, in fact, consists of a veneration of the cross, preceded and followed by a procession with the relic of the cross. It is stated that the veneration of the cross is accompanied by various hymns and that it centres around believers kissing the relic. Moreover, the prayer offered during Terce reveals that the ritual is accompanied by prostration before the cross.[39] It is also to be noted that two locations are mentioned: Terce is celebrated in the Church of the Holy Cross, but there is a prelude in the cathedral of the city where the relic of the cross is kept. First, there is a small ritual around the cross relic, after which a procession bearing the cross relic moves from the cathedral to the Church of the Cross. Here, the veneration takes place, after which the relic is taken back to the cathedral, again in procession. This appears, therefore, to be a stational liturgy somewhat similar to the papal liturgy on Good Friday in Rome, as described in OR 23.[40]

The cross relic had to be brought back at the end of Terce for the practical reason that the relic was needed for the beginning of None. Since there is no mention of it being moved to a different church, it can be assumed that None was celebrated in the cathedral to which the relic had been brought. None begins with a procession to the altar, during which a deacon carries the relic on a dish. He is

Holy Week has been included as well as some votive masses in *Liber Ordinum Episcopal (Cod. Silos, Arch. Monástico, 4)*, ed. José Janini (Burgos, 1991), pp 176–84. **37** AntL, 271–2; *LO*, 386–95. **38** The description 'after the Gospel', which is absent in the *LO*, could indicate that the Gospel is read in the cathedral first and that this is followed by a procession to the Church of the Cross; this would then concern an adverb of time. It could also refer to the evangelistary that was possibly carried in front of the cross during the procession; this would then concern an adverb of place. **39** *LO*, 394: *Exaudi me prostratum coram adorandam sanctam gloriosissimam tuam Crucem.* **40** See pp 37–9, 'the papal liturgy', above.

preceded by the precious gold cross with the relic and by the evangelistary without its covering, followed by the bishop. As soon as the dish with the cross relic is placed on the altar, the bishop, the priests, and the deacons ascend to the presbytery barefoot and the bishop commences with the *Popule meus*, followed by the liturgy of the Word and the *indulgentia* rite.[41] After the cross relic has been presented so prominently at the beginning of None, it is not mentioned again. During None the *indulgentia* rite is the central point, yet the introductory rubric emphatically refers to the cross. What is more, the prominent position of the cross throughout the celebration of None must have ensured that its role remained focal: from the outset and throughout, the cross provides the perspective through which reconciliation and the forgiveness of sins are made possible.

The liturgical texts

On Good Friday, the cross takes an eminent place not only ritually, but also textually. This is especially the case for the hour of Terce. The three antiphons (*LO*, 387–9) that are sung during the procession of the cross relic to the Church of the Cross consist of texts that originate from or are inspired by the book of Wisdom (Wis 14:5–7; 16:6–8).[42] All these antiphons emphasize the wood (that is, the cross relic) that is being carried. Using a nautical metaphor, a piece of wood that promises a safe voyage at sea is typologically linked to the healing salvation that the cross brings; according to the exegesis of the church fathers, the wood in the first mentioned passage of the book of Wisdom is an allegory of Noah's ark, which is a prefiguration of the cross.[43] The verse that is sung after the procession, during the veneration of the cross, also seems to refer to the cross as a relic. After all, there is no talk of a *crux*, but instead listeners are enjoined to *Ecce lignum gloriosum* ('behold the glorious wood'). Furthermore, it is described in more concrete or detached terms not as the cross on which Christ or the salvation of the world has hung, but the wood on which his limbs have hung (*cristi saluatoris membra*). The final passage of the verse can be interpreted indirectly as a rubric or direction from which one can conclude that during the veneration of the cross prayers were said

41 AntL, 272; *LO*, 395. **42** *LO*, 387: *Signum habentes salutis ad conmemorationem mandati legis tue exiguo ligno credimus animas nostras ut transeuntes mare liberemur per te omnium saluatorem* ('Because we have a sign of salvation (redemption) to commemorate the commandment of your law, we entrust our lives to (this) small piece of wood that crossing the sea we might be saved by you, Saviour of all'.). *LO*, 388: *Iter facimus, ligno portante nos inuocantes te pater ut transeuntes mare per lignum liberemur* ('We make this journey and while the wood is carrying us we call to you, father, that crossing the sea we might be saved through this wood'.). *LO*, 389: *Benedictum est lignum per quod fit iustitia in hoc autem ostendisti domine inimicis nostris quia tu es qui liberas ab omni malo* ('Blessed is the wood through which justice was achieved, for in it you reveal our enemies, Lord, because it is you who is the liberation from every evil'.) **43** See Hugo Rahner, *Symbole der Kirche: die Ekklesiologie der Väter* (Salzburg, 1964), pp 341–2.

and people lay prostrate on the ground (*prosternatio*): *Fletu producentes omnes preces hic prosternite*. The veneration of the cross is also accompanied by a three-line song of praise about the cross, which has the opening line *Crux fidelis*. This short lyrical text is a song of praise for the cross and emphasizes the exceptional uniqueness of the tree that was selected to carry Christ as a sweet burden (*dulce pondus*).

The long anonymous hymn *Ab ore verbum prolatum*, an *abecedarium* of twenty-three verses, which was also sung during the veneration of the cross, probably dates from the seventh or eighth century and may be even older.[44] Dominant themes that make the meaning of the cross and the crucifixion concrete are the attainability of Paradise, the vanquishing of opponents – especially the devil – the cleansing of sin, and the harrowing of hell. This last theme, which is closely linked to the descent into hell as described in the apocryphal gospel of Nicodemus, seems to be characteristic of the Hispanic and Gallican liturgical traditions, where it is elaborated more frequently than in the Roman or Frankish liturgies.[45] By descending into hell himself, Christ has disempowered and conquered the snake in its own territory.[46] The several healing effects of the redemption that are mentioned in the hymn are realized by Christ's incarnation and by his resurrection, but especially by his suffering and death on the cross. The cross symbolizes both Christ and the redemption he brings. Therefore, the cross is also an image of the desire to share in Christ's joy.

Alongside the descent into hell, there is another aspect that demands attention because it is specific to the Gallican and especially the Hispanic liturgical texts. Following the Christological debate in the fourth and fifth centuries on the vision of Christ as Son of God, the central question of the relationship between the divinity and the humanity of Jesus continued to stir controversy for centuries. Arianism and Adoptionism, which emphasized the humanity of Jesus, still had considerable support in Gaul, north Italy and on the Iberian Peninsula in the early Middle Ages.[47] Adoptionism experienced a revival in the second half of the eighth century and gathered both adherents and strong opponents.[48] Liturgical texts that

44 Josef Szövérffy, '"*Crux fidelis* …": prolegomena to a history of the holy cross hymns', *Traditio*, 22 (1966), 13–14. For a comprehensive commentary on these hymns, see Van Tongeren, 'La vénération de la croix', 119–26. **45** See Van Tongeren, *Exaltation of the cross*, pp 270–2. **46** This early Christian representation of the redemption is part of the so-called concept of *recirculatio*; see Van Tongeren, *Exaltation of the cross*, pp 88–9. **47** For discussion of the impact of these controversies upon the depiction of the crucifixion in Spain, see García de Castro Valdés, this volume. **48** See Jaroslav Pelikan, *The Christian tradition: a history of the development of doctrine*, 1: *the emergence of the catholic tradition (100–600)* (Chicago and London, 1971), pp 226–77; Herman Wegman, *Liturgie in der Geschichte des Christentums* (Regensburg, 1994), pp 115–19; Arnold Angenendt, *Das Frühmittelalter: die abendländische Christenheit von 400 bis 900* (Stuttgart, Berlin and Cologne, 1990), pp 60–2, 349–50; H. Meyer, 'Alkuin zwischen Antike und Mittelalter: ein Kapitel frühmittelalterlicher Frömmigkeitsgeschichte', *Zeitschrift für katholische Theologie*, 81 (1959), 306–50, 405–54 at 311–17; Celia Chazelle, *The crucified God in the Carolingian era: theology and art of Christ's Passion*

appeared in the era of Arianism and Adoptionism in the areas in which these currents were operative show various traces of the battle against them. In opposition to the emphasis on the humanity of the Son, his divinity is accented and enlarged in these texts. The hymn *Ab ore verbum prolatum* also contains anti-Arian elements such as the birth of the Logos, and the description of Christ as the only-begotten of the Father (*Dei patris unicus*).[49]

Both aspects of Christ's essence, that is to say his humanity and deity, also appear in the oration offered during the veneration of the cross (*LO*, 394). By his incarnation and death, Jesus has broken down the gates of hell and has conquered death. Consequently, each man can ask him to assume and forgive his sins. This prayer also provides evidence that suggests opposition to Arian influences for it emphasizes Jesus' divinity; for example, he is addressed as creator of the world (*conditor mundi*) and it is emphasized that he is equal to the Father and the Spirit (*equalis patri sanctoque spiritui*), in spite of his Incarnation.

One of the manuscripts of the *LO* mentions another hymn to be sung during the veneration of the cross, which, to a large extent, overlaps with Venantius Fortunatus' hymn of the cross, *Crux benedicta*.[50] This song of praise has the cross as an object that is blessed and that radiates, shines and glitters, an object that is powerful in its fecundity, sweet and noble. The perspective shifts to what Jesus has achieved on the cross: there he washed away sin. Furthermore, by his death, the cross is transformed into a fertile and richly embellished tree, which has a unique healing meaning, namely the cross brings salvation from death.

We have seen that, during the celebration of None, the cross plays a minor role in ritual terms. Nevertheless, it is prominently present because it is carried in procession at the beginning of the celebration and placed on the altar. The None texts refer often to Jesus' death but also, by means of a continuation of these references, they reveal the consequences of his death. The importance of his death is tangibly imagined in the form of the cross.

None begins with the *Improperia*, a genre of text that was already known in the classical world and that is also part of several early medieval liturgical traditions. The version preserved in the Hispanic liturgy for Good Friday consists of Micah 6:1–8. The refrain specifically connects this text to Good Friday by placing the exodus from Egypt as a healing act of God, which is contrasted to the crucifixion as the ungrateful answer of the people.[51] The liturgy of the Word, consisting of Is 52:13–53:12, Ps 22, and the Passion in a Gospel harmonization,

(Cambridge, 2001). **49** Rahner, *Symbole der Kirche*, p. 18, considers this hymn to be anti-Arian. **50** For a comprehensive commentary, see Van Tongeren, 'La vénération de la croix', 126–8; idem, *Exaltation of the cross*, pp 246–8. **51** AntL, 272: ... *quia eduxi te de terra Egipti parasti crucem mici*. For more on the *Popule meus* and associated literature, see Louis van Tongeren, 'Les *Improperia* du vendredi saint au banc des accusés', *Questions liturgiques: Studies in Liturgy*, 83 (2002), 240–56. The main question is how to understand *Popule meus* (my people) in the refrain: as referring to the Jewish

immediately follows.[52] The choice of these particular readings is not remarkable, emphasizing as they do the typology of None as the hour of Jesus' death. What is remarkable is the way in which the New Testament epistles are read. A so-called 'cento', a juxtaposition of fragments from different biblical books, is read. In this case, the cento is very complex. Diverse passages are brought together in an anthology that witnesses to the meaning and content of Christ's death on the cross. The dead Christ is the Easter lamb (1 Cor 5:7) and the crucified Christ is an abomination and a folly for Jew and heathen (1 Cor 1:23). To the Galatians, Paul says 'with Christ I have died and Christ lives in me' (Gal 2:19–3:1). In the same way, the baptized share in Christ's death and are also party to his resurrection (Rom 6:3–4). But to die on the cross and there to dethrone the devil, the ruler of the dead, Christ first had to take on the appearance of man (Heb 2:14–15).[53] Having become equal to man, he has humbled and humiliated himself, and subjected himself to death on the cross (Phil 2:7–8). By his crucifixion, Christ has become a curse and has freed us from the curse of the Law because, as Paul quoting Deuteronomy 21:23 records, he 'who hangs on the wood is cursed' (Gal 3:13–14). On the cross, Christ has destroyed that which burdens and weighs us down, and by the cross he has triumphed over the rule of the powers; as a result of the crucifixion, Jewish law is no longer in operation (Col 2:14–15).[54] The blood of Christ is a spotless offering that cleanses us and heralds the new covenant (Heb 9:11–14, 16–20). This cleansing act removes sin. Christ, who himself was without sin, has taken up our sins upon the cross (1 Pet 2:21–25; 3:18; Gal 1:4).

This cento from the New Testament epistles refers to the death on the cross, but it neither dwells on the details of Christ's death nor expresses compassion with his humiliation, torture and painful suffering. Instead, the cento concentrates on the liberating and redeeming meaning of the death on the cross, focusing specifically on the forgiveness of sin. In this way, the construction of this cento connects the *indulgentia* rite during None with the cross.

After these readings, there follows a sermon in two parts, which starts with a reference to the crucifixion:[55] 'Jesus has as a ransom for our salvation today hung on the scales of the cross', and so he has with his death paid the price for the redemption of the world. The text emphasizes the despair of the crucifixion and

people or to the church. **52** No concrete pericopes are mentioned in AntL and *LO*. They are found, however, in the lectionaries of Silos and San Millán in *Liber commicus*, ed. Justo Pérez de Urbel and Atilano Gonzalez y Ruiz-Zorilla (Madrid, 1950–5), pp 342–52, or the lectionary of Aniane (see Pierre Salmon, *Le lectionnaire de Luxeuil. Edition et étude comparative. Contribution à l'histoire de la Vulgate et de la liturgie en France au temps des Mérovingiens* (Rome and Vatican City, 1944), p. cxi), and the Alcala Bible (in D. de Bruyne, 'Un système de lectures de la liturgie mozarabe', *Revue bénédictine*, 34 (1922), 147–55 at 150). **53** In connection with *Überlistungstheorie*, which is of relevance here, see Van Tongeren, *Exaltation of the cross*, pp 144–5. **54** In relation to the concept of *chirographum*, which is central here, see Lukken, *Original Sin in the Roman liturgy*, pp 176–81. **55** For the text of the sermon and the rest of the service, see *LO*, 397–401.

the torture and humiliation that Jesus, himself innocent, has undergone because of our guilt. Now that he has opened the doors of Paradise and crushed the gates of hell, he will lead the faithful to his kingdom.

In summary, in the Hispanic liturgy, the celebration of the cross on Good Friday is placed within a framework of reconciliation and, conversely, the celebration of reconciliation is embedded in the remembrance of the salutary crucifixion.

CONCLUSION

The presence of a cross relic was vital for the development and spread of the cult and the veneration of the cross. Without cross relics, a cross cult would not have developed in fourth-century Jerusalem. In the West, also, the rise and spread of the cult of the cross was connected to the presence of cross relics.

In Rome, the veneration of the cross on Good Friday emerged around the year 700 in two different celebrations, which coexisted. The faithful could participate in both. The original liturgy of the Word had been extended by the addition of several ritual elements: a procession, the veneration of the cross and a communion rite. The fact that these elements are not yet brought together in a balanced manner but coincide only partially indicates that this liturgical practice did not have a long history but must have appeared around 700. By the mid-eighth century, the liturgy of Good Friday had evolved into a celebration with a balanced form and structure. The procession had disappeared and the liturgy of the Word, the veneration of the cross and the communion rite are ordered as three separate parts. The textual elements of the Roman celebration shine a light on the unity in theme that is characteristic of the early Christian Easter liturgy, in which crucifixion and resurrection are celebrated as one.

A specific emphasis on suffering and death manifests itself in the procession of the papal liturgy in Rome (OR 23), which is enacted as an imitation of the historic path to Calvary and in Psalm 91, a psalm of suffering, which is given in OR 24 as an alternative response psalm. In the Roman papal liturgy, it seems as if the procession is accompanied by a focus upon Christ's suffering, and where there is no procession it is his glory that is emphasized. This holds true also of the Gallican liturgy, where there is no procession and Christ's victory is recalled. In the Hispanic liturgy, however, the relic of the cross and the procession by which its veneration is preceded are used to accentuate the glorious victory that the crucifixion represents

Only a few texts have survived in the Gallican liturgy, which does not incorporate the veneration of the cross into the Good Friday celebrations. These texts explore the healing meaning of the redemptive death on the cross, which

manifests itself in the remission of sin and the expulsion of the devil. Emphasis, too, is placed upon the fact that Jesus is both man and God.

In the Hispanic tradition, the Good Friday liturgy has two foci: the veneration of the cross and the *indulgentia* rite. Both are emphatically connected: reconciliation takes place within the context of the cross.

A stable factor in the history of the cult of the cross is the ritual manner in which the cross was treated, in what was and continued to be a clearly physical act. The cross was approached on bare feet and people lay prostrate on the ground in front of it. The cross was not only displayed so that people could see it, but it was also touched and venerated with a kiss.

In the liturgical texts, there are historical references to Jesus' suffering and death on the cross, but they are not dominant. These references emphasize what Jesus brought about through his Passion and death: namely, salvation and redemption. Jesus conquered death, the devil and the underworld when he died on the cross. This is why the cross is a sign of victory. This corresponds to the image that dominates the early medieval iconography of the cross,[56] in which Christ is portrayed standing on the cross as the living conqueror, the king who reigns from the cross. The crucifixion scene was rarely depicted during this period. In the second millennium, by contrast, a different image prevailed: that of Christ hanging on the cross as a suffering, bleeding and humiliated man, crowned with thorns. In the early Middle Ages, the cross was the tool of victory and not yet the instrument of passion it would become later in the Middle Ages.[57]

The cross symbolizes Jesus' act of redemption. Furthermore, because the cross participates in the reality to which it is a reference, namely Christ's redeeming death, Christ and the cross can be identified with one another. The cross is a reference to the crucified. Therefore, the veneration of the cross concerns Christ and, conversely, Christ's acts of salvation are transferred to the cross. This is why the cross is a salutary sign that in itself is able to act as a mediator in salvation, and therefore the cross is worthy of veneration.

56 See, for example, K. Niehr, 'Kreuz, Kruzifix. F. Ikonographie, II Abendland', *Lexikon des Mittelalters*, 5 (Munich, 2002), 1495–6; U. Köpf, 'Kreuz IV: Mittelalter', *Theologische Realenzyklopädie*, 19 (Berlin and New York, 1990), 751–6; E. Delaruelle, 'Le crucifix dans la piété populaire et dans l'art, du VIe au XIe siècle' in idem, *La piété populaire au Moyen Age* (Torino, 1975), pp 27–42.
57 See Katharina Schüppel, *Silberne und goldene monumentale Kruzifixe: Ein Beitrag zur mittelalterlichen Liturgie-und Kulturgeschichte* (Weimar, 2005), p. 272.

Seeing the crucified Christ: image and meaning in early Irish manuscript art

JENNIFER O'REILLY

Though central to New Testament accounts of human salvation, the crucifixion does not feature either in the surviving art of the catacombs and early Christian sarcophagi or in the repertoire of fourth-century Christian art after the conversion of Constantine. The two earliest known examples in the West are from Rome, a carved ivory and a panel from the doors of Santa Sabina, c.420–32.[1] They are roughly contemporary with Pope Celestine's sending of Palladius in 431 beyond the old imperial frontier to be the first bishop 'to the Irish who believe in Christ'.[2] The long delay before the first extant Irish representations of the crucifixion, as of other figural images of Christ, has been ascribed to the remoteness and perceived distinctive character of the early Irish church before the ascendancy of the *Romani* in the controversy over the dating of Easter.[3] Remarkably few representations of the crucifixion, however, have survived from anywhere, East or West, before the eighth century, even in areas where representational art was deeply rooted and in works that depict other scenes from the Passion narrative.

In contrast, the symbol of the cross survives in multiple forms and media throughout the early Christian world. As the sign of salvation, it was depicted with a variety of iconographic conventions, some of which were to be adapted in

1 Gertrud Schiller, *Iconography of Christian art*, 2 (London, 1972), figs 323, 326; *Picturing the Bible: the earliest Christian art*, ed. Jeffrey Spier (New Haven, CT, and London, 2007), Maskell Ivories, cat. 57; also p. 227, fig. 1; cat. 55, 56; Dina Tumminello, *La crocifissione del portale di S. Sabina e le origini dell' iconologia della crocifissione* (Rome, 2003). See Harley McGowan, this volume. **2** Prosper Tyro, *Contra Collatorum*, c.21; *PL*, 51:271. T.M. Charles-Edwards, *Early Christian Ireland* (Cambridge, 2000), pp 202–14. **3** As argued by Michael W. Herren and Shirley Ann Brown, *Christ in Celtic Christianity: Britain and Ireland from the fifth to the tenth century* (Woodbridge, 2002), pp 47–65, 234–5, 250–60, esp. p. 189. Recent work has qualified the picture of isolation: see, for example, Tomás Ó Carragáin, *Churches in early medieval Ireland* (New Haven, CT, and London, 2010),

Insular representations of the crucifixion, as will be seen. The cross was shown with expanded terminals, for example, raised on a stand or a mound, framed by an honorific arch, encircled or displayed within a laurel wreath of victory. It was often shown with equilateral arms, emphasizing the four cardinal directions, or combined with Greek letters, either the initials of the sacred name of Christ (XP) or his apocalyptic title, *alpha* and *omega*. It could be represented as a precious jewelled object or stylized tree of life, sometimes revealed between paired figures, whether men or angels, birds or animals. Such devices do not simply recall the historical crucifixion but variously suggest the triumph of the cross and its cosmic and eschatological significance.

The exalted cross could be identified with Christ himself, as is most clearly evident on small sixth-century *ampullae* that were mass-produced for pilgrims to Jerusalem. The sites of the crucifixion and resurrection were enshrined within the precincts of the Constantinian basilica, marking the finding-place of the relics of the cross; the compressed designs of the *ampullae* reflect the cult of the holy places and possibly the monumental images once displayed in the churches there.[4] Many *ampullae* feature a cross that does not bear Christ but is flanked by the two thieves, sometimes by Mary and John as well, or by the spear-bearer and sponge-bearer. The empty tomb is enshrined below the cross, signifying the resurrection. A portrait bust of Christ appears above or at the centre of the cross, which is shown as a standard of victory or *lignum vitae*, attended by symbols of sun and moon and revered by two genuflecting human figures. Within a single image, therefore, the cross could symbolically represent the crucifixion and acclaim Christ, risen, ascended and glorified.[5]

What is different about depicting Christ on the cross is that it focuses attention on his identity; it necessarily conveys some view about his humanity and divinity and about the reality and significance of his suffering and death. The theological issues had long been debated and were influentially articulated in the *Tome* of Leo the Great, which he emphasized was but an exposition of the Scriptures and the faith handed on by the apostles, safe-guarded by the Fathers of the church and confessed in the creed by all the faithful throughout the world, if with differing degrees of understanding. The *Tome* was endorsed by the Council of Chalcedon in 451 and both were affirmed by the Lateran Council of 649 and the Council of Constantinople (III) in 680–1. Leo and the theology of Chalcedon were repeatedly invoked in the early medieval West as a measure of right belief.[6]

pp 8–9, 15–47 for expressions of *romanitas* in pre-seventh-century Irish material culture. **4** For the influence of the veneration of the cross in the holy places on its liturgical commemoration in the West, see Van Tongeren, this volume. **5** André Grabar, *Ampoules de Terre Sainte (Monza-Bobbio)* (Paris, 1958); Schiller, *Iconography of Christian art*, 2, fig. 324. **6** Insular familiarity with the issues is increasingly being recognized. Bede, for example, had access to the *acta* of the Lateran Council of 649, which had been brought from Rome and copied at Wearmouth at the time of the Hatfield

Doctrinal orthodoxy was asserted by Columbanus and Cummian alike, notwith-standing their use of differing Easter tables; Bede defended the teaching of Aidan on the identity of Christ and the means of redemption.[7] Arguably, the language of the debate may also be discerned in the unique inscription above the first extant Insular illumination of the crucifixion, in the Durham Gospels of the late seventh or early eighth century (pl. 1).[8]

The theological tradition of early Latin Christendom is an important larger context in which to view the regional distinctiveness of the iconography and style of Insular manuscript images of the crucifixion, in order to understand something of the meaning and purpose they might have carried for contemporaries.[9]

'THE SON OF GOD WAS CRUCIFIED': THE THEOLOGY OF THE CROSS

Leo explained that humankind had been created in the divine image and likeness (Gen 1:26, 27), but had been deceived into sin and death by the devil. The restoration of fallen humanity was effected when the Word, the Son of God, himself took on human weakness and mortality; through the power of his divinity, his incarnate body was raised from death and glorified, thereby transforming humanity: 'Overcoming the author of sin and death would be beyond us, had not he whom sin could not defile, nor death hold down, taken up our nature and made it his own' (see Heb 2:14). In the divinity that he shared with the Father, Christ was sinless. In his humanity, he 'was like us in all respects except for sin' (Heb 4:15) because, through his virgin mother, he took on human nature at the Incarnation as it had been first created, without the stain of inherited sin.[10] The

Council, 679, where 'the bishops of the island of Britain' affirmed Chalcedon and the other ecumenical councils and the Lateran Council, in preparation for the Council of Constantinople in 680–1: *Historia ecclesiastica*, 5:17–18, *Bede's Ecclesiastical history of the English people*, ed. and trans. B. Colgrave and R.A.B. Mynors (Oxford, 1969), pp 384–91. For discussion of Northumbrian contacts with Rome and responses to Christological developments there, see Éamonn Ó Carragáin, *Ritual and the rood: liturgical images and the Old English poems of the Dream of the Rood tradition* (London and Toronto, 2005), pp 223–79. **7** Jennifer O'Reilly, 'The image of orthodoxy, the *mysterium Christi* and Insular gospel books', *L'Irlanda e gli irlandesi nell'alto medioevo: Settimane di studio della fondazione centro italiano di studi sull'alto medioevo*, 57 (2010), 651–705 at 654–5, 678–82. **8** David Ganz, 'Roman manuscripts in Francia and Anglo-Saxon England', *Roma fra oriente e occidente: Settimane di studio della fondazione centro italiano di studi sull'alto medioevo*, 49 (2002), 604–47 at 612–20; Jennifer O'Reilly, '"Know who and what he is": the context and inscriptions of the Durham Gospels crucifixion image' in Rachel Moss (ed.), *Making and meaning in Insular art* (Dublin, 2007), pp 301–16. **9** The manuscripts to be discussed are the Durham Gospels, the St Gall Gospels, the Southampton Psalter, the Book of Kells and a Continental copy of the Pauline Epistles: Würzburg, Universitätsbibliothek Cod. M.p.th. f. 69. **10** *Non enim superare possemus peccati et mortis auctorem, nisi naturam nostram ille susciperet et suam faceret quem nec peccatum contaminare nec mors potuit detinere*: Leo, *Tome (Epistula, 28)*, in *Decrees of the ecumenical councils*, ed. and trans. Norman P. Tanner (2 vols, London and Washington, DC, 1990), i, pp 77–82 at p. 77.

Lateran Council of 649 clarified the point by explaining that because in his humanity Christ was born incorrupt and without sin, his human will was not in conflict with his divine will but in perfect union in willing and bringing about human redemption. Though co-equal with the Father in his divinity, he was therefore humbly obedient to the Father, even to the death of the cross (see Phil 2:8).[11] The explanation of the role of Christ's death in effecting human salvation was therefore related not only to belief in his divinity and humanity, but to a particular understanding of the relationship of his two natures.

Leo emphasized that at the Incarnation the two natures were maintained, complete and unconfused, but in inseparable communion in a single person, who alone could restore the relationship between God and humankind:

> To pay off the debt of our state, invulnerable nature was united to a nature that could suffer, so that in a way that corresponded to the remedies we needed, 'one and the same Mediator between God and man, the man Christ Jesus' (1 Tim 2:5) could both on the one hand die and on the other be incapable of death.[12]

On the cross, Christ's humanity was manifested in his suffering and death; in his divinity he could not suffer but, because his human nature was inseparably united with his divine nature in one person at the Incarnation, it was possible to say, as in the creed, that the only begotten Son of God was crucified.[13] The point was summarized in Isidore's *Etymologiae*, a work known to seventh-century Irish writers: 'Only the man endured the cross, but because of the unity of person, the God is also said to have endured it … Therefore we speak of the Son of God as crucified, not in the power of his divinity, but in the weakness of his humanity'.[14]

Though not prescribing any particular iconography for the representation of the crucifixion, Leo rhetorically visualized the scene for one who had failed, through spiritual blindness, to recognize Christ's full humanity: 'Let him see what nature it was that hung, pierced with nails, on the wood of the Cross. With the side of the Crucified laid open by the soldier's spear, let him identify the source from which the blood and water flowed, to bathe the Church of God with font

11 See M. Hurley, '"Born incorruptibly": the third canon of the Lateran Council, 649', *Heythrop Journal*, 2 (1961), 216–36; *Concilium lateranense a.649 celebratum*, ed. R. Riedinger (Berlin, 1984), pp 370–1. **12** *Et ad resolvendum conditionis nostrae debitum natura inviolabilis naturae est unita passibili, ut quod nostris remediis congruebat, unus atque idem 'mediator dei et hominum homo Christus Iesus' et mori posset ex uno et mori non posset ex altero*: *Decrees of the ecumenical councils*, i, p. 78. **13** *Decrees of the ecumenical councils*, i, p. 80. **14** *Solus igitur homo pertulit crucem, sed propter unitatem personae et Deus dicitur pertulisse. Filium ergo Dei crucifixum fatemur, non ex virtute divinitatis, sed ex infirmitate humanitatis*: Isidore, *Etymologiae*, 7:2:48–9, ed. W.M. Lindsay (Oxford, 1911); *The etymologies of Isidore of Seville*, trans. Stephen A. Barney, W.J. Lewis, J.A. Beach and Oliver Berghof (Cambridge, 2006), p. 157.

and cup'.[15] In scripture and patristic literature, physical sight and imaginative envisioning are used as figures of spiritual insight that may lead to a deeper understanding of what is beyond all images.[16] The Fathers exhort the reader to open their eyes when reading God's word (Ps 118:18), to see with unveiled face (2 Cor 3:6–18), with inner sight (*interiore acie*), with the eyes of the mind or the heart, *illuminatos oculos cordis vestri* (Eph 1:18), and they repeatedly warn that only the pure in heart will see God (Mt 5:8). There is some broad analogy in the conventions by which early medieval artists engaged the viewer to look with faith on a representation of the crucified Christ and 'see' who he really is.

The evangelization of the Insular peoples involved the transmission not only of the Latin scriptures but of patristic traditions of biblical interpretation. The practice of elucidating the underlying spiritual meaning of a particular text in the light of other scriptural texts was made familiar at various levels of understanding through commentaries and devotional literature, homilies, hagiography and hymns, and especially in the monastic hours and the liturgy. The crucifixion images of Insular origin or influence to be discussed here appear in manuscripts of biblical and liturgical Latin texts. Though viewing the images was related to the practice of *lectio divina*, the spiritual insights they offered were mediated through a distinctive visual experience.

Peter Brown has identified the late sixth-century appearance of the codified *pictura*, opening a window on another and invisible world, as expressing a shift in Christian imagination and sensibility and marking a departure from the more accessible and realistic art of late antiquity.[17] Figural images and Christian iconography were part of what Irish artists inherited from the diverse artistic traditions of late antiquity and the contemporary Christian world, but that inheritance was selectively appropriated and transformed within a visual culture not governed by classical conventions of representation and naturalism. Figural images and Christological motifs such as the cross, the *chi* and the lozenge were adapted and assimilated in the inventive interplay of abstract forms and frames, colour and ornament, symmetry and asymmetry that characterizes Insular book art.[18] It was

15 *Videat quae natura transfixa clavis pependerit in crucis ligno et aperto per militis lanceam latere crucifixi intellegat unde sanguis et aqua fluxerit, ut ecclesia dei et lavacro rigaretur et poculo: Decrees of the ecumenical councils*, i, p. 81. **16** See Herbert L. Kessler's collection of papers, *Spiritual seeing: picturing God's invisibility in medieval art* (Philadelphia, 2000). **17** Peter Brown, 'Images as a substitute for writing' in Evangelos Chrysos and Ian Wood (eds), *East and West: modes of communication* (Leiden, 1999), pp 15–34 at pp 32–4. Herbert Kessler's response, 'Real absence: early medieval art and the metamorphosis of vision' in *Spiritual seeing*, pp 104–48, identifies a further watershed in the late eighth and ninth centuries, separating Western image theory (and the idea that art, being material, might only help raise the viewer towards spiritual vision by engaging the corporeal senses and mind) from 'Byzantine notions that the icon was transparent, a window onto the higher reality' (p. 124). **18** Meyer Schapiro, *The language of forms: lectures on Insular manuscript art* (New York, 2005), pp 99–155.

an art peculiarly suited to conveying a sense of the numinous, as the earliest extant Insular illumination of the crucifixion may show.

THE DURHAM GOSPELS

E.A. Lowe described the Durham Gospels as 'written in Northumbria, in a great centre of calligraphy in the direct line of Irish tradition, or else in Ireland itself'.[19] The book's origins remain controversial. It has generally been assigned to Northumbria and its formal Insular half-uncial script most closely compared with that of the Lindisfarne Gospels, recently dated c.710–21.[20] The Durham Gospels may well be earlier, however; certainly, it preserves Irish codicological traditions more fully. The essential features of its crucifixion iconography (the robed Christ flanked by two angelic figures and by the spear-bearer and sponge-bearer, with cup-shaped sponge) appear in all media in Ireland, but Richard Bailey has noted that they are not found in combination in pre-Romanesque Northumbria after this first example, which, he suggested, may reflect the earlier existence of the iconographic type in Ireland.[21] Others have argued that the Durham Gospel Book was itself produced in Ireland.[22]

The damaged crucifixion image, folio 38a verso, shares an important feature with a well-known Mediterranean iconographic type, but is not a mere derivative or reduction of that type.[23] In contrast to the earliest Roman images of the crucifixion, which show the crucified Christ as an almost naked heroic figure in a symbolic setting, early east Mediterranean images depict him in a long sleeveless *colobium*, flanked by the spear-bearer and the sponge-bearer and attended by Mary and John, sometimes with the two thieves and soldiers.[24] With varying degrees of Greco-Roman naturalism, the crucifixion is visualized in the landscape of Golgotha, suggesting the circumstantial reality of the event. The earliest surviving representation of this crucifixion type appears, possibly interpolated or repainted, in the prefatory illuminations of the late sixth-century Syriac Rabbula Gospels.[25]

19 Durham Cathedral Library, MS A.II.17: E.A. Lowe, *Codices latini antiquiores*, II (Oxford, 1935; 2nd ed., 1972), cat. 149. **20** *The Durham Gospels*, ed. C.D. Verey, T.J. Brown and E. Coatsworth (Copenhagen, 1980); Michelle P. Brown, *The Lindisfarne Gospels: society, spirituality and the scribe* (London, 2003), pp 48–53, 252–64, 401–2. **21** R. Bailey, 'A crucifixion plaque from Cumbria' in John Higgitt (ed.), *Early medieval sculpture in Britain and Ireland* (Oxford, 1986), pp 8–13; Elizabeth Coatsworth, 'The "robed Christ" in pre-Conquest sculptures of the crucifixion', *Anglo-Saxon England*, 29 (2000), 153–76. **22** Daibhí Ó Cróinín, 'Review of the Durham Gospels facsimile commentary', *Peritia*, 1 (1982), 352–62; W. O'Sullivan, 'The Lindisfarne scriptorium: for and against', *Peritia*, 8 (1994), 80–94 at 84–7. **23** Lawrence Nees, 'On the image of Christ crucified in early medieval art' in Michele Camillo Ferrari and Andreas Meyer (eds), *Il Volto Santo in Europa: Culto e immagini del Crocifisso nel Medioevo. Atti del Convegno internazionale di Engelberg (13–16 settembre 2000)* (Lucca, 2005), pp 345–85. **24** On these Roman figures, see Harley McGowan, this volume. **25** Florence, Biblioteca Laurenziana, Cod. Plut. I.56, fo. 13. *Picturing the Bible*, cat. 82,

The iconography was also known in the early medieval West, for example in the wall-painting of the crucifixion in the Theodotus chapel in Santa Maria Antiqua, *c*.750, in Rome, which was open to Byzantine cultural influences in the seventh and early eighth centuries.[26]

The cross in the Durham Gospels image is not shown realistically wedged into the rocky mound on Golgotha, as in the Theodotus chapel and Eastern examples, but takes the form of the cosmological cross. The horizontal beam is unusually low and wide so that, like the vertical shaft, it extends to the frame, the four expanded terminals suggesting the four cardinal directions. Two small human figures below the cross-beam and two angelic beings above it symmetrically flank the central axis spanning earth and heaven. The upright body of Christ is almost coterminous with the cross; he is arrayed in a long-sleeved robe, with upper arms close to his sides and forearms extended in a priestly *orans* gesture.[27] The linear design of abstract patterned shapes on the same plane as the frame is far removed from the illusionist figural forms and spatial depth of the Rabbula Gospels.

What the Durham image does share with the Rabbula Gospels crucifixion type is the depiction of Christ as though simultaneously receiving the sponge of vinegar to his lips, immediately before his death (Mt 27:48–50, Mk 15:36–7, Jn 19:28–30), and the lance to his side, even though John's Gospel, which alone describes that incident, specifies his side was wounded only after he was pronounced dead (Jn 19:30–4). Discussion has sometimes foundered on the question of whether the arrangement shows Christ alive or dead.

The marginal inscription above the Durham image instead enigmatically exhorts the reader: 'Know who and what he is' ('*scito quis et qualis est*'). The picture does not record a historical moment but presents a theological mystery through a visual paradox: Christ is shown both wounded and exalted.[28] While the humanity in which he once could be seen and touched is implicit in the very representation of his incarnate body, there is no emotive or realistic evocation of his suffering and death, in contrast to some representations of the crucifixion in Carolingian and Anglo-Saxon art. In the Durham Gospels image, the sponge-bearer and spear-bearer respectively testify to that suffering and death, but the emblematic tableau they form does not diminish the magisterial authority of the crucified. On the contrary, the composition gives new life to the antique pictorial convention whereby small attendant figures help denote the high status of the large frontal figure they symmetrically flank.

pl. 82D; *In the beginning: Bibles before the year 1000*, ed. Michelle P. Brown (Washington, DC, 2006), cat. 62. **26** Schiller, *Iconography of Christian art*, 2, figs 327, 329, 328. **27** The pose is most closely paralleled in one of the Palestinian *ampullae* designs (Monza, 12, 13), which shows the robed Christ standing, without the cross, as noted by Otto-Karl Werckmeister, *Irisch-northumbrische Buchmalerei des 8 Jahrhunderts und monastische Spiritualität* (Berlin, 1967), p. 58, pl. 17a. **28** For further examples of the connection between this theme and the trope of seeing and spiritual insight,

The account of sponge and spear in John's Gospel presents a theological insight into the voluntary and providential nature of the crucifixion. John testifies that Jesus knew that all things had now been accomplished and, in order that scripture might be completed, he said 'I thirst' (see Ps 22:15, Ps 69:21). The sponge of vinegar was proffered and then he gave over the spirit: *tradidit spiritum* (Jn 19:28–30). Augustine commented that in this passage we may discern 'the Mediator between God and man' (1 Tim 2:5), for 'he who was manifested as man suffered these things, and he himself, who was hidden as God, foreknew and arranged them all', for the sake of human salvation. Augustine described the wound in the side of Christ's dead body as the life-giving source of the sacraments whereby the dead are raised; blood and water flowed from the wound (Jn 19:34) for the remission and cleansing of sins.[29] Early patristic descriptions of the church, born from the side of Christ on the cross as Eve was born from the side of the first Adam, and of the wound as the source of baptism and the Eucharist by which the one Church is divinely sustained, were familiar in Irish exegesis, notably Cummian's Paschal letter of *c.*631, and the eighth-century compendium known as the Irish Reference Bible.[30]

John's Gospel already presents the crucifixion as an exaltation, and the wounding of Christ's side as the fulfilment of two Old Testament prophecies (Jn 19:31–7). John's first citation sees the wounded Christ prefigured in the paschal victim (Ex 12:46), the second gnomically foretells, 'They shall look on him whom they pierced' (Zach 12:10), which the Fathers linked to the use of the same prophecy in John's apocalyptic vision of Christ coming again in glory, when 'every eye shall see him, even those who pierced him' (Rev 1:7).

The Durham Gospels crucifixion image is not a didactic aid, teaching such material to unbelievers. It is a great icon, communicating a sense of the divine presence. The intensity of Christ's gaze draws the viewer to look with the eye of faith on 'him whom they pierced' and to respond accordingly. What the beholder sees is guided by enigmatic signs, including the arrangement of spear and sponge, which does not literally illustrate the Gospel account of the crucifixion but visually expounds its significance. The process of deciphering the signs prompts recollection of what is already known from the Gospels, from related images and texts, from the liturgy, in the light of which the viewer may be brought to a fuller recognition of who Christ is.

Jennifer O'Reilly, 'Early medieval text and image: the wounded and exalted Christ', *Peritia*, 6–7 (1987–8), 72–118. **29** Augustine, *In Iohannis evangelium*, CCSL, 36, *Tractatus*, 120, pp 434–5. **30** *Cummian's letter 'De controversia paschali'*, ed. M. Walsh and D. Ó Cróinín (Toronto, 1988), p. 78, ll 157–60; Ps-Jerome, *Expositio quatuor evangeliorum*, PL, 30, 587; *Tractatus Hilarii in septem epistolas canonicas*, *Scriptores Hiberniae Minores*, Pars 1, CCSL, 108B, p. 86; The 'Irish Reference Bible', Paris, BN, lat. 11561, fo. 173v: *Sicut de latere dormientis Adam facta e uxor ita ex latere xpi in cruce dormientis sacramenta ecclesiae fluxerunt.*

The signs include inscriptions. In the Old Testament, the Almighty declares: 'I am the first and the last (*ego primus et ego novissimus*) and besides me there is no God' (Is 44:6). Variants of the title are identified with Christ in the apocalyptic vision: 'I am *alpha* and *omega*, the first and the last, the beginning and the end'.[31] Patristic commentators, followed by Isidore, Bede and the compilers of the Irish Reference Bible, used the *alpha* and *omega* as a means of expounding the consubstantiality of the Father and the Son, and Christ's eternal divinity as well as the humanity he took on in time. He is 'the first', because by him all things were made (Jn 1:3) and he is 'the last' because by him all things are restored (Eph 1:10).[32] There are numerous Insular examples of the early Christian cryptogram that depicts the Greek letters *alpha* and *omega* either side of the exalted cross or the *chi-rho*.[33] In the Durham Gospels, however, the *alpha* and *omega* and the words *initium* and *et finis* (Rev 21:6) flank the head of the crucified Christ and the *titulus* inscribed above him on the cross: *hic est ihs rex iudeorum*.

The once-iridescent wings of the two attendant heavenly beings form a mandorla around Christ's head, enclosing also the *titulus* and the *alpha* and *omega*. The winged figures evoke the two golden cherubim above the ark in the tabernacle and the temple, from between whom God spoke to his people (Ex 25:18–22; 3 Kings 6:23–27). They may further recall the theophany of the two seraphim above the altar in the temple (Is 6:3), regarded as prophetic of Christ (Jn 12:41).[34] In the context of the Durham image, the *alpha* and *omega* not only refer to the revelation of Christ's eternal divinity at the end of time but proclaim the divinity and universal sovereignty of the crucified Christ, which is concealed from those who see only his humanity and the literal meaning of the mocking *titulus*: 'This is Jesus the king of the Jews'. The depiction of the crucified Christ as encompassing all time and space, signified by his apocalyptic title and the cosmological nature of the cross, conveys something of the mystery that is confessed in the Creed: the Son of God was crucified.

The evangelists describe how the Roman soldiers had clothed Jesus in scarlet or purple and mockingly hailed him as 'king of the Jews', but took this robe from

31 *Ego alpha et omega primus et novissimus principium et finis* (Rev 22:13; 21:6) and *ego sum alpha et omega principium et finis* (Rev 1:8, 17); he is here described as 'clothed with a garment down to the feet' (Rev 1:13). **32** Bede, *Expositio Apocalypseos*, ed. R. Gryson, *CCSL*, 121A, p. 239, ll 33– 7; p. 571, ll 39–45. E.A. Mater, 'The Apocalypse in early medieval exegesis' in R.K. Emmerson and B. McGinn (eds), *The Apocalypse in the Middle Ages* (Ithaca, NY, 1992), p. 44. **33** The motif is framed at the end of Luke's Gospel in Ussher Codex I, Dublin, Trinity College MS A:4:15 (55), fo. 149v: George Henderson, *From Durrow to Kells: the Insular gospel-books, 650–800* (London, 1987), p. 58, fig. 22. **34** Jerome, *Ep.* 18A, *The letters of Jerome*, ACW, 33, p. 82. For the cherubim, *Bede: On the Tabernacle*, trans. Arthur Holder (Liverpool, 1994), pp 16–21; *Bede: On the Temple*, trans. Sean Connolly (Liverpool, 1995), pp 46–52. On the visual ambiguity of Insular representations, see George Henderson, 'Cherubim and seraphim in Insular literature and art' in Elizabeth Mullins and Diarmuid Scully (eds), *Listen, O isles, unto me: studies in medieval word and image* (Cork, 2011), pp

him and clothed him in his own raiment before leading him to the place of crucifixion.[35] Patristic exegesis played on the royal and imperial connotations of the colour to expound its other significance as the colour of blood, and hence an image of Christ's incarnate body. Since Origen, the metaphor of Christ putting on his fleshly body like a garment, veiling his divinity, had been much used by the Fathers, including Leo the Great.[36] Citing Ambrose, Jerome and Augustine, Bede commented that, mystically, in the colour with which the Lord was vested by the soldiers, we may understand the flesh in which he was enrobed and offered up in his Passion, as prophesied by Isaiah (Is 53:2). Purple represents both the blood that was poured out for us and the eternal kingdom that he entered after his Passion, enabling us to enter too.[37] In the Durham Gospels, the picturing of Christ enthroned on the cross, royally robed in purple edged with orpiment simulating gold, is a visual conceit simultaneously alluding to the suffering flesh of his humanity, which clothed his invisible divinity, and to the risen body of the heavenly king, whose humanity shares in the glory of his divinity.

The context of the crucifixion picture in the manuscript provides an aid to understanding how it may have been read by contemporaries. It is positioned, not in John's account of the crucifixion, but on the verso of the last page of Matthew's Gospel. The words are ornately displayed within a cruciform frame whose outer edge matches that of the crucifixion overleaf.[38] The framed text (Mt 28:17–20) describes the last of Christ's resurrection appearances before he disappeared from the apostles' sight at the Ascension. The passage culminates in Christ's final command and promise to his disciples: 'Go and teach all peoples, baptizing them in the name of the Father and of the Son and of the Holy Spirit, teaching them to observe all things whatsoever I have commanded you. And behold, I am with you always, even to the end of the world' (Mt 28:19–20).

All or part of the text is highlighted in some other Insular Gospel books. Christ's command that all peoples be baptized, *in nomine patris, et filii, et spiritus sancti*, uses a Trinitarian baptismal formula that is unique in the New Testament. The verse's doctrinal importance appears in early Christological exegesis and was elaborated by Columbanus, Isidore and Bede.[39] The rite of baptism described in the Gelasian Sacramentary, the Bobbio Missal and the Irish Stowe Missal invokes

263–77 at p. 270. **35** Mt 27:28–31; Mk 15:17–20; Jn 19:2–5. George Henderson, *Vision and image in early Christian England* (Cambridge, 1999), pp 122–35, on the colour purple. **36** Origen, *Homilies on Exodus* 9,1, *SC*, 321 (1985), p. 280. Nicholas Constas, 'Weaving the body of God: Proclus of Constantinople, the Theotokos and the Loom of the Flesh', *JECS*, 3:2 (1995), 169–94 at 180–92; Joanne D. Sieger, 'Visual metaphor as theology: Leo the Great's sermons on the Incarnation and the arch mosaics at S. Maria Maggiore', *Gesta*, 26 (1987), 83–91. **37** Bede, *In Lucam* VI and *In Marcum* IV, *CCSL*, 122, pp 396, 627–8. **38** Henderson, *From Durrow to Kells*, fig. 70, pp 58, 80–4; R. Stevick, 'The Echternach Gospels' evangelist-symbol pages: forms from "The True Measure of Geometry"', *Peritia*, 5 (1986), 284–308 at 299. **39** Columbanus, *Sermo*, 1, in *Sancti Columbani Opera*, ed. G.S.M. Walker (Dublin, 1957), p. 60, ll 16–23; Isidore, *Etymologiae*, 9:19:45; Bede,

the typological image of the water from Christ's wounded side (Jn 19:34) and the blessing over the font quotes the baptismal formula of Christ's command to his disciples (Mt 28:19).[40]

The Durham image of the crucified Christ with wounded side, set in a liturgical Gospel book and associated with the framed text of Matthew 28:17–20, is a visual summation of the Gospel taken to the ends of the earth. It pictures the source of the sacraments by which the risen and ascended Christ, though no longer visible to earthly sight, continues to fulfil his promise to be present with the faithful, and it anticipates his return at the end of the world.

Finally, the inscriptions that frame the Durham crucifixion provide unique documentation of some of the associations contemporaries made with the picture. The lines above the crucified Christ begin by formally addressing the beholder: *Scito quis et qualis est* ('Know who, and what kind, he is'). The inscription does not give a literal description of the accompanying hieratic image. Rather, in the manner of ekphrastic *tituli* on some Byzantine icons, it heightens the paradox and extends the visual image's range of allusion. Using a different emotional register, it poignantly speaks of one 'in whom no sin was found, who suffered such things for us, caused by this' (meaning on account of this our sin).[41] The words partially echo 1 Pet 2:21–22, *Christus passus est pro nobis … qui peccatum non fecit, nec inventus est dolus in ore*, and bring the idea of sinless suffering for the sake of human redemption to a reading of the crucifixion image.

The inscriptions along the remaining three sides of the picture urge readers to respond to the suffering and death, the resurrection and ascension of Christ by participating in the means of their redemption: 'Casting down the author of death, renewing our life if we suffer with him/He rose from the dead and sits at the right hand of God the Father/So that when we have been restored to life, we may reign with him'.[42] The general sense derives from St Paul's familiar teaching that all who are baptized in Christ are baptized into his death in order that, 'as Christ rose from the dead (*surrexit a mortuis*) by the glory of God the Father, so we also may walk in newness of life' (Rom 6:3–4). Christ, in dying and rising from the dead, overcame sin but, in order to live with him, each of the faithful needs to be crucified with him and die to sin (Rom 6:5–9; Col 2:12–13). The Pauline images are concerned with the continuing inner conversion of the baptized and the *transitus* from death to life. Leo the Great commented that if we truly believe what we profess in the Creed, then

Homelia, 2:8, *CCSL*, 122, pp 233–8. **40** E.C. Whitaker, *Documents of the baptismal liturgy* (London, 1970), pp 29, 187, 207, 218. **41** *Scito quis et qualis est qui talia cuius titulus cui/nulla est inventa passus p(ro) nobis p(ro)p(ter) hoc culpa*. O'Reilly, '"Know who and what he is"', pp 310–16. **42** *Auctorem mortis deiecens uitam nostram restituens si tamen conpatiamur/Surrexit a mortuis … sedet ad dexteram d(e)i patris/Ut nos cum resuscitatos simul et regnare faciat …* Transcribed and trans. in

in Christ we are crucified, we are dead, we are buried; on the third day too, we are raised. Hence, the Apostle says: 'If you have risen with Christ, seek those things which are above, where Christ is sitting on God's right hand' (Col 3:1–4; 2:12).[43]

The belief expressed in the Durham inscriptions that 'If we suffer with him … together we shall reign' (see Rom 8:17 and 2 Tim 2:12) summarizes a major Pauline theme of continuing inner conversion that repeatedly occurs in patristic and monastic literature. Cassian, for example, presented the humility and obedience of the monastic life itself as a daily crucifixion and dying to the world, so that 'you no longer live, but he lives in you who was crucified for you' (Gal 2:20). The monk, as though fixed to the gibbet of the cross, directs the gaze of his heart to the heavenly place where he is sure he will go.[44] The Rule of St Benedict describes lifelong monastic obedience to Christ's teaching as 'a share in the sufferings of Christ that we may deserve also to share in his kingdom'.[45]

Columbanus' *Regula monachorum* opens with insistence on obedience, which was exemplified in Christ's humble obedience to the Father, even to the point of death on the cross (Phil 2:5–8); he cites Christ's own command that his disciples should take up the cross and follow him (Mt 10:38). Monks are to be crucified to the world (Gal 6:14) and seek heavenly things.[46] In Epistle 4, Columbanus exhorted his monks to be 'sharers in the Lord's Passion; for if we suffer with him, together we shall reign' (see Rom 8:17, 2 Tim 2:12).[47] This spiritual counsel, very close to that inscribed on the Durham crucifixion, stems from the belief that the solidarity of Christ's divine nature with his sinless human nature, which brought about human salvation, requires that redeemed humanity should be united with him. Like Augustine, Leo the Great and Gregory the Great, Columbanus spoke of the crucified Christ as *exemplum* and *sacramentum*, both the example of humble submission to the divine will and the mystery by which humanity is restored and enabled to follow him:

> The Gospels are full of this matter, and of it they are chiefly composed; for this is the truth of the Gospel, that the true disciples of Christ crucified should follow him with the cross. A great example has been shown, a great mystery [*sacramentum*] has been declared; the Son of God willingly, for 'he was offered up because he himself willed it' (Is 53. 7), mounted the cross as a

Durham Gospels, p. 59. **43** Leo, *Tractatus*, 72:3, *De passione Domini*, CCSL, 138A, pp 443–4, ll 57–64. **44** *Institutes*, 4:34, 35: *John Cassian: The Institutes*, trans. Boniface Ramsey (Mahwah, NJ, 2000), pp 97–8; *Conlationes*, 19:8: *Jean Cassien Conferences*, 3, ed. E. Pichery (Paris, 1959), p. 46. **45** *The Rule of St Benedict*, ed. Timothy Fry (Collegeville, MN, 1980), Prologue, p. 166. **46** *Opera*, pp 125, 127; see *Instructio*, 10:2, p. 103: 'we cannot live to him unless we first die to ourselves, that is, to our wills'. **47** Columbanus, *Ep.* 4:6, *Opera*, p. 33.

criminal, 'leaving to us', as it is written, 'an example [*exemplum*], that we should follow in his footsteps' (1 Pet 2:21). Blessed then is the man who becomes a sharer in this Passion and this shame. For there is something wonderful there concealed.[48]

All 'the secrets of salvation' (*salutis mysteria*) are hidden in this paradox and from it proceeds Columbanus' teaching on monastic obedience and humility as pre-eminently the way of the cross and therefore the way of perfection.

Word and image in the Durham Gospels summon the reader to come before the gaze of the crucified Christ, to see who and what he is, and to respond by imitating him. Potentially, the act of seeing is both revelatory and transformative.

ST GALL GOSPELS

The Durham crucifixion has some unique features but its basic iconographic type recurs in Irish manuscripts, metalwork and stone carving over a long period, modified by variant details and differing contexts.[49] It appears at the end of the St Gall Gospels, probably of the middle to late eighth century (pl. 2).[50] Again, Christ's suffering and death are not realistically represented, but the nails and side wound are indicated and Christ is not as austerely frontal and hieratic a figure as in the Durham Gospels: his youthful beardless face is slightly turned aside and his feet and lower legs are seen in profile. Above the cross-beam are two angels, rather than cherubim, holding books. There is no *titulus*. The cross-beam is higher than in the Durham Gospels but all four straight projections of the cross extend to the frame.[51] Christ spans the cross with arms horizontally outstretched.

The composition is animated by the looping agitated ribbon folds of the sleeveless garment of reddish purple that forms Christ's body. In a Christian context, the ancient lozenge-shaped symbol of the *tetragonus mundi* or four-fold world could signify Christ as the divine Creator-Logos. At the beginning of the St Gall Gospels, this symbol is conspicuous at the centre of the diagonal cross that

48 *Evangelia plena sunt de hac causa et inde sunt maxime conscripta: haec est enim veritas evangelii, ut veri Christi crucifixi discipuli eum sequantur cum cruce. Grande exemplum ostensum est, grande sacramentum declaratum est: Dei filius voluntarius (**oblatus** est enim **quia ipse voluit**) crucem ascendit ut reus, **relinquens nobis**, ut scriptum est, **exemplum, ut sequamur vestigia eius**. Beatus igitur est, qui huius passionis et huius confusionis fit particeps. Inest enim ibi aliquid admirabile celatum*: Columbanus, *Ep.* 4:6, *Opera*, p. 31; Leo, *Tr.*, 63:4 and *Tr.*, 72:1, *CCSL*, 138A, pp 384–5, ll 64–73, pp 441–2, ll 15–19. **49** Peter Harbison, 'The bronze crucifixion plaque said to be from St John's (Rinnagan), near Athlone', *Journal of Irish Archaeology*, 2 (1984), 1–18. **50** St Gallen Stiftsbibliothek Cod. Sang. 51, p. 266. **51** Robert Stevick, 'A geometer's art: the full-page illuminations in St Gallen Stiftsbibliothek Cod. Sang. 51, and Insular gospel books of the 8th century', *Scriptorium*, 44 (1990), 161–92 at 186, 188, notes the golden mean in the ratio of the crossbeam to the vertical shaft.

forms the initial Greek letter *chi* of Christ's name, announcing his incarnation at Matthew 1:18; here at the close of the book, the lozenge shape is concealed in the pattern of drapery on the breast of the Crucified.

In the text of the St Gall Gospels, the unique account of the wounding of Christ's side from John's Gospel (Jn 19:34) is interpolated into Matthew's Gospel on page 75, following the description of how one who stood at the cross offered Christ a sponge of vinegar on a reed (Mt 27:49): *Alius autem accepta lancea pupungit latus eius et exit aqua et sanguis* ('Another, however, having taken a lance, pierced his side and water and blood came out'). Martin MacNamara has noted that the interpolation, which represents an early harmonizing tradition witnessed in some fourth-century Greek manuscripts, was transmitted in Latin Gospel texts largely through Irish manuscripts.[52]

In the context of a Gospel book, the Insular iconography of the crucified Christ with wounded side would particularly have evoked the Eucharist. In the account of the institution of the Eucharist in 1 Corinthians 11:23–5, Christ identifies the bread with his body, *quod pro vobis tradetur*, and the wine with his blood, and commands that the bread and wine be received in commemoration of his death and in anticipation of his future return: 'For as often as you shall eat this bread and drink this cup, you show forth the death of the Lord, until he come'. This verse begins the lection 1 Corinthians 11:26–32 in the Irish Stowe Missal.[53] A series of scriptural acclamations at the fraction includes the text, 'the bread which we break is the body of our Lord Jesus Christ, Alleluia. The chalice which we bless is the blood of our Lord Jesus Christ. Alleluia' (see 1 Cor 10:16–17).[54]

The belief that each celebration of the Eucharist 'shows forth the Lord's death' had been allusively developed in patristic tradition and liturgy, but the symbolic re-enactment of the Passion at the Eucharistic altar came to be more overtly presented as a series of parallels, impressing on the faithful that in receiving the sacrament they were united to the crucified body. In the Irish vernacular commentary on the Mass, which was appended to the Latin texts of the Stowe Missal, probably soon after its completion, *c.*800, the stages of Christ's Passion and resurrection recalled in the liturgical actions of the Eucharist are spelled out. The *commixtio*, or mixing of water and wine in the chalice before consecration, is interpreted as symbolizing the union of Christ's divinity with his humanity, and his union with humankind, at his conception. The host on the paten is the body of Christ on the cross; the *fractio panis* before the communion is the breaking of

52 Martin MacNamara, 'Bible text and illumination in St Gall Stiftsbibliothek Codex 51, with special reference to Longinus in the crucifixion scene' in Mark Redknapp, Nancy Edwards, Susan Youngs, Alan Lane and Jeremy Knight (eds), *Pattern and purpose in Insular art* (Oxford, 2001), pp 191–202 at pp 193–4. **53** Dublin, RIA, MS D.II.3, fos 12–67: fos 15–15v, 33v, *The Stowe Missal*, ed. G.F. Warner (London, 1911), p. 5: *Fratres, quotiescumque manducabitis panem hunc, et bibetis calicem istum, mortem domini adnunciabitis donec ueniat.* **54** *The Stowe Missal*, II, pp 5, 18.

Christ's body with the nails and the spear, when baptism and the Eucharist were born from his side; the priest cuts off a fragment of the host, as Christ's right side was pierced.[55]

In the St Gall crucifixion image, however, the wound is indicated by the position of the spear-bearer on Christ's left. John's Gospel does not specify on which side Christ was wounded. The usual depiction of the wound, not on the side of the heart but on Christ's right side, in both Eastern and Western crucifixion scenes, doubtless to some extent reflects the general favouring of *dextra* rather than *sinister* found in many cultural contexts, including numerous biblical texts. Because of Christ's identification as the new temple, prefigured in the temple in Jerusalem (Jn 2:19–21), the healing water of life that issued from the right side of the temple in Ezekiel's vision (Ezek 47:1–2) was in exegesis and liturgy related to the healing sacramental stream that issued from Christ's side on the cross.[56] Furthermore, Bede commented that the door leading to the upward spiral stair within the temple was aptly placed on the right side of the building (1 Kings 6:8), 'because holy church believes that Christ's right side was opened by the soldier'. Noting, as Augustine had done, that the verb used in John 19:34 is 'opened' (*unus militum lancea latus eius aperuit*), Bede regarded the wound in Christ's right side as the door of salvation, opened to admit the faithful, through baptism and the Eucharist, to their heavenward mystical ascent.[57]

The depiction of the spear-bearer on Christ's left in the St Gall Gospels and in most other examples of the Irish crucifixion type (including the Athlone Plaque, the Southampton Psalter, some of the late cast crucifixion plaques and all but four of the high crosses), distinguishes them from almost all surviving early crucifixion scenes elsewhere, though there is no evidence to suggest the motif represents a doctrinal difference. The assumption that it is the periphery's conservative preservation of a revered early Christian type, superseded elsewhere, is difficult to demonstrate.

One of the earliest Western representations of the crucifixion, showing Christ wearing the brief loincloth or *subligaculum*, depicts Mary and John to his right and a figure standing on his left with a raised hand holding the remnant of a dagger.[58] In the same set of Maskell Ivories from Rome, *c*.420–30, the wound is also indicated on Christ's left side in the scene where he reveals it to Thomas as a visible proof of the reality of his bodily resurrection (Jn 20:25–8). An Eastern example much closer to the Insular crucifixion type, in that it depicts Christ's full-length robe with long sleeves, the cup-shaped sponge and the sponge-bearer and spear-bearer to Christ's right and left respectively, is a gilded silver paten, now believed to have been made in central Asia in the ninth or tenth century, though showing

55 Translation: *Stowe Missal*, ii, pp 41–2. **56** Ó Carragáin, *Ritual and the rood*, p. 151. **57** *Et bene in parte domus dextrae quia dextrum eius latus a milite apertum sancta credit ecclesia*: Bede, *De templo* and *In Ezram et Neemiam*, CCSL, 119A, pp 166, 300–1. **58** Maskell Ivories, British Museum: see

similarities with early works from Syria and Palestine, such as the *ampullae* from the holy places. It shows, however, two sacramental streams issuing separately from beneath Christ's right and left armpits.[59] The idea that the spear went through Christ's body, piercing both sides, is perhaps suggested in Prudentius' composition of *tituli*, which purport to accompany pictorial scenes from sacred history. The caption for the Passion begins 'Pierced through either side, Christ gives forth water and blood'.[60]

The Durham Gospels crucifixion shows the wound on Christ's right, as do a few later Irish examples in metalwork and stone, the fragmentary stone carving from the Calf of Man, and the Insular-influenced image in the Würzburg Pauline Epistles (pl. 4).[61] The Athlone Plaque is of interest, for it is closer to the Durham crucifixion than to St Gall in depicting Christ's long-sleeved garment and the expanded terminals of the cross, yet it shows the spear-bearer on Christ's left. The Irish commentary on the Mass appended to the Stowe Missal assumes the wound was on Christ's right, but its account of how this is symbolized in the actions of the fraction of the host may indicate a potential source of confusion. The particle cut off from the bottom of the half of the host on the priest's left hand is described as 'the figure of the wounding with the lance in the armpit of the right side; for westwards was Christ's face on the cross, to wit, *contra ciuitatem*, and eastwards was the face of Longinus; what to him was the left to Christ was the right'.[62]

In the Durham Gospels, the descriptive name *Longinus* (lance-bearer) is written beside the figure on Christ's right, as is the equivalent in the Rabbula Gospels. In the St Gall crucifixion, the unnamed figure with the spear, standing on Christ's left, receives a thin stream of blood from Christ's wounded side into his eye. This is probably the earliest pictorial witness to the apocryphal story that blood from Christ's wound healed Longinus of his blindness. The origins of the story are uncertain. It features, with variants, in the rich tradition of apocrypha in Irish sources, but mostly at a later date than the St Gall Gospels, as in the *Acts of Pilate (Gospel of Nicodemus)*. Its earliest appearance, however, is in Blathmac's eighth-century poem on Mary, which tells how, at the crucifixion, 'his heart was pierced, wine was spilled … the blood of Christ flowing through his gleaming sides'; the same blood instantly 'cured the fully blind man who, openly with his two hands, was plying the lance'.[63]

Harley McGowan, this volume. **59** *Byzantium, 330–1453*, ed. Robin Cormack and Maria Vassilaki (London, 2008), cat. 286. **60** *Traiectus per utrumque latus laticem atque cruorem/Christus agit: Tituli historiarum*, 42, *Prudentius*, ed. and trans H.J. Thomson (2 vols, Cambridge, MA, 1961), ii, p. 367. **61** Harbison, 'The bronze crucifixion plaque', 5–7 notes examples, including the crosses at Moone, Castledermot south, Ullard and Arboe, and the Calf of Man panel, pl. 5. Cormac Bourke, 'The chronology of Irish crucifixion plaques' in R.M. Spearman and John Higgitt (eds), *The age of migrating ideas: early medieval art in northern Britain and Ireland* (Edinburgh, 1993), pp 175–81, figs 21:1b–f; see Murray, this volume. **62** *Stowe Missal*, ii, 41. **63** *The poems of Blathmac Son of Cu*

The visual reference to the Longinus story in the St Gall crucifixion may seem a narrative intrusion into a symbolic image, but it is not arbitrary. The healing of Longinus' blindness and his consequent conversion emphasizes the theme of physical sight and spiritual insight, already present in the canonical Gospel text. The evangelist, writing in the person of an eye-witness to the wounding of Christ's side, declares: 'he who saw it has given testimony and his testimony is true ... that you may believe' (Jn 19:34–5). Instead of the spear-bearer, unique to John's account, Matthew and Mark describe the Roman centurion who, standing by the cross and watching the eschatological signs accompanying Christ's death, was brought to recognize the identity of the Crucified: 'Truly this was the Son of God' (Mt 27:54; Mk 15:39). The accounts are in effect harmonized in the later recension of the apocryphal *Acts of Pilate*, and in the Irish *Passion of Longinus* in the Leabhar Breac, where Longinus is identified with the centurion.[64]

The St Gall image tells the apocryphal story with extreme economy. The pupil of Longinus' left eye is still an unseeing slit but the right eye into which the healing blood falls has already been made whole. Following Longinus' gaze as he looks up at Christ and sees the source of his physical healing, the reader is drawn to look on this corporeal image with the inner eye and to see the source of salvation.

Whereas the Durham Gospels presents Christ crucified, risen, ascended and glorified in a single image, in the St Gall Gospels the theme is distributed over two facing pages that have complementary frames and compositions; the diptych concludes and epitomizes the Gospel book (pp 266–7). Opposite the crucifixion is the vision of the risen and ascended Christ in the glory of his *parousia* or Second Coming, attended by angels blowing trumpets. The twelve apostles stand in the lower register looking up, as at the ascension, when they were assured that the same Jesus taken up from them into heaven would come 'in like manner as you have seen him go into heaven' (Acts 1:11).

St Paul proclaimed that 'he who descended is the same who ascended above all the heavens that he might fill all things' (Eph 4:10). The identity of Christ's person in the two facing scenes in the St Gall Gospels, however, is not represented by duplication of the features and pose of his head. The frontal, bearded, hieratic Christ, bearing the triumphal standard of the cross, reveals his exaltation and authority, described by Paul. Christ had reconciled all humanity to God 'in one body by the cross' (Eph 2:16); God raised him from the dead to the heavenly places and 'made him head over all the Church, which is his body' (Eph 1:20–3;

Brettan, ed. and trans. James Carney (Dublin, 1964), stanzas 57–8, pp 20–1; McNamara, 'Bible text and illumination', pp 197–200; Harbison, 'The bronze crucifixion plaque', 13; Ann Dooley, 'The Gospel of Nicodemus in Ireland' in Zbigniew Izydorczyk (ed.), *The medieval Gospel of Nicodemus: texts, intertexts and contexts in Western Europe* (Tempe, AZ, 1997), pp 361–401 at pp 365–8. **64** For the depiction of the crucifixion in the homilies preserved in the Leabhar Breac, see Mullins, this

5:23, 30). Augustine emphasized that this body 'cannot be deprived of its head; if the head is in glory forever, so are the limbs'. Though the head of the body is in heaven and its members on earth, at the ascension the head went before as an assurance that the members of the body would follow. Meanwhile, members of the body are to serve him and grow in unity and likeness to him.[65] Using the same Pauline image, Gregory the Great said that Christ through his incarnate body achieved immortality for humanity and in his ecclesial body brings them to perfection. Gregory therefore urged all the members of Christ's body to grow spiritually 'unto a perfect man, into the measure of the fullness of Christ' (Eph 4:13), like the holy apostles who stood near to the Saviour, 'as the chest cleaved to the head'.[66] Columbanus repeatedly used the Ephesians metaphor to argue that belief in the unity of Christ's person requires the unity and fraternal love of the members of his body on earth in carrying out his commandments.[67]

In the St Gall Gospels, the unified body of the faithful is represented by the apostles, set beneath the half-length figure of Christ their head.[68] The apostles share one figural type and pose, as on the high cross at Moone, and are differentiated only by the colours and folds of their garments. They are identified by their number.[69] Augustine and Gregory saw the universal nature of the church symbolized in that number, divisible into four parts of three each.[70] The numerological significance of the twelve apostles taking the fourfold Gospel and baptism in the name of the Trinity to the four corners of the world, in accordance with Christ's command in Matthew 28:19 to teach all peoples, was a patristic *topos* well known to Insular commentators.[71]

In the St Gall Gospels, the arrangement of the apostles in four groups of three draws attention to the sacramental sign of their number. At the same acute angle as the spear-bearer and sponge-bearer look up at the Crucified in the facing picture, the apostles look up towards the glorified Christ at his return. The pupils of one apostle alone, at the centre of the upper row, turn to invite the viewer's gaze

volume. **65** Augustine, *Enarrationes in psalmos*, CCSL, 39, Ps 89:5; Ps 90, 2:14, pp 1269–70. Leo the Great on the Ascension, *Tractatus*, 73:4, CCSL, 138A, pp 452–3: 'the hope of the body is raised, whither the glory of the head has gone before'. **66** *Homiliae in Hiezechielem*, CCSL, 142 (1971), 1:6, 8, p. 71. **67** Columbanus, *Opera, Ep.* 2:8, p. 20, ll 30–3; p. 22, ll 16–20, citing Eph 1:2, 4:13, and *Ep.* 5:13, p. 50, ll 24–7, p. 52, ll 10–13, citing Eph 2:14, 4:10. **68** For the *figura* of 'Christ, the head, and his body, the church' as the first of the rules in Tyconius' handbook on biblical interpretation, *Liber regularum*, summarized by Augustine in *De doctrina christiana* and used by Bede and Irish commentators, see Carol Farr's discussion of the Book of Kells, fo. 202v: *The Book of Kells: its function and audience* (London, 1997), pp 66–75, 91–2. **69** George Henderson, 'The representation of the apostles in Insular art, with special reference to the new apostles frieze at Tarbat, Ross-shire' in Alastair Minnis and Jane Roberts (eds), *Text, image and interpretation: studies in Anglo-Saxon literature and its Insular context in honour of Éamonn Ó Carragáin* (Turnhout, 2007), pp 473–94 at pp 477–80. **70** *Enarrationes in psalmos*, 86:4, pp 1201–2; Gregory, *Moralia in Iob*, 1,14,19, CCSL, 143, p. 34, ll 22–5. **71** Bede, *Expositio actuum apostolorum*, 1:16, CCSL, 121, pp 11–12; Bede, *Homelia*, 1:13, CCSL, 122, p. 126; Irish Reference Bible: Paris, BN, MS lat. 11561, fos 132,

too. Looking at the diptych, members of the body of Christ on earth see an affirmation of belief in Christ's overcoming of death, promising eternal life with him for all who follow the faith and practice handed on by the apostles.

THE SOUTHAMPTON PSALTER

A third manuscript example of the Irish iconography of the crucifixion survives from the post-Viking period in the different context of the archaic Irish Southampton Psalter, *c.*1000, which has Old Irish as well as Latin glosses (pl. 3).[72] Its preservation of a hallowed early Irish type is highlighted by comparison with the contemporary Ramsey Psalter, whose crucifixion frontispiece illustrates the contrary direction taken by late Anglo-Saxon art.[73] During the period of Benedictine monastic reform in the tenth and eleventh centuries, Anglo-Saxon art was strongly influenced by Continental monasticism, spirituality and *ars sacra* – liturgical manuscripts, ivories and precious metalwork – which had assimilated and adapted a much greater range of figural art and iconography from late antiquity than appears in early Insular art.[74] The drawing of the crucifixion in the Ramsey Psalter movingly portrays the dead Christ. His humanity is conveyed through the naturalistic representation of his body, clothed only in a loincloth. Blood issues from his five wounds, his eyes are closed, his head slumped on his shoulder and he is flanked, not by the sponge-bearer and spear-bearer, but by his grieving mother and beloved disciple; there are no angelic attendants.

The crucifixion is depicted with many iconographic variants in late Anglo-Saxon manuscripts but centres on the stripped body of Christ, witnessed by Mary and John. An important exception is the Tiberius Psalter, *c.*1050, which shows Christ in a loincloth but preserves the flanking figures of the spear-bearer and the sponge-bearer, with cup-shaped sponge, from the early Irish type. Christ is pierced beneath the right arm, blood spurts from the wound and, in allusion to the apocryphal story of Longinus, the spear-bearer rubs his eyes and raises his head to look up at Christ.[75] The crucifixion scene is part of a prefatory Christological pictorial cycle that includes scenes of David overcoming the lion and Goliath, subjects also preserved in Irish Psalter illustration.

In the New Testament and patristic exegesis, in the monastic office, private prayers and the liturgy, the psalms are interpreted as revealing the mystery of

183v–188. **72** Cambridge, St John's College MS C9 (59), fo. 38v. J.J.G. Alexander, *Insular manuscripts, 6th to 9th century* (London, 1978), cat. 74. **73** London, BL, Harley MS 2904, fo. 3v; *Anglo-Saxon manuscripts, 900–1066*, ed. Elzbieta Temple (London, 1976), cat. 41, pl. 142; Jennifer O'Reilly, 'St John as a figure of the contemplative life: text and image in the art of the Anglo-Saxon Benedictine reform' in N. Ramsey, M. Sparks and T. Tatton-Brown (eds), *St Dunstan, his life, times and cult* (Woodbridge, 1992), pp 165–85, pl. V. **74** Barbara C. Raw, *Anglo-Saxon crucifixion iconography and the art of the monastic revival* (Cambridge, 1990), pp 95–110. **75** O'Reilly, 'The

Christ.[76] In Ireland, there was also a tradition of psalm commentary that gave a historical as well as a spiritual interpretation and emphasized the typology of David and Christ.[77] The Irish Southampton Psalter follows a patristic practice of dividing the psalm text at Psalms 1, 51 and 101, but unusually has framed figural images opposite the framed initial pages of each of the three divisions. Kathleen Openshaw argued that, within what was probably a well-established Irish Psalter tradition, the three pictures do not directly illustrate the psalms they preface but together present a symbolic programme depicting spiritual combat against evil, pictured through the typology of David and Christ.[78] The first and third divisions open with scenes of David overcoming the lion and slaying Goliath. They are Old Testament types or prefigurings of Christ overcoming sin, death and the devil, which is represented by the scene of the crucifixion, folio 38v, at the second division of the psalter. The images provide a meditative focus for the reader who prays the psalms and shares with Christ in the daily spiritual battle.[79]

The early Insular iconography of the crucifixion is preserved in a highly stylized form in the Southampton Psalter. The hair, ears and body of Christ, as well as his purple garment, are rendered as abstract shapes and patterns formed of Celtic spirals, peltas and interlace. The constituent elements of the composition are outlined and connected by calligraphic dotting. Christ is a staring, orant figure, seen as though standing before the unsupported horizontal beam of the cross with his feet turned outwards; the small spear-bearer on his left does not look up but the sponge-bearer, also in profile, is larger and has a prominent eye. The stem supporting the sponge extends from his right hand, pierces his face just by his eye, then rises between the outstretched right arm of Christ and the crossbeam towards Christ's face. The modern viewer may find this particular example of Insular interwoven forms bizarre and yet acknowledge that it succeeds in drawing attention to the direction of the sponge-bearer's gaze, just as the spear and the spurt of blood in the St Gall crucifixion connect the spear-bearer's eye with Christ and also guide the eye of the beholder.[80]

Together with the more richly allusive spear, the cup-shaped sponge was an integral part of the Irish iconography of the crucifixion and it too could have served to cue familiar texts and images in the memory and imagination of a meditative contemporary reader. It may be useful, for example, simply to recall

wounded and exalted Christ', 94–100. **76** Martin McNamara, 'Christology and the interpretation of the psalms in the early Irish church' in T. Finan and V. Twomey (eds), *Studies in patristic Christology* (Dublin, 1998), pp 196–233 at pp 209–16. **77** Martin McNamara, 'Psalter text and psalter study in the early Irish church', *PRIA*, 73C (1973), 201–98. **78** Kathleen Openshaw, 'The symbolic illustration of the psalter: an Insular tradition', *Arte Medievale*, 2nd ser., 6 (1992), 41–59. **79** Kathleen Openshaw, 'Weapons in the daily battle: images of the conquest of evil in the early medieval psalter', *Art Bulletin*, 75 (1993), 17–38 at 19–20, 24. **80** See Isabel Henderson, 'Understanding the figurative style and decorative programme of the Book of Deer' in Katherine

here one brief detail about the sponge in St John's account of the crucifixion and how densely that was read by patristic and Insular commentators. Whereas Matthew and Mark say the sponge of gall or vinegar was raised to Christ's lips on a reed (Mt 27:48; Mk 15:36), John specifies that the sponge was filled from a vessel and put upon hyssop (Jn 19:29).

The hyssop in John's account of the crucifixion was directly related in exegesis to the image of hyssop in Psalm 50, the penitential psalm *Miserere me*, which, with the customary canticles, closes the first division of the psalms and precedes the crucifixion picture in the Southampton Psalter. Those praying through the words of the psalmist seek divine forgiveness: 'Have mercy on me, O God ... wash me from my iniquity and cleanse me from my sin ... You will sprinkle me with hyssop and I shall be cleansed; you will wash me and I shall be whiter than snow' (Ps 50:3–4, 9). In his commentary on the psalm, Cassiodorus notes that hyssop was dipped in sacrificial blood and sprinkled on the unclean in ritual purification (Lev 14:6) and interprets the allusion to this use of hyssop in Psalm 50:9 as denoting the mysteries of absolution of sins through the saving blood of Christ.[81] The connection was already made in the New Testament's presentation of the redeeming sacrifice of Christ as foreshadowed when Moses purged the people by sprinkling on them the blood of calves and goats with hyssop (Heb 9:11–20).

It was earlier noted that Augustine found in St John's account of Christ's thirst and his reception of the prophesied sponge of vinegar (Jn 19:28–30) an encoded revelation of 'the Mediator between God and man' (1 Tim 2:5), who both suffered these things and divinely arranged them for the sake of human salvation. Harmonizing the Gospel accounts, Augustine saw the sponge of vinegar as placed on hyssop and raised up on a reed. He noted that hyssop is a lowly herb with purgative properties. It betokens the humility of Christ: 'Hence it is said in the psalm, "Purge me with hyssop, and I shall be clean" (Ps 50:7)'.[82] This exegesis is closely repeated in the Irish Reference Bible's commentary on John; the plant lore on hyssop's purgative powers and its use in the sprinkling of lamb's blood in Old Testament ritual cleansing was also transmitted for Insular writers by Isidore's *Etymologiae*.[83]

Augustine expanded on the Christological importance of what is signified by hyssop: 'it is by Christ's humility that we are cleansed because, had he not "humbled himself, and become obedient unto the death of the cross" (Phil 2:8), his blood certainly would not have been shed for the remission of sins, or, in other

Forsyth (ed.), *Studies in the Book of Deer* (Dublin, 2008), pp 32–66 at pp 33–7. **81** Cassiodorus, *Explanation of the Psalms* (3 vols, New York, 1990), i, p. 501. Hyssop was also used to sprinkle the blood of lambs on Israelite households at their deliverance from slavery in Egypt (Ex 12:7, 21–7); St John alludes to the Passover lamb (Ex 12:46) in his account of the wounding of Christ's side (Jn 19:37). **82** Augustine, *In Iohannis evangelium, Tr.*, 119:4, 5, pp 659–60. **83** Paris, BN, MS lat. 11561, fo. 182v; Isidore, *Etymologiae*, 17:9, 39.

words, for our cleansing'.[84] Hyssop also signifies the desired penitential response of the faithful, for it is the humility of Christ, in laying aside the glory of his divinity at his incarnation and suffering death in obedience to the Father's will, which both effects the redemption of sinful humankind and offers the pattern to be followed by the 'contrite and humbled heart'. Augustine here refers to the psalmist's understanding that the sacrifice that God truly desires from the faithful is 'an afflicted spirit: a contrite and humbled heart, O God, thou wilt not despise' (Ps 50:17).[85]

THE BOOK OF KELLS

The Book of Kells is most unusual in having two full-page figural images of Christ within the Gospel text, each accompanied by a full-page framed enlargement of the opening words of the adjacent text. In Matthew's account of the crucifixion, there is a blank page (fo. 123v) that may possibly have been reserved for another such figural image.[86] The facing recto, folio 124, is entirely given over to the ornamented framing and enlargement of the opening words of Matthew 27:38, 'Then there were crucified with him two thieves' (pls 5, 6).[87]

The passage that immediately precedes these words in Matthew's Gospel appears on folio 123, the recto of the blank page. It describes how 'They came to the place called Golgotha, the place of Calvary. And they gave him wine to drink mingled with gall' (see Ps 68:21); they divided his garments, fulfilling the prophecy of Psalm 21:19, which is quoted: Then, 'sitting down, they watched him there'. Finally, the written *causam* of his offence was placed above his head on the cross: 'This is Jesus, the king of the Jews' (Mt 27:33–7). The centred last line on folio 123 contains simply the abbreviated wording of the superscription or *titulus*: *Hic est rex iudeorum*. As this page has only fifteen lines of text, several of them very short, rather than the usual seventeen lines, the next half-dozen words of Matthew's Gospel could easily have been fitted in after the *titulus*. Instead, these words were separately framed and enlarged on folio 124.

The description of Christ crucified between or in the midst of two thieves occurs in all four of the Gospel accounts.[88] In Mark 15:27–8, it is already interpreted as a fulfilment of Isaiah's prophecy that the Messiah would be 'numbered

84 *In Iohannis evangelium, Tr.*, 119:4, pp 659–60. **85** The words are part of the psalm text that directly faces the crucifixion image in the late Anglo-Saxon Winchcombe Psalter, Cambridge University Library MS Ff. I. 23, fos 87v–88, *c*.1030–50: *The Cambridge illuminations: ten centuries of book production in the medieval West*, ed. P. Binski and S. Panayotova (London, 2005), cat. 17. **86** These three examples occur at passages that had been highlighted by a minor enlarged initial in earlier Insular Gospel books: Patrick McGurk, 'Two notes on the Book of Kells and its relation to other Insular gospel books', *Scriptorium*, 9 (1955), 105–7. **87** Vulgate: *Tunc crucifixi sunt cum eo duos latrones*; the Book of Kells, fo. 124 has *Tunc crucifixerant*. **88** Mt 27:38; Mk 15:27–8; Lk

among the wicked', which continues, 'he has borne the sins of many and has prayed for the transgressors' (Is 53:12); the prophecy is duly noted in Augustine's commentary on John's account.[89] In another context, Éamonn Ó Carragáin has discussed the Old Testament canticle from Habakkuk, a chant in the Roman liturgy probably dating from the fifth century, used weekly at Lauds and, together with John's Gospel account of the Passion, in the readings on Good Friday.[90] The *vetus latina* version of Habakkuk in patristic and Insular exegesis and the liturgy includes the enigmatic prophecy that the Lord will be recognized or made known between two living beings (Hab 3:2).[91] One of several ways in which the prophecy was seen to be fulfilled was in the revelation of Christ's humanity and divinity at his crucifixion between two thieves.[92] In some early symbolic crucifixion images, as at Santa Sabina, Christ stands manifested between two very small symmetrical figures of the thieves; on a metalwork plaque from Clonmacnoise he stands between two small flanking crosses, which form an addition to the basic crucifixion iconography the plaque shares with the Durham and St Gall Gospels and the Southampton Psalter.[93]

While we cannot know what iconography of the crucifixion, if any, was intended for the blank folio 123v in the Book of Kells, the layout of the facing Gospel text on folio 124 offers its own comment on the significance of the event it describes. Three groups of wide-eyed onlookers surround the framed text like the spectators at the crucifixion; they are in profile, looking from the text towards the blank page. The framed text is hard to read at first sight. The words following *Tunc crucifixerant* are set out in two widely V-shaped panels, one inverted beneath the other. In each panel, the lettering radically changes direction and the angular display script, including some obscure letter forms, is set against different coloured backgrounds, without regard to word separation. But the two inscribed V-shaped panels share a golden outline so that they can be read together as forming one diagonal cross, which is also the Greek letter *chi*.[94]

23:33; Jn 19:18. **89** *Et cum sceleratis reputatus est et ipse peccata multorum tulit et pro transgressoribus rogavit* (Is 53:1, Vulgate); *et cum iniquis reputatus est* (Mk 15:28); *et inter iniquos deputatus est*: Augustine, *In Iohannis evangelium, Tr.*, 117, 3, p. 653. **90** For the commemoration of the cross in ritual and word on Good Friday, see Van Tongeren, this volume. **91** *In medio duorum animalium innotesceris.* Ó Carragáin, *Ritual and the rood*, pp 184–5. **92** Bede, *De tabernaculo*, CCSL, 119A, p. 20; *In Habacuc*, CCSL, 119B, p. 383. In the Book of Kells, fo. 183v, immediately next to the account of Christ crucified between thieves in Mark 15:27, a small lion is pictured lying down but with his eye open, which possibly highlights in another way the text's revelation of Christ's two natures. In a work well known to Insular commentators, Gregory the Great had used the *Physiologus* tradition that the lion sleeps with its eyes open as an image of Christ in his two natures, 'because, in the same death in which, through his humanity, our Redeemer could sleep, through his immortal divinity he kept vigil': *Homiliae in Hiezechielem prophetam*, 1, 4:1, ed. M. Adriaen, CCSL, 142, p. 47. **93** Bourke, 'The chronology of Irish crucifixion plaques', fig. 21a. Some of the Palestinian *ampullae* display the exalted cross, or the standing robed figure of Christ, between the two thieves and venerated by genuflecting figures. **94** Isidore, *Etymologiae*, 1:3:11; 1:14:14 noted that the Latin letter X signifies

On closer examination of this chiastic structuring of the text, it can be seen that the small cross marking its beginning also forms the letter *chi*, and that the two letters that follow it (looking like R and I) are, similarly, not in Matthew's text at all; they represent the Greek letter *rho* and the Latin ending of the abbreviated sacred title, XPI, so that the text reads *Tunc crucifixerant XPI cum eo duos latrones*. This interpolation into the Gospel text, concealed from the casual glance, provides a gloss on the *titulus* of the cross contained in the previous sentence and discloses who 'the king of the Jews' really is: for those with eyes to see, the one crucified between two thieves is Christ, the prophesied Messiah.

In an arcane development of patristic custom, Hiberno-Latin commentators revealed Christ's universal sovereignty, concealed beneath the title 'king of the Jews', by expounding the symbolic significance of the three sacred languages in which, according to Luke and John, the *titulus* was written.[95] Here, however, in the context of Matthew's Gospel, the Book of Kells is elaborating a textual tradition already established in the earliest surviving illuminated Insular manuscript, Durham A.II.10, the fragmentary remains of a Gospel book or New Testament. An enlarged initial letter marks the text, 'Then there were crucified with him two thieves' (Mt 27:38).[96] In the preceding sentence, the abbreviated title of Christ is inserted into Matthew's text of the *titulus* on the cross, so that it reads *Hic est ihs xps rex iudeorum*. Exactly the same interpolation appears in the Irish Reference Bible's commentary on the *titulus* in Matthew's Gospel.[97]

THE WÜRZBURG EPISTLES

Through the influence of the Irish and Anglo-Saxon missions to Francia, several of the Insular traditions discussed here survive in the depiction of the crucifixion in an eighth-century Continental manuscript, Würzburg, Universitätsbibliothek cod. M.p.th. f. 69, fo. 7v (pl. 4).[98] The image originally prefaced the text, the Pauline Epistles, which pre-eminently preach Christ crucified.[99] The Insular

the cross by its shape (*crux decussata*) and that the name of Christ is written using the letter (*chi*), which makes the sign of the cross. Werckmeister, *Irisch-northumbrische Buchmalerei des 8 Jahrhunderts*, pp 147–70; Suzanne Lewis, 'Sacred calligraphy: the chi-rho page in the Book of Kells', *Traditio*, 36 (1980), 134–59. **95** Augustine, *In Iohannis evangelium, Tr.*, 117, 4, 5, pp 653–4; Robert McNally, 'The "*tres linguae sacrae*" in early Irish biblical exegesis', *Theological Studies*, 19 (1958), 395–403 at 400–1. **96** Durham Cathedral Library, MS A.II.10, fo. 3. **97** Paris, BN, MS lat. 11561, fo. 155v. **98** Alexander, *Insular manuscripts*, cat. 55, commenting on its stylization and colouring, thought it likely the image was a copy of an Irish model. Catherine E. Karkov, 'Tracing the Anglo-Saxons in the Epistles of Paul: the case of Würzburg, Universitätsbibliothek M.p.th. f. 69' in Jane Roberts and Leslie Webster (eds), *Anglo-Saxon traces* (Tempe, AZ, 2011), pp 133–44 at pp 133–4 documents previous discussion of the manuscript's production in one of a group of nunneries in Franconia and its membership of a group of manuscripts that are assumed to have been written by women. **99** Examples: the crucified Christ: 1 Cor 1:17–24, 2:7–8, 15:3–14; Gal 3:1, 5:1; Phil

features of the crucifixion iconography are combined with Frankish ornament and additional motifs, some of which are most unusual; some additions emphasize the eschatological character of the crucifixion scene and others extend its range of allusion. Lawrence Nees judges the image to be 'an appropriate invention by the scribe-painter for the Pauline Epistles that follow, which are the ultimate source for its theological orientation'.[100]

The cross is covered with lozenge-shaped patterns simulating precious metal-work. It is suspended like a crucifix from a monumental arch, whose ornament incorporates multiple forms of the cross and the *chi*. Christ is an upright figure in a long-sleeved robe patterned with stylized folds, as in the Durham Gospels, though the robe is belted and his arms are outstretched from the shoulder.[101] His body is conformed to the cross and shares the outline of the cross-shaft; three cross-rays radiate from his head. There are no attendant cherubim or angels, but on the crossbeam are two confronted birds, reminiscent of an early Christian iconography of the exalted cross or Christogram suggesting the resurrection.[102] The spear-bearer and sponge-bearer are not pictured, though their symbolic function is indicated by the shaftless head of the spear and the cup-shaped sponge, which are displayed against the body of the Crucified, on his right and left respectively.

In *De locis sanctis*, Adomnán of Iona had described how these two objects, detached from or with only part of their shafts, were displayed and revered as relics of the Passion in the holy places of Jerusalem. Recounting what he presents as the eye-witness experience of the pilgrim Arculf and recalling St John's gospel testimony of sponge and spear, Adomnán brings these two physical signs of the historical reality of the crucifixion vividly before the inner eye of the reader. 'The sponge, which was soaked in vinegar, placed on hyssop by those who crucified the Lord, and put to his lips' (see Jn 19:29), was viewed by pilgrims in the *exedra* situated between the basilica of Golgotha, on the site of the crucifixion, and the *martyrium*, where the cross of the Lord and the crosses of the two thieves had been

2:8; redemption through blood of Christ: Rom 3:22–5, 5:10; dying to sin in order to live with Christ: Rom 6:2–10, 8:17; Gal 2:20, 5:24, 6:14; 2 Tim 2:12. The Pauline Epistles were the subject of Hiberno-Latin commentaries and received glossing in Old Irish as well as Latin, notably in the eighth-century Würzburg, Universitätsbibliothek Cod. M.p.th. f. 12: Próinséas Ní Chatháin, 'Notes on the Würzburg Glosses' in Próinséas Ní Chatháin and Michael Richter (eds), *Ireland and Christendom: the Bible and the missions* (Stuttgart, 1987), pp 190–9. **100** Nees, 'On the image of Christ crucified', p. 361. **101** Nees, 'On the image of Christ crucified', pp 349–52, argues that early parallels for the long-sleeved garment of Christ in some Ottonian manuscripts and on the Lucca crucifix known as the *Volto Santo* 'are entirely Western, not Eastern'. As the closest parallels, he cites Insular examples, the Durham Gospels and the Athlone Plaque, whose iconographic type became known in centres of Insular influence in Francia, as witnessed in the Würzburg Epistles. For the *Volto Santo*, see Bacci, this volume. **102** For example, Roman sarcophagus, *c.*350, Vatican Museum, *Picturing the Bible: the earliest Christian art*, cat. 46; the seventh-century Valerianus Gospels, Munich, Bayerische Staatsbibliothek, Clm.6223, fo. 202v, Nees, 'On the image of Christ

found, as recorded in Adomnán's accompanying plan.[103] Through the perforated lid of a reliquary, Arculf saw and touched the sponge, conserved in the silver chalice that Christ had used at the Last Supper. Arculf also saw the lance with which the soldier 'pierced the side of the Lord when he was hanging on the cross. This lance is in the porch of the basilica of Constantine (the *martyrium*), inserted in a wooden cross, and its haft is split in two parts'.[104]

In the Würzburg crucifixion image, the two diminutive crosses of the thieves are depicted below the crossbeam, rather as the letters *alpha* and *omega* are suspended like pendant jewels from the arms of the exalted cross displayed beneath an honorific arch in contemporary Frankish manuscripts that show late antique and Lombardic influences.[105] Christ's features – the beard and moustache, the long-sleeved robe and orant pose – recur in miniature in the two thieves, whose bodies are scarcely to be distinguished from their crosses.

Beneath the towering crucifixion image, and similarly spanning the width between the columns supporting the arch, there is a boat carrying nine small figures. The second figure from the right points to the helmsman, who works the outsize steering oar; none of the others is rowing. A larger beardless figure, identified as Christ by his cross-nimbed halo, stands in their midst, almost on the same central axis as the cross that rises above him like a huge mast.[106] The boat does not provide a literal illustration of the Gospel miracles of Christ with the disciples on Lake Galilee, stilling the storm or saving Peter from the waves. Moreover, the composition and restricted palette closely unify the crucifixion scene, the figures in the boat, and the arch that frames them all.

The common patristic linking of cross and boat made use of the understanding that lignum, meaning wood or tree, could refer to the cross.[107] The Fathers sometimes saw the *lignum crucis* itself as the vessel by which the faithful

crucified', fig. 12. **103** Adomnán, *De locis sanctis*, ed. and trans. Dennis Meehan (Dublin, 1983), 1:7, 8, pp 51–3 and p. 47 for a copy of Adomnán's inscribed drawing in Vienna, Cod. 458, fo. 4v. Thomas O'Loughlin, *Adomnán and the holy places* (London, 2007), pp 177–88 and Appendix 8 on the survival and diffusion of Adomnán's text, which appears in the ninth-century catalogues of Würzburg and Bobbio. **104** *De locis sanctis*, 1:8, p. 51. The spear and sponge were not only objects of devotion but could function as symbols of Christ's victory. Pictured without their bearers, they are triumphantly displayed, like *arma Christi*, against the empty cross in the illustration to Psalm 21 in the Utrecht Psalter and they accompany the figure of Christ enthroned in glory in the Anglo-Saxon illuminations of the Galba (Athelstan) Psalter, fo. 2v: O'Reilly, 'The wounded and exalted Christ', 84–5. **105** Early Christian motifs of the exalted cross with pendant *alpha* and *omega* set beneath an arch are adapted and combined in the frontispieces of the Gelasian Sacramentary, Vatican Library Reg. lat. 316, and Augustine's *Quaestiones in Heptateuch*, Paris, BN, MS lat. 12168, which also has a marigold-cross rosette and inscription, XPI IHS: *Europe in the Dark Ages*, ed. Jean Hubert, Jean Porcher and W.F. Volbach (London, 1969), pls 175, 188. **106** The diptych of crucifixion and *parousia* in the St Gall Gospels, pp 266–7, discussed above, also depicts Christ with two different facial types. **107** New Testament references to the crucifixion such as, 'whom you put to death, hanging him *in ligno*' (Acts 5:30; 10:39; 13:29) and 'he bore our sins in his body *super lignum*' (1 Pet 2:24), reflect Deut 21:22–3, which is cited by St Paul in Gal 3:13. For discussion of the wood of the

would be carried to their heavenly home. Patristic images of the sea-journey of the spiritual life have been recognized as an element in Irish voyage literature and in scenes of penitential monastic exile in the *Vita Columbae* and the *Vita Brendani*.[108] Jonathan Wooding has drawn attention to the Irish *topos* of the hide-covered boat, symbolic of the carnal, mortal nature of those who voyage through turbulent seas inhabited by demons, and cites examples of such a vessel being strengthened by wood, 'that is to say, the church is saved by the cross and death of the Lord'.[109] A vertically orientated panel on the eighth- or ninth-century Kilnaruane (Bantry) pillar, which was once a cross-shaft, depicts a boat with four or more rowers and a helmsman.[110] Protective crosses appear beneath stern and bow and a further small cross is positioned behind the helmsman with a steering-oar, who, as in the Würzburg image, is not represented as Christ.

The sea-faring image in Psalm 106 (107) particularly lent itself to patristic and Insular expositions of the cross as a vessel. The psalmist extols the mercy of God in delivering those in tribulation from the enemy and the shadow of death. They are pictured in the image of those who 'go down to the sea in ships' and experience the terrors of the deep. In their affliction, they cried to the Lord, who stilled the storm 'and brought them to the haven which they wished for' (Ps 106:23–30). Cassiodorus glosses 'ships' in verse 23 as 'the churches which sail over the stormy waters of this world on the wood of the cross'.[111] Sandra McEntire has suggested that the scene in the Würzburg manuscript 'could well be the imaging of the commentary of Cassiodorus on Psalm 106, where he describes the ship which crosses the sea as having Christ as the pilot, the rowers as the apostles, and the holy pontiffs as select passengers'.[112]

Of closer relevance to some features of the Würzburg image, and to its function as a frontispiece to the Pauline Epistles, is Augustine's commentary on the same psalm, where he similarly interprets Psalm 106:23–30 as a metaphor of the spiritual life, with its storms of dissension and temptation, but does not describe Christ as the pilot or helmsman of the ship or the apostles as oarsmen. Rather, he emphasizes that both those who steer (implying those who teach) and

cross in early hymns, see Van Tongeren, this volume, pp 46–7. **108** Jonathan Wooding, 'St Brendan's boat: dead hides and the living sea' in John Carey, Máire Herbert and Pádraig Ó Riain (eds), *Studies in Irish hagiography: saints and scholars* (Dublin, 2001), pp 77–92; Diarmuid Scully, 'The third voyage of Cormac in Adomnán's *Vita Columbae*' in Roberts and Minnis (eds), *Text, image, interpretation*, pp 209–32. **109** *Expositio evangelii secundum Marcum*, ed. M. Cahill, *Scriptores Celtigenae*, 2, CCSL, 82, pp 27–8 on Mark 4:3; *Vita Brendani*, cap. 10, cited by Wooding, 'St Brendan's boat', pp 88, 91. **110** Jonathan Wooding, 'Biblical narrative and local imagery on the Kilnaruane Cross-Shaft, Co. Cork' in Redknapp et al. (eds), *Pattern and purpose in Insular art*, pp 253–9. **111** Cassiodorus, *Expositio in psalmorum*, CCSL, 98, pp 979–80. **112** Sandra McIntire, 'The devotional context of the cross before AD1000' in Paul E. Szarmach with Virginia Darrow Oggins (eds), *Sources of Anglo-Saxon culture* (Kalamazoo, MI, 1986), pp 345–56 at p. 351; cited by Nees, 'On the image of Christ crucified', p. 363, who also discusses nautical images in the work of

those who are conveyed by them risk shipwreck if they do not put their trust in God.[113] Augustine cites St Paul as one such steersman or helmsman (*gubernator*).

Though he might assume his readers' familiarity with Paul's own testimony that he survived literal shipwreck three times and was 'a night and a day in the depth of the sea' (2 Cor 11:23), Augustine quotes instead from the opening of the same epistle, from Paul's account of unspecified tribulations suffered on one of his missions when he and an unknown number of companions were so hard pressed they almost despaired of life: 'But we had in ourselves the answer to death: that we should not trust in ourselves but in God who raises the dead' (2 Cor 1:8–9).[114] Their story of divine deliverance and faith in the resurrection is seen to be figured in the psalmist's image: 'he brought them into the haven of their desire' (Ps 106:30). Augustine accordingly exhorts all members of the universal church, including its helmsmen (*populi et seniores, negotiatores et gubernatores*), not to trust in their own merits and wisdom but in the mercy of God.

Discussing the common metaphor of the church or the soul as a ship, buffeted by the spiritual storms and dangers of this earthly life and providentially brought at last to the port of heaven, Hugo Rahner showed the particular influence on the patristic imagination of the sea voyage of Odysseus who sailed through tempests and temptations, longing to reach his father's house and binding himself to the mast lest he yield to the sirens' call.[115] Ambrose, Paulinus of Nola and other Fathers urged the faithful similarly to bind themselves, 'not with corporeal fetters like Odysseus to the mast, but with spiritual knots to the wood of the cross' in order to avoid temptation. Christ himself was seen as being voluntarily fastened to the wood of the cross to save the human race from the shipwreck of the world.[116] This body of patristic tradition may illuminate a novel feature in the Würzburg image.

Lawrence Nees has noted that the two angels hovering beneath the thief on Christ's right, and the two black birds beneath the thief on his left, awaiting the souls of the two thieves and suggesting their different fates, present the viewer with the choice of accepting or rejecting salvation.[117] The apocryphal detail is made intelligible by the Gospel account of the two thieves' differing responses to Christ

Columbanus. **113** *Volens Dei ut ad eum clamarent et hi qui gubernant, et hi qui portantur, Dixit, et stetit spiritus procellae*: Augustine, *Enarrationes in psalmos*, CCSL, 40, p. 1577, trans. in *NPNF*, 1st ser., 8, p. 534. **114** Augustine introduces Paul's words in 2 Cor 1:8 with *Audite de hac re vocem cuiusdam gubernatoris periclitari, humiliati, liberati*: CCSL, 40, p. 1578, ll 37–8. **115** Hugo Rahner, *Greek myths and Christian mystery* (London, 1963), pp 328–86, figs 9–11. **116** Ambrose, *Expositio in Lucam*, IV, 2, 3, CSEL, 32, pp 139–41; Paulinus of Nola, *Epistula*, 23, 30, CSEL, 29, p. 186; Paulinus of Nola, *Epistula*, 23, 30, CSEL, 29, p. 186; trans. P.G. Walsh (2 vols, New York, 1967), ii, p. 33; Maximus of Turin, *Homilia*, 49, *De Cruce Domini*, 1, PL, 57:339. **117** Nees, 'On the image of Christ crucified', pp 360–1, nn 48, 49. For the role of the two thieves, identified by their apocryphal names, in another Continental crucifixion miniature with a restricted palette, Angers MS 24, and for analysis of the composition's polarities of left and right, see Kitzinger, this volume.

crucified. St Luke uniquely describes the Saviour's promise of paradise for the thief who recognized him, even on the cross, as Lord, king and judge, who confessed his own wrongdoing and Christ's innocence and sought entry into his kingdom. The other thief neither had appropriate fear of God nor recognized the prophesied Messiah in the figure crucified beneath the mocking *titulus*. He blasphemed, 'If you are the Christ, save yourself and us' (Lk 23:38–43). The Würzburg frontispiece reveals the identity of Christ, crucified between two thieves in fulfilment of prophecy and with the *titulus* on the cross-head entirely replaced by his sacred title, IHS XPS.[118] The angel-like figures accompanying the penitent thief extend down to the figures in the boat below; the expository, teaching gesture of the standing figure of Christ in the boat draws attention to the crucifixion scene and the cautionary fate of the other thief. The occupants of the boat gaze out at the viewer; one echoes Christ's gesture.

The believing thief was often cited as an example of the faith that recognizes the divinity of the crucified Christ. Maximus of Turin commented that the suffering of the cross, which constitutes a stumbling block to some (see 1 Cor 1:23), seemed to increase the thief's faith: he saw the wounds of the crucified but believed him to be God.[119]

Paulinus of Nola used the story of the blessed thief within the convention of offering spiritual consolation to a friend. He wrote to Sulpicius Severus, sending him a relic of the cross as a sign of the promised resurrection, for, 'as Scripture says, "If we suffer with him we shall also reign with him" (Rom 8:17)'. He was here citing a well-known text of St Paul that has already been discussed in connection with the inscription of the Durham Gospels crucifixion. Paulinus hoped the relic would evoke the extreme example of faith in the resurrection shown by the thief. When he saw Christ crucified and suffering the same punishment as himself, he acknowledged him as 'the Lord of majesty' and asked 'Lord, remember me when you come into your kingdom'. Through the faith of a moment, the thief was the first, before the martyrs and apostles, to enter the kingdom prepared for the blessed (Mt 25:34).[120] Both thieves were sinners, but the penitent believer received mercy rather than judgment, a popular theme that appears in the private prayers and liturgy of the Anglo-Saxons.[121]

In an influential sermon on the cross, Maximus of Turin directly linked the example of the thief with the image of the boat. He argued that because Christ was willingly fastened to the wood of the cross to save the whole human race from

118 Written with a Greek *pi* rather than a *rho*. **119** *Sermons of Maximus of Turin*, trans. Boniface Ramsey (New York, 1989), sermon 74, pp 181–2. Listing examples of how the humanity and divinity of Christ were manifested, Leo the Great spoke of the one who was nailed to the cross as the one who opened the gate of paradise for the thief: *Tome*, Ep 28, *Decrees of the ecumenical councils*, p. 80. **120** *Ep.* 31.6, *Letters of Paulinus of Nola*, ii, p. 133. **121** Examples cited by Raw, *Anglo-Saxon crucifixion iconography*, p. 95.

death, we too if bound to the cross, 'which is like the mast in the ship of the church', may sail through the temptations and perils of this world and reach the house of our Father in safety. As proof, he cited Christ's own words, 'for while hanging on the wood of the cross he declared to the thief beside him, "This day you will be with me in paradise" (Lk 23:43)'. The words enable Maximus to set the thief, representing sinful humanity, in the context of salvation history and St Paul's argument that Christ died for sinners, redressing the sin of Adam; sinners, through faith, have access to this grace (see Rom 5:1–12). He describes how the thief had long been straying from his course and suffering shipwreck 'and never would have returned to paradise, his home, from which the first man had once departed, had he not been bound to the mast of the cross'.[122] The sense is that the thief had, through his act of faith, spiritually bound himself to the cross of Christ in his last hour and was thus the first to benefit from the safe passage it offers all the faithful.

Augustine had memorably used the image of the cross as a vessel in his commentary on St John's gospel, giving metaphorical expression to aspects of the theology of the cross, the identity of Christ and the response of the faithful to the crucified Christ, which are discussed later in the commentary, in the tractates on the crucifixion. Augustine explains that trying to comprehend the divine mystery contained in John's opening acclamation, 'In the beginning was the Word and the Word was with God, and the Word was God', is like seeing and longing for one's native land from a distance, without knowing how to traverse the intervening sea. It was in order to bring humankind to that divinity he shares with the Father, that the Word became incarnate and 'appointed the wood (*lignum*) by which we may cross the sea. For no one is able to cross the sea of this world unless borne by the cross of Christ.'[123]

Like St Paul, Augustine acknowledges that people have differing capacities for spiritual understanding, but insists that both those who can already see something of Christ's immutable divinity and those 'of weaker eyesight' are to cling to this wood. Provided they 'do not depart from the cross and the Passion and resurrection of Christ', those of lesser understanding will be 'conducted in that same ship to that which they do not see' as those who do see.[124] Conversely, he cites St Paul to reprove those who have already achieved some understanding of the divine Creator through studying his creation but who, blinded by pride in their own intellect and wisdom, despise the lowliness of the cross (see Rom 1:20–2). They

122 Maximus of Turin, *Homilia*, 49, *De cruce domini*, 1, *PL*, 57, 339, trans. Rahner, *Greek myths and Christian mystery*, p. 383. **123** Augustine, *In iohannis evangelium*, 2:2, 3, pp 12–13. *Instituit lignum, quo mare transeamus. Nemo enim potest transire mare huius saeculi, nisi cruce Christi portatus*: p. 12, ll 31–3. Finbarr Clancy, 'The cross in Augustine's *Tractatus in Iohannem*', *Studia Patristica*, 33 (1997), 55– 62 at 61–2. **124** *In iohannis evangelium* 2:3, p. 12, trans. in *NPNF*, 1st ser., 7, pp 14–15.

do not realize that the crucified Christ, whom they see only dimly from afar, is God incarnate.

The argument extends to the salvation history of fallen humanity, cast out through pride far from the fatherland, whose redemption could only be effected through the humility of the crucified Christ; there is no means of passing through the waves of this world to our native land except borne by 'the wood of his humiliation'. Augustine says that if Christ had come as God, he would not have been recognized, therefore he appeared as man. By his incarnation 'he made an eye-salve to cleanse the eyes of our heart (*oculos cordis*) to enable us to see his majesty by means of his humility'. The eyes of the heart had been blinded by carnal desires. When '"the Word was made flesh and dwelt among us", he healed our eyes, "and we beheld his glory, the glory as of the only begotten of the Father" (Jn 1:14)'. His divine glory can be seen by no one unless they are healed by the humility of his flesh. Augustine therefore reiterates 'See you do not depart from the wood by which you may cross the sea'. All the faithful are to learn from the crucified Christ, through whom humanity itself is transformed and brought at last to share in the divine life.[125]

The frontispiece in the Würzburg Pauline Epistles is not a literal illustration of any of these texts but an inventive aid to meditation that might call to mind a range of such mental images, enriching a reading of the crucifixion image at various levels for those who identified themselves with the figures in the boat, taught by Christ. The Insular iconography of the crucifixion, and the visual exemplum of the contrasting responses and rewards of the two thieves, guide readers to see divine glory in the crucified Christ, who was made literally visible in human flesh. The recognition of who Christ is and the understanding of how to appropriate redemption and reign with him are linked. The cross that spans the great portal is revealed as the means by which the heavenward journey is to be accomplished.

125 *In iohannis evangelium* 2:16, *NPNF*, 7, p. 18.

1 The Crucifixion. Durham Gospels, fo. 38v (image courtesy of the Cathedral Chapter, Durham).

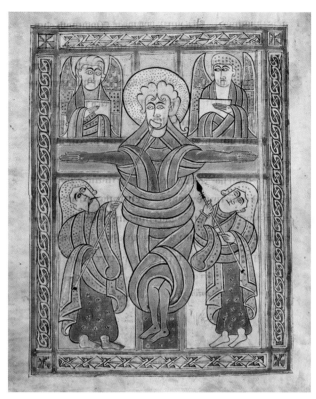

2 The Crucifixion. St Gall Gospels. St Gallen, Stiftsbibliothek, Cod. Sang. 51, p. 266: Irish Evangelary from St Gall (Quatuor evangelia) (www.e-codices.unifr.ch; reproduced courtesy of the Abbey Library, St Gall).

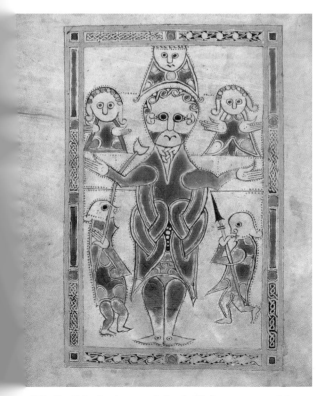

3 The Crucifixion. Southampton Psalter, fo. 35v (image courtesy of the Master and Fellows of St John's College, Cambridge).

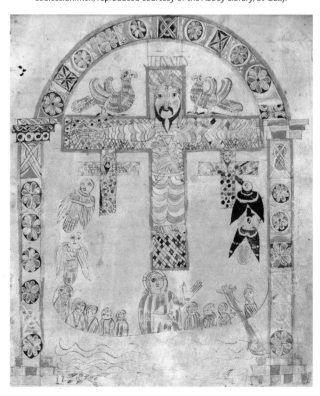

4 The Crucifixion. Würzburg Pauline Epistles, fo. 7r (image courtesy of the University of Würzburg).

5 Possible crucifixion placement, Book of Kells, fo.123v
(© image courtesy of Trinity College Dublin).

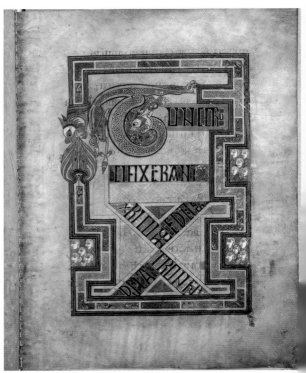

6 Opening words of Matthew 27:38, 'Then there were crucified with him two thieves', Book of Kells, fo. 124r (© image courtesy of Trinity College Dublin).

7 San Salvador de Valdediós, Asturias. Painted crosses on the eastern wall of the chancel (photograph by César García de Castro Valdés).

8 (*opposite*) Santullano, Oviedo. Painted cross on the upper part of east wall of the transept (photograph courtesy of Lorenzo Arias Pára...

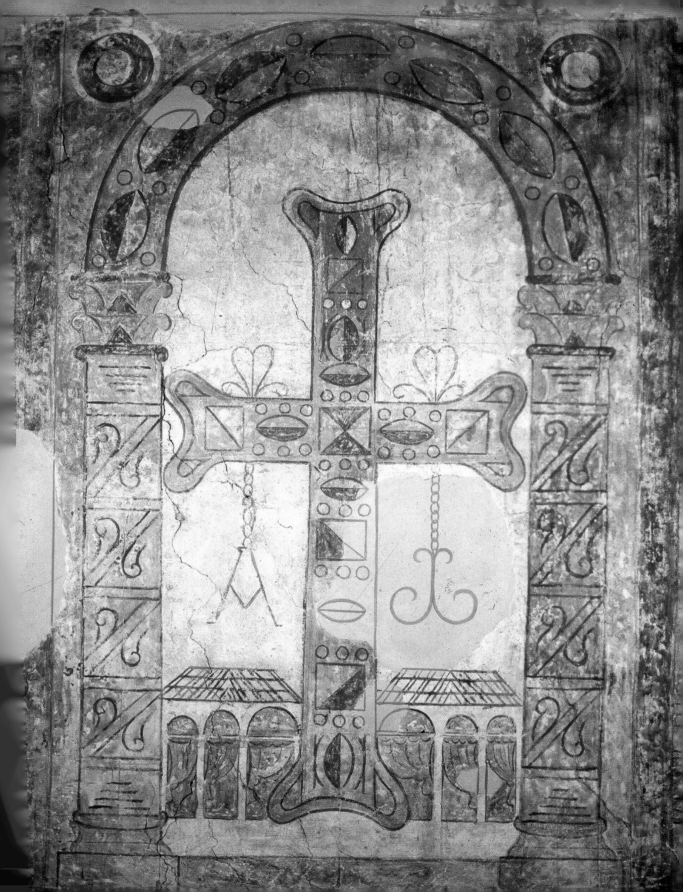

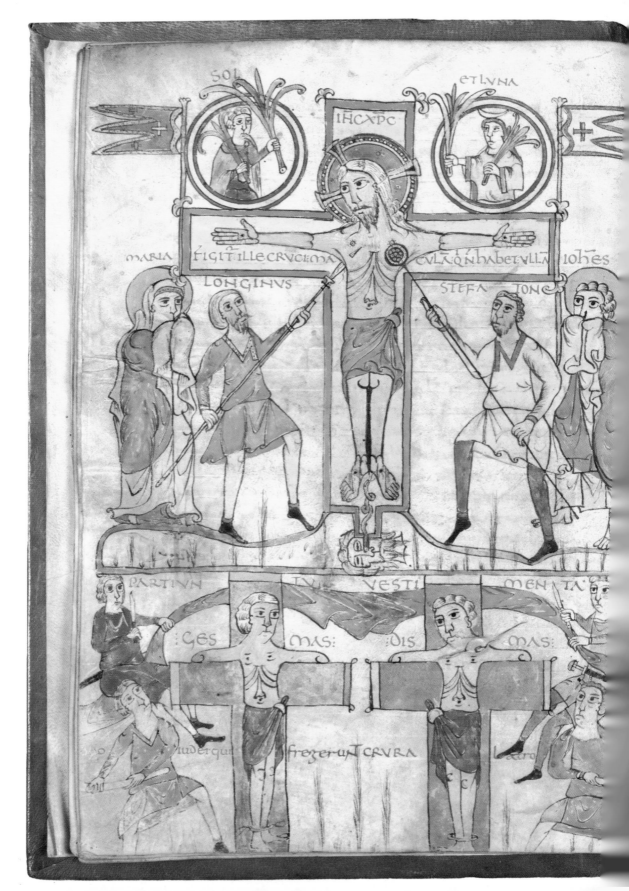

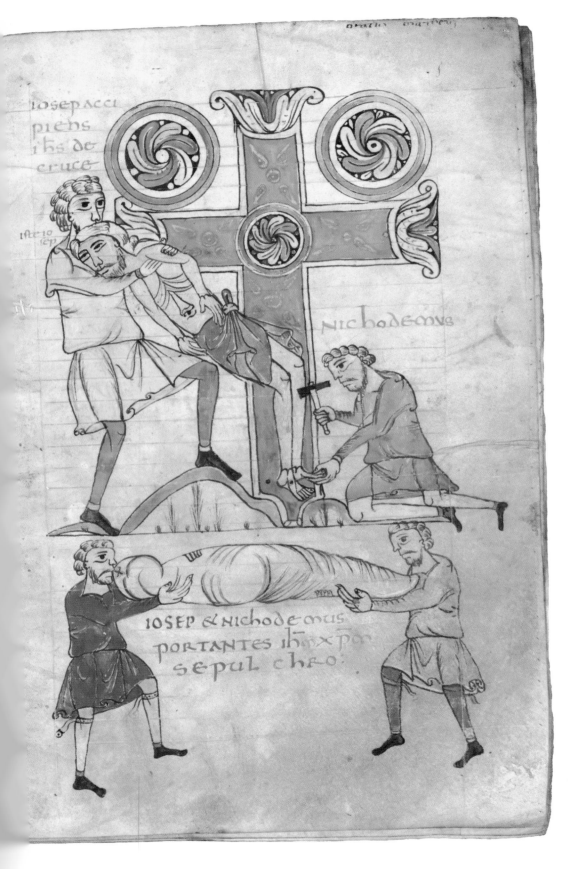

iosep acci
piens
ihs de
cruce

iste io
sep

NICHODEMVS

IOSEP & NICHODEMVS
PORTANTES IHM XPM
SEPUL CHRO.

9 Crucifixion and
Deposition. Angers,
Bibliothèque Municipale,
MS 24, fos 7v–8 (© image
courtesy of Bibliothèque
Municipale, Angers).

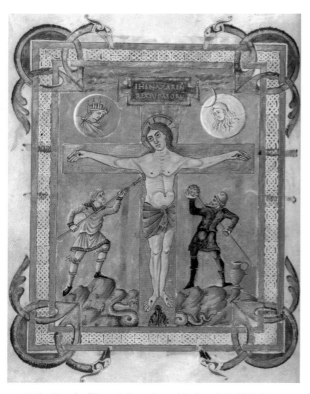

10 The Gospels of François II, opening to Matthew. Paris, Bibliothèque Nationale de France, MS lat. 257, fo. 12v (© image courtesy of the Bibliothèque Nationale de France).

11 The Gospels of François II, Paris, Bibliothèque Nationale de France, MS lat. 257, fo. 13 (© image courtesy of the Bibliothèque Nationale de France).

12 Domschatz Essen, MS 1, fo. 24v (© image courtesy of Martin Engelbrecht, Essen).

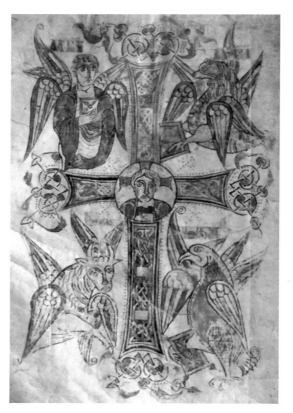

13 Domschatz Essen, MS 1, fo. 55v (© image courtesy of Martin Engelbrecht, Essen).

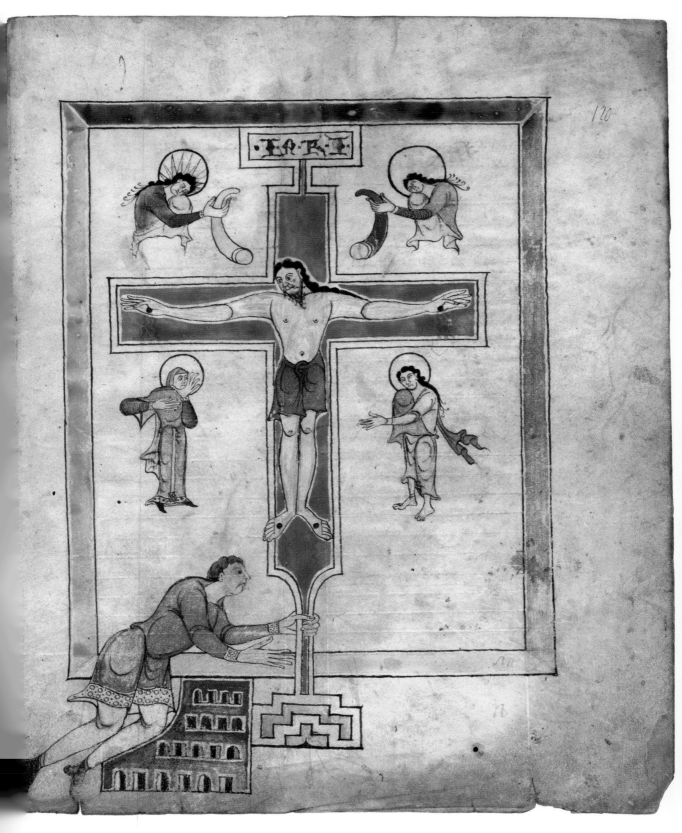

14 Crucifix added to the Psalter of Louis the German. Staatsbibliothek zu Berlin, MS Theol. lat. fol. 58, fo. 120 (© image courtesy of the Staatsbibliothek zu Berlin).

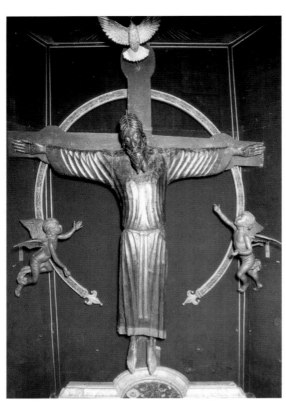

15 *Volto Santo*. Lucca, San Martino (photograph by Michele Bacci).

16 (*below*) The Beirut image stabbed by the Jews, detail from the Berardenga Antependium, 1215. Siena, Pinacoteca Nazionale (photograph by Michele Bacci).

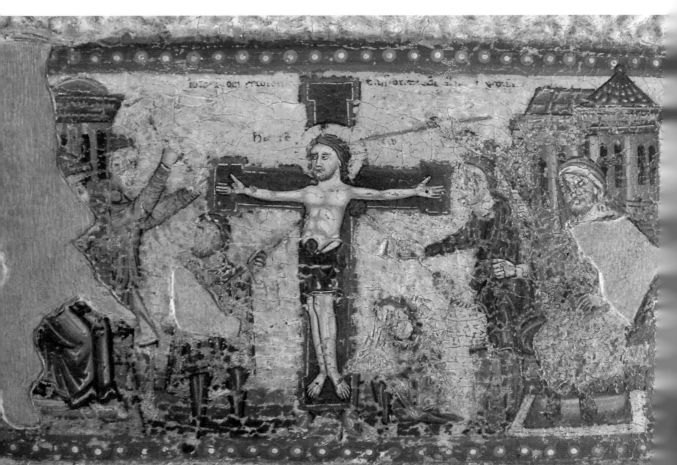

The Blythburgh Tablet: envisioning the wounds of Christ

CAROL NEUMAN DE VEGVAR

In early medieval England, imagery of Christ on the cross was not limited to the conventional format of the crucified corpus, but could be evoked symbolically through the quincunx, evoking Christ's wounds. Reference to the wounds, in conjunction with the presence of the cross and the absence of the corpus, could evoke not only the affective presence of the cross itself but also the dual nature of Christ, both human and divine, and the promise of salvation. The original ornamentation of the Blythburgh Tablet, combining the surviving relief carving with now-lost metalwork, offered to knowledgable observers the opportunity to meditate on this nexus of signs.

The Blythburgh Tablet (figs 4.1, 4.2) is half of a writing diptych now in the collection of the British Museum. Made of whalebone, and dated to the eighth century, the tablet was found along with three styli on the site of the Anglo-Saxon priory at Blythburgh, Suffolk.[1] The find site is listed in Domesday Book as the 'hundred of Blything', a particularly wealthy Anglo-Saxon royal manor.[2] The history of Blythburgh as a high-status site began in the Middle Anglo-Saxon period, however, well before the composition of Domesday Book: discoveries of Ipswich ware on the site indicate significant prosperity here in the eighth century, although a comprehensive archaeological investigation of the site has not yet been

[1] In 'N.S.', 'Excursions: report and notes on some findings', *Proceedings of the Suffolk Institute of Archaeology and History*, 34:2 (1978), 154–6, the notes for the excursion of 19 July 1977 give a seventh-century date for the object, but Leslie Webster, in Webster and R.I. Page, '65: Leaf from a writing-tablet' in Leslie Webster and Janet Backhouse (eds), *The making of England: Anglo-Saxon art and culture, AD600–900* (London, 1991), p. 81, gives it an eighth-century date. [2] *Domesday Book: a complete translation*, ed. Ann Williams and G.H. Martin (London, 1992; repr. 2003), pp 1186–7; 'N.S.', 'Excursions', 155, notes that Blythburgh was, like Melford, ten times as well endowed as the average Anglo-Saxon church of the era of Domesday Book.

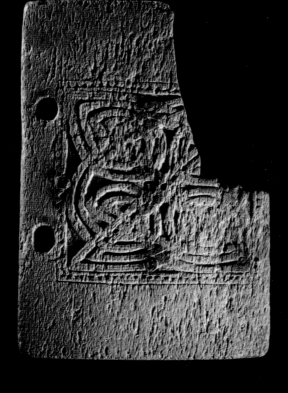

undertaken.[3] The tablet was probably discovered at the end of the nineteenth or in the first two years of the twentieth century. It was first described in the report of J.G. Waller to the Society of Antiquaries of London on 30 January 1902 and was presented to the British Museum by Seymour Lucas, the landowner, in the same year.[4]

The tablet measures 9.4cm in height by 6.3cm in width. It is warped so that the front surface now bows forward. The corners are softly rounded rather than sharply angled. It is incomplete; as seen from the front, it is missing a substantial part of its upper right quarter. Two large holes along the left edge of the tablet probably accommodated metal loops or leather binding straps that served as hinges to attach the tablet to a second tablet, now lost.[5] On one side of the surviving tablet, the inner surface, a rectangular recess is carved out to contain the

3 'N.S.', 'Excursions', 155. 4 John Green Waller, 'Proceedings for 30 January 1902', *Proceedings of the Society of Antiquaries of London*, 19 (1901–3), 40–2. 5 Such hinges had been traditional for Roman wood and ivory writing tablets; Roman military diplomas were incised on waxed bronze

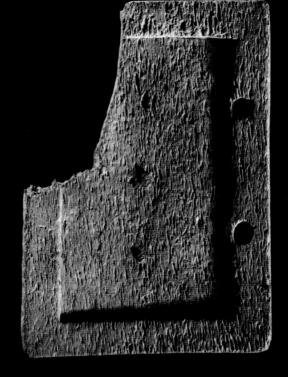

wax that served as the writing surface. The frame for this recess curves inward around the hinge holes, suggesting that these holes were drilled before the recess was carved out. In the recessed area, several lines of runes are very lightly incised along the long axis of the tablet; there are also three and possibly more runes on the rim. On the other side, presumably the front or outer surface of the diptych, the tablet displays a low-relief cross in continuous interlace. The cross is framed by a border of incised small equilateral triangles, arranged with their points outward, between incised parallel lines.

The interlace cross was probably originally ornamented by the addition of metalwork held in place by rivets. At the three remaining ends of the cross arms and at their intersection are a total of four rivets; an additional rivet is thought to have marked the now-lost right cross arm end. Together, these five rivets would

panels also held together with metal rings: see Hans Foerster, *Abriss der Lateinischen Paläographie* (2nd ed., Stuttgart, 1963; repr. 1981), p. 39.

originally have formed a quincunx. The surviving rivets all penetrate to the back of the tablet, but those forming the quincunx would have been under the wax in the recess in the verso, and there is no structural need for these rivets where they are located. An additional rivet is found at the lower right corner of the cross, but neither of the other two surviving corners of the cross has a comparable rivet or a mark to show its former presence. Given its location, the lone corner rivet may have provided part of an attachment point for a now-lost strap or clasp holding the diptych shut when not in use, a suggestion for which there may be documentary support, as will be shown.

In addition to the rivets themselves, there are areas of discolouration of the whalebone on the front of the panel. Although the most recently published colour images from the British Museum show only faint marks on the whalebone around the rivet heads, larger areas of discolouration around each of the rivets are clearly visible during close out-of-case viewing under good light.[6] These marks are broader than would probably be generated by the oxidation of the rivets themselves. This residue suggests that the rivets held in place small metalwork ornaments, possibly made of the gilded silver foil in common use for decorative mounts in this period, which would leave such dark discolourations due to the oxidation of the silver. Discolouration also extends inwards from the top centre rivet area toward the centre rivet, which suggests that the rivets also held in place a foil cross overlaying the interlace carved cross, but this trace could as easily be the result of seepage of corrosion products in damp soil, especially as there are no similar stains between the left and bottom rivets and the central one.[7] Further, the design of the carved interlace cross does not leave space to accommodate a foil cross overlay or otherwise suggest the intention of such an addition.

The runes incised into the back of the tablet, visible under a binocular microscope, were first noted by Martin Biddle and were discussed by Ray Page in an article in 1989 and later in the 1991 *Making of England* catalogue.[8] The runes in the recess are in irregular rows and were probably intended as trial letterforms rather than a text to be read; the letters do not form known words, although some letter sequences may reflect commonly used Latin orthography. Page believed that the runes were cut by one hand, whom he dubbed the 'scribbler', but subsequent examination by David Parsons revealed two or more stages of writing.[9] The

6 I thank Sonja Marzinzik for having graciously arranged out-of-case access to the tablet. The marks around the rivets are also visible, albeit incompletely, in the black and white photograph published with Webster and Page, '65: Leaf from a writing-tablet', p. 81. 7 The area between the rivet at the right and the centre is disrupted by the absence of much of the upper right corner of the tablet. 8 R.I. Page, 'Roman and runic on St Cuthbert's coffin' in Gerald Bonner, D. Rollason and C. Stancliffe (eds), *St Cuthbert, his cult and his community to AD1200* (Woodbridge, 1989), pp 257–65 at p. 259; Webster and Page, '65: Leaf from a writing-tablet', p. 81. 9 David Parsons, 'Anglo-Saxon runes in Continental manuscripts' in Klaus Düwel (ed.), *Runische Schriftkultur in kontinental-*

4.3 Springmount Bog writing tablet. One of a group of six yew wood tablets inscribed with extracts from the Psalms, from Ballyhutherland, Co. Antrim, early seventh century. Dublin, National Museum of Ireland (4–1914.2), partial view (image courtesy of the National Museum of Ireland).

absence of coherent words strongly suggests that the tablet was being used for practice in writing sequences of runic letter forms, most cut through the wax into the whalebone, a not uncommon phenomenon of tablet inscription, but elsewhere carved into the whalebone rim around the recess for the wax. Given the medium of the tablet and its probable originally intended use, as shall be shown here, the carelessness evidenced by the letter trials on the rim suggests a secondary phase in the tablet's history, after it was demoted from its original purpose.

The object is clearly a writing tablet, but its more specific purpose is debated. Most writers to date have simply referred to it as a writing tablet and have seen the runes on the verso as the result of practice in letter forms and sequences typical of the use of such tablets by students or trainees in a scriptorium. However, most ordinary waxed or inked writing tablets from antiquity are made of wood. The use of waxed writing tablets has been traced back to the late Bronze Age: a pair of

skandinavischer und –angelsächsischer Wechselbeziehung (Berlin, 1994), pp 195–220 at pp 208–10. Partly on the basis of the Blythburgh runes, Parsons argues that runes were normally used for informal messages and notes in the monastic context, a reconstruction that R.I. Page, *Introduction to English runes*, 2nd ed. (Woodbridge, 1999), pp 30–4, has argued overextends the value of the surviving evidence. However, the Blythburgh Tablet further confirms the evidence of the Franks Casket and the Ruthwell Cross that runes were certainly used in highly learned ecclesiastical circles. A recently discovered tablet (Norwich, Castle Museum) inscribed in runic letters with the Latin words 'For the soul of …' indicates that the transposition into runes of Latin texts with religious content was also not unheard of (Timothy Pestell, pers. comm.).

wooden tablets with ivory hinges was discovered in the 1980s in the fourteenth-century-BC shipwreck found off the south coast of Turkey near the Ulu Burun promontory.[10] Larger collections from the Roman period include those found at Pompeii, at Vöröspatak in Transylvania, and at Vindolanda on Hadrian's Wall.[11] Wooden waxed tablets continued to be a common medium for writing into the sixteenth century and in more limited use as late as the nineteenth century.[12] However, surviving examples from the early medieval period are rare. The one surviving Insular example of wooden writing tablets from the early medieval period is the early seventh-century assembly of six yew wood tablets inscribed with passages from Psalms 30–2, found at Springmount Bog, Ballyhutherland, Co. Antrim (Dublin, NMI; fig. 4.3).[13] However, texts indicate that such wooden writing tablets were in common use in Insular ecclesiastical centres and at their missions abroad: Adomnán notes in *De locis sanctis* that he used waxed tablets to note down Arculf's accounts of his travels in the Holy Land before transcribing them to parchment, as did Willibald in presenting a draft of his vita of Boniface before Bishops Lul of Mainz and Megingaud of Würzburg. One of Aldhelm's *Enigmata* refers to a waxed writing tablet with *calciamenta*, which Michael Lapidge and James Rosier translate as 'shoes', following the English translation of multiple references in the Vulgate.[14] However, a different reading of this passage is also possible. In early Christian and Insular manuscripts, ecclesiastical figures such as

10 Raymond Clemens and Timothy Graham, *Introduction to manuscript studies* (Ithaca, 2007), p. 4. For an image of this tablet, see George F. Bass, 'Oldest known shipwreck reveals splendors of the Bronze Age', *National Geographic Magazine*, 172:6 (Dec. 1987), 693–733 at 731. **11** For the extant classical exempla, see Foerster, *Abriss der Lateinischen Paläographie*, pp 40–2; Robert Marichal, 'Les tablettes à écrire dans le monde Romain' in Élisabeth Lalou (ed.), *Les tablettes à écrire de l'antiquité à l'époque moderne*, Bibliologia: Elementa ad Librorum Studium Pertinentia, 12 (Turnhout, 1992), pp 165–86. For Vindolanda, see Alan K. Bowman, *The Roman writing tablets from Vindolanda* (London, 1983); Bowman and J. David Thomas, *The Vindolanda writing-tablets*, Tabulae Vindolandenses II (London, 1994); Bowman and Thomas, *Vindolanda: the Latin writing-tablets* (Stroud, 1984), which also provides a list of extant examples found in Britain to 1984 (pp 34–5). **12** Élisabeth Lalou, 'Les tablettes de cire médiévales', *Bibliothèque de l'école des chartes*, 147:1 (1989), 123–40 at 123; and Michelle P. Brown, 'The role of the wax tablet in medieval literacy: a reconsideration in light of a recent find from York', *British Library Journal*, 20 (1994), 1–15. **13** Paul Mullarkey and Michelle P. Brown, '64 (a–b) Writing-tablets' in Webster and Backhouse (eds), *The making of England*, pp 80–1; E.C.R. Armstrong and R.A.S. MacAlister, 'Wooden book with leaves indented and waxed found near Springmount Bog, Co. Antrim', *JRSAI*, 50 (1920), 160–6. **14** '*Calciamenta mihi tradebant tergora dura*'. Aldhelm, *The poetical works*, trans. Michael Lapidge and James L. Rosier (Cambridge, 1985), no. 32, pp 76 and 250, n. 29. Wilhelm Wattenbach, *Das Schriftwesen im Mittelalter*, 4th ed. (Graz, 1958), p. 64, notes that in St Gall, Stiftsbibliothek Cod. 242, Aldhelm's line is glossed *Sicut videtur in tabulis Scotorum*, suggesting that this practice was specifically Insular. In an alternative reading of Aldhelm's line, Čelica Milovanović-Barham, 'Aldhelm's *Enigmata* and Byzantine riddles', *Anglo-Saxon England*, 22 (1993), 51–64 at 59–60 argues that Aldhelm is borrowing on Isidore of Seville's (*Etymologiae*, 19:34 :2) derivation of *calciamenta* from *calo*, in reference to the wooden lasts used by shoemakers, to allude to a wooden writing tablet. An alternative reading of Aldhelm's use of *calciamenta* might be 'book satchel', but Aldhelm's use of the plural seems to preclude that option.

evangelists and apostles, as well as Christ and the symbolic Man of Matthew, are conventionally shown wearing sandals, usually visualized as an assemblage of straps.[15] Further, references in the Vulgate to the removal of footwear often use the verb *solvere*, suggesting loosening or unbinding.[16] Actual footwear in England in the era of the Blythburgh Tablet also frequently involved straps, either tied or toggled.[17] So the reference to *calciamenta* in Aldhelm's riddle may refer, by allusion to shoes, to one or more straps holding the diptych shut when not in use. If such straps were the norm for Insular writing tablets, the extra rivet in the lower right corner of the cross on the Blythburgh Tablet may have served to attach some sort of strap holder, or the strap itself.

However, the Blythburgh Tablet differs from the extant Romano-British waxed tablets, the other surviving Insular tablets and the Insular text references in that it is made of whalebone rather than wood. As opposed to the evidently ubiquitous writing tablets made of wood, waxed tablets of animal materials, especially ivory, were high-prestige items used by the elite from late antiquity onward for particular occasions worthy of celebratory announcement and conspicuous display. The well-known consular diptychs are the premier but not the only examples of this type (figs 4.4, 4.5).[18] The largest of such ivory tablets are also extraordinary in size and impress by their conspicuous consumption of ivory, a valuable commodity; the British Museum diptych panel of an archangel, commonly identified as Michael, probably produced in or in the environs of the imperial court in Constantinople in the early sixth century, is fully 42.8 by 14.3cm (fig. 4.6).[19] Such ivory diptychs could be massive enough to be wielded as weapons: according to Pseudo-Lucian, a group of actors or singers from the court of the Emperor Nero used their diptychs to dispatch a competitor.[20] Ivory writing tablets continued to be made

15 This artistic convention probably responds to three passages in the Vulgate Gospels: Mt 10:10 and Lk 3:5, where Christ forbids his apostles to wear shoes (*calciamenta*) in their mission, and Mk 6:9, where they may wear sandals (*calchiatos sandaliis*). As an extension of this distinction, John Cassian, in *Institutiones* 1:9:1–2, distinguishes between *calciamenta* (shoes) and *gallices* (sandals); see Jean Cassien, *Institutions Cénobitiques*, ed. and trans. Jean-Claude Guy (Paris, 2001), pp 48–51. **16** Ex 3:5, Josh 5:15, Ruth 4:7, Acts 7:33 and 13:25, but see also Mk 1:7 and Lk 3:16, which refer to the undoing of a shoe latchet (*corrigiam solvere*). **17** Gale R. Owen-Crocker, *Dress in Anglo-Saxon England*, rev. ed. (Woodbridge, 2004), p. 190. **18** Richard Delbrueck, *Die Consulardiptychen und verwandte Denkmäler*, Studien zur Spätantiken Kunstgeschichte, 2 (Berlin, 1929), p. 20 and catalogue, pp 81–279. **19** Susan A. Boyd, '481 Leaf of a diptych with an archangel' in Kurt Weitzmann (ed.), *Age of spirituality: late antique and early Christian art, third to seventh century* (New York, 1979), pp 536–7. **20** Wattenbach, *Das Schriftwesen im Mittelalter*, p. 58, n. 3, quoting Pseudo-Lucian, *Nero*, ch. 9. The passage translates: 'For in fact they held in front of them – as if they were daggers – ivory (writing) tablets folded over double. Pushing the Epirote up against a nearby column, they broke (smashed in) his throat (*pharynx*), striking (him) with the (sharp) edge of their tablets'. The text was probably written by one of the Philostrati and primarily concerns Nero's Isthmian Canal project; the events described occurred at the nearby Isthmian Games. The victim, either from the region of Epirus or named Epirotes, was competing over-ambitiously against Nero and his troupe; he died of the injuries received in this ambush. I thank Professor Donald Lateiner of

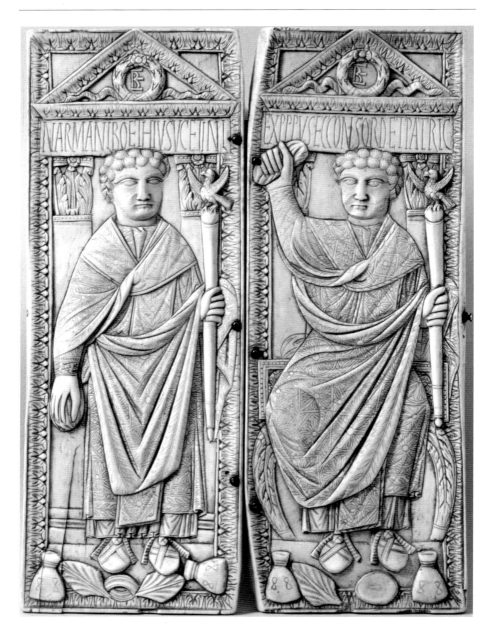

4.4 Ivory diptych of Boethius, consul in 487. Exterior of both panels, Rome, fifth century. Brescia, Museo Civico dell'Éta Cristiana (image courtesy of Scala/Art Resource, NY).

throughout the Middle Ages in many different circumstances where the medium was available; there is a particularly strong revival of the production and use of small ivory writing diptychs, especially in France, in the thirteenth century.[21]

the Department of Humanities-Classics, Ohio Wesleyan University, for the translation and explanation of the text. **21** Lalou, 'Les tablettes de cire médiévales', 123–40; eadem, 'Inventaire des tablettes médiévales et présentation générale' in E. Lalou (ed.), *Les tablettes à écrire*, pp 233–88. See also Raymond Koechlin, *Les Ivoires Gothiques Français* (2 vols, Paris, 1968), i, pp 432–45; Bernard

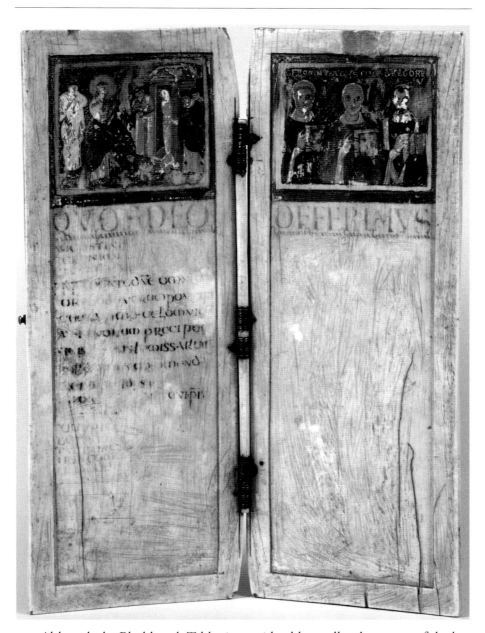

4.5 Ivory diptych of Boethius, consul in 487. Interior of both panels, Rome, fifth century. Brescia, Museo Civico dell'Éta Cristiana (image courtesy of Scala/Art Resource, NY).

Although the Blythburgh Tablet is considerably smaller than most of the late antique ivories from the Mediterranean basin, the choice of whalebone gives it similar status. Ivory was increasingly unavailable even in Francia by the eighth

Bousmanne, 'À propos d'un carnet à écrire en ivoire du XIVe siècle conservé à la Bibliothèque Royale de Belgique' in Bert Cardon, Jan Van der Stock and Dominique Vanwijnsberghe, with the collaboration of Katherina Smeyers (eds), *'Als Ich Can': Liber Amicorum in memory of Professor Dr Maurits Smeyers* (Paris, 2002), pp 166–202; Mark Cruse, 'Intimate performance: an ivory writing

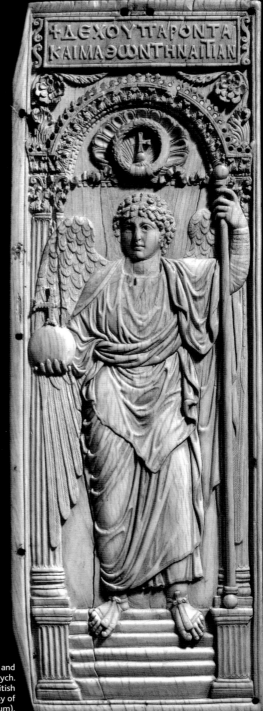

4.6 The Archangel Michael with orb and staff. Right half of an ivory diptych. Constantinople, c. 525–50. London, British Museum (© image courtesy of the Trustees of the British Museum).

century due to the deflection of African ivory by Muslim traders to north African principalities and eastward via the port of Basra to China.[22] By the ninth century, Carolingian ivory carvers were increasingly forced to fall back on recycled scraps of ivory for their projects, resulting in the use of small-scale panels set into wooden or metalwork frames in what Lawrence Nees has aptly called the Metope Style.[23] Further downstream along the trade routes and diplomatic exchange networks, the Anglo-Saxons were aware of the use of ivory on the mainland, but had no access to the medium itself. Whalebone was considered an appropriate substitute and was used for high-status objects for elite circles such as the Franks Casket (London, British Museum), the Gandersheim Casket (Braunschweig, Herzog Anton Ulrich-Museum) and the Larling Plaque (Norwich, Castle Museum) as well as for the Blythburgh Tablet. But whalebone was not merely conveniently available *ersatz*. As Vicki Szabo has noted for the Franks Casket, but equally true for all of these objects, a flat slab of whalebone of consistent grain would most probably have to come from the larger deep-water whales, very probably the jawbone of a sperm whale.[24] The eighth-century Anglo-Saxons were not deep-water whalers; accidental stranding was their primary source of deep-sea whalebone. Sperm whales do not normally enter the North Sea; usually their migration back and forth between the North Atlantic and the Arctic Ocean takes them to the west of Ireland. Sperm whales enter the North Sea in error due to navigational problems; once in it, they progress southward into shallower water, eventually stranding on the coasts of the Continent and England. Stranding happens quite rarely, as documentation across much of the historical era demonstrates.[25] Once procured from a stranded whale, whalebone cannot be used immediately; it must be stored, often for a year or more, to allow the oil to seep out.[26] Whalebone was thus neither readily available in quantity to the Anglo-Saxons nor immediately usable once obtained; it required both access to a rare resource and the circumstances to sequester that resource for later use. Small wonder that in later eras, access to whales and whale products was restricted by law to the elite.[27] A writing tablet made of this rare and valued material would most probably be considered as a high-status object, not a schoolbook for casual use.

In a personal comment to Leslie Webster recorded in her entry on the Blythburgh Tablet in the *Making of England* catalogue, Michael Lapidge suggested

tablet cover in The Cloisters' in Eglal Doss-Quinby, Roberta L. Krueger and E. Jane Burns (eds), *Cultural performances in medieval France: essays in honor of Nancy Freeman Regolado* (Cambridge, 2007), pp 57–67. **22** Avinoam Shalem, *The Oliphant: Islamic objects in historical context* (Leiden, 2004), pp 23–37. **23** Lawrence Nees, *Early medieval art* (Oxford, 2002), p. 187. **24** Vicki Ellen Szabo, *Monstrous fishes and the mead-dark sea: whaling in the medieval north Atlantic* (Leiden, 2008), p. 55, n. 79. **25** Chris Smeenk, 'Strandings of sperm whales, *Physeter macrocephalus*, in the North Sea: history and patterns', *Bulletin van het Koninklijk Belgisch Instituut voor Natuurwetenschappen – Biologie*, 67–Suppl. (1997), 15–18. **26** Szabo, *Monstrous fishes*, pp 160–1. **27** Mark Gardiner, 'The exploitation of sea mammals in medieval England: bones and their social context',

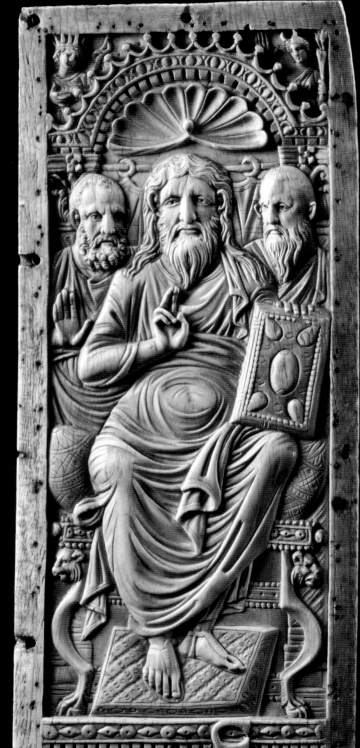

4.7 Christ enthroned. Front panel of an ivory diptych. Constantinople, mid-sixth century. Berlin, Skulpturensammlung und Museum für Byzantinische Kunst (Staatliche Museen) (image courtesy of Juergen Liepe; Bildarchiv Preussischer Kulturbesitz/Art Resource, NY).

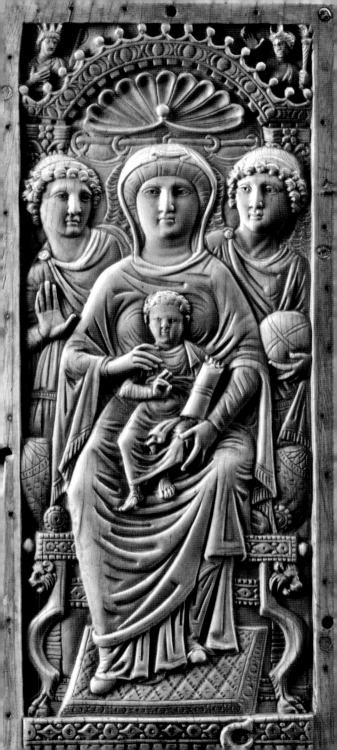

, considering its decoration, the tablet might be part of a li
h diptychs were part of the equipment of the Mass in t
rch; on their wax interiors were inscribed passages from scri
liturgy or lists of the names of those, including saints, religi
e considered worthy of commemoration in the commu
vers, during which the diptychs were laid on the altar.[29] As
latter practice, the term 'diptych' came to refer not only to t
he list of names that it contained and to the associated liturg
r to diptychs of the baptized, diptychs of the living and the
ishops; and to heretics, schismatics and criminals being
tychs' as a form of excommunication.[30] On the Continent,
antique ivory diptychs were frequently reused as liturgical
sul's image being identified in inventories as saints.[31] T
mple of such reuse is the diptych of Boethius, who was m
escia, Museo Civico dell'Éta Cristiana; fig. 4.4). Here, the i
ntings of the Raising of Lazarus and of Ss Jerome, Augus
w the paintings, the two panels are inscribed together in
S DEO OFFERIMUS, followed by the opening formulae of the
's, and then by lists of names; the inscriptions have been da
he seventh century (fig. 4.5).[32] New ivory diptychs were
pose, such as a mid-sixth-century example from Const
lpturensammlung und Museum für Byzantinische Kun
wing Christ and Mary enthroned on the exterior surfaces; c
imns of names were later inscribed in Carolingian semi-unci
whalebone for the Blythburgh Tablet may well be a reflectic
a period and region where ivory was unavailable. Begin
tury, however, as the numbers of those to be commemorated
mbers and lay patrons, grew past the capacity of the dip
dual shift away from the use of diptychs to *libri vitae* in t
ices. For the readings from the Gospel and the Epistles, lec

aeological Journal, 154 (1997), 173–95. **28** Webster and Page, '65: Leaf
1. **29** Wattenbach, *Das Schriftwesen im Mittelalter*, p. 59. For th
inuing use of the diptychs in the Eastern rites, see Robert F. Taft, *A histor*
ysostom (4 vols, Rome, 1978–2008), iv, *The diptychs* (1991). Taft no
servative practice maintained the diptychs in the Liturgy of the Word p
reas in the East, they were read during the offertorial intercessions (pp 2
oni, 'I dittici eburnei nella liturgia' in Massimiliano David (ed.), *Ebu*
orio tra Antichità e Medioevo (Bari, 2007), pp 299–315 at pp 301–2; T
Delbrueck, *Die Consulardiptychen und verwandte Denkmäler*, p. 22 and
oni, 'I dittici eburnei', 304–5. **32** Delbrueck, *Die Consulardiptychen und*
03–6. **33** Bernhard Bischoff, *Latin paleography: antiquity and the Mia*
Cróinín and David Ganz (Cambridge, 1990), p. 14; Susan A. Boyd, '474

source volumes were increasingly available. The ivory liturgical diptychs were then often reused as ornamental centrepieces for the covers of such books; Delbrueck's classic study of the consular diptychs shows that a significant number of surviving panels served in both capacities in the course of their histories.[34] However, the Blythburgh Tablet seems instead to have been eventually demoted for use in the classroom or scriptorium, eventually falling into the hands of the 'scribblers', several of whom, over time, casually cut into the whalebone itself with their letterform trials.

If indeed the Blythburgh Tablet is the front half of a liturgical diptych, the purpose of the image of the cross may have been to support such liturgical use. If the diptych was used for readings from the Gospel, the cross on the front of the diptych, like the crosses on book covers and in the illuminated carpet pages of gospel volumes, served to mark and dedicate the place of Christ's presence in the holy text.[35] If the tablet was part of a diptych containing a list of the names of those, dead or living, who were deserving of commemoration in the community's devotions, then the cross on the front panel places the names on the interior of the tablet in close proximity to and under the protection of this holy sign.[36] This arrangement is analogous to the protective placement of the cross beside the names of the dead in carved inscriptions, as at Deerhurst.[37]

The cross on the Blythburgh Tablet may, however, be meaningful here in more than its presence and placement. The cross is made up of what Gwenda Adcock, in her now-standard guide to Anglo-Saxon ornament, called a 'spiralling pattern' of interlace consisting of a single continuous strand.[38] This sense of endless continuity ornamenting a cross suggests both the historical wellspring of salvation in the crucifixion and resurrection and the future eternity of salvation for those whose names may have been inscribed within the diptych.[39] Simultaneously, the

the Virgin' in Weitzmann (ed.), *Age of spirituality*, pp 528–30. **34** Delbrueck, *Die Consular-diptychen und verwandte Denkmäler*, pp 81–279. **35** Michelle P. Brown, *The Lindisfarne Gospels: society, spirituality and the scribe* (London, 2003), pp 316–19. **36** David Johnson, 'The *crux usualis* as apotropaic weapon in Anglo-Saxon England' in Catherine E. Karkov, Sarah Larratt Keefer and Karen Louise Jolly (eds), *The place of the cross in Anglo-Saxon England* (Woodbridge, 2006), pp 80–95; Carol Neuman de Vegvar, '*In hoc signo*: the cross on secular objects and the process of conversion' in Sarah Larratt Keefer, Catherine E. Karkov and Karen Louise Jolly (eds), *Cross and culture in Anglo-Saxon England: studies in honor of George Hardin Brown* (Morgantown, WV, 2008), pp 79–117. **37** John Higgitt, 'Emphasis and visual rhetoric in Anglo-Saxon inscriptions', unpublished paper presented at *Shaping understanding: form and order in the Anglo-Saxon world, 400–1100*, The British Museum, 7–9 March 2002. Professor Higgitt's paper was left unfinished at his tragic and untimely death and will not be included in the published proceedings of the conference. **38** Gwenda Adcock, 'A study of the types of interlace on Northumbrian sculpture', MPhil., University of Durham, 1974, as cited in Rosemary Cramp, *Grammar of Anglo-Saxon ornament: a general introduction to the corpus of Anglo-Saxon stone sculpture* (Oxford, 1984), p. xxxi. **39** Gertrud Schiller, *Iconography of Christian art*, 2, trans. Janet Seligman (London, 1972), pp 7–9, reads the ornamented cross without a *corpus* as *crux invicta*, a symbol of the resurrection, via association with the *crux*

cross form in combination with the use of continuous interlace evokes the dual
nature of Christ: the mortal man who suffered on the cross and the eternal divinity
without material or temporal limits. Éamonn Ó Carragáin has clearly synopsized
the concern of the Anglo-Saxon church, and Bede in particular, in his *Commentary
on Mark*, with the dual nature of Christ in the wake of the Synod of Hatfield's
acceptance of the condemnation of Monotheletism by Pope Martin I and the
Lateran Council of 649.[40] In addition to Bede, many Insular writers of the period
reflected on Christ's dual nature, from Anglo-Saxon homilists mining the *Homilies
on Ezekiel* of Gregory the Great to the Irish hymnodists of the Antiphonary of
Bangor and Columbanus in his *Epistolae*.[41] The dual nature of Christ was further
made explicit for the eighth-century period of the Blythburgh Tablet by the
promulgation of the Chalcedonian Definition of the Faith through the widespread
use, in England as elsewhere, of the Athanasian Creed, undoubtedly well known
in the ecclesiastical community at Blythburgh.[42] In other words, the concept
possibly underlying the design of the cross on the Blythburgh Tablet was widely
familiar in Insular ecclesiastical contexts.

Against this background, the quincunx of rivet heads, perhaps holding in
place gilded metalwork mounts gleaming against the duller surface of the
whalebone, may be understood as representing or remembering the five wounds
of Christ without the display of the actual corpus. This simultaneous presence and
absence of Christ's suffering body invites further meditation on his dual nature,
allowing the viewer to envision Christ's death on the cross while at the same time
contemplating the temporally continuous and divine aspect of his unified person.
Gregory the Great, whose writings were widely studied in Anglo-Saxon England,
had seen meditation on Christ's Passion as a point of transition between the seen
and the unseen, a passageway to the unseen world beyond the physical.[43] In this
context, the materials of the Blythburgh Tablet, whalebone obtained through the
death of the whale and enduring metal, possibly gilded silver giving the appearance
of gold that would never tarnish, may have relayed the same message: the mortal
juxtaposed with the eternal.

gemmata installed *c.*440 on Golgotha by Theodosius II. Barbara Raw, '*The Dream of the Rood* and its
connections with early Christian art', *Medium Ævum*, 39 (1970), 239–56 at 242–3, reads the *crux
gemmata* as a symbol of the glorified and divine Christ: 'it recalls the death of Christ only in so far
as death was the source of his glory' (243). See also Éamonn Ó Carragáin, 'The meeting of Saint Paul
and Saint Anthony: visual and literary uses of a Eucharistic motif' in Gearóid Mac Niocaill and
Patrick F. Wallace (eds), *Keimelia: studies in medieval archaeology and history in memory of Tom Delany*
(Galway, 1988), pp 1–72 at p. 7. **40** Éamonn Ó Carragáin, *Ritual and the rood: liturgical images
and the Old English poems of the Dream of the Rood tradition* (London and Toronto, 2005), pp 225–8.
41 Carol Neuman de Vegvar, 'The Echternach Gospels lion: a leap of faith' in Catherine E. Karkov,
Michael Ryan and Robert F. Farrell (eds), *The Insular tradition* (Albany, NY, 1997), pp 167–88 at
pp 175–7. **42** Neuman de Vegvar, 'The Echternach Gospels lion', pp 173–5. **43** Gregory, *In
Hiezechihelem prophetam*, 2:1:16, in Barbara C. Raw, *Anglo-Saxon crucifixion iconography and the art
of the monastic revival* (Cambridge, 1990), p. 16.

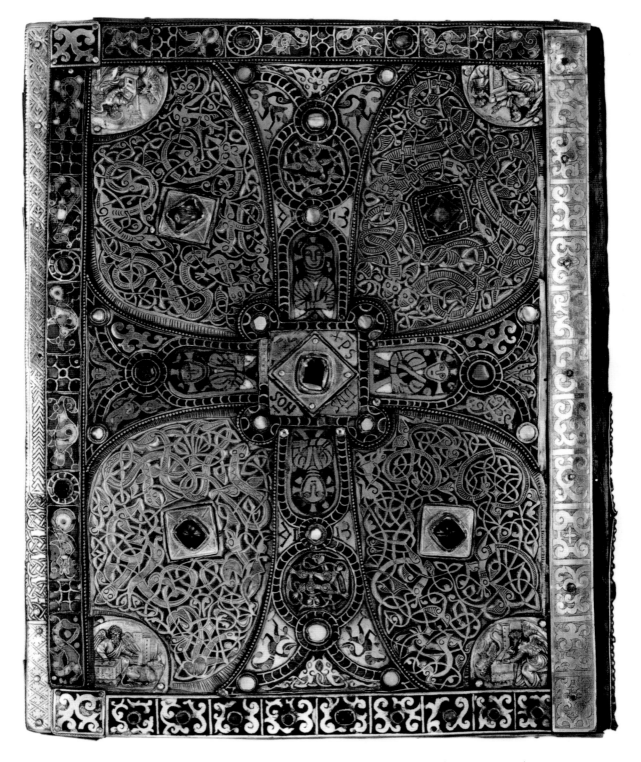

4.9 Lindau Gospels, back cover. Area of Salzburg; third quarter of the eighth century. New York, Pierpont Morgan Library (image courtesy of the Pierpont Morgan Library, NY).

The wounds of Christ were often a focus of meditation and comment for early medieval writers, in England as elsewhere. The wounds of Christ, particularly but not limited to the wound in his side, were understood in the eighth century, both by writers such as Bede and by designers of visual imagery, as sources of the Eucharist.[44] By extension of this association, the wounds were protective and a source of salvation. As George Hardin Brown has pointed out, for Bede the wound in Christ's side was also a metaphor for the entry into Noah's ark and for the entry through the right side of Solomon's temple, in both cases a passageway to salvation.[45] Brown has shown how Bede, in commenting on the Song of Songs, 'Come my dove into the clefts of the rock, into the crannies of the wall' (Cant 2:14), builds on Apponius in identifying the crannies and clefts here as the wounds of Christ offering protection to the whole Church as well as to the individual faithful.[46] The protective role of the wounds may account for the proliferation of the quincunx in a range of probably secular contexts in Anglo-Saxon England, in the layout of perforations in strainer spoons as well as on disc brooches, on the bases of palm cups and globular beakers, and in the design of coins.[47] It is of course equally often found with both triumphal and protective implications in Insular ecclesiastical contexts and in their affiliates on the Continent, as on monastic grave markers or covers, and on the back cover of the Lindau Gospels (New York, J. Pierpont Morgan Library; fig. 4.9) where the five large gems at the crossing and in the reentrant angles of the cross are visually linked by their prominent size.[48] In these contexts too, the quincunx may be intended to play a protective role for the person in the grave or the text in the binding by reference to the wounds of Christ. Other metalwork examples include the Rupertus Cross, a standing cross perhaps intended for placement near an altar

44 Raw, *Anglo-Saxon crucifixion iconography*, pp 80, 238, for discussion of the imagery of the Wounds at the *Te igitur* in the eighth-century Sacramentary of Gellone (Paris, BN, MS lat. 12048, fo. 143v) and in Bede's *Homelia*, 2:15, *In ascensione Domini (Luc. 24:44–53)*. For text of the latter, see Bede, *Homeliarum evangelii libri*, II, ed. David Hurst (Turnhout, 1955), p. 284. **45** George Hardin Brown, 'Bede and the cross' in Keefer et al. (eds), *Cross and culture in Anglo-Saxon England*, pp 19–35 at pp 27–9. Raw, 'The Dream of the Rood', p. 240, considers that 'it is unlikely that devotion to the five wounds was known in Anglo-Saxon England', but her own and Brown's evidence from Bede demonstrates that the subject was certainly of interest in learned ecclesiastical circles, and the ubiquity of the quincunx as design motif (below) in post-conversion England suggests strongly that the theme was probably known, possibly through such homilies as Bede's, to a wider audience. **46** Brown, 'Bede and the cross', p. 28. **47** For spoons, see Neuman de Vegvar, '*In hoc signo*', p. 115. For brooches and drinking vessels, see Gale R. Owen-Crocker and Win Stephens, 'The cross in the grave: design or divine?' in Keefer et al. (eds), *Cross and culture in Anglo-Saxon England*, pp 118–52 at pp 125, 145, 147. For coins, see Anna Gannon, 'A chip off the rood: the cross on early Anglo-Saxon coinage' in ibid., pp 153–71 at pp 159–61 and fig. 2a. **48** On grave markers, covers or inclusions, see Rosemary Cramp, *Corpus of Anglo-Saxon Stone sculpture I: County Durham and Northumberland* (London, 1984), Hartlepool 0–8 and Monkwearmouth 4, pt 1, pp 97–101, 123; pt 2, pls 84–5 (figs 429–49) and 110 (fig. 600). On the Lindau cover, see Peter Lasko, *Ars Sacra, 800–1200* (London, 1972), pp 8–9 and pl. 2. For the protective powers of the cross within a Catalan context, see

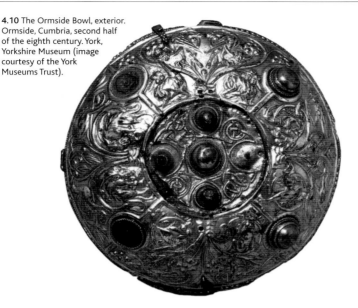

4.10 The Ormside Bowl, exterior. Ormside, Cumbria, second half of the eighth century. York, Yorkshire Museum (image courtesy of the York Museums Trust).

(Bischofshofen, Pongau, Austria), and the Ormside bowl (York, Yorkshire Museum; fig. 4.10), possibly originally intended as either a chalice or a secular winecup.[49] Much more could be done to explore the iconographic range and the implications of placement of the quincunx in Insular art and material culture in general, as on numerous Anglo-Saxon, Irish, Welsh, Scottish and Manx stone crosses.[50] Another factor is the use of this motif in texts, as in the debate over the number, placement and meaning of the five jewels in the description of the cross in *The Dream of the Rood*, in which context other symbolic meanings of the number five have also been brought into the question.[51]

The wounds of Christ were also understood as an anticipated index of salvation at the Last Judgment. According to Bede, the wounds of Christ would be visible at the Judgment; however, while those about to be damned would see

Camps i Sòria, this volume. **49** Leslie Webster, '133 Standing Cross (so-called Rupertus Cross) (copy)' and '134 The Ormside Bowl' in Webster and Backhouse (eds), *The making of England*, pp 170–3. **50** For the quincunx's relationship to the wounds of Christ in sculpture, see Gannon, 'A chip off the rood', pp 159–61; Nancy Edwards, *A corpus of early medieval inscribed stones and stone sculpture in Wales II: south-west Wales* (Cardiff, 2007), p. 63. Examples: for Wales: Mark Redknap and John M. Lewis, *A corpus of early inscribed stones and stone sculpture in Wales I: south-east Wales and the English Border* (Cardiff, 2007), pp 89–94. For Ireland: Peter Harbison, *The high crosses of Ireland: an iconographical and photographic survey*, II: *photographic survey* (Bonn, 1992), figs 14–15, 19, 150, 263, 269, 391–2, 447, 631, 635, 637. For Scotland: J. Romilly Allen and Joseph Anderson, *The early Christian monuments of Scotland* (Edinburgh, 1903; repr. Balgavies, 1993), I.2, p. 55. For Man: Philip M.C. Kermode, *Manx crosses* (London, 1907; repr. Balgavies, 1994), pls VII, IX, XIV, XV, XXI. **51** Howard R. Patch, 'Liturgical influence in *The Dream of the Rood*', *Proceedings of the Modern Languages Association*, 34:2 (1919), 233–57 at 242–5; Annemarie E. Mahler, '*Lignum Domini* and the opening vision of *The Dream of the Rood*: a viable hypothesis', *Speculum*, 53:3 (1978), 441–59 at 447.

only Christ's suffering body, the blessed would see him in his glory.[52] A visualization of this idea may perhaps be seen in the fragmentary embossed image from the front of the eighth- or ninth-century Winchester Reliquary (Winchester, City Museum). Here, the enthroned Christ in glory holds and gestures toward a rectangular object, probably the Book of Judgment, ornamented with five bosses, which David Hinton has suggested may refer to the wounds of Christ.[53] The four non-central bosses are placed in the corners of a rectangle, so that together the bosses form an X rather than a cross. Hinton rightly points out that this arrangement of bosses may be purely decorative, but the X shape may also refer to the Greek letter *chi* and thereby serve as an indicator of Christ's presence. The five bosses arranged in this configuration may, here and elsewhere in Insular art, refer to the visibility of Christ's wounds at the Last Judgment, while the rest of the image simultaneously presents Christ in his glory, the vision promised to the saved at the end of time.

The Blythburgh relief, a cross without a corpus displaying wounds without a body, may similarly convey a promise of salvation at the end of days. As rendered in continuous interlace with rivets and possibly gilded silver mounts on the outer surface of the Blythburgh Tablet, the continuously interlaced cross with quincunx invites the viewer to envision Christ's suffering humanity and his eternal divinity together, either as an identifying marker for the presence of a scriptural reading within the diptych, or as a source of protection and means of salvation for those whose names were inscribed on the inside of the diptych, and through prayer, in the memory of the community.

52 Raw, *Anglo-Saxon crucifixion iconography*, pp 108–9, quoting Bede, *Homilia*, XI, *In Vigilia Pentecostes* in *PL*, 94, pp 189–97 at p. 193: *Sed enim cunctis hominibus, seipsum vero solis manifestabit electis. Nam et reprobi in iudicio Christum videbunt, sed, sicut scriptum est, **videbunt in quem transfixerunt**, soli autem regem in decore suo videbunt oculi iustorum.* **53** David A. Hinton, 'Interpretation' in David A. Hinton, S. Keene and K. Qualmann, 'The Winchester Reliquary', *Medieval Archaeology*, 25 (1981), 45–77 at 64. The book in Christ's hand is more clearly visible in Nigel Fradgley's reconstruction drawing of the front of the reliquary in this essay (p. 65) than in photographic images of the reconstructed reliquary.

Some questions on the function and iconography of the cross in the Asturian kingdom

CÉSAR GARCÍA DE CASTRO VALDÉS

From its very inception, the kingdom of Asturias (722–910), and its successor, the kingdom of León (910–1037), offer a wide visual and documentary repertoire utilizing the sign of the cross, in contexts from monumental and funerary sculpture to manuscript miniatures and legal documents.[1] In part, this characteristic can be explained in terms of continuity with the Visigothic kingdom of Toledo, where interest in the cult of the cross developed during the seventh century. However, the predominance of this most Christian of signs during the eighth to the tenth centuries requires specific explanation, and reference to continuity alone will not suffice. Rather, the kingdom must be seen against its contemporary backdrop; of a Europe embroiled in debates on the meaning of images, spurred on by the iconoclastic controversy, Adoptionism and the sacramental Christology and theology being developed in intellectual Carolingian circles.

This essay addresses the iconographic manifestations and context of the appearance of the cross in these kingdoms. Common to all cross iconography of Asturias-León is the absence of representations of Christ crucified. Always it is the gemmed cross, sign of *parousia* and victory, that is found; images of Christ's redemptive sacrifice, or of his glory dominating death from the instrument of his torment, are conspicuous by their absence.[2] This trait is a legacy from the Visigothic kingdom of Toledo (507–711), which also lacked representations of the

1 I am most grateful to Jenifer Ní Ghrádaigh for her kind invitation to participate in the conference at Cork, and for her accurate translation of the original Spanish text. 2 For discussion of the implications of the absence of Christ's wounded body upon an Anglo-Saxon cross, see Neuman de Vegvar, this volume.

crucifixion. In fact, the cross as symbol is frequently found in churches reliably dated to the seventh century, such as San Juan de Baños del Cerrato, Palencia (661),[3] or San Pedro de la Nave, Zamora, dating to the final quarter of the same century.[4]

At the first of these churches, a Greek cross with flared arms, volute finials and a central medallion of pearls and trefoils within the arms, is sculpted on the keystone of the western doorway. This cross is repeated on the keystone of the triumphal arch before the sanctuary, identical in design except for its more elongated form. An allusion to the *parousia* is clearly made, not only through the model chosen for these crosses, but also by their location at the entrance to church and sanctuary. The flared arms and scrolled finials refer to the iconography of the legendary cross of Constantine, as it was depicted in sculpture and painting from the reign of Theodosius onwards.[5] The ring of pearls is a typically Byzantine motif, while the trefoils allude to the cross as the Tree of Life, an interpretation developed by patristic writers in the earliest strands of exegesis on the Passion. Meanwhile, in San Pedro de la Nave, the sculptured friezes of the interior of the sanctuary depict Greek crosses within medallions. These have flared arms, with straight or concave ends whose corners are often extended into defined spikes, while circles like gems or cabochons are occasionally found within the arms. These crosses differ from those at Baños in lacking a central medallion. Their iconographic context is noteworthy: vine scrolls, left-turning helicoidal rosettes, six- and twelve-petalled rosettes and ivy scrolls; all being allusive of the Eucharist and the eternal and everlasting life that follows. Identical designs and programmes appear in the imposts of the lateral doors on the north and south sides of the church (fig. 5.1).

The appearance of the cross of the Second Coming in monumental sculpture of the second half of the seventh century was preceded by the adoption of cruciate Byzantine coin types in Visigothic mints from the reign of Leovigildo (573–86)

3 Helmut Schlunk and Theodor Hauschild, *Hispania Antiqua: die Denkmäler der frühchristlichen und westgotischen Zeit* (Mainz, 1978), pl. 107b; Pedro de Palol, *La basílica de San Juan de Baños* (Palencia, 1988), pp 33, 54. 4 Schlunk and Hauschild, *Hispania Antiqua*, pls 130a , 130b, 132; Jean-Marie Hoppe, 'Ensayo sobre la escultura de San Pedro de la Nave' in Caballero Zoreda (ed.), *La iglesia de San Pedro de la Nave (Zamora)* (Zamora, 2004), pp 323–425 at pp 331–6. Space does not permit detailed discussion of the reasons for retaining the traditional dating to the seventh century of both churches, despite some recent disputes: see Luis Caballero Zoreda and Fernando Arce, 'La iglesia de San Pedro de La Nave (Zamora): Arqueología y arquitectura', *Archivo Español de Arqueología*, 70 (1997), 221–74; Luis Caballero Zoreda and Santiago Feijoo Martínez, 'La iglesia altomedieval de San Juan Bautista de Baños de Cerrato (Palencia)', *Archivo Español de Arqueología*, 71 (1998), 181–242; *La iglesia de San Pedro de la Nave (Zamora)*, ed. Luis Caballero Zoreda. 5 Erich Dinkler, *Signum crucis: Aufsätze zum Neuen Testament und zur Christlichen Archäologie* (Tübingen, 1967), pp 67–71; César García de Castro, 'Génesis y tipología de la cruz gemada en Occidente' in Javier Fernández Conde and César García de Castro Valdés (eds), *Poder y simbología en Europa, siglos VIII–X. Actas del Symposium Internacional, Oviedo, 22–7 de septiembre 2008* (Gijón, 2009), pp 371–400.

5.1 San Pedro de La Nave, Zamora. Carved cross on the south portico impost (photograph by the author).

onwards.[6] These were systematically used by Recesvinto (653–72) and his successors until Égica (687–700), and feature Greek crosses with flared arms on a pedestal on their reverse, deliberate copies of the golden *solidus* minted by Tiberius Constantine (578–82). From Égica onwards, coins minted jointly with his son Witiza incorporate Latin crosses and cruciform monograms, while those minted by Witiza alone (700–11) return to the type of the Greek cross on a pedestal, as do those of his successor, Achila, in the Tarraconensis province after the Arabic conquest.[7]

A very considerable repertoire of gemmed crosses on sheet gold with soldered cabochon mounts bear testimony to the Visigothic goldsmithing tradition; one need only cite the seventh-century treasures of Guarrazar and Torredonjimeno.[8] All of these gemmed crosses adopted the Greek type of flared arms with straight terminals, although some Latin types do appear among the unadorned examples. The repoussé decoration consists of foliate ivy scrolls, which allude to perpetual life, as made possible by the cross. The crosses of Guarrazar and Torredonjimeno are both pendant crosses of small dimensions (less than 23cm in total height), designed to hang from votive crowns, in their turn located above altars or at the entrance to sanctuaries, where they would have hung from rings embedded in the vaulting. Cruciform motifs also occur on the many fragmentary remains of

6 Maria José y Rafael Chaves, *Acuñaciones previsigodas y visigodas en España desde Honorio a Achila II: Catálogo general de las monedas españolas, II* (Madrid, 1984), p. 57; Aloiss Heiss, *Descripción general de las monedas de los reyes visigodos de España* (Paris, 1877; repr. Madrid, 1978), pl. I. **7** Chaves, *Acuñaciones previsigodas y visigodas*, p. 119; Heiss, *Descripción general de las monedas de los reyes visigodos de España*, pls VII–XII. **8** Alicia Perea (ed.), *El tesoro visigodo de Guarrazar* (Madrid, 2001); eadem, *El tesoro visigodo de Torredonjimeno* (Madrid, 2009).

5.2 Cross of the Angels, Cámara Santa, Oviedo. Obverse. Image courtesy of the Archbishopric of Oviedo, in collaboration with the Fundación María Cristina Masaveu Peterson (photograph by Santiago Relanzón).

decorative sculpture that survive from lost Visigothic buildings of the second half of the sixth century. These display Greek crosses with expanding arms and concave or straight terminals, sometimes with a central medallion. This type is found throughout the entire peninsula, and its distribution is, indeed, coterminous with architectural remains of this period. This suggests that, as an iconographic type, this Greek cross may have been diffused along official channels. During the sixth century, these crosses coexisted with large gemmed chi-rho symbols, which disappeared in the first half of the seventh century.[9]

After the destruction of the kingdom of Toledo and the Arab conquest of most of the peninsula (711–14), a nucleus of resistance emerged in the north in the shelter of the Cantabrian Mountains. This was to become the kingdom of Asturias. The earliest epigraphic evidence that survives from this period is the inscription commemorating the consecration and dedication of a church of the Holy Cross in Cangas de Onís, under the patronage of Favila and his wife Froiliuba, dated to 737. Although the inscription is now lost, this early Asturian document is preserved through an excellent photograph and many transcriptions and drawings.[10] From these, we know that this church, of which it records *demonstrans figuraliter signaculum alme crucis*, represented symbolically or allegorically the sign of the cross, which is alluded to as *tropheo crucis*. It is not clear what we are to understand as symbolizing the cross here, whether the cruciform ground plan of the church itself or the presence of a large painted cross within the building.[11]

No further evidence now survives of devotion to the cross in the Asturian kingdom until the reign of Alfonso II (791–842). Alfonso was the monarch responsible for the creation of the first of the great gemmed Asturian crosses, the Cross of the Angels of the cathedral of San Salvador of Oviedo, donated in the year 808 (Hispanic Era 846; fig. 5.2). This is also the foremost example of jewelled metalwork made in the kingdom to have survived to the present day.[12] It is a reliquary in the form of a Greek cross, consisting of a cherrywood core covered with gold foil and precious stones on front and back. Its dimensions are 46.5 by

9 María Cruz Villalón, *Mérida visigoda: La escultura arquitectónica y litúrgica* (Badajoz, 1985), pp 287–302. **10** Achim Arbeiter and Sabine Noack-Haley, *Hispania Antiqua: Christliche Denkmäler des frühen Mittelalters. Von 8. bis ins 11. Jahrhundert* (Maguncia, 1999), pl. 7c; Ciriaco Miguel Vigil, *Asturias monumental, epigráfica y diplomática* (Oviedo, 1887; repr. Principado de Asturias, 1987), pl. JV. **11** Francisco Diego Santos, *Inscripciones medievales de Asturias* (Oviedo, 1994), pp 226–7; García de Castro Valdés, *Arqueología cristiana de la Alta Edad Media en Asturias* (Oviedo, 1995), pp 181–4; Manuel Cecilio Díaz y Díaz, *Asturias en el siglo VIII: La cultura literaria* (Oviedo, 2001), pp 31–41. For analysis of painted crosses in an Italian context, see Bacci and Schüppel, this volume. **12** Helmut Schlunk, 'The crosses of Oviedo', *Art Bulletin*, 32 (1950), 91–114; Helmut Schlunk and Victor H. Elbern, *Estudios sobre la orfebrería del Reino de Asturias* (Oviedo, 2008); Francisco Diego Santos, *Inscripciones medievales de Asturias* (Oviedo, 1994), pp 55–8; García de Castro Valdés, 'La Cruz de los Ángeles' in César García de Castro Valdés (ed.), *Signum salutis: Cruces de orfebrería de los*

45.5cm, with a thickness of 2.5cm. The arms widen progressively from a central disk, and their ends are straight. The back of the cross is entirely covered with extremely fine filigree. The lateral arms still contain the rings from which hung chains of pearls and precious stones, which contemporary sources term *pendilia*. Its abstract and aniconic symbolism is enriched by the allusive filigree work which references the cross as *arbor vitae* or Tree of Life, and by the rigour of its numerology, which is composed around the numbers four, twelve, and forty-eight. On the reverse is the inscription commemorating its donation:

+ *SVSCEPTVM PLACIDE MANEAT HOC IN HONORE DEI OFFERT ADEFONSVS HVMILIS SERVVS XPI QVISQVIS AVFERRE PRESVMSERIT MIHI NISI LIBENS VBI VOLVNTAS DEDERIT MEA FVLMINE DIVINO INTEREAT IPSE HOC OPVS PERFECTVM EST IN ERA DCCCXLVI HOC SIGNO TVETVR PIVS HOC SIGNO VINCITVR INIMICVS*	Let this offering remain undisturbed in honour of God. The humble servant of Christ, Adefonsus, offers it. May whoever shall presume to remove it from me, except when my will shall have given it voluntarily, perish by divine lightning. This work was completed in the year 846 of the era. The pious man is protected by this sign. The enemy is conquered by this sign.

Formally, the prototype for this whole series of wooden-core, gold-foil crosses seems to have been established with the well-known Cross of Justin II (565–78) from the Capitoline Treasury of St Peter's, Rome.[13] Its dimensions are closest to those of the Cross of the Angels (40.7 by 33.5cm), although the reverse, with its figural decoration, was never imitated in Spain. The reliquary purpose of the Oviedo cross can be deduced from the small boxes contained within the extremities of the four arms, fitted with sliding lids and intended to house relics. As the cross did not originally have a shaft that would have allowed its placement on the altar table, nor was it intended to be hung above the altar, its use must have been processional. It has been argued that it may have been carried in the manner depicted in the apse mosaics of San Vitale, Ravenna, where Bishop Maximian is shown grasping a similarly shaftless cross.[14] However, the fineness of the gold foil, the delicacy of its filigree and gem mounts, as well as the letters soldered to the back, would all argue against this. It seems, therefore, that the cross was not intended to be held in this manner.

This Greek cross type was not the only model with wide distribution at this early period. The Byzantine type, consisting of a Latin cross with arms forked at

siglos V al XII (Oviedo, 2008), pp 120–7. **13** Christa Belting-Ihm, 'Das Justinuskreuz in der Schatzkammer der Peterskirche zu Rom', *Jahrbuch des Römisch-Germanischen Zentralmuseum Mainz*, 12 (1965), 142–66. **14** Helmut Schlunk, *Las cruces de Oviedo* (Oviedo, 1985), p. 24; Schlunk and Elbern, *Estudios sobre la orfebrería del Reino de Asturias*, p. 145.

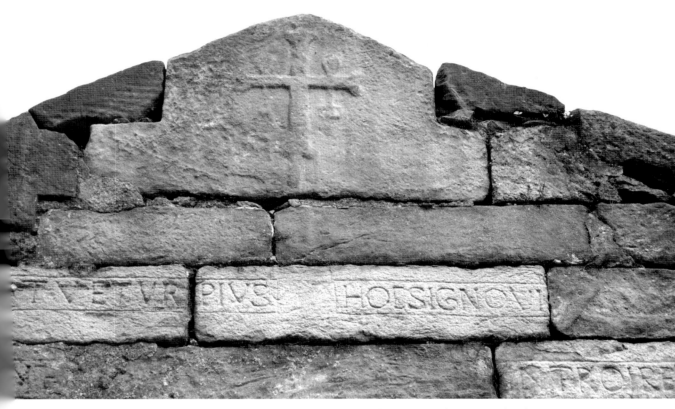

their extremities, is found contemporaneously in mural painting of the church of Santullano de Oviedo (San Julián de los Prados), also founded by Alfonso II in the first decades of the ninth century (pl. 8), and as relief sculpture on the enigmatic Foncalada de Oviedo. The mural paintings at Santullano show a great gemmed Latin cross beneath a gem-encrusted arch, which is repeated four times in the centre of the upper pictorial register of the interior of the church.[15] This creates an east–west axis, from the door to the sanctuary, marked out by this great exalted cross, flanked on either side by vases with foliate ornament and panels with representations of palace façades, from whose entablatures hang long curtains of purple. An A and Ω hang from its arms, and above this are stylized flames, imitating the metal candleholders found on, for instance, the seventh-century Cross of Moses from the monastery of St Catherine of Sinai.[16] On either side of

15 Helmut Schlunk and Magín Berenguer, *La pintura mural asturiana de los siglos IX y X* (Oviedo, 1957; repr. Principado de Asturias, 1991), pls 3, 4, 8, 12, 13; Lorenzo Arias Páramo, *La pintura mural en el Reino de Asturias en los siglos IX y X* (Gijón, 1999), pp 39, 85. **16** Kurt Weitzmann and Ihor Ševčenko, 'The Moses Cross at Sinai', *Dumbarton Oaks Papers*, 17 (1963), 365–98; Yota Ikonomaki-Papadopoulos, 'Church metalwork' in Konstantinos Manafis (ed.), *Sinai: treasures of the*

5.3 Foncalada, Oviedo. Carved cross on the top of the eastern façade (photograph by the author).

the cross shaft, beneath the transom, are architectural figures. These consist of buildings with gabled roofs, seen in longitudinal section, with an arcade of round-headed arches diminishing in height and breadth from the shaft of the cross outwards. The arches have curtains gathered to left and right respectively. The consensus is that these buildings represent Jerusalem and Bethlehem. To date, these mural paintings have been interpreted, in broad terms, as an image of the heavenly Jerusalem, presided over by the cross,[17] and as the greatest expression of a supposed early medieval Spanish aniconic tradition.[18] This interpretation would read the moderate iconoclasm of the first Carolingian generation, such as Theodulf of Orleans and Benedict of Aniane, as an echo of this Spanish tradition, also played out by a second generation of scholars, such as Agobardo of Lyon and Claudius of Turin, and expressed in the *Libri Carolini* and the *Opus Caroli contra synodum* and proclaimed in the canons of the Council of Frankfurt of 794. Space precludes further analysis of this now, but it should be stated that any definitive interpretation of these paintings still eludes us, as many other questions about the monument remain unanswered, and these could impact on our interpretation of the presence of the triumphant cross.

On the pediment of the façade of the aedicule of the Foncalada (fig. 5.3) is depicted a similar cross to that of Santullano, plain and unadorned, and in this instance, with a processional shaft. The cross is accompanied by an inscription which runs across the whole façade of the chapel, as follows:[19]

IN HOC SIGNO TVETVR PIVS IN HOC SIGNO VINCITVR INIMICVS SIGNVM SALVTIS PONE DOMINE IN FONTE ISTO VT NON PERMITTAS INTROIRE ANGELVM PERCVTIENTEM	The pious man is protected by this sign. The enemy is conquered by this sign. Place this sign of salvation, O Lord, in this spring so that you do not allow the angel of death to enter.

The epigraphy allows us to date the inscription to the first half of the ninth century.

There is, furthermore, a third type of cross known from the reign of Alfonso II, which ought not to be overlooked. This is the cruciform composition that is found on folio 220v of the great Bible kept in the Benedictine abbey of the Holy Trinity of La Cava dei Tirreni, Italy, a work of Danila, which has been linked to the Asturian monarchy.[20] The text is disposed against a blue background, forming

monastery (Athens, 1990), pp 263–310 at pp 264–5. **17** Schlunk and Berenguer, *La pintura mural asturiana de los siglos IX y X*, pp 100–5. **18** Isidro Gonzalo Bango Torviso, 'L'Ordo gothorum et sa survivance dans l'Espagne du Haut Moyen Âge', *Revue de l'art*, 70 (1985), 9–20 at 15–17. **19** Diego Santos, *Inscripciones medievales de Asturias*, pp 105–7; García de Castro Valdés, *Arqueología cristiana de la Alta Edad Media en Asturias* (Oviedo, 1995), pp 90–2. **20** Teófilo Ayuso Marazuela, *La Biblia visigótica de la Cava dei Tirreni: Contribución al estudio de la Vulgata en España* (Madrid,

5.4 Santa María de Naranco, Oviedo. Carved cross on the eastern façade (photograph by the author).

a cross with straight arms and a large central square, of a design not otherwise found in the visual repertoire of the kingdoms of Asturias or León. This graphic gambit is particularly striking given that the codex does not contain a single figurative or narrative illustration of the biblical text.

The brief reign of Ramiro I (844–50) has left us two buildings of far-reaching importance in the history of architecture: Santa María de Naranco, whose layout and plan denote a secular purpose, but from which survives an altar consecrated in 848,[21] and the church of San Miguel de Lillo, now two thirds ruined.[22] The

1956); Paolo Cherubini, 'La Bibbia di Danila: un monumento trionfale per Alfonso II di Asturie', *Scrittura e Civiltà*, 23 (1999), 75–131; John Williams, *La miniatura española en la Alta Edad Media* (Madrid, 1987), pl. I. **21** García de Castro Valdés, *Arqueología cristiana de la Alta Edad Media*, pp 109–20, 473–87; García de Castro Valdés, 'Notas sobre teología política en el Reino de Asturias; la inscripción del altar de Santa María de Naranco (Oviedo) y el testamento de Alfonso II', *Arqueología y territorio medieval*, 10:1 (2003), 137–70. **22** García de Castro Valdés, *Arqueología cristiana de la*

standard Greek cross with flared arms on a stand features strikingly in the articulation of the minor façades of Santa Maria, both east and west, where it is found in the two vertical bands that form their compositional axes (fig. 5.4). The stands of the cross reliefs are supported by a horizontal line, in its turn supported by an X-shaped motif. The ancient cosmological relationship between the cross and the X is very clear here.[23] In the interior, the same motifs and composition are repeated on the two faces of the walls that divide the central nave from the lateral galleries. They thus form the same west–east axis already described at Santullano. They also anticipate the apotropaic function of the cross of the Second Coming as found on façades of buildings from the reign of Alfonso III and his successors.

The apogee of goldsmithing production in Asturias is reached with the great Cross of Victory, donated by King Alfonso III and his wife Scemena to the cathedral of Oviedo on Easter Sunday, 27 March 908 (Hispanic Era 946; fig. 5.5). The inscription on the back of the cross says:[24]

+ *SVSCEPTVM PLACIDE MANEAT*
HOC IN HONORE DEI QVOD
OFFERVNT FAMVLI XPI ADEFONSVS
PRINCES ET SCEMENA REGINA
QVISQVIS AVFERRE HOC DONARIA
NOSTRA PRESVMSERIT FVLMINE
DIVINO INTEREAT IPSE HOC OPVS
PERFECTVM ET CONCESSVM EST
SANCTO SALVATORI OVETENSI SEDIS
HOC SIGNO TVETVR PIVS HOC
SIGNO VINCITVR INIMICVS ET
OPERATVM EST IN CASTELLO
GAVZON ANNO REGNI NSI XLII
DISCVRRENTE ERA DCCCCXLVI

Let this offering which prince Adefonsus and queen Scemena, servants of Christ, make remain undisturbed in honour of God. May whoever shall presume to remove our gifts from here perish by divine lightning. This work was completed and granted to the church of the Holy Saviour at Oviedo. The pious man is protected by this sign. The enemy is conquered by this sign. And it was produced in the castle of Gauzon in the 42nd year of our reign in the year 946 of the era.

This consists of a reliquary in the shape of a Latin cross with a core of oak wood covered with gold foil and with an extremely rich complement of precious jewels and enamels on the reverse. Its dimensions are 93 by 72cm. The flared arms

Alta Edad Media, pp 406–20; Luis Caballero Zoreda, María de los Ángeles Utrero Agudo, Fernando Arce Sainz and José Ignacio Murillo Fragero, *La iglesia de San Miguel de Lillo (Asturias): Lectura de paramentos* (2006) (Gijón, 2008). **23** Victor H. Elbern, 'Die Stele von Moselkern und die Ikonographie des frühen Mittelalters' in *Fructus Operis, I* (Regensburg, 1998), 99–138; Stefan Heid, *Kreuz, Jerusalem, Cosmos: Aspekte frühchristlicher Staurologie* (Münster, 2001), pp 19–28. For discussion of the X in the context of Insular art, see Neuman de Vegvar, this volume. **24** Diego Santos, *Inscripciones medievales de Asturias*, pp 58–60; García de Castro Valdés, 'La Cruz de la Victoria' in García de Castro (ed.), *Signum salutis*, pp 156–65.

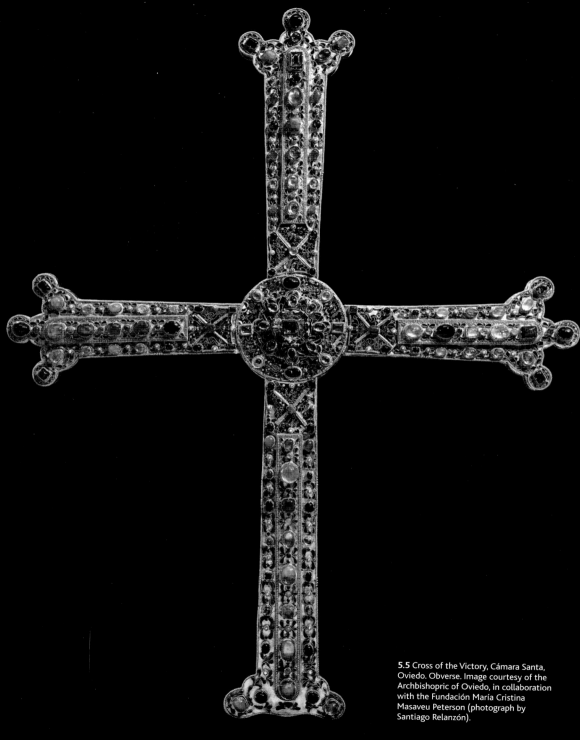

5.5 Cross of the Victory, Cámara Santa, Oviedo. Obverse. Image courtesy of the Archbishopric of Oviedo, in collaboration with the Fundación María Cristina Masaveu Peterson (photograph by Santiago Relanzón).

end in a triple lobe, each of which further swells into a disk on which the terminal gems are mounted. The arms join in a central disk, which housed the reliquary box. The combination of triple lobes with disks is a typological innovation that finds a striking parallel in the great cross donated by Nicephoros Fokas to the monastery of Great Lavra (Megistí Lavra) of St Athanasios of Mount Athos (963–9).[25] In terms of goldsmithing, it represents a considerable rupture with the past, as the continuity of the Cross of Angels type is attested even into the reign of Alfonso III, who, in the year 874 gave an exact replica to the church of Santiago de Compostela, unfortunately lost since 1906.[26]

The back of the piece is plain, apart from the inscription, four stones mounted on each of the terminals of the arms, and the rich central medallion.[27] By contrast, the face is of such material splendour and technical virtuosity as to make the cross one of the most outstanding examples of early medieval Western metalwork. As well as the gemstones, there are eight enamel plaques, which represent the *tria genera animantium*: fishes, beasts and birds. Even though the disposition of the gems and their chromatic order have suffered irreversible alterations, making problematic their original layout, the cross offers an elaborate iconographic programme governed by the idea of the Second Creation fulfilled in the mystery of the cross.[28]

Two years after Alfonso III and Scemena's donation, their son Fruela and his wife Nunilo, future monarchs of León between 924 and 925, gave a reliquary casket known as the Caja de las Ágatas (Casket of the Agates) to San Salvador of Oviedo.[29] The silver plate that forms the base of the casket bears an engraved cross, about which are the lines of a commemorative inscription, which conforms to the tenor of the dedicatory texts on the earlier crosses. The type of cross chosen here is that of a gemmed Latin cross with forked arms, flanked by the Tetramorphs, the symbols of the evangelists (fig. 5.6).[30] The tradition of donating crosses of the Asturian iconographical type to ecclesiastical institutions is thus continued by the kings of León, sons and grandsons of the Asturian kings. So, for instance, Ramiro II of León in 940 gave a cross of gilded brass to the monastery of Santiago de Peñalba, now preserved in the Museo de León, clearly an impoverished copy of the Cross of the Angels.[31]

25 André Grabar, 'La precieuse croix de la Lavra Saint-Athanase au Mont-Athos', *Cahiers Archéologiques*, 19 (1969), 99–125. **26** Schlunk, 'The crosses of Oviedo', 99–101; Schlunk and Elbern, *Estudios sobre la orfebrería del Reino de Asturias*, pp 69–75. **27** For detailed discussion of an Anglo-Saxon cross decorated with five rivets to represent the five wounds of Christ, see Neuman de Vegvar, this volume. **28** Victor H. Elbern, 'Die Tria Genera Animantium am Lebensbrunnen', *Fructus Operis*, I, pp 77–95; idem, 'Ein fränkisches Reliquiarfragment in Oviedo, die Engerer Burse in Berlin und ihr Umkreis', ibid., pp 157–88. **29** Elbern, 'Ein fränkisches Reliquiarfragment'; Carlos Cid Priego, *La Cruz de la Victoria y las joyas prerrománicas de la Cámara Santa* (Oviedo, 1997), pp 60–3. **30** Diego Santos, *Inscripciones medievales de Asturias*, pp 60–1. **31** Grau Lobo, 'Cruz de Santiago de Peñalba' in García de Castro (ed.), *Signum salutis*, pp 166–9

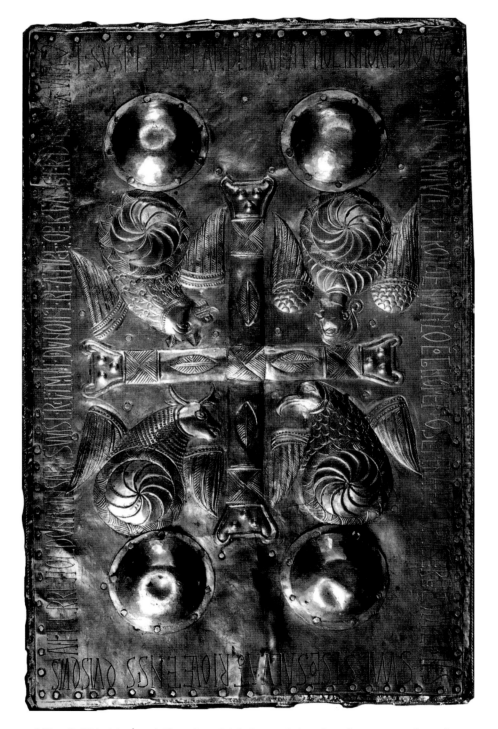

5.6 So-called 'Caja de las Ágatas', Cámara Santa, Oviedo. Cross on the base plaque (image courtesy of Deutsches Archäologisches Institut, Abteilung Madrid, neg. A479, Peter Witte).

5.7 Santo Adriano de Tuñón, Asturias. Painted cross on the south wall of the chancel (photograph by the author).

Both types, the type inherited from the Visigoths and that which Alfonso II created, achieve a similar dissemination, and are found on commemorative plaques, mural paintings, inscriptions and the lintels of many of the buildings patronized by the aristocracy of Asturias-León. Thus, under Alfonso III (866–910), the church of the royal foundation of Santo Adriano de Tuñón (consecrated in 891) has, on the south wall of the central chapel, a red cross with a shaft, the flared arms of which terminate in volutes (fig. 5.7).[32] San Salvador de Valdediós (consecrated in 893) has three painted crosses on the internal east wall of the chancel, and also on the wall of the first-floor Galilee chapel. The central one is a gemmed Greek cross with central medallion, gilded, with an A and Ω hanging from its arms, and stylized flames, while those on either side are red Latin crosses, plain, with forked arms (pl. 7). On the exterior, a cruciform plaque bearing a Latin cross of forked arms, with dangling apocalyptic letters, and flames, dominates the western façade at exactly the same height as the crosses of the interior gallery.[33]

Plaques with a similar form and function to that of Valdediós, but decontextualized, survive in considerable numbers from all the territories that formed the kingdom of Asturias. The example of Valdediós, and the above-mentioned cross of the Foncalada above the arch of the aedicule, allow an understanding of their original context: they are apotropaic signs, located above entrances and openings in all types of buildings. For instance, two foundation plaques from the

32 Schlunk and Berenguer, *La pintura mural asturiana de los siglos IX y X*, pl. 32; Lorenzo Arias Páramo, *La pintura mural en el Reino de Asturias en los siglos IX y X* (Gijón, 1999), pp 164–5.
33 Schlunk and Berenguer, *La pintura mural asturiana de los siglos IX y X*, pls 34, 35, 37; Arias Páramo, *La pintura mural en el Reino de Asturias en los siglos IX y X*, pp 144, 156.

5.8 Castle of Oviedo. Foundational inscription, kept at the Archaeological Museum of Asturias (photograph by the author).

fortress erected in Oviedo by Alfonso III in the year 875 remain, one of which bears the same inscription as the metalwork crosses (fig. 5.8).[34] Further to this, we must note the inscription of the altar slab from Santa María de Leorio, Gijón (1051):[35]

CRUCIS ALME / FERO SIGNUM / FUGIE DEMON. / ERA LXXXVIIII

I bear the sign of the life-giving cross. Flee, Demon! In the year 1089 of the era (AD1051).

A variation on the iconography of the cross, consisting of the creation of a cruciform pattern in the openwork sculpture of stone lattices for windows or other opes, is found in a piece from San Martín del Mar, Villaviciosa, perhaps of ninth-

34 Diego Santos, *Inscripciones medievales de Asturias*, pp 103–5; García de Castro Valdés, *Arqueología cristiana de la Alta Edad Media en Asturias* (Oviedo, 1995), pp 88–9; 121–2. **35** Diego Santos, *Inscripciones medievales de Asturias*, pp 199–200; García de Castro Valdés, *Arqueología Cristiana*, pp 144–5.

century date, and in the lattices of the chancel arch of Santa Cristina de Lena (post-848–late ninth century).[36] Since this lattice was intended to frame the illumination of the altar by the setting sun, as symbolic anticipation of the *parousia* or Second Coming of a triumphant Christ in majesty at the end of time, it indeed makes manifest the cross of light, the very sign of Christ, as a purely luminous visualization (*staurós photoeidés*).[37] Here we find materialized the early medieval Christological formula, expressed verbally in phrases such as: PAX, LUX, LEX, REX, uniting the attributes of Christ – peace, light, law, kingship – with his ultimate symbol, the cross.[38]

As seen above, the cross is strikingly present as insignia, sign and iconographic motif in the kingdom of Asturias from its very foundation. We know the origin of the texts that accompany its image. The phrase HOC SIGNO TVETVR PIVS HOC SIGNO VINCITVR INIMICVS is an Asturian composition, and appears to be inspired by the text of Constantine's vision on the eve of the Battle of the Milvian Bridge in 312, as described by Lactantius and Eusebius. However, the second part of the couplet alludes to that most dire enemy of the Christian, Satan, which suggests that it was composed very much later than the fourth century. It most probably dates no earlier than the seventh century, and may derive from a monastic milieu, where the influence of the Evil One was a strong preoccupation.

The second phrase associated with the cross, *SIGNVM SALVTIS PONE DOMINE IN … VT NON PERMITTAS INTROIRE ANGELVM PERCVTIENTEM*, is a direct quotation from an antiphon of the Hispanic liturgy.[39] This was intoned twice: first in the *Ordo quando sal ante altare ponitur antequam exorcizetur*;[40] and second in the *Responsurias de letanías de clade dicendi*, in the *Officium de una virgine*.[41] The context of these words is clear: it entails confrontation with evil, whether in the ceremony of exorcism, or in the recitation of litanies invoking divine protection against plagues and catastrophes. The reference to the passage of the exterminating angel of Passover (Ex 12:23–4) reaffirms its apotropaic character, which can also be deduced from the placement of these inscribed plaques above windows and doors. It is also perfectly in accord with the habitual tendency of Spanish Christians, in their confrontation with Islam, to analyse and interpret both their history and their present situation in apposition with the most significant features of the *historia salutis* of the people of Israel.

36 García de Castro Valdés, *Arqueología Cristiana*, pp 269, 260–1. 37 Ernst Hartwig Kantorowicz, 'The king's advent and the enigmatic panels in the doors of Santa Sabina', *Art Bulletin*, 26 (1944), 207–31 at 224. 38 Bernhard Bischoff, 'Kreuz und Buch im Frühmittelalter und in den ersten Jahrhunderten der spanischen Reconquista' in *Bibliotheca docet: Festgabe für Carl Wehmer* (Amsterdam, 1963), pp 19–34. 39 For detailed discussion of the depiction of the cross in the Hispanic liturgy for Good Friday, see Van Tongeren, this volume. 40 *Liber Ordinum Episcopal (Cod. Silos, Arch. Monástico, 4)*, ed. José Janini (Abadía de Silos, 1991), p. 77. 41 Louis Brou and José Vives, *Antifonario de la catedral de León* (Madrid and Barcelona, 1959), p. 427.

Finally, the third phrase, *CRUCIS ALME FERO SIGNUM: FUGIE DEMON*, is a direct citation of a verse of San Eugenio, bishop of Toledo during the seventh century, who wrote it as a phylactery or charm against demons in his sleeping quarters.[42] The presence of this charm on a Eucharistic item is due, no doubt, to fear of profanation.

The intensity of use, however, as well as the number of cross-related motifs appears to increase considerably during the reigns of Alfonso III and his Leonese descendents, from 866 to 951. To relate this apogee to the background of victorious martial confrontations with the Cordoban emirate, which characterized the political policies of Alfonso III (866–910), his son Ordoño II (914–24) and his grandson Ramiro II (931–51), can hardly be erroneous. Alfonso's reign coincided with a time of profound political and institutional weakness in the Andalusian emirate, under Muhammed I, Al Mundhir and Abdallah, a crisis that is known to scholarship as the first *fitna*. The victories of Valdejunquera and Polvoraria (878), and his triumphant expedition to the valley of the Guadiana, in the very heart of Al-Andalus (882), firmly established Alfonso III's supremacy among the various Hispanic powers. The peace he imposed on Córdoba allowed him to double the territorial expansion of his kingdom, and undertake a decisive work of administrative reorganization of it. For their part, Ordoño II and Ramiro II survived the attacks of the first caliph, Abd-al-Rahman III, once the serious crisis of the *fitna* was over. This resistance culminated in the victory of Simancas (939), which resonated on a European scale, and led to the donation, in thanksgiving, of the Cross of Santiago de Peñalba mentioned above. Contemporary chronicles from Oviedo – above all the so-called *Crónica Albeldense* (ch. 17, §43), which concludes in 883 – exude optimism in the joint face of eschatological hopes, and longing for the definitive expulsion of the Muslim enemy.[43] The motif of the Cross of the Second Coming is thus revealed in this context as both the most efficacious accompaniment to war, and as a symbol of an anticipated and final victory:

> *Dehinc pretermitendo et numquam adiciendo nomina Ismaelitarum divina clementia indiferenter a nostris provintiis predictos trans maria expellat et regnum eorum a fidelibus Xpi possidendum perpetuum concedat. Amen.*

Next, passing over and never mentioning the names of the Ishmaelites, may divine mercy drive the aforementioned men without distinction from our provinces and across the seas, and grant their kingdom to be held forever by the Christian faithful.

42 *PL*, 87, pp 367–8. **43** Juan Gil Fernández, José Luís Moralejo and Juan Ignacio Ruiz de la Peña, *Crónicas Asturianas* (Oviedo, 1985), p. 182.

In the year with which the chronicle concludes, 883, this wish seemed close to realization, as indicated by the triumphant colophon of the *Codex Rotense* in which the chronicle is recorded:[44]

> *Quod etiam ipsi Sarrazeni quosdam prodigiis vel astrorum signis interitum suum adpropinquare predicunt et Gotorum regnum restaurari per hunc nostrum principem dicunt; etiam et multorum Xpianorum revelationibus atque ostensionibus hic princeps noster gloriosus domnus Adefonsus proximiori tempore in omni Spania predicetur regnaturus. Sicque protegente divina clementia inimicorum terminus quoddidie defecit et ecclesia Domini in maius et melius crescit. Et quantum perficit Xpi nominis dignitas, tantum inimicorum tabescit ludibriosa calamitas.*

Because even the Saracens themselves foretell by means of portents or the signs of the stars that their death is drawing near and they say that the kingdom of the Goths is being restored by this our prince. This prince, our glorious lord Adefonsus, is predicted by the revelations and prophecies of even many Christians also to be about to rule in the whole of Spain in a very short time. And so, with the protection of divine mercy, the end of the enemy approaches by the day and the church of God grows greater and better. And as much as the dignity of the name of Christ achieves, by so much does the laughable misfortune of the enemy grow worse.

Just so, furthermore, Alfonso III used the Cross of Oviedo as a motif to accompany his ex-libris, composed by a labyrinthine pattern in which can be read *Adefonsi principis librum*. Two manuscripts with Isidorian material survive from his private library (Escorial, P.I.7; Escorial, T.II.25).[45] This model proved seductive in later centuries, as evidenced by the series of manuscripts with this motif of the Cross of Oviedo that survive, from the Leonese bible of Juan and Vímara, of 920 (Archivo Catedral, MS 6)[46] to the *Beatus* of Fernando I and Sancha, the work of Facundus, 1047 (Madrid BN, Vitr. 14–2),[47] and including the Antiphonary of León Cathedral (MS 8),[48] commissioned by the Abbot Ikila in the first half of the tenth century, the *Beatus* of Valcavado, the work of Obeco, 970 (BU Valladolid, MS 1789),[49] the so-called *Códice Vigilano* from the monastery of Albelda of 976 (Escorial, d.I.2),[50]

44 Ibid., p. 188. **45** Manuel Cecilio Díaz y Díaz, *Códices visigóticos en la monarquía leonesa* (León, 1985), pp 305–6. **46** Díaz y Díaz, *Códices visigóticos en la monarquía leonesa*, pp 307–8; Carlos Cid Priego, *La Cruz de la Victoria y las joyas prerrománicas de la Cámara Santa* (Oviedo, 1997), p. 108. **47** Díaz y Díaz, *Códices visigóticos en la monarquía leonesa*, pp 328–32, 429–30; Cid Priego, *La Cruz de la Victoria*, p. 111. **48** Díaz y Díaz, *Códices visigóticos en la monarquía leonesa*, pp 308–9; Cid Priego, *La Cruz de la Victoria*, p. 94. **49** Díaz y Díaz, *Códices visigóticos en la monarquía leonesa*, pp 351–2; Cid Priego, *La Cruz de la Victoria*, p. 111. **50** Díaz y Díaz, *Libros y librerías en la Rioja altomedieval* (Logroño, 1991), pp 63–71; Soledad de Silva y Verástegui, *Iconografía del siglo X en el*

the *Liber Commicus* of the RAH (cód. 22),[51] the *Codex Aemilianensis* (Escorial, d.I.1), a copy of the Vigilano in San Millán de La Cogolla (994),[52] or the *Liber Scintillarum* of the RAH (cód. 26).[53]

No doubt owing to this aristocratic usage, such Asturian cross types were widely employed on tomb-slabs, stellae, sarcophagi and in other funerary objects. All of these bear witness to a developing Christianization in the northern lands of the Iberian Peninsula, which advanced in tandem with the consolidation of institutional ecclesiastical structures. There had been some Christianization here prior to the eighth century, but evidence is merely testimonial, and Christian presence appears to have been slight. Thus, the expanding distribution of the sign of the cross indicates, depending on its context, both an ideological agenda and a growing sense of social ownership in the cross. At the same time, the complexity of the symbolism of the great gemmed Asturian crosses constitutes the most solid evidence of the intellectual heights reached in the kingdom. Thus, these bear witness to the joint creative capacity of its thinkers and artists, and to their fruitful exploitation by the Asturian rulers.

The absence of representations of the crucified Christ is a characteristic common to the artistic production of all the political entities in the Iberian Peninsula during the early Middle Ages. The rich tradition of reflection on the Passion of Christ that impregnates contemporary Carolingian literature, from Alcuin of York to John Scottus Eriugena, finds no reflection in iconography south of the Pyrenees, either among free Christians, or those subject to Islamic rule.[54] Various factors have been cited to explain this peculiarity. Firstly, there is the supposed aniconic Hispanic tradition, which is first manifested in Canon XXXVI of the Council of Iliberris-Elvira of 306 (*Ne picturis in ecclesia fiant. Placuit picturas in ecclesia esse non debere; nec quod colitur et adoratur, in parietibus depingatur*).[55] However, its strict observance is belied by the documented evidence of figurative sculpture in Visigothic and early medieval churches. Also cited is the supposed influence of Spanish monks,[56] but this is utterly contradicted by the alignment of Eastern monasticism against iconoclasm during the Byzantine controversy on the cult of images. There are also those who have seen in this supposed aniconicism a reflection of orthodox Christianity in the face of the hypothetical doctrinal deviation known as Adoptionism.[57] But, given the lack of any official condemnation of this Toledan doctrine in the Asturian sources, there are no objective grounds in

reino de Pamplona-Nájera (Pamplona, 1984), pl. XII. **51** Díaz y Díaz, *Libros y librerías*, pp 183–6; Cid Priego, *La Cruz de la Victoria*, p. 111. **52** Díaz y Díaz, *Libros y librerías*, pp 155–62; Silva y Verástegui, *Iconografía del siglo X en el reino de Pamplona-Nájera*, pl. XIII. **53** Díaz y Díaz, *Libros y librerías*, pp 218–20; Cid Priego, *La Cruz de la Victoria*, p. 111. **54** For detailed discussion of the depiction of Christ on the cross in Eriugena's poetry, see Hawtree, this volume. **55** Gonzalo Martínez Díez and Félix Rodríguez, *La Colección Canónica Hispana, IV. Concilios galos. Concilios hispanos, primera parte* (Madrid, 1984), p. 253. **56** Bango Torviso, 'L'Ordo gothorum et sa survivance'. **57** Jerrilynn Dodds, 'Las pinturas de Santullano: Arte, diplomacia y herejía', *Goya*, 191

favour of an anti-Adoptionist hypothesis as an explanation for the lack of figurative imagery in Asturias at the end of the eighth and beginning of the ninth century.

It is surprising that a liturgy so theologically inclined to emphasize the Incarnation of the Word as was the Hispanic should not have contributed to the development of an iconography of the Incarnation. This paradox does require some explanation. The theological–liturgical insistence on the material reality of the Incarnation of the Word is easily understood once we take into account that until the Third Council of Toledo in 589, the official theology of the kingdom of Toledo was Arian. This Council, however, saw the proclamation of Recaredo's conversion to the Roman faith, and the subsequent abjuration of Arianism.[58] As such, it is even more paradoxical that representations showing the *vera humanitas Christi*, manifested most clearly in his Passion, should be lacking. Among the liturgical sources related to the cult of the cross, of particular interest is the *Ordo quando rex cum exercitu ad prelium egreditur* (*Liber Ordinum Episcopalis*, ch. 48),[59] of disputed date, but certainly in use during the ninth century. This describes a ceremony performed on the eve of battle, during which a gold cross with a relic of the *lignum crucis* (the wood of the True Cross) is surrendered to the king, while the final blessing delivered by the bishop condenses a compendium of ideas illustrative of the iconological content of the *signum crucis*:

> *Signum salutaris clavi et ligni, quod devotis manibus sacre princeps suscepisti, sit tibi ad tutelam salutis et incrementum perpetue benedictionis. Egressum tuum in pace directurum excipiat, et per viam tuis exercitibus crux christi semper adsistat. Religiosa vobis consilia referat, et fortia bellicae promptionis preparet instrumenta. Lignum quoque hoc, per quod christus spoliavit principatus et potestates triumphans eos in semedipso, cum fiducia efficiatur vobis ad singularis glorie victoriam propugnandam. Amen. Ut per victoriam sancte crucis et ceptum ab hinc iter feliciter peragatis, et florentes ad nos triumphorum vestrorum titulos reportetis. Amen.*

Of equal importance is the *Benedictio crucis*, the text of which is preserved in the same *Liber Ordinum* (ch. 58, §303):[60] *Christe domine ... consecra tibi munus hoc famuli tui tropheo scilicet victorie tue, redemtionis nostre. Accipe hoc signum crucis insuperabile, quo ex diaboli exinanita potestas est, et mortalium restituta libertas* The rubric is punctuated by: *Si crux tantum simplex est, usque hic legitur hec oratio. Si autem cum ornato est, usque in finem legitur:*

(1995), 258–323. **58** Gonzalo Martínez Díez and Félix Rodríguez, *La Colección Canónica Hispana, V. Concilios hispanos, segunda parte* (Madrid, 1992), pp 49–73. **59** *Liber Ordinum Episcopal*, pp 146–8. **60** Ibid., pp 155–6.

Rutilet huius muneris auro ignitas sinceritas offerentium. In margaritis nitescat fidei candor. In lapidibus iaspidinis bone spei viror appareat. In iacintinis nitescat celestia, spiritalisque conversation demonstretur. Sic enim tota eius metalli qualitas spiritalium sacramentorum virtute ornetur, ut quod hic variatur generum specie multimoda offerentium proficiat ad salutem, et omnibus virtutibus bonis presenti in evo repleti, in eternum cum sanctis mansionem accipiant a deo patre omipotenti, et a te domine iesu christo simulque ab spiritu sancto.

The liturgy of Good Friday centred on the adoration of the *Lignum crucis – Ordo VIᵃ feria in Parascefen*, from the same *Liber Ordinum Episcopalis* (ch. 84),[61] includes the hymn *De ligno domini*, in which verses 85–102 contain yet another textual reference to the *signum salutis* of the Second Coming, to be recited during the adoration of the cross, as it was being kissed by each participant:[62]

I have seen the coming of the king [with] ranks of angels carrying before them the sign of the cross, performing the rites. Struck with terror, all the evils of the world fly away with a fearful cacophany. The sound of the heavenly trumpets will ring out so that … (ut). The earth gives up its dead. Christ the judge comes with the rays of the sun, the justice [ratio] of the returning king, Christ the Lord. The kingdom is being brought to the righteous, a punishment [is being brought] to sinners. Let the fostering cross protect us then and drive away [God's] anger.[63]

The meaning or sense of these compositions is grounded in the idea of the cross as a victorious instrument against evil, and protector of whoever should carry it, while also, and at the same time, presaging parousia. This explains the iconological insistence of the Spanish examples on the cross as sign, and the concomitant marginalization of any reference to the crucifixion.

This also serves to distance Spain from post-iconoclastic Byzantium, where the purely abstract gemmed cross of the West, derived in its materiality from the barbarian goldsmithing traditions, is nowhere to be found, with the exception of the Georgian crosses from Martvili, of the ninth–tenth centuries.[64] From the abundant examples preserved from the middle of the ninth century onwards, it is clear that its intercessory and apotropaic role, as an aid to *virtus* (saints, archangels,

61 Ibid., pp 179–80. **62** For detailed discussion of the liturgy of Good Friday, see Van Tongeren, this volume. **63** *Preferente signum crucis/Angelorum agmina/Cernui venturo regi/Prebentes obsequia/ Terrore concusa ruet/Cuncta mundi macina/Quum terribili clangore/Tubarum voz celitos/Sonuerit ut extinctos/Terra reddat mortuos/Reddituri rationem/Christo regi domino. Raddiis solis ad instar/ Christus iudex veniet/Conlaturus piis regnum/Inpiis supplicium/Crux nos tunc alma protegat/Et ab ira eruat.* Translated by Richard Hawtree. **64** Chalva Aminarachvili, *L'Art des ciseleurs géorgiens* (Paris, 1971), pp 50–8; Leila Zaalovna Khuskibadze, *Medieval cloisonné enamels at the Georgian State Museum of Fine Arts* (Tbilisi, 1984), p. 29.

déesis), predominates – and not the allusive and abstract character that it takes on in the West – and is emphasized by its accumulation of gemstones.[65]

The first appearance of the crucifixion in the Iberian Peninsula is found in the codex of the *Explanatio in Apocalypsin* of Beatus of Liébana of 975 (now in the cathedral of Girona), the work of Emeterio and Ende, illuminators from the monastery of San Salvador de Tábara, in the kingdom of León.[66] Also from this period, or perhaps from the early years of the eleventh century, are the reliefs in the church of San Miguel de Villatuerta (Navarre), which include a crucifixion showing Christ crowned.[67] These are isolated examples, which indeed confirm the estrangement of Spanish iconographic traditions from crucifixion iconography.

The transition towards a receptive attitude to other models of cross iconography can be traced to manuscripts from Rioja, which date to the end of the tenth century. Thus the image of the *Maiestas Agni* from the *Codex Aemilianensis* of the RAH[68] anticipates the iconography of the exaltation of the haloed Lamb, inserted in a mandorla in the centre of the cross, accompanied by the apocalpytic letters and the instruments of the Passion: lance and hyssop rod, with the cup of gall and vinegar, flanking a processional cross. For its part, the RAH *Liber Scintillarum*'s incorporation of the figures of Ss John and Mary, traced by a later hand in a simple outline over the depiction of the Cross of Oviedo, sheds light on knowledge of traditional iconographic types of the Calvary.[69]

It was only with the accession to the Castillian throne of Fernando I (1037–65), however, son of Sancho III of Navarre (1000–35), that any true Europeanization of the iconography of the Iberian Peninsula commenced. Under his patronage, the extraordinary ivory crucifix from San Isidoro de León (now kept in the National Archaeological Museum, Madrid), dated c.1063, was created,[70] followed at the end of the eleventh century by the cross of Carrizo de La Ribera (now in the Museo de León).[71] In fact, the rupture with tradition was far from definitive, as is shown by the depiction of the Cross of Oviedo in the *Beatus* commissioned by both monarchs, with the significant presence of the Lamb at its foot, grasping it, which gives the image a redemptive content that is related to the Passion and absolutely alien to the original type. The motif had already appeared in the *Codex Aemilianensis* (994), although it is lacking in the *Vigilanus* (976), of which this is a copy.[72] From this it may be deduced that it is exactly in the transition between these two works that this iconographic innovation was produced.

65 John Cotsonis, *Byzantine figural processional crosses* (Washington, DC, 1994), pp 46–54; García de Castro Valdés, 'Génesis y tipología de la cruz gemada en Occidente', pp 371–400 at pp 391–2, 396. **66** John Williams, *La miniatura española en la Alta Edad Media* (Madrid, 1987), p. 29. **67** Soledad de Silva y Verástegui, *Iconografía del siglo X en el reino de Pamplona-Nájera* (Pamplona, 1984), pl. 27. **68** Silva y Verástegui, *Iconografía del siglo X en el reino de Pamplona-Nájera*, pl. 7. **69** Silva y Verástegui, *Iconografía del siglo X en el reino de Pamplona-Nájera*, p. 150; Cid Priego, *La Cruz de la Victoria*, p. 111. **70** Ángela Franco, 'Cruz de Fernando I y Sancha, León' in García de Castro (ed.), *Signum salutis*, pp 275–9. **71** Luis Grau Lobo, *Museo de León: Guía* (León, 2007), pp 130–3. **72** Silva y Verástegui, *Iconografía del siglo X en el reino de Pamplona-Nájera*, pls 13, 12.

Christ on the cross and Eriugena's *Carmina* for Charles the Bald

RICHARD HAWTREE

This essay examines early medieval Irish attitudes to Christ's crucified body by looking at the writings of the ninth-century philosopher John Scottus Eriugena. Although Eriugena flourished at the court of Charles the Bald in Carolingian Francia, his strikingly original synthesis of both Eastern and Western Christian thought on a range of subjects from the dignity of man to predestination constitutes a European-wide turning-point in medieval approaches to both body and spirit. Eriugena presents his philosophical speculations most fully in his vast production entitled *Periphyseon*.[1] This work affirms humanity's potential to return to the Godhead. Just as at the Incarnation God became man, Eriugena follows Augustine in contending that man can become like God. The mystery of Christ's cross is central to such a process. This elaborate schema, so expansively developed in the *Periphyseon*, finds concise expression in the poems (*Carmina*) that Eriugena composed for the Carolingian monarch Charles the Bald.[2] In these often short verses, Christ's cross emerges as a fundamental structural device through which Eriugena addresses the paradoxical relationship between earthly power and divine sovereignty.

JOHN SCOTTUS ERIUGENA AND THE WESTERN ANTI-SPECULATIVE TRADITION

Anglo-Saxon England and Carolingian Francia, two cultures with close contacts to Ireland in the half-century before and after AD800, produced poetry that places

1 On the *Periphyseon*, see John J. O'Meara, *Eriugena* (Oxford, 1988), pp 80–154. Close philosophical analysis is found in Dermot Moran, *The philosophy of John Scottus Eriugena: a study of idealism in the Middle Ages* (Cambridge, 1989). **2** The *Carmina* were edited by Ludwig Traube in

the body of Christ upon the wood of the cross.[3] Literature and theology combine strikingly in lines that are deceptively simple from the Northumbrian Ruthwell Cross: 'Christ was on the cross' (*[+]Crist wæs on rodi*).[4] This combination of Christ and the cross is not presented in abstract terms, but is shown to be a fruitful conjunction that demands an audience: 'Yet eager nobles came there from afar to that one [Christ]' (*Hwepræ þer fusæ fearran kwomu/æþþilæ til anum*).[5] These lines, recalling the journey of the Magi, emphasize the uniqueness of the crucifixion as the fulfilment of the divine plan inaugurated at the Incarnation, while simultaneously advocating Christ's heroic status. One of the most important distinctions between the Ruthwell *tituli* and the Vercelli Book text of the *Dream of the Rood* to which it is clearly related is to be found in Ruthwell's insistence on the public character of Christ's sacrifice. Christ suffers 'valiantly before all men' (*[m]odig f[ore allæ] men*).[6] The Ruthwell runic inscriptions place Christ on the cross between heaven and earth, at once 'powerful king,/Lord of heaven' (*riicnæ Kyninc,/heafunæs Hlafard*)[7] and a mortal man, 'exhausted' (*limwoerignæ*).[8]

The Carolingian scholar Hrabanus Maurus' (776/84–856) poem '*Versus isti sunt scripti in ara capellae*' (Poem LXXX.XI, 'Verses inscribed on a chapel altar') is composed in the same tradition. The crucifixion is understood as a moment when God is powerfully revealed, as a theophany:

> Thus with arms outstretched he embraces the whole world;
> Christ transfixed on the cross, God in the heavens.
> He has destroyed death, he has broken the sceptre of the tyrant,
> he himself has restored eternal rest to his own.[9]

Here, Christ's outstretched arms span, and by so doing close, the theological distance between Christ's human suffering *in cruce* and God's heavenly reign *in arce*, between God the Father and God the Son.

The Ruthwell runic *tituli* and the poems of Hrabanus suggest that in the eighth and ninth centuries the image of Christ on the cross was emerging as an especially useful means of resolving those Christological debates that had troubled the West in the seventh century.[10] Irish scholars on the Continent were fully aware

MGH, Poetae latini aevi carolini, III.2 (Berlin, 1896), pp 518–56. The most recent edition is that of Michael Herren, ed. and trans., *Iohannis Scotti Eriugenae Carmina* (Dublin, 1993). All subsequent references to the *Carmina* use the text and translation in Herren's edition. **3** This is in notable contrast to much of the other material under discussion here. For discussion of an artefact from Anglo-Saxon England in which the body of Christ is absent, see Neuman de Vegvar, this volume. For presence in absence within a Hispanic context, see García de Castro Valdez, this volume. **4** *The Dream of the Rood*, ed. Michael Swanton (Exeter, 1987), p. 96, Ruthwell Text III. **5** Ibid., p. 96, Ruthwell Text III. **6** Ibid., p. 94, Ruthwell Text I. **7** Ibid., p. 94, Ruthwell Text II. **8** Ibid., p. 96, Ruthwell Text IV. **9** *Expansis manibus sic totum amplectitur orbem/ In cruce confixus Christus in arce Deus./ Extinxit mortem, confregit sceptra tyranni,/ Aeternam requiem reddidit ipse suis. MGH, Poetae latini aevi carolini, II*, ed. Ernst Dümmler (Berlin, 1882), p. 234. **10** The heresy of

of such Christological contentions, a fact perhaps wryly intimated in the Würzburg *Glosses on the Pauline Epistles*. Commenting on 1 Corinthians 1:18 'For the word of the cross, to those perishing is indeed foolishness' (*Verbum enim crucis, pereuntibus quidem stultitia es*t),[11] the Old Irish glossator notes 'it is not agreeable to them that the Lord was crucified, and it is foolishness' (*[…] .i. ní date leu incoimdiu dochrochad* et *isburbe*).[12] The next gloss declares 'it [the crucifixion] will be a great question, for one school will attack the other' (*.i. bid cuingid rochuingid argebaid inscol foraréli*).[13] In a third gloss, Paul's argument is summarized as follows: 'that which men could not do by their wisdom, he could do it by his cross' (*.i. aní nad comnactar dóini trianecne cotánic som triachroich …*).[14] The fears expressed by these Irish scholars recall the writings of Columbanus, who was anxious to emphasize Irish orthodoxy. In his fifth epistle, composed in 613, Columbanus wrote to the papacy:

> … we, in respect of the unity of the person, in whom it pleased the fullness of deity to reside bodily, believe in one Christ, his divinity and humanity, since he who descended is himself he who ascended above every heaven that he might fill all things if anyone should think otherwise concerning the incarnation of the Lord, [he] is an enemy of [the] faith …[15]

Likewise, in 'Instructio I' (*De Fide*), Columbanus advocates the primacy of faith:

> Therefore let no man venture to seek out the unsearchable things of God, the nature, mode and cause of his existence. These are unspeakable, undiscoverable, unsearchable; only believe in simplicity and yet with firmness, that God is and shall be even as he has been, since God is immutable.[16]

Columbanus shared this anti-speculative position with Gregory the Great and the approach surfaces occasionally in Insular texts; the *Collectanea pseudo-Bedae* selects passages from Gregory's homilies:

Monotheletism was a particular problem. On the Monothelete crisis of 649–57, see Éamonn Ó Carragáin, *Ritual and the rood: liturgical images and the Old English poems of the Dream of the Rood tradition* (London and Toronto, 2005), p. 225. As late as the eighth century, the heresy of Adoptionism flourished briefly in the Iberian Peninsula: see García Castro de Valdez, this volume. **11** 'Epistola ad Corinthios I' in *Thesaurus Paleohibernicus*, ed. and trans., John Strachan and Whitley Stokes (2 vols, Cambridge, 1901; repr. Dublin, 1975), ii, p. 545, no. 18. All references are to this edition. **12** No. 6, p. 545. **13** No. 7, p. 545. **14** No. 14, p. 545. **15** *Nam nos pro unitate personae, in qua complacuit* **plenitudinem divinitatis inhabitare corporaliter**, *unum Christum credimus, divinitatem eius et humanitatem, quia* **qui descendit ipse est, qui ascendit super omnes caelos, ut adimpleret omnia**. *Si quis aliter de incarnatione Domini senserit, hostis est fidei […]*. Ibid., p. 52, ll 10–14 and p. 53. **16** *Nullus itaque praesumat quaerere investigabilia Dei, quid fuit, quomodo fuit, quo fuit. Haec sunt ineffabilia, inscrutabilia, investigabilia; simpliciter tantum, tamen fortiter, crede quod sic est Deus et sic erit, quomodo fuit, quia inconvertibilis Deus est.* Ibid., p. 62, ll 33–7 and p. 63.

The mysteries of divine power which cannot be comprehended are not to be examined by the intellect, but to be venerated in faith. Explain, if you know how, the heavenly spheres, the turning-points of the earth, the abysses of the waters, where they end, and whence they are suspended. For we know that the world was created from nothing, and hangs suspended in nothing. But if there is something which is called nothing, then surely there is not nothing; if this nothing is nothing, the mass of the universe hangs suspended from nowhere, nor is there anywhere which is created as it is: how, therefore, can what we know to exist be nowhere?[17]

This Irish philosophical interest in the relationship between 'nothing' and 'something' recurs as late as the eighteenth century in George Berkeley's commonplace book: 'The mathematicians talk of what they call a point, this they say is not altogether nothing nor is it downright somthing [sic], now we Irish men are apt to think something and nothing near neighbours.'[18] In his essay 'Crazy John and the bishop', the literary theorist Terry Eagleton notes a kinship between George Berkeley and John Scottus Eriugena: 'For Berkeley, then, as much as for his great Irish philosophical predecessor John Scottus Eriugena, the sensible universe itself, as the expressive symbol of its creator's unsearchable depths, must itself finally elude all rigorous determination.'[19] Using the work of the theologian John Milbank, particularly *The word made strange*, Eagleton concludes that 'For both thinkers, what we call the world is a "self-referential labyrinth of signs" which can no more be closed off than the perpetual event of interpretation itself.'[20] Eriugena's elaborate synthesis of neoplatonic philosophical thought, as expressed fully in the *Periphyseon* and distilled in the *Carmina*, questions the traditional Western theological perspectives advocated by Gregory the Great and Columbanus. Eriugena, like Bishop Berkeley nine centuries later, is deeply concerned with notions of Being and Nothingness and, in addition, with presenting an image of the universe in all its labyrinthine glory. The moment when Christ was on the cross offers Eriugena unique opportunities to explore these philosophical questions. Yet not all early medieval Irish commentary was as conservative as the words of Columbanus or the Old Irish glosses on the Pauline Epistles might suggest. In

17 *Diuinae autem uirtutis mysteria quae comprehendi non possunt, non intellectu discutienda sunt, sed fide ueneranda. Dic ergo si nosti gyros coeli, terrae cardines, aquarum abyssos, ubi finiuntur, ubi suspensi sunt? Scimus autem quod ex nihilo factum sit, pendeat in nihilo. Sed si est aliquid, quod dicitur nihilum, iam nihil non est: si hoc nihil est nihilum, nusquam mundi moles dependet, nec est ubi sit, quod creatum est ut sit: quomodo ergo nusquam est, quod nouimus quia est?* Collectanea Pseudo-Bedae, ed. Martha Bayless and Michael Lapidge (Dublin, 1998), p. 160, §290. This text is a cento based on Gregory's Homilies on Ezekiel: *In Ezech.* II, *Hom.* VIII.10, VIII.9, X.20 (*CCSL* 142, pp 343–44, 395). See Bayless and Lapidge, *Collectanea*, p. 161. 18 George Berkeley, *Philosophical commentaries* (London, 1944), p. 124. 19 See Terry Eagleton, *Crazy John and the bishop and other essays on Irish culture* (Cork, 1998), p. 19. 20 Ibid., p. 19. Eagleton here quotes from John Milbank, *The word made*

'The resurrection of the world', John Carey analyses the late ninth-century text *In tenga bithnua* ('The ever-new tongue') in relation to Eriugena's ideas.[21] Carey makes a strong case for viewing Eriugena in the context of vernacular Irish texts:

> It has usually been held that Eriugena owed his erudition, as well as the ideas on which he based his philosophy, not to sources available in Ireland, but to the intellectual opportunities which he found awaiting him on the Continent. But this is no longer the only perspective available. As progress in our understanding of the language has enabled specialists to decipher more and more of the puzzles of Old Irish literature, it has repeatedly been shown that behind the unfamiliar imagery and arcane diction of the early texts may lie broad learning, subtle reasoning, and spiritual profundity.[22]

In this project, Carey responds to the plea of Dermot Moran for a more comparative textual approach to the problems of Eriugena's philosophy:

> I am not talking here about the distinguishing features of the Celtic church, its date for Easter, or the shape of the tonsure and such like; rather I am suggesting that the categories of sainthood and deification (*theosis*) be compared, or the Greek contemplation (*theoria*) with the imaginative visions (*fís*) of Irish literature … [E]riugena's commentary on the scriptures should be compared with surviving Irish commentaries.[23]

ERIUGENA AND CHRIST'S CRUCIFIED BODY

Throughout his writings, Eriugena puts forward an exalted conception of the human body. In *Periphyseon*, Book IV, he declares 'Thus, just as Divine Essence is infinite, so human substance, made in its image, is bounded by no definite limit' (*Itaque sicut diuina essentia ad cuius imaginem facta est infinita est, ita illa humana substitutio nullo certo fine terminatur*).[24] The potential of the human mind is therefore uncircumscribed and this idea leads Eriugena to develop his concept of

strange (Oxford, 1997), p. 101. **21** John Carey, *A single ray of the sun: religious speculation in early Ireland. Three essays* (Andover and Aberystwyth, 1999), pp 75–106. **22** Ibid., p. 81. **23** Dermot Moran, 'Nature, man and God in the philosophy of John Scottus Eriugena' in Richard Kearney (ed.), *The Irish mind: exploring intellectual traditions* (Dublin, 1985), pp 91–106 at p. 94. **24** In quoting both text and translation from Eriugena's *Periphyseon*, I have consulted the following editions: *Iohannis Scotti Eriugenae Periphyseon*, ed. and trans. Inglis Patrick Sheldon-Williams (3 vols (covering Books I–III), Dublin, 1968, 1972, 1981); *Iohannis Scotti Eriugenae Periphyseon (De Divisione Naturae) Liber Quartus*, ed. Edouard Jeauneau (with assistance from Mark A. Zier) and trans. John J. O'Meara and Inglis Patrick Sheldon-Williams (Dublin, 1995); *PL*, 122. For clarity in translation, I have frequently used *John the Scot: Periphyseon: On the division of nature*, trans. Myra L. Uhlfelder and J. Potter (Indianapolis, IN, 1976). For the above quotation, the Latin text is from Jeauneau, *Periphyseon*,

deificatio, the process by which the human intellect attains full union with God.[25] In *Periphyseon*, Book II, Eriugena declares that the human body is created by the mind: 'For (the mind) is made from God in the image of God out of nothing, but the body it creates (itself), though not out of nothing but out of something'.[26]

Eriugena follows Maximus Confessor in asserting the wondrous supremacy of human nature:

> In man every creature visible and invisible has been created and so he is called the 'workshop of all things', since in him all things after God are contained. Hence he is also customarily called the mean, since, consisting of body and soul, he comprehends within himself and collects into a unity the extremes, namely the spiritual and the corporeal, which are far distant from each other.[27]

If the human body can attain to such dignity, it follows that the body of Christ must represent corporeal form in all of its perfection:

> For indeed when the Word of God itself took on human nature, there was no created substance which he did not assume therein. And so by assuming human nature he assumed every created thing. And if in this way [the Word] has saved and restored that human nature which he assumed he has assuredly restored every creature visible and invisible.[28]

Carey adduces a parallel between this passage in Eriugena and the words of the celestial Philip in *In tenga bithnua*:

> With [Christ] the whole world rose again; for the nature of all creation was in the body which Jesus had put on. For if the Lord had not suffered for the sake of the race of Adam, and if he had not risen again after death, the whole world would be destroyed together with the race of Adam …[29]

p. 74, ll 12–13 and the translation is from Uhlfelder, *Periphyseon*, p. 244. **25** On *deification*, see the synthesis of Eriugena's thought in Dermot Moran's article 'Eriugena' in Thomas Duddy (ed.), *Dictionary of Irish philosophers* (Bristol, 2004), pp 119–26 at p. 124. **26** As translated by Moran in 'Nature, man and God', p. 103. In this discussion of Eriugena's views on the body, I build on the work of Moran, especially section IV of 'Nature, man and God', pp 101–5. **27** *In quo, videlicet homine, omnis creatura visibilis et invisibilis condita est. Ideoque* **officina omnium** *dicitur, quoniam in eo omnia, quae post deum sunt, continentur. Hinc etiam* **medietas** *solet appellari, extrema siquidem longeque a se distantia, spiritualia scilicet et corporalia, in se comprehendit et in unitatem colligit, corpore et anima consistens. PL*, 122, 893B–C; Uhlfelder, p. 295. **28** *Ipsum siquidem Dei Verbum, quando accepit humanam naturam, nullam creatam substantiam praetermisit, quam in ea non acceperit. Accipiens igitur humanam naturam, omnem creaturam accepit. Ac per hoc si humanam naturam, quam accepit, saluauit et restaurauit, omnem profecto creaturam uisibilem et inuisibilem restaurauit. PL*, 122, 912C. Cited by Carey, *A single ray of the sun*, p. 92. **29** *Asreracht in doman uile leis, uair ro bui*

Here we encounter an important early Irish approach to Christ's soteriological mission. If Christ had not suffered on the cross, the whole of creation would meet destruction. Both Eriugena and the author of *In tenga bithnua* assert that 'the nature of all creation was in the body which Jesus had put on'. By the same token, 'the nature of all creation' also hung with Christ upon the wood of the cross.

THE SIN OF EDEN, THE CROSS OF CHRIST AND ERIUGENA'S POEMS FOR CHARLES THE BALD

David Greene and Frank O'Connor write that 'The one thing that Irish poets did not do was to write dramatic lyrics in the air in the manner of Browning'.[30] Yet these famous lines about Eve clearly demonstrate that in their engagement with texts, the early medieval Irish were interested in listening to voices:

> I am Eve, great Adam's wife,
> because of me has Jesus died;
> it were I, thief of my children's heaven,
> by all rights were crucified.[31]

In a manner familiar to medieval readers from the exegesis of the psalter, Eve's voice declaring that she should suffer on the cross also encompasses the voice of Christ on the cross. This section explores some of the ways in which the *Carmina* of Eriugena, poems that frequently evoke the Passion, engage with the image of the *croch saithir*, the cross of travail.[32] It is this *croch saithir* that constitutes the elusive centre of the Old Irish lyric concerning Eve, a lyric that demonstrates how Irish vernacular tradition linked the sin of Eden with the cross of Christ.

Both Eriugena's *Periphyseon* and the *Carmina* for Charles the Bald show his awareness of a complex theory of textual study, especially the reading of the Bible, handed down by patristic writers. Both Eriugena and Maximus put forward an optimistic assessment of humankind's position within the hierarchy of creation. Although man's knowledge of his divine origin was obscured by the Fall, the Incarnation has restored human potential to be reunited with the Godhead. The central sin of mankind, which brought about the Fall, occurred because of a

aicnedh na ndula uile isin choluinn arroet Issu. Ar mani chesad in Coimdiu darceand sil Adhaimh, 7 mani eseirghedh iar mbas, dolegfaide in doman uile la sil nAdaim la tíchtain in bratho. In tenga bithnua was first edited by Whitley Stokes as 'The evernew tongue', *Ériu*, 2 (1905), 96–162 with the passage cited at pp 104–5. **30** David Greene and Frank O' Connor (eds), *A golden treasury of Irish verse* (London, 1967), p. 157. **31** *Mé Éba, ben Ádaim uill; mé ro-sáraig Ísu thall, mé ro-thall nem ar mo chloinn, cóir is mé do-chóid 'sa crann.* Text and translation in James Carney (ed.), *Medieval Irish lyrics* (Berkeley, CA, 1967), pp 72–3. **32** The phrase 'croch sa(it)hir' occurs in section 19 of *The tract on the Mass in the Stowe Missal*. This text is edited in *Thesaurus palaeohibernicus*, p. 255.

misreading of God's divine purpose. The close relationship between the biblical book of Genesis and the idea of reading itself is clearly brought out in Hymn V by Ephrem the Syrian:

> The lines were like a bridge
> For my eyes and my spirit
> To cross together,
> To enter together the story of Eden.
> As my eyes read,
> They transported my spirit across the bridge;
> my spirit in turn knew how to bring rest
> To my eyes, in their reading.
> For, as the book was being read,
> As my eyes rested, my spirit laboured.
> As I discovered both the bridge and the door to Paradise
> Within this book,
> I passed over and entered.[33]

Ephrem's desire to listen to the voice of God in his reading contrasts with the refusal of Adam and Eve to engage with that voice. Eriugena, like Ephrem, is especially concerned with the idea of listening to God's voice. In the *Periphyseon*, he explores the voice of God in Eden, while in the *Carmina*, Eriugena considers how his audience, and especially Charles the Bald himself, should apprehend the Word of God hanging from the cross.

Eriugena's use of Ambrose in Book IV of the *Periphyseon* forms part of a complex 'Genesis tradition', which understands the first book of the Bible as the model text expressing the actions of God in history.[34] Eriugena is discussing God's voice in the Garden of Eden and quotes from Ambrose's *De Paradiso* XIV:

> In what way does God speak? With a corporeal voice? Not so, but by that power which is greater than any possible voice of the body, and which pours forth oracles; the voice which the prophets have heard, the voice which the faithful hear, the voice which the impious do not understand.[35]

Eriugena uses Ambrose's conception of God's voice speaking through scripture to argue that the events of Genesis should be interpreted in an extra-temporal context:

33 Translation in Agnes Cunningham, *Prayer: personal and liturgical* (Wilmington, DE, 1985), pp 73–4. 34 On the Genesis tradition, see Thomas O'Loughlin, *Teachers and code-breakers: the Latin Genesis tradition, 430–800* (Turnhout, 1998). 35 *Quomodo loquitur deus? Nunquid uoce corporea?* **Non utique, sed uirtute quadam praestantiore, quam uox corporis potest, et fundit oracula.** *Hanc*

Paradise is not a localized or particular piece of woodland on earth, but a spiritual garden sown with the seeds of the virtues and planted in human nature, or, to be more explicit, is nothing else but the human substance itself, created in the image of God, in which the Tree of Life, that is the Word and wisdom of God gives fruit to all life.[36]

For Eriugena, God's *vox* in Eden is a manifestation of the divine Word. The interpretation of Genesis 3:8 ('And they heard the voice of God as he was walking towards evening') provides a framework for the reading of all events in scripture. Eriugena finds further nourishment in Ambrose's *De Paradiso*:

> For while sin boils up in the body … the sense of the transgressor does not think of God … does not hear him walking in the Holy Scriptures, [he] does not hear him walking in the minds of men.[37]

The relationship between the walk and the voice of God in Eden prompts reflection upon Eriugena's attitude to Christ's suffering on the cross. Eriugena believes that contemplation of the cross leads directly to apprehension of the Word of God. In *Carmen* 8 of the *Carmina*, Eriugena tells Charles: 'Know that Christ is the first principle of the universe: he is the Word, born of the Father's bosom, creating all things' (*Rerum principium primum cognoscite Christum: / Verbum cuncta creans natum de pectore patris*).[38]

This relationship between God's voice in the Garden of Eden and God's Word hanging on the cross exemplified in both the *Periphyseon* and in the *Carmina* is also central to an enriched understanding of the Insular cross. The Irish high cross was designed to promote an awareness of God 'walking' both in Scripture and in the 'minds of men'. In his *Carmen* 5, Eriugena specifically links the events of Eden to those on the cross. Man refuses to embrace the image of God:

> But man, refusing to embrace this remarkable image, fell, and dragged his offspring with him to the depths. Yet lest a divine image of such magnitude be lost forever, God began to assume the likeness of man. Thus born into the world, and suffering under the law of impious men, by his death he willingly destroyed my own. That God, through whom all things are, have life, have fixity and motion, died so that man himself might live.[39]

uocem eius prophetae audierunt, hanc uocem fideles audiunt, impii non intelligunt. Jeauneau, *Periphyseon*, pp 232, 233. **36** *Paradisum non localem terrenumue quendam locum esse nemorosum, sed … ipsam humanam substantiam ad imaginem dei factam, in qua lignum uitae … omnem fructificat uitam.* Ibid., pp 232, 233. **37** *Nam dum culpa feruet in corpore, … non cogitat deus sensus errantis, … non audit deum ambulantem in scripturis diuinis, ambulantem in mentibus singulorum.* Ibid., pp 230, 231. **38** Herren, pp 86, 87, ll 25–6. **39** *Hanc homo praeclaram speciem complectere nolens,/*

In this way, the Fall and the crucifixion both become aspects of the same unified Paschal mystery. Eriugena explores the implications of the 'Pascha' in *Carmen 3*. After explaining that the first 'Pasch' involved God's creation of the universe, he describes the second 'Pasch': 'But alas, wretched man was deceived by the woman and consort, who, unwitting, was ruined through the wiles of the snake' (*Eheu, sed miserum decepit femina coniunx, quam prius incautam perdidit astus ΟΦΙϹ*).[40] The exegetical purpose underlying Eriugena's *Carmina* on the cross is expressed powerfully later in the same poem. Eriugena reveals the manner in which Old Testament symbols prefigure the redemption accomplished by Christ: 'These were once the images of Christ who will come, in whom are manifest things that were long concealed' (*Haec quondam fuerant uenturi ΙΔΑΛΜΑΤΑ Christi, in quo conlucent, quae latuere diu*).[41]

The 'cross' poems of Eriugena provide a striking textual vantage-point from which to consider Irish attitudes to the representation of Christ on the cross. The link between Eriugena's *Carmina* and Irish high crosses was first explored by Hilary Richardson in the Festschrift for Ann Hamlin published in 2007.[42] Eriugena's writing in *Carmen 3* about the Eucharist is equally applicable to the increasingly elaborate high crosses of the ninth century and later:

> Now we solemnize the sacred symbols of these acts
> When things first known to the mind appear to the eyes,
> When the pious mind and heart can grasp the body of Christ,
> The flow of sacred blood, and the price of the world.[43]

In *Carmen 2*, Eriugena appears to be describing a high cross of Irish type:

> Behold the orb that shines with the rays of the sun,
> Which the cross of salvation spreads from its height,
> Embracing the earth, the sea, the winds and the sky
> And everything else believed to exist far away.[44]

Corruit et prolem traxit ad ima suam./ Sed ne tanta dei penitus transiret imago,/ Hanc speciem hominis coepit habere deus./ Hinc natus mundo, passus sub lege malorum,/ Morte sua mortem perdidit ipse meam./ Quo sunt, quo uiuunt, quo stant, quo cuncta mouentur, Ille deus moritur, uiuat ut ipse homo. Ibid., pp 76, 77, ll 15–22. **40** Ibid., pp 68, 69, ll 23–4. **41** Ibid., pp 70, 71, ll 45–6. **42** Hilary Richardson, 'Eriugena and Irish high crosses' in Marion Meek (ed.), *The modern traveller to our past: studies in honour of Ann Hamlin* (Belfast, 2007), pp 78–83. Some time earlier, in 1993, Michael Herren had lamented the neglect of these texts (Herren, p. 11). Richardson points out the relationships between some of Eriugena's ideas and scenes on Irish high crosses, including the Fall, the sacrifice of Isaac and the Last Judgment. For example, she relates Eriugena's description of the symbolism of the number '8', which associated the number with resurrection, to a panel of eight bosses on the east face of the Cross of the Scriptures at Clonmacnoise. **43** *Harum nunc rerum celebrantur symbola sacra,/ Dum parent oculis mentibus nota prius,/ Dum corpus Christi, dum sacri sanguinis undam,/ Et pretium mundi mens pia corde sapit.* Ibid., pp 70, 71, ll 61–4. **44** *Aspice*

Concerning the allegorical mode of interpretation, Eriugena continues: 'There is no difference of meaning in the acts I have mentioned, if one learns to love symbolic expression' (*Est quoque non dispar sensus praefatibus actis,/ Si quis ΣΥΜΒΟΛΙΚΑΣ discit amare notas*).[45]

Eriugena is frequently rejected as a source for Irish intellectual conditions. His work, especially that involving Greek, is often attributed exclusively to Continental influence. Yet here, in *Carmen* 2, we find him describing a wheel-head cross and summarizing those essential typological images that enrich so many Insular monuments. Moreover, Eriugena's poems on the cross were not primarily composed as spiritual meditations but were specifically directed towards the Carolingian monarch Charles the Bald.[46] Therefore, these literary texts, like the material monuments they complement, suggest a powerful connection, stretching in its implications back to Constantine, between the symbol of the cross and temporal as well as spiritual jurisdiction.

Eriugena's attitude to the crucifixion is fundamentally affective. In *Carmen* 1, we read:

> See the wood of the cross that embraces the four-cornered world: of his own accord did our Lord hang upon it. ... Behold the pierced palms, the shoulders and feet, the temples girt with the cruel wreath of thorns. From the midst of his side, the unlocked fount of salvation, flow living drafts of water and blood.[47]

This image of Christ crucified arises from both a distinguished Irish tradition of scriptural commentary and from Eriugena's exalted conception of the nobility of the human body.

As this essay has shown, Eriugena follows Maximus 'Confessor' in suggesting that man occupies the pinnacle of creation: 'For man ... was created with a nature of so high a status that there is no creature, whether visible or intelligible, that cannot be found in him.' (*Homo siquidem ... in tanta naturae conditae dignitate creatus est, ut nulla creatura, sive visibilis sive invisibilissit, sit quae in eo reperiri non posit*).[48] Dermot Moran summarizes the implications of these philosophical positions as follows: 'Eriugena thinks of all things as present in God's wisdom (the Son). It is a short step from this to seeing all things as present in the human mind

praeclarum radiis solaribus orbem,/ Quos crux saluiflua spargit ab arce sua./ Terram Neptunumque tenet flatusque polosque,/ Et siquid supra creditor esse procul. Ibid., p. 64, ll 1–4, p. 65. **45** Ibid., pp 64, 65, ll 32–3. **46** On Charles the Bald and his court, see Margaret T. Gibson and Janet L. Nelson (eds), *Charles the Bald: court and kingdom* (Aldershot, 1990); note also Janet L. Nelson, *Charles the Bald* (London, 1992). **47** *Ecce crucis lignum quadratum continet orbem,/ In quo pendebat sponte sua dominus... /... Aspice confossas palmas humerosque pedesque./ Spinarum serto tempora cincta fero./ In medio lateris, reserato fonte salutis,/ V(ital)es haustus, sanguis et unda, fluunt.* Herren, p. 58, ll 19–20, 23–6, p. 59. **48** *PL*, 122, 531A.

because Christ is, Eriugena says, the perfect man.'[49] Eriugena thus understands redemption as a movement from formlessness to perfect incorporation in the mystical unity of the Trinity. This idea is succinctly expressed at the beginning of *Periphyseon*, Book IV:

[T]he Father warms, the Son warms and the Holy Spirit warms (for with one and the same heat of love they cherish us and nourish us, and so lead us forth from the kind of formlessness of our imperfection, which was the result of the transgression of the first man, 'to the perfection of man when the era of Christ shall be fulfilled'. Now, the perfection of man is Christ, in whom all is consummated.[50]

Eriugena's presentation in his poems of both Christ on the cross and Christ in the Eucharist is reflected in a number of Irish texts, especially the 'Stowe Missal Mass Tract'. Section 19 declares:

19. … Let the particle of the host which you receive be reverenced as a portion of Christ upon the cross. Thus there must be in each one's life some cross of trouble or hardship, uniting him with the Lord's crucified body. No one should swallow down the host without tasting it.[51]

The more literal translation offered in the *Thesaurus Palaeohibernicus* reads:

This is what God deems worthy, the mind to be in the symbols of the Mass, and that this be thy mind: the portion of the host which thou receivest (to be) as it were a member of Christ from his cross, and that there may be a cross of labour [*croch sa(it)hir*] on each (in) his own course, because it unites to the crucified Body. It is not meet to swallow the particle without tasting it, as it is improper not to seek to bring savours into God's mysteries.[52]

This passage corresponds precisely to Eriugena's poetic evocation of the Eucharist in which the 'pious mind' may 'grasp the body of Christ'. The 'Mass Tract' places emphasis upon the affective response to the Passion ('savours' or 'feelings'). This is

49 Moran, 'Nature, man and God', p. 103. **50** *[c]alificat pater, calificat filius, calificat spiritus sanctus, quia uno eodemque caritatis aestu et nos fouent et nutriunt, ac ueluti ex informitate quadam imperfectionis nostrae post primi hominis lapsum, **in uirum perfectum, in plenitudinem aetatis Christi** educant. Vir autem perfectus est Christus, in quo omnia consummata sunt [...].* Jeauneau, *Periphyseon, Liber Quartus*, p. 4, ll 5–9 and p. 5. **51** 19. … *arafoemi din obli amail bith ball dicrist assachroich 7 arambe croch sa(it)hir for cach arith fein ore noenigether frisinchorp crochthe. Nitechte aslocod inparsa cenamlaissiuth amal nan coer cen saigith mlas hirruna de….* Thesaurus Palaeohibernicus, II, p. 255. The translation is supplied here from an article by Willibrord Godel (OSB) trans. from German into English by Patrick Rogers: 'Irish prayer in the early Middle Ages', *Milltown Studies*, 4 (1979), 60–99. **52** *Thesaurus Palaeohibernicus*, II, p. 255.

emphasized earlier in the 'Mass Tract', where the *fractio* is described with specific attention to Christ's body:

11. The Host on the paten (is) Christ's flesh on the tree of the cross.
12. The fraction on the paten is the breaking of Christ's body with nails on the cross.
13. The meeting wherewith the two halves meet after the fraction (is) a figure of the wholeness of Christ's body after his resurrection.[53]

This allegorization of the Mass in the Stowe Missal was comprehensively attacked by Willibrord Godel: '[it] concentrates … upon relatively insignificant details of ceremonial … the disproportionate emphasis upon ritual gestures like … the breaking of the host and its distribution … points towards an ossification of the cult'.[54] This attitude is misguided. Irish texts demonstrate an acute awareness of the physical 'breaking' of Christ's body on the cross. The aim of the 'Stowe Missal Mass Tract' is to strengthen the intellectual and spiritual connections between Christ's body on the cross and his *corpus* consumed in the Eucharistic mystery. It is a central characteristic of Eriugena's poetry of the cross that it moves directly from the contemplation of Christ's physical suffering to a profound reflection on the Mass. Eriugena's *Carmen* 3 declares that Christ was 'alone' in his suffering: 'He alone was the victor, having defeated the Prince of this World pouring out pure offerings of his own blood' (*Qui solus uictor, prostrato principe mundi, Sanguinis et proprii fundens libamina pura*).[55] Christ's lonely death here contrasts powerfully with the priests thronging Charles the Bald's churches: 'Throughout the long naves curtains are spread and drawn, holy priests around your altars cry out with joy' (*Cortinis patulis (et) longa per atria tentis Presbyteri sancti reboant altaria circum*).[56]

This affectivity is also found in the poems of Blathmac. Blathmac's lengthy poem on the life of Christ serves as a vernacular Irish counterpart to Eriugena's Latin verse. The moment of crucifixion is evoked at stanza 50:

When his cross was placed
Between the two crosses of the condemned ones
He was raised (alas!) upon the cross;
It was very pitiful.[57]

53 '11. *Indoblae forsinméis colind crist hi crann cruche.* 12. *Acombag forsinmeis corp crist do chombug cocloaib forsinchroich.* 13. *Incomrac conrecatar indalleth iarsinchombug figor ógé chuirp críst iarnesérgo.* Ibid., p. 253. **54** Rogers, 'Irish prayer in the early Middle Ages', 76. **55** Herren, p. 70, ll 47, 51, p. 71. **56** Ibid., p. 70, ll 71, 73, p. 71 **57** *Ó ro-suidiged a chroch eter di chroich na n-érthroch arrócbad iarum-moruar! – frisin crann-sin; ba rothruag.* James Carney (ed. and trans.), *The poems of Blathmac Son of Cú Brettan, together with the Irish Gospel of Thomas and a poem on the Virgin Mary*

From stanzas 120 onwards, Blathmac outlines his response:

> 120. I bitterly lament Christ being crucified …
> 121. Alas, for anyone who has seen the son of the living God
> Stretched fast on the cross!
> Alas, the body possessing wisest dignity
> That has plunged into gore![58]

These Irish parallels complement those spiritually affective attitudes explored in Eriugena's poems. Eriugena makes a very striking claim for the importance of the 'monumental' cross described in *Carmen* 2:

> The wave of your blood
> In which the altar of the cross is bathed,
> Purges, redeems, releases, leads us back to life
> And shows to your elect that they are Gods.[59]

In *Carmen* 9, Eriugena grapples with the central paradox of the 'croch saithir', the life-giving meaning of Christ's flesh hanging on the cross ('For life suffered with the flesh, which hung alone'; *Nam compassa fuit carni, quae sola pependit*, l. 16):

> The acumen of pure reason goes deeper
> And concludes that the flesh of life is life …
> Therefore the flesh of Christ is the most real life;
> By living and dying it consumed all death.[60]

In this formulation, contemplation of the cross allows the spectator to return to the Godlike state of Adam and Eve in Paradise before the Fall. When the cross is 'read' in a spiritual manner, God's 'flesh' on the cross is given new life: 'Your Lord is alive, he is here! See for yourself him whom you mourn!' (*Viuus adest dominus; quem gemis ipsa uide*).[61] In his *Carmina* for Charles the Bald, Eriugena uses conventional typology and imagery to create a striking textual presentation of Christ on the cross. In his *History of Western philosophy*, Bertrand Russell suggested that the Irish of the early Middle Ages were not interested in 'theological niceties'.[62]

(Dublin, 1964), pp 18, 19. **58** 120. *Monuar dam-sa Críst i croich* 121. *Mairg ad-chondairc mac Dé bí fricroich ina gloethrigi; dirsan corp ro-mesc hi crú, co n-ordun as ecnaidiu.* Ibid., p. 42. **59** *Sanguinis unda tui, qua madet ara crucis,/ Nos purgat, redimit, uitamque reducit,/ Electisque tuis praestitit esse deos.* Herren, p. 66, ll 58–60, p. 67. **60** *Altius ingreditur purae rationis acumen./ Et carnem uitae uitam sic colligit esse: … … ΣΑΡΞ igitur Christi substat uerissima uita, Viuens ac moriens mortem consumpserat omnem.* Herren, p. 90, ll 17–18, 23–4, p. 91. **61** Ibid., p. 66, *Carmen,* 2, l. 54. **62** Bertrand Russell, *History of Western philosophy* (London, 1946; repr. 2004), p. 375.

Eriugena, whose writings reflect such a powerful fusion of Irish and Carolingian traditions concerning the Passion, shows Russell's contention to be profoundly mistaken.

CONCLUDING REMARKS

Even when early medieval Irish texts seem at their most radical and daring, as when, for example, the communicant is asked to envision Christ's suffering body while receiving the host, the problem of heresy is rarely forgotten. The last sentence of the 'Stowe Missal Mass Tract' tells us not to get the host stuck under our back teeth: '(this) symbolizing that it is improper to dispute overmuch on God's mysteries, lest heresy should be increased thereby'.[63] Eriugena appears to have been less concerned about heresy. His great theological authority Maximus 'Confessor', despite championing the cause of orthodoxy against Monotheletism at the Lateran Council of 649, ultimately fell foul of his Byzantine masters, most probably losing his tongue and right hand in the process. In 1210 and 1225, Eriugena's work suffered papal condemnation and this attitude resurfaced again during the turmoil of the Counter-Reformation. Eriugena's masterly philosophical synthesis was misread as tending towards pantheism and in the seventeenth century the Vatican authorities were swift to place Thomas Gale's first printed edition on the Index of prohibited works.[64] Study of Eriugena was negatively affected by the prevalence of 'systematic' theology in the centuries that followed. His work did not fit neatly into scholastic categories. O'Loughlin notes that 'to generations of clerical scholars raised in this debased scholasticism … there was no theology from Ireland and even Eriugena did not count as he did not leave a position with his name attached to it to be either cited or attacked'.[65] Despite the spectre of heresy in the early modern period and comparative neglect in the face of the resurgent Thomism of the twentieth century, Eriugena's system presents a powerful and profoundly optimistic vision of Christ's saving work in the world. Christ's suffering on the cross is central to this divine mission. The shedding of Christ's blood on the cross is also fundamental to Eriugena's conception of the return of all Creation to unity with divinity. The relationship between the Passion and this return is strikingly expressed at the close of *Periphyseon*, Book V. Eriugena considers:

> [T]he general return of all human nature saved in Christ to the pristine state of its creation, and, as into a kind of Paradise, to the dignity of the divine

63 *Thesaurus Palaeohibernicus*, II, p. 255. **64** On Eriugena and heresy, see Moran, 'Nature, man and God', p. 93. **65** Thomas O'Loughlin, *Celtic theology: humanity, world and God in early Irish writings* (London, 2000), p. 204.

image by the merit of that One whose blood was shed for the salvation of all humanity in common.[66]

In this passage, Eriugena unites the 'Genesis tradition' explored in *Periphyseon*, Book IV, with the emphasis on Christ's suffering body that the reader encounters in his *Carmina* for Charles the Bald. Both of these strands in Eriugena's thought, the emphasis on Genesis and Christ's cross, are key aspects of early Irish Christian literature. Eriugena's texts seek neither a Carolingian nor an Irish audience; his words are directed to all created things.

66 *[i]n reditu generali totius humanae naturae in Christo salvatae in pristinum suae conditionis statum, ac veluti in quendam paradisum in divinae imaginis dignitatem, merito unius, cujus sanguis communiter pro salute totius humanitatis fusus est.* PL, 122, 1020B. Uhlfelder, *Periphyseon*, p. 357.

The liturgical cross and the space of the Passion: the diptych of Angers MS 24

BEATRICE KITZINGER

The gospel manuscript Angers, Bibliothèque Municipale, MS 24 contains one of the most dramatic images produced in northwestern France at the turn of the ninth to tenth centuries (pl. 9).[1] A Passion sequence in diptych form, running from crucifixion to entombment, appears before Matthew's text as the major pictorial component of the manuscript.[2] The Angers Passion could be defined and approached from multiple perspectives – as a collection of pictorial elements, as prefatory gospel illumination, as a painting in double registers and diptych format, as one of four surviving crucifixion images from gospel books attributed to the Breton region.[3] Although the painting has often been cited as the first occurrence of the Deposition in Western manuscripts, and mentioned in comparative studies for one element or another of its teeming iconography, the image as a whole has

1 Angers 24 is attributed to Brittany or the Loire Valley and dated to the late ninth or early tenth century. Its provenance is unknown. The manuscript measures 30.7 by 21cm (cut down), and contains the four Gospels with prologues, chapter lists and canon tables. The general prefaces are lost. For extended discussion of the manuscript, including its localization and dating, I refer the reader to my dissertation, 'Cross and book: late Carolingian Breton Gospel illumination and the Instrumental Cross' (PhD, Harvard, 2012). Essential bibliography on the manuscript appears in *La France romane au temps des premiers capétiens*, ed. Danielle Gaborit-Chopin (Paris, 2005), no. 8, p. 59. Matthias Exner integrated Angers 24 into his discussion of Carolingian crucifixion iconography in *Die Fresken der Krypta von St Maximin in Trier und ihre Stellung in der spätkarolingischen Wandmalerei* (Trier, 1989), favouring a tenth-century date. On the illumination of Breton gospel books, see, fundamentally, Geneviève Micheli, *L'Enluminure du haut moyen âge et les influences irlandaises* (Brussels, 1939), pp 96–100, 174, 187; Francis Wormald, *An early Breton Gospel book: a ninth-century manuscript from the collection of H.L. Bradfer-Lawrence*, ed. J.J.G. Alexander (Cambridge, 1977), p. 10, n. 3, p. 19, n. 3. 2 Angers 24 also contains canon tables (fos 1–5), one Evangelist portrait (Mark, fo. 41v), and several richly decorated initials. My thanks to Marc-Edouard Gautier for granting access to the manuscript and furnishing photographs. 3 Along with Oxford, Bodleian Library, MS Laud lat. 26; Troyes, Bibliothèque Municipale, MS 960; and

not to date been the focus of study.[4] I will begin here by discussing the painting as a picture, aiming to establish something of its complex content and system of argument before examining the role of the image as a part of its manuscript. Ultimately, the diptych must be understood as a component of Angers 24's presentation of the Gospels, defined by the combination of its pictorial content and its position within the gospel book.

The Angers diptych characterizes the Passion in four principal respects, running along a causal continuum. The crucifixion, deposition and entombment are, first and foremost, described as a sequence of historical events. Second, they represent the source of salvation. Third, Christ's death represents salvation partly because it is the wellspring of Ecclesia, the universal church. Finally, the Passion is the source of salvation through its heirs in the rites, signs and sacraments of the church in practice. Although distinguishable, these registers of interpretation are closely intertwined within the image; the diptych coordinates its content and composition to create a rich field of argument. At its core, this argument enacts the replacement of history by liturgy, demonstrating the origin, justification, and purpose of the church's work and instruments, building dynamic continuity between the spaces of Golgotha, church and gospel book. Movement between these spaces pivots on the cross, characterized as a sign endowed by the crucifixion with its mediating power. The relationship between cross-sign and codex expresses the centrality of the cross to the significance of the Gospel, and, in turn, the centrality of the cross-sign to the mediating apparatus of the church, of which the gospel *book* is part.[5] The theologies expressed by the Angers diptych hold few surprises in view of established early medieval crucifixion exegesis, particularly in the Augustinian tradition.[6] However, the Angers diptych stands apart in surviving early medieval Gospel illumination for its sophisticated construction and complex theological expression – embodied both in its content and its form.

Cambridge, Fitzwilliam Museum, MS 45–1980. **4** On elements of iconography in the Angers image, see Gertrud Schiller, *Ikonographie der christlichen Kunst*, II (Gütersloh, 1968), figs 390, 545, pp 124, 142, 177, 181; Walter Cook, 'The earliest painted panels of Catalonia (V)' and idem (VI), in *Art Bulletin*, 10 (1927–28), 153–204, 305–65 at 193–4, 325. **5** On the distinction between 'Gospel' and 'gospel book', see Thomas Lentes, '*Textus Evangelii*. Materialität und Inszenierung des 'Textes' in der Liturgie' in L. Kuchenbuch and U. Kleine (eds), *Textus im Mittelalter. Komponenten und Situationen des Wortgebrauchs im schriftsemantischen Feld* (Göttingen, 2006), pp 133–48. **6** On early medieval crucifixion theology, see Celia Chazelle, *The crucified God in the Carolingian era: theology and art of Christ's Passion* (Cambridge, 2001). See also, esp., Marie-Christine Sepière, *L'Image d'un dieu souffrant: aux origines du crucifix* (Paris, 1994); and Éamonn Ó Carragáin, *Ritual and the rood: liturgical images and the Old English poems of the Dream of the Rood tradition* (London and Toronto, 2005). As few indications internal to the manuscript guide a choice of sources, I have cited authors whose circulation throughout the Carolingian and Insular world (including Brittany) is well established. On Breton production of theological editions, see Julia Smith, *Province and empire: Brittany and the Carolingians* (Cambridge and New York, 1992), pp 169–74.

THE NARRATIVE COMPOSITION

The narrative detail of the Angers Passion sequence is matched in the Carolingian period only by the Metz school Passion ivory held at the Musée du Louvre (c.850–70). It is unparalleled within surviving manuscripts with gospel content before the Codex Egberti (c.985).[7] The left half of the diptych presents Golgotha in two registers with Longinus and Stephaton, Mary and John, and the sun and the moon flanking Christ's yellow cross, bordered in orange. The thieves Gesmas and Dismas appear below.[8] Two men break the thieves' legs and two more divide Christ's garment. All persons are named in neat labels, and longer inscriptions describe the division of the garment and specify 'two Jews' as the thieves' assailants.[9] A further inscription, to be discussed below, runs along the transverse of the cross. In the right half of the diptych, Nicodemus and Joseph of Arimathea remove Christ from the cross – now orange with a yellow border, blooming and studded with faded gems – and carry his wrapped body to the sepulchre.[10] These events are also recapitulated in text.[11]

The composition is scrupulously balanced. John's errant foot represents the only formal dissonance in the left-hand panel. On the right, the fluidity of the Deposition scene is re-stabilized by a chiastic colour structure created by reversed hues in Joseph and Nicodemus' garments, and by the solid horizontal of the lower register. The two panels are generally bound together across their registers and the gutter by the repetition of hues. This unifying rhythm of colour was probably born of budget restrictions: the limited number of inks used in the painting are in the greatest part no different from those used for the lettering, rubrics and highlights of the text body. The parchment was also ruled for text: no special provisions were made for the illumination beyond the reservation of two full pages for a carefully planned and executed composition.

The balance of colour and form builds a whole of diverse parts, first on each side of the diptych and then across the two-page span; this visual coherence

7 On Angers 24 and the Codex Egberti (Trier, Stadtsbibliothek Cod. 24), see Exner, *Die Fresken der Krypta von St Maximin in Trier*, esp. pp 95ff. For the Louvre ivory (OA 6000), see Danielle Gaborit-Chopin, *Musée du Louvre, Département des Objets d'Art Catalogue: Ivoires médiévaux Ve–XVe siècle* (Paris, 2003), no. 37, pp 140–5, with reference to Angers 24 at p. 145. The sixth-century St Augustine Gospels (Cambridge, Corpus Christi College, MS 286) also includes an exceptionally detailed Passion sequence (fo. 130), but this ends at the carrying of the cross. **8** The usual positions of the thieves are reversed: Gesmas, the Bad Thief, appears to Christ's sinister and Dismas, the Good Thief, to Christ's dexter side. The reversal of the thieves, like the double-register format of the image, offers greater scope for analysis than I can offer here. It is not a simple labelling error, as the integral attributes of jewels on Dismas' cross and the parallel stance of his figure to Christ's indicate that Dismas is correctly designated as the thief destined for paradise. **9** *Partiuntur vestimenta*; *Duo judei qui fregerunt crura latrones.* **10** The gems in the Angers cross were originally yellow, probably orpiment; the pigment is now almost entirely abraded. **11** *Iosep accipiens Ihesus de cruce; Iosep &*

underlies the conceptual interdependence of the image's two registers and two sides. The importance of the scenic detail in Angers 24 surpasses its place in the development of Western pictorial Passion narrative. The attributes of narrative – sequence, description, causality – are critical to the soteriological and ecclesiological arguments framed within the image. The events of the Passion become the source of the signs of salvation. The structure of the image demonstrates the continuity and distinction between them, while its contents layer in pictorial exegesis on the meaning of the story.

ESCHATOLOGY AND ECCLESIOLOGY

The Angers crucifixion is generous in its offer of redemption through Christ's death. Blood falls from Christ's body into Stephaton's hair and Longinus' beard and onto Adam's head below the cross: the crucifixion is the engine of salvation, even for the guilty.[12] The parallel between Christ's and Adam's two-pointed beards highlights the common idea that Christ's sacrifice made good Adam's sin, as does the unusual treatment of the snake. Instead of twining around the thorn of the cross, a Carolingian iconography that partly serves to establish the cross as the instrument conquering sin and the devil,[13] the snake coils delicately around itself, forging an explicit connection between Christ and Adam (fig. 7.1). The snake emerges from Adam's head and loops upward to Christ's feet, reaching out its tongue to graze his left heel.[14] One possible reading of this touch emphasizes the serpent's subjugation in an unusually reconciled spirit that might even be called tribute when compared to other similar interactions.[15] Nicodemus cradles Christ's

Nichodemus portantes Ih[esu]m Chr[istu]m sepulchro. **12** On Adam's head beneath the cross, see Schiller, *Ikonographie der christlichen Kunst*, ii, pp 124–5. Reims, Bibliothèque Municipale, MS 8, a Breton/Loire gospel book from *c.*923 with important connections to Angers 24, contains a lengthy note on the grave of Adam beneath the cross and the conquest of grace over sin (fo. 45v), derived from Jerome. **13** 'Partly', because the thorn of the cross represents a visual element separable from the snake. On the cross as Christ's instrument of conquest, and on the snake see particularly Chazelle, *Crucified God in the Carolingian era*, pp 254–66; and eadem, 'An *exemplum* of humility: the crucifixion miniature in the Drogo Sacramentary' in E. Sears and T.K. Thomas (eds), *Reading medieval images: the art historian and the object* (Ann Arbor, MI, 2002), pp 27–35. On the Carolingian crucifixions, see the chapters devoted to them by Sepière, *L'Image d'un dieu souffrant.* **14** In neither the Gospels of François II (Paris, BN, MS lat. 257), further discussed below, nor the 'Coronation Sacramentary' from Metz (Paris, BN, MS lat. 1141) does the snake reach Christ's foot. In only a scant handful of ivories dated to the tenth or eleventh century does the snake's tongue touch Christ: see Schiller, *Ikonographie der christlichen Kunst*, ii, fig. 376, p. 124; Adolph Goldschmidt, *Die Elfenbeinskulpturen aus der Zeit der karolingischen und sächsischen Kaiser, VIII.–XI. Jahrhundert* (Berlin and Oxford, 1914), i, no. 54, ii, no. 30. **15** A touch to Christ's foot constitutes a bid for intercession in two eleventh-century Cologne works: the ivory of Ss Victor and Gereon, and the 'Herriman and Ida' cross. For both, see *Ornamenta Ecclesiae: Kunst und Künstler in der Romanik* (Cologne, 1985), i, B9, pp 157–8, ii, E32, pp 238–41. Further on the gesture, see Joanna Cannon,

7.1 Angers, MS 24, fo.7v.
Detail: Adam's head below the cross.
(© image courtesy of Bibliothèque
Municipale, Angers).

foot on the deposition side, confirming the spot as a point of access and adulation.[16] The defeated serpent stands for the crucifixion's triumph over sin, and the Angers designer was interested in redemption. The stance of Dismas mirrors that of Christ and his cross is studded with now almost completely faded yellow gems. Both attributes proclaim the thief's reformation, his cross functioning as a sign of triumph similar to Christ's own. The jewels of Dismas' cross exalt repentance; together, the thief, the subdued snake and Adam's head address the possibilities for salvation opened by the crucifixion.[17]

The crucifixion's promise of redemption is realized in Angers through the church. The specificity of the snake's address to Christ also recalls the more violent

'Kissing the Virgin's foot: *Adoratio* before the Madonna and Child enacted, depicted, imagined', *Studies in Iconography*, 31 (2010), 1–50, esp. 5–10, 35, n. 6. **16** A mourner kisses Christ's foot in this position on the Metz Passion ivory. **17** On the choice represented by the thieves, see Lawrence

relationship between the serpent's head and Eve's heel from Genesis 3:15.[18] For Augustine, Eve's task of subduing the snake (temptation and sin) is taken up by the church. Augustine identified Eve, born from the side of sleeping Adam, with the church 'that was to come', born from Christ's side in the sacramental blood and water of the wound he received from Longinus (brutally pronounced in Angers 24).[19] The inscription on the cross identifies Christ himself with the church: 'He is fastened to the cross, he who has no blemish at all'.[20] The core of this text, *maculam qui non habet ullam*, assimilates Christ to Paul's description in Ephesians 5:25–7 of a spotless *ecclesia*.[21] This pure church resulted directly from Christ's sacrifice, and numerous authors adopt Paul's language to describe it.[22] In a similar spirit, various patristic and Carolingian authors parallel Christ's unbroken body – against the broken bodies of the two thieves – to the unity of the church, and read the division of Christ's garments as the dissemination of the sacraments or the Gospels throughout the Christian world.[23] Both the iconographic choices of the left-hand panel and its very principle of scene selection express an ecclesiological vision of the redemption offered by the crucifixion.[24]

Nees, 'On the image of Christ crucified in early medieval art' in M.C. Ferrari and A. Meyer (eds), *Il Volto Santo in Europa: Culto e immagini del Crocifisso nel Medioevo. Atti del Convegno internazionale di Engelberg (13–16 settembre 2000)* (Lucca, 2005), pp 345–86 at pp 360–1. On the connection between Christ and the brazen serpent, see Herbert Kessler, 'Christ the magic dragon', *Gesta*, 48:2 (2010), 119–34; Beate Fricke, *Ecce fides: die Statue von Conques, Götzendienst und Bildkultur im Westen* (Munich, 2007), pp 137ff. **18** Genesis 3:15: *... nimicitias ponam inter te et mulierem et semen tuum et semen illius ipsa conteret caput tuum et tu insidiaberis calcaneo eius.* **19** For example, Augustine, *Expositiones in psalmos*, Exposition 4:6 of Ps 103 (*CCSL*, 40, pp 1525–6). See Chazelle, *Crucified God in the Carolingian era*, p. 73; Louis van Tongeren, *Exaltation of the cross: toward the origins of the feasts of the cross and the meaning of the cross in early medieval liturgy* (Leuven and Sterling, VA, 2000) on the concept of 'recirculation'. **20** *Figitur ille cruci, maculam qui non habet ullam.* **21** Eph 5:25–7: *... gloriosam ecclesiam non habentem maculam aut rugam ...* **22** The spirit of the text is close to the upper inscription of the Durham Gospels crucifixion as untangled by Jennifer O'Reilly: *Scito quis et qualis est, cuius titulus [est] cui nulla est inventa culpa.* See O'Reilly, '"Know who and what he is": the context and inscriptions of the Durham Gospels crucifixion image' in Rachel Moss (ed.), *Making and meaning in Insular art* (Dublin, 2007), pp 301–16 at p. 315. Emphasis on Christ's immaculate nature in Angers is related to the image's elements of redemption and salvation, as opposed to guilt. The word *maculam* is not especially common in exegetical texts: its most regular appearance occurs in citations of Paul by prominent patristic and Carolingian authors such as Cassiodorus, Augustine, Gregory, Isidore, Ambrose, Smaragdus, Alcuin, Hincmar of Rheims, Walafrid Strabo and Hrabanus Maurus. **23** On the ecclesiological division of Christ's garments, see, for example, Bede, *In S. Joannis Evangelium Expositio*, 19 (*PL*, 92, 911B–912D). On Christ's body as the whole church, see, for example, Augustine, *Enarrationes in psalmos* on Ps 33:4, Sermon 2:7 (*CCSL*, 38, p. 286). **24** It is worth noting the colophon texts of Angers 24 in this context. On fo. 125v appear two notes in black and red ink, respectively. One describes the Evangelists as *quattuor milites* who divide Christ's garment, tapping into the exegetical tradition invoked above. The other serves as *explicit* for the volume and links the manuscript to a certain bookseller Gaudiosus near St Pietro in Vincoli in Rome: *Explicit numerus evangeliorum iiiior mathei: marci: luce: iohannes: s[e]c[un]d[u]m hieronimum de statione gaudio libri: ad vincula sci petri: civitate romana.* The repercussions of this inscription are manifold; here we may simply observe that the

The thorned form of the cross is significant in this context. The thorn articulates the cross as an object, an independent player in the crucifixion scene. Visual emphasis on the cross as an entity distinguished from the body of the Crucified echoes reams of theological reflection on the cross' role as an object and a sign before, during and after the crucifixion, as well as liturgical focus on the cross sign in the form of manufactured crosses and reliquaries.

The most important of possible interpretations for the two flags attached to the cross' transverse, unique in this form to Angers 24, evokes the liturgical cross. A common epithet, *vexillum*, defines the cross as banner and standard of the death-conquering Christ.[25] Laced to their poles, the Angers flags are fastened to the cross by vegetal finials that anticipate the blooming of the cross on the right. They proclaim the triumphal nature of the crucifixion in terms derived not from the historical but from the theological and liturgical language defining the cross.[26] The Golgotha cross is already treated like its material counterpart in the liturgy: hailed with *Vexilla regis* and exalted as the crowning element of Golgotha, with the thieves' crosses in both a physically and conceptually supporting role.

On the crucifixion side of the diptych, the thorn of the cross is clearly planted underground: Golgotha appears in cross-section. On the deposition side, the cross sits atop a responsive ground line, its lower end following the contours of the earth, its scale reduced relative to the figures around. This more ambiguous relationship of the cross to its setting furthers its articulation as an independent sign. The cross is part of the scene but presses forward from the ground: the thorned form is exposed as part of its essence, beyond the narrative point at which the cross was driven into the hill. The theological importance of the planted 'depth' of the cross was taken up by many.[27] The common prompt for reflection on the *profundum crucis* is again Paul, Ephesians 3:17–18, on the 'breadth and length and depth and height' of Christ's charity (*caritas*).[28] Theologians read these measurements as the dimensions of the cross, with depth associated with the mysterious and hidden (*occulta*) – most often with the judgment or will (*judicia* or *voluntate*) of the God who calls men to participate in grace.[29]

The thorned form shows more of the cross than it leaves concealed,[30] but this draws attention to the complete body of the object. The Angers designer, who also emphasized grace in Christ's falling blood and Dismas' redemption, showed the full figure of the cross as part of his excavation of the crucifixion. He invoked the

makers of the manuscript took care to cultivate a direct link between their codex and the seat of the church. **25** On the theological implications of the hymn at the heart of the epithet, '*Vexilla regis*', see Katharina Christa Schüppel, *Silberne und goldene Monumentalkruzifixe: ein Beitrag zur mittelalterlichen Liturgie-und Kulturgeschichte* (Weimar, 2005), pp 213–17. **26** On the early medieval prominence of liturgical/theological crucifixions over narrative ones, see Nees, 'Christ crucified', p. 372. **27** Augustine, Isidore, Bede, Alcuin and Hrabanus Maurus, among others. **28** Eph 3:17–18: ... *possitis conprehendere cum omnibus sanctis quae sit latitudo et longitudo et sublimitas et profundum* ... **29** For example, Bede, *In Lucae Evangelium Expositio*, 6:23:33 (*CCSL*,

hidden elements of the cross below the earth and their illumination in grace, his painting acting as the agent of revelation on the meaning of the cross and Christ's sacrifice upon it, and consequently on the importance of the cross as sign.

THE DIPTYCH AS LITURGICAL SPACE

The Angers image sets narrative in the service of reflection on the nature of the church's signs. The diptych creates a dynamic, liturgically inflected space, in which the Passion scenes demonstrate the origin of the church's central sign. The cross sign stands for the source, power and promise of church rites overall, principally the Mass. Many early medieval crucifixions state the equivalence of the Crucified and the body consumed in the Eucharist, but the Angers diptych stages the generation of both the sacrament and its sign.

Various elements of the Angers image propose the relationship between the crucifixion and the Eucharist: the falling blood, and emphasis on the dead body of Christ in the deposition and entombment – the latter particularly in view of Elizabeth Parker's work on the deposition as an essentially liturgical theme.[31] The invocation of the Mass, though, is best accomplished in the diptych through the transformation of the cross. Early medieval exegesis on the Eucharistic liturgy established it as the historical sacrifice brought into the present moment.[32] The inscriptions of the Angers diptych embody the shift from history to imminence: in the left panel, all verbs indicate past action or passive description (*figitur, partiuntur, fregerunt*). On the right, all verbs indicate present continuous action (*accipiens, portantes*). The stage of the action changes from the set piece of Golgotha to a more fluid field that evokes liturgical space. On the deposition side, the terminals of the cross are widened and vegetal, it has acquired a central medallion, and the spaces previously occupied by the sun and the moon are filled by swirling cosmic rosettes. These forms – not infrequently including a thorn on the cross – are the province of stonework panels mounted as ambos and chancel screens (fig. 7.2).[33] In stone, the story of the sacrifice is subsumed by its theological

120, p. 402). **30** A closely related iconography suggests the depth of the cross without displaying it in full: for example, the 'Ursus' ivory (Goldschmidt, *Die Elfenbeinskulpturen aus der Zeit der karolingischen und sächsischen Kaiser*, i, no. 166). **31** Elizabeth C. Parker, *The descent from the cross: its relation to the extra-liturgical 'Depositio' drama* (New York, 1978). See also Parker, this volume. **32** Paschasius Radbertus represents the extreme of this position but he stands at one end of a spectrum; see Celia Chazelle, 'Crucifixes and the liturgy in the ninth-century Carolingian church' in Ferrari and Meyer (eds), *Il Volto Santo in Europa*, pp 67–94. For discussion of the ways in which various early medieval liturgies bring the celebrations of Good Friday into the present moment, see Van Tongeren, this volume. **33** On stonework installation, see Erika Doberer, 'Die ornamentale Steinskulptur an der karolingischen Kirchenausstattung' in W. Braunfels and H. Schnitzler (eds), *Karl der Grosse: Lebenswerk und Nachleben*, III: Karolingische Kunst (Düsseldorf, 1965), pp 203–33. Victor Elbern first suggested a conceptual as well as a visual parallel between cross-pages and chancel

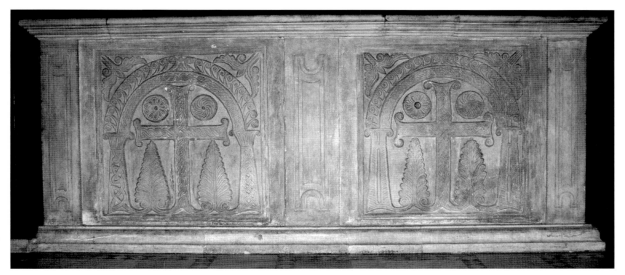

7.2 Chancel screen, Rome, Santa Sabina (photograph by the author).

meaning: the cross becomes a sign of eternal life closely integrated with cosmology.[34] The cross defines the fabric of liturgical space, indicating the meaning and goals of ritual activity. As soon as cross and corpus are separated in the Angers diptych, the cross assumes a role that is equivalent both visually and conceptually to the fixed cross of a chancel panel, or a portable cross set over the altar.[35] Its historical part having been played, the cross becomes a sign of its own meaning (cosmic order) and promise (triumph over death), as these are made accessible through the church. The ecclesiology of the crucifixion panel bears fruit in the sacramental space of the deposition panel. As the cross on the left is a clearly articulated object set into the hill of Golgotha to perform the crucifixion's sacrifice; the cross on the right is set above the shrouded body, which, in its sacramental form, fulfils the promise of that sacrifice. The cross is the sign glossing the meaning of Eucharistic bread, and standing in for the no-longer-visible body of Christ.[36] The setting of the sign through the thorned form of the cross states the act of visual exegesis: the *ara crucis* gives way to the *signum crucis*.[37]

screens: see 'Zierseiten in Handschriften des frühen Mittelalters als Zeichen sakraler Abgrenzung' reprinted in *Fructus Operis: Kunstgeschichtliche Aufsätze aus fünf Jahrzehnten*, I, ed. P. Skubizewski (Regensburg, 1998), pp 42–64. **34** For succinct discussion of cosmological imagery related to the cross, see Martin Werner, 'The cross-carpet page in the Book of Durrow: the cult of the True Cross, Adomnan and Iona', *Art Bulletin*, 72:2 (June 1990), 174–223 at 211ff. **35** The only comparable transformation of the cross between Crucifixion and Deposition known to me occurs in Boulogne-sur-Mer, Bibliothèque Municipale, MS 20, the Odbert Psalter from St-Bertin, *c.*1000. See Rainer Kahsnitz, 'Der christologische Zyklus im Odbert-Psalter', *Zeitschrift für Kunstgeschichte*, 51 (1988), 33–125; Exner, *Die Fresken der Krypta von St Maximin in Trier*, p. 116, n. 201. **36** For the theme of presence in absence in an Anglo-Saxon and Hispanic context, see Neuman de Vegvar and García de Castro Valdés, this volume. **37** On the *ara crucis*, see Jane Rosenthal's summary in 'The historiated canon tables of the Arenberg Gospels' (PhD, Columbia University, 1974), p. 113.

THE CROSS-SIGN AS BRIDGE

The *signum crucis* is itself a medieval designation both for the theological concept of the cross and its incarnation in the man-made objects of the church.[38] The *signum crucis* is a ubiquitous presence in liturgical space, in both object- and pictorial forms. Sacramentally, the liturgical cross accomplishes nothing. It stands, however, for everything, because its form derives directly from the historical instrument of Christ's sacrifice. In practice, the cross is the mediator *par excellence* between history and liturgy, because theologically its form participates equally in both.[39] Its tangible presence as an object available for ritual attention partly substitutes (along with the Eucharist and the gospel book) for the invisible person of Christ, while its presence as a sign relative to the altar demonstrates the continuity between sacred past and ritual present.

Two other important late Carolingian images indicate the centrality of this continuity to early medieval conceptions of the cross: the crypt fresco from St Maximin in Trier (fig. 7.3), and the crucifixion image added to the Psalter of Louis the German (pl. 14). In both cases, the cross participates equally and simultaneously in sacred history and present ritual. The images explicitly state the function of the cross-sign upon which the Angers diptych draws, by describing the nature of the cross-object in a pictorial medium.

In the fresco from St Maximin in Trier, an image of the cross orchestrates a link between actual liturgical space and historical space.[40] The St Maximin fresco is among the earliest surviving crucifixion scenes placed directly over an altar, originally installed on the west side of the crypt.[41] The painting draws a direct genealogy between the True Cross, the liturgical cross and the altar below. The image presents an energetic crucifixion including the rare element of two men nailing Christ's feet to the cross.[42] The scene is framed by a palmette border that follows the shape of the wall below the vaulting. The long thorn of the cross traverses the painted border, a dog-headed serpent twining around its shaft.[43] The

38 Many examples of the term applied to artwork may be found in Julius von Schlosser, *Schriftquellen zur Geschichte der karolingischen Kunst* (Hildesheim and New York, 1974; after Vienna, 1892), particularly in the *carmina* of Hrabanus and Alcuin (for example, pp 349–61). See also Helen Gittos, 'Hallowing the rood' in Sarah Larratt Keefer, Catherine E. Karkov and Karen Louise Jolly (eds), *Cross and culture in Anglo-Saxon England: studies in honor of George Hardin Brown* (Morgantown, WV, 2008), pp 242–75, esp. pp 264ff. **39** Hrabanus Maurus insisted upon this point in his great compendium of cross theology *In honorem sanctae crucis*: see Chazelle, *Crucified God in the Carolingian era*, pp 99–118. **40** The fresco is dated to *c.*890: Exner, *Die Fresken der Krypta von St Maximin in Trier*, p. 211. **41** See ibid., p. 122. Exner suggests interpretive approaches to the configuration in 'Saint-Maximin de Trèves: relations entre programme artistique et usages liturgiques dans une crypte du haut Moyen Âge' in *L'emplacement et la fonction des images dans la peinture murale du Moyen Âge* (Saint-Savin, 1992), pp 35–44 at p. 37. **42** Exner, *St Maximin*, pp 78 and 107–20. The two men are labelled *iudeus infelix* in cryptic lettering, which calls for comparison with Angers 24's, *iudei qui fregerunt*. **43** As in Angers, the cross from St Maximin is

7.3 Crypt fresco from St Maximin in Trier (image courtesy of R. Schneider, Museum am Dom Trier).

painted cross, with its foot in liturgical space and its body integrated with the historical scene, replaces a metalwork object installed on or behind the altar to visualize the relationship between the sacrifice on Golgotha and the sacrifice enacted on the table.[44] In the Angers image, the right-hand cross set above the shrouded body accents that body's soteriological significance in a sacramental context by virtue of the link between the two sides of the diptych and the replacement of the cross' primarily historical, scenic form by its equivalent liturgical sign. The Trier fresco represents the same progression along a vertical axis, with an actual – rather than a representational – sacramental body at the end of the line.

In the Psalter of Louis the German, the cross links a purely pictorial space of devotion with historical elements. The image of supplication added to the older manuscript appears in a context of penitential texts.[45] The Carolingian noble

visible below the ground. The join between thorn and earth is damaged on the left but clear on the right, and the vessel placed below Christ's feet rests on the ground line. **44** The painting is displayed in Trier in a reproduction of its archaeological context, including an altar block scaled according to documentation from the excavation. At eye level to the block, the point of the cross thorn reaches the table. For the dynamic and permanent installation of crosses at altars, and the identification of the altar with Golgotha, see Peter Springer, *Kreuzfüsse: Ikonographie und Typologie eines hochmittelalterlichen Gerätes* (Berlin, 1981), pp 13–55. Exner notes the functional parallel to a cross object in Trier: 'Die Wandmalereien der Krypta von St Georg in Oberzell auf der Reichenau', *Zeitschrift für Kunstgeschichte*, 58:2 (1995), 153–80 at 165. **45** The psalter image (Berlin, Staatsbibliothek, MS Theol. lat. fol. 58, fo. 120) is dated to the late ninth century and ascribed to

Arnulf kneels at an arcaded *prie dieu* in the margin of a multicoloured rectangle, grasping the thorn of a monumental green cross that spans the border between the spaces defined by the frame.[46] In Arnulf's space, the cross exists as a tangible object mounted on a stepped base. This common form of cross-base refers to the jewelled monument to the crucifixion erected on Golgotha hill.[47] Even without the extraordinarily concrete characterization of the object-sign, the cross here derives its form from a manufactured instance associated with liturgical commemoration. Installation and utility in liturgically inflected devotional space define the psalter cross' form and nature.[48]

The source of the cross' power as a devotional aid is established in the psalter by the elements of a crucifixion scene that appear within the frame. Through its planes, the image separates Mary, John, the sun and the moon, and the person of Christ himself visually and conceptually from Arnulf. Via Arnulf's access to the cross object, though, the contemporary noble and the historical figures share the same visual and conceptual space within the frame. The prototype of Arnulf's cross object – the True Cross – is continuous with but distinguishable from the tangible material sign derived from the historical source. The green colour defines the cross as the Tree of Life, its size exalts the cross, and the crucifixion scene shows the origin of all the salvific potential of the sign. Arnulf's devotion to the cross reveals the nature of the object to the viewer of the image, and his physical contact with the cross substitutes for contact with Christ himself. The ultimate recipient of the prayers is invoked in the prayer text, which begins *Redemptor mundi* ... The Redeemer offers his foot and his gaze to the devotee, confirming the power of the mediating instrument. Arnulf's touch and look remain anchored on the cross, interacting with Christ through the object.[49] In this, the cross functions not only

southern Germany. See W. Koehler and F. Mütherich (eds), *Die Karolingischen Miniaturen*, VII.1 (Wiesbaden, 2009), pp 64–5, hereafter cited as *KM* VII. The prayer *ante crucem dicenda* immediately preceding the image establishes the penitential context, as do the neumed extracts from Boethius' *Consolatio Philosophiae* added in the same hand at the front of the psalter. On the *Consolatio* as a penitential work: Sam Barrett, 'Music and writing: on the compilation of Paris, BN, lat. 1154', *Early Music History*, 16 (1997), 55–96. For the cross prayer, see André Wilmart, 'Prières médiévales pour l'adoration de la croix', *Ephemerides liturgicae*, 46 (1932), 22–65 at 31. **46** For identification of the nobleman, see Fabrizio Crivello, 'Ein Name für das Herrscherbild des Ludwigpsalters', *Kunstchronik*, 60:6 (2007), 216–19. Eric Goldberg associates the additions with Louis himself in *Struggle for empire: kingship and conflict under Louis the German, 817–76* (Ithaca, NY, 2006), pp 286–87. **47** Martin Werner, 'On the origin of the form of the Irish high cross', *Gesta*, 29:1 (1990), 98–110 at 100; Schüppel, *Silberne und goldene monumentale Kruzifixe*, pp 199–202 ('Das Vorbild Golgotha'). **48** On the ninth-century cultivation of psalters as prayer books bringing liturgical space into the private sphere, see Nell Gifford Martin, 'Reading the Huntingfield Psalter (Pierpont Morgan Library, M. 43): devotional literacy and an English psalter preface' (PhD, University of North Carolina at Chapel Hill, 1995), p. 12. Even before the additions, the older psalter was designed for private prayer: morning and confessional orations follow the psalm texts, along with excerpted penitential psalms: see *KM* VII, p. 65; see also, Goldberg, *Struggle for empire*, at p. 46 on the function of a private prayerbook. **49** See Cynthia Hahn, 'Vision' in C. Rudolph (ed.), *A companion to medieval*

as a sign of Christ's sacrifice and its attendant promise of salvation and succour; the object-cross functions also as a sign for the efficacy of the church's mediating instruments – among which the psalter manuscript itself belongs.

The *signum crucis* is the pivot point between history and liturgy, not because it effects real contact between them, as the Eucharist and *vasa sacra* do,[50] but because its form and its installation may propose a two-way analogy between Golgotha and the spaces of the church. Liturgical manuscripts constitute one such space.[51] Analysis of the image content of the Angers diptych leads to consideration of the deep-seated connection between cross and gospel codex. The Angers crosses do not bridge temporal and pictorial space as the psalter cross so explicitly does, or temporal and architectural space as in the St Maximin fresco. Rather, their instrumental form reflects upon the project of the gospel book as a whole, itself representative of both the historical past and the liturgical present, active in the Church's work in anticipation of the eschaton.[52] The image functions as an integral component of the codex's presentation of the Gospel to these ends.

ARGUMENT THROUGH POSITION: THE PLACEMENT OF THE DIPTYCH

The position of the Angers image between Matthew's chapter list and Gospel Incipit is original. With a crucifixion in direct preface to Matthew's Gospel, the Angers manuscript is part of a small group, comprising one other Breton crucifixion image (Oxford, Bodleian Library, MS Laud lat. 26),[53] and the luxury ninth-century northern French gospel codices Cologne, Diözesanbibliothek, MS 14, in which only Mary and John survive as half of a former diptych,[54] and Paris,

art: Romanesque and Gothic in northern Europe (Malden, MA, 2006), pp 44–64 at p. 51 for an alternative reading of the crucifixion as the view of Arnulf's inner eye. See also Corine Schleif, 'Kneeling on the threshold donors negotiating realms betwixt and between' in E. Gertsman and J. Stevenson (eds), *Thresholds of medieval visual culture: liminal spaces* (Woodbridge, 2012), pp 195–216 at p. 204. **50** See Chazelle, *Crucified God in the Carolingian era*, pp 39–52 on the *res sacrata* defined by the *Opus Caroli regis* (*Libri Carolini*). **51** For several studies approaching the idea of manuscripts as sacred space in a literal sense, including some observations on the integration of objects, see Ernst Kitzinger, 'A pair of silver book covers in the Sion treasure' in U.E. McCracken, L.M.C. Randall, R.H. Randall (eds), *Gatherings in honor of Dorothy Miner* (Baltimore, MD, 1974), pp 3–17; see also Lawrence Nees, 'The colophon drawing in the Book of Mulling: a supposed Irish monastery plan and the tradition of terminal illustration in early medieval manuscripts', *Cambridge Medieval Celtic Studies*, 5 (summer 1983), 67–91; Michelle Brown, *The Lindisfarne Gospels* (Toronto and Buffalo, NY, 2003), esp. pp 319ff; and Carol Neuman de Vegvar, 'Remembering Jerusalem: architecture and meaning in Insular canon table arcades' in Moss (ed.), *Making and meaning in Insular art*, pp 242–56. Martin Werner's, 'Cross-carpet page' is fundamental in this context. **52** For this characterization of gospel books, extensively elaborated in recent studies, see, for example, Heather Pulliam, *Word and image in the Book of Kells* (Dublin, 2006); Éamonn Ó Carragáin, '"Traditio evangeliorum" and "sustenatio": the relevance of liturgical ceremonies to the Book of Kells' in *The Book of Kells*, pp 398–436. **53** On the rarity of crucifixion images in Carolingian gospel manuscripts, see *KM* VII:1, pp 44–5. **54** *Glaube und Wissen im Mittelalter: Die Kölner Dombibliothek*, ed. J. Plotzek and U.

Bibliothèque Nationale, MS Latin 257, the 'Gospels of François II' (pls 10, 11).[55] However, because of the importance of the cross in Angers, and in view of the demonstrable combination of Insular and Carolingian influences in Breton scriptoria,[56] we must situate the diptych not only in relation to these Matthew-crucifixions, but also among the categories of crosses occurring specifically before Matthew, and crosses or crucifixions in other prefatory positions. In other words, in the broadest terms, the diptych combines features of a Carolingian crucifixion and an Insular cross page.

The group of Matthew-crosses includes books such as the Lindau Gospels,[57] including a cross-page at Matthew that is not part of a full sequence of prefatory crosses for each Gospel. Gospel books from (or derived from) Tours that combine the 'L' and 'I' of Matthew's opening *Liber* into a cross also count within this cluster.[58] Laon, Bibliothèque Municipale, MS 63 provides a particularly rich example (fig. 7.4): the potential of the L/I combination is fully realized by turning the text opening into a *maiestas crucis*.[59] The four Evangelist symbols surround the cross created by the two letters, placing a *maiestas crucis* in the same position as a more elaborate, full-page example that appears in the Carolingian Essen Gospels (pl. 13).

The crosses and crucifixes mentioned above are physically and conceptually part of Matthew. In the François Gospels, the connection between Evangelist and crucifix is particularly strong. The crucifix appears as half of an opening with Matthew's Evangelist portrait. The two sides are bound by the ground line, and by the position of the Evangelist: Matthew looks up at his symbol but his position refers back to the facing crucifix. Each other Evangelist is placed in diptych relationship only to his symbol. Deep integration of the cross and the beginning of Matthew appears likewise in the Lindau Gospels, where a green cross underlies the entire text of the Incipit. In Angers 24, the direct preface to the diptych is a note following Matthew's chapter list, in which an invocation of the Trinity prefaces the announcement of Matthew's account and the genealogy of Christ.[60]

The formulation, 'now is begun the Gospel according to Matthew', becomes theologically quite literal if we view the diptych as the opening of Matthew's

Surmann (Munich, 1998), pp 332–42; *KM* VII:1, pp 204–14, pls 54–62. The Cologne crucifixion is presumed, based on codicological probability and the improbability of Mary and John facing any other subject: *KM* VII:1, pp 48–9. **55** *Trésors carolingiens: livres manuscrits de Charlemagne à Charles le Chauve* (Paris, 2007), no. 56, pp 210–12; *KM* VII, pp 194–203, pls 44–53. **56** See Micheli, *L'Enluminure du haut moyen âge et les influences irlandaises*; Charles Rufus Morey, with Carl Hermann Kraeling and Edward K. Rand, *The Gospel-Book of Landévennec (The Harkness Gospels) in the New York Public Library* (Cambridge, 1931), pp 225–86 at p. 260. **57** New York, Pierpont Morgan Library, MS 1, fo. 13v, attributed to St Gallen, 883–90: see Anton von Euw, *Die St Galler Buchkunst vom 8. bis zum Ende des 11. Jahrhunderts* I (St Gallen, 2008), no. 99, pp 408–11 **58** Six further gospel books attributed to Breton/Loire scriptoria include this feature. **59** On Laon 63, see Wilhelm Koehler, *KM* I:1, pp 269–79. **60** *In divide sanctae trinitatis honomate/Nunc orditur evangelium cata matheum xri autem generatio.*

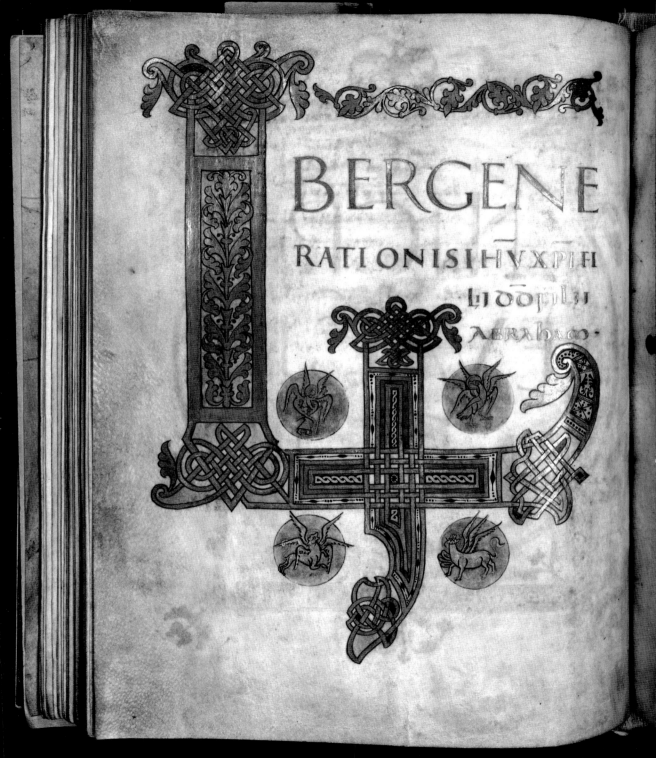

LIBER GENE
RATIONIS IHV XPI FI
LII DD FILII
ABRAHAM·

Gospel. Along with the resurrection, the crucifixion is the primary event in Christ's life unifying all four Gospel accounts, and, as the key moment in salvation history, it is also the point at which the Gospels' importance really begins.[61] I will return all too briefly to the idea of prefatory crosses/crucifixes as the Gospels' summary and standard; here we remain with crosses integrated particularly with Matthew. Matthew's symbol is the man, and his Gospel begins with Christ's mortal genealogy.[62] Any cross in direct preface to Matthew, particularly when isolated in a manuscript's decorative scheme, thus communicates an emphasis on the Incarnation, invoking Christ's mortal, sacrificial body. The *maiestas crucis* examples in Essen and Laon present the cross as an actual substitute for the person of Christ.[63] In Laon, the cross formed through the 'L/I' underscores the conceptual constellation, adding the idea of Christ the Word to the ancestry of Christ the man and the anticipation of Christ's return in majesty. In the Essen *maiestas crucis*, the bust portrait and the book held by Christ accomplish the same end, with the added incarnation of the Word as the gospel book.[64] The body of Christ is implicit in the cross that invokes its sacrifice and represents the sign of the Second Coming.[65] Because of this, crucifixes or crucifixions integrated with Matthew amount to particularly explicit statements of a theme already present in Matthew crosses.

The insistence on Christ's connection to Adam in the Angers diptych, and the repeated invocation of his physical body, reflect the heightened awareness of Incarnation linked to the context of the image. The diptych lays out the ultimate importance of the Incarnation – salvation through sacrifice, the creation of the church and the creation of the sacramental body – as realized through the story of the crucifixion. The blooming, jewelled cross becomes the summary sign for all these elements. The diptych takes on the role played in other gospel books by a cross-page, with the narrative that generated the sign fully elaborated along with a breadth of form for the cross that parses the nature of the sign.[66]

In the broader tradition of surviving Carolingian and Insular gospel books, the crucifixions of Angers 24 and the François Gospels are as closely related to

61 On the cross and the harmony of the gospels, see Jennifer O'Reilly, 'Patristic and Insular traditions of the Evangelists: exegesis and iconography of the four-symbols page' in A.M.L. Fadda and Éamonn Ó Carragáin (eds), *Le isole brittaniche e Roma in età romanobarbarica* (Rome, 1998), pp 49–94. **62** See Martin Werner, '*Crucifixi, sepulti, suscitati*: remarks on the decoration of the Book of Kells' in *The Book of Kells*, pp 450–88 at p. 458. **63** See especially Ó Carragáin, *Ritual and the Rood*, pp 325–7; Anne-Orange Poilpré, *Maiestas Domini: une image de l'Eglise en Occident Ve–IXe siècle* (Paris, 2005). **64** On bust portraits of Christ on crosses, see Poilpré, *Maiestas Domini*, p. 157; Nancy Netzer, *Cultural interplay in the eighth century: the Trier Gospels and the making of a scriptorium at Echternach* (Cambridge and New York, 1994), pp 103–7. **65** The artist of Angers 24 again maximized the effect of his limited colour: the pink used sparingly to tint Christ's body appears again in the halo cross, proposing equivalence between the flesh and the cross-sign. **66** The François Gospels crucifix could also be called a cross-page 'augmented' by the Crucified: standing out in gold and set forward against the scenic background, the cross here also creates an image that distinguishes

cross-pages in their prefatory function within the codex than they are to the few remaining crucifixions internal to gospel manuscripts.[67] The meditative potential of the Angers diptych certainly associates the painting with images such as the Durham Gospels crucifixion (Durham Cathedral Library, MS A.II.17, fo. 38av; pl. 1), which appears within the 'Little Apocalypse' at the end of Matthew's text (24:30).[68] The diptych bears equally close comparison with the self-contained Crucifixion/Second Coming diptych following the text of the St Gall Gospels (pl. 2). The image's position, however, also allies it with the surviving cross-page of St Gall, integrated with Matthew's genealogy (p. 6), or with the full prefatory cross-sequences of Insular gospels such as Lindisfarne (London, BL, MS Cotton Nero D.IV). Crucial to the nature of all these examples is the images' profound integration in the project of the manuscript as a whole; their expression of the instrumental book's role in transmitting the meaning of the Gospel story along with its text. The cross may serve as a sign for this relationship between the codex and its contents, as much as it also stands for the overarching meaning of the Gospels.

THE MULTIFACETED CROSS-SIGN

The two crosses in Angers 24 render a comparison to cross-page sequences more than a passing remark. Such sequences cast the cross in different lights over a series of portraits. These portraits occasionally include invocation of the narrative that Angers so extensively describes: Lindisfarne's cycle, as Christine Maddern has argued, begins with a cross-page whose geometric fields suggest the generating story behind the sign.[69] The Lindisfarne Matthew cross includes the objectifying elements of bosses and articulated terminals, while the remaining cross-pages are more concerned with theologically freighted geometry, building up a set of cross theologies over several folios.[70] Through the Preface and Matthew crosses, like Angers 24, the Lindisfarne sequence includes, among other facets of the Cross, the ecclesiological/liturgical aspect of the *signum crucis* delivered by its incarnation as a material sign.

between cross, Crucified and crucifixion. **67** The following argument holds for Oxford, Laud lat. 26, and probably for Cologne 14 as well, based on the isolation of the crucifix. On the exegetical role of cross pages, see especially Brown, *The Lindisfarne Gospels*, pp 312ff. **68** A note in brown ink in the upper right-hand corner of fo. 9 in Angers 24 reads, *oratio matheus*, perhaps indicating a contemplative approach to the painting. The precise function of the image in liturgy or prayer remains an open question. On Durham, see O'Reilly, this volume, and eadem, '"Know who and what he is"'; George Henderson, *From Durrow to Kells: the Insular gospel-books, 650–800* (London and New York, 1987), pp 57–9. Articulated crosses, embedded in a scene, play a critical role in both Durham and St Gall. Matthew 23:30 underlies the idea of the cross as harbinger of the Second Coming. **69** Christine Maddern, 'The Northumbrian name stones of early Christian Anglo-Saxon England' (PhD, York, 2009). **70** Brown, *The Lindisfarne Gospels*, pp 325ff.

Such sequences of varying cross-portraits represent an important principle of depicting the cross that is not limited to manuscripts. The principle applies equally to processional crosses and True Cross reliquaries that juxtapose symbolic portraits of the cross with representations of the historical cross. As three-dimensional objects, such examples use their own physicality to argue for the unity of multiple concepts contained in the single sign.[71] A codex or a multipart image may work similarly.

In the field of manuscript illumination, the Essen Gospels throw Angers' incorporation of the sequential-cross concept into particularly clear relief. The *maiestas crucis* is the second of two cross-pages (pls 12, 13). These are closely related to Angers 24 in their content, but the nature of Essen's two pages is equivalent to that of Angers' two crosses.[72] The Essen crosses flank Jerome's prefaces as frontispiece and Matthew-cross. The first Essen cross shares the finials of the first Angers cross and is related to the cosmic imagery of the Angers roundels. Its inscription includes a conditional progression kin to the causal structure of the Angers diptych. The verse first expresses the nurturing power of the cross and then describes its beatific nature as contingent on belief in Christ: *Crux almifica/In Christo credentes beatifica*. The cross is depicted as an abstracted, theological concept with an analogous object in the signs of the church, as implied by the articulated form of the central medallion and the curved, split terminals.[73] The second cross with evangelist symbols sounds the notes of eschatology in Angers' *crux gemmata*, along with the Incarnation elements discussed above.

The two images of the cross presenting different versions of its significance are physically separated in Essen, their sequential connection built by the body of the book. In Angers, the diptych format of the single opening underscores the dependence of these various aspects of the cross upon one another as distinct components of the single sign. The image's form elucidates the continuity between two visions of the cross, while the Passion narrative in which the crosses appear demonstrates the origin of the sign's significance. The pictorial *signum crucis* in turn represents both the standard and the very identity of the book that incorporates it.

In a prefatory position for a gospel book, the cross summarizes and proclaims both the event of the crucifixion as the Gospels' unifying element, and the

71 See, for example, the Lothar Cross (pl. 25a–b). On the grouping of multiple cross portraits, see Conor Newman and Niamh Walsh, 'Iconographical analysis of the Marigold Stone, Cardonagh, Inishowen, Co. Donegal' in Moss (ed.), *Making and meaning*, pp 167–83. The most common configuration for the two sides of Western metalwork crosses presents one jewelled side and one side of vine scrolls and a central lamb (the 'Ardennes Cross' in the Germanisches Nationalmuseum, Nürnberg, represents a rare Carolingian survival): the contrast between two faces embodies the double nature of the event they interpret and commemorate. **72** My thanks to Dr Birgitta Falk for granting access to the manuscript. On the Essen Gospels, see Micheli, *L'Enluminure du haut moyen âge et les influences irlandaises*, pp 84–6. **73** The split form of the terminals corresponds to those of the Ardennes Cross. The central medallion appears in object cases ranging from the giant sixth-century Antioch Cross held in the Metropolitan Museum of Art, New York (with a bust portrait, inv.

meaning of that event for the soteriological project in which the gospel book is one of the church's elemental instruments. In its isolated prefatory role, the function of the Angers image is related to that of a book cover – the most common site of surviving crucifixion imagery from the Carolingian world. This Carolingian deployment of the scene often retains at its core an older tradition of gospel book covers defined by crosses.[74] The thorned crosses common to a subset of Carolingian ivory crucifixions probably made for manuscript covers distinguish, like Angers 24, between cross and crucifixion.[75] The identity of the cross-sign *as* a sign – and particularly as an instrumental sign – illuminates the function of the gospel manuscript. The gospel book embodies and substitutes for Christ's presence in the liturgy.[76] Defining the body of the book as representative of the body of the cross strengthens this identification because, as in a *maiestas crucis*, the image of the cross comes to stand for a fundamental aspect of the person of Christ. Further defining the gospel book as representative of the instrumental *sign* of the cross points up the codex's status within the church and liturgy. The gospel book is an exceptionally powerful mediator of Christ's presence, but it falls short of providing direct communion. In the direct relationship it claims to the crucifixion and the heavenly liturgy,[77] the Mass is the prime vehicle for continuity between the church's instruments – book, cross, bread – and their invisible counterparts – the Word, the cross and the body of Christ. In its assimilation of the Gospel itself to the *signum crucis* at the beginning of the text proper, the Angers diptych offers a context for church-mediated salvation represented by a direct relationship between the historical Passion and its liturgical heir. The Angers diptych belongs to a large family of objects and images working to negotiate the gap between the presence of signs and the absence of their source. In this, the image reflects the nature of the cross-sign at its core, and the book that carries both.[78]

no. 50.5.3) to the sadly torqued gold example from the seventh-century Staffordshire Hoard. **74** On cross-bindings: Frauke Steenbock, 'Kreuzförmige Typen frühmittelalterliche Prachteinbände' in V. Elbern (ed.), *Das erste Jahrtausend: Kultur und Kunst im werdenden Abendland am Rhein und Ruhr*, I (Düsseldorf, 1962), pp 495–513; John Lowden, 'The Word made visible: the exterior of the early Christian book as visual argument' in E. Klingshirn and L. Safran (eds), *The early Christian book* (Washington, DC, 2007), pp 13–47. The Lindau Gospels has it both ways: see von Euw, *Die St Galler Buchkunst vom 8. bis zum Ende des 11. Jahrhunderts*, pp 409, 410–11 on the cross and crucifix covers as an historic pair. **75** Sèpiere and Fricke have each suggested that the development of crucifixion iconography represents an introduction of narrative to mitigate excessive devotion to the cross-sign: see Sepière, *L'Image d'un dieu souffrant*, p. 31; Fricke, *Ecce fides*, p. 133. Chazelle proposed that the rise of crucifixion iconography in the Carolingian period is linked to increasing interest in interpreting the liturgy as a whole: see Chazelle, 'Crucifixes and the Liturgy'. **76** Lentes, '*Textus Evangelii*', p. 147; see also Ó Carragáin, '"*Traditio Evangeliorum*" and "*Sustenatio*"', pp 401–7. **77** See especially Chazelle, *Crucified God in the Carolingian era*, pp 81–99 on the Gellone Sacramentary. **78** For valued guidance while preparing this essay, I particularly thank Jeffrey Hamburger and Lawrence Nees, John Parker, Walter Gern, Matthias Exner, Elizabeth Parker, and Adrian and Elizabeth Kitzinger.

Mass and the Eucharist in the Christianizing of early medieval Europe

CELIA CHAZELLE

Give me an old lump of stone
Rough, unhewn and weather beaten
To stand upon the place I lie
Big enough to sit yourself upon
And small enough for tired feet
To touch the ground.
There, small children's jumps
Will be safe on summer afternoons.
Cut my name on the north side!
Where the sun seldom stops to shine
Cut it deep where the rain can run
And drops can hide and tiny mosses
Grow to green the grooves of letters there!
Cut 34, my birth, I'm told
And the partner year, it waits to meet!
And side by side they'll stay in stone
Till time and tide will wear them down
Below the best that eyes can see.

Cut these words of measurement
To sum my days on sun-lit paths
Or icy roads of fear and cold
When bothers came to break my hope
Or strengthen sinews in my soul.
So artist, with your chisel sharp,
Have a glass of winter wine!
And cut the letters 'HE' for me
And then a sip and then a cut
Till 'FAILED' is carved in perfectly!
And please, my friend, no dismal dot
To stop at that and say no more
One word more for goodness sake
To make a plea to passing wind
'Tis all I ask when I am gone
One kindly word to qualify
'HE FAILED'
Give me 'NICELY'

MICHAEL DOYLE[1]

1 I am grateful to many friends and colleagues for sharing ideas and bibliographic references, reading drafts of this essay and listening to me talk on and on about early medieval Mass rituals. Special thanks to Michelle Brown, Bernadette Filotas, Helen Foxhall Forbes, David Ganz, Gary Macy and Rosamond McKitterick; John Munns and Alan Thacker for opportunities to speak at Emmanuel College Cambridge and the University of London, in February 2009; Joseph Hlubik for much information about ancient and modern liturgies; and the organizers of the wonderful *Envisioning Christ on the Cross* conference in March 2010. My appreciation also to the College of New Jersey for

The poet Michael Doyle was raised on a family farm in Rossduff, Co. Longford, Ireland.[2] Ordained to the priesthood in 1959, he left soon thereafter for the United States, following in the footsteps of several relatives and countless other Irish emigrants to North America. He spent his first decade in the US teaching in Catholic schools in Camden, New Jersey, and nearby towns, when Camden was a largely white, middle class city. But its economy spiralled downhill in the 1960s, and in the later sixties Doyle ran into trouble for publicly denouncing the Vietnam War. In 1971, in the midst of heated racial violence in Camden, he was arrested with a group called the 'Camden 28' for breaking into a government building to destroy military draft records. The Camden 28 faced forty-seven-year prison sentences when they went on trial in 1973, but the jury acquitted them in part because Doyle and the historian Howard Zinn, who was called as a witness for the defence, so forcefully argued for the moral imperative of civil disobedience against governments that perpetrate injustice.[3] The next year, the bishop offered Doyle the position of pastor at Sacred Heart in Camden, a church at the time falling into ruin, in the middle of an impoverished, predominantly black, and non-Catholic neighbourhood. But Sacred Heart quickly filled with local Catholics and Catholics from the suburbs, many of whom left their home churches to join Doyle in protest at the failure of other clergy to oppose the war and racism.

Today, Camden, its population over 50 per cent black and almost 40 per cent Hispanic, is the poorest city in the United States, though New Jersey is one of the two wealthiest states.[4] Doyle has spent over forty years working to alleviate the manifold racial, economic and environmental injustices inflicted on the city's residents. The theme of failure in 'Give Me Nicely' stems from his knowledge that for the present, these conditions remain intractable; his efforts to combat them, like those of numerous colleagues, friends and parishioners, fall tragically short. And yet the sense of hope to which the poem also alludes – the hope that he will have failed 'nicely' – is a reminder of the theology of the crucifixion that infuses

a SOSA award that provided a teaching reduction for this research. **2** The poem, previously unpublished, appears here with the author's permission. Other poems by Doyle are published in Michael Doyle, *It's a terrible day, thanks be to God*, foreword by Daniel Berrigan (Camden, NJ, 2003); the book can be purchased through the Camden non-profit organization, the Center for Environmental Transformation: online at http://camdencenterfortransformation.org/you.htm (accessed 18 Dec. 2010). The details of the poet's life are taken from this book, conversations with him and Sean Dougherty's moving 2008 documentary, 'Poet of poverty': http://poetofpoverty.com/ (accessed 18 Dec. 2010). **3** Anthony Giacchino nicely tells the dramatic story in a 2007 documentary, 'The Camden 28': www.camden28.org (accessed 18 Dec. 2010). **4** US Census Bureau 2006 data shows Camden to be the nation's poorest city measured by median household income and percentage living in poverty: Camconnect, 'Poverty in Camden', online at www.camconnect.org/documents/poverty_handout.pdf (accessed 18 Dec. 2010). The median household income for New Jersey (as of 2008) was $70,347, the nation's second highest: US Census Bureau, *Small area income and poverty estimates*, online at www.census.gov/did/www/saipe/data/highlights/2008.html (accessed 18 Dec. 2010).

his spirituality and indeed his entire worldview. For Doyle, the story of the crucified Christ, a story with failure at its centre, holds out the promise that the forces aligned against justice will someday be turned upside down. The crucifixion together with the resurrection, a transformation of death into life, defeat into victory, sorrow into joy, is the fundamental paradigm governing human history, even in a place like twenty-first-century Camden.

Let us turn back thirteen hundred or so years now to the seemingly unrelated topic of the Christianization of early medieval Europe. As I hope will be evident by the end of this essay, the career of an Irish priest in a modern American ghetto is less disconnected from that situation than it may presently seem. Studies of early medieval Christianity typically focus on the narrow ranks of the elite and the institutions they controlled. To some extent, the focus is understandable, given that the lower social strata of the period were largely illiterate, and elite milieux, where the means of textual production were concentrated, produced virtually all our surviving sources. In the last few decades, however, early medieval historians have increasingly directed their attention to the Christian beliefs and practices of lower level communities – to the channels through which the common populus, for the most part originally pagan, learned about Christian conventions, the meaning that conversion held for them, their understanding and adaptation of Christian rituals and doctrine, and ways that their relationship with Christianity evolved over time. The preponderance of evidence for investigating these issues has to be filtered from the writings of educated circles, texts that primarily set out their authors' interpretations of Christian thought and practice. It is critical to remain sensitive to the biases; very often, 'popular' attitudes and customs can only be discerned by probing beneath rather opaque layers of elite rhetoric. When early medieval authors refer to certain rituals among ordinary populations as pagan or magical, for example, we must remember that the labels do not necessarily reflect the viewpoints of participants. Sometimes, there are good reasons to suspect they saw the same practices as perfectly Christian and orthodox. If we analyse with this caution in mind, though, reading against the grain, we can glean some interesting insights into the processes by which early medieval Europeans became Christian.

One way to describe the diffusion of Christianity at all social levels of early medieval Europe is by reference to baptism: by the twelfth century as was not true in the fifth – to take these commonly cited end and starting points of the early medieval era – it was the norm for infants in most of Europe to be baptized.[5] Among the children who survived into adulthood, we can further surmise, the

5 On the gradually emerging preference for infant baptism in the early Middle Ages, see Peter Cramer, *Baptism and change in the early Middle Ages, c.200–c.1150* (Cambridge, 1993), pp 113–29, 138–40. But the development was very uneven, with much local and regional variation: see Felice Lifshitz, 'A cyborg initiation? Liturgy and gender in Carolingian East Francia' in Celia Chazelle and Felice Lifshitz (eds), *Paradigms, methods and periodization: rethinking early medieval studies in twenty-

majority were also Christian in the sense of being acquainted with certain teachings of the faith. However lacking in formal schooling and regardless of what they actually believed, which is harder to determine, the majority were surely aware of – most basically – the concepts of a triune God of Father, Son and Spirit, the existence of heaven and hell, the future salvation of the blessed and damnation of the wicked, and doubtless other doctrines as well.[6] But the most significant changes that came with Christianization, it has been suggested, had to do with perceptions of physical space, as the landscape grew increasingly dotted with monasteries, churches and other Christian sites, and of history or time.[7] The theological outlook of Michael Doyle obviously has profound differences from that of early medieval Christians, yet it is reasonable to think that by the twelfth century, as was not true in the fifth, most Europeans similarly envisaged Christ's Passion as a turning point in human history. True, this intellectual shift occurred earlier in elite groups than with common laypeople, yet by the twelfth century, it seems to have pervaded all social ranks. For the majority of Europeans by the close of the early medieval period, the crucifixion and its outcome in the resurrection, both symbolized by the cross, bisected time from creation to the Last Judgment. Although episodes of the distant past, they were the key to every person's hope of salvation in the future, and thus their occurrence impinged on every moment in the past, present and future.

This worldview spread within the broader population of early medieval Europe partly through the preaching and teaching of Christian clergy, monks, nuns and other ministers. More important than their speech alone, however, were the words plus actions of their rituals. While baptism and penance also evoke the crucifixion and resurrection, the primary liturgical ceremony for this was the Mass. If we take the modern Catholic Mass as a comparison, since Catholicism is the Christian denomination in which Masses are most celebrated today, each performance is clearly designed to recall the Last Supper and, in the Eucharist, Christ's sacrifice on the cross. Additionally, the Mass is a daily ritual within a weekly liturgical cycle that includes the fast of Friday, the day of the crucifixion, and culminates with the Mass of Sunday, the day of the resurrection. And Masses

first-century America (New York, 2007), pp 101–17; and Sarah Foot, '"By water in the spirit": the administration of baptism in early Anglo-Saxon England' in John Blair and Richard Sharpe (eds), Pastoral care before the parish (Leicester, 1992), pp 171–92 at pp 186–90. **6** See G.R. Evans, The church in the early Middle Ages (London, 2007), pp 9–18, 50–2; Richard Fletcher, The barbarian conversion: from paganism to Christianity (Berkeley, CA, 1999), pp 5–9. The combined missionary strategy of preaching and baptism is highlighted in Bede's story of Augustine's conversion of King Ethelbert of Kent: Bede, Historia ecclesiastica, 25–6, in Historiam ecclesiasticam gentis Anglorum; Historiam abbatum; Epistolam ad Ecgberctum; una cum Historia abbatum auctore anonymo, ed. Charles Plummer (2 vols, Oxford, 1896), i, pp 44–7. **7** Yitzhak Hen, 'Converting the barbarian West' in Daniel E. Bornstein (ed.), Medieval Christianity (Minneapolis, MN, 2009), pp 29–52, at pp 36–9; Fletcher, The barbarian conversion, pp 242–84.

are the core ceremonies in the interlocking annual cycles of the temporal and sanctoral, the former tracing events surrounding Christ's life, death and resurrection – the observances of Christmas, Holy Week, Easter and so on – and the latter honouring the saints.

Before the reforms ushered in by the Second Vatican Council, one striking characteristic of Catholic Masses was their high degree of uniformity. On any given day in churches throughout the world, the same language, Latin, would be heard for this service, and most ritual actions were more or less identical. Yet even Catholics only familiar with the more differentiated post-Vatican II liturgies would be surprised at the variety of Christian ritual customs in early medieval Europe, above all, it seems, those of non-elite communities. Historians of early medieval Christianity have analysed this situation for baptism, penance and the deathbed, but much less for Masses, and references to 'the' early medieval Mass in their studies suggest an assumption that the liturgy had basically the same structure wherever conducted.[8] There are hints in our sources, though, of such an array of practices pertaining to Masses and Eucharists, especially in places removed from the main centres of Christian authority, wealth and learning, as to invite us to wonder whether we are dealing with a single ritual category or – as I think makes better sense of the evidence – a rather large, interrelated group of food- and drink-ceremonies.[9] It is impossible to gain a clear view of the frequency with which ordinary early medieval populations and their Christian ministers celebrated Masses or what they regarded as Masses, or of how they understood the ceremonies; one difficulty is determining the forms of ritual they might have identified in this way.[10] But whenever 'Masses' were performed, different ritual leaders clearly did some very different things.

The following pages survey these conditions before more briefly discussing how the Carolingian clerical hierarchy sought to impose, at lower social levels, more uniform practices conforming to elite customs for Masses and to educate participants about their meaning. While these efforts to systematize Mass ritual had only limited success, they were critical to strengthening the hold of

8 To cite just one major work: Josef A. Jungmann, *The Mass: an historical, theological and pastoral survey*, trans. Julian Fernandes (Collegeville, MN, 1976), see esp. pt I, chs 5–6, pp 54–74. On baptism, see Susan Keefe, *Water and the word: baptism and the education of the clergy in the Carolingian Empire* (2 vols, Notre Dame, IN, 2002) and Lifshitz, 'A cybourg initiation?', 101–17; on death rituals, see Frederick Paxton, *Christianizing death: the creation of a ritual process in early medieval Europe* (Ithaca, NY, 1990); on penance, see the work of Rob Meens, for example, 'Penitentials and the practice of penance in the tenth and eleventh centuries', *Early Medieval Europe*, 14 (2006), 7–21. **9** Compare Carole M. Counihan, 'The social and cultural uses of food' in Kenneth F. Kiple and Kriemhild Coneè Ornelas (eds), *The Cambridge World History of Food* (2 vols, Cambridge, 2000), ii, pp 1513–23; and the articles in Michael Dietler and Brian Hayden (eds), *Feasts: archaeological and ethnographic perspectives on food, politics and power* (Washington, DC, 2001). **10** See Yitzak Hen, *Culture and religion in Merovingian Gaul, 491–751* (Leiden, 1995), pp 71–2.

Christianity in lower ranking populations and, in the process, to the inculcation there of Christian notions of time and history. It is plausible that as Mass liturgies acceptable to the Carolingian clergy were performed over and over again in individual communities, and the weekly and annual liturgical cycles of which they were central elements unfolded, the sacred past they evoked gradually penetrated the fabric of local life. Slowly, Jesus' life, death and resurrection, along with other stories recalled through the ceremonies (stories from the Bible and narratives of the saints) were pulled into the present, reinforcing for believers the sense of living within a shared frame of Christian time.[11]

EARLY MEDIEVAL MASSES AND EUCHARISTS

The best place to begin a survey of early medieval customs for Masses and Eucharists is with the ingredients of the latter.[12] Early medieval liturgical guidebooks and commentaries, doctrinal tracts, letters and other writings from these centuries reveal a firm consensus in educated circles that 'the Eucharist' is confected of bread and wine or wine mixed with water, elements that become in some sense Christ's body and blood.[13] In practice, though, particularly in northern Europe, the sacrament often did not include wine, one reason being the problems maintaining a regular supply.[14] Accounts of miraculous transformations of water into wine hint at the difficulty, as does the ninth-century Old Saxon poem, *Heliand* (*Saviour*), which refers to 'wine' at the Cana wedding made from apples or fruit.[15] Other literature points to a norm of Eucharists consisting of bread alone or bread with another drink. The Irish *Voyage of St Brendan* implies the monks celebrated bread and water Eucharists; a decree from a council held in Braga in 675 condemns the serving of milk and bunches of grapes.[16] A sixth-century decree from Auxerre forbids the use of water mixed with honey; the tenth-century scholar Regino of Prüm warns against using honey and milk.[17] English priests sometimes

11 The late Robert Markus eloquently discusses analogous processes in earlier centuries, in *The end of ancient Christianity* (Cambridge, 1990), pp 125–35; see esp. p. 127. **12** See 'The Eucharist in early medieval Europe' in Ian Christopher Levy, Gary Macy and Kristen Van Ausdall (eds), *A companion to the Eucharist in the Middle Ages* (Leiden, 2012), pp 205–49. **13** See the classic study, with references to early medieval literature, by Henri Cardinal de Lubac, *Corpus mysticum: the Eucharist and the church in the Middle Ages, historical survey*, trans. Gemma Simmonds (London, 2006). **14** Michael McCormick, *Origins of the European economy: communications and commerce, AD300–900* (Cambridge, 2001), pp 609, 653–4, 699. **15** For example, see Giselle de Nie, *Views from a many-windowed tower: studies of imagination in the works of Gregory of Tours* (Amsterdam, 1987), pp 112–13; *Heliand* 24, 26, in *Heliand und Genesis*, ed. Otto Behaghel (Tübingen, 1958), ll 2015–16, 4633, pp 72, 160. **16** *Navigatio S. Brendani abbatis*, 10–11, ed. Carl Selmer (Notre Dame, IN, 1959), pp 20–8. My thanks to Éamonn Ó Carragaín for bringing this source to my attention. *Concilio de Braga* 3 (a. 675), in *Concilios Visigóticos e Hispano-Romanos*, ed. José Vives (Barcelona, 1963), p. 372. **17** On the four paradisal liquids (milk, honey, wine and oil), see Jennifer O'Reilly, 'The Hiberno-Latin tradition of the evangelists and the Gospels of Mael Brigte',

served beer, and twelfth-century theologians discussed whether it was valid to add only a drop of wine to a large quantity of water to extend reserves.[18]

As for the bread, this seems a ubiquitous ingredient for Eucharists, yet, as the ruling against grapes suggests, other solid food could be present for the ritual. Until the Carolingian period and in many communities long after, women baked the bread for Masses, and they and their families brought it to the altar with other offerings such as money, property titles or food that was laid there to be blessed or 'consecrated', as some sources state.[19] The instructions for a twelfth-century ordeal stipulate that the accused should eat cheese and bread placed on the altar, both evidently blessed during the Mass. Some sacramentaries contain special Mass prayers of consecration for grapes and beans.[20] The tenth-/early eleventh-century writer Burchard of Worms mentions gifts of corn, grapes and oil.[21] The Carolingian scholar Walafrid Strabo reiterates earlier decrees against gifts of milk, honey, vinegar, vegetables, meat and birds, and he insists that these should be blessed with different prayers than for consecrating the Eucharist. The implication is that he knew of clergy allowing such gifts and using the same prayers for them as for the Eucharistic consecration. Walafrid also denounces laypeople who persist, in his day, in placing slaughtered lambs on or near the altar for 'consecration' in the Easter Mass, then ritually eating them as the first food of the subsequent feast.[22] The food brought to altars was thus varied and, texts imply, amounts could be large. Council rulings note that after Masses, left-over oblations should be divided between the church, the clergy and the poor;[23] but like the Easter lambs, some of this 'consecrated' food was obviously consumed by those who brought it. Such rituals endured despite efforts by clergy to restrain them. Educated writers believed that Eucharists should consist of bread, wine and water alone, distinguished these ingredients from other food gifts, and advocated rituals making the differences clear. But for many early medieval Christians, it is apparent, Eucharists of bread with water, honey, milk or another drink were perfectly valid, and Mass ceremonial

Peritia, 9 (1995), 290–309, esp. 293–5. **18** These and other substitutes for the wine of Eucharists are discussed in an important, as yet unpublished essay by Gary Macy, 'Bloody marvelous: discussions of the wine in medieval Eucharistic theology'. I am grateful to Dr Macy for permitting me to reference his work. **19** David Ganz, 'Giving to God in the Mass: the experience of the offertory' in Wendy Davies and Paul Fouracre (eds), *The languages of gift in the early Middle Ages* (Cambridge, 2010), pp 18–32; my thanks to Prof. Ganz for allowing me to read and reference his article prior to its publication. Also see Arnold Angenendt, 'Das Offertorium' in *Zeichen-Rituale-Werte*, ed. Gerd Althoff unter Mitarbeit von Christiane Witthöft (Münster, 2004), pp 71–150, esp. pp 78–82, 88–94. **20** Anglo-Saxon ordeal by *corsned*: 'Corsned', *Oxford English Dictionary* (2nd ed., Oxford, 1989). See nos 238–9, *A source book for mediaeval history*, ed. and trans. Oliver J. Thatcher and Edgar H. McNeal (New York, 1905), pp 409–10; Derek Rivard, *Blessing the world: ritual and lay piety in medieval religion* (Washington, DC, 2009), pp 51–3. **21** Burchard of Worms, *Decretum*, 5:8, *PL*, 140, col. 754; Ganz, 'Giving to God'. **22** Walafrid, *Libellus de exordiis et incrementis quarundam in observationibus ecclesiasticis rerum*, 19, ed. Alice Harting-Correa (Leiden, 1996), pp 108–9. **23** Angenendt, 'Offertorium', pp 97–8.

blended smoothly into the offering, sharing and consumption of other food blessed and consecrated at the same altars with the same or different prayers. Almost certainly, many participants did not differentiate Eucharists from these other gifts or distributions of food and drink as sharply as more learned clergy would have liked.

Beyond the question of the ingredients of Eucharists, we need to consider the actions and speech of the liturgies in which they were confected. It is important to note that the term 'Mass' (*missa*) is ambiguous in early medieval writings, particularly from before the eighth century. Often it seems to refer to ceremonies solely of prayers, recitations, music or readings, with no evident Eucharistic consecration.[24] If we focus, though, only on the Mass rituals clearly involving Eucharists that are outlined in liturgical guides like sacramentaries and ordinaries, most dating from the eighth century and later, we find a broadly similar structure.[25] In general, these books stipulate, the liturgy should begin with the clergy's entrance, followed by a series of prayers and readings from scripture or other sacred literature, then possibly a homily. Another set of prayers should be recited before the offertory, and then catechumens and penitents who would not receive communion were dismissed. After this came an additional prayer or prayers to consecrate the bread and wine, the section of the service sometimes designated the canon of the Mass. Then the prayer 'Our Father' should be recited, sometimes with other texts, communion distributed, and the liturgy should conclude with a final prayer or prayers.

But within this frame there was again space for numerous local and regional variations. Narrative sources indicate that communities made their own arrangements for where celebrants and other participants sat or stood during Masses, the decoration of worship spaces and other features. Different sacramentaries assign the same prayers and recitations to the Masses of different days, or different ones to the same liturgical events, and record special prayers for a huge swathe of votive Masses and Masses for saints' feast days.[26] Manuscripts were revised as they changed hands to suit different local needs; the Stowe Missal, an Irish service book probably written for an itinerant cleric in the early ninth century, shows substantial alterations to the order of the Sunday Mass when a different community acquired it not long after its completion.[27] Different versions exist of the narrative of

24 Jungmann, *The Mass*, pp 64–5; Hen, *Culture and religion in Merovingian Gaul*, p. 67. The meaning of *communio* similarly evolved; I discuss this briefly in 'The Eucharist in early medieval Europe', n. 64 (see n. 12, above). **25** For surveys of these texts, Eric Palazzo, *A history of liturgical books from the beginning to the thirteenth century*, trans. Madeleine Beaumont (Minnesota, MN, 1998), pp 37–56; Cyrille Vogel, *Introduction aux sources de l'histoire du culte chrétien au moyen âge* (rev. ed., Spoleto, 1975), esp. pp 31–187. **26** Yitzhak Hen, *The royal patronage of liturgy in Frankish Gaul: to the death of Charles the Bald (877)* (Woodbridge, 2001), pp 28–33; idem, 'The liturgy of the Bobbio Missal' in Yitzhak Hen and Rob Meens (eds), *The Bobbio Missal: liturgy and religious culture in Merovingian Gaul* (Cambridge, 2004), pp 140–53. **27** Sven Meeder, 'The early Irish Stowe

institution, the recitation in the canon echoing Jesus' words over the bread and wine at the Last Supper; and the narrative is missing from most Mozarabic liturgical manuscripts.[28] The seventh-century bishop Isidore of Seville implies its usage was unfamiliar to him; instead, according to Isidore, the 'Our Father' is the final of seven 'sacrificial prayers' corresponding to the seven-form Spirit, 'by whose gift the offerings are sanctified' (*cuius dono ea quae offeruntur sanctificantur*).[29] A letter by Pope Gregory the Great may similarly allude to Masses in which the bread and wine were consecrated through the 'Our Father'.[30]

Furthermore, we must remember that the sources just discussed, even a non-luxury book like the Stowe Missal, were produced in and for relatively educated circles. Many clergy, religious and ministers in lower level early medieval communities had limited literacy and, regardless of their ability to read, owned few if any writings, nothing approaching a comprehensive set of liturgical manuals. Accordingly, the majority must have relied primarily on memorized prayers and ritual or, more frequently, since memory may have often proved inadequate, their own creativity. Such conditions are suggested by surviving council decrees and other writings – reflecting again the perspective of elite circles – that complain about clergy who recite ritual texts incorrectly and stress the need for them to learn certain ones by heart. The eighth-century scholar Bede advised Archbishop Egbert of York that priests ignorant of Latin, and thus presumably unable to read, should memorize the 'Our Father' and Apostles' Creed in the vernacular. Bede expected them to 'consecrate the heavenly mysteries' (*consecrandis mysteriis caelestibus*); did he envisage consecration with these two texts alone, or with improvised prayers?[31] While his letter does not enable us to answer this question, overall it seems that, as was true in antiquity,[32] many ministers in early medieval Europe viewed Mass prayers and actions as flexible and to some degree extemporaneous – akin, it would appear, to popular songs, which have traditionally combined fixed structures and formulae learned through repetition with newly invented material.[33] If so, this made for an infinitely greater variety of Mass rituals than we can directly discern from surviving literature. Indeed, the growing production of liturgical books from the eighth century may well have been partly motivated by concerns to restrain such customs and, instead, disseminate the notion that rituals *should* follow set norms, not be improvised.

Missal's destination and function', *Early Medieval Europe*, 13 (2005), 179–94. **28** Rose Walker, *Views of transition: liturgy and illumination in medieval Spain* (London, 1998), pp 154–73, esp. pp 161–2; Raúl Gómez-Ruiz, *Mozarabs, Hispanics and the cross* (Maryknoll, NY, 2007), p. 62 (concerning the institution narrative). **29** Isidore, *De ecclesiasticis officiis*, 1:15, CCSL, 113, ed. Christopher M. Lawson (Turnhout, 1969), pp 17–18. **30** Gregory, *Registrum*, *Ep.* 9:26, CCSL, 140A, ed. Dag Norberg (Turnhout, 1982), p. 587. **31** Bede, *Epistola ad Ecgberctum*, in *Historiam ecclesiasticam*, ed. Plummer, i, pp 408–9. **32** Palazzo, *A history of liturgical books*, p. 36, with reference to earlier bibliography. **33** Albert Lord, *The singer of tales*, ed. Stephen Mitchell and Gregory Nagy (2nd ed., Cambridge, 2000), esp. pp 99–138; compare L. Michael White, *Scripting*

Similarly, various texts condemning 'false' priests and bishops and implying tensions over clerical ordination point to divergent opinions about the proper qualifications for ritual leadership.[34] Early medieval ecclesiastical administration, we should bear in mind, was highly decentralized, especially before the Carolingian period.[35] Episcopal jurisdiction was uneven; relationships between clerical offices and between them and male or female religious houses fluctuated. Countless ministers at lower social levels worked more or less autonomously, with little interference from higher up the ecclesiastical ladder. One corollary, increasing again the potential diversity of customs for Masses, is that many Christian communities chose their ritual leaders – male and female – from among their own members and developed their own criteria for selection.[36] While these leaders are sometimes criticized in contemporary writings, they clearly had followers who believed their ministry legitimate. Many male clergy were married, and some leaders or co-leaders of Masses were women. A late fifth-century letter of Pope Gelasius refers to women serving at altars; a letter from three sixth-century Gallican bishops chastises two priests from Brittany for conducting Masses in partnership with their female 'co-residents', and a few later texts hint, as well, at Masses with women ministers.[37] In this light, it is reasonable to think that married male clergy (such as probably the two Breton priests) sometimes celebrated Masses with their spouses, whether in public or in their household gatherings. And women-only Masses or analogous ceremonies likely occurred at times when women assembled without men, such as in convents, though the evidence is ambiguous. Some episodes in the *Life of Burgundofara*, a seventh-century abbess of Faremoutiers, for example, may hint at these rituals; one passage tells of a nun who, at God's command, approached Burgundofara for confession and reconciliation 'with the sacred body' (*sacroque corpore reconciliata*); another recounts how a nun miraculously recited a form of Eucharistic prayer.[38]

Jesus: the Gospels in rewrite (New York, 2010), pp 87–105. I am grateful to Fr Joseph Hlubik for this suggestion and for directing me to both of these works. **34** For example, *Concilium Germanicum A742*, Praef., 1, 3, 4, *Monumenta Germaniae Historica* [henceforth *MGH*], *Leges*, 3, *Concilia*, 2, ed. Societas aperiendis fontibus (Hannover, 1906), pp 2, 3; *Concilium Francofurtense A794*, 27–9, *MGH*, *Leges*, 3, *Concilia*, 2, p. 169; and see *The letters of Saint Boniface*, trans. Ephraim Emerton, with a new introduction and bibliography by Thomas F.X. Noble (New York, 2000), nos 64 (80) (reply of Pope Zacharias), pp 122–4; 34 (44) (reply of Pope Gregory III), p. 49; 40 (50), p. 58; 41 (51) (reply of Zacharias), p. 62. **35** For an excellent overview of these conditions and Christianity's evolution in this social and cultural environment, see Julia Smith, *Europe after Rome: a new cultural history, 500–1000* (Oxford, 2005), esp. pp 217–39. **36** Gary Macy, *The hidden history of women's ordination: female clergy in the medieval West* (Oxford, 2008), pp 26–35. **37** *Les sources de l'histoire du Montanisme*, ed. Pierre de Labriolle (Fribourg, 1913), pp 227–8; Macy, *Hidden history*, pp 61–3. **38** 'Life of Burgundofara', 13, 16, in *Sainted women of the Dark Ages*, ed. and trans. Jo Ann McNamara (Durham, 1992), pp 165–8; Jonas, *Vita S. Columbani* 2, *MGH*, *Scriptorum rerum Merovingicarum*, 4, *Passiones vitaeque sanctorum aevi Merovingici*, ed. Bruno Krusch (Hannover, 1902), pp 133, 135. See (though I think reading the evidence for 'Masses' too narrowly), Gisela

Not only were there variant forms of Mass ritual, however, and different criteria for deciding who could minister. Adding further to the range of customs was the interweaving of Masses with other rituals both inside and outside churches: ordeals and feasts, as noted earlier, but also animal sacrifices, rituals for the dead and relic processions, among others.[39] Early medieval liturgical manuals outline Mass ceremonies as if they had a clear beginning and end; but another possible aim behind the books' production – besides those already suggested – was to define these ritual boundaries. At what point did a Mass stop and a feast, procession or dance begin? Boniface appears to accuse contemporary priests of sacrificing animals, and many early medieval Christians may have viewed priest-led and other animal sacrifices (the lambs for Easter altars?) before, after or during Masses as stages of a single liturgy.[40] The ambiguity of boundaries also seems to have been spatial. While the clergy performed Masses, lay participants conducted their own affairs nearby; early medieval writers complain about congregations engaged in business transactions, gossiping, even fighting while the liturgies were underway.[41] Clearly, there were different ideas about how to distinguish the sacred space for Masses from space suitable for other activities.

Also presenting interpretive difficulties are the recorded rituals utilizing previously consecrated bread: did participants consistently differentiate these ceremonies from Masses? Early medieval penances for dropping consecrated bread outdoors may refer to clergy or lay people who took it from churches, sometimes to distribute in other locales.[42] What the recipients in those places did with the bread is not always clear, though it must have usually been consumed, sometimes in communion services; two twelfth-century Italian manuscripts prepared for convents contain prayers for these services closely resembling Mass prayers.[43] But other occasions for eating blessed or consecrated bread also presented themselves. Gregory of Tours refers to special bread (*eulogias*) that Christians who had not taken communion would receive at the close of a Mass, a custom analogous to the distributions of blessed (non-consecrated) bread at the end of Masses in modern Orthodox churches.[44] Already consecrated bread was doubtless sometimes used for

Muschiol, *Famula dei: zur Liturgie in merowingischen Frauenklöstern* (Münster, 1994), esp. pp 101–6, 192–222. **39** See, for example, Einhard, 'The translation and miracles of the blessed martyrs, Marcellinus and Peter', 1:12, 14; 2:6; 3:1, 4, in *Charlemagne's courtier: the complete Einhard*, ed. and trans. Paul E. Dutton (Petersborough, 1998), pp 81–2, 89, 92, 94. **40** *Letters of St Boniface*, no. 64 (80) (reply of Zacharias), p. 122. **41** See Hen, *Culture and religion in Merovingian Gaul*, pp 72–5. **42** 'Penitential of Theodore', 12:6, 8, 'Penitential ascribed by Albers to Bede', 14:2, 3, in John T. McNeill and Helena M. Gamer, *Medieval handbooks of penance: a translation of the principal Libri Poenitentiales* (New York, 1938, repr. 1990), pp 195, 230. **43** Jean Leclercq, 'Eucharistic celebrations without priests in the Middle Ages', *Worship*, 55 (1981), 160–8 **44** … *ipse clamare coepit et dicere, quod non recte eum a communione sine fratrum conibentia suspenderemus. Illo autem haec dicente, cum consensu fratris qui praesens erat, contestatam causam canonicam, eulogias a nobis accepit*: Gregory of Tours, *Decem Libri Historiarum* 5:14, ed. Bruno Krusch and Wilhelm Levison

communion after baptism and, more clearly, for the deathbed *viaticum*.[45] Bread, possibly Eucharistic, along with wine, Mass vessels and Mass texts are also mentioned in records of 'pagan' and 'magical' ceremonies (possibly Christian to participants): bread talismans and votive offerings, passages from Mass prayers included in incantations, chalices used for divination, consecrated wine mixed into special potions.[46]

Finally, we should note those early medieval practices that appear not to involve Mass ingredients, implements or priests but suggest interesting parallels. The sacrifices (of animals?) conducted inside churches and the effigies made from dough (here, too, bread became body) referenced in the eighth-century *Indiculus superstitionum et paganiarum* fit here,[47] as do numerous attested meal rituals. Eating and drinking could be much ritualized events in early medieval Europe, with blessings over the food and drink if participants were Christian and other Mass-like ceremonial. The choreography of feasting in *Beowulf*, where the king (called the loaf- or bread-guardian in some Anglo-Saxon sources) hosts the feasts and the queen ritually passes the cup, recalls the Masses of the Breton priests who distributed the bread while their wives or female associates presented the chalice.[48] Certain early medieval sacramentaries contain prayers for a meal ceremony called an *agape* (a Greek term for love); Carolingian and later texts refer to a monastic drinking ritual called the *caritas* (Latin for love), with gospel readings and sung praises to God.[49] A few early medieval narratives refer to meals that seem staged to evoke Masses, like the dinners that, according to Venantius, the sixth-century Queen Radegund hosted for her priests after their Sunday Masses.[50] Most textual references to feasting concern the elite, but ordinary Christians engaged in such

(Hannover, 1951), p. 208. **45** Keefe, *Water and the Word*, pp 49–50, 112–15; Paxton, *Christianizing death*, pp 32–4, 44–5, 51–2, 120–1. **46** Examples of such practices in Bernadette Filotas, *Pagan survivals, superstitions and popular cultures in early medieval pastoral literature* (Toronto, 2005), pp 243, 307–9; Valerie I.J. Flint, *The rise of magic in early medieval Europe* (Princeton, NJ, 1991), pp 214, 283, 285, 298; Don C. Skemer, *Binding words: textual amulets in the Middle Ages* (Philadelphia, 2006), pp 78, 79, 87–96, 257. **47** *Indiculus superstitionum et paganiarum*, *MGH, Legum*, 1, ed. Georg Heinrich Pertz (Hannover, 1835), pp 19–20; Filotas, *Pagan survivals*, p. 87. The *Indiculus* is conveniently reprinted online in '*Indiculus superstitionum et paganiarum*', *Wikipedia*: http://de.wikipedia.org/wiki/Indiculus_superstitionum_et_paganiarum (accessed 18 Dec. 2010). **48** *Beowulf: a new verse translation*, trans. R.M. Liuzza (Peterborough, 2000), ll 607–41; *Sources de l'histoire du Montanisme*, pp 227–8. See Michael Enright, *Lady with a mead cup* (Dublin, 1996), pp 2–16, 20–1. **49** For meal blessings, *Liber sacramentorum romanae aeclesiae ordinis anni circuli* (Cod. Vat. Reg. lat. 316/Paris, BN, 7193, 41/56) (*Sacramentarium Gelasianum*), 86–7, ed. Leo C. Mohlberg, L. Eizenhöfer and P. Siffrin (3rd ed., Rome, 1960), p. 232. Prayers for agape rituals in *Sacramentarium Gelasianum mixtum*, ed. Sieghild Rehle, introduction by Klaus Gamber (Regensburg, 1973), pp 74–5; and *Sacramentarium Gelasianum*, ed. Mohlberg et al., pp 205–6. On *caritas* ceremonies, see Carol Neuman de Vegvar, 'A feast to the Lord: drinking horns, the church and the liturgy' in Colum Hourihane (ed.), *Objects, images and the word* (Princeton, NJ, 2003), pp 231–56. **50** Venantius, *Vita Radegundis*, 1:18, *PL*, 72, col. 657; *Sainted women of the Dark Ages*, ed. and trans. McNamara, p. 78.

celebrations, too. An Anglo-Saxon council of 787 ruled that priests should not wear regular dress when performing Masses or use drinking horn-chalices, conceivably because of worries that their Masses were too similar to other feasts.[51] A comparable fear may lie behind the decree of the Council of Aachen (816) forbidding *agape* feasts inside churches; the decree implies that participants ate while reclining, perhaps to emulate the disciples at the Last Supper.[52] The confluence of Mass and other meal rituals may also cast light on the evident anxiety of some bishops about convent banquets. In the bishops' eyes, nuns who hosted feasts, blessing and serving the food and drink, perhaps too closely recalled male clergy conducting Masses. And some nuns may have understood their actions in precisely these terms.[53]

Studies of devotional practices in early medieval Europe generally treat Mass and Eucharist as if they were fixed, uniform categories: the Eucharist consisted of bread and wine mixed with water; the Mass entailed a defined sequence of prayers and actions led by male priests. There is little doubt that this was how the learned elites saw the rituals, which had acquired this fairly clear form in their circles by late antiquity.[54] But although, throughout the early Middle Ages, educated religious and clergy sought to disseminate their beliefs and practices among lower level populations, they met decidedly uneven success, and many alternative ways of defining Mass, Eucharist and Mass leadership seem to have flourished. The words and actions of Masses, the choice of drink, the food blessed or consecrated alongside the bread, the gender and other qualifications of ministers, and other features varied with local circumstances. Moreover, Mass rituals, ingredients and instruments could be separated out and recast for other purposes and blended into other sacrifices, oblations and magic or meal ceremonies. Most early medieval Christians with any knowledge of Masses, however performed, surely thought of the rituals and their Eucharists as possessing certain attributes not belonging to other food and drink ceremonies. Masses, they probably understood, commemorated Christ's Passion in a special way; the Eucharist was a special channel of divine power and salvation because it was (in some sense) his body and blood.[55] But, particularly in communities distant from the major centres of power and learning, the blending of

51 'English Church [Legatine Synods] AD787', 10, in *Councils and ecclesiastical documents relating to Great Britain and Ireland*, ed. Arthur Haddan and William Stubbs, 3 vols, *Volume 3: The English Church, 595–1066* (Oxford, 1871), pp 451–2. Discussed in Neuman de Vegvar, 'Feast to the Lord', 231–56. 52 *LXXX. Item in eodem concilio t. XXVIII. in ecclesia prandia non debere fieri. Quod non oporteat in dominicis, id est in Domini ecclesiis, convivia, quae vocantur agapae, fieri nec intra domum Dei comedere vel accubitos sternere*: Concilium Aquisgranense 816, MGH, Concilia, 2, Concilia aevi Karolini, 1, ed. Albert Werminghoff (Hannover, 1906), p. 367. 53 See Bonnie Effros, *Creating community with food and drink in Merovingian Gaul* (New York, 2002), pp 16, 39–54. 54 On the development of the Mass and the Eucharist through the fourth century, see Paul Bradshaw, *Eucharistic origins* (London, 2004). 55 I discuss the different ways these doctrines were understood in learned early medieval circles in 'The Eucharist in early medieval Europe' (see n. 12, above).

Masses and Eucharists with other devotional practices, and Christian-priestly with other ritual leadership, must have encouraged divergent ideas about these practices to persist. The emphatic distinctions made in our sources, writings of the learned elite, between Masses and rituals for other purposes, Eucharists and other types of sacrifice, the bread and wine of a Mass and other blessed or enchanted food and drink, correctly appointed priests and false priests or even sorceresses, and so forth were not universally accepted. A comment by the ninth-century Carolingian monk-priest Gottschalk illustrates the possibilities for disagreement. Near the beginning of one of his treatises on the Eucharist, Gottschalk recalls a feast he attended in Bulgaria where, he says, his noble host invited him to drink 'in love of the god who makes his blood from wine'. Gottschalk pointedly identifies his host as a pagan (paganus), but I think we should ask ourselves whether – if the episode is not fictional – the noble himself saw the feast as a Mass, the food offered as Eucharist, and his own role as that of a Christian priest.[56]

The conditions just surveyed are most evident in writings predating the Carolingian era, yet they can be traced in later centuries, as well, to varying degrees depending on the region. In the eighth and ninth centuries, however, the growing power and wealth of the Carolingian church and its royal and noble patrons facilitated a number of developments with a direct impact on liturgical conventions. Many new churches and monasteries were founded throughout the empire, particularly in Saxony, a territory with little earlier exposure to Christianity. The ranks of Carolingian clergy and monks expanded, as did the proportion of monks who took vows recognized as priestly within this clerical hierarchy.[57] Carolingian scholars and councils put new emphasis on clerical celibacy.[58] A growing number of schools taught monks and clerics to read and perform ritual according to 'correct' standards, and many, many more books were produced: Bibles, homily collections and a multiplicity of works that guided the clergy in the proper conduct of liturgies.[59]

That these developments did not uniformly reach lower social levels is evident from the concerns Walafrid and Burchard of Worms express about the behaviour of laypeople in their day.[60] Nonetheless, compared with earlier centuries, the

56 … *nam quondam in terra Vulgarorum quidam nobilis potensque paganus bibere me suppliciter petuit in illius dei amore qui de uino sanguinem suum facit …*: Gottschalk, *De corpore et sanguine Domini*, in *Oeuvres théologiques et grammaticales de Godescalc d'Orbais*, 23, ed. D.C. Lambot (Louvain, 1945), p. 325. **57** Mayke de Jong, 'Carolingian monasticism: the power of prayer', *New Cambridge medieval history, Vol. II, c.700–c.900* (Cambridge, 1995), pp 622–53, esp. pp 647–9; Gisela Muschiol, 'Men, women and liturgical practice in the early medieval West' in Leslie Brubaker and Julia M.H. Smith (eds), *Gender in the early medieval world: East and West, 300–900* (Cambridge, 2004), pp 198–216 at 209–10. **58** Mayke de Jong, '*Imitatio morum*: the cloister and clerical purity in the Carolingian world' in Michael Frassetto (ed.), *Medieval purity and piety: essays on medieval clerical celibacy and religious reform* (New York, 1998), pp 49–80. **59** On these developments, essays in *The new Cambridge medieval history II* remain unsurpassed, esp. those in Part III, 'Church and society', pp 563–678; and Part IV, 'Culture and intellectual developments', pp 681–844. **60** See

increase in Carolingian clergy and their improved resources did enable the more widespread dissemination of practices for Masses that elite circles regarded as orthodox. While Carolingian writers offer little direct insight into what happened in lower level communities, the following scenario seems generally plausible. As monk-priests and other clergy of the Carolingian imperial church – supposedly celibate men, with recognized sacerdotal status – spread their ministry, other, Christian and non-Christian ritual leaders were pushed to conform to their dictates. Local ministers whose leadership had formerly been respected within their communities but who had worked more or less independently of the imperial church, now interacted with priests trained in specific prayers and ritual actions, equipped with some liturgical books and, probably, other intriguing ritual objects such as portable altars, Mass vessels, relics, crosses and so forth, and backed by regional lords. Some local ritual leaders were likely absorbed into the same instiutional structure to which these rivals belonged, but many were marginalized or saw their functions redefined – perhaps because they were women, or perhaps married men who would not separate from their families. Some, though previously seen as legitimate, probably count among the 'false' clergy, heretics, and so-called magicians, prophetesses, sorceresses and so forth condemned in Carolingian writings.

Equally, rituals they had performed in the past, but that conflicted with those of the Carolingian institutional clergy, were suppressed or reclassified as heretical, magical or pagan. Followers were taught that only liturgies conforming to official norms were acceptable, and efforts were made to clarify the differences between them and the customs the Carolingian clergy sought to end. As far as Masses were concerned, local populations learned, only celibate male priests should celebrate them; prayers and other recitations should conform to set forms in correct Latin, and the actions to set procedures; no other ritual meals or sacrifices should occur inside churches; the Eucharists should consist only of bread or bread and wine mixed with water, no other food and drink; and Mass leaders should wear distinctive, 'clerical' vestments. Carolingian legislation also reveals new attempts to restrict women's roles in Masses, rulings that again helped differentiate Mass ceremonial from other food- and drink rituals and the routines of ordinary life. The first capitulary of Bishop Theodulf of Orleans, for instance, enjoins his priests to prepare the bread for Masses alone or only with 'their boys' (whereas women were the bread makers in early medieval homes); bans women from approaching the altar (whereas the wives of men hosting feasts might sit, stand or eat alongside their husbands); and forbids clergy from celebrating Masses in homes or other 'vile locations' (*vilibus locis*) or living with women.[61]

Filotas, *Pagain survivals*, pp 1–2. **61** Theodulf, 'Erstes Kapitular', 5–12, *MGH*, *Capitula episcoporum*, 1, ed. Peter Brommer (Hannover, 1984), pp 107–11. See Suzanne Wemple, *Women in Frankish society: marriage and the cloister, 500 to 900* (Philadelphia, 1985), esp. pp 143–8.

As this work to bring local practices in line with those of the Carolingian hierarchy continued, ordinary people were also instructed – through sermons and other speech – to recognize the superior benefits of the new Mass liturgies. The large volume of surviving Carolingian exegetical literature on the Mass and Eucharist, a quantity far exceeding that from earlier centuries in Western Europe, illumines the extent of this pedagogical effort and the nature of the instruction.[62] Two enormously popular Carolingian treatises of the ninth century, judging from the many surviving copies, offer good examples: the *Book of Offices* written by Amalarius in the early 820s, which he re-edited twice in the 830s, and the treatise, *De corpora et sanguine Domini* that Paschasius Radbertus wrote in the early 830s and revised in the early 840s.[63] The *Book of Offices*, the most detailed known early medieval liturgical commentary in Latin, contains four books on the temporal cycle, clerical offices and vestments, the Mass, and the divine office; Paschasius' tract is the first known Latin treatise exclusively on the Eucharist. Despite stirring controversy soon after their publication, both treatises circulated widely in the ninth and later centuries; one hundred or more manuscripts of each in different versions survive.[64] Given this number of copies, we can safely assume that doctrinal bits from both works filtered into the teachings of Carolingian clergy at lower social levels.[65]

For purposes here, the most significant feature of both treatises is the vivid language with which the Mass is tied to the crucifixion, the Eucharist to the crucified Christ. Paschasius offers the most explicit exposition from early medieval Europe of the doctrine that, spiritually and imperceptibly, the bread and wine of the Mass become not simply Christ's body and blood but the very body or flesh (*caro*) born in Bethlehem and crucified in Jerusalem. This change occurs when the priest recites the words Jesus spoke over the bread and wine at his Last Supper,

62 See Celia Chazelle, *The crucified God in the Carolingian era: theology and art of Christ's Passion* (Cambridge, 2001), pp 132–64, 209–38. **63** Amalarius, *Liber Officialis*, in *Amalarii episcopi opera liturgica omnia*, ed. J.-M. Hanssens (3 vols, Vatican, 1948–50), ii; Paschasius, *Pascasius Radbertus De corpore et sanguine Domini cum appendice epistola ad Fredugardum*, ed. Beda Paulus (Turnhout, 1969). **64** On the manuscripts of the *Liber officialis*, see *Amalarii opera*, i, pp 120–200; Christopher A. Jones, *A lost work by Amalarius of Metz* (London, 2001), pp 8–9, 19–23. On the manuscripts of Paschasius' *De corpora*, see Paulus, 'Einleitung', *De corpore*, CCCM, 16, pp vii–xlviii at pp ix–xxxvi. I discuss Amalarius' treatise in 'Amalarius' *Liber officialis*: spirit and vision in Carolingian liturgical thought' in Giselle de Nie, Karl Morrison and Marco Mostert (eds), *Seeing the invisible in late antiquity and the early Middle Ages* (Turnhout, 2005), pp 327–57; and Paschasius' treatise in 'Figure, character and the glorified body in the Carolingian Eucharistic controversy', *Traditio*, 47 (1992), 1–36 and *Crucified God in the Carolingian era*, pp 210–25, with references to earlier literature. **65** Passages from Amalarius' text were incorporated into liturgical manuals: Roger E. Reynolds, 'Image and text: a Carolingian illustration of modifications in the early Roman Eucharistic *Ordines*', *Viator*, 14 (1983), 59–75 at 64. Paschasius composed his treatise to assist Warin of Corvey in his instruction of Saxon novices at Corvey, eventual priests, who presumably then went out to preach and teach in the surrounding countryside: see Paschasius, *De corpore, Prologus*, CCCM, 16, pp 4–5.

Paschasius asserts, words in a Mass that only priests can repeat.[66] The identity this recitation forges beween bread and wine and the historical flesh and blood means, in his belief, that the unique sacrifice on the cross is replicated in every Mass liturgy, and thus that the Mass is a unique manner of feast. Only this food and drink, the saving body and blood of Christ that nourish believers 'until the end of the age', can unite them with the incarnate Christ 'from his flesh and bones', rendering them 'two in one flesh'. Through the Eucharist, the faithful are fed corporally as well as spiritually, the foundation of hope for the resurrection of body along with soul at the end of time.[67]

As for Amalarius, while he agrees that Christ's body and blood are spiritually present through the consecrated elements – no early medieval Christian writer denies this precept – he does not explicitly identify the Eucharist with the historical flesh and blood. The principal concern of the *Book of Offices* is not to explain the nature of the sacramental transformation but to ferret out the spiritual meaning of each perceptible feature of Mass ritual. The stress is on the liturgy's typology of sacred historical events, in particular the Passion through the resurrection, and of the objects related to that history: the cross, the tomb, the cloth that wrapped Jesus' body, and so on.[68] For Amalarius, the sacred significance of every text, implement, action and vestment of the Mass and the Eucharist's ingredients is proof that they are all divinely ordained. The pinnacle of the ceremony, as he understands it, the stages from the offertory through the Eucharistic consecration, is a dramatic performance that places believers mystically in the presence of Jesus at his Passion and burial, witnessed through the 'eye' of the mind.[69] 'In the sacrament of bread and wine, as indeed in my memory', Amalarius writes, 'the Passion of Christ is on display'. In the Mass, in the present, Christ ascends the cross.[70]

An infrequent theme of art before the Carolingian era, the crucified Christ is suddenly depicted in a plethora of Carolingian liturgical settings: on church furnishings and walls, in sacramentaries and gospel books and on book covers.[71] Like the treatises by Amalarius and Paschasius, the artwork again signals the conviction of Carolingian clergy that it is their Masses, and theirs alone, that liturgically commemorate the crucifixion and re-present Christ's sacrificed body and blood in the Eucharist. Granted that most surviving images were produced for elite audiences, this doctrine increasingly filtered into lower social ranks. Although

66 Paschasius, *De corpore*, 15, *CCCM*, 16, pp 92–6. **67** See Paschasius, *De corpore*, 7, 18, 19, 21, *CCCM*, 16, pp 37–40, 100, 101, 112–13. **68** See Paul Rorem, *The medieval development of liturgical symbolism* (Bramcote, 1986), pp 21–4. **69** Amalarius, *Liber officialis*, Praef. 1, *Praefatiuncula*, 3, pp 19, 25. **70** *In sacramento panis et vini, necnon etiam in memoria mea, passio Christi in promptu est.… Sicut in superioribus Christi corpus est vivum in sacramento panis et vini, atque in memoria mea, ita in praesenti ascendit in crucem*: Amalarius, *Liber officialis*, 3:25, pp 340–3, see 3:19, 3:26, pp 343–50; also Amalarius, *Liber officialis*, Proemium, 6, p. 14. **71** See Chazelle,

early medieval clergy (including Paschasius and Amalarius) believed the Eucharist should be received daily since mortals daily sin, many of their lay contemporaries may have attended Masses – or ceremonies that the elites agreed were Masses – at best a few times a year.[72] Yet even so, the repetition of the Mass liturgies of the elite over the course of the temporal cycle, year after year, in different communities of the Carolingian Empire, gradually deepened participants' understanding of the crucifixion and resurrection as the pivotal events in human history. A corollary was the slow erosion of countless alternative ritual customs in lower level communities, powerful conduits in their own right of spiritual and supernatural power.

CODA

To return to the present: Whether one sees the changes traced here as for the better or worse or neutrally, it should be apparent that a line of sorts can be drawn from the unity of practice the Carolingian clergy worked to achieve, as did with increased success clergy in later medieval centuries, to the work of a priest like Michael Doyle in Camden. Despite the variable elements and languages of post-Vatican II liturgies, the structure of a modern Catholic Mass remains essentially the same wherever celebrated, and the manifestation of unity is a core meaning ascribed to the ceremony. No matter where or when the ritual is performed, for believers, the consecration of bread and wine mixed with water, with similar prayers and actions as in other churches, recalls and re-presents the same historical events: the last supper and the sacrifice on the cross. As many of them understand, this is a ritual that links them not only to Catholics in other churches and to Christ, but to the entire world.[73] For Doyle, such unity in, with and through the crucified body of a poor carpenter from Nazareth ought to set every participant on the side of the world's poor in the struggle against oppression. Although he worries about failing the poor of Camden's streets, others have a very different view of what he has accomplished.[74] But without the daily sacrifice of 'the' Mass, it is unlikely that he would have found the energy to endure in Camden all these past years.

And yet somewhat like the laypeople Walafrid worried about, who held onto their own customs for Masses (at least for a time) and resisted the pressure from Carolingian clergy to change, Doyle and his parishioners are not the type to blindly obey earthly authority when its demands conflict with their sense of what is valid, appropriate or right. One illustration is of course his stand against the

Crucified God in the Carolingian era, pp 239–99. **72** Julia Smith, 'Religion and lay society', *New Cambridge medieval history II* (n. 57, above), pp 654–78, at pp 662–3. **73** Pierre Teilhard de Chardin, *Hymn of the universe*, ch. 1: 'Mass on the world'. Online at www.religion-online.org/showchapter.asp?title=1621&C=1535 (accessed 28 Aug. 2011) (*Hymn of the universe* was first published in 1961). **74** Nicely discussed by Tom Roberts, 'A love for transformation', *National Catholic Reporter* (7 Dec. 2009, online at http://ncronline.org/news/love-transformation (accessed

Vietnam War. Let me close, however, with another, smaller illustration that touches again on the Mass. This story, which concerns not Doyle himself but one of his parishioners, perhaps illumines just a bit further what happened in medieval communities, since it is so noticeably reminiscent of the convergence of Mass and feasting discussed earlier. The story begins with a dinner invitation the parishioner received some forty-five years ago, in Philadelphia, from a priest living on the campus of her university. Vatican II was only a few years old. She and twenty or so friends sat around the table, a relaxed, informal social gathering. In the middle of the meal, the priest began to talk about scripture; and then to her surprise he stood, recited a prayer of consecration over bread and a glass of wine, and passed them to his guests. Everyone said amen and shared this food and drink. There was a brief silence as they reflected on what had happened and perhaps offered prayers of their own, before the conversation and dinner resumed.

That was all; the sacred rose out of and gently subsided back into the ordinary. For many of, if not all, the guests at the dinner, that moment was as much a Mass and the bread and wine Eucharist as may have been true for the host and guests of the feast Gottschalk attended in ninth-century Bulgaria. Today, a half century after the opening of Vatican II, when Rome is more insistent than ever on separating the sacred from the worldly, male clergy – allegedly celibate – from women and other laity, church from home and accordingly Mass from meal, there are certainly many Catholics who would perceive events like the Philadelphia dinner-Mass with antipathy. Yet I have listened to enough similar stories and reflections on their meaning, from audience members who have heard me talk about early medieval Masses and Eucharists, to know that such occasions have by no means ceased to take place. In the view of some, given the recent revelations of abuse and other scandals involving the Church of Rome, it is more imperative than ever to develop varied expressions of devotion outside the channels that institutional clergy control or think they control – whether rituals centred on meals or other communal gatherings.[75] Historians interested in the Christianization of early medieval Europe would do well to consider the powerful draw still today of liturgies like these, carefully planned in advance or improvised on the spur of the moment, which respond to immediate, deeply felt spiritual needs within the groups where they arise. Recognition of the seriousness of these needs and the attraction of these rituals, even in our supposedly secularized culture of the twenty-first century, may help us better appreciate the challenges early medieval clergy faced as they sought to move laypeople in their own time away from beloved, diverse, local traditions for Masses and other rites of sacrifice, oblation and food- and drink-sharing.

18 Dec. 2010).　**75** For an eloquent call on modern Catholics to rethink Mass and Eucharist in light of the clerical abuse scandals, see the three-part article by Thomas Whelan, 'Unlearning and relearning', *Doctrine and Life*, 60:2 (2010), 2–11; 60:3 (2010), 2–10; 60:4 (2010), 2–12.

PART II

Contemplate the wounds of the Crucified

Sacrifice and salvation in Echtgus Úa Cúanáin's poetic treatise on the Eucharist

ELIZABETH BOYLE

The Eucharistic feast is fundamental to Christianity, as a commemoration and enactment of Christ's sacrifice on the cross, and as a liturgical celebration of the salvation promised by his resurrection. However, the exact nature, properties and function of the bread and wine at the Eucharistic feast have long been the subject of debate and dispute.[1] In 1080 or 1081, as the Berengarian controversies continued to rage on the European stage, clerics in the southwest of Ireland wrote to one of the greatest living authorities on Eucharistic doctrine, Lanfranc, archbishop of Canterbury, to ask him questions of theological and practical importance, regarding whether or not the Eucharist need be administered to newly baptized infants in order to ensure their salvation. In his response (which was in the negative), Lanfranc highlighted the conjunction between the narrative of Christ's execution and resurrection, and the salvation of the individual, as they are enacted through the Eucharistic feast. Commenting on Christ's declaration that 'Except you eat the flesh of the Son of Man, and drink his blood, you shall not have life in you' (Jn 6:54), Lanfranc wrote:

> Therefore the Lord's saying must be understood in this way. Let every believer who can understand that it is a divine mystery, eat and drink the flesh and blood of Christ not only with his physical mouth but also with a tender and

[1] For a theological and historical overview of the development of Eucharistic doctrine in Europe, see Edward J. Kilmartin SJ, *The Eucharist in the West: history and theology*, ed. Robert J. Daly SJ (Collegeville, MN, 1998). For detailed studies of the period under consideration here, see Gary Macy, *The theologies of the Eucharist in the early Scholastic period: a study of the salvific function of the sacrament according to the theologians, c.1080–c.1220* (Oxford, 1984); J. de Montclos, *Lanfranc et Bérenger: La controverse Eucharistique du XIe siècle* (Louvain, 1971). For a discussion of the Eucharist

loving heart: that is to say, with love and in the purity of a good conscience rejoicing that Christ took on flesh for our salvation, hung on the cross, rose and ascended; and following Christ's example, and sharing in his suffering so far as human weakness can bear it and divine grace deigns to allow him. This is what it means to eat the flesh of Christ and drink his blood truly and unto salvation.[2]

Thus, the letter's Irish audience is reminded that the Eucharist involves both a real transformation of the bread and wine into the body and blood of Christ, and also a symbolic re-enactment of Christ's Passion. Lanfranc makes explicit the link between the crucifixion and the Eucharist, but also offers his audience the opportunity, 'so far as human weakness can bear it', to share in Christ's suffering, and invites them to eat with the heart as well as with the mouth. The Eucharist, as it is presented in Lanfranc's letter, is both an institutional ritual and an intimate moment of affective piety. In the same letter, Lanfranc goes on to refer again to Christ's suffering on the cross, here quoting Augustine:

Blessed Augustine expounds this text in his book *De doctrina Christiana*, where he says, 'He seems to be ordering us to commit an outrage or an obscene act. It is therefore a figure of speech: we are directed to share in the Lord's suffering and to meditate tenderly and profitably on the fact that it was for us that his flesh was wounded and crucified'. It is figurative speech that Augustine calls 'a figure'. He does not (as many schismatics have thought and have not yet ceased to think) deny that the flesh and blood of Christ are really present. The Lord himself says in the Gospel, 'He who eats my flesh and drinks my blood dwells in me and I in him'. Blessed Augustine expounds this text as follows: 'To eat and drink the flesh and blood of Christ until salvation is to dwell in Christ and have Christ dwelling in you'. Even Judas who betrayed the Lord, received in his mouth as the other apostles did; but because he did not eat in his heart he received the judgment of eternal damnation.[3]

and bread and wine used in Carolingian Francia, see Chazelle, this volume. **2** *The letters of Lanfranc, archbishop of Canterbury*, ed. and trans. Helen Clover and Margaret Gibson (Oxford, 1979), no. 49. *Necesse est ergo predictam Domini sententiam sic intelligi, quatinus fidelis quisque diuini misterii per intelligentiam capax carnem Christi et sanguinem non solum ore corporis sed etiam amore et suauitate cordis comedat et bibat: uidelicet amando et in conscientia pura dulce habendo quod pro salute nostra Christus carnem assumpsit, pependit resurrexit ascendit, et imitando uestigia eius, et communicando passionibus ipsius in quantum humana infirmitas patitur et diuina ei gratia largiri dignatur. Hoc est enim uere et salubriter carnem Christi comedere et sanguinem eius bibere.* **3** *Letters*, no. 49: *Quam sententiam in libro* **De doctrina Christiana** *beatus Augustinus exponens sic ait: 'Facinus uel flagicium iubere uidetur. Figura ergo est precipiens passioni dominicae communicandum esse, et suauiter atque utiliter in memoria recondendum quod pro nobis caro eius uulnerata et crucifixa sit'. Figuram uocat*

Again, a balance is maintained between the Eucharist as an institutional, collective act, and the Eucharist as a moment of interiority: Lanfranc condemns the 'schismatics' who continue to deny the reality of Christ's presence in the bread and wine, while simultaneously repeating Augustine's direction to 'share in the Lord's suffering' and to 'meditate tenderly' on his wounds and his crucifixion.

Although Lanfranc undoubtedly embraced a Paschasian belief in the substantive transformation of the bread and wine into the body and blood of Jesus Christ,[4] his letter to the Irish clerics – with its mildly exasperated tone induced by the literalism of the Irishmen's question – emphasizes a slightly more figurative understanding of the Eucharist than does his *De corpore et sanguine Domini adversus Berengarium Turonensem* (composed in 1062–3, edited by Lanfranc in 1079),[5] which is a polemic written to refute Berengar's rejection of the Real Presence. Lanfranc never presented a systematic theology of the Eucharist, and it must be borne in mind that his writings on this topic are responses: *De corpore* a response to Berengar, his former teacher, and the letter to Domnall Úa hÉnna and his colleagues a response to an Irish misunderstanding of the English and Continental position on the necessity of receiving the Eucharist in order to ensure the salvation of the soul. Nevertheless, Lanfranc's letter to the Irish clerics articulates many of the problems that faced early medieval theologians when they considered Eucharistic doctrine: to what extent are Jesus' words to be understood literally or figuratively? How does one overcome instinctive revulsion at the cannibalistic overtones of Jesus' commandment? How does the intention of the person giving or receiving the Eucharist affect its salvific efficacy?

These same questions are explored in a medieval Irish poetic treatise on the Real Presence in the Eucharist, written probably at some point between *c.*1050 and *c.*1150, by Echtgus Úa Cúanáin of Roscrea, in modern-day Co. Tipperary. Indeed, perhaps it was Lanfranc's letter, so emphatic in pointing out his Irish correspondents' misunderstanding of a particular point of doctrine, that impressed upon Munster clerics the need for wider clarification of the theology of the Eucharist and the importance of having uniformity of belief among clergy and laity alike.[6] Echtgus' treatise outlines in clear but sophisticated terms the

figuratam locutionem; neque enim negat ueritatem carnis et sanguinis Christi, quod plerisque scismaticis uisum est et adhuc non cessat uideri. Et Dominus in euangelio: 'Qui manducat carnem meam et bibit sanguinem meum in me manet et ego in eo'. Quod exponens beatus Augustinus ait: 'Hoc est nanque carnem Christi et sanguinem salubriter comedere et bibere: in Christo manere et Christum in se manentem habere'. Nam et Iudas qui Dominum tradidit cum ceteris apostolis ore accepit; sed quia corde non comedit iudicium sibi aeternae damnationis accepit. **4** Paschasius Radbertus, *De corpore et sanguine Domini*, ed. Bede Paul (Turnhout, 1969). **5** Lanfranc of Canterbury, *De corpore et sanguine Domini adversus Berengarium Turonensem*, PL, 150, 407–42; *Lanfranc of Canterbury on the body and blood of the Lord; Guitmund of Aversa on the truth of the body and blood of Christ in the Eucharist*, trans. Mark G. Vaillancourt (Washington, DC, 2009). **6** For an overview of the sources for, and a useful synthesis of recent scholarship on, Eucharistic doctrine in medieval Ireland, see Neil Xavier O'Donoghue, *The*

theological significance of the Eucharistic feast, with the stated aim of educating the clergy and the laity in correct Eucharistic doctrine.[7] The text of Echtgus' poem on the Eucharist survives in ten early modern or modern manuscripts, dating from the seventeenth to the nineteenth century.[8] Some of the eighteenth- and nineteenth-century copies ascribe to the text a sixteenth-century date of composition (1544, 1554 or 1564), which in itself is interesting, given the context of Protestant objections to the doctrine of transubstantiation, but the evidence of the text would suggest that this is without foundation.[9] Linguistically, the text is Middle Irish, and I see no reason that it should not be dated, following the opinions of Aubrey Gwynn and Gerard Murphy, to the eleventh or twelfth century.[10] There are two main families of manuscripts, one of which transmits a version of the text that comprises eighty-six quatrains, the other of which comprises only the first thirty-five quatrains. The manuscript-witnesses of the longer version are older, and there is internal evidence to suggest that this represents the earlier form of the text. For that reason, this study will focus on the entire eighty-six-quatrain text, rather than the shorter, later version. Although matters of style are outside the scope of the present discussion, it is also worth noting briefly that, in terms of rhyme and metre, the text is an accomplished literary work that adheres to the norms of medieval Irish poetic composition. More pertinent to our present purposes, however, is the simple but important fact that this is poetry as theology, and theology as poetry. This dynamic interplay

Eucharist in pre-Norman Ireland (Notre Dame, IN, 2011). However, as O'Donoghue notes, many of the relevant sources are in dire need of re-editing, and there is much basic groundwork to be done before more concrete conclusions can be drawn. I hope that my current work on Echtgus' text will make some small contribution in this regard. **7** The text was edited from Brussels, Bibliothèque Royale, MS 5100–4, pp 16–18, by A.G. van Hamel during the First World War: 'Poems from Brussels MS 5100–4', *Revue Celtique*, 37 (1917–19), 345–52 at 345–9. Without wishing to diminish van Hamel's achievement in completing this work in what must have been very difficult political circumstances, his edition is sadly inadequate, containing numerous errors of transcription. Therefore, all quotations from the text in what follows are from my own semi-diplomatic transcription from that manuscript, which I have completed as part of a forthcoming edition of the text, to be published in the *Medium Ævum* Monographs Series; all translations are my own. The translation published by Gerard Murphy ('Eleventh- or twelfth-century Irish doctrine concerning the Real Presence' in J.A. Watt, J.B. Morrall and F.X. Martin (eds), *Medieval studies presented to Aubrey Gwynn SJ* (Dublin, 1961), pp 19–28) is rather loose in places, which is particularly problematic in a text expounding a theological doctrine that relies so heavily on grammatical and semantic interpretation (for example, a great deal of doctrinal debate regarding the Eucharist centres on how one understands the *est* in *hoc est enim corpus meam*). **8** Brussels, Bibliothèque Royale, MS 5100–4 [B]; Dublin, University College, MS Franciscan A33 [F]; Cambridge, University Library, MS Add. 708 [C]; Dublin, National Library of Ireland, MS G315 [G]; Maynooth, National University of Ireland, MS 3F19 [M1]; Maynooth, National University of Ireland, MS 3F20 [M2]; Maynooth, National University of Ireland, MS 4B2 [M3]; Dublin, RIA, MS Fvi1 [D1]; Dublin, RIA, MS 23G24 [D2]; Dublin, RIA, MS 23G25 [D3]. **9** D1 and D2 give the date of composition as 1544; G and D3 as 1554; M1 and M3 as 1564. **10** Aubrey Gwynn and Dermot F. Gleeson, *A history of the diocese of Killaloe* (Dublin, 1962), p. 74; Murphy, 'Eleventh- or twelfth-century

between form and function raises similar questions to the studies of the interplay between theology and visual art that are found elsewhere in this volume. We might ask ourselves whether the form in which Echtgus wrote his text had any theological implications for his treatise, and even how its form affects our own appreciation of both its aesthetic and its doctrinal value. In the case of Echtgus' composition, I would argue that the act of writing theology in a mode that requires adherence to strict metrical rules acted as a form of insurance, so to speak, fixing the text within the constraints of rhyme and metre, and perhaps thus ensuring a more reliable transmission for this elucidation of a central point of Christian doctrine.

While Echtgus wrote the text, as he tells us, to educate priests and the laity in correct Eucharistic doctrine, he is also concerned with his own salvation. He writes: 'Oh Christ, who suffered for my sake, there is nothing better than prayer to you; forgive my sins, oh God, oh son of the Virgin Mary'.[11] Echtgus continues: 'For the Lord's sake, pray with me, that I may attain union with the king of the stars, I have practised my calling without aversion, Echtgus my name, I am a descendant of Cúanán'.[12] This personal declaration illustrates several themes that give the text its literary and theological coherence: first, the significance of the salvation of the individual – in this case, the author himself – second, the importance of the priest in his role as enactor of the narrative of sacrifice and salvation as it is played out in the Mass (here illustrated by the use of the term *gairm*, 'calling' or 'vocation', to indicate Echtgus' own clerical status),[13] and third, the idea of completeness and unity. This latter theme is expressed on a number of levels throughout the text, and pertains to the completeness of the body of Christ as it is present in each Eucharistic host and simultaneously in heaven; the completeness or virginity of Mary throughout Christ's conception and birth; and also the completeness or unity of the church, both among its constituent members, and in the relationship between Christ and the church, as in this example where Echtgus hopes for ultimate union with God. The purpose of the present study is to highlight instances of these various thematic strands, insofar as they reflect the text's concern with the narrative, the performance, and the theology of sacrifice and salvation.[14]

doctrine', p. 20. **11** §83: *A C[h]ríst rochés tar mo chenn, [t]h'atach nocon fhuil ní as ferr, maith mo chaire damh, a Dhé, a meic Maire ingine.* **12** §84: *Ar in coimdhidh guided lem, co rís aéntaidh rígh na renn, ro chlechtus mo gairm gan gráin, Echtgus m'ainm im ua Cúanáin.* **13** We have no biographical information about Echtgus, but can infer from this reference that he was a monk and/or a priest. It has been assumed by some scholars that Echtgus is the same person as an Ísác Úa Cúanáin, bishop of Roscrea, whose death is recorded in the *Annals of the Four Masters* in 1161 (see, for example, the *Dictionary of Irish biography*, http://dib.cambridge.org/, in which there is one entry under 'Ua Cúanáin, Echtgus (Isaac)'). However, given the nature of the medieval Irish ecclesiastical system, in which families were often linked with particular ecclesiastical foundations for many generations, this identity cannot be asserted unreservedly. Echtgus and Ísác may be the same person, or they may simply have been members of the same family. **14** For the importance of the unity of

Echtgus begins his text by emphasizing the Real Presence of the body and blood of Christ within the bread and wine of the Eucharistic feast. He then locates that feast within the context of the narrative of Christ's Passion, thus establishing the connection between Christ's sacrifice and the salvation promised by the Eucharist. He writes: 'Have you heard of the bread and the wine, truly the body of Christ, and his blood, which he gave to his disciples – beautifully he relinquished them – the Thursday before his suffering?'[15] Echtgus' wording here deliberately echoes aspects of the account of the Last Supper as it is described in the liturgy:

> Who the day before he suffered, took the bread into his holy and venerable hands: having raised his eyes to heaven, unto thee, O God, his Father almighty, giving thanks to thee, blessed, broke it, and gave it to his disciples, saying: Take, all of you, and eat of this: For this is my body.[16]

The influence of the liturgy on Echtgus' text can most notably be seen in the 'Thursday before his suffering' (*dia dardain riana chésadh*), 'which he gave to his disciples' (*tuc dá muintir*), and 'truly the body of Christ' (*corp críst … iar fír*). I suggest that the purpose of these liturgical echoes in the Irish text is to evoke the idea of Christ as a priest, performing the Eucharistic rite, alongside his depiction as the principal character in the narrative of the Last Supper. That Echtgus consciously sought to interlink the Last Supper with the words of the liturgy is supported by his later explicit characterization of Christ as a priest: 'The best priest under heaven, Christ himself as you know, gave his body and his blood to Judas; since he was evil it did not help him'.[17] We might note the use of the word *sacart*, 'priest', to describe Christ; this in contrast to the depiction of Judas as the apotheosis of the wicked priest: 'Judas, though the ordained man was evil, if he

the church in a visual context, see Harley McGowan, this volume. **15** §6: *In cuala in abhlainn sin fín, corp Críst is a fhuil iar fír, tuc dá muintir caín roscar, dia dardain riana chésadh* **16** *Qui pridie quam pateretur, accepit panem in sanctas, ac uenerabiles manus suas: eleuatis oculis in caelum ad te Deum Patrem suum omnipotentem, tibi gratias agens, benedixit, fregit, dedit discipulis suis, dicens: Accepite, et manducate ex hoc omnes. Hoc est enim corpus meum.* This section of the 'words of institution' combines elements from Mt 26:26–7, and 1 Cor 11:23–4. In the absence of any consensus about the form of the Mass being used in eleventh- and twelfth-century Ireland, I have opted (admittedly arbitrarily) to cite the form as found in *Le canon de la messe romaine. Édition critique*, ed. B. Botte OSB, *Textes et études liturgiques*, 2 (Louvain, 1935), p. 38. I have added punctuation and capitalization; the translation is my own. See also *The missal of St Augustine's Abbey, Canterbury, with excerpts from the antiphonary and lectionary of the same monastery*, ed. Martin Rule (Cambridge, 1896), pp 42–3. **17** §24: *In sacart is ferr fo nimh, Críst fodéin, is deimhin libh, tucc d'Iúdas a chorp 'sa fhuil, uair rob olc ní rofhogain.* See Lanfranc's letter to Domnall Úa hÉnna: *Nam et Iudas qui Dominum tradidit cum ceteris apostolis ore accepit; sed quia corde non comedit iudicium sibi aeternae damnationis accepit*; 'Even Judas who betrayed the Lord, received in his mouth as the other apostles did; but because he did not eat in his heart he received the judgment of eternal damnation', *Letters*, no. 49.

had given the body of Christ to a holy man, after believing and after repenting his sins, it would have been a complete, pure sacrifice'.[18] Although the translation, 'ordained man' (literally 'man of ecclesiastical rank'), is slightly awkward, it indicates the contrast expressed in the text between the priest, Christ and Judas, who is not accorded that title. Of particular significance is the last line of this quatrain, which emphasizes that, notwithstanding the sinfulness of the cleric who dispenses the Eucharistic host, the sincerity and virtue of the recipient ensures its salvific function. Here we see a balance established between the significance of the priest, as enactor of the Eucharistic feast, and that of the individual, whose pure intention can overcome the sinfulness of the priest dispensing the Eucharist. This may have had particular resonance during the period of ecclesiastical reform in Ireland, when the morality of priests was brought into question, and the issue of clerical chastity was foregrounded in religious rhetoric. Echtgus' statement that the salvific efficacy of the Eucharistic host is undiminished by the priest's unworthiness may have been made with particular individuals in mind. Certainly Echtgus' non-priestly audience (whether that consisted of monks who were not ordained priests, or a wider lay audience, or both) is reassured that, whether the priest is worthy or not, the Eucharist can be a complete and pure sacrifice. As noted above, the theme of completion and wholeness is key to understanding the text.

The word *ógh*, meaning 'complete', 'entire', 'perfect' and 'virgin', occurs no fewer than fourteen times in the text.[19] Elsewhere, other vocabulary and imagery are employed to emphasize the completeness of Christ's body, both within the Eucharistic host, and simultaneously as it exists in heaven. For example, Echtgus tells us 'There is no blade or fire, there is certainly no element, which boasts tonight, oh Son of God, that disperses the resurrected body'.[20] That the body of Christ is present in each Eucharistic host, and yet is simultaneously complete in heaven, is an issue that is addressed extensively in Echtgus' poem, but we should note that it was also a central concern for Lanfranc in his objections to Berengar's interpretation of the Eucharist. Berengar suggested that if the body of Christ were present in the Eucharistic host, Christ as he exists in heaven would be divided, and thus lessened, when the host was broken into pieces and eaten. Lanfranc countered that the body of Christ was present in each host, and that when the host is broken and eaten, Christ's body continues to exist simultaneously in heaven, complete and entire.[21] Indeed, Echtgus' vocabulary of unity and completeness is reminiscent of Lanfranc's description of Christ's body in heaven as 'immortal, inviolate, whole, uncontaminated and unharmed'.[22] Echtgus emphasizes this point by stating that

18 §25: *Iúdas, gerbh olc in fer gráidh, da tucadh corp Críst do fhir cháidh, iar creidimh iar coi cinad, ropad edbairt ógh idhan.* **19** §§3, 4, 22, 25, 27, 34, 38 (4 times), 39, 57, 61, 85. In this regard, it may be significant that the death-notice for Ísác Úa Cúanáin in the *Annals of the Four Masters* describes him as *ógh* ('virgin') (see n. 13, above). **20** §69: *Ní fhil íarann na teinidh, ní fhuil nach dúil co deimhin, maidhes anocht a meic Dé, scailes corp na héiseirge.* **21** *De corpore*, c.11. **22** *De corpore*,

'though the wafer can be divided in its own form, the body of the king cannot truly be divided in any way',[23] and that 'though there be many hosts on the paten, all believe – question it not – that every single host is complete, without flaw or weakness, that it is a perfect body'.[24]

But another kind of completeness with which Echtgus is greatly concerned is the completeness, or wholeness, of the church. He describes the desirability of having a 'complete/perfect church',[25] and invokes the topos of Christ as the head of the church and the believers as its body. He explicates the mixing of the water and the wine in the chalice thus:

> By the water – gentle judgment –
> the believing people are understood;
> Christ, head of all, without sin, is understood,
> by the smooth wine, without doubt.
>
> As they have been joined as one,
> the water and the true lovely wine,
> Christ is joined, noble completeness of knowledge,
> together with the church.[26]

Importantly, we are reminded that the unity of the church is not merely an abstract concept, but rather it has real, practical implications. Echtgus offers this pastoral advice to priests: 'My counsel to ordained people: if the ignorant approach them, do not give them the manifest body, until they might discover correct belief.'[27] Indeed, in the final quatrain of the text, we see the practical application of Echtgus' composition. He writes: 'A blessing upon all pure, ordained people, for the sake of the king of heaven and earth. Let them commit this to memory for God's sake; let them deliver it to the people'.[28] The text was ostensibly written to be learnt by priests and preached to the people.[29] Here we see the text functioning

c.18 (PL, 150, 430C): ... *immortali, inviolato, integro, incontaminato, illaeso* ... ; *Lanfranc of Canterbury*, p. 66. **23** §69: *Acht cia gaibh in abhlu eimh, rannugadh ina deilbh féin, ní gheibh co fír ó nach mudh, corp in rígh a rannughadh.* **24** §72: *Cidh imdha pars forsin tesc, creitit cách ná bíd 'na ceist, is lomnan cen locht cen lasc, is corp comhlan cech aenphars.* **25** §27: *Ar aí chena is edh is chóir, don ecclais airmitnigh óig* ... **26** §32–3: *Triasan uiscce bithe in breth, tuicter popal na creitmech, tuicther Críst cenn cáich cen col, triasin fín mbláith cen baeghol./ Mar ro haccomlait maraen, in t-uiscce isin fín fírchoémh, accomhlatar sáer slán fís, Crist maraén ris an eclais.* **27** §82: *Comairle uaim don aés gráidh, madhat buirb tísat 'na ndáil, ná tabhrat dóibh in corp nglé, co fágbat cóir na creidme.* **28** §86: *Beannacht ar an aes ngráidh nglan, ar dáigh rígh nimhe is talman, mebraighet sin ar Dhia ndil, derlaiccet dona daoinibh.* **29** There remains the interesting question of the exact context within which the text would have been 'delivered to the people'. We might, for instance, consider the text as some sort of poetic homily, which would have been preached during Mass. There are other vernacular Irish poetic texts with strong catechetical elements that raise similar questions of function and performance, such as the twelfth-century poem on the origins of liturgical chant, which was

within a wider context of ecclesiastical reform, not only in the poem's obvious themes, in its stated desire for uniformity of belief at all levels of society, but also in the more subtle themes – particularly the emphasis on the role of the clergy, but also perhaps in the text's concern with virginity (another form of completeness, which recurs in the text).[30]

Echtgus and Lanfranc use the same passages from the writings of Ambrose to emphasize Mary's virginal state throughout Christ's conception and birth. Although Echtgus may have had access to complete copies of Ambrose's *De mysteriis* and *De sacramentis*, it is equally possible that Lanfranc's *De corpore* was Echtgus' immediate source, given that all of the passages in Echtgus' text that I have been able to identify as deriving from Ambrose, are also quoted in *De corpore*.[31] For example, Lanfranc quotes Ambrose directly, saying

> If we seek the usual course, a woman after mingling with a man usually conceives. It is clear then that the Virgin conceived contrary to nature. And this body which we make is from the Virgin. Why do you seek here the course of nature in the body of Christ, when the Lord Jesus himself was born of the Virgin contrary to nature?[32]

Echtgus makes the same point thus:

> It is thus were ever born,
> The children of Adam for all time,
> Of the lust of a man in union with woman,
> From their joining besides.
>
> Mary bore a good son,
> Christ, our abbot and our noble lord,
> Without lust in her body,
> Without joining of her virginity.

edited and translated by Brian Ó Cuív: 'St Gregory and St Dunstan in a Middle-Irish poem on the origins of liturgical chant' in N. Ramsey, M. Sparks and T. Tatton-Brown (eds), *St Dunstan: his life, times and cult* (Woodbridge, 1992), pp 273–97. **30** On the movements for ecclesiastical reform in Ireland at this time, see Denis Bethell, 'English monks and Irish reform in the eleventh and twelfth centuries', *Historical Studies*, 8 (1971), 111–35. See also Martin Holland, 'Dublin and the reform of the Irish church in the eleventh and twelfth centuries', *Peritia*, 14 (2000), 111–60; Martin Brett, 'Canterbury's perspective on church reform and Ireland, 1070–1115' in Damien Bracken and Dagmar Ó Riain-Raedel (eds), *Ireland and Europe in the twelfth century: reform and renewal* (Dublin, 2006), pp 13–35. **31** On Lanfranc's extensive familiarity with Ambrose's writings, see Margaret Gibson, *Lanfranc of Bec* (Oxford, 1978), pp 40, 83. **32** Ambrose, *De mysteriis*, 8:52, 53; quoted in Lanfranc, *De corpore*, c.18 (*PL*, 150, 431C–D): *Si ordinem quaerimus, viro mixta femina generare consuevit. Liquet igitur quod praeter naturae ordinem Virgo generavit, et hoc quod conficimus corpus ex Virgine est. Quid hic quaeris naturae ordinem in Christi corpore, cum praeter naturam sit ipse Dominus*

Complete before the birth of her son, great deed,
Complete at his birth, without doubt,
Complete after his birth, enduring the practice,
Complete throughout time perpetually.

If you believe in the birth of Christ, without concealment,
From the virgin in the face of nature,
Believe that he is concealed (it is not sinister),
In the form of wine and wafer.[33]

The emphasis placed on Mary's virginity not only echoes Lanfranc's *De corpore*, but may also have resonated with a clerical audience in light of contemporaneous debates about clerical chastity and the issue of hereditary entitlement to ecclesiastical office.[34]

The wider intellectual context of ecclesiastical debates in eleventh- and twelfth-century Munster remains to be fully explored and is outside the scope of the present study. However, in an analysis of the twelfth-century high cross at Roscrea, which depicts Christ on the cross on one side, and a bishop on the other, Raghnall Ó Floinn has suggested that the depiction of the bishop wearing a mitre more reminiscent of papal than episcopal headgear, on this and other contemporary crosses, may have been 'a deliberate attempt to stress the apostolic role of the bishop in the twelfth-century Irish church'.[35] Ó Floinn notes that Bernard of Clairvaux, in his Life of Malachy (Máel Máedóc Úa Morgair) of Armagh, describes how, after instructing Malachy to return to Ireland with the palls and to convene a general council, Innocent II 'took his mitre from his own head, and placed it on Malachy's head', thus representing direct papal authority for Malachy's reforming agenda.[36] Bernard's Life of Malachy, written shortly after Malachy's death in 1148, may also provide a context for our understanding of Echtgus' text.

Jesus partus ex Virgine?; trans. in *Lanfranc of Canterbury*, p. 68. Other examples from Ambrose that appear in both Echtgus' text and Lanfranc's *De corpore*, ch. 18, are Moses' staff turning into a serpent and then returning to its original form (see Ambrose, *De mysteriis*, 8:49–51) and the provision of manna to the Israelites as described in Exodus (see Ambrose, *Epistola ad Irenaeum*). For the theological and philosophical discussion of nature, and specifically Christ's nature, in the works of Eriugena, see Hawtree, this volume. **33** §§36–9: *Is amhlaidh ro chinset riamh/ clanna Adaim co himcian,/ d'accobur fhir d'óentaidh mná/ dia n-accomul archena./ Ruccastar Muire mac maith/ Críst ar n-ab is ar n-ardfhlaith,/ cen accobur ina cri/ cen accomhal a hóigi./ Ogh ria mbreith a meic maith modh/ ógh icá breith ní baeghol,/ ógh iarna breith buan in bés,/ ógh tria bithiu do bithghrés./ Ma creti gein Críst cen cleith/ ón óigh i n-aighid n-aicnidh,/ creit a beith fo cleith ni clé,/ i ndeilbh fhína is abhlainne.* **34** For a sceptical view of the significance of this issue, see Martin Holland, 'Were early Irish church establishments under lay control?' in Bracken and Ó Riain-Raedel (eds), *Ireland and Europe in the twelfth century*, pp 128–42. **35** Raghnall Ó Floinn, 'Bishops, liturgy and reform: some archaeological and art historical evidence' in Bracken and Ó Riain-Raedel (eds), *Ireland and Europe in the twelfth century*, pp 218–38 at p. 234. **36** Cited in Ó Floinn, 'Bishops, liturgy and reform', p. 234.

That the Eucharistic controversies of eleventh-century Europe were well known to the Irish is not only suggested by Lanfranc's side-swipe at Berengar in his letter to the Irish clerics written in 1080/1,[37] but is also suggested by the fact that those debates are evoked in the Irish Eucharistic controversy depicted in Malachy's *Vita*. It is clear that Bernard would wish his audience to believe that there was some sort of Berengarian controversy in Ireland during Malachy's lifetime (1094/5–1148), and that Malachy himself acted in the role of Lanfranc. Although it may ultimately derive from a genuine Irish controversy, Bernard's narrative contains so many Berengarian elements that it possesses little value as an historical account. As he describes it, a learned cleric from Lismore preaches that the presence of Christ in the Eucharist is figurative rather than real:

> In his own eyes a knowledgable man, he had the presumption to say that in the Eucharist there is only a sacrament and not the *res sacramenti*, that is only the sanctification and not the true presence of the body.[38]

He is twice called before an assembly of clerics (the first behind closed doors, the second in public) at which he is denounced as a heretic after refusing to accept the orthodox position on the Real Presence. As with Echtgus, Bernard emphasizes Malachy's concern for uniformity of belief, and for the unity of the church. The parallels that Bernard draws with the Berengarian controversy are obvious, and need not detain us unduly, but it is worth noting that the vocabulary with which the Irish heretic is said to have described the Eucharist – that it is only the sacrament and not the *res sacramenti* – explicitly evokes Berengar's arguments as characterized by Lanfranc in chapter 10 of his *De corpore*.[39] Furthermore, the two assemblies of clerics are undoubtedly meant to echo the councils of 1059 and 1079 at which Berengar was made to recant his views on the Real Presence. In the absence of any other evidence, the idea that the Life preserves an account of a genuine Eucharistic controversy in Ireland cannot be substantiated. However, what are noteworthy for our purposes are the broader thematic parallels between Echtgus' treatise and Bernard's Life of Malachy. For example, through miraculous intervention, this hagiographical narrative brings an Irish heretic from his rejection of the Real Presence in the Eucharist to a deathbed acceptance of Catholic doctrine and receipt of the Eucharist, thus ensuring the heretic's ultimate salvation. While fleeing in dishonour from the second assembly, the heretic is seized by a

37 *Letters*, no. 49: *Neque enim negat ueritatem carnis et sanguinis Christi, quod plerisque scismaticism uisum est et adhuc non cessat uideri*, 'He does not (as many schismatics have thought and have not yet ceased to think) deny that the flesh and blood of Christ are really present'. **38** Bernard of Clairvaux, *Life of Malachy*, §57, *PL*, 182, 1073–1118 (1105C–1106A): *Is sciolus in oculis suis, praesumpsit dicere, in Eucharistia esse tantummodo sacramentum, et non rem sacramenti, id est solam sanctificationem, et non corporis veritatem. Bernard of Clairvaux: the life and death of Saint Malachy the Irishman*, trans. Robert T. Meyer (Kalamazoo, MI, 1978), pp 71–2. **39** *PL*, 150, 421A;

malady that leaves him unable to move. A passing madman tells him that this is a forewarning of death, but we are informed that it was God speaking through the madman, because the heretic had gained nothing from the counsel of sane men. The heretic is thus reconciled to correct doctrine on the Real Presence:

> Within the hour the bishop was called, truth was acknowledged and error rooted out. He confessed that he had been in the wrong and was absolved. Then he asked for the *viaticum* and a reconciliation was effected. At practically the same moment that his lips renounced all his faithless wrongdoing he was dissolved by death.[40]

The use of a divine miracle to confirm the truth of a Paschasian belief in the Real Presence, and therefore ensure the salvation of an individual, is evocative of Lanfranc's statement that God can use miracles as a way of convincing those who entertain doubts about the transformation of the bread and wine into the body and blood of Christ: 'worthy miracles ... by which the veil of visible and corruptible realities is removed, and Christ is seen as he truly is – his flesh and blood appearing to bodily eyes'.[41] Certainly, Echtgus also makes use of such a miracle to support his position on the Eucharist when, drawing on Paschasius Radbertus' *De corpore et sanguine Domini*, he recounts the narrative of the Eucharistic host being transformed, on the altar of St Ninian, into the Christ child.[42] In Echtgus' version of the miracle, the doubtful cleric Flagellus (in Paschasius' *De corpore*, the priest is called Plecgils) beseeches God to reveal the true form of the Eucharistic host, whereupon it is transformed into the infant Jesus.[43] As with the episode in the Life of Malachy, it is a cleric who takes the central role in this episode, and his individual salvation is assured after divine intervention allows him to recognize the 'true' form of the Eucharistic host. However, if we return to the letter from Lanfranc with which this study began, we might note a contrast here: where Lanfranc invites us, following Augustine, to 'share in Christ's suffering', and to 'meditate tenderly and profitably on the fact that it was for us that his flesh was wounded and crucified', Echtgus turns not to the crucified Christ, but rather to the Christ-child, as the object of affective piety. This affords his audience a different, though equally intimate, example of Eucharistic devotion.

Lanfranc of Canterbury, p. 51. **40** *PL*, 182, 1106: *Eadem hora accitur Episcopus, agnoscitur veritas, abjicitur error. Confessus reatum absolvitur, petit Viaticum, datur reconciliatio: et uno pene momento perfidia ore abdicatur, et morte diluitur*; Bernard of Clairvaux, p. 72. **41** *PL*, 150, 427B: *digna miracula, quibus rerum visibilium atque corruptibilium ablatis tegumentis, sicuti revera est, appareret corporalibus oculis caro Christi et sanguis*; *Lanfranc of Canterbury*, p. 61. **42** *De corpore et sanguine Domini*, c.14. **43** Paschasius' source for this miracle was the *Miracula Nynie Episcopi*, which was known to him through Alcuin (ed. Karl Strecker, *Poetae Latini aevi Carolini*, IV:II–III (Berlin, 1923), pp 943–61). I am currently preparing a detailed study of this passage of Echtgus' text for publication.

As with other texts composed within the context of the ecclesiastical reform movement in Ireland, Echtgus looks to Carolingian sources for elucidation of correct doctrine and exegetical interpretation.[44] In the case of the miracle of the Christ-child on the altar of St Ninian, it is Paschasius' *De corpore* that is Echtgus' probable source. However, that is not to say that Irish authors looked to earlier Carolingian sources to the exclusion of more contemporary sources. Indeed, Lanfranc may have been one such contemporary source, as I have suggested here. It is difficult to prove beyond doubt that Echtgus knew Lanfranc's *De corpore*, although the letter from the Munster clergy to Lanfranc suggests at least that he was known in Ireland to be an authority on Eucharistic doctrine. Both Lanfranc and Echtgus (and indeed other contemporary authors on Eucharistic doctrine, such as Lanfranc's pupil Guitmund of Aversa) looked to the same biblical passages and the same authorities – Ambrose, Augustine, Paschasius – for support of their doctrinal stance. Echtgus' transposition of his material into the Irish language makes it particularly difficult to identify instances where he might be drawing on Lanfranc's work, rather than directly from earlier sources. But what is important is that this Irish author was, at the same time as other better-known thinkers elsewhere in Europe, articulating an orthodox theological position on the Eucharist for the purpose of promoting uniformity of belief throughout the church. Furthermore, while doing so he drew on the same authorities and the same textual heritage as Lanfranc. This shows the extent to which the Irish church was participating in, and responding to, the intellectual debates that arose in Western Europe during the early scholastic period. That Irish churchmen felt able to write to Lanfranc to clarify issues regarding Eucharistic doctrine is further evidence of their integration in this intellectual *milieu*. In this regard, the emphasis in Echtgus' text on ideas of completion and perfection not only reflects the literary and theological sophistication of the text, but also alludes to the wider cultural context within which the text was composed: it is illustrative of a wider perception of the need for unity within the church, a need that was highlighted by movements for ecclesiastical reform throughout Europe.[45]

Although Christ's sacrifice on the cross implicitly underlies the Eucharistic celebration, Echtgus is more concerned with other elements of the Passion narrative, particularly Christ as enactor of the first Eucharistic feast at the Last Supper, and the resurrected Christ as he is present in the bread and the wine of the Eucharist and simultaneously in heaven, according to Catholic belief. Perhaps in this we can also see the influence of Lanfranc, who, in favouring the resurrection

44 Compare, for example, Gille of Limerick's use of Carolingian sources in his *De statu ecclesiae*: see Michael Richter, 'Gilbert of Limerick revisited' in Alfred P. Smyth (ed.), *Seanchas: studies in early and medieval Irish archaeology, history and literature in Honour of Francis J. Byrne* (Dublin, 2000), pp 341–7. **45** For an overview, see Gerd Tellenbach, *The church in Western Europe from the tenth to the early twelfth century*, trans. Timothy Reuter (Cambridge, 1993).

theology of Ambrose, also downplayed the role of Christ's crucifixion in his Eucharistic treatise in comparison to, say, Paschasius Radbertus.[46] Echtgus' use of a miracle narrative in which the host is turned into the Christ-child on the altar moves the focus of devotion away from the crucified Christ, but still offers his audience an equally affective and intimate form of Eucharistic piety. The major doctrinal controversies that raged across Latin Christendom have long commanded scholarly attention, but localized, indirect, vernacular responses to these controversies (the reaction 'on the ground', so to speak) have generally been overlooked. However, by highlighting a few of the themes reflected in Echtgus' poem on the Eucharist, it is hoped that the present study has shown how the wider theological implications of the Passion's narrative of sacrifice and salvation might have been understood and expounded in eleventh- and twelfth-century Ireland.[47]

46 Gibson, *Lanfranc of Bec*, p. 74. Gibson also emphasizes Lanfranc's concern for the unity of the church, which she argues was greater than his need 'to clarify the technical problems of Eucharistic definition' (p. 97), which suggests another point of comparison with Echtgus. **47** In addition to research presented at the 'Envisioning Christ on the Cross' conference at University College Cork, this essay incorporates work presented at research seminars in the Department of Celtic and Gaelic Studies, University of Glasgow, and the Department of Celtic and Scottish Studies, University of Edinburgh, and I would like to thank those who attended for their useful comments and suggestions. I gratefully acknowledge the support of the Leverhulme Trust and the Isaac Newton Trust in funding my research.

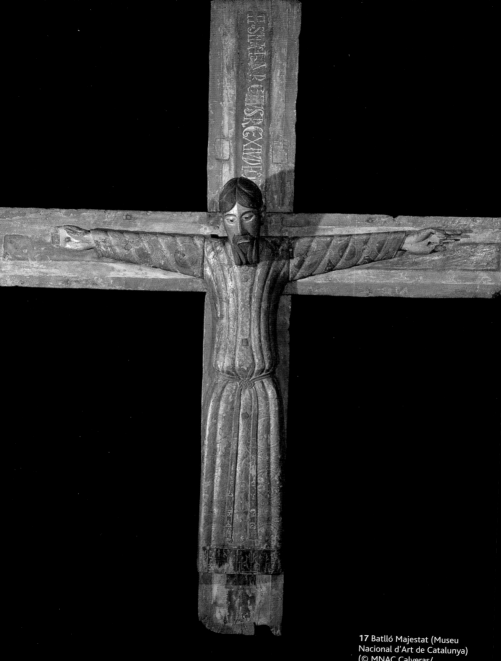

17 Batlló Majestat (Museu Nacional d'Art de Catalunya) (© MNAC Calveras/

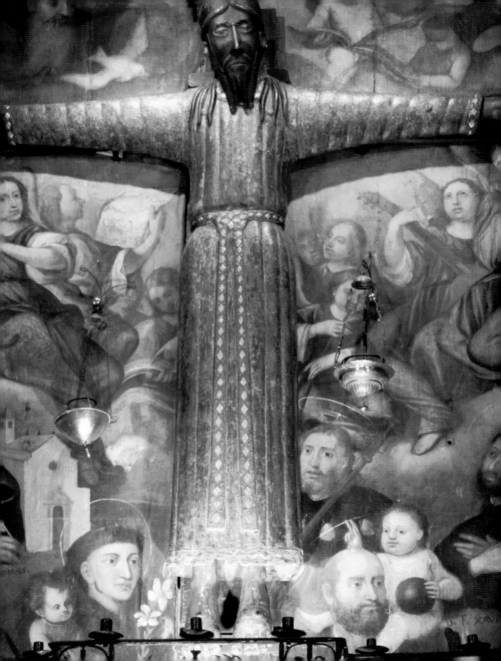

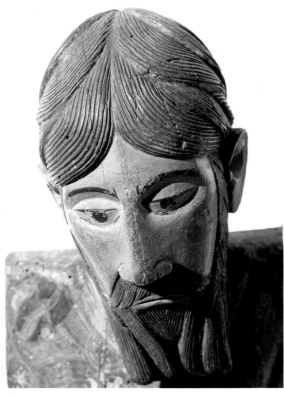

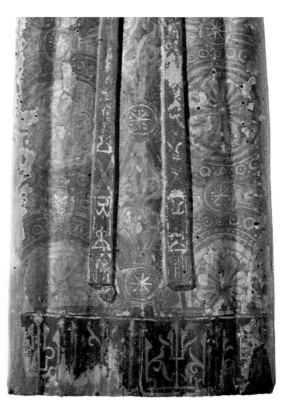

19 Batlló Majestat: head (© MNAC Calveras/Mérida/Sagristà).

20 Batlló Majestat: tunic (© MNAC Calveras/Mérida/Sagristà).

21 Portail of Ripoll: head of the *Maiestas Domini* (photograph by Jordi Camps i Sòria).

22 Sant Joan les Fonts Majestat: head (image courtesy of Museu d'Art de Girona).

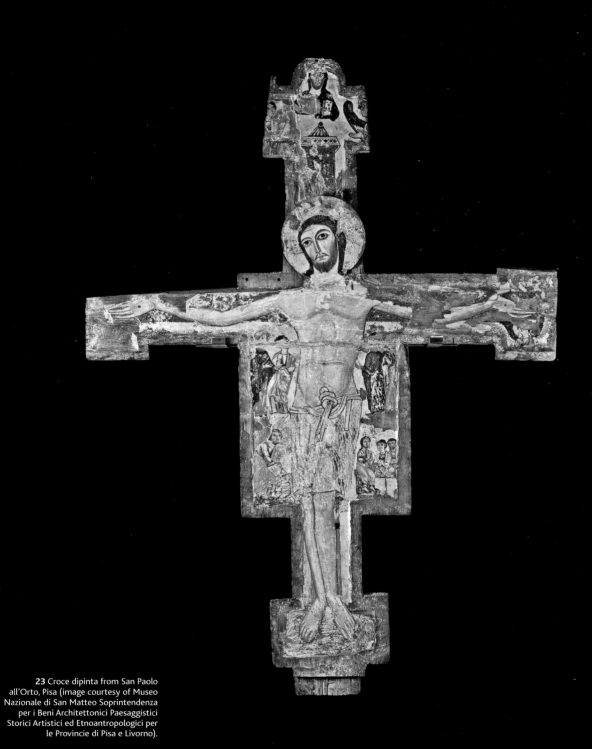

23 Croce dipinta from San Paolo all'Orto, Pisa (image courtesy of Museo Nazionale di San Matteo Soprintendenza per i Beni Architettonici Paesaggistici Storici Artistici ed Etnoantropologici per le Provincie di Pisa e Livorno).

24 Croce dipinta, Salerno, Museo Diocesano (photograph by Antonio Braca).

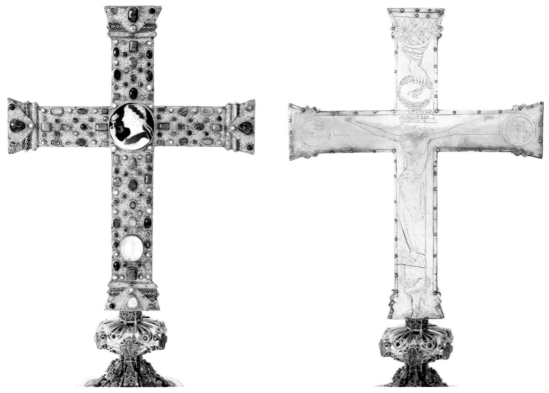

25a, 25b Lothar Cross, Aachen (© Domkapitel Aachen; photograph by Pit Siebigs).

26 Cross of Dublin. Royal MS 13. B.viii, British Library (© image courtesy of the British Library).

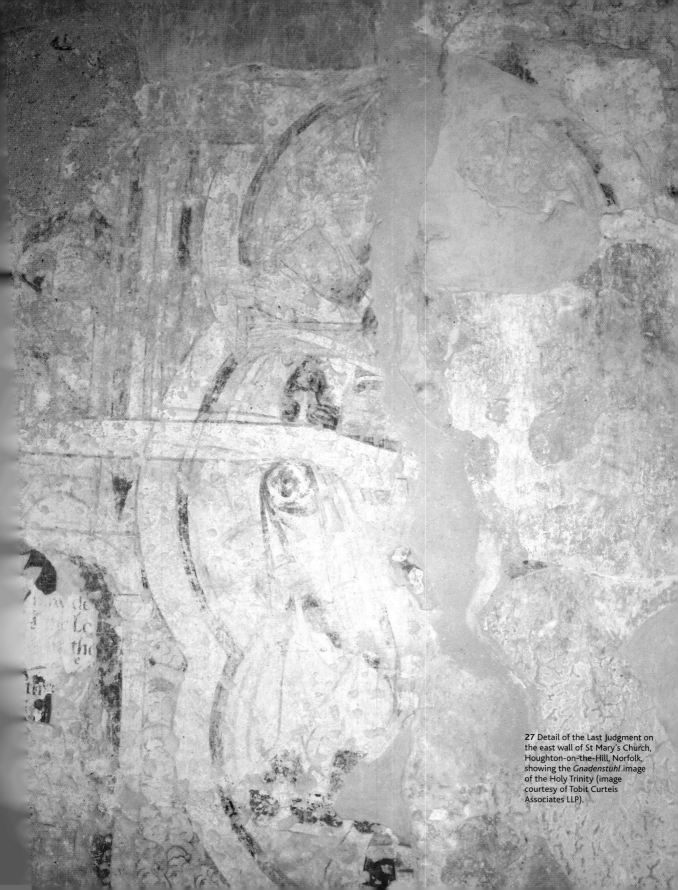

27 Detail of the Last Judgment on the east wall of St Mary's Church, Houghton-on-the-Hill, Norfolk, showing the *Gnadenstuhl* image of the Holy Trinity (image courtesy of Tobit Curteis Associates LLP).

28 The Last Judgment, east wall of St Mary's Church, Houghton-on-the-Hill (image courtesy of the English Heritage Photogrammetric Unit).

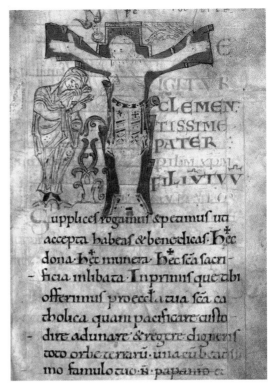

29 *Te igitur* initial from a Missal from Sherborne Abbey (*c.* 1060), Cambridge, Corpus Christi College, MS 422, p. 53 (image courtesy of the Master and Fellows of Corpus Christi College, Cambridge).

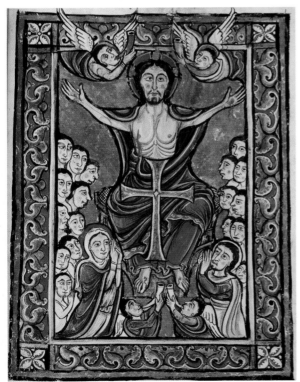

30 Christ in Judgment, New York, Morgan Library, MS M44, fo. 15 (*c.* 1175) (© image courtesy of the Pierpont Morgan Library, New York).

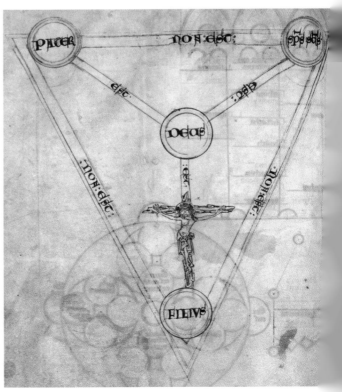

31 *Scutum fidei*, London, British Library, Cotton MS, Faustina B.VII, fo. 43v (© image courtesy of the British Library Board).

Preaching the Passion: *imitatio Christi* and the passions and homilies of the Leabhar Breac

JULIET MULLINS

PREACHING AND PERFORMANCE

The medieval church was responsible for providing for all the rites of passage of a Christian's life, from birth to death, and beyond. As an essential corollary to this, it assumed the task of interpreting these rites and rituals, which it achieved by tracing meaningful patterns between the present and the past, forging connections between history and liturgy, and preaching the timelessness of the truth of Christ. As the language of St Paul's letters makes clear (esp. Rom 6:3, 6–7), the Passion of Christ is central to this endeavour – and particularly to the celebration of baptism and the Eucharist – as believers are called upon to crucify themselves with Christ and nail themselves to the cross (Gal 2:19). The image of taking up one's cross bore particular resonance for those who had dedicated their lives to the service of God and taken clerical or monastic orders, but the importance of the Passion to lay expressions of piety should not be overlooked, for the effective celebration of the church's ritual requires the involvement of the Christian community as a whole.[1] During the early medieval period, this reached its zenith in the powerful ceremonies surrounding the Good Friday rituals of the *veneratio crucis*, which were celebrated in Jerusalem from the fourth century, and by the end of the seventh century in Rome.[2] In this ceremony, the congregation is encouraged to vividly picture and partake in Christ's Passion and death – a process often associated with the late medieval tradition of the *Meditationes vitae Christi*, but recorded in texts as early as Egeria's fourth-century account of her pilgrimage to Jerusalem – in a communal and yet intensely individual expression of inner spirituality. Liturgical

1 The difficulties encountered when attempting to trace lay practices are discussed in detail by Chazelle, this volume. **2** See Van Tongeren, this volume, esp. pp 34–41.

evidence from the earliest period thus suggests that the members of a medieval congregation, both lay and religious, were familiar with a carefully balanced, nuanced understanding of the devotional and doctrinal elements of Christ's Passion, its physical enactment and its connection with God's promise to redeem and renew.

One of the most important means by which the theological, doctrinal and devotional implications of the church's rites were disseminated and the theory behind the performance of its rituals explained was through preaching.[3] From its inception, preaching has represented an interface between the authorities of the church and the wider population, including those it wishes to convert, those in orders or ordained and those who are not, and those who oppose it. Sermons and homilies had been gathered into collections, copied and circulated from the fifth century;[4] influential figures such as Gregory the Great composed sermons to be delivered to clerical and lay audiences; and during the ninth-century Carolingian 'renaissance', large-scale compilations were made containing homiletic material culled from the writings of the church Fathers for preaching to lay audiences throughout the lands under Charlemagne's control.[5] Although presumably delivered in the vernacular, in these examples the original oral act of preaching is transformed into a text that conforms to the conventions of a *literary* genre and

3 For discussion of the categorization of preaching material, the definition of 'sermon' and an introduction to medieval preaching, see Beverly Mayne Kienzle, 'Introduction' in B.M. Kienzle (ed.), *The sermon: typologie des sources du moyen âge occidental, 81–3* (Turnhout, 2000), pp 143–74. The issues of literacy, orality and the development of the sermon as a genre are addressed in several of the contributions and responses in *Speculum sermonis: interdisciplinary reflections on the medieval sermon*, ed. Georgina Donavin, Cary J. Nederman and R. Utz (Turnhout, 2004), most notably in Wim Verbaal, 'Preaching the dead from their graves: Bernard of Clairvaux's lament on his brother Gerard', pp 113–39; Peter Howard, 'Sermons reflecting upon their world(s): a response to Stephen Morris, Wim Verbaal, Eve Salisbury and Emily Michelson', pp 181–94; Thom Mertens, 'Relic or strategy: the Middle Dutch sermon as a literary phenomenon', pp 293–314. **4** Throughout this essay, the terms 'sermon' and 'homily' will be used interchangeably, for while the distinction between the two is recognized by modern scholars, evidence would suggest that this distinction would not have been acknowledged by most medieval writers. For the diversity of terms used to describe preaching materials among the writings of the church Fathers, see Christine Mohrmann, '*Praedicare-tractare-sermo*: essai sur la terminologie de la prédication paleochrétienne', *La Maison-Dieu*, 39 (1954), 97–107; for the Irish terms used to designate preaching, see Martin McNamara, 'Irish homilies, AD600–1100' in Thomas N. Hall, with Thomas D. Hill and Charles D. Wright (eds), *Via crucis: essays on early medieval sources and ideas in memory of J.E. Cross* (Morgantown, WV, 2002), pp 235–84 at pp 239–45. **5** Various church councils had decreed the need for preaching in the vernacular, most famous of which is arguably Charlemagne's *Admonitio generalis* of AD789, which called for preaching to all the people of Europe. See Thomas L. Amos, 'Preaching and the sermon in the Carolingian world' in Thomas Leslie Amos, Eugene A. Green and Beverly Mayne Kienzle (eds), *De ore Domini: preacher and word in the Middle Ages* (Kalamazoo, MI, 1989), pp 41–60; idem, 'The origin and nature of the Carolingian sermon' (PhD, Michigan State University, 1983), pp 193–236; Mary Clayton, 'Homiliaries and preaching in Anglo-Saxon England', *Peritia*, 4 (1985), 207–42; repr. in P.E. Szarmach (ed.), *Old English prose: basic readings* (New York and London, 2000), pp 151–98.

translated into the lingua franca of the church, Latin.[6] It is from Anglo-Saxon England that the first vernacular compilations survive, representing, according to Milton McCormick Gatch, 'a peculiarly English effort to assemble useful cycles of preaching materials in the native tongue'.[7] Despite their physical and cultural proximity, Gatch argues that within the Irish tradition there is little evidence of a comparable interest in preaching. As this essay hopes to demonstrate, although contemporary homiliaries do not survive and much of the material has been dated to the period *c.*1200, nevertheless the medieval Irish material extant, both Latin and vernacular, demonstrates a concern with preaching and particularly with preaching the Passion, which, in Ireland as elsewhere in Europe, lies at the heart of the homiletic tradition.

The early Irish homiletic tradition is preserved across a number of manuscripts, many of which were copied centuries after the texts they contain were composed, in collections that divorce the material from their original context, which may now prove irrecoverable.[8] One such manuscript collection is the Leabhar Breac (Dublin, RIA, 23P16), known also as the Leabhar Mór Dúna Doighre and the Speckled Book of Mac Egan, which contains a body of works edited by Robert Atkinson in his 1887 *Passions and homilies of the Leabhar Breac*.[9] The Leabhar Breac is an early fifteenth-century compilation copied some time between Christmas 1408 and Halloween 1411, probably by Murchadh Ó Cuindlis (fl. 1398–1411) for the Clann Mac Aodhagáin (Mac Egans) in Duniry, now Co. Galway.[10] It has yet to be determined for what purpose the manuscript was compiled; its contents represent a mixture of material, both in terms of genre and

6 For the transformation of Latin texts into the vernacular, see Roger Wright, *Late Latin and early Romance in Spain and Carolingian France* (Liverpool, 1982), pp 112–22. **7** Milton McCormick Gatch, 'The achievement of Ælfric and his colleagues in European perspective' in Paul E. Szarmach and Bernard F. Huppé (eds), *The Old English homily and its backgrounds* (Albany, NY, 1978), pp 43–73 at pp 51–4. Gatch argues that until a satisfactory edition of the Leabhar Breac is available, 'nothing can be said about the history of vernacular preaching in Ireland on the basis of this florilegium' (p. 54). The current author would contest this assertion, and hopes to demonstrate that despite the difficulties presented, there is evidence of the liturgical use of some of these sermons and homilies at some stage in their transmission history. **8** For a survey of sermons in early Irish, see Hildegard L.C. Tristram, *Sex aetates mundi: Die Weltzeitalter bei den Angelsachsen und den Iren. Untersuchen und Texte* (Heidelberg, 1985), pp 133–52; Brian Murdoch, 'Preaching in medieval Ireland: the Irish tradition' in Alan J. Fletcher and Raymond Gillespie (eds), *Irish Preaching, 700–1700* (Dublin, 2001), pp 42–8. For a recent discussion of manuscripts, see Máire Herbert, 'Medieval collections of ecclesiastical and devotional materials: Leabhar Breac, Liber Flavus Fergusiorum and The Book of Fenagh' in Bernadette Cunningham and Siobhán Fitzpatrick (eds), *Treasures of the Royal Irish Academy Library* (Dublin, 2009), pp 33–43, esp. pp 33–6. **9** *The passions and homilies from the Leabhar Breac*, ed. and trans. Robert Atkinson (Dublin, 1887). This is an outdated and unsatisfactory edition: see also the review by Whitley Stokes, *Transactions of the Philological Society* (1888–9), 203–34. **10** See K. Mulchrone et al., *Catalogue of Irish manuscripts in the Royal Irish Academy* (28 vols, Dublin, 1926–70), 27, no. 1230, pp 3379–404; Tomás Ó Concheanainn, 'The scribe of the Leabhar Breac', *Ériu*, 24 (1973), 64–79.

date, and some of the texts or sections of them appear more than once.[11] Many of the texts are religious or devotional, including the Rule of Mael Ruain (d. 792), the ninth-century martyrology known as *Félire Óengusso* ('The Martyrology of Óengus'), the *Saltair na Rann* ('Psalter of the Quatrains'), which is conventionally dated to *c*.988, and the late eleventh-/early twelfth-century *Aislinge Meic Con Glinne* ('The Vision of Mac Conglinne'). Non-religious pieces include *Sanas Cormaic* ('Cormac's Glossary'), ascribed to Cormac mac Cuilennáin (d. 908). Amid this collection there stands a sizable corpus of homiletic material – the so-called 'passions and homilies' – covering certain feasts for the *temporale* and *sanctorale*, as well as sermons on liturgical and catechetical themes. There are twelve texts described as Passions (*Pais*) of the apostles and other biblical and apocryphal figures (such as Longinus, the spear-bearer), five of which appear immediately following three different accounts of the Passion of Christ (the Passions of the apostles Peter and Paul, Bartholomew, James, Andrew and Philip, pp 172–80 in O'Longan's transcription).[12] There are also Lives of various saints, including Colum Cille (Columba), Brigit, Patrick and Martin of Tours, and two accounts dedicated to the Archangel Michael. At first sight, these appear to be narrative pieces of varying length (typically 3–5 pages of the manuscript), but many contain internal references to the feast day upon which the account is to be read, and in some instances – such as the Lives of Patrick and Colum Cille and the account of the martyrdom of St Stephen (pp 24–35) – the reading for the day remains attached (in Latin), as will be discussed further below. Other texts within the manuscript that appear to have had some form of preaching function include the *Procept na Machaabdai* ('The teaching of the Machabbees'), which is said to have been preached on their festival on the calends of August (p. 183, col. 2, line 17); sermons for some of Holy Week (pp 40–52), Pentecost (pp 52–6) and the Circumcision of Christ (p. 56); and various individual items on topics such as charity (p. 66), almsgiving (p. 68), and a piece entitled *Sermo ad reges* (pp 35–39) that draws upon the Hiberno-Latin *De duodecim abusivis saeculi*. Four of the texts edited in Atkinson's *Passions and homilies* deal directly with the crucifixion narrative: a Passion of the image of Christ (pp 1–4 in O'Longan's transcription), and three accounts of the Passion of Christ that draw upon the synoptic Gospel accounts and the apocryphal Gospel of Nicodemus (pp 160–70). The two accounts from the Gospel of Nicodemus, the first part containing the trial and Passion of Christ, the second concerned with the Harrowing of Hell, have been

11 For instance, the Gospel of Nicodemus appears twice, at fos 160a–163b and 170a–172b, and again at fos 223a–227a. The first part (fos 160a–163b and 170a–172b) has been edited by Atkinson, pp 113–24 and 359–71, and pp 143–51 and 392–400. The second part (fos 223a–227a) is edited together with the first by Ian Hughes for the Irish Texts Society. See *Stair Nicoméid: The Irish Gospel of Nicodemus*, ed. and trans. Ian Hughes (London, 1991), p. ix. **12** *Leabhar Breac: The Speckled Book*, lithographic facsimile by Joseph O'Longan (Dublin, 1876).

dated to *c.*1200 and my own linguistic analysis of the Passion of the Image of Christ would tend to place this text within the same period.[13] Elsewhere in the manuscript, we find a second version of the Gospel of Nicodemus, also dated to *c.*1200, an account of the crucifixion appearing as part of a synopsis of the New Testament, and various texts dedicated to the cross, including two accounts of the finding of the true cross, four pieces on the benefits of making the sign of the cross, and an account of the exaltation of the cross.

It is with the Passion texts that were preached that this essay is concerned, and with those sermons that draw upon the crucifixion as inspiration and call upon believers to aspire to imitation. There is some question as to whether all these texts should be considered sermons or homilies, and Atkinson's corpus has not been universally accepted, for while some contain references to the feast or occasion upon which they were delivered, others have no such indications of performance.[14] The texts, moreover, derive from 'widely differing periods', although some attempt has been made to associate a core collection of homilies with Mael Ísu Ua Brollcháin (d. 1086), while others have contended that the language of many of the texts in this group belongs to the twelfth century.[15] As a collection, therefore, the passions and homilies present various anomalies in terms of function, date and discourse. Nevertheless, as a corpus, it provides evidence of a degree of continuity between early and late medieval sermons in Ireland, to the extent that we find a standard repertoire consisting of material that draws upon stories from the New Testament and apocrypha with a particular focus upon the Passion, basic catechetical teaching and moral exhortation, as well as a heavy emphasis upon

13 *Stair Nicoméid*, ed. and trans. Hughes, pp xi–xii. **14** This is, in itself, of little consequence, for it is far from unusual for homiletic materials to lose their preaching features when transferred to a new context, and indeed we might question why such relics remain in a fifteenth-century collection clearly not intended for liturgical use and compiled at a time when the norms of preaching had undergone considerable change. **15** Gearóid Mac Eoin, 'Observations on some Middle-Irish homilies' in Próinséas Ní Chatháin and Michael Richter (eds), *Irland und Europa im frühem Mittelalter: Ireland and Europe in the Early Middle Ages* (Stuttgart, 1996), pp 195–211 at p. 211. Mac Donncha has produced a number of studies of the Leabhar Breac in which he posits that the passions and homilies represent the basis of an eleventh-century homiliarium composed by Mael Ísu Ua Brollcháin and the research of Jean Ritmueller appears to confirm this supposition. See Frederic Mac Donncha [Finnbar Mac Donnchada], 'Na hoimilí sa Leabhar Breac, i Lebor na hUidhre, i Leabhar Mhic Cárthaigh Riabaigh, agus i Vita Tripartita Sancti Patricii, a mBunús, a nÚdar, agus nDáta' (PhD, University College Galway, 1972); idem, 'Medieval Irish homilies' in Martin McNamara (ed.), *Biblical studies: the medieval Irish contribution* (Dublin, 1976), pp 59–71; Jean Ritmueller, 'The Hiberno-Latin background of the Leabhar Breac homily *In cena Domini*', *Proceedings of the Harvard Celtic Colloquium,* 2 (1982), 1–10. The evidence for an eleventh-century homiliary has been challenged by, for example, McNamara, 'Irish homilies, AD600–1100', p. 248. A twelfth-century date is argued for the collection as a whole by Georges Dottin, *Manuel d'Irlandais Moyen*, I (Paris, 1913); individual pieces are treated in Máire Herbert, *Iona, Kells and Derry: the history and hagiography of the monastic familia of Columba* (Dublin, 1996); eadem, 'The life of Martin of Tours: a view from twelfth-century Ireland' in Michael Richter and Jean-Michel Picard (eds), *Ogma: essays in Celtic*

eschatological concerns. In order to appreciate the treatment of the Passion in these sermons, it will be useful in the first instance to consider the broader homiletic tradition in Latin and the vernacular, and the wider cultural evidence for the purpose and practice of preaching in medieval Ireland.

Preaching in medieval Ireland

The earliest reference to preaching in a source with Irish connections is found in Columbanus' *Instructiones* (*c.*612–15), a selection of thirteen sermons aimed at a monastic community. The *Instructiones*, like the single homily surviving from Eriugena's presumably much larger corpus, a homily on the Prologue to the Gospel of John, was aimed at a well-educated, exclusive, Continental audience and is thus an important but atypical example.[16] Evidence of preaching to broader audiences, clerical, monastic and/or lay, is ambiguous and relatively scant in the period prior to the Anglo-Norman Conquest, and it is not until the later medieval period that preaching in the Irish church is attested in abundance.[17] Nevertheless, there are various pointers that, when taken together, would suggest that practice in Ireland was little different from elsewhere in Europe during this period, with homilies preached on Sundays and saints' feast days during the Divine Office and to the laity during the Mass.[18]

From the surviving written evidence, preaching was held in high regard in early medieval Ireland and had both a kerygmatic and a didactic function. Thus, for instance, in the passions of the apostles and lives of the saints preserved in fifteenth-century manuscripts such as the Book of Lismore and Leabhar Breac, the apostles and saints preach to unbelievers and proclaim the good news of the Gospel in instructional texts that often retain the vestiges of their original homiletic form. In some instances, the Gospel passage is copied also. So, for example, in the Leabhar Breac's *Passion of St Stephen*, the *peroratio* concludes with

studies in honour of Próinséas Ní Chatháin (Dublin, 2001), pp 76–84. **16** *Sancti Columbani Opera*, ed. and trans. G.S.M. Walker (Dublin, 1957), pp 60–120. The attribution of these sermons to Columbanus has been the source of considerable debate: see Claire Stancliffe, 'The thirteen sermons attributed to Columbanus and the question of their authorship' in Michael Lapidge (ed.), *Columbanus: studies in the Latin writings* (Woodbridge, 1997), pp 193–202. Thomas O'Loughlin has pointed out that in their written form, 'they seem analogous to the *Ennarationes in psalmos* of Augustine: although once delivered vive voce in an assembly, from the time they were written down they were consulted as a book is studied rather than as prompts to new homiletic action'. See Thomas O'Loughlin, 'Irish preaching before the ninth century: assessing the extent of our evidence' in Fletcher and Gillespie (eds), *Irish preaching, 700–1700*, pp 18–39 at p. 22. **17** See Alan John Fletcher, *Late medieval popular preaching in Britain and Ireland: texts, studies and interpretations* (Turnhout, 2009); idem, 'Preaching in late medieval Ireland: the English and the Latin tradition' in Fletcher and Gillespie (eds), *Irish preaching, 700–1700*, pp 56–80; Colmán N. Ó Clabaigh OSB, 'Preaching in late medieval Ireland: the Franciscan contribution' in *Irish preaching, 700–1700*, pp 81–93; Richard H. and Mary A. Rouse, *Preachers, florilegia and sermons: studies on the 'Manipulus florum' of Thomas of Ireland* (Toronto, 1979). **18** See Clayton, 'Homiliaries and preaching'.

a comparison of the numerous holy and righteous who have suffered for Christ with the saint:

> … whose festival and commemoration fall at this period and time, i.e. St Stephen the protomartyr of the New Testament. It at this time, indeed, that Christians revere the festival and commemoration of this martyr on the seventh before the calends of January, as to the day of the solar month etc. Luke the Evangelist further tells something of the passion and of the conflict of this noble martyr, how he suffered at the hands of the unbelieving Jews for the faith of Christ, saying …[19]

The law texts reveal that preaching was the responsibility of the priest and considered on a par with baptism, the rites of the dead and the offering of the Mass; the early eighth-century *Bretha nemed toísech* ('The first judgments concerning privileged ones') records that the neglect of ecclesiastical duties includes: 'being without baptism, without communion, without the Mass, without praying for the dead, without preaching' (*beth gan bathais, cin comna, cen oifrenn, cin imond anma, cin precept*).[20] Frequently, in both literary and law texts, preaching is associated with the Mass (*praicecht 7 oiffrenn*),[21] but also with the Divine Office (*celebrad & procept*).[22] In this respect, Irish practice appears to differ little from that on the

19 *The passions and homilies from the Leabhar Breac*, pp 82, 325. All references will be to this edition (henceforth *P&H*), and to the version of this produced at CELT: Corpus of Electronic Texts, compiled by John Carey and Philip Irwin with proof corrections by Aideen O'Leary: www.ucc.ie/celt/published/G206000/index.html (accessed 28 May 2013). All translations are my own. … *dia ta lith & foraithmet i n-ecmung na rea-se & ina aimsire-si .i. Sanctus Zepanus Noui Testamenti protomartir. Is and iarum airmitnigit na Cristaige lith & foraithmet in martiri-sea i sept Kalaind Enair ar-ai lathi mis grene &rl. Atfet iarum Lucas suiscelaig ní do chesad & do chumluing in martir uasail-sea, amal fo-ró-damair o Iúdaidib amirsechaib, ar ires Crist, dicens …* The passage from Acts 6:8–8:2 follows in Latin, raising interesting questions as to the intended use and function of these texts in their fifteenth-century context. **20** *Bretha Nemed toísech* in D.A. Binchy (ed.), *Corpus Iuris Hibernici* (6 vols, Dublin, 1979), vi, p. 2211, ll 27–8. See also Liam Breatnach, 'The first third of *Bretha Nemed toísech*', *Ériu*, 40 (1989), 1–40 at 11; idem, *A companion to the Corpus Iuris Hibernici* (Dublin, 2005). A similar formula is found in the section on the duties of the priest found in the version of the Rule of Patrick appended to the Leabhar Breac Rule of the Céli Dé, but here preaching is not mentioned: 'On his part again, the baptism and communion, that is, the sacrament, and intercessory prayer for the living and the dead, and Mass every Sunday and every chief high-day and every chief festival, celebration of all the canonical hours, and chanting of the three fifties [the psalter] daily, unless hindered by teaching or the duties of a spiritual friend.' See *Rule of the Céli Dé*, ed. and trans. E.J. Gwynn, 'The Rule of Tallaght', *Hermathena*, 44, second supplemental vol. (Dublin, 1927), pp 80–1. **21** *Corpus Iuris Hibernici*, ii, p. 503, l. 11. In a passage on clerical travel on Sundays, reasons for travelling the thousand paces include 'watching a sick man, and for administering communion to him, and to the young, and to the laity who are under spiritual direction who come to attend Mass, and to hear preaching and for urgent matters besides etc.' (*fri torrome fir galair fri tabhairt comne do 7 do ocaib 7 tuathibh biti fo anmchairtes dotiagat do airsemh offrind 7 do etsecht procepti 7 do raetaibh tricibh cene 7 cetera*). See 'The monastery of Tallaght', ed. and trans. E.J. Gwynn and W.J. Purton, *PRIA*, 29C5 (1911), 115–79 at 156–7. **22** Plummer

Continent, although whether those homiletic texts that survive were composed for preaching to the laity during the Mass, to the clergy, those in orders or a mixed audience and the occasion(s) upon which they would be delivered or read is more vexed. In a homily on the feast of St Michael in the Leabhar Breac, it is recorded that the three requirements of the feast are: 'celebrating [the Divine Office?] and preaching the word of God, giving alms to the poor, and offering the body and blood of Christ to the people during the Mass'.[23] Citing Plummer (see n. 22), McNamara has argued that here, as in the *Aislinge Meic Con Glinne* ('The Vision of Mac Conglinne'), a version of which is preserved in the same manuscript, 'preaching is in the context of the Divine Office, not of Mass … preaching was a feature of the public recitation of the Divine Office on Sundays and on saints' feast days'. He adds further that 'one can presume that individual homilies were intended for a particular liturgical celebration, although it does not seem possible to determine whether this was for a religious or monastic community.'[24] As we shall see below, there is considerable evidence for preaching to the laity during the early medieval period in Ireland, even if the surviving sermons are less explicit about their audience, and certainly by the twelfth century, when many of the homilies of the Leabhar Breac appear to have been composed, the provision of preaching for those not part of the religious or monastic life would have been expected also.

Medieval historians have argued that the monasteries of eighth-, ninth- and tenth-century Ireland were part of larger communities that included members of the laity, for whom baptism, Eucharist and preaching had to be provided as the law texts stipulate, and we might assume that the life and death of Jesus would from the core of this provision.[25] According to the seventh-century *Liber Angeli*,

claims that *celebrad* ('to celebrate') if used without qualification refers almost always to the canonical hours and not the Mass. See *Vitae Sanctorum Hiberniae*, ed. Charles Plummer (2 vols, Oxford, 1910; repr. Dublin, 1997), i, p. cxv, n. 14; Martin McNamara, 'Irish homilies, AD600–1100', p. 244. **23** *P&H*, pp 218 and 456. A similar construction is found in the third account of the Passion (pp 141, 390): *is e in cetna herdach, celebrad & procept brethri Dé; is e in t-erdach tánaise, almsana do thabairt i n-anoir in choimded, do sheirc & trocaire forna bochtaib; is e tra in tres erdach, in n-oifriund, a n-déntar hídpairt chuirp Crist & a fhola tar chend na fírén.* 'This is the first ceremony, the celebration [of the Divine Office?] and preaching the word of God; the second ceremony is the giving of alms in honour of the Lord in love and mercy to the poor; the third ceremony is indeed during the Mass to offer the body and blood of Christ to each of the people'. **24** McNamara, 'Irish homilies, AD600–1100', pp 244–5, 248. **25** See, for example, Westley Follett, *Céli Dé in Ireland: monastic writing and identity in the early Middle Ages* (Woodbridge, 2005), esp. pp 171–81; Colmán Etchingham, *Church organization in Ireland, AD650 to 1000* (Maynooth, 1999); for the exclusivity of the *céli Dé*, see Brian Lambkin, 'Blathmac and the Céili Dé: a reappraisal', *Celtica*, 23 (1999), 132–54. Much of the recent discussion of monastic towns has been driven by the work of Charles Doherty, 'Some aspects of hagiography as a source for Irish economic history', *Peritia*, 1 (1982), 300–28; idem, 'The monastic town in early medieval Ireland' in Howard B. Clarke and Anngret Simms (eds), *The comparative history of urban origins in non-Roman Europe: Ireland, Wales, Denmark, Germany, Poland and Russia from the ninth to the thirteenth century* (Oxford, 1985), pp 45–75. For a

the laity were permitted 'to hear the word of preaching in the church of the northern district' in Armagh.[26] The law text *Córus bésgnai* ('The ordering of discipline') records that the laity are 'entitled to its prerogatives from the church, i.e., baptism, communion, requiem and Mass are required of each church to all as a right of faith, together with the preaching of the word of God to all those who listen and comply with it'.[27] As far as preaching texts themselves are concerned, the Latin collection known as *In nomine Dei summi*, which has been dated by its editor to the eighth century and is traditionally associated with Ireland, contains homilies composed for the purpose of preaching to the laity during the Eucharist, and it is often assumed that the Old Irish homily dated to *c*.800 was likewise composed for such a purpose.[28] The tenth-century *Catechesis Celtica* contains homilies found also in English and Continental collections aimed at the laity and used within the context of the Mass, but the Irish connections of this collection remain speculative. Overall, there would seem to be considerable evidence in favour of preaching to the laity from an early period. Certainly by the twelfth century, when the homilies on the Passion preserved in the Leabhar Breac appear to have been written, we would expect that the church would preach to the laity on a regular basis in line with the Continental reforms brought to Ireland.[29] The question then arises as to what extent these Passion homilies are a response to such developments and a reflection of twelfth-century concerns, and how far they engage with established traditions that date back to a much earlier period.

Today, the Venerable Bede is renowned for his *Historia ecclesiastica gentis Anglorum*, but during the medieval period it was his homilies and commentaries that won him greater fame. Although originally composed for monks, many of his sermons were adapted for mixed and lay audiences in England and on the

critique of Doherty's conclusions, see Mary A. Valante, 'Reassessing the Irish "monastic town"', *Irish Historical Studies*, 31:121 (1998), 1–18, who nevertheless supports the heterogeneous nature of Irish religious communities. **26** *Liber Angeli*, John Gwynn ed., *The Book of Armagh* (Dublin and London, 1913), fos 20r–22r; trans. in Kathleen Hughes, *Early Christian Ireland: an introduction to the sources* (New York and London, 1972); and *The Patrician texts in the Book of Armagh*, ed. and trans. Ludwig Bieler (Dublin, 1979). See N.B. Aitchison, *Armagh and the royal centres in early medieval Ireland: monuments, cosmology and the past* (Woodbridge, 1994), p. 240. **27** *Corpus Iuris Hibernici*, v, pp 526–31, ll 18–30. **28** R. McNally, 'Seven Hiberno-Latin sermons', *Traditio*, 35 (1979), 121–43; O'Loughlin, 'Irish preaching before the ninth century', pp 30–8. 'Eine altirische Homilie', ed. Kuno Meyer, *Zeitschrift für celtische Philologie*, 4 (1903), 241–3 [ed. from a MS in the RIA]; 'An Old Irish homily', ed. J. Strachan, *Ériu*, 3 (1907), 1–10 [ed. from the Yellow Book of Lecan]. See O'Loughlin, 'Irish preaching before the ninth century', pp 22–5; Martin McNamara, 'Sources and affiliations of the *Catechesis Celtica* (MS Vat. Reg. lat. 49)', *Sacris Erudiri*, 34 (1994), 187–237; Tristram, *Sex aetates mundi*, esp. pp 133–52; Clayton, 'Homiliaries and preaching'; James E. Cross, *Cambridge, Pembroke College, MS 25: a Carolingian sermonary used by Anglo-Saxon preachers* (London, 1987); idem, 'On Hiberno-Latin texts and Anglo-Saxon writings' in Thomas O'Loughlin (ed.), *The scriptures in early medieval Ireland* (Turnhout, 1999), pp 69–79. **29** See, most recently, Marie Therese Flanagan, *The transformation of the Irish Church in the twelfth century* (Woodbridge, 2010).

Continent, most famously by Ælfric of Eynsham.[30] His Eastertide homily on the women at the empty tomb is concerned with 'what we should be doing in imitation of this same reading' (*quae nobis sint ex eiusdem lectionis imitatione gerenda*).[31] According to Bede, the stone was rolled back to reveal Christ's resurrection to those who came in search of his body, but to those who continue to search for Christ today divine mysteries are revealed:

> Mystically, the rolling away of the stone implies the disclosure of the divine sacraments, which were formerly hidden and closed up by the letter of the law. The law was written on stone. Indeed in the case of each of us, when we acknowledge our faith in the Lord's passion and resurrection, his tomb, which had been closed, is opened up.[32]

In the third account of the Passion in the Leabhar Breac, the same interpretation of the stone of the tomb is applied in a passage in which the reading of the day is explained in historical, mystical, moral and anagogical terms, for 'it is fitting indeed to know that the resurrection of Christ was prefigured and prophesied long indeed before by the sages of the Old Testament, as the church tells every year at this Easter festival'.[33] The fourfold exegesis offered at the end of this account of the Passion complements the typological and anagogical meanings ascribed to the crucifixion throughout: Christ is the willing sacrifice whose death fulfils the prophecies of the Old Testament, but also the God incarnate through whom the Trinity might be understood.[34] In the Irish homily, the mystical sense of the open tomb refers to 'the mystery of the Old Testament disclosed today in the New Testament'.[35] The moral sense of the rolling away of the stone recalls Bede's interpretation, for in both the action of removing the stone is related to the individual's growing understanding of the divine mysteries, as the homilist explains:

30 The literature on Ælfric and Bede is extensive: see Malcolm Godden, *Ælfric's Catholic Homilies: introduction, commentary and glossary* (Oxford, 2000). **31** Bede, *Homeliarum Evangelii Libri II*, ed. David Hurst (Turnhout, 1955), 2:10, p. 246 (ll 1–5). **32** *Mystice autem reuolutio lapidis sacramentorum est reuolutio diuinorum quae quondam littera legis claudebantur occulta. Lex enim in lapide scriptum est. Etenim et nobis singulis cum fidem dominicae passionis et resurrectionis agnouimus monumentum profecto illius quod clausum fuerat apertum est. Hom. 2:10, CCSL, 122, p. 247; Bede the Venerable: Homilies on the Gospels, Book Two*, trans. Lawrence T. Martin and David Hurst OSB (Kalamazoo, MI, 1991), p. 90. **33** *P&H*, pp 136, 384: *Is coir tra a fhis, co ro-fiugrad & co ro-terchanad o chein mair anall esergi Crist ó sruthib petarlacthi, amal labras in eclas cecha bliadna arin sollamain-si na cásc.* **34** *P&H*, pp 126, 373: 'Ar-áide, niba hí mo thoil-si bess imon césad do rér mo chollaidechta & mo doennachta', ol Ísu, 'acht bud hi do thoil-si, a athair némda!' Inann tra toil dóib iar n-doendacht & diadacht,* '"Nevertheless, it shall not be my will concerning the Passion, according to my corporeity and my humanity", said Jesus, "but let it be thy will, heavenly father!", for they have the same will in humanity and deity'. **35** *P&H*, pp 138, 386: *In adnocul ó-bela, is ed doforne sin: glanrúin na petarlacthi do fhollsiugud indíu isin nú-fiadnaise.*

'For an angel of God came from heaven' denotes the preaching of the word of God to the faithful out of the holy Scripture; and the name of heaven is here given to the Scripture for its nobility and splendour. 'When the angel came, he rolled away the stone from the grave and sat thereon' refers to the divine teaching overcoming the hardness of the heart and mind of every believing man, and bringing him to learn and understand the truth of the Gospel.[36]

In Bede's homily, the interpretation of the angels from heaven makes it clear that this is aimed at a monastic audience, when they are said to be

> … especially present to us when we give ourselves in a special way to divine services, that is, when we enter the church and open our ears to sacred reading, or give our attention to psalm-singing, or apply ourselves to prayer, when we celebrate the solemnity of the Mass.[37]

By contrast, the Irish text discusses preaching in inclusive terms that might suggest that the intended audience included the laity. For the moral sense of the passage is considered 'fitting for every faithful person to learn and contemplate; for it is through the fulfilment of this interpretation that every faithful person comes into harmony with Christ and the church'.[38] Moreover, the two Marys represent

> the body and soul of the man who labours for God; or else, the two kinds of life in which each Christian in the present life pays perfect service to the Lord, *uita actualis et uita theoretica*; the actual life, when the mind is perpetually fixed on ploughing and reaping, and the contemplative life, in which it is ever fixed on God.[39]

Although it is perhaps questionable whether this fourfold exegesis would have been accessible to 'every faithful person', there is nothing overly complex about the language in which it is expressed. Indeed, the conclusion to the third Passion text

36 *P&H*, pp 140, 388: *Uair tanic aingel Dé do nim, is ed doforne sin: procept brethri Dé; dona h-irsechu asin scriptúir nóim; & ainm nime ann-sin forsin scriptuir [ara h-uaisle] & ara h-etrochta. O thanic in t-aingel, ro-la in cloich on adnocul & desid furri, is ed doforne sin: in forcetul diada do fortamlugud for dúire cride & menman cech oen duine iresaig, & dia tabairt do foglaimm & do etargnaugud na firinde soscelda.* **37** *Maxime … adesse credendi sunt cum diuinis specialiter mancipamur obsequiis, id est aim ecclesiam ingressi uel lectionibus sacris aurem accommodamus uel pslamodiae operam damus uel orationi incumbimus uel etiam missarum sollemnia celebramus. Hom.* 2:10, CCSL, 122, p. 249. **38** *P&H*, pp 139, 388: *is cubaid da cech iresach do fhóglaim & do ind[ith]miugud; ar is tria chomallad in etargna-sin no-s-cuibdigenn cech iresach do Christ & don eclais.* **39** *P&H*, pp 140, 388: *corp 7 anmain in duine shoethriages ar Dia; no is ed doforne: na da bethaid iars-a fhognann cech iresech i-fhos co forbthi do'n choimdid; actális uita et tethorica uíta .i. in betha actalta, a memma i n-ar 7 i mbuain do-gres; 7 in betha theorda .i. a menma i n-Dia do-gres.*

offers an interpretation that draws upon exegesis related to if not derived from Bede, yet conveys it in a manner appropriate to the wider communities addressed by the twelfth-century (and earlier) reforms. Thus, although the early Irish tradition might appear lacking in preaching material when compared to its nearest neighbours, that which does survive reflects contemporary developments in the preaching, theology and devotional practices of the broader Latin Church.

Performing the Passion

Although aimed at distinct audiences and derived from diverse origins, across the Irish homiletic tradition we witness a continued concern with the core issues of suffering, salvation and sacrament, which are brought together at the moment of the crucifixion. The oldest homily in the Irish language is the Cambrai Homily (*c.*AD700), which is preserved in Cambrai, Bibliothèque Municipale, MS 679 (formerly 619). It opens with a quotation from Matthew 16:24: 'If anyone wishes to come after me, let him deny himself and take up his cross and follow me' (*Si quis vult post me venire, abneget semet ipsum et tollat crucem suam et sequatur me*). The purpose of this call by Christ, the homilist explains, is to inspire the believer 'that he banish from himself his vices and his sins and that he gather his virtues and receive stigmata and signs of the cross for Christ's sake'.[40] This understanding of the cross as both a symbol of Christian suffering and a call to *imitatio* is repeated throughout the homiletic tradition, with a particular emphasis in the passions and homilies preserved in the Leabhar Breac, where torture, atonement, forgiveness, sacrifice and judgment are recurring themes. So, in the *Passion of Philip*, for example, the apostle calls upon the people to 'Overcome and crucify your carnal wills by fasting, by prayer and abstinence, by almsgiving of food and clothing to the poor and needy of the living God'.[41] In the liturgy, the suffering of Christ is recalled and the 'stigmata and signs of the cross' physically enacted through the words and actions of the people and their priests during the celebration of the Eucharist, with particular emphasis in the solemnities of Holy Week, particularly Good Friday's *veneratio crucis*.[42] The cross as a physical object played an important role in these quasi-dramatic ceremonies and whether a processional cross or a jewelled cross reliquary, it became an actor in the performance that bore Christ to his death, as evident in the words engraved on the

40 'The Cambrai Homily' in *Thesaurus Palaeohibernicus: a collection of Old-Irish glosses, scholia, prose and verse*, ed. and trans. John Strachan and Whitley Stokes (2 vols, Cambridge, 1901–3; repr. Dublin, 1987), ii, pp 244–7 at p. 244: *insce inso asber ar féda Ísu fri cach n-óen din chenélu dóine are n-indarbe a dualchi óod ocus a pecthu ocus ara tinóla soalchi ocus are n-airema futhu ocus airde cruche ar Chríst.* **41** *P&H*, pp 112, 357: *[T]roeothaid & crochaid bar tola collaide i n-áine, i n-ernaigti, i n-abstanait, i n-almsanib bíd & étaig do bochtu & adilcnechaib Dé bíi.* **42** For editions and translations of quasi-dramatic ceremonies for Holy Week and Easter, see *Medieval Drama*, ed. and trans. David Bevington (Boston, MA, 1975).

Brussels reliquary cross commissioned by the Anglo-Saxon nobles Æthelmær and Æthelwold in memory of their brother Ælfric *c.*AD1000: 'Rood is my name. Once I trembling bore a powerful king drenched in blood' (*rod is min nama geo ic ricne cyning/bær byfigende blode bestemed*).[43] In comparison, participation in the re-enactment of these events is less explicit in the Leabhar Breac passions and homilies; nevertheless, performance and *imitatio* here play a pivotal role. For throughout this otherwise varied and disjointed corpus, the example of the apostles, the saints, and even in some accounts the converted pagans and Jews demonstrate the importance of *imitatio* in both exegetical and devotional terms. For, as the homilist explains in the *peroratio* to the *Passion of St George*,

> One of the expressions of that psalm is suitable for the praise of the Lord's martyrs, when the prophet says here, 'Precious in the sight of the Lord is the death of his saints' [Ps 115:15]. Truly precious and happy is the death of those who imitate Christ in death.[44]

Or, as Christ himself reveals to Peter when asked 'Where are you going, Lord?':

> 'Lord, where are you going?' i.e. 'Where are you going, Lord', and Christ said, 'I am going to Rome to be crucified again'. It is this that Christ said to me: 'Follow me, for I am going again to Rome to be crucified' i.e. to be crucified in his members, i.e. the apostles.[45]

With their focus upon *imitatio Christi*, these texts engage with a sophisticated theological narrative evidenced across various media in Ireland and on the Continent in which the historical reality of the crucifixion is set against the timelessness of the truth concealed/revealed within. In the manuscript art and carved stonework produced in early medieval Ireland, this process is at work when, for example, Christ is depicted alive upon the cross and yet pierced by the spear held by Longinus.[46] The non-chronological imagery used allows the artist to evoke disparate events simultaneously and thus to express religious truths through events performed at different times. On the Continent, the eternal truth of Christ's revelation upon the cross and the enduring importance of *imitatio Christi* had been explored by theologians well known within an Insular context, including

43 See Murray, this volume, on the evidence for Irish processional crosses, which may have borne bronze crucifixion plaques. 44 *P&H*, pp 72, 314: *Oen didiu do briathraib in pshailm-sin is cubaid re molad martíre in choimded, a n-atbeir in fáid sund: 'Pretiosa est in conspectu Domini mors sanctorum eius'* [Psalm 115. 15]. *Ueri pretiosa et felix est mors quae Christi mortem emitatur.* 45 *P&H*, pp 94, 338: *'[D]omine quod uádis?' .i. 'Cia leth tégi, a tigerna?' et dixit Christus, 'uade in Roma crúcifige iterum'; is ed atbert Crist frim-sa . i. 'no-m-tóchoisc, ar tégim doridisi dom crochad do Róim'. i. dia crochad ina ballaib .i. na h-apstail.* 46 See O'Reilly, this volume.

scholars such as Leo the Great, Hrabanus Maurus and Alcuin, who had strong and direct connections with the Irish church.[47]

IMITATIO AND IMAGE IN THE LEABHAR BREAC

In the letters and sermons of Leo the Great, written in response to the Christological controversies that culminated in the Council of Chalcedon (AD451), *imitatio* is a central concern: the crucifixion provides an example by which the believer might find a human model to imitate and a divine model to worship:

> For the cross of Christ, which was set up for the salvation of mortals, is both a sacrament and an example: a sacrament whereby the divine power takes effect, an example whereby man's devotion is excited. For to those who are rescued from the prisoner's yoke, redemption further procures the power of following the way of the cross by imitation.[48]

Knowledge of Leo's writings is well attested in the Insular world, where imitation of the cross and the crucifixion is most commonly associated with monasticism and with the suffering that those bound to a religious life for Christ must endure.[49] As Columbanus explains in a letter to his monks of *c*.610,

> For this is the truth of the Gospel, that the true disciples of Christ crucified should follow him with the cross. A great example has been shown, a great mystery has been declared; the Son of God willingly (for he was offered up because he himself willed it) mounted the cross as a criminal, leaving to us, as it is written, an example that we should follow in his footsteps. Blessed is the man who becomes a sharer in this Passion and this shame.[50]

47 See Celia Chazelle, *The crucified God in the Carolingian era: theology and art of Christ's Passion* (Cambridge, 2001). **48** Leo the Great, *Tractatus*, 72:1, ed. Antoine Chavasse (Turnhout, 1973), pp 441–2, ll 15–19. Translation in *NPNCF*, 2nd ser., xii, trans. Philip Schaff and Henry Wace (Buffalo, NY, 1894; repr. New York, 1980), p. 184: *Crux enim Christi, quae saluandis est impensa mortalibus, et sacramentum est et exemplum, sacramentum, quo uirtus impletur diuina, exemplum, quo deuotio incitatur humana, quoniam capituitatis iugo erutis, etiam hoc praestat redemptio, ut eam sequi possit imitatio.* **49** See O'Reilly, this volume, esp. pp 53–6; eadem, '"Know who and what he is": the context and inscriptions of the Durham Gospels crucifixion image' in Rachel Moss (ed.), *Making and meaning in Insular art* (Dublin, 2007), pp 301–16; Liam de Paor, *Saint Patrick's world* (Dublin, 1993), p. 90. **50** Columbanus, *Ep.* 4:6, pp 30–1, ll 22–7: *[H]aec est enim veritas evangelii, ut veri Christi crucifixi discipuli eum sequantur cum cruce. Grande exemplum ostensum est, grande sacramentum declaratum est: Dei filius voluntarius (oblatus est enim quia ipse voluit) crucem ascendit ut reus, reliquens nobis, ut scriptum est, exemplum, ut sequamur vestigia eius. Beatus igitur est, qui huius passionis et huius confusionis fit particeps.* See O'Reilly, '"Know who and what he is"', pp 311–12.

Imitatio was not something to be limited to the learned and religious, however. As a well-known passage from Gregory the Great's letter to Serenus, bishop of Marseilles, makes clear, although the pope held reservations about the adoration of pictures and stipulated that they should be limited to the subject of the Trinity, nevertheless he concedes that both image and text could be used to inspire the literate and illiterate to follow Christ:[51]

> It is one thing to venerate a picture, but another to learn from narrative pictures what ought to be venerated. For what scripture is for those who read, a picture offers to the illiterate who look upon it, for in it the unlearned see what they ought to imitate [*quod sequi debeant*] and those who do not understand writing read from it.[52]

Imitation is inspired by the combination of image and word, and it is thus of interest to note that the Leabhar Breac opens with an account of the Passion of an image of Christ (*Pais h-Imaigine Crist*). The narrative recounts a re-enactment of the Passion in which the Jewish community in Beirut scourge and pierce a full-sized image of Christ from the side of which blood and water consequently flow.[53] The Irish text is probably of twelfth-century date, and although well-known across Europe is ultimately derived from an iconodulic tradition originating in the East. The associated feast of the *Passio imaginis* was celebrated in Girona in the tenth century and in Anglo-Saxon England in the eleventh, when we are told that a copy of the *Volto Santo* in Lucca was brought back by Leofstan, abbot of Bury (1044–65), and by the end of the twelfth century, as Michele Bacci has shown, the association between the story of a full-sized image of Christ sculpted by Nicodemus and the *Volto Santo* was well established.[54] Such stories were not unknown in Ireland; Roger of Howden records a dispute in 1197 between the archbishop of Dublin and John, lord of Ireland, as a result of which the crucifix in

51 Celia Chazelle, 'Pictures, books and the illiterate: Pope Gregory I's letters to Serenus of Marseilles', *Word and Image*, 6 (1990), 138–53. **52** Gregory the Great, *Registrum XI.10* in Dag Norberg (ed.), *Registrum Epistularum Libri VII–XIV* (Turnhout, 1982), p. 874. *Aliud est enim picturam adorare, aliud per picturae historiam, quid sit adorandum, addiscere. Nam quod legentibus scriptura, hoc idiotis praestat pictura cernentibus, quia in ipsa ignorantes uident, quod sequi debeant, in ipsa legunt qui litteras nesciunt.* **53** The wounding of Christ's side is described in St John's Gospel alone, although it was to become a prominent feature in Mediterranean and Insular art of the medieval period: see Lawrence Nees, 'On the image of Christ crucified in early medieval art' in Michele Camillo Ferrari and Andreas Meyer (eds), *Il Volto Santo in Europa: Culto e immagini del Crocifisso nel Medioevo. Atti del Convegno internazionale di Engelberg (13–16 settembre 2000)* (Lucca, 2005), pp 345–85. In an Irish context, the passage was of such importance that it was incorporated into the other Gospels: see Robert E. McNally, *The Bible in the early Middle Ages* (Westminster, 1959; repr. Atlanta, GA, 1987). **54** Barbara C. Raw, *Anglo-Saxon crucifixion iconography and the art of the monastic revival* (Cambridge, 1990), pp 91–2; Michele Bacci, 'Nicodemo e il *Volto Santo*' in Ferrari and Meyer (eds), *Il Volto Santo in Europa*, pp 15–40 at pp 15–17; and Bacci, this volume.

Holy Trinity Cathedral, Dublin, was humiliated and bled from its side in recognition of the wrong done to its archbishop.[55] As the opening text in the Leabhar Breac, the *Pais h-Imaigine Crist* plays an important role in raising the issue of the depiction of the divine image at the very start of the compilation and thus demonstrating a continuing concern for theological controversies emerging from the Continent. In a vivid account that engages with many of the issues raised during the Iconoclast controversy in Byzantium and discussed with great fervour across the early medieval West, the homilist demonstrates how 'through material images of Christ, who is himself the true image of God, man, created in God's image, learns to know God, rather than merely knowing about him.'[56] The image was 'of equal height, firmness and breadth with Christ himself, for Nicodemus, a secret friend of Christ, had moulded this image in the shape of Christ so that he might be with him and honour him'.[57] Although an image and a material object made by man, nevertheless the power that it conveys is no more diminished and the effect that torture by the Jews has literally moves heaven and earth:

> As heaven shook and trembled at the suffering of Christ at that time in the first Passion, and gloom and darkness overcame the sun and the moon and all the stars of heaven besides, when the foundations of the abyss were shaken, and a vast and wondrous earthquake sent forth the dead living up from below – thus was it done also in the second Passion of the holy image of Christ, the Son of God.[58]

This Passion is re-enacted throughout the homiletic and hagiographic texts by which this account is followed; so, for example, in *The Passion of George*, the saint recalls the image of the crucifixion in his hour of need and is strengthened to imitate it as a result:

55 Roger of Howden, *Chronica Rogeri de Houedone*, ed. William Stubbs (4 vols, London, 1868–71), iv, pp 29–30; see Marie Therese Flanagan, 'Devotional images and their uses in the twelfth-century Irish church: the crucifix of Holy Trinity Cathedral, Dublin, and Archbishop John Cumin' in Howard B. Clarke and J.R.S. Phillips (eds), *Ireland, England and the Continent in the Middle Ages and beyond: essays in memory of a turbulent friar, F.X. Martin OSA* (Dublin, 2006), pp 67–87. See also Bacci and Ní Ghrádaigh, this volume. Among the relics preserved at Armagh, according to the *Liber Angeli*, was a cloth soaked with the blood of Christ, suggesting a long tradition of particular devotion to the Passion and the wounds of Christ: see *Liber Angeli*, pars. 18–19 in Bieler (ed.), *The Patrician texts in the Book of Armagh*, p. 186. 56 Barbara C. Raw, *Trinity and incarnation in Anglo-Saxon art and thought* (Cambridge, 1997), p. 6. 57 *P&H*, pp 42–43, 279: *Is amlaid didiu bui in delb-sin, cu comard cobsaid comlethan fria Crist fessin, uair Nicodemus cara inclethi do Crist, is e do-rigne in himaigin-seo fo deilb Crist, co m-beth aice hi oca h-adrad.* 58 *P&H*, pp 42, 279: *[A]mal ro-bidg & immeclaig neam hi cesad Crist tall isin cet chesad, & tanic temel & dorchatu dar grein & dar esci & dar rennaib nime ar-chena, & ro-chraithit fothada na h-aibesi, & talam-chumscugud adbul ingnath, co r-chuir-sium na mairb beoa as suas – is amlaid-sin do-ronad isin cesad tanaise na h-imaigine noemi-seo Crist meic De.*

Indeed, when George came there and saw the wheel, it is this that he began to deliberate upon: how he might be delivered from this wheel. But then shaking his head in repentance at the thought, he said: 'Shame on you, George. Remember the time when Christ was crucified between the two thieves. Hear me now, O God! Make haste to deliver me from the diseases that are on every side, for in you my soul confides.'[59]

The example of the saints is intended – like the crucifixion before it – to inspire first penance and then imitation in the believer. Various accounts of saints and sinners – including the apostate Marcellinus, Longinus, the Jews of Beirut and the heathen Josias who is baptized and dies with James – demonstrate the forgiveness offered by Christ to the individual sinner, illustrated most prominently perhaps by the example of the Good Thief who is crucified on his right hand:

Luke says it was the second thief only who blasphemed him: the name of this thief was Gestus. But Dismus believed in Jesus and Jesus said to him, 'Today you shall be with me in Paradise in the kingdom of my Father'. So that is an example for the people of swift repentance that they might be earnest in turning to God that he grants them forgiveness.[60]

In the passions and homilies of the Leabhar Breac, the theological and doctrinal traditions of the early medieval church are combined with the needs and demands of a specific if idealized audience. Vernacular preaching is imbued with an ideology that has developed within monastery or cathedral communities, and yet through its performance it has the capacity to stretch out to incorporate a much wider community of believers. Although derived from apocryphal sources and transmitted through narratives that are simple and direct, the theology behind the depiction and imitation of the divine image is subtle and sophisticated. It was Augustine who expounded the relationship between God and man made in the image of God in his *De Trinitate*, which, during the Carolingian period, was developed further by Alcuin and others to include discussion of images depicting God, specifically the Son of God, who represents both man as image and the divine source upon which sinless man was modelled. As Augustine and his followers were keen to point out, Christ is not only a model to be imitated

59 *P&H*, pp 75, 317: *O thanic tra Georgí, & o'tconnairc in roth, is ed ro-s-imraid oice, indus no-m-saerfaither o'n roth-sa, & is ed atbert, la cúmscugud a chind co n-aithrige de-sin, 'Mairg det-siu, a Georgí, bat cúimnech ina h-amsire-si, in ro-crochad Crist eterna dá latrand; no-m-cluin-se anosa, a Dé dianaig do-m-shaerad ona galaraib filet as cech aird, uair is innut tairises m'animm.'* **60** *P&H*, pp 134, 382. *Indissid Lucás conid he in dara latrand nama do-s-gni a écnach-sum: Gestus didiu a ainm in latraind-sin. Dismus tra ro-chret-side do Ísu; & ro-ráid Isu fris: 'Bia-su imalle frim-sa indíu i pardus i fhlaith m'athar'. Conid desmirecht sin do lucht na dian-aithrige, acht corop díchra a comshod co Dia, co tabair dilgud doib.*

(although this is an important feature of Christian devotion), he also represents the means of salvation by which man might be restored to his original pre-Lapsarian likeness to God. The image of Christ had a dual function also: it was an expression of a community's belief and orthodoxy – as Jennifer O'Reilly has remarked, 'the image of the crucified Christ functioned as a visual *credo*'[61] – but it was also a stimulus to meditation and devotion through which the believer might come to know and understand Christ. Of such images, Leo the Great had proclaimed:

> Let him see what nature it was that hung pierced with nails on the wood of the cross, and with the side of the crucified laid open by the soldier's spear let him understand from where the blood and water flowed to wash the church of God with font and cup.[62]

As Leo makes clear, through the Passion sacrament and sacrifice are inextricably entwined. It is this evocative fusion that lies at the heart of many of the passions and homilies of the Leabhar Breac, which, through narratives told in language that is often simple, reiterative and formulaic[63] – and which has thus been largely ignored by literary critics who condemn it for being conventional, conservative, and unoriginal in a culture where the radical, novel, and unique are prized[64] – offer a coherent and sometimes complex Christology. In many instances, the performative contexts of the early medieval homilies and sermons that survive are forever lost: the passions and homilies of the Leabhar Breac survive in a fifteenth-century manuscript amid works of various genres, both sacred and secular. Nevertheless, the diverse and disparate voices that emerge from these texts reveal a coherent vision in which the historical event of the Passion and its continued performance

61 Jennifer O'Reilly, '"Know who and what he is"', p. 302. **62** Leo the Great, *Epistula Papae Leonis ad Flavianum ep. Constantinopolitanum de Eutyche*, in *Decrees of the ecumenical councils*, ed. N.P. Tanner (2 vols, London, 1999), i, pp 77–82 at p. 81. *Videat quae natura transfixa clavis pependerit in crucis ligno et aperto per militis lanceam latere crucifixi intellegat unde sanguis et aqua fluxerit, ut ecclesia dei et lavacro rigaretur et poculo.* Note also similar comments by Augustine, this time in relation to the written word as the source of meditation and understanding, when he claims that: '... our whole intention, when we hear the psalm, the prophet and the law, all that was written before our Lord Jesus Christ came into the flesh, is to see Christ there, to understand Christ there'. Augustine, *Ennarationes in psalmos*, ed. E. Dekkers and J. Fraipont (Turnhout, 1956), p. 378. **63** As Mac Donncha notes of the Latin-Irish homilies: 'Clarity and simplicity are sought, positive definite expressions are used rather than subtle ones. There is quite an amount of simplifications of reducing to one identical expression several Latin ones. Great care is taken to make perfectly clear the subject and object of sentences. The translation is fairly free, at times very free with the addition of much extra matter, sometimes close and accurate. It is not always free from Latinisms, and we get the impression of dealing with a person, who was not always conscious when he was slipping from one language to another': Mac Donncha, 'Medieval Irish homilies', p. 68. **64** The great scholar of early Irish, Whitley Stokes, for example, described the homilies in the Leabhar Breac as 'nearly worthless': see Murdoch, 'Preaching in medieval Ireland: the Irish tradition', p. 40.

in the present play a central role. The continuity across this corpus cannot be fully appreciated until a modern, superior edition is available and further analysis of the individual texts has been undertaken. Nevertheless, the importance of the Passion as the source of inspiration for *imitatio* is clear. Although aimed at distinct audiences and derived from diverse origins, yet across the Irish homiletic tradition we witness a continued concern with the core issues of suffering, salvation and sacrament, which are brought together at the moment of the crucifixion, when – to paraphrase Augustine – God becomes man that man might once more become one with God.

The *Volto Santo*'s legendary and physical image

MICHELE BACCI

In the last decades, art historians have frequently laid emphasis on the 'cultic' role played by images in the religious experience of the Middle Ages, although no special efforts have been made to provide the ambiguous term 'cult' with a more circumstantiate meaning.[1] Actually, this word can be safely used as a generic expression to hint at both individual and collective forms of religious expression, including liturgical rites, devotional acts and mystical experiences, as well as private, domestic and votive practices. The way in which images are involved in such religious manifestations may vary according to different factors: they can prove to be simply instrumental to the performance of ritual and pious acts, or play a much more decisive role as visual foci of a well consolidated cultic phenomenon, being invested with relic-like, documentary or miraculous qualities. The latter case was much less widespread than the former and, as some scholars have remarked, was much more an outcome of the early Modern era, rather than a hallmark of medieval spirituality.[2]

Yet, medieval religious literature was indeed responsible for working out many legendary motifs that described Christian images as vehicles of God's intervention in the human dimension: widely disseminated by both devotional and liturgical texts and eventually used as theological and didactic arguments, such stories happened in the course of time to be associated with material images and used as rhetorical tools to shape the latter's 'personality' in universally recognizable and powerful terms. This encounter caused a most crucial shift of status, by virtue of

1 Reference to the scholarly trend inaugurated by Hans Belting's famous book *Bild und Kult: eine Geschichte des Bildes vor dem Zeitalter der Kunst* (Munich, 1990) is here implied. 2 See, especially, the papers gathered in E. Thunø and G. Wolf (eds), *The miraculous image in the Middle Ages and Renaissance* (Rome, 2004).

which an ordinary image was gradually credited with possessing supernatural qualities, resulting from its identification with the mythical protagonist of a renowned miracle. Such a process usually proves to be very difficult to illustrate, as we are often no more able to recognize the whole range of conflations between the ideal archetype and its material counterpart: one can wonder, for example, if and to what extent the transformation of an image into a cult-object implied a more or less thorough reshaping of its material appearance, and if and to what extent the latter could be expected to visualize its mythical counterpart, for example by adopting compositional, iconographic and stylistic features that conveyed an idea of ancientness and exotic otherness. In the present essay, I would like to analyse such dynamics by offering a different look at the *Volto Santo* in Lucca. This very odd object is especially interesting because of its controversial perception as both cross and image, holy face and whole body, three-dimensional statue and icon, piece of furnishings and cultic object, true-to-life portrait and disappointing artwork at the same time. In order to decide how to interpret such contradictory features, it proves necessary to explore the *Volto Santo*'s long-lasting cultic prehistory, starting from the age of the iconoclastic controversies.

On 11 March 843, the *basilissa* Theodora put an end to the long-lasting iconoclastic controversy by celebrating a solemn procession with icons through the streets of Constantinople. Such an event was perceived by the Byzantine church as the final victory over heresy and as the beginning of a new Christian era: this implied, as Marie-France Auzépy has pointed out, a thorough rethinking of collective identity, which was achieved by means of an increased emphasis on the concept of tradition, intended as an allegedly uninterrupted transmission and observance of the usages that had been established in the apostolic past and could be repeated without alteration in the extra-temporal dimension of the liturgy.[3] Icons ceased to be either mere manifestations of devotional piety or subjects of legendary fiction and started to be perceived as material symbols of orthodox self-awareness. Gradually, during the late ninth and tenth century, these icons began to play the role of protagonist in the annual commemoration of the Triumph of Orthodoxy over iconoclasts, a commemoration that was celebrated on the first Sunday of Lent. Starting on the evening of Saturday's *ton kolyvon* (that is, 'of the cakes', a feast commemorating a famous miracle of St Theodore Tiron), this celebration was meaningfully superimposed on the earlier commemoration of Moses and Aaron, probably in order to assert that image worship, prohibited by God's words on Mount Sinai, was now made possible and even necessary by the

3 Marie-France Auzépy, 'La tradition comme arme de pouvoir: L'exemple de la querelle iconoclaste' in J.-M. Sansterre (ed.), *L'autorité du passé dans les sociétés médiévales* (Brussels and Rome, 2004), pp 79–92 at p. 90. Compare also Andrew Louth, 'Introduction' in Andrew Louth and Augustine Casiday (eds), *Byzantine orthodoxies: papers from the thirty-sixth spring symposium of Byzantine studies, University of Durham, 23–25 March 2002* (Aldershot, 2006), pp 1–11.

new covenant manifested by Christ's Incarnation. It was also known as 'the day of dedications' since the most emotionally charged moment in the celebration of 843 had consisted in the re-consecration of all churches profaned by the Iconoclasts.[4]

As in 843, the Feast of Orthodoxy consisted of solemn offices and public processions with icons and crosses, which shared the same space as their believers; there, the latter had the chance to look at holy images and learn that, in worshipping them, they were acting as true Orthodox Christians. It was in front of these icons that the *synodikon* of orthodoxy was publicly read, as well as several other texts, including pseudo-Damascene's *Third homily on images*, the so-called *Epistola synodica*, and, most notably, accounts of a number of miracles performed by icons in the past. Such miracles were often selected on the basis of alleged authorship by certain of the church Fathers, which enabled them to sound as authoritative as the traditional readings from John Chrysostom's works used in Lent and included in the *Triodion*.[5] One such miracle was the story of the injured image of Beirut, which was commonly attributed to Athanasius of Alexandria and, as such, had been cited in the sessions of the Ecumenical Council of Nicaea in 787; it was especially favoured as it described an act of iconoclasm *ante litteram*, with an image of Christ that, after being stabbed by some Jews, had started pouring forth large quantities of blood that had immediately proved to operate miraculous healings; such details as the final mass conversion of the Beirut Jews to Christianity and the dedication of the town synagogue to the Holy Saviour enabled defenders of image-worship to establish a direct parallelism with the events of 843.[6]

The Beirut narrative, which was by far the most common of the liturgical lessons for the Feast of Orthodoxy, was often associated with other stories, including those of the Edessa Mandylion, the Hierapolis Keramidion, the Marian *acheiropoieton* in Lydda, the icon of the Virgin Mary that had spoken to St Mary the Egyptian in Jerusalem, and the image of Christ stabbed with a knife by a Jew in the Hagia Sophia of Constantinople (which was itself a local variant of the Beirut archetype). Such a selection was instrumental in establishing a direct connection with the images celebrated by tradition and a number of icons and holy mementoes being worshipped in the Byzantine capital and probably involved

4 Jean Gouillard, 'Le synodikon de l'Orthodoxie: Édition et commentaire', *Travaux et mémoires*, 2 (1967), 1–316 at 45, 134–5; Dimitra Kotoula, 'The British Museum Triumph of Orthodoxy Icon' in Louth and Casiday (eds), *Byzantine orthodoxies*, pp 121–30 at p. 124. 5 Gouillard, 'Le synodikon', 129–38. 6 Michele Bacci, 'Quel bello miracolo onde si fa la festa del santo Salvatore: studio sulle metamorfosi di una leggenda' in Gabriella Rossetti (ed.), *Santa Croce e Santo Volto: Contributi allo studio dell'origine e della fortuna del culto del Salvatore (secoli IX–XV)* (Pisa, 2002), pp 7–86. See also Michele Bacci, 'The Berardenga Antependium and the *Passio ymaginis* office', *JWCI*, 61 (1998), 1–16; Jean-Marie Sansterre, 'L'image blessée, l'image souffrante: quelques récits de miracles entre Orient et Occident (VIe–XIIe siècle)' in J-M. Sansterre (ed.), *Les images dans les sociétés médiévales: pour une histoire comparée* (Rome, 1999), pp 113–30 at pp 116–22.

in the annual celebrations: the Beirut image itself, which was said to display a crucifixion, had been preserved since 975 in the Chalke chapel in the Great Palace in Constantinople, whereas the Mandylion and Keramidion were included in the treasure of the Pharos chapel, and the icon of St Mary the Egyptian was displayed on the main entrance of the naos (nave) of the Hagia Sophia.[7]

This association with local tradition was probably deliberate and aimed partly at pleasing the audience of Lenten sermons, and partly at emphasizing that God's miraculous intervention by means of holy images was by no means restricted to ancient and geographically alien icons. Such a process was already fully accomplished by the late eleventh century, when sermons including up to five stories set in Constantinople itself started to circulate: these included an episode of injury to the famous Hodegetria icon, the image in the Hagia Sophia, and the icons of Maria Rhomaia and Christ Antiphonetes, which were said to have been committed by Patriarch Germanos to the waves of the Bosphorus at the start of iconoclasm.[8] By such means, the space-time dimension of legends happened to overlap with the believers' everyday environment, that is, with the cult-places, streets and squares that, on the occasion of the Feast of Orthodoxy, were enlivened by long processions led by the very effigies that were evoked in sermons, as is shown by a late icon (*c*.1400) in the British Museum, where the palladium of Constantinople, the Hodegetria, plays the role of protagonist.[9]

In approximately the same period, the church in Rome (which had been a stronghold of the iconodulic party) seems to have developed a special liturgical celebration, known as the *Passio imaginis Domini* or *Festum Salvatoris*,[10] in analogy with the Feast of Orthodoxy. It consisted of the commemoration of the Beirut miracle, which already by the tenth century had been fixed on 9 November in Catalan and Italian calendars.[11] The story, known from Anastasius the Librarian's translation of the Acts of the Council of Nicaea, dating from *c*.873,[12] circulated in at least four different variants including important additions: one told that, in order to commemorate the miraculous event, the bishop of Beirut had solemnly converted the local synagogue into a church dedicated to the Saviour and had

7 On these narratives and the sacred objects associated with them, see Ernst von Dobschütz, 'Coislinianus 296', *Byzantinische Zeitschrift*, 12 (1903), 534–67 at 545–6; Bacci, 'Quel bello miracolo', pp 15–16. **8** Ernst von Dobschütz, *Christusbilder: Untersuchungen zur christlichen Legende* (Leipzig, 1899), pp 213**–32**. **9** Kotoula, 'The British Museum Triumph of Orthodoxy Icon'. Athanasios Markopoulos, 'Ὁ θρίαμβος τῆς Ὀρθοδοξίας στὴν εἰκόνα τοῦ Βρετανικοῦ Μουσείου: Τὰ πρόσωπα καὶ τὰ κείμενα', Δελτίον τῆς χριστιανικῆς ἀρχαιολογικῆς ἑταιρείας, ser. IV, 26 (2005), 345–52. For the importance of place to the development of liturgical processions, see Van Tongeren, this volume. **10** Bacci, 'Quel bello miracolo', pp 16–40, and texts published at pp 60–70. **11** The earliest witness is a passional in the archives of Girona Cathedral (MS 11, fo. 117v): see Luís Serdá, 'Los martirologios de la Marca Hispánica en la evolución litúrgica de la misma', *Ausa*, 1:9 (1952–4), 387–9 at 388. For further evidence, see Bacci, 'Quel bello miracolo', pp 27–8 and texts at pp 60–1. **12** Anastasius the Librarian, *Translation of the Acts of the 7th Ecumenical Council*, ed. Giovan Domenico Mansi (53 vols, Florence and Venice, 1759–98), xiii, cols 23–31.

instituted an annual feast on 9 November.[13] Another one stated that the image was an authentic portrait of Christ painted by the pharisee Nicodemus in the night following Christ's crucifixion and that many ampullae filled with the holy blood shed from its surface had been disseminated throughout the Christian world on the initiative of the bishop of Beirut.[14] The feast of the *Passio imaginis* was widespread in several areas of Europe at least until it started being substituted by the feast of the dedication of the Lateran basilica from the twelfth century onwards. By means of the latter, the Roman curia attempted to transpose into a Roman setting the basic motifs of the ancient Eastern legend, and especially the final conversion of the Beirut synagogue into a church dedicated to the Holy Saviour; in the view of Lateran canons, it was important to assert that the 'Basilica Salvatoris' in Rome had been the first one to bear such a venerable dedication.[15] Yet, before this process of 'Romanization' was enacted, the feast of 9 November had constituted a specifically Western way of celebrating victory over the icono-clastic heresy, focused on the most widespread of Byzantine liturgical readings on images, and imbued with a strong Christological meaning.

In my view, the choice of 9 November instead of the first Sunday of Lent was aimed at maintaining the original association with the feast of St Theodore Tiron, which was not movable in Roman tradition, but fixed on the aforementioned date. The Roman church felt that it had preserved the memory of the dedication of the Beirut synagogue as a consequence of its long-lasting Petrine association with the patriarchate of Antioch, within whose jurisdiction the Lebanese town fell; given that the story described nothing more than a re-enactment of the crucifixion, it worked out a specific Office modelled on those used for the Invention (3 May) and the Exaltation of the Cross (14 September). Yet, the connection with the Byzantine Feast of Orthodoxy is best revealed by a number of passionals pertaining to the most important Roman churches, where a selection of miracles performed by images is included among the lessons for the *Festum Salvatoris*.[16] The passional composed by canon Bibianus for the Lateran basilica in the late eleventh century includes a short sermon on the *Dedicatio ecclesiae lateranensis*, followed by five Byzantine stories: the stabbed image of the Hagia Sophia, the *acheiropoieta* of Lydda and Gethsemane, the Edessa Mandylion and, last but not least, the Beirut image itself.[17] Moreover, the use of multiple lessons is confirmed by the expression

13 Edited in *PG* 161, 819–24. **14** First witnessed by an eleventh-century manuscript in the Vatican Library (Rome, Vatican Library, lat. 641, fos 134–6), ed. Pietro Savio, 'Ricerche sulla Santa Sindone: Icone del Salvatore', *Salesianum*, 18 (1958), 578–640 at 610–16. See E. Galtier, 'Byzantina', *Romania*, 29 (1900), 501–27. **15** Frederick George Holweck, *Calendarium liturgicum festorum Dei et Dei matris Mariae* (Philadelphia, 1925), p. 380; Policarpo Radó, *Enchiridium liturgicum* (Rome, Freiburg im Breisgau and Barcelona, 1966), ii, p. 1313; Pierre Jounel, *Le culte des saints dans les basiliques du Latran et du Vatican au douzième siècle* (Rome, 1977), p. 306; Bacci, 'Quel bello miracolo', pp 34–9. **16** Bacci, 'Quel bello miracolo', pp 32–4. **17** Rome, Archivio del Vicariato, Fondo Lateranense, MS A80, fos 223–26v. See Jounel, *Le culte des saints dans les basiliques du Latran*

Miracula de imagine Domini, which occurs in a number of lectionaries, and by the association of the Beirut legend with the story of the Hagia Sophia icon, and the legend of the Lucca *Volto Santo* in several later manuscripts.[18] The unique combination of readings in the late twelfth-century passional from Santa Maria Maggiore in Rome, which includes only stories within a purely Roman setting (such as the Veronica, the Lateran *acheiropoieton*, and the *Arcus Pietatis*), can be considered to represent a clear attempt at thorough Romanization of the feast.[19]

Yet, notwithstanding all efforts on the part of the Lateran canons, the 'Basilica Salvatoris' continued to be regarded as owing its dedication to the special worship of the Beirut image. An ampulla of holy blood was kept among the basilica's most precious relics and such authors as Iacobus of Varagine and at least some of the manuscripts of Guillelmus Durandus' *Rationale divinorum officiorum* had no doubts in identifying it with one of the ampullae filled by the bishop of Beirut;[20] moreover, when the regular canons of Bergen Cathedral in Norway received a holy thorn of Christ's crown on 9 November 1214, they discovered in their books that the date corresponded, in Roman usage, to the commemoration of the translation of the blood ampulla from Beirut to the Lateran basilica and of its subsequent dedication to the Holy Saviour.[21] By the late twelfth century, an image of Christ located in the Lateran Patriarchium at the entrance to the chapel of St Sylvester started playing the role of cultic substitute of the Beirut image: a number of later sources state that it had shed blood, later preserved in the ampulla, after being struck with a stone by a Jew during the feast of the dedication of the Lateran basilica on 9 November. Unfortunately, there is no documentary evidence from which to ascertain whether this image was purposefully created to play this role or whether it was an older artwork previously used as a visual focus in the *Passio imaginis* feast. Yet, it is interesting to observe that some extant texts, while witnessing that it displayed Christ on the cross,[22] describe it as either 'the Lord's face' (*vultus dominicus*)[23] or 'a painted image of the Lord's majesty' (*dominicae maiestatis depictam imaginem*).[24]

et du Vatican, pp 305–7; Sansterre, 'L'image blessée', p. 119; Bacci, 'Quel bello miracolo', p. 32 and n. 66. **18** Bacci, 'Quel bello miracolo', p. 32 and n. 68; idem, 'Nicodemo e il *Volto Santo*' in Michele Camillo Ferrari and Andreas Meyer (eds), *Il Volto Santo in Europa: Culto e immagini del Crocifisso nel Medioevo. Atti del Convegno internazionale di Engelberg (13–16 settembre 2000)* (Lucca, 2005), pp 15–40 at p. 34. **19** Rome, Vatican Library, Fondo S. Maria Maggiore, MS 2, fos 234–49v. See Michele Bacci, 'San Salvatore "prope Arcum Pietatis"' in Francesco Caglioti (ed.), *Giornate di studio in ricordo di Giovanni Previtali* (Pisa, 2002), pp 15–28. **20** John of Varagine, *Legenda aurea*, ed. Giovanni Paolo Maggioni (Florence, 1998), pp 934–5; Guillelmus Durandus, *Rationale divinorum officiorum*, ed. A. Davril and T.M. Thibodeau (Turnhout, 1995), p. 64. **21** *Lectiones Bergenses*, in *Exuviae sacrae Constantinopolitanae*, ed. Paul de Riant (2 vols, Geneva, 1877–8), ii, pp 5–6. **22** Stefano, rector of Santa Maria in Impruneta, *Prolagho* [*c*.1370], in *Capitoli della Compagnia della Madonna dell'Impruneta* (Florence, 1866), p. 9. **23** Gervase of Tilbury, *Otia imperialia* (*c*.1214–15), iii, p. 25, ed. S.E. Banks and J.W. Binns, *Gervase of Tilbury, Otia Imperialia: Recreation for an Emperor* (Oxford, 2002), pp 604–5. **24** Gerald of Wales, *Gemma ecclesiastica*

Much the same semantic ambiguity characterizes the complex history of the Holy Face of Lucca (pl. 15), the legendary and cultic physiognomy of which, as several authors have pointed out, is closely related to the tradition concerning the Beirut image.[25] Its origins are still most controversial: first witnessed in the mid-eleventh century, its renown was already so widespread in the early twelfth century as to be invoked by English kings and worshipped by pilgrims from several parts of Europe.[26] Its cult emerged in the peculiar context of the cathedral church of San Martino (previously dedicated to the Holy Saviour), which was by then ruled by the same regular canons established in the Lateran basilica; it is a well-known fact that, in the wake of the Gregorian Reform (especially under Bishop Rangerius in the second half of the eleventh century), many efforts were made to imitate in Lucca the usages and traditions of the Roman church. In a way, the cult of the cross was especially enhanced in this period: the offices of the Invention and Exaltation were most solemnly performed and, as we learn from a document dating from c.1070,[27] two altars connected with the worship of the cross faced each other, as in Roman basilicas, in the middle of the nave: one was located 'before the old cross' and one *ante vultum*, before the Holy Face, which had been built in honour of several saints, including Cornelius and Cyprian. The very fact that the latter's feast fell on 14 September, the day of the Exaltation, indirectly corroborates the identification of the *vultus*, already in this early phase, with a figurative cross or crucifix.[28]

[1197], i, 31, ed. John Sherren Brewer, *Giraldi Cambrensis opera* (London, 1862), ii, p. 103. The image is mentioned also in the following sources: Albinus, *Gesta* [c.1180], xi, p. 3, ed. Paul Fabre and Louis Duchesne, *Le 'Liber censuum' de l'Église romane* (2 vols, Rome, 1905–10), ii, p. 123; Cencius Camerarius, *Ordo Romanus* [1192], 58, ibid., p. 312; anonymous, *Mirabilia urbis Romae* [c.1360], ed. Gustav Parthey (Berlin, 1869), p. 52. See Gerhard Wolf, *Salus populi Romani: Die Geschichte römischer Kultbilder im Mittelalter* (Weinheim, 1990), pp 80, 106, 276, n. 345; Bacci, 'Quel bello miracolo', pp 37–8. **25** Francesco Paolo Luiso, *La leggenda del Volto Santo: Storia di un cimelio* (Pescia, 1928), pp 36–9; Chiara Frugoni, 'Una proposta per il *Volto Santo*' in Clara Baracchini and Maria Teresa Filieri (eds), *Il Volto Santo. Storia e culto* (Lucca, 1982), pp 15–48 at p. 20; Jean-Claude Schmitt, 'Cendrillon crucifiée: à propos du *Volto Santo* de Lucques' in *Miracles, prodiges et merveilles au Moyen Âge* (Paris, 1995), pp 241–69 at pp 246–7; Michele Camillo Ferrari, '*Imago visibilis Christi*: le *Volto Santo* de Lucques et les images authentiques au Moyen Âge', *Micrologus*, 6 (1998), 29–42, at 40–1); idem, 'Il *Volto Santo* di Lucca' in Giovanni Morello and Gerhard Wolf (eds), *Il volto di Cristo* (Milan, 2000), pp 253–62; Michele Bacci, '"Ad ipsius Christi effigiem": il *Volto Santo* come ritratto autentico del Salvatore' in the Municipality of Lucca (ed.), *La Santa Croce di Lucca, il Volto Santo: Storia, tradizioni, immagini* (Lucca, 2003), pp 115–25; idem, 'Nicodemo e il *Volto Santo*'; Raffaele Savigni, 'Lucca e il *Volto Santo* nell'XI e XII secolo' in Ferrari and Meyer (eds), *Il Volto Santo in Europa*, pp 407–97 at p. 408. **26** On the early history of the *Volto Santo*, see especially R. Savigni, *Episcopato e società cittadina a Lucca da Anselmo II (†1086) a Roberto (†1225)* (Lucca, 1996), pp 376–94; idem, 'Il culto della croce e del *Volto Santo* nel territorio lucchese' in the Municipality of Lucca (ed.), *La Santa Croce di Lucca*, pp 131–72; and Ferrari, 'Identità e immagine del *Volto Santo* di Lucca' in ibid., pp 93–102; G. Concioni, *Contributi alla storia del Volto Santo* (Pisa, 2005). **27** First published by Almerico Guerra and Piero Guidi, *Compendio di storia ecclesiastica lucchese* (Lucca, 1924), p. 54. See Piero Guidi, 'Per la storia della cattedrale e del *Volto Santo* (note critiche)', *Bollettino storico lucchese*, 4 (1932), 169–86. **28** Bacci, 'Nicodemo e il *Volto Santo*', pp 33–7. On the *altares*

Liturgical manuscripts from either Lucca or the Tuscan churches taking inspiration from Lucchese usages demonstrate that the *Passio imaginis* was one of the major feasts of the liturgical year.[29] By the thirteenth century, if not earlier, its office was performed in front of the *Volto Santo* itself and included lessons from the Beirut narrative.[30] The close connection with the latter is pointed out, in any case, by the many analogies and direct references to it which can be detected in the so-called Leobinian legend, the story of the *Volto Santo* most probably composed in the early twelfth century:[31] explicit hints are represented by the attribution to Nicodemus and the mention of an ampulla of holy blood among the relics associated with the image.[32] The identification of the original *Volto* with the present-day monumental wooden crucifix has often been disputed in the scholarly debate, on both historical and artistic grounds.[33] Some have wondered why a three-dimensional image should have been labelled as 'holy face' – an expression that would have been more appropriate in connection with such images as the Edessa Mandylion or the Veronica in the Vatican basilica.[34] Yet, contemporary documents witness that the word *vultus*, often employed to indicate holy portraits such as those painted by St Luke, could indeed be used as synecdoche to indicate crucifixes; in more general terms, it conveyed the idea of the image as true-to-life reproduction of Christ's physical appearance and height that was asserted in the *Passio imaginis* story.[35]

ante cruces facing each other at the middle of the nave in Roman basilicas, see Sible De Blauuw, *Cultus et décor: Liturgia e architettura nella Roma tardoantica e medievale: Basilica Salvatoris, Sanctae Mariae, Sancti Petri* (Rome, 1994), pp 192, 261, 670–1. **29** Bacci, 'Quel bello miracolo', pp 30–1. **30** As recorded by the late thirteenth-century *Ordo officiorum* of San Martino: Lucca, Biblioteca Capitolare, MS 608, fo. 63v. **31** *Relatio Leobini diaconi*, ed.Gustav Schnürer and Joseph M. Ritz, *Sankt Kümmernis und Volto Santo* (Düsseldorf, 1934), pp 127–34. **32** Bacci, 'Nicodemo e il *Volto Santo*', pp 25–6. **33** The late eleventh-century document published by Guerra and Guidi, *Compendio*, p. 54, which witnessed the existence of both an 'old' and a 'new' cross in the church of San Martino, has been used as evidence for the substitution of an older cult-object with a new sculpted crucifix: see Gustav Schnürer, 'Sopra l'età e la provenienza del *Volto Santo* in Lucca', *Bollettino storico lucchese*, I (1929), 77–105; Geza de Francovich, 'Il *Volto Santo* di Lucca', *Bollettino storico lucchese*, 8 (1936), 3–29; A. Pedemonte, 'Ricerche sulla primitiva forma iconografica del *Volto Santo*', *Atti della R. Accademia lucchese di scienze, lettere ed arti*, n.s., 5 (1942), 119–44; Reiner Haussherr, 'Das Imerwardkreuz und der *Volto Santo*-Typ', *Zeitschrift für Kunstwissenschaft*, 16 (1962), 129–70; Hansmartin Schwarzmaier, *Lucca und das Reich bis zum Ende des 11. Jahrhunderts* (Tübingen, 1972), p. 353; Clara Baracchini and Antonino Caleca, *Il Duomo di Lucca* (Lucca, 1973), pp 14–15; Antonino Caleca, 'Il *Volto Santo*: un problema critico' in Baracchini and Filieri (eds), *Il Volto Santo: Storia e culto*, pp 59–69; Romano Silva, 'La datazione del *Volto Santo* di Lucca: un problema irrisolto' in the Municipality of Lucca (ed.), *La Santa Croce di Lucca*, pp 76–81; Valerio Ascani, 'Il Crocifisso tunicato di Rocca Soraggio e la diffusione dell'iconografia del *Volto Santo* di Lucca nella Toscana del Duecento' in Antonia D'Aniello (ed.), *Il Volto Santo di Rocca Soraggio: storia e restauro* (Lucca, 2009), pp 9–18. **34** Hansmartin Schwarzmaier, *Movimenti religiosi e sociali a Lucca nel period tardo-longobardo e carolingio (contributo alla leggenda del Volto Santo)* (Lucca, 1973), pp 14–17 and 24; Frugoni, 'Una proposta', pp 16 and 19. **35** Bacci, 'Nicodemo e il *Volto Santo*', pp 15–17; idem, '"Ad ipsius Christi effigiem"', pp 115–18.

By the end of the twelfth century, when the Leobinian legend was enriched with an appendix devoted to its most famous miracles, the role of the *Volto Santo* as an authentic portrait was further emphasized by alleging that Nicodemus had sculpted it by exactly reproducing the size, breadth and height of Christ's body as imprinted on his funerary shroud.[36] In my view, such a reference might be explained as a strategy to rationalize the conceptual hiatus between monumental cross and holy face implied by the *Volto Santo*, by connecting it with the only extant *acheiropoieton* displaying Christ's whole body: the latter was the holy shroud first described as being in the church of Blachernae at Constantinople by the Crusader Robert de Clari in 1204; it is possibly (yet not necessarily) identical with the *sindone* later worshipped in Liray, Chambéry and Turin. This Byzantine relic was publicly exhibited on Fridays and reproduced on liturgical textiles employed in Easter rituals.[37]

According to Chiara Frugoni's view, it may well be that a kind of *acheiropoieton* or holy imprint on a textile was worshipped in Lucca before being substituted by a monumental crucifix;[38] yet, the specific context of the Saviour cult, in its close connection with the story of the injured icon of Beirut, makes this unlikely. In reproducing both the Saviour's appearance and height (as stated by the Leobinian legend), a monumental crucifix could efficaciously convey the idea of a true-to-life portrait that had suffered the same outrages and tortures inflicted on Christ better than any other kind of image. And in many respects it constituted a truthful, almost sacramental, replica of his body. Moreover, both Eastern and Western believers were accustomed to attribute to a cross-shaped object the role of documenting the real dimensions of the Saviour's body: such was the famous *crux mensuralis*, a tall golden cross that was worshipped in the Hagia Sophia in Constantinople and was frequently indicated as a unit of measurement in the medieval West.[39]

The idea of an original *Volto Santo* as distinct from the one presently worshipped in Lucca was born out of the stylistic reading proposed by such scholars as Geza de Francovich and others, who connected it with the art trends inaugurated by Benedetto Antelami and accordingly dated the crucifix to the late twelfth or early thirteenth century.[40] Subsequently, scholars have made many efforts to reconstruct the Lucchese prototype: in the 1990s, the radiocarbon dating

36 *Relatio Leobini diaconi*, 1, p. 128; *Miracula*, 6, Lucca, Biblioteca Statale, MS Tucci-Tognetti, fo. 12v.
37 Irina Shalina, *Relikvii v vostochnochristianskoy ikonografii* (Moscow, 2005), pp 113–32.
38 Frugoni, 'Una proposta', pp 26–32. **39** G. Majeska, 'Notes on the Skeuophylakion of St Sophia', *Vizantiyskiy Vremennik*, 55 (1998), 212–15. On the impact of the *crux mensuralis* on Western cult-phenomena, see M. Bacci, 'Vera croce, vero ritratto e vera misura: sugli archetipi bizantini dei culti cristologici del Medioevo occidentale' in Jannic Durand and Bernard Flusin (eds), *Byzance et les reliques du Christ* (Paris, 2004), pp 223–38. **40** See the essays cited in n. 34. For detailed analysis of Antelami's Deposition at Parma, see Parker, this volume.

of the wood of the *Volto Santo* in Borgo Sansepolcro to the eighth century seemed to offer an extraordinary solution, which was, however, viewed with much suspicion, given that formal solutions displayed by the image seemed more compatible with a twelfth-century dating.[41] Most recently, it has been proposed that the Lucchese image presents affinities with German wooden sculptures of the last decades of the eleventh or the early twelfth century.[42]

Be this as it may, it seems clear that the use of a wooden crucifix as a visual focus in the special worship of the Saviour in Lucca (first clearly implied by the term *vultus lignetus* employed by an author writing in *c.*1172),[43] was nothing more than the final outcome of a cultic process rooted in the Roman-oriented liturgical usages of the regular canons and in the celebration of an unconventional feast honouring an image instead of a holy person. More difficult to ascertain is whether the *Volto Santo*'s iconographical features must be explained against the same background. On the whole, they seem to rely on very archaic models, such as the outward appearance of the face, with its long bifurcate beard and hair falling down onto the shoulders, and the long-sleeved tunic, closed with a belt that is usually interpreted as hinting at the second coming of Christ according to Revelation 1:13, where the Son of Man is described as 'dressed in a robe reaching down to his feet and with a golden sash around his chest'.[44] Did the *Volto Santo* contribute to the spread of such an iconography or did it simply adopt an already widespread type?

The second hypothesis seems to be the more likely one. Only a few of the crucifixes represented in a long-sleeved tunic can be clearly recognized as copies of the Lucchese archetype, such as the one in Bocca di Magra (itself connected with the cult of the blood shed by the Beirut image),[45] the cross in Rocca Soraggio (at some time worshipped in a church whose main feast fell on 9 November),[46] and

41 *Il Volto Santo di Sansepolcro: Un grande capolavoro medievale rivelato dal restauro*, ed. Anna Maria Maetzke (Cinisello Balsamo, 1994); Anna Maria Maetzke, 'Il *Volto Santo* di Sansepolcro' in Ferrari and Meyer (eds), *Il Volto Santo in Europa*, pp 193–207. See especially the critical remarks by F. Gandolfo, 'Due questioni aretine', *Confronto*, 3:4 (2004), 100–23. **42** Arturo Carlo Quintavalle, 'Rosano e i crocifissi viventi della riforma: dal "*Volto Santo*" di Lucca a Batlló', *OPD restauro*, 20 (2008), 139–70. **43** Rorgo Fretellus de Nazareth, *Descriptio de locis sanctis* [1172], 74, ed. Petrus Cornelis Boeren, *Rorgo Fretellus de Nazareth et sa description de la Terre Sainte: histoire et édition du texte* (Amsterdam, 1980), p. 42. **44** Hausherr, 'Das Imervardkreuz', pp 156–8. See also Herbert Kurz, *Der Volto Santo von Lucca: Ikonographie und Funktion des Kruzifixus in der gegürteten Tunika im 11. Jahrhundert* (Regensburg, 1997); Francesca Pertusi Pucci, 'I crocifissi tunicati di Force e di Amandola nell'ascolano: Osservazioni e ipotesi', *Rivista dell'Istituto nazionale di archeologia e storia dell'arte*, ser. III, 8–9 (1985–6), 365–98; idem, 'I crocifissi lignei in abito regale e sacerdotale: Ipotesi sulla origine e diffusione di un culto' in Rossetti (ed.), *Santa Croce e Santo Volto*, pp 87–118. **45** Agostino Pertusi and Francesca Pertusi Pucci, 'Il crocifisso ligneo del Monastero di Santa Croce e Nicodemo di Bocca di Magra', *Rivista dell'Istituto nazionale d'archeologia e storia dell'arte*, s. III, 2 (1979), 31–51; Fulvio Cervini, 'Volti Santi in Liguria e in Lombardia' in Ferrari and Meyer (eds), *Il Volto Santo in Europa*, pp 41–66 at pp 41–4. **46** Stefano Martinelli, 'Il *Volto Santo* di Rocca Soraggio: un inedito crocifisso ligneo medievale nell'Alta Garfagnana' in D'Aniello (ed.), *Il Volto*

other crucifixes preserved in Tuscany.[47] Other examples, such as the Sondalo crucifix with its distinctive chiton-like tunic, or even the famous crucifix of Imerward in Brunswick Cathedral, which was described by Erwin Panofsky and Reinhold Hausherr as closely connected to the *Volto Santo* on stylistic and compositional grounds, can hardly be considered to replicate directly the Lucchese archetype, given that no evidence is available concerning their relationship to the cultic phenomena and liturgical practices connected to the latter.[48] Moreover, the hypothesis about the early worship of a direct copy of the Holy Cross of Lucca in Bury St Edmunds, England, as proposed by Diana Webb, is only conjectural.[49]

In Ireland, where the Beirut legend was well known and the long-sleeved tunic had often been employed in the representation of the crucifixion, the worship of a monumental crucifix of this type seems to have developed in the twelfth century, before the Anglo-Norman conquest in 1171.[50] According to Gerald of Wales (d. 1223), there was in Christ Church Cathedral, Dublin, 'a most miraculous cross, displaying the crucified Jesus' face' (*crux quaedam virtuosissima, vultus praeferens crucifixi*).[51] As in a number of like stories, it was considered to be especially efficacious in protecting economic transactions. The miniature accompanying the text in the London manuscript of the *Topographia Hibernica* (pl. 26) represents it as a monumental crucifix with long-sleeved tunic; its wide folds and the lack of a prominent belt seem to rule out any direct hint at the Lucca *Volto Santo*.[52]

In the same way, specific reproductions of the Lucchese cult-phenomenon are completely unknown in twelfth-century Catalunya, where a large number of crucifixes with long-sleeved tunic (locally known as *majestats*) were carved.[53] On the contrary, the *Passio imaginis* feast was well rooted in that area and associated with the liturgical life of the regular canons, whose connections with Rome, as for instance in Santa Maria in Besalú, have been frequently pointed out. In at least

Santo di Rocca Soraggio, pp 19–54. **47** Clara Baracchini and Maria Teresa Filieri, 'L'immagine del *Volto Santo* nell'arte sacra' in Baracchini and Filieri (eds), *Il Volto Santo: Storia e culto*, pp 95–100. **48** Erwin Panofsky, 'Das Braunschweiger Domkruzifix und das "*Volto Santo*" zu Lucca' in *Festschrift für Adolf Goldschmidt* (Leipzig, 1923), pp 37–44; Hausherr, 'Das Imervardkreuz'. On the representations of the *Volto Santo* in manuscripts, see Jean-Claude Schmitt, 'Les images d'une image: La figuration du *Volto Santo* de Lucca dans les manuscrits enluminés du Moyen Âge' in Herbert L. Kessler and Gerhard Wolf (eds), *The Holy Face and the paradox of representation* (Bologna, 1998), pp 205–27. **49** Diana Webb, 'The Holy Face of Lucca', *Anglo-Norman Studies*, 9 (1986), 227–37. See also Audrey Scanlan-Teller, 'The *Volto Santo* in the British Isles' in Ferrari and Meyer (eds), *Il Volto Santo in Europa*, pp 499–525. **50** Mullins discusses the *Passio imaginis* in an Irish context in her essay in this volume; for further discussion of Gerald of Wales' account of the Christ Church crucifix, see Ní Ghrádaigh, this volume. **51** Gerald of Wales, *Topographia hibernica*, ii, 44–6, ed. James F. Dimock (London, 1867), pp 128–9. **52** London, BL, MS Royal 13 B VIII, fo. 23v. **53** Manuel Trens, *Les majestats catalanes* (Barcelona, 1966); R. Bastardes, *Las talles romàniques del Sant Crist a Catalunya* (Barcelona, 1978); Jordi Camps, 'L'escultura en fusta' in Manuel Castiñeiras and Jordi Camps (eds), *El Romànic a les colleccions del MNAC* (Barcelona, 2008), pp 136–63 at pp 145–50. For further discussion of the majestat iconography, see Camps, this volume.

one case, that of the majestat in Beget, we know that even in the present day its feast is solemnly celebrated on 9 November. Such circumstances even led Marcel Durliat to suggest that all majestats were indeed visual interpretations of the legendary Beirut icon and were originally connected with altars dedicated to the *Passio imaginis*.[54]

Yet, even this latter hypothesis risks being misleading. The main difficulty in establishing a direct connection between the '*Volto Santo*'/'Majestat' types and the Beirut image lies in the fact that the few extant representations explicitly hinting at it simply display it as a standard crucifix with perizonium. Such characteristics are shown by a fifteenth-century wooden statue in Valencia Cathedral, which at least in the eighteenth century was reputed to be the original Beirut image,[55] and by the earlier and later narrative cycles, such as the miniature in the twelfth-century Stuttgart Passional,[56] the Berardenga Antependium (dating from 1215; pl. 16),[57] a French miniature of the fourteenth century,[58] and the late fifteenth-century carved retablo in Felanitx, Mallorca.[59] It seems clear that such images basically aimed at representing the profaned object in the most standard and conventional way; therefore, it proves more useful to postulate that the cult of the majestats and the *Volto Santo* echoed some traits of the legendary Beirut image and that the latter's widespread renown, made possible by its liturgical commemoration, corroborated the idea of an archetypal crucifix, whose generic appearance was occasionally manifested by adopting old-fashioned features taken after eastern Mediterranean models.

One such feature was represented by facial hair, with its distinctive bifurcate shape.[60] By the eleventh century, the representation of Christ as a long-bearded and long-haired man was not especially popular in the West, where a clean-shaved face was still often preferred. According to Isidore of Seville and other authors, a beard and all other superfluous down had to be avoided, as they manifested male viciousness.[61] Yet, replicas of the *acheiropoietic* portraits of Christ contradicted this

54 Marcel Durliat, *Christs romans: Roussillon, Cerdagne* (Perpignan, 1956), pp 33–4; idem, 'La signification des Majestés catalanes', *Cahiers archéologiques*, 37 (1989), 69–95. On the *Passio imaginis* in Catalunya, see also Josep Gudiol i Cunill, *Nocions de arqueologia sagrada catalana* (Vic, 1902), pp 318–19; Juan B. Ferreres, *Historia del misal romano* (Barcelona, 1929), pp 131 and 310–12. 55 Carlos Espí Forcén, *Recrucificando a Cristo: Los judíos de la* Passio imaginis *en la isla de Mallorca* (Mallorca, 2009), pp 57–60; Luís Arciniega García, 'La *Passio imaginis* y la adaptiva militancia apologética de las imágenes en la Edad Media y moderna a través del caso valenciano', *Ars Longa*, 21 (2012), 7–94. 56 Albert Boeckler, *Das Stuttgarter Passionale* (Augsburg, 1923), p. 22; Heinz Schreckenberg, *The Jews in Christian art: an illustrated history* (New York, 1996), p. 259. 57 Michele Bacci, 'The Berardenga Antependium and the *Passio Ymaginis* Office', *JWCI*, 61 (1998), 1–16; Raffaele Argenziano, *Alle origini dell'iconografia sacra a Siena* (Florence, 2000), pp 147–70. 58 Schreckenberg, *The Jews*, p. 260. 59 Carlos Espí Forcén, 'Jews desecrating a crucifix: a "*Passio imaginis*" altarpiece from Mallorca', *Iconographica*, 8 (2009), 83–97; idem, *Recrucificando a Cristo*, pp 63–82. 60 Pertusi Pucci, 'I crocifissi lignei in abito regale e sacerdotale', p. 100. 61 See especially Robert Burchard and Constantijn Huygens, 'Introduction' in *Apologiae duae. Gozechini*

view by showing the Saviour with a long, bifurcate beard and flowing hair: such a detail, which is constantly repeated in the copies of the Edessa Mandylion, was also appropriated, from the thirteenth century onwards, by devotional replicas of the Roman Veronica.[62] They both relied on physiognomic types that had been established in the Syro-Palestinian area in the proto-Byzantine period and aimed originally at characterizing Christ as a Nazirean – that is, a man consecrated to God according to the Book of Numbers (chapter 6), whose hair and beard should have never been touched by any razor.[63] Latin translations of Byzantine literary portraits of the holy personages happened to stress again such a connection: in the *Letter of Lentulus*, possibly dating from the thirteenth century but relying on much earlier texts, it was clearly stated that Christ had long hair and bifurcate beard according to the standard Nazirean look.[64]

The long-sleeved tunic was another means to attribute a deliberately archaic appearance to the image of the Saviour.[65] By the eleventh century, this feature, without the knotted belt, was relatively widespread in the arts of northern Europe: it was commonplace in Ottonian book illumination, as is revealed by the famous miniatures in the Uta Codex and the Gospels of Henry II, and had been preceded by a number of earlier representations, many of them being detectable in Insular and more specifically Irish art, such as the Durham Gospels, the Athlone Plaque and the incised stone on the Isle of Man.[66] The occurrence of such solutions on small metalwork objects, such as some pectoral crosses from tenth-century Scandinavia,[67] may hint at compositional and morphological connections with Byzantine and Near Eastern *encolpia*, which were frequently embellished by

epistola ad Walcherum: Burchardi, ut videtur, abbatis Bellevalis Apologia de barbis (Turnhout, 1985), pp 47–150. **62** Gerhard Wolf, 'From Mandylion to Veronica: picturing the "disembodied" face and disseminating the true image of Christ in the Latin West' in Wolf and Kessler (eds), *The Holy Face*, pp 153–79. **63** Michele Bacci, 'L'invenzione della memoria del volto di Cristo: osservazioni sulle interazioni fra iconografia e letteratura prosopografica prima e dopo l'Iconoclastia' in Arturo Carlo Quintavalle (ed.), *Medioevo: immagine e memoria* (Milan, 2009), pp 93–108. **64** *Epistola Lentuli*, ed. Dobschütz, *Christusbilder*, p. 319**. See also Cora Elizabeth Lütz, 'The letter of Lentulus describing Christ', *Yale University Library Gazette*, 50 (1975), 91–7. **65** On the so-called *tunica manicata* and its variants, see especially Trens, *Majestats*, pp 26–8; Klaus Wessel, 'Die Entstehung des Crucifixus', *Byzantinische Zeitschrift*, 53 (1960), 95–111; Hausherr, 'Das Imervardkreuz'; Ernst Hagemann, 'Zur Ikonographie des gekreuzigten Christus in der gegürteten Tunika', *Niederdeutsche Beiträge zur Kunstgeschichte*, 13 (1974), 97–122; M. Armandi, '*Regnavit a ligno Deus*: Il crocifisso tunicato di proporzioni monumentali' in Maetzke (ed.), *Il Volto Santo di Sansepolcro*, pp 124–35; Elizabeth Coatsworth, 'The "robed Christ" in pre-Conquest sculptures of the crucifixion', *Anglo-Saxon England*, 29 (2001), 153–76; Lawrence Nees, 'On the image of Christ crucified in early medieval art' in Ferrari and Meyer (eds), *Il Volto Santo in Europa*, pp 345–85. See also Camps, this volume. **66** See the bibliographic survey by Nees, 'On the image', pp 349–51. Detailed discussion of the depiction of Christ in these and related Insular works is offered by Ní Ghrádaigh and Murray, this volume. **67** For a notable example unearthed in Novgorod, see V.Ya. Petrukhin and T.A. Pushkina, 'Novye dannye o protsesse khristianizatsii Drevnerusskovo gosudarstva' in Leonid Belyaev (ed.), *Archaeologia abrahamica: Issledovaniya v oblasti arkheologii i khudozhestvennoy traditsii Iudaizma, khristianstva i Islama* (Moscow, 2009), pp 157–68 at pp 163–4 and fig. 9.

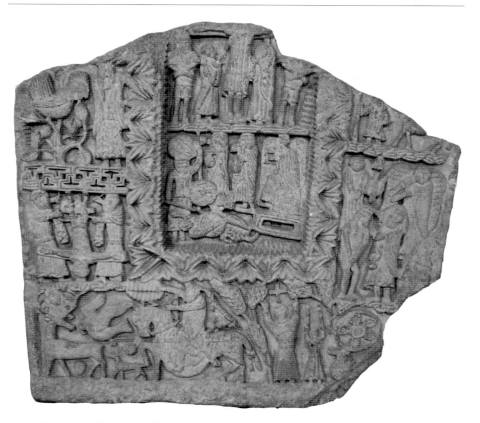

11.1 Marble altar screen from the church of Tsekbelda, seventh–eighth century. Tbilisi, Shalwa Amiranashvili Museum of Fine Arts (photograph by the author).

incised images of the crucified with long garments rendered in a linearly simplified way. The clothing solution displayed by such objects as a small reliquary cross from the eleventh century in a private collection in Germany,[68] for example, could be easily misunderstood as a long-sleeved tunic, even if its closest model was probably the sleeveless *kolobion* widespread in proto-Byzantine iconography, especially in the Syro-Palestinian area (notable examples are the miniature of the crucifixion in the Rabbula Gospels, the crucifixion icon on Mount Sinai, and the early eighth-century mural painting in Santa Maria Antiqua in Byzantine-ruled Rome).[69]

Pectoral crosses undoubtedly played a role in disseminating such an iconography and one can wonder, with Reinhold Hausherr, if the long-sleeved tunic was anything more than a Western misunderstanding of the Byzantine *kolobion*. Yet, the latter is sometimes rendered in a peculiar way, with portions of the garment extended over Christ's arms, as in a cross in the Benaki Museum in Athens,[70] or looking much like an authentic long-sleeved robe, as in a sixth-century gold pendant in the British Museum in London,[71] another pectoral cross in the

68 *Rom und Byzanz: Archäologische Kostbarkeiten aus Bayern*, ed. Ludwig Wamser and Gisela Zahlhaas (Munich, 1998), p. 201, no. 291. **69** Nees, 'On the image', pp 346–9. **70** *Byzantium, 330–1453*, ed. Robin Cormack and Maria Vassilaki (London, 2008), p. 429, no. 197. **71** Wessel,

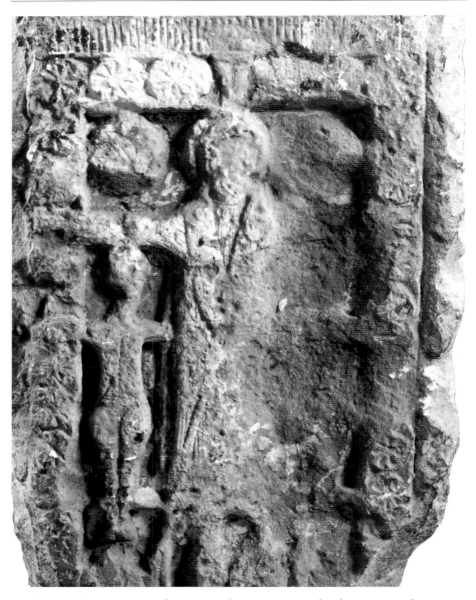

11.2 Crucifixion, detail of the stone pillar from Satskhenisi, sixth century. Tbilisi, Shalwa Amiranashvili Museum of Fine Arts (image after Machabeli, *Early medieval Georgian stone crosses*, 2008).

Byzantine Museum in Athens,[72] and, even more clearly, in a sixth-century Egyptian *encolpion* now in the Dumbarton Oaks collection in Washington.[73] Some hitherto neglected artworks point out that such variants were by no means unknown in the arts of the Eastern Christians.

A marble altar screen dating from the seventh or eighth century from the Georgian church of Tsekbelda, now in the Shalwa Amiranashvili Museum of Fine

'Die Entstehung', fig. 5. **72** Inv. no. T234; see Brigitte Pitarakis, *Les croix-reliquaires pectorales byzantines en bronze* (Paris, 2006), p. 57 and fig. 35. **73** *Byzantium, 330–1453*, p. 411, no. 129.

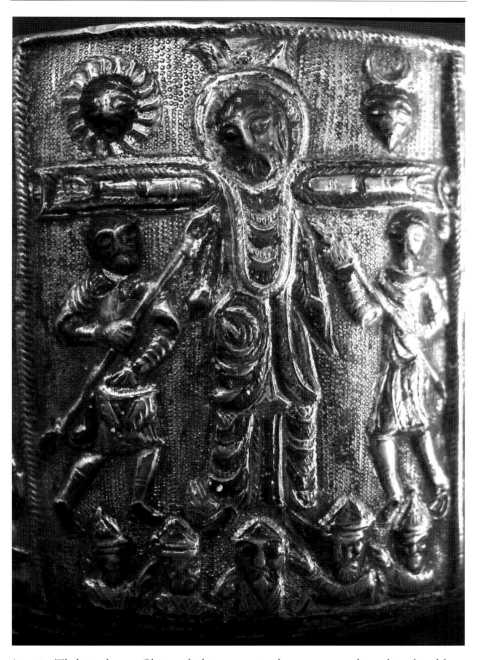

11.3 Crucifixion, detail of a Syrian silver bowl, ninth–tenth century. Ushguli (Zemo Svaneti), Chazhashi tower-museum (photograph by the author).

Arts in Tbilisi, shows Christ clad in a tunic that covers at least his shoulders, as it is possible to recognize even in its present precarious state (fig. 11.1).[74] In the same museum, the sixth-century stone pillar from Satskhenisi

74 Shalwa Amiranashvili, *Monumentalnaya skulptura Gruzii: Figurnye relefy V–XI vekov* (Moscow, 1977), p. 61 and fig. 61.

(fig. 11.2) is carved with Gospel scenes including a crucifixion with Christ accompanied by the two thieves: whereas the latter are shown naked, Jesus is clearly wearing a long tunic, with a large band – looking much like a priestly *homophorion* – starting at each side of the neck and crossing the middle of his body. A narrow transversal strip, being still visible to the left on the lower portion of the body, can be viewed as a remnant of a now vanished belt.[75]

An enigmatic silver bowl (fig. 11.3) preserved in the village of Ushguli in the remote region of Upper Svaneti displays still another version of the robed Christ: in the crucifixion scene, the tunic is rendered in a strongly geometrical way, with flowing hems on the back and one uninterrupted band hanging, like a necklace, over the chest. Such an unusual solution may be interpreted as the outcome of a late artist's misunderstanding of an already old-fashioned formula: even if this controversial item (displaying a combination of Gospel scenes and figures of holy horsemen) has been described as a sixth-century Georgian work,[76] such details as the use of niello, the Arabic inscription in the Nativity scene and the fully developed iconography of the equestrian saints make much more plausible that it was executed in Syria some time in the ninth or tenth century. The use of archaizing models is hinted at all the more by the representation of the adult Christ within a hexagonal font in the baptism scene (here represented twice), according to a solution rooted in Syriac artistic tradition.[77]

The presence of Syrian metalwork in such a remote location as Ushguli is a self-evident witness to the strong connections between Georgia and the Christian communities of the Syro-Palestinian area. That the theme of the long-sleeved tunic variously embellished with strips and bands originated in Syria and was disseminated from there is confirmed by its use in a ninth- or tenth-century paten now preserved in the Hermitage (fig. 11.4). Though found in the region of Perm, in the Urals, it is made of a silver alloy that can be connected with the area of Semireche, in present-day Kyrgyzstan, where Nestorian communities were active in the Middle Ages. As such, it displays what can be considered to be a specifically Syrian iconography, representing Christ in the facial type with short beard and curling hair that was connected with the Syro-Palestinian area. He and the two thieves are clad in a long-sleeved garment, with a band crossing over their chest. Such a scheme probably proved to be instrumental in conveying the Nestorian concept of Christ as both 'impassible and passible', suffering in the flesh yet being

75 Kitty Machabeli, *Early medieval Georgian stone crosses* (Tbilisi, 2008), p. 122 and pl. 34. **76** Nina Iamanidze, 'Art and identity of eighth-century Georgia: the case of sculpture' in Valentino Pace (ed.), *L'VIII secolo: un secolo inquieto* (Udine, 2010), pp 228–31, esp. p. 230. A later date in the seventh or eighth century was proposed by Giorgi N. Chubinashvili, 'Siriyskaya chasha v Ushgule', *Vestnik muzeya Gruzii*, 11:2 (1941), 1–19 [repr. in idem, *Voprosy istorii iskusstva* (Tbilisi, 2002), pp 128–31]. **77** N. Iamanidze, 'Rite et aménagements baptismaux à l'époque paléochrétienne: le témoignage des sources archéologiques géorgiennes', *Zograf*, 32 (2008), 13–22, esp. 16.

11.4 The silver paten of Semireche, ninth–tenth century. Saint Petersburg, Hermitage (photograph by the author).

beyond suffering in the nature of his Godhead; anyway, its general meaning was not bound to any specific theological tradition and could work equally well as a visual tool to hint at Christ's 'body of Resurrection' as prefigured by his sacramental body.[78]

At the same time, the iconographic formula of the Crucified wearing a long tunic found its way also to Western Europe, and a carved stone from pre-Conquest England – found in Thornton Steward, Yorkshire[79] – indicates that even the variant with crossing bands was occasionally employed. The inclusion of a belt instead of crossing bands eventually succeeded in conveying analogous messages,

78 Vladislav P. Darkevich and B.I. Marshak, 'O tak nazyvaemom siriyskom blyude iz Permskoy oblasti', *Sovetskaya arkheologiya*, 2 (1974), 213–22; Boris I. Marshak, *Silberschätze des Orients* (Leipzig, 1986), pp 320–4; Grigori L. Semënov, *Studien zur sogdischen Kultur an der Seidenstraße* (Wiesbaden: 1996), pp 66–7; *Khristiane na vostoke. Iskusstvo melkitov i inoslavnykh khristian* (Saint Petersburg, 1998), pp 194–5, nn 261–2; Wassilios Klein, *Das nestorianische Christentum an den Handelswegen durch Kirgyzstan bis zum 14. Jahrhundert* (Turnhout, 2000), pp 107–8. 79 Coatsworth, 'The "robed Christ"', pp 169–70 and pl. IIIc.

and in associating it more strictly with the Apocalyptic prophecy; incidentally, in some pilgrims' tokens from the fourteenth century and a fifteenth-century miniature reproducing the *Volto Santo*, the belted *tunica* seems to be combined with overlapping bands.[80] In general terms, the use of the *tunica manicata* and its many variants in connection with crucifixes that displayed Christ in both his historical and parousiac dimension aimed at providing a consistent number of worshipped images with a specifically 'exotic' and old-fashioned appearance, connected with Eastern Christian or even Islamic art. 'Otherness' was eventually emphasized by such means as the use of a definitely 'Oriental' ornamental repertory, like the roundels in the Batlló Majestat, which have been recently connected with decorations used in the Islamic lands of Central Asia.[81] The widespread liturgical worship of the *Passio imaginis* disseminated from Rome throughout Europe may have encouraged believers to associate it with concrete images and to use the latter as visual foci during the celebrations. In such a context, a deliberately archaizing appearance, such as that displayed by the Lucca *Volto Santo*, the crucifix of Imerward, the Dublin cross and the Catalan majestats, would have been perceived as both a specific way to evoke the legendary Syriac icon of Christ stabbed in Beirut, and a more conventional tool to convey the alleged portrait-like authenticity and miraculousness of an old image of the crucified Saviour.

Yet, in the specific case of the *Volto Santo*, there is one more detail which deserves to be emphasized in this respect: not unlike many of the oldest monumental crosses of Ireland (of the Clonmacnoise and Ossory groups), it makes use of a peculiar type of cross, which appears to be intersected by a circled crossing, or ring. Such a solution was peculiar enough to be reproduced and emphasized in the first official image of the famous cult-object in the illuminated manuscript made for the local confraternity of the *Volto Santo* in the early fourteenth century,[82] and was constantly included in almost all of the representations of its miracles during the late Middle Ages.[83] Probably this element contributed to enhance the perception of the Holy Face of Lucca as an old-fashioned and exotic artefact, as was so frequently (and often irreverently) pointed out by many authors in the thirteenth and fourteenth centuries.[84] By then, nobody would have been able to understand its meaning, which was rooted in the

80 *Il Volto di Cristo*, pp 273–5, entries nn VI.8, VI.10, VI.11. **81** Eva Baer, 'The Majestat Batlló: a wooden crucifix in Eastern style' in Martina Müller-Wiener, with Christiane Kothe, Karl-Heinz Golzio and Joachim Gierlichs (eds), *Al-Andalus und Europa zwischen Orient und Okzident* (Petersburg, 2004), pp 183–8. **82** Lucca, Archivio arcivescovile, MS Tucci-Tognetti, fo. 2r. *Il volto di Cristo*, p. 272, entry no. VI.5. **83** Schmitt, 'Les images d'une image', pp 218–20. See also M. Seidel and R. Silva, *Potere delle immagini, immagini del potere. Lucca città imperiale: iconografia politica* (Venice, 2007), pp 91–130, 251–66. **84** Matthew G. Shoaf, 'Image, envy, power: art and communal life in the age of Giotto' (PhD, University of Chicago, 2003), pp 53–99.

iconographic conventions of early Christianity.[85] With its circular shape, looking like the wreaths of victory widespread in early Christian iconography, it was instrumental in evoking Christ's triumph over death: its occurrence in a number of Coptic and Syriac artworks of the sixth/seventh century (as well as in later examples from Nubia) makes plausible the suggestion that it originated in the Near East, and more specifically in the visual manifestations of the cross-worship that were worked out in its major cult-centre, Mount Golgotha in the holy city of Jerusalem.

85 Martin Werner, 'On the origin of the form of the Irish high cross', *Gesta*, 29 (1990), 98–110.

Romanesque majestats: a typology of *Christus triumphans* in Catalonia

JORDI CAMPS I SÒRIA

Catalonia is one of the regions of Romanesque Europe that has preserved a large quantity of works carved in wood, of a quality and typological and stylistic variety as yet barely known and not always sufficiently valued. Most of these are in the main Catalan museums and in private collections, although some examples still exist as objects of worship in what seem to be their original churches. All of this adds up to a unique heritage.

Until now, the study of these pieces has mainly focused on questions relating to typologies, their meaning, and their classification according to stylistic tendencies and potential workshops. Recently, though, approaches to do with worship and the liturgy have begun to be of interest.[1] The study of these fields, however, presents a number of obstacles, aside from those normally posed by wood sculpture of the Middle Ages. In the first place, account must be taken of the difficulties presented by the variable state of preservation in which the objects are found, due both to their deterioration and to the numerous remodellings and adaptations, some very recent, that they have undergone, and that in some cases have conspicuously changed their original appearance. Secondly, except in very rare instances, there is an almost total want of clear chronological references, and this has necessarily led to the classification of works through typological and stylistic comparison. Finally, there is our ignorance of the origin of some important pieces proceeding from the antiquities market and from private

1 W.W.S. Cook and J. Gudiol Ricart, *Pintura e imaginería románicas* (Madrid, 1950; 2nd ed. 1980), pp 279–317; Joan Ainaud de Lasarte, 'La sculpture polychrome catalane', *L'Œil*, 1:4 (1955), 33–9; E. Junyent, 'La imatgeria', *L'art català* (Barcelona, 1957), i, pp 191–204; idem, *Catalogne romane* (Sainte-Marie-de-la-Pierre-qui-vire (Yonne), 1961), ii (La nuit des temps, 13), pp 267–70; C. Llarás Usón, 'La talla', *Catalunya Romànica*, 27 (Barcelona, 1998), 117–26.

collections, with the resulting confusion this causes.[2] To all this we must add that some works known and photographed at the beginning of the twentieth century have disappeared or were partly destroyed during the Spanish Civil War, all of which has hampered their current analysis.

The presence of an ample and coherent group of images of Christ in majesty in Catalonia, traditionally called 'majestats', which belong especially to the twelfth century although they are also found later, raises a question as to the role of the *Volto Santo* (Holy Face) of Lucca as a major reference and possible prototype for such carvings.[3] Generally speaking, this historiographical problem is inscribed within the framework of the relations that can be established between the centres of the Catalan Romanesque and those of Tuscany (and different Italian contexts in general), a question that was dealt with and brought up to date in, for example, the exhibition *El Románico y el Mediterráneo: Cataluña, Toulouse y Pisa (1120–1180)*, held in Barcelona in 2008.[4]

In a broader sense, however, the case of Catalonia poses the problem of sources and models in the inclusion of images in the round – a question going almost hand-in-hand with the introduction of monumental sculpture in the chronological setting of the twelfth century in an area for which clear and definite early medieval references are lacking, unlike much of Carolingian and post-Carolingian Europe. In this respect, it is important to remember that a key question when it comes to understanding the variety and typological singularity of some series of images in wood, whether of the Madonna, the groups of the Descent from the Cross, or, obviously, the different kinds of crucifixes, lies in determining what their external sources are within a general Western European framework, and what the role of the particular local context might be, still marked in the twelfth century by the situation of the Iberian Peninsula and, particularly, of the Catalan counties.

At any rate, this essay endeavours to analyse the most representative of the known Catalan examples of majestats and to discuss aspects of their production, their meaning and their points of contact with other European examples, especially pieces from the *Volto Santo* group in Lucca. We will thus try and ascertain the extent to which they retain their singularity and how they differ from similar pieces from Tuscany and the centre of Italy. Likewise, we will pose

2 J. Barrachina i Navarro, 'Introducció' and 'La talla en fusta' in 'Obra romànica dispersa en colleccions no tractada fins ara: El col·leccionisme a Catalunya', *Catalunya Romànica*, 26 (Barcelona, 1997), 335–41, 351–2. **3** P. Thoby, *Le Crucifix des origines au Concile de Trente: étude iconographique* (Nantes, 1959); M. Trens, *Les majestats catalanes* (Barcelona, 1966); R. Bastardes i Parera, *Les talles romàniques del Sant Crist a Catalunya* (Barcelona, 1978); M. Durliat, 'La signification des Majestés catalanes', *Cahiers Archéologiques*, 37 (1989), 69–95. See also Bacci, this volume. **4** *El romànic i la Mediterrània: Catalunya, Toulouse i Pisa. 1120–1180*, ed. M. Castiñeiras and Jordi Camps (Barcelona, 2008). For painted wooden crucifixes in Tuscany, see Schüppel, this volume.

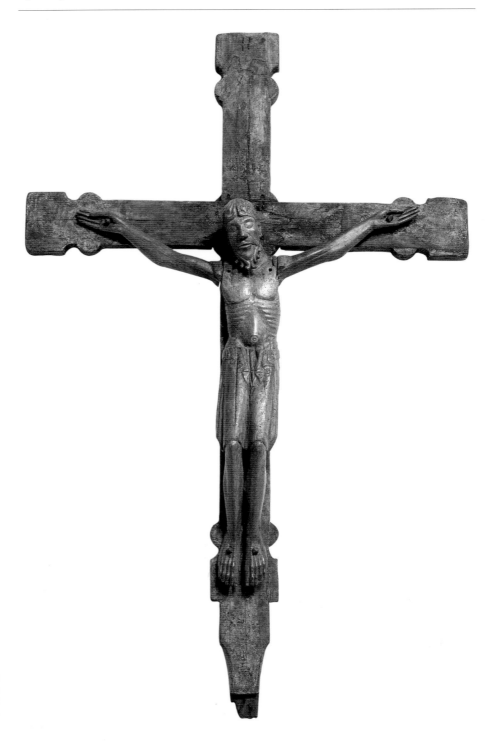

12.1 Crucifix of 1147 (Museu Nacional d'Art de Catalunya) (© MNAC Calveras/Mérida/Sagristà).

questions concerning their centres of production and their relationship to other artistic locations in Catalonia.

Most of the known crucifixes of this type are localized in the northeast part of Catalonia, in an area extending from the eastern Pyrenees to the environs of the episcopal centres of Vic, Girona and Barcelona. Some of the most notable images pertain to this particular area, like those in Caldes de Montbui (between Vic and Barcelona) and Beget (in the Pyrenees, not far from Ripoll),[5] and the Batlló Majestat (preserved in the Museu Nacional d'Art de Catalunya),[6] which, despite its unknown origin, slots perfectly into the Pyrenean group (pl. 17). Around these examples there is an important group of pieces from La Cerdanya, the Rosellón and the area of Ripoll and Besalú, with examples like the majestats of La Trinitat, La Llagona, Angostrina (stolen in 1976), Éller, La Pobla de Lillet, Sant Boi de Lluçanès, Sant Joan les Fonts and Santa Maria de Lluçà, among others.[7] In the current state of research, the appearance of this group is usually dated to around the middle of the twelfth century.

It has to be remembered that, as of now, some of the examples of the *Christus patiens* can also be situated within this chronological framework, if we bear in mind that one of the most outstanding cases can be dated with precision to 1147 (fig. 12.1).[8] In effect, an image preserved in the MNAC, originating from an unspecified building of the diocese of Urgell, contained some bundles of relics and the remains of two parchments, among which there figured the image's consecration year, 1147. Along with this, an important series of examples datable to some time during the twelfth century appear in northeast Catalonia, many in the area pertaining to the ancient Bishopric of Urgell.

To return to the majestats, as we have already stated, among the different images, those of Caldes and Beget, plus the Batlló are outstanding. Known and studied since the end of the nineteenth century, the first of these, the Caldes image, was mostly destroyed following the fire of 1936, the head being the only original element to survive. The handling of its apparel (known from drawings and photographs prior to 1936) clearly differs from other known Catalan examples, being a one-off in that regard.[9] Yet, a clearly homogeneous group appears to be centred between the Rosellón area and the vicinity of Ripoll and Vic, to which,

5 J. Camps i Sòria, 'Majestat de Beget' in C. Mendoza and M.Ocaña (eds), *Convidats d'honor: Exposició commemorativa del 75è aniversari del MNAC* (Barcelona, 2009), pp 96–101. **6** Museu Nacional d'Art de Catalunya (MNAC 15937). J. Folch i Torres, 'Una "Majestat" romànica', *Gaseta de les Arts*, 1.4 (desembre 1928), 1–2; J. Camps i Sòria, 'Majestat Batlló', *Prefiguració del Museu Nacional d'Art de Catalunya* (Barcelona, 1992), pp 154–6. **7** Trens, *Les majestats catalanes*; R. Bastardes i Parera, *Les talles romàniques del Sant Crist a Catalunya*, pp 85–213; Durliat, 'La signification des Majestés catalanes'. **8** J. Ainaud de Lasarte, 'Un Crist romànic datat', *Butlletí de la Societat Catalana d'Estudis Històrics*, 2 (1953), 341–4; idem, 'La consagració dels Crists en creu', *Liturgica*, 3 (1966), 11–20. **9** Trens, *Les majestats catalanes*, pp 115–20.

among many others, the Beget and the Batlló majestats belong. The first is still preserved in its probable church of origin, a modest parish church that depended during the twelfth century on the Benedictine monastery of Sant Pere de Camprodon, in the Catalan eastern Pyrenees (pl. 18). A number of *Goigs* ('Joys', popular liturgical songs of the nineteenth century) describe some of the miraculous interventions of the image and the devotion accorded to it. Its current appearance, particularly as regards its polychromy, is the result of different interventions and adaptations, especially the one that served to adapt it to the presbytery, and the construction of a new altarpiece in 1787.[10] The first results of the restoration process it is currently undergoing have not, unfortunately, revealed significant remains of the original polychromy. From an iconographical, compositional and stylistic point of view, however, it displays the features peculiar to and representative of Catalan majestats: the *manicata* (sleeved) tunic with parallel folds, slanting on the arms, descending on the body, cinched at the waist by a belt whose ends fall straight down; the open hands; the noticeably inclined head with a pronounced beard; the hair that falls symmetrically in three locks before the shoulders. The solemn attitude insists upon the idea of the living Christ triumphing over death, with the eyes clearly open. This description might coincide, up until this point and in broad outlines, with that of images like the *Volto Santo* in Lucca and with other crucifixes from Italy and other parts of Europe.

In any case, like other Catalan examples, the Beget Majestat shows a clear tendency towards formal simplification. Defined through the uniform thickness of the pieces of wood, the volumes tend more towards surface and angle, without the modelling and feeling of relief of other examples, something that goes hand-in-hand with a tendency towards schematization and a simplification of the structuring of the body. This is one of the features that define a large number of the Catalan majestats from a formal perspective, probably due to differences in terms of workshops and the wood carvers who oversaw their production. We will come back to this question later. By contrast, Italian crucifixes (Lucca, Sansepolcro, Bocca di Magra and so forth), have a greater sense of volume and more modelling of the facial features, with more rounded surfaces and undulating lines. Comparatively speaking, the Catalan works are at something of a remove from these examples, and also from other works of reference like the Imerward Crucifix in Brunswick (fig. 12.2).[11] The present cross of the Beget Majestat is modern, so that we know little or nothing of the original. Nevertheless, other examples provide us with further information about the polychromy, decorative motifs and inscriptions.

10 Ibid., pp 120–2; Bastardes, *Les talles romàniques del Sant Crist a Catalunya*, pp 109–14; Camps, 'Majestat'. 11 G. de Francovich, 'Il *Volto Santo* di Lucca', *Bollettino Storico Lucchese*, 8 (1936), 3–28; *Il Volto Santo: Storia e culto*, ed. Clara Baracchini and Maria Teresa Filieri (Lucca, 1982); Michele Camillo Ferrari and Andreas Meyer (eds), *Il Volto Santo in Europa: Culto e immagini del Crocifisso nel*

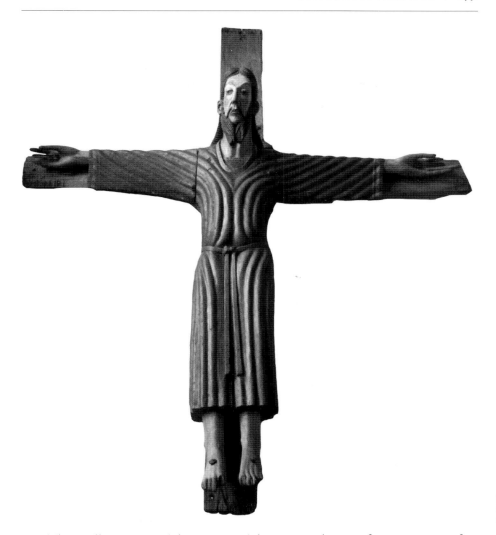

12.2 Crucifix of Imerward, Brunswick (photograph by the author).

The Batlló Majestat (pls 17, 19, 20) has retained a significant amount of its polychromy. Manifestly smaller than the Beget one, it is more than likely that it comes from the same area. Its exact provenance is unknown, although it seems to have been bought by the industrialist and collector Enric Batlló from an antique dealer in the town of Olot (twenty miles to the northwest of Girona, and not far from Ripoll and Besalú). Since it was published at the beginning of the twentieth century, particularly by Joaquim Folch i Torres (keeper and later director of the Museum in Barcelona), it has attracted attention due to the fact that it has preserved much of this polychromy.[12] On the face of it, what stands out is the treatment of the tunic, richly adorned in the manner of a piece of Byzantine

Medioevo. Atti del Convegno internazionale di Engelberg (13–16 settembre 2000) (Lucca, 2005).
12 Folch i Torres, 'Una "Majestat" romànica', 1–2; Camps i Sòria, 'Majestat Batlló', 154–6.

origin, with a series of circular medallions that describe floral motifs. In fact, similar resources are observed in other examples of such majestats, including those in Angostrina, since lost, and Sant Boi de Lluçanès. Its repertoire has also been related to Islamic (or Al-Andalusian) textiles deposited and utilized in churches, as proposed by Joan Ainaud, who compared the decorative schema of the tunic with a silk shroud from the former cathedral of Roda de Isávena (Ribagorza, now in Aragon), dated to sometime in the tenth or eleventh century.[13]

A similar example is to be found in mural painting, in the depiction of the tunic of the apostle James in the Sant Climent de Taüll complex, which dates approximately to the time of the church's consecration in 1123. In another context and historical moment, there is the interesting example of the tunic of Emperor Constantine guiding Pope Sylvester to the gates of Rome in the St Sylvester chapel of the church of Santi Quattro Coronati, consecrated in 1246. At all events, this is a very developed motif with numerous variations. It suffices to cite the example of the clothing of King Jaume I in a depiction of the conquest of Majorca in a Barcelona palace, datable to the end of the thirteenth century.

This character is reinforced with the motifs of the edging of the sleeves and the collar, with rhomboidal shapes that imitate precious objects and gold-coloured linings, with the application of jewels, and so on. As in other examples, this helps to underline the solemn nature of the image and to insist on the association of Christ with royalty. Another detail that has given rise to various commentaries is that of the stylized plant motifs on the bottom edge of the tunic, which recall the characters of Kufic script. Currently undergoing study is their possible relationship to Islamic characters, but this is a feature that, in different forms, is also visible in Al-Andalusian textiles.

In any case, the Batlló Majestat presents other features that are undergoing analysis, following the tests that were carried out on it in 2008 and 2009, and which led to the discovery of a previous layer of polychromy.[14] The inscriptions are also under investigation. The *titulus* currently visible is superimposed on another, more primitive one that occupied a smaller surface area. The Batlló Majestat has some remains, albeit much deteriorated, on the reverse side of the cross, on which the presence of the *Agnus Dei* inscribed on a *clipeus* is evident. On this are visible the traces of an inscription, which is undergoing study along with other vestiges that remain on the crosspiece and the upper arm.

An analysis of the inscriptions is more eloquent in the cases of the majestats of Sant Joan les Fonts and Sant Miquel de Cruïlles. Trens and Durliat dealt with the question of the inscriptions in great detail, from the presence of the *titulus*,

13 Joan Ainaud de Lasarte, *Art Romànic: Guia* (Barcelona, 1973), p. 92. **14** Antoni Morer i Munt, Núria Prat i Grau and Joaquim Badia i Gómez, 'Noves aportacions en l'estudi de les tècniques pictòriques: la Majestat Batlló, la Majestat d'Organyà i el Frontal de Planès' in Castiñeiras et al. (eds), *El romànic i la Mediterrània*, pp 221–9.

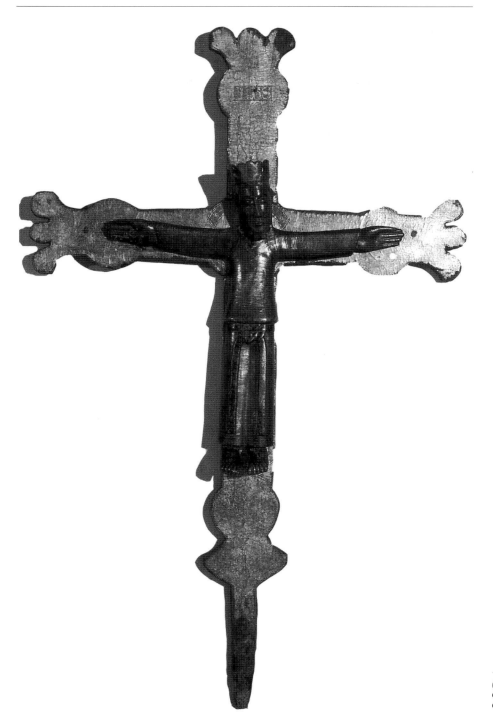

12.3 Majestat of Organyà
(Museu Nacional d'Art de
Catalunya) (© MNAC
Calveras/Mérida/Sagristà).

arranged vertically within the upper arm of the cross (Batlló, Santa Maria de Lluçà and La Llagona), to those that appear on the back, especially around the *Agnus Dei*.[15] All this enables us to establish some approximate constants in this type of image, to which we will refer later on.

As has become clear, most of the Catalan majestats are concentrated in the northeast triangle of Catalonia. A few examples from areas further to the west may be cited, however, especially in the vicinity of La Seu d'Urgell. Outstanding among these is the Organyà Majestat, datable to the middle of the twelfth century, and repainted during the fourteenth (fig. 12.3).[16] We might also cite a representative group on a different material support, like that in Sant Joan de Caselles in Andorra. In this instance, the image of Christ is elaborated in stucco (or plaster), with a strong sense of volume, applied to the wall next to the painted figures of Longinus and Stephaton in a Calvary group (fig. 12.4).[17] Its formal, volumetric handling and its composition are at one with the images in wood of the majestats, as shown by a comparison with works with simpler volumes like those in Éller and Viliella (also belonging to the Bishopric of Urgell).

It is likely that some of these last images were created in workshops connected to the Bishopric of Urgell, around the cathedral, from which a large number of altar objects also emerged, like the frontals of the Apostles or that of Ix.[18] One of the issues over which much ink has been spilled is the place of origin of such wood sculpture (crucifixes, Madonnas and saints) and other objects of polychromed carved wood. Previously, the existence of workshops linked to monastic and cathedral centres was mooted, the output of which would gradually be directed towards creating pieces of liturgical furniture (altar panels, baldachins, shrines and images), not only for the particular building but also for centres within its influence. Recently, this thesis has been reinforced by the iconographical, compositional and technical analysis of a series of works with links with Ripoll (pl. 21) and La Seu d'Urgell. We cannot go into the question of pictorial technique here, specifically of the close relationship of these pieces to a pharmacopoeia located in a Ripoll codex from 1134, as studied by Manuel Castiñeiras. But this enables us to consolidate evidence for the existence of a workshop in Ripoll in connection with different pieces of altar furniture. The activity of the workshop also extended to images, in such a way that some pieces, like the majestats of Beget, Batlló and

15 Durliat, 'La signification des Majestés catalanes', 83, n. 90. **16** J. Camps i Sòria, 'Majestat d'Organyà' in Castiñeiras et al. (eds), *El romànic i la Mediterrània*, pp 408–9. **17** M. Planas et al., 'Sant Joan de Caselles', *Catalunya Romànica*, 6 (Barcelona, 1992), 448–51; Durliat, 'La signification des Majestés catalanes', 84–6; C. Mancho, 'Le stuc en Catalogne: carrefour de cultures ?' in C. Sapin (dir.), *Stucs et décors de la fin de l'Antiquité au Moyen Âge (Ve–XIIe siècles). Actes du Colloque International tenu à Poitiers du 16 au 19 septembre 2004* (Turnhout, 2006), pp 167–78, esp. pp 175–6, fig. 11. **18** M. Castiñeiras, 'The Catalan Romanesque painting revisited: the altar frontal workshops (with a technical report by A. Morer and J. Badia)' in Colum Hourihane (ed.), *Spanish medieval art:*

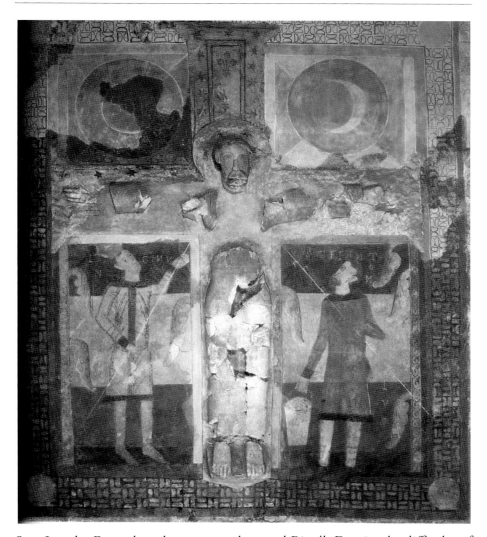

12.4 Majestat of Sant Joan de Caselles (Andorra, Pyrenees) (photograph by the author).

Sant Joan les Fonts, have been grouped around Ripoll. Despite the difficulty of relating some examples on account of differences of style, it is relevant to examine the Sant Joan les Fonts Majestat (pl. 22).[19] The more rounded forms, the prominent nose and the more markedly voluminous cheeks of this example suggest a direct rapport with the figure of the *Maiestas Domini* on the façade of Santa Maria de Ripoll (pls 21, 22). Notwithstanding the difference in quality of the treatment of the relief, a comparison between the two figures speaks volumes. Not only is there a resemblance in sculptural terms, but there are also similarities displayed by the plant motifs decorating the cross, as well as figurative elements (figures from the Tetramorph) that keep to the same stylistic line, and that also

recent studies (Tempe, AZ, 2007), pp 119–53. **19** Cook, Gudiol and Ricart, *Pintura e imaginería románicas*, p. 284, fig. 349; Durliat, 'La signification des Majestés catalanes', 76–8, figs 8–12.

compare with a range of panels like the Esquius frontal and the Ribes baldachin,[20] along with that of Montgrony.

We cannot go into the issue right now of the distribution of these examples in different areas. This would involve an analysis that calls for a clear knowledge of their chronology, a matter that is by no means settled and which in some instances, as in the area of Ribagorza and the Valle de Aran, can lead us in the direction of disparate moments of the twelfth century.[21] What we can say is that in both the modality of the *Christus triumphans* and the *Christus patiens* there is also an output in Catalonia throughout the thirteenth century. In terms of what is of interest to us, it will suffice to cite examples like the majestats from Cruïlles (Ampurdán) and Travesseres (Cerdanya).

When it comes to contextualizing the presence of images of the *Christus triumphans* in Catalonia, a missing fragment of the paintings in Sant Quirze de Pedret has sometimes been cited. Photographs were taken of a fragment, probably on the north wall facing the church's south door, in which a figure dressed in a tunic can just about be made out, with a compositional organization similar to the one we observe in the majestats, with the halo in the background.[22] Despite the reasonable doubts the image presents, and the vagueness of the sources that refer to it, the attribution of an image of this type is plausible. The little that can be said from the stylistic point of view appears to correspond to the painted cycle datable to the beginning of the twelfth century. The Pedret paintings are inscribed within a context of reform that has also been emphasized for the presence of those images in relation to the context of the *Volto Santo* in Lucca. In principle, the state of the question as to the dating of the images, which have rarely been considered to be earlier than the second third of the twelfth century, might give the impression that we are moving away from that historical and artistic context, from the creation of some of the mural groups in Catalonia. A slightly earlier dating cannot be ruled out for some cases, however.

There are also minor reflections of this typology in monumental sculpture, and precisely in the vicinity in which the examples of images worked in wood are located. In the first instance, there is a relief in the church of Sant Esteve d'en Bas, whose original location is unknown, in which the *Christus triumphans* is flanked by the figures of the Madonna and St John the Evangelist, as on Calvary.[23] The

20 M. Castiñeiras, 'Baldaquí de Ribes' and 'Taula dita d'Esquius' in Castiñeiras et al. (eds), *El romànic i la Mediterrània*, pp 378–9 and 380–1. 21 See, for example, J. Camps i Sòria and X. Dectot, 'Les Descentes de la Croix du Val de Boí et leur infuence: problèmes de style et de chronologie' in J. Camps and A. Dectot (eds), *Catalogne romane: Sculptures du Val de Boí* (Paris and Barcelona, 2004), pp 71–9. 22 Trens, *Les majestats catalanes*, p. 135, lam. 31. See also M. Guardia and C. Mancho, 'Pedret, Boí, o dels orígens de la pintura mural romànica catalana' in Guardia and Mancho (dirs), *Les fonts de la pintura romànica* (Barcelona, 2008), pp 117–59, 125–6, fig. 2. 23 A. Noguera i Massa, 'Les majestats romàniques a Besalú', *III Assemblea d'Estudis del comtat de Besalú* (Besalú, 1976), pp 251–2.

crude nature of the forms is an obstacle to dating the relief, which on occasions has been loosely situated in the twelfth century, without greater precision. Scholars have also cited the rough, schematic relief of the voussoirs of the doorway of the church of Sant Julià de Corts, not far from Girona.

Iconographically speaking, the figure of Christ on the cross in Sant Esteve d'en Bas concurs with the images of wood, thus permitting a typological relationship to be established between the relief and such images. The same is not true of certain Limoges enamel plaques from the first half of the thirteenth century preserved in Catalan museums, the Catalan provenance of which is uncertain since they arrived via the art market. This is shown by a piece in the Museum in Barcelona in which we see the figure of the crucified Christ dressed in three pieces of clothing, in contrast to monumental Catalan examples in wood.[24] A clothed Christ from Saint-Martial in Limoges, covered in silver, might reflect this peculiarity, however, as has been argued in relation to an object preserved in the Louvre that is similar to the one in Barcelona.[25]

We also have information about images that have gone astray, the sources of which are somewhat vague and do not provide us with sufficient data to determine their chronology and history. Thus, references exist in early twentieth-century guides to a 'clothed' crucifix in the church of the monastery of Sant Martí del Canigó, and to one in the church of Sant Cristòfol de Toses, but the lack of extant *in-situ* photographs prevents their identification as majestats. Apart from what is strictly the Catalan eastern Pyrenees, in 1902, Gudiol i Cunill, a key figure in historiography in Catalonia at the beginning of the twentieth century, also cited a clothed crucifix (a majestat?) that had existed until the eighteenth century in the cathedral in Vic.[26]

Over and above the possibility of arriving at an explanation different to that of other twelfth-century European examples, an important question to consider is what the relationship between the *Volto Santo* in Lucca and the spread of the majestats in Catalonia might have been.[27] Likewise, another issue to be raised is that of the aspects of the legend of the Lucca Christ that might have made their way, sooner or later, into Catalonia. The known documentation may provide a few indications, albeit vague ones. In no instance is there a source from the Middle Ages that speaks of a specific image, as is the case of Lucca. And it was not until the seventeenth century that there was a direct allusion to an image – namely, to the majestat in Caldes in 1635.

In any event, other sources from the tenth and eleventh centuries may allude to the cult of images of Christ Triumphant. Thus, we have traditionally used the

24 J. Duran-Porta, 'Placa central d'una creu' in Castiñeiras et al. (eds), *El romànic i la Mediterrània*, pp 426–7. **25** E. Taburet-Delahaye, 'Christ d'applique' in *L'Oeuvre de Limoges: Émaux limousins du Moyen Âge* (Paris, 1995), pp 184–5. **26** J. Gudiol i Cunill, *Nocions d'arqueologia sagrada catalana* (Vic, 1902), p. 319. **27** See Bacci, this volume.

appearance of the word *vultus* in the church in Estamariu (near La Seu d'Urgell) in 1063 and 1092: *ad imso vultu vel ad majestatem Domini da Stamariz.*[28] Later, the words *volto*, *vultus* or *bult* will appear time and again in the texts of the Joys (in Catalan, *Goigs*): the most revealing instance is that of the missing images of Toses (cited above), which according to the texts of the *Goigs* is related to the *Volto Santo* in Lucca.[29] Another clear example of the tradition in using the term is that of the majestat in Organyà: according to an oral source from the beginning of the twentieth century, by which time it was already abandoned in the sacristy of the church, it was called Bulto by the parish priest.

In other instances, elements that appear in the legend of the Lucca image are brought together: thus, in the case of the majestat in Caldes, the *Goigs* of the nineteenth century recount that it was sculpted by Nicodemus, as was the majestat in Pobla de Lillet.[30] The theme of the journey, of the change of whereabouts, is also implicit when in the cases of the Beget and Bellpuig majestats the same Joys (*Goigs*) allude to a different, albeit nearby, origin.[31]

Another important feature that enables a link with the eastern Mediterranean to be made are the references to the cult of the Christ of Beirut. Gudiol, Trens and Durliat pick up on it in relation to the cathedrals of Girona and Vic, especially in the case of Girona Cathedral, whose martyrologies allude to the celebration of the *Passio imaginis* and the cult of the Christ of Beirut, celebrated on 9 November.[32] We can add that nowadays the great feast of Beget is also celebrated on 9 November.

Marcel Durliat tried to come up with an explanation for the Catalan majestats, not only on account of their typological similarities with Italian examples but also due to the features presented by the original decoration of the crosses that had been preserved. Maintaining the idea of Christ on the cross as a triumphant, regal image, he evokes figurative depictions on the obverse and reverse of the crosses, as well as extant traces of a few inscriptions. The centre of the reverse is always occupied by a depiction of the *Agnus Dei*, while the ends are taken up with the Tetramorph. At the present time, some of the inscriptions that appear on them, where allusions to the *Agnus Dei* and the image of Christ saving humanity from sin are habitual, are being studied. As a consequence, Durliat associates some of these features with the text of the Apocalypse. Presented on the obverse of some crosses, such as the one in La Llagona, are Mary and John the Evangelist, as on Calvary, the same thing occurring in many crosses of different typologies and supports.[33] At any rate, the images painted on the reverse must have been placed on the altar, visible from both sides. The Batlló Majestat and the

28 Trens, *Les majestats catalanes*, p. 38. **29** Ibid., p. 161. **30** Ibid., pp 115–20, 124–7. **31** Ibid., pp 120–3, 142–3. **32** See also M. Bacci, 'Nicodemo e il *Volto Santo*' in Ferrari and Meyer (eds), *Il Volto Santo in Europa*, pp 15–40. **33** Durliat, 'La signification des Majestés catalanes', 81.

majestats of Sant Joan les Fonts, Lluçà and La Llagona are images of moderate size, approximately four feet tall. Other, more monumental ones, as in Beget, Bellpuig, Caldes and Pobla de Lillet, appear as an object of devotion in later Joys/*Goigs*, but have not retained their original cross. Probably the latter would be set out in the church in a different way to the former.

As we have seen, some eleventh-century sources may display a relationship of sorts between the interest in Catalonia in the *Christus triumphans* and the cult of the Christ of Beirut. In particular, the historiography has utilized the word *vultus* from Estamariu as a clearer reference. Moreover, some *Goigs* from the modern period relate Catalan images to the *Volto Santo* in Lucca, to the authorship of Nicodemus, and to the eastern Mediterranean. It would be worth ascertaining if these allusions have to do with a local tradition that has its roots in Romanesque images in the eleventh and twelfth centuries, or if, on the contrary, they are connected with the continuity of the spread of the cult of the *Volto Santo* in more recent times. Arguments for inclining towards the first hypothesis are not lacking, bearing in mind the varied relationships that united Catalonia and Italy, particularly Tuscany, and also the western Mediterranean.

In the light of the examples considered above, and compared to crucifixes like the one in Lucca, but also those in Sansepolcro and Bocca di Magra, the stylistic differences remain clear. These differences are simply attributable, perhaps, to the nature of Catalan workshops like the one in Ripoll. Moreover, some details lead us to interpret the synthetic character of the iconography of Catalan images, whose function varies according to their format.

The context of reform initiated in the last few decades of the eleventh century, reflected in Catalonia in the important groups of mural painting from around the year 1100, might also have favoured the development of the Catalan majestats. In fact, during the twelfth century, there were many different aspects that connect Catalonia in artistic terms with different Italian areas like Lombardy, Tuscany and even Rome. This iconography may, through intermediaries like Lucca, be understood within a context marked by centres of pilgrimage, even by that of the Crusades, which also led to the western Mediterranean and the Holy Land. All the same, the chronology for some of these images has almost always been situated between the middle decades of the twelfth century and later moments, which even extend to the 1180s. Perhaps it will be necessary to revise these dates.[34]

34 I would like to conclude by mentioning two important new studies published after the writing of this essay: R. Marks, 'From Langford to South Cemey: the road in Anglo-Norman England', *Journal of the British Archaeological Association* (2012), 172–210; I. Lovés, J. Paret, M. Marsé, M.J. Gracia and L. Domedel, 'La sculpture romane catalane sur bois: étude et restauration du Christ de Casarilh et la Majesté de Beget', *Les Cahiers de Saint-Michel de Cuxa* (2012), 101–12.

Medieval painted crosses in Italy: perspectives of research

KATHARINA CHRISTA SCHÜPPEL

Eighty years have passed since the publication of *La croce dipinta italiana e l'iconografia della passione* by Evelyn Sandberg-Vavalà.[1] To this day, the book that appeared in print in Verona in 1929 is the key text regarding medieval painted crosses – that is, cross-shaped panels of wood bearing the painted image of the crucified Christ. The British art historian wrote her studies on Italian painting under a pseudonym – she was actually named Evelyn May Graham Kendrew – making her an interesting subject for research on women in the relatively new discipline of art history in the first half of the twentieth century.[2] Her book, which followed the equally fundamental essay she had written on the medieval painted crosses in Sarzana and Lucca,[3] remains the most comprehensive publication on the complex topic subject of the *croci dipinte* in Italy and, thanks to the numerous charts, an indispensible work of reference.

The rich material published by Sandberg was largely neglected by subsequent scholarship on medieval crucifixes. Instead, the painted crosses were understood as peripheral examples of medieval panel painting. Two painted crosses, the analyses of which have suffered from such a overly style-based approach, are the Florentine crosses of Cimabue at Santa Croce and Giotto at Santa Maria Novella. Such scholarship aims merely to place the works within the chronology of the artists' œuvre.[4]

1 Evelyn Sandberg-Vavalà, *La croce dipinta italiana e l'iconografia della passione* (Verona, 1929; repr. Rome, 1980). 2 John Pope-Hennessy, 'Mrs Evelyn Sandberg-Vavalà', *Burlington Magazine*, 103 (1961), 466–7. An insight into the topic of female medievalists is given by *Women Medievalists and the Academy*, ed. Jane Chance (Madison, 2005). 3 Evelyn Sandberg-Vavalà, 'Quattro croci romaniche a Sarzana e a Lucca', *Dedalo*, 9 (1928), 65–96, 129–44. 4 *Cimabue: Le crucifix de Santa Croce*, ed. Umberto Baldini and Ornella Casazza (Ivrea, 1982); *Giotto: La Croce di Santa Maria Novella*, ed. Marco Ciatti and Max Seidel (Florence, 2001).

For that reason, the study of early painted crosses, especially from the period before 1200, is less developed when compared to the encouraging results of research on sculpted crucifixes in the context of contemporary wooden sculpture,[5] or in the context of gold and silver works[6] – to name but two wider fields – in Italy in the recent decades. With regard to the study of sculpted crucifixes, two tendencies can be observed. Firstly, the traditional iconographical approach followed by Sandberg has been enriched by historical, theological and liturgical perspectives. Moreover, there has been a shift of focus from Umbria and Tuscany as the traditional regions of medieval crucifix production to central and southern Italy.[7] This essay advocates this shift of emphasis within the study of the *croci dipinte*, with a view to repositioning them within research on crucifixes.

Sandberg's conception of the painted crosses as products of the twelfth century, derived from small-scale metal crosses, has long been accepted.[8] Certainly, an increase in this type of cross can be traced in the twelfth and thirteenth centuries, especially in western Tuscany. Also discernible here at this time is a high level of appreciation for Byzantine panel painting, together with the acquisition of Byzantine icons, and the imitation of certain forms of paraliturgical practice using icons, as performed in medieval Byzantium.[9] Looking at the written sources, the evidence suggests that painted crosses in all probability were already part of the overwhelming flood of pictures criticized by the theologians of the ninth and tenth

5 *Sacre passion: Scultura lignea a Pisa dal XII al XV secolo*, ed. Mariagiulia Burresi (Milano, 2000); *La Croce: Dalle origini agli inizi del secolo XVI*, ed. Boris Ulianich with Gaetano Curzi and Brigitte Daprà (Naples, 2000); Ministero per i Beni e le Attività Culturali, Soprintendenza per i Beni Architettonici, per il Paesaggio, per il Patrimonio Storico, Artistico e Demoetnoantropologico di Arezzo (ed.), *La Bellezza del Sacro: Sculture medievali policrome* (Arezzo, 2002). **6** Adriano Peroni, 'Il Crocifisso della badessa Raingarda a Pavia e il problema dell'arte ottoniana in Italia' in *Kolloquium über spätantike und frühmittelalterliche Skulptur*, ed. Victor Milojčić (Mainz, 1970), ii, pp 75–109; *Il Crocifisso di Ariberto: Un mistero millenario intorno al simbolo della cristianità*, ed. Ernesto Brivio (Cinisello Balsamo, 1997); Gaetano Curzi, 'Tra Saraceni e lanzechenecchi: Crocifissi monumentali di età carolingia nella basilica di S. Pietro', *Arte medievale*, 2 (2003), 15–28; Katharina Christa Schüppel, *Silberne und goldene Monumentalkruzifixe: Ein Beitrag zur mittelalterlichen Liturgie-und Kulturgeschichte* (Weimar, 2005); Katharina Christa Schüppel, 'Fede e iconografia: Le croci di Ariberto' in Ettore Bianchi, Martina Basile Weatherhill and Manuela Beretta (eds), *Ariberto da Intimiano: Fede, potere e cultura a Milano nel secolo XI* (Cinisello Balsamo, 2007), pp 298–307; Adriano Peroni, 'Il crocifisso monumentale del Sant' Evasio di Casale: Per una nuova lettura' in Alessandro Casagrande, Enzo Repetti, Gabriella Parodi, Manuela Meni, Lorena Palmieri and Paolo Robero (eds), *Arte e carte nella diocesi di Casale* (Alessandria, 2007), pp 174–99. **7** In the beginning: *Sculture lignee nella Campania*, ed. Federico Bologna and Raffaello Causa (Naples, 1950). Followed by (among others): *Scultura e arredo in legno fra Marche e Umbria*, Atti del primo convegno, Pergola 24–25 ottobre 1997, ed. Giovan Battista Fidanza (Pergola-Ponte San Giovanni, 1999); *Scultura lignea in Basilicata: Dalla fine del XII alla prima metà del XVI secolo*, ed. Paolo Venturoli (Torino, 2004); *Sculture in legno in Calabria: dal Medioevo al Settecento*, ed. Pierluigi Leone de Castris (Pozzuoli, 2009). **8** Sandberg-Vavalà, *La croce dipinta italiana*, pp 72–3. **9** Michele Bacci, 'Pisa e l'icona' in Mariagiulia Burresi and Antonino Caleca (eds), *Cimabue a Pisa: La pittura pisana del Duecento da Giunta a Giotto* (Ospedaletto (Pisa), 2005), pp 59–64 (with further literature). See also Bacci, this volume.

centuries. The Ritual of the Abbey St-Amand in northwestern France, which has been dated to around the year 800, is one of the earliest texts to mention the use of a painted cross. In it, the *Ordo letaniae maior* stipulates that a cross described as a *crux picta* should be carried in procession on St Mark's day (25 April).[10] A few years later, Claudius, bishop of Turin (d. 827), vehemently rejected the presence of any kind of image within the church, including painted crosses.[11] Also in the first half of the ninth century, Jonas of Orléans noted the parallel existence of golden, silver and painted images of the Crucified. Because he does not mention the cross-shape of the painted panel, the possibility cannot be excluded that he also might have been referring to wall paintings or to icons depicting the crucifixion.[12] Two more references date to the mid- and the second half of the eleventh century. In 1038, Ariberto, archbishop of Milan and donor of the famous monumental crucifix of gilded copper to the monastery of St Dionigi, ordered a painted cross, the form of which has been controversial, which was to be fixed onto the Milanese chariot before the decisive battle against the imperial forces.[13] Finally, the *Vita Gauzlini* by Andreas of Fleury (*c.*1042) mentions the commissioning by Abbot Gauzelin of a painted cross from the Lombard artist Nivardus.[14] Thus, a good argument can be made that from the early Middle Ages onwards, painted crosses existed as a third category of cross, in addition to monumental crucifixes sculpted in wood or made from precious metals.

The first comprehensive studies regarding medieval painted crosses set out to organize the extensive regional material, recognized for its artistic value, in order to make it accessible for further research. These studies did not attempt interpretation: a great number of works of art had to be classified. Sandberg chose iconographical criteria; after the Second World War, Edward B. Garrison formed groups of painted crosses according to formal criteria. Garrison, who, according to his preface, was fully aware of the arbitrary character of his approach, discussed the painted crosses within the wider context of 'Italian Romanesque panel painting'. His 'illustrated index' also includes panels depicting Christ as Saviour, the Madonna and the saints.[15] In the years following, the painted crosses were

10 *Ordo Romanus*, XXI, 10. Compare Michel Andrieu, *Les Ordines Romani du haut Moyen Âge* (5 vols, Louvain, 1931–61, repr. 1965–74), iii, p. 248; Eric Palazzo, *Histoire des livres liturgiques: le Moyen Âge. Des origines au XIIIe siècle* (Paris, 1993), p. 195. **11** Claudius of Turin, *Adversus Theutmirum* in *Epistolae*, ed. Ernst Dümmler (Berlin, 1895), p. 611. **12** Jonas of Orléans, *De cultu imaginum libri tres*, lib. I, *PL*, 106, 340. **13** Adriano Peroni, 'L'oreficeria ottoniana in Lombardia e le testimonianze del crocifisso di proporzioni monumentali' in *Milano e i Milanesi prima del Mille (VIII–X secolo). Atti del 10° Congresso internazionale di studi sull'alto medioevo (Milano, 26–30 settembre 1983)* (Spoleto, 1986), pp 325–6; Ernesto Brivio, 'L'acquisizione del crocifisso al Duomo' in Brivio (ed.), *Il crocifisso di Ariberto*, p. 142, n. 34. **14** André de Fleury, *Vie de Gauzlin, Abbé de Fleury/Vita Gauzlini Abbatis Floriacensis Monasterii, Par. 65a*, ed. Robert-Henri Bautier and Gillette Labory (Paris, 1969), pp 132–3. **15** Edward B. Garrison, *Italian Romanesque panel painting: an illustrated index* (Florence, 1949). Since 1998 in extended and updated form: Edward B. Garrison, *Italian Romanesque panel painting: an illustrated index. New edition on CD-ROM, with rev. bibl. and iconclass* (London, 1998).

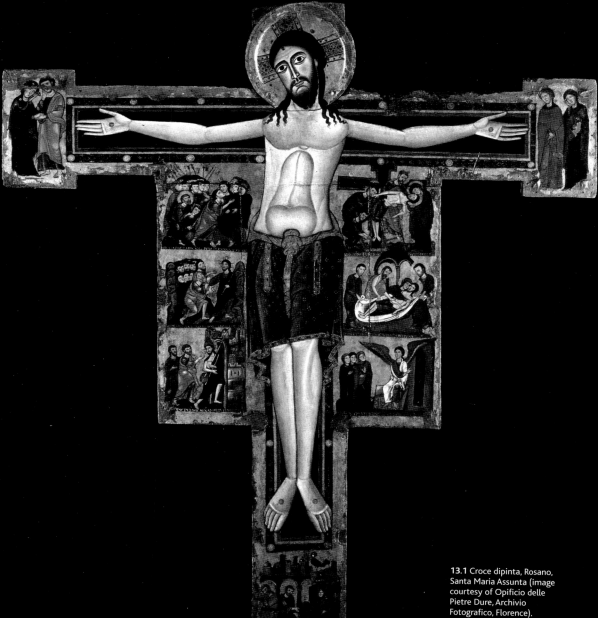

13.1 Croce dipinta, Rosano, Santa Maria Assunta (image courtesy of Opificio delle Pietre Dure, Archivio Fotografico, Florence).

examined in studies on medieval panel painting, but only in an ancillary role. The same is true of their treatment in works on artists like Giunta Pisano, Cimabue or Giotto, and in works on regional 'schools' of painting, such as that of Bologna.[16] The consistent focus is on Tuscany, Umbria and Emilia. An exception deserving of mention was the publication of the Sicilian painted crosses by Maria Concetta di Natale in 1992.[17]

In the last few years, the situation has changed, as the presumption that many unrestored crosses were late and of low quality has been challenged. Moreover, in the study of single crosses, the connection between technical expertise and historical context began to play an increasingly decisive role. Two important projects were the restoration of the painted cross in the cathedral in Sarzana, signed by Maestro Guglielmo in 1138,[18] and the examination of the cross from the Benedictine abbey of Rosano sull'Arno (fig. 13.1), probably donated between 1129 and 1134, during the years of office of the abbess Sofia from the family of the Conti Guidi.[19] In the art historical essay accompanying the publication on the restoration of the Rosano cross, Alessio Monciatti placed the crucifix in a Roman context, establishing parallels with the giant bibles of the late eleventh century, the Santa Cecilia (Rome, Vat. Barb. lat. 587) and the Pantheon Bible (Rome, Vat. lat. 12958), and with contemporary wall paintings like the fragments from San Nicola in Carcere.[20] Another early work that has been discussed in the context of the art of the Reformation is the painted cross from San Paolo all'Orto in Pisa (pl. 23),

16 For example: *Duecento: Forme e colori del Medioevo a Bologna*, ed. Massimo Medica (Venezia, 2000). **17** Maria Concetta Di Natale, *Le croci dipinte in Sicilia: L'area occidentale dal XIV al XVI secolo* (Palermo, 1992). See also: Maria Concetta Di Natale, 'Le croci dipinte in Sicilia: Dalla devozione alla musealizzazione' in Katharina Christa Schüppel (ed.), *Mittelalterliche Tafelkreuze: Akten des Studientags der Bibliotheca Hertziana am 3. und 4. November 2005, Römisches Jahrbuch der Bibliotheca Hertziana*, 38 (2007/8), pp 173–204. **18** The Sarzana cross is dated to 1138. It bears the inscription: *ANNO MILLENO CENTENO TER QUOQUE DENO OCTAVO PINXIT GUILLELMUS ET HEC METRA FINXIT*. Compare Sandberg-Vavalà, *La croce dipinta italiana*, pp 517–38; Garrison, *Italian Romanesque panel painting* (1998), no. 498; Roberto Bellucci, C. Castelli, Marco Ciatti and Cecilia Frosinini, 'Una croce dipinta monumentale del XII secolo: Studi e restauri', *OPD restauro*, 12 (2000), 137–45; *Pinxit Guillielmus: Il restauro della croce di Sarzana*, ed. Marco Ciatti, Cecilia Frosinini and Roberto Bellucci (Florence, 2001). **19** *La croce di rosano e la pittura del XII secolo: Storia e tecnica*, ed. Marco Ciatti, Cecilia Frosinini and Roberto Bellucci (Florence, 2010). A conference in Florence was dedicated to the Rosano cross and related problems: Elisa Tagliaferri, 'La pittura su tavola nel XII secolo: Riconsiderazioni e nuove acquisizioni a seguito del restauro della Croce di Rosano. Convegno Internazionale, Firenze, Kunsthistorisches Institut, 8–9 gennaio 2009', *Kunstchronik*, 62 (2009), 553–61. **20** Alessio Monciatti, 'La croce dipinta dell'abbazia di Santa Maria Assunt a Rosano ritrovata' in Frosinini et al. (eds), *La croce di Rosano*, pp 49–70. Angelo Tartuferi, by contrast, held the view that the crucifix had been painted in the third quarter of the twelfth century in eastern Tuscany. See Angelo Tartuferi, 'Qualche osservazione sulla Croce dipinta di Rosano restaurata' in Arturo Carlo Quintavalle (ed.), *Medioevo: Immagine e memoria* (Milan, 2009), pp 252–8. An early date, around the year 1100, has been suggested by Arturo Carlo Quintavalle: 'Rosano e crocifissi viventi della Riforma, dal *Volto Santo* di Lucca a Batlló', *OPD restauro*, 20 (2008), 139–70.

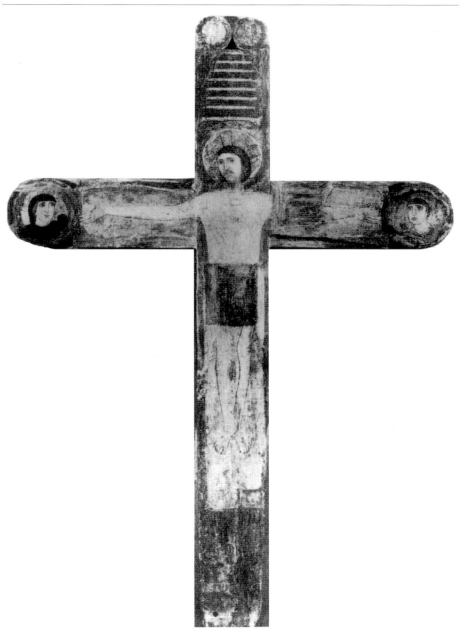

13.2 Croce dipinta, Fondi, Cathedral of San Pietro Apostolo (after Boris Ulianich, 'Il Crocefisso di Fondi: Il più antico dipinto su tavola esistente in Italia?' in *Fondi tra Antichità e Medioevo. Atti del convegno 31 marzo–1 aprile 2000*, ed. Teresa Piscitelli Carpino (Fondi, 2002), pp 251–306).

set in relation to the Umbro-Roman Bibles and the church decoration of San Pietro in Valle in Ferentillo from the second half of the twelfth century by Mariagiulia Burresi and Antonino Caleca.[21]

All this is important because it frees the intriguing topic of the *croci dipinte* from its former fixation on Tuscany. Considered as a whole, the painted crosses

21 Burresi and Caleca, *Cimabue a Pisa*, p. 8. See also Antonino Caleca, 'Il crocifisso dipinto di

first of all seem an 'Italian' phenomenon: the vast majority of painted crosses is preserved on the Italian peninsula. In Italy, in turn, Tuscany and Umbria are the regions where most painted crosses can be found. It is worthwhile, however, to call attention to some pieces in central and southern Italy, which are interesting for their early date and their high artistic quality.

The painted cross in Fondi is among the earliest *croci dipinte*, even earlier than the painted crosses from San Paolo all'Orto in Pisa (early twelfth century, Pisa, Museo Nazionale e Civico di San Matteo) and in the cathedral in Sarzana (dated to 1138).[22] It was brought to scholarly attention by Edward Garrison before it fell into oblivion for many years (fig. 13.2).[23] It was found in the brickwork of the Holy Cross chapel of the cathedral of San Pietro in the 1930s. The Crucified is shown in front of the gilded cross bars. He is accompanied by the *imagines clipeatae* of Mary and John at the lateral ends and by the personifications of sun and moon at the upper end of the cross. The cross was seriously damaged during the bombing of Fondi in the Second World War and its condition was adversely affected by subsequent restorations.[24] Valentino Pace pointed out the inadequacy of the piece's traditional dating to the second quarter of the twelfth century in his article on medieval painting in Campania in the mid-1990s;[25] he was followed by Boris Ulianich, who suggested an alternative dating to the second half of the eleventh century.[26] As I have argued elsewhere, based on stylistic considerations, a date around the year 1000 should also be taken into account.[27] In this context, the similarity of the figure of Christ – the proportions of which must originally have been considerably more elegant as shown by photographs taken during the 1940s restoration – to representations of the Crucified from the second half of the tenth century plays a decisive role. The upper part of the body may originally have been similar to figures like the Crucified on the Byzantine diptych in the treasury of the

Guglielmo a Sarzana' in Ciatti et al. (eds), *Pinxit Guillielmus*, p. 14; Tartuferi, 'Qualche osservazione sulla Croce dipinta di Rosano restaurata', p. 253. On Ferentillo, see *Gli affreschi di San Pietro in Valle a Ferentillo: Le storie dell'antico e del nuovo testamento*, ed. Giulia Tamanti (Naples, 2003). **22** On Sarzana, see n. 18; on San Paolo all'Orto, see n. 21, above. **23** Edward B. Garrison, 'Post-war discoveries: early Italian paintings (V)', *Gazette des Beaux-Arts*, 34 (1948), 5–22 at 6–14; *Arte a Gaeta: Dipinti dal XII al XVIII secolo*, ed. Maria Letizia Casanova Uccelli (Florence, 1976), pp 22–3; Valentino Pace, 'La pittura medievale in Campania' in Carlo Bertelli (ed.), *La pittura in Italia, vol. I: L'Altomedioevo* (Milano, 1994), p. 249; Boris Ulianich, 'Il Crocefisso di Fondi: Il più antico dipinto su tavola esistente in Italia?' in Teresa Piscitelli Carpino (ed.), *Fondi tra Antichità e Medioevo. Atti del convegno 31 marzo–1 aprile 2000* (Fondi, 2002), pp 251–306; Boris Ulianich, 'Il Crocefisso di Fondi. Il più antico dipinto su tavola esistente in Italia?' in Ulianich (ed.), *La croce. Iconografia e interpretazione (secoli I–inizio XVI)* (3 vols, Naples, 2007), iii, pp 187–233; Katharina Christa Schüppel, 'Der Gekreuzigte als Himmelsleiter: Das Tafelkreuz in San Pietro in Fondi', *Iconografica*, 8 (2009), 29–48; Valentino Pace, 'Introduzione al colloquio: Contesti di devozione alla croce e al crocefisso' in Schüppel (ed.), *Mittelalterliche Tafelkreuze*, pp 57–8. **24** Garrison, 'Post-war discoveries', p. 6. **25** Pace, 'La pittura medievale in Campania', p. 249. **26** Ulianich, 'Il Crocefisso di Fondi', pp 250–306. **27** Schüppel, 'Der Gekreuzigte als Himmelsleiter', pp 29–48.

cathedral in Milan (second half of the tenth century)[28] or the Ringelheim crucifix (*c.*1000).[29]

On the other hand, despite the numerous alterations of its original form, the Fondi cross cannot be compared to the more schematic, less lively images of the Crucified typical of the twelfth century. This is also true for the *croci dipinte* in Sarzana, in San Michele in Foro in Lucca,[30] in the cathedral in Spoleto,[31] and also for the cross from San Paolo all'Orto in Pisa: the body of the Crucified in Pisa looks more slender and is defined by line as the decisive artistic element and not, as at Fondi, by volume. Moreover, the Crucified at Pisa in its effect upon the viewer seems much more distant than its equivalent at Fondi. Another detail worthy of consideration is the proximity of the busts of Sol and Luna – the only 'original' parts of the cross – to Ottonian book illumination, for example to the figure of Sol in the crucifixion scene of the Lorsch Sacramentary (Chantilly, Musée Condé, MS 40, fo. 4, late tenth century).[32] Eight horizontal golden lines are located in the upper part of the vertical cross bar, between the cross halo of the figure of Christ and the personifications of Sol and Luna.[33] Usually the cross titulus was situated in this place,[34] but in Fondi no traces of letters are preserved. Elsewhere, I have proposed an interpretation of the eight lines as symbolizing the heavenly ladder.[35] The heavenly ladder is one component in a symbolic scheme

28 Rossana Boscaglia and Mia Cinotti, *Tesoro e Museo del Duomo* (2 vols, Milan, 1978), ii, cat. 4a–b, pp 52–3 (with further literature). **29** Barbara Ruhnau, 'Der Ringelheimer Kruzifix – Zustand und Erhaltung einer ottonischen Großskulptur' in Hans-Herbert Möller (ed.), *Restaurierung von Kulturdenkmalen: Beispiele aus der Niedersächsischen Denkmalpflege* (Hameln, 1989), pp 273–8; Elisabeth Epe at al., cat. 5, in *Kirchenkunst des Mittelalters: Erhalten und Erforschen*, ed. Michael Brandt (Hildesheim, 1989), pp 85–106; Rainer Kahsnitz with Klaus Endemann, cat. VII–31, in *Bernward von Hildesheim und das Zeitalter der Ottonen*, ed. Michael Brandt and Arne Eggebrecht (2 vols, Hildesheim and Mainz, 1993), ii, pp 496–500. **30** Sandberg-Vavalà, *La croce dipinta italiana*, pp 517–38; Garrison, *Italian Romanesque panel painting*, no. 504 (second half of the twelfth century). **31** Now in the cathedral of Santa Maria Assunta in Spoleto, dated to 1187. Compare Sandberg-Vavalà, *La croce dipinta italiana*, pp 613–19; Lorenza Cochetti Pratesi, 'Precisazioni su Alberto, Sozio' in *Storia e arte in Umbria in età comunale. Atti del VI convegno di studi umbri* (2 vols, Gubbio, 1971), i, pp 83–100; Giordana Benazzi, 'La croce di Alberto nel Duomo di Spoleto' in Corrado Fratini et al. (eds), *Quando Spoleto era romanica: Antologia per un Museo del Ducato. Una mostra nella Rocca* (Rome, 1984), pp 61–73; Giordana Benazzi, 'Il crocifisso di Alberto nel Duomo di Spoleto: Una croce tra oriente e occidente', *Art e dossier*, 63 (1991), 34–7; Alice Ann Driscoll, *Alberto Sotio, 1187, and Spoleto: the Umbrian painted cross in Italian medieval art* (PhD, University of North Carolina, Chapel Hill, 2005). **32** Brigitte Nitschke, *Die Handschriftengruppe um den Meister des Registrum Gregorii* (Recklinghausen, 1966), pp 54–7; Henry Mayr-Harting, *Ottonian book illumination: an historical study* (2nd ed., London, 1999), p. 39. **33** Ulianich interprets the golden lines as a symbolic representation of the seven heavens: Ulianich, 'Il Crocefisso di Fondi', 301–2. **34** On the cross titulus, see Sabrina Longland, 'Pilate answered: What I have written I have written', *Metropolitan Museum of Art Bulletin*, 26 (1967–68), 410–29; Gad Sarfatti, A. Pontani and P. Zamponi, 'Titulus crucis' in *Giotto: la Croce di Santa Maria Novella*, pp 191–202; Anna Pontani, 'Note sull'esegesi e l'iconografia del Titulus Crucis', *Aevum*, 77 (2003), 135–85. **35** On the heavenly ladder, see Christian Heck, *L'échelle céleste dans l'art du Moyen Âge: Une image de la quête du*

that imagines the life of Christ as a unified series of descents and ascents.[36] The link between the heavenly ladder and the life of Christ is the analogy between Jacob's beatific vision and the redemption of mankind by Christ's death on the cross. Chromatius of Aquileia said 'The ladder extending from the earth to the heavens is the cross of Christ, by which there is a place for us in heaven, [the cross] which truly has opened the way to heaven.'[37] In the Western European theological tradition, discussion of the heavenly ladders – based on Gen 28:10–22 – appears from the third century on and is understood both in tropological and eschatological terms.[38]

From late antiquity onwards, the heavenly ladder was a metaphor both for the cross and for the Crucified. The cross recalls the ladder, showing the way to heaven by means of its steps. In a further elaboration, the Crucified himself was understood as the 'heavenly ladder' – as the writings of Quodvultdeus (d. *c.*454) and Isidore of Seville (d. 636) said:

> The rod is St Mary, the rod is Christ himself, the rod is the cross. And from that rod what great and wonderful things did this architect do! He made the tree of the cross, and a stairway to heaven through which man, fallen, rose to the Father. What a miracle, brothers, of this architect, that he made from his rod a stairway of such a kind that he placed its top in heaven, and through it he himself both ascends and descends.[39]

and

> Jacob dreams of the death, or the Passion, of Christ … Moreover, the ladder [in his dream] is Christ, who said: I am the way.[40]

As early as the sixth century, the connection between crucifixion and ascension was made in the *Collectio Veronensis*, whose author interpreted the heavenly ladder as a symbol of the ascension of Christ: 'Therefore, that ladder which Jacob saw, as it is said, stretching from the earth to heaven, signified the descent and ascent of the

ciel (Paris, 1997). **36** Ibid., p. 170. **37** '*Scala firmata a terra usque ad caelum, Crux Christi est, per quam nobis locus ad caelum est, quae uere perducit usque ad caelum.*' Chromatius of Aquileia, *Sermo* I, 6, CCSL, 9A, p. 5. **38** Heck, *L'échelle céleste dans l'art du Moyen Âge*, pp 29–50. **39** *Et de ista virga quam magna et mira fecit hic architectus! et arborem fecit crucis … et scalas coeli per quas hominem lapsum ad Patrem levavit. Quale miraculum, fratres, hujus architecti, ut de virga sua faceret scalas, et tales quarum caput in coelum poneret, et per eas ipse et ascenderet et descenderet.* Quodvultdeus, *De cataclysmo*, VI, 8, CCSL, 60, p. 418. Heck, *L'échelle céleste dans l'art du Moyen Âge*, pp 50–1. The English translation follows Nicole Fallon, 'The cross as tree: the wood-of-the-cross legends in Middle English and Latin texts in medieval England' (PhD, University of Toronto, 2009), p. 151. **40** *Somnus iste Jacob, mors, sive passio Christi est [...]. Porro scala Christus est, qui dixit: Ego sum via.* Isidore of Seville, *Quaestiones in Veterum Testamentum. In Genesin*, XXIV, 2–3, PL, 83, p. 258. Heck, *L'échelle céleste dans l'art du Moyen Âge*, pp 50–1. The translation is my own.

Lord'.[41] This association persisted throughout the Middle Ages. In some cases, it even took on a life of its own: in the first book of the *Rationale divinorum officiorum* (1286–91), Guillelmus Durandus states that the image of Christ (*Salvatoris ymago*) on the steps of a ladder was an image of the ascension:

> Because the image of the Saviour in the crib commemorates the Nativity, his image on his mother's lap commemorates his childhood, his painted or sculpted image on the cross reminds us of the Passion ... and his image on the steps of a ladder makes us think about the ascension.[42]

Throughout the Middle Ages, this ladder was most often depicted with seven rungs.[43] The eight golden lines at the upper end of the cross in Fondi may be read as the heavenly ladder according to the system 'seven plus one': in medieval exegesis, the eighth step of the ladder symbolized eternity.[44]

Four other pieces requiring scholarly attention are the painted crosses in the Museo Diocesano in Salerno (pl. 24);[45] in Casape, in the Monti Prenestini east of Rome;[46] in the Museo Nazionale di Capodimonte in Naples, from the Benedictine abbey of San Paolo in Sorrento;[47] and in the abbey church of Santa Maria at San Nicola dei Tremiti, an island just off the coast of Puglia.[48] The crosses in Salerno and Casape have been dated to the late twelfth century and the years around 1200 respectively. The pieces from Sorrento and in San Nicola dei Tremiti, by contrast, are thirteenth-century works.

All pieces discussed up to this point reveal that the early painted crosses in particular are precious works of art of the highest artistic quality. We are not dealing with a low-cost mass product, an idea that has been favoured by the strong association of the late pieces with the mendicant orders, but with sumptuous single pieces, highlights of the artistic production of their respective time and region.

One of the most urgent concerns today, besides the minimizing of undue emphasis on Tuscany, is the analysis of the painted crosses in terms of visual content, beyond a merely formal approach. We know of three different kinds of painted cross. The majority show relatively few narrative scenes, depicting the

41 *Illa ergo scala quam uidit Iacob de terra, ut dictum est, pertingentem ad caelum, descensum et ascensum d(omi)ni significabat [...].* Heck, *L'échelle céleste dans l'art du Moyen Âge*, p. 177. *Collectio Veronensis*, IV, CCSL, 87, p. 61. **42** *Nam [Saluatoris ymago] picta in presepio rememorat natiuitatem; depicta in matris gremio, puerilem etatem; depicta uel sculpta in cruce, passionem ... depicta uero in scalarum ascensu, ascensionem [...].* *Rationale Divinorum Officiorum*, I, 3, 7, CCCM, 140, p. 37. **43** Heck, *L'échelle céleste dans l'art du Moyen Âge*, p. 51 **44** Ibid., pp 244–5. **45** Maria Pia Di Dario Guida, *Icone di Calabria e altre icone meridionali* (Soveria Mannelli – Messina, 1993), pp 133–6; Ulianich, 'Il Crocefisso di Fondi', 200. **46** Garrison, 'Post-war discoveries', 15–20. **47** Di Dario Guida, *Icone di Calabria*, pp 133–6; Ulianich, 'Il Crocefisso di Fondi', 200. **48** Valentino Pace, 'La pittura delle origini in Puglia (secc. IX–XIV)' in Cosimo D. Fonseca (ed.), *La Puglia fra*

crucifixion, the resurrection (or a subsidiary scene) and the ascension, images corresponding to the most important ecclesiastical feasts between Good Friday and Ascension Day. By this means, the crosses not only depict the biblical account, but also comment upon the liturgical rites of the high Middle Ages: the named feasts are those associated in the *Ordines Romani* and the later medieval *Libri Ordinarii* with liturgical practices involving the cross. The crucifixes in San Pietro in Fondi[49] and from Santi Giovanni e Paolo in Spoleto,[50] and the cross in the cathedral in Mazara del Vallo, Sicily,[51] belong to this first type of painted cross.

Besides this first type, already in the twelfth century another type of painted cross can be found. In this, the central panel is expanded to form an 'apron', on which many small scenes depicting Christ's Passion appear to either side of his crucified body. Some scenes are even doubled. On the cross from San Martino in Pisa, for example, the main subject, the crucifixion, appears once in monumental form and again on the right side of the central panel, implying both a timeless and a narrative reading of the scene respectively.[52] Around 1230, the painted cross with many small scenes on the apron became less important and was substituted by the third type, showing the dead Christ in front of the now ornamentally decorated central panel. The works by Giunta Pisano in Pisa and in Bologna might be cited in this regard.[53]

Original location within the church, monastery or convent is a significant factor, but cannot always be recovered. Here, ancillary evidence may be helpful. Three scenes in the upper church of St Francis in Assisi (the prayer in San Damiano, the celebration of Christmas at Greccio and the verification of the stigmata) thus give us an insight into the positioning of such painted crosses.[54]

A deeper understanding of the place of the painted crucifixes in the life of medieval convents, parish churches, churches of mendicant orders and cathedrals has been sought by this author through the analysis of examples in Arezzo, Lucca

Bisanzio e l'Occidente (Milan, 1980), p. 357. **49** See n. 23, above (Fondi). **50** See n. 31, above (Spoleto). **51** Di Natale, *Le croci dipinte in Sicilia*, pp 14–17; Leo Di Simone, *Vexilla regis: La croce dipinta di Mazara del Vallo, icona pasquale della liturgia* (Panzano in Chianti, 2004). **52** On the painted cross from San Martino in Pisa (originally with a now-lost signature by Enrico di Tedice), see, recently, Antonino Caleca, 'La pittura del Duecento e del Trecento a Pisa e a Lucca' in Enrico Castelnuovo (ed.), *La pittura in Italia: Il Duecento e il Trecento* (2 vols, Milano, 1986), i, p. 235; James H. Stubblebine, 'A crucifix for Saint Bona', *Apollo*, 125 (1987), 160–5 at 164–5; Burresi and Caleca, *Cimabue a Pisa*, p. 32; Mariagiulia Burresi, Lorenzo Carletti and Cristiano Giometti, *I pittori dell'oro: Alla scoperta della pittura a Pisa nel Medioevo* (Ospedaletto (Pisa), 2002), p. 34; Lorenzo Carletti, cat. 20, in *Cimabue a Pisa*, pp 136–9. **53** Dino Campini, *Giunta Pisano Capitini e le croci dipinte romaniche* (Milan, 1966), pp 39–77, 182–6; Miklòs Boskovits, 'Giunta Pisano: Una svolta nella pittura italiana del Duecento', *Arte illustrata*, 6 (1973), 339–52; Burresi and Caleca, *Cimabue a Pisa*, pp 26, 31; Luciano Bellosi, cat. 52, in *Duecento: Forme e colori del Medioevo a Bologna*, pp 203–7; Lorenzo Carletti, cat. 10, 12, in *Cimabue a Pisa*, pp 116–17, 120–1. **54** On the decoration of the upper church of San Francesco, see Serena Romano, *La basilica di San Francesco ad Assisi: Pittori, botteghe, strategie narrative* (Rome, 2001); Bruno Zanardi, *Il cantiere di Giotto: Le storie di San*

and Naples. The study was based on the question of whether preferences for sculpted or painted crucifixes existed in the different liturgical contexts of the single cities, in line with their respective economic histories, the rivalries between parish churches and cathedrals and the acceptance of painting and sculpting as different artistic media in the context of the cross cult. One of the results has been the striking contrast between crucifix production in Lucca, in the twelfth and thirteenth centuries a centre of panel painting, and Naples, where a clear preference for sculpted crucifixes can be observed.[55]

Two art historical publications of recent years have been dedicated to the Franciscan context. Manfred Luchterhandt suggested a role for the painted crosses with small Passion scenes within the liturgy of the hours, especially the *Officium sanctae crucis*. The small narrative scenes are recognized as illustrations of the psalms for the Divine Office.[56] In his study *In medio ecclesiae*, Donal Cooper examined the function of choir screens and the painted crosses on top of them in Franciscan churches in eastern Tuscany and in Umbria. He interprets the monumental painted crosses showing the dead Christ as a kind of visual compensation for the celebration of the Eucharistic Mass on the main altar, inaccessible and invisible to the faithful.[57] The idea of the visualization of the sacrifice of the Mass and the corresponding ahistorical understanding of the crucifixion has been formulated also by Staale Sinding-Larsen.[58] The character of the cult image of single pieces has been addressed by Michele Bacci in his studies on the painted cross in Santa Giulia in Lucca and on the painted cross from San Pierino in Pisa.[59]

As I have argued elsewhere, the possible relationship between painted crosses and icons as two-dimensional images of the sacred requires further attention.[60] The two-dimensional painted crosses were particularly appreciated in western Tuscany, a region in close contact with the eastern Mediterranean and known for the import of Byzantine icons. Other Italian regions reacted later. In fact, one of the

Francisco ad Assisi (Milan, 1996). On the display of the painted cross in the 'Christmas at Greccio', see Chiara Frugoni, 'Sui vari significati del Natale di Greccio, nei testi e nelle immagini', *Frate francesco*, 70 (2004), 35–147 at 92ff. **55** Katharina Christa Schüppel, 'Pictae et sculptae: Tafelkreuze und plastische Kruzifixe im lokalen liturgischen Kontext. Die Städte Lucca, Arezzo und Neapel' in Schüppel (ed.), *Mittelalterliche Tafelkreuze*, pp 77–112. **56** Manfred Luchterhandt, 'Von der Ikone zum Retabel. Offizienliturgie und Tafelbildgebrauch im Dugento, Erster Teil: Die Kreuzoffizien', *Westfalen*, 80 (2002), 267–322. **57** Donal Albert Cooper, *In medio ecclesiae: screens, crucifixes and shrines in the Franciscan church interior in Italy (c.1230–c.1400)* (2 vols, Boston Spa, 2000); idem, 'Projecting presence: the monumental cross in the Italian church interior' in Robert Maniura and Rupert Shepherd (eds), *Presence: the inherence of the prototype within images and other objects* (Aldershot, 2006), pp 47–69. **58** Staale Sinding-Larsen, 'Some observations on liturgical imagery of the twelfth century', *Acta ad archaeologiam et artium historiam pertinentia*, 8 (1978), 193–212. **59** Michele Bacci, 'La croce di Santa Giulia' in *San Martino di Lucca* (2 vols, Lucca, 1995–8), ii, pp 87–102; idem, 'Shaping the sacred: painted crosses and shrines in thirteenth-century Pisa' in Schüppel (ed.), *Mittelalterliche Tafelkreuze*, pp 113–29. **60** Schüppel, 'Pictae et sculptae', 79–80.

earliest painted crosses in Sicily, the crucifix made by the Maestro della Croce di Castelfiorentino (Palermo, Palazzo Abatellis, Galleria Regionale della Sicilia), was an import from Tuscany.[61]

Another point of interest remains the question of the ultimate impact of the Gregorian Reform in Italy on the early, precious painted crosses of high artistic value in the twelfth century.[62] The relationship, on a stylistic level, between the Rosano crucifix and Roman works has already been placed in the context of the reform by Alessio Monciatti.[63] But can the problem also be addressed on an additional content level, based on the idea of a 'picture theory of the reform'? The difficulty of reading works of art in the reform context has recently been stressed by Herbert Kessler, who characterized the art of the reform as an 'instrument of pedagogy, conversion and spiritual elevation'.[64] As Kessler pointed out, the sole reliable basis of every study on the reforming character of art remains the texts on art by the protagonists of the reform, for otherwise connections risk becoming random or arbitrary.[65]

The conjunction between the choice of scenes and the iconography of a painted cross with the central concerns of the reform has been discussed by Cecilia Frosinini, in her essay on the Sarzana cross. She reads the depiction of the *Christus triumphans* as representing the Gregorian idea of the triumphant church. The scene of Peter striking Malchus is interpreted as a symbol of the conflict between church and *imperium*, the existence of an inscription as indicating that the cross belongs to the culture of reform, abounding in inscriptions and *tituli*.[66] The question of an ultimate relationship between the small scenes on the central panels of the twelfth-century crosses and key issues of the Gregorian Reform was also considered by Arturo Carlo Quintavalle in his article 'Rosano e i crocifissi viventi della Riforma'.[67]

The era of the *croci dipinte* closes in the late Middle Ages. Due to a new devotional piety, the painted crosses were abandoned, especially in the context of the mendicant orders, in favour of a new type of so-called *crocifissi dolorosi*.[68]

61 Di Natale, *Le croci dipinte in Sicilia*, p. 8. **62** On the art of the reform in Italy, see Hélène Toubert, *Un art dirigé: Réforme grégorienne et iconographie* (Paris, 1990). **63** Monciatti, 'La croce dipinta dell'abbazia di Santa Maria Assunt a Rosano ritrovata', pp 51–6. **64** Herbert Kessler, 'A Gregorian Reform theory of art?' in Serena Romano and Julie Enckell Julliard (eds), *La riforma Gregoriana: tradizioni e innovazioni artistiche (XI–XII secolo)* (Rome, 2007), pp 25–48, esp. pp 47–8. **65** Kessler, 'A Gregorian Reform theory of art?', p. 26. **66** Cecilia Frosinini, 'La riforma gregoriana e la nascita della croce dipinta' in Ciatti et al. (eds), *Pinxit Guillielmus*, pp 27–30. **67** Quintavalle, 'Rosano e crocifissi viventi della Riforma, dal *Volto Santo* di Lucca a Batlló', *OPD restauro*, 20 (2008), 139–70. **68** Still of fundamental interest with regard to the *crocifissi dolorosi* in Italy. See Géza de Francovich, 'L'origine e la diffusione del crocifisso gotico doloroso', *Kunstgeschichtliches Jahrbuch der Bibliotheca Hertziana*, 2 (1938), 143–61. See also *Crocifissi dolorosi*, ed. Giovanni Zanzu (Cagliari-Sassari, 1998); Clara Baracchini, 'Crocifissi dolorosa: Un caso italiano' in *Scultura e arredo in legno fra Marche e Umbria*, pp 217–24; Michele Tomasi, 'Il Crocifisso di San

Contemporary scholarship must, therefore, release these artefacts from the confines of a connoisseurial and curatorial approach. The aim of this new scholarship is to restore this rich field of research, neglected since the ambitious projects of Sandberg and Garrison, to wider scholarly attention, and to contextualize the painted crosses in a diversity of ways. In the last decade, this methodology has been fruitfully applied to the sculpted medieval crucifixes in Italy, particularly the crucifixes of the *Volto Santo*-type.[69] A new understanding of the role of the painted cross in liturgy is fundamental, coupled with an awareness of the existence of painted crosses before the twelfth century. Discussion concerning the relationship between the *croci dipinte* and the art of the Gregorian Reform in the late eleventh and twelfth centuries must first be attempted, not only from a stylistic and from an art-theoretical point of view, but also from a source-based perspective. Further insights will emerge with the change of perspective from Tuscany alone, to include Rome and central or southern Italy. Since the discussion is still wide open, the painted crosses constitute one of the most promising fields for future research on medieval crucifixes. More discoveries are to be expected with every new restoration.

Giorgio ai Tedeschi e la diffusione del "Crocifisso doloroso"' in *Sacre passion: Scultura lignea a Pisa dal XII al XV secolo*, pp 57–76; Raffaele Casciaro, 'Ipotesi sul Maestro dei Beati Becchetti e spunti sulla questione dei Crocifissi gotici dolorosi tra Marche e Umbria' in Maria Giannatiempo López and Antonio Iacobini (eds), *Nuovi contributi alla cultura lignea marchigiana. Atti della giornata di studio (Matelica 20 novembre 1999)* (Sant'Angelo in Vado, 2002), pp 31–55. **69** *Santa Croce e Santo Volto: Contributi allo studio dell'origine e della fortuna del culto del Salvatore (secoli IX–XV)*, ed. Gabriella Rossetti (Pisa, 2002); *La Santa Croce di Lucca. Il Volto Santo: storia, tradizioni, immagini. Atti del convegno, Villa Bottini (1–3 marzo 2001)* (Empoli, 2003); Michele Camillo Ferrari and Andreas Meyer (eds), *Il Volto Santo in Europa: Culto e immagini del Crocifisso nel Medioevo. Atti del Convegno internazionale di Engelberg (13–16 settembre 2000)* (Lucca, 2005). See also Bacci, this volume.

Towards an emotive Christ? Changing depictions of the crucifixion on the Irish high cross

JENIFER NÍ GHRÁDAIGH

INTRODUCTION

Among the most spectacular artistic productions of medieval Ireland are its high crosses (fig. 14.1). These stone monuments, of anything up to seven metres in height, as at Moone, Co. Kildare (fig. 14.2), and dating mostly to the ninth and tenth centuries, are embellished with high relief ornamental and scriptural scenes. They have often been seen as a bridge between late antique stone carving and its monumental revival in the Romanesque style of the eleventh and twelfth centuries.[1] In comparison with early Christian art, Lawrence Nees has recently characterized their iconography as focusing on 'less recondite imagery, representing mainly well-known events drawn from the Old and New Testaments', and has emphasized their universal appeal to a non-learned audience.[2] This view of their imagery as being easily decipherable to secular viewers is in itself debatable given the complex typological schemes, often opaque in meaning, around which their ostensibly narrative sculpture is organized.[3] It is certain, however, that Christ's crucifixion, which is given a prominent positioning on nearly all the complete crosses surviving, generally at the centre of the cross head, was universally recognizable.[4] Much has been written on the sculptural qualities of these crosses,

1 Roger Stalley, 'European art and the Irish high crosses', *PRIA*, 90C (1990), 135–58 at 136–7. **2** Lawrence Nees, *Early medieval art* (Oxford, 2002), pp 205–6. **3** See, for instance, as examples of necessary interpretative frameworks, Shirley Alexander, 'Daniel themes on the Irish high crosses' in Catherine E. Karkov, Michael Ryan and Robert T. Farrell (eds), *The Insular tradition* (Albany, NY, 1997), pp 99–114; Malgorzata D'Aughton, 'The Kells Market Cross: the Epiphany sequence reconsidered', *Archaeology Ireland*, 18:1 (spring 2004), 16–19. **4** Although itself invested with

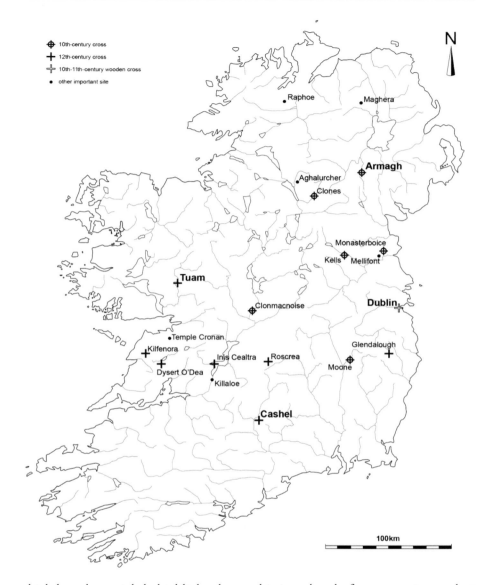

14.1 Map showing high crosses of tenth and twelfth centuries mentioned in text (map by Hugh Kavanagh).

which have been rightly highlighted as sophisticated and often expressive works.[5] It is puzzling, therefore, that the images of the crucified Christ are not more engaging, especially given the emotional tone of literary compositions of this date and earlier.[6] It will be suggested below that the Romanesque crosses, although

varieties of shades of meaning: Kees Veelenturf, 'Irish high crosses and Continental art: shades of iconographical ambiguity' in Colum Hourihane (ed.), *From Ireland coming* (Princeton, NJ, 2001), pp 83–101. **5** See, most recently, Roger Stalley, 'Artistic identity and the Irish scripture crosses' in Rachel Moss (ed.), *Making and meaning in Insular art* (Dublin, 2007), pp 153–66. **6** See, for instance, the eighth-century devotional poems of Blathmac, whose emotional tone finds no reflection

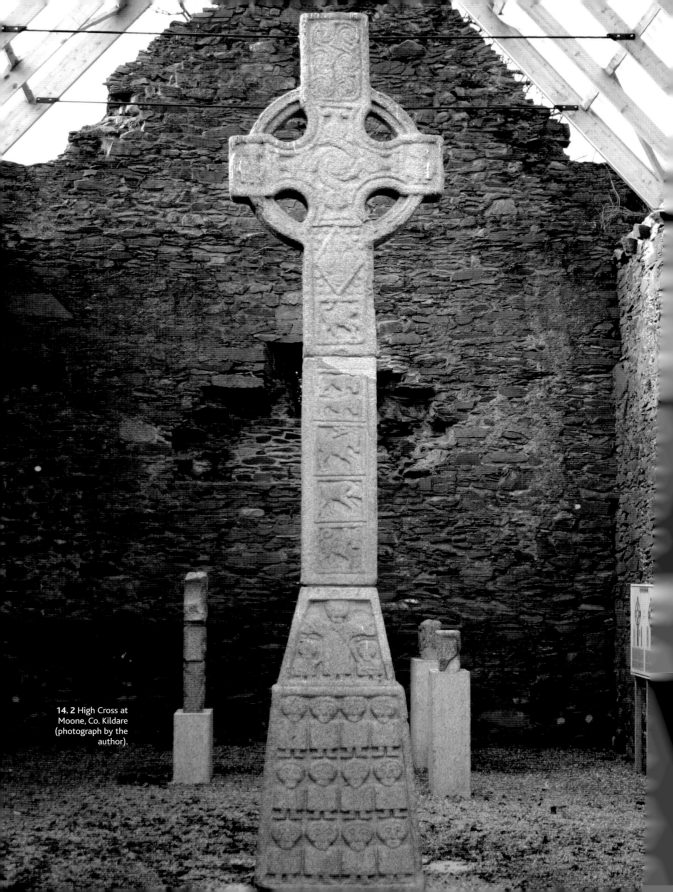

14. 2 High Cross at
Moone, Co. Kildare
(photograph by the
author).

usually dismissed as a late and unworthy addendum to the high cross tradition of sculpture, in fact show a decided development in expressive qualities, and that this is due to their association with key figures in the reform movement of the Irish church. Such expressiveness may be related to a greater interest in the laity and their participation in the Eucharist in twelfth-century Ireland. Such Irish interest in the Real Presence in the Eucharist, coupled with the importance of lay understanding and participation, is clear both from the poetic treatise written by Echtgus Úa Cúanáin in the late eleventh/early twelfth century, and by the Irish clerical appeal to Lanfranc on the question in c.1080.[7]

This also raises the question of the relationship between visual representation, audience and models. To modern eyes, the later crosses seem far less comparable to European art than those of the tenth century.[8] Yet, in responding to contemporary theological preoccupations by reworking Continental models known from metalwork exempla, they highlight the diversity of stylistic means used in the Romanesque period to create effective, and affective, art.[9] Any stigmatization of their formal qualities points to our own methodological shortcomings and shows yet again just how flawed interpretations of the medieval image achieved through formal analysis may be. An awareness of the subjectivity of perception, for both the medieval and the modern audience is therefore essential when addressing these crosses. We should bear in mind that as late as the eleventh century contemporary Irish metalwork was valued in the empire, as shown by the laudatory comment by Thangmar on the 'rare and exceptional' vessels of Irish and Anglo-Saxon manufacture in his life of St Bernward, bishop of Hildesheim.[10] And indeed, audience must take centre stage in any analysis of emotional or affective imagery.

IRISH CRUCIFIXION IMAGERY IN THE TENTH TO TWELFTH CENTURIES: MONAINCHA AND MONASTERBOICE

There is no better example of the difficulties of reconciling contemporary perceptions and material remains than Gerald of Wales' description of Monaincha,

in related art: Martin McNamara, 'Bible text and illumination in St Gall Stiftsbibliothek Codex 51, with special reference to Longinus in the crucifixion scene' in Mark Redknapp, Nancy Edwards, Susan Youngs, Alan Lane and Jeremy Knight (eds), *Pattern and purpose in Insular art* (Oxford, 2001), pp 191–202. **7** On both, see Boyle, this volume. **8** Peter Harbison, 'The otherness of Irish art in the twelfth century' in Hourihane (ed.), *From Ireland coming*, pp 103–20. **9** Roger Stalley has argued that a bronze crucifix figure might have been the model for the head of Tuam Market Cross, while the cross arms of the Glendalough Market Cross may derive from Ottonian metalwork models: 'The Romanesque sculpture of Tuam' in Alan Borg and Andrew Martindale (eds), *The vanishing past: studies of medieval art, liturgy and metrology presented to Christopher Hohler* (Oxford, 1981), pp 179–95. **10** Discussed most recently by Raghnall Ó Floinn, 'Innovation and conservatism in Irish metalwork of the Romanesque period' in Karkov et al. (eds), *The Insular tradition*, pp 259–81 at p. 261.

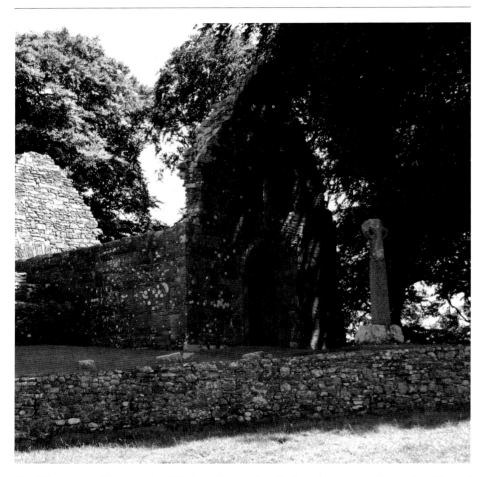

14.3 Monaincha, Co. Tipperary (photograph by the author).

Co. Tipperary (fig. 14.3). Writing about the distinctiveness and peculiarities of Ireland towards the end of the twelfth century, Gerald, an Anglo-Norman cleric, did not mince his words in his descriptions of a people and a culture he found alien. His criticisms of what he saw as the deviance of Christianity were trenchant: he noted, for instance, that 'of all the peoples it [the Irish] is the least instructed in the rudiments of the faith. They do not pay tithes or first fruits or contract marriages.'[11] It is in his accounts of miracles and the miraculous that the description of Monaincha occurs:

> There is a lake in the north of Munster which contains two islands, one rather large and the other rather small. The larger has a church venerated from the earliest times. The smaller has a chapel cared for most devotedly by a few celibates called 'heaven-worshippers' or 'god-worshippers' [Céli Dé].[12]

11 Gerald of Wales, *The history and topography of Ireland*, trans. J.J. O'Meara (London, 1982), p. 106.
12 Gerald of Wales, p. 60.

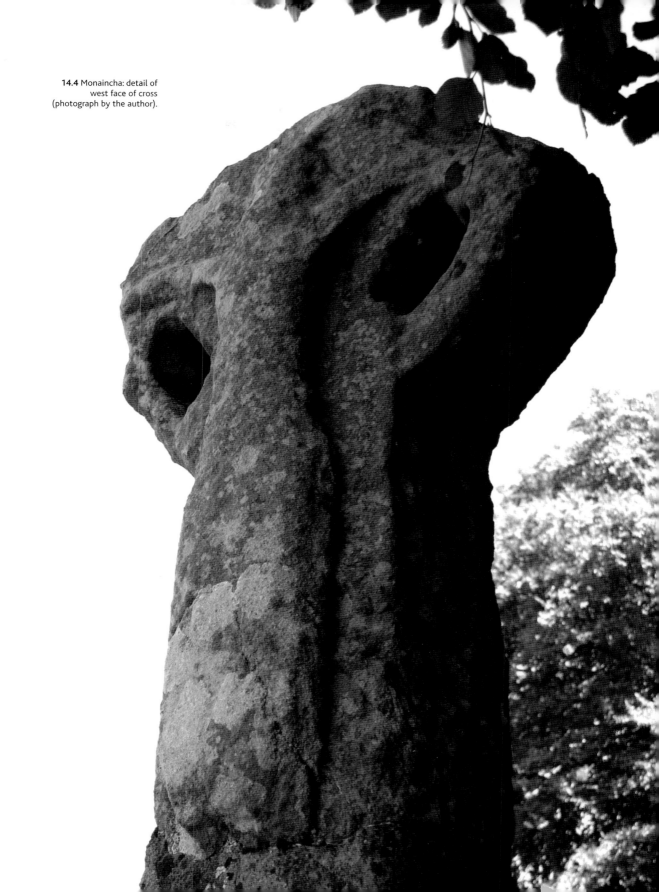

14.4 Monaincha: detail of
west face of cross
(photograph by the author).

Gerald's description effectively highlights the peculiarities of the Irish church, as perceived not merely in his time but by more recent scholars, both in terms of material culture – here the layout of small, clustered churches – and in terms of practice, with native, rather than Benedictine orders being the norm.[13] But looking at the material evidence remaining from the site, a high cross and a Romanesque church, one is struck immediately by how much these are part of a common European artistic repertoire.[14] The church has a Romanesque doorway and chancel arch whose chevron decoration is not far removed from those of English parish churches, while in plan it similarly conforms. Indeed, the adoption of the nave and chancel plan in Ireland in *c.*1100 can be related to liturgical and theological changes emanating from the Roman church that stressed the mystery of the sacrament and the different roles of laity and celebrant, which Irish clerics were increasingly concerned with conforming to.[15] Echtgus Úa Cuanáin's treatise further shows Irish awareness of symbolic readings of such architectural form: the chancel and nave metaphorically represent, and indeed literally contain, Christ, head of the church, and his believers, the body of the church.[16] Thus innovations in architectural form were made necessary by, coupled with, and interpreted through the reforms that brought the Irish church into line with the church in Europe.

Is the same true of sculptural expression? The cross at Monaincha (fig. 14.4) is radically different from the earlier multi-panelled scripture crosses such as Moone. The entire west face is given over to a large, long-robed figure of Christ, who dominates the cross and whose body is not confined to the cross-head alone. The east face is covered in elaborate animal interlace, now sadly worn, which originally must have had strong skeuomorphic overtones, resembling contemporary metalwork. Implicit here is the contrast of a gemmed cross with a crucifixion. Hitherto, such jewelled crosses have been interpreted as referencing the memorial cross erected at Golgotha. By comparison, however, with the contrastive positioning of crucifixion and Last Judgment on west and east faces of the tenth-century crosses, reference to the *parousia* appears far more probable.[17]

13 See Tomás Ó Carragáin, *Churches in early medieval Ireland: architecture, ritual and memory* (New Haven, CT, and London, 2010); Colmán Etchingham, *Church organisation in Ireland, AD650 to 1000* (Maynooth, 1999), pp 319–62; Marie Therese Flanagan, *The transformation of the Irish church in the twelfth century* (Woodbridge, 2010). 14 See Tadhg O'Keeffe, *Romanesque Ireland: architecture and ideology in the twelfth century* (Dublin, 2003), pp 252–5; Peter Harbison, *The high crosses of Ireland: an iconographical and photographical survey* (3 vols, Bonn, 1992), pp 138–9; Rhoda Cronin, 'Late high crosses in Munster: tradition and novelty in twelfth-century Irish art' in M.A. Monk and John Sheehan (eds), *Early medieval Munster: archaeology, history and society* (Cork, 1998), pp 138–46. 15 See, for instance, John Fleming, *Gille of Limerick (c.1070–1145): architect of a medieval church* (Dublin, 2001). 16 Tomás Ó Carragáin, 'The architectural setting of the Mass in early medieval Ireland', *Medieval Archaeology*, 53 (2009), 119–54 at 144–7. This is part of an ongoing tradition of such metaphor, also found in Cogitosus' seventh-century description of the church at Kildare. 17 Lawrence Nees, 'On the image of Christ crucified in early medieval art' in Michele Camillo

Jane Hawkes has suggested in an Anglo-Saxon context that the glittering poly-chrome skeuomorphic form of the Sandbach Crosses may have represented the *crux gemmata* of the Apocalypse.[18] However, to find analogies for this means of representing Passion and *parousia* in radically different formal language on the one monument, we must look further afield. Such dualistic representation is particularly common in metalwork from the empire from at least the tenth century onwards, such as the Lothar Cross of *c.*985/91 (pl. 25).[19] Evidence that such models were known in Ireland is tantalizingly slight. The Cross of Otto and Mathilde, *c.*983, or others like it, provides a parallel for the otherwise puzzling sculpting of the cross arms of the Glendalough Market Cross into capitals (fig. 14.7).[20] Bishop Dúnán had acquired the foundation relics for Christ Church Cathedral in Dublin in Cologne in *c.*1030, and Irish kings certainly gave gifts of metalwork to the emperor at this period, which suggests reciprocal exchange; Continental metal-work from this period does survive in the archaeological record, but no imported altar crosses.[21] Thus, although impossible to prove, the contrast of Christ's bodily crucifixion on one side of the cross, with a gemmed parousiacal cross on the other, is likely to result from knowledge of metalwork crosses from the empire.

However, this is no straight copy. The dedication of one whole face of the cross to the crucifixion is found not only in such metalwork but also in wood sculpture, where long-robed figures are more common; examples include the Borgo San Sepolcro *Volto Santo* figure of the eighth or ninth century.[22] Recent research suggests that such images may have been relatively widespread in Western Europe, albeit in wood rather than in stone, even if most surviving examples, such as the Battló Majestat from Catalonia, are twelfth century in date.[23] Models from Anglo-Saxon and early Anglo-Norman England, such as the now-lost stone

Ferrari and Andreas Meyer (eds), *Il Volto Santo in Europa: Culto e immagini del Crocifisso nel Medioevo. Atti del Convegno internazionale di Engelberg (13–16 settembre 2000)* (Lucca, 2005), pp 345–8 at p. 357 notes of the tenth-century crosses, 'this pairing is essential, that the two images are designed to be read together almost like a diptych.' For the association of the jewelled cross with Golgotha, see H. Richardson, 'The jewelled cross and its canopy' in Cormac Bourke (ed.), *From the isles of the north: early medieval art in Ireland and Britain* (Belfast, 1994), pp 177–86; for the Romanesque period, see Jenifer Ní Ghrádaigh, 'Mouthing obscenities, Christological typologies? Complexities of meaning at Dysert O'Dea' in Roger Stalley (ed.), *British Archaeological Association transactions: medieval art and architecture in Limerick and south-west Ireland* (Oxford, 2011), pp 42–62 at p. 52. **18** Jane Hawkes, *The Sandbach crosses: sign and significance in Anglo-Saxon sculpture* (Dublin, 2002), p. 147. **19** Peter Lasko, *Ars sacra, 800–1200* (New Haven, CT, and London, 1994), p. 101; see also the cross on the imperial crown, of *c.*973/83, pp 81–3. **20** Stalley, 'The Romanesque sculpture of Tuam'. **21** Raghnall Ó Floinn, 'The foundation relics of Christ Church Cathedral and the origins of the diocese of Dublin' in Seán Duffy (ed.), *Medieval Dublin*, 7 (Dublin, 2006), pp 89–102; idem, 'The late medieval relics of Holy Trinity Church, Dublin' in John Bradley, Alan J. Fletcher and Anngret Simms (eds), *Dublin in the medieval world: studies in honour of Howard B. Clarke* (Dublin, 2009), pp 369–89; idem, 'Innovation and conservatism', 261–6. **22** See Camps, this volume. **23** Nees, 'On the image of Christ', pp 345–55. For the Battló Majestat, see Camps, this volume.

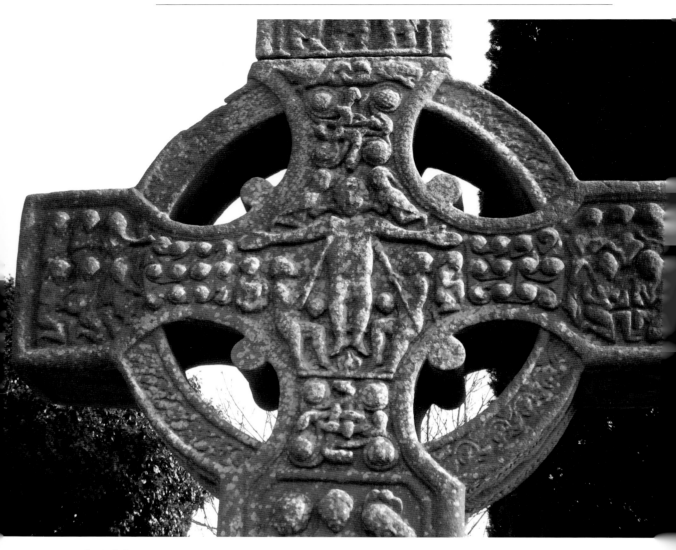

14.5 Cross of Muiredach, Monasterboice, Co. Louth: west face (photograph by the author).

crucifixions from Winchester, Glastonbury and Waltham, which were miraculous 'speaking' images, may have been crucial too.[24] In Ireland, this represents a decisive change from past models, where on tenth-century crosses the crucifixion is only one among many panels. Such an intensification of focus on Christ's body suggests, just as the architectural innovations do, a re-engagement with theological debates on Christ's presence. That the overall schema should derive from altar

24 C.R. Dodwell, *Anglo-Saxon art: a new perspective* (Manchester, 1982), pp 118–19. Ó Floinn, 'The late medieval relics', p. 377 has cited these figures as comparisons to the lost Christ Church Cathedral crucifix. Irish twelfth-century sculpture is in general highly indebted to English models: see Roger Stalley, 'Three Irish buildings with West Country origins' in N. Coldstream and P. Draper (eds), *Medieval art and architecture at Wells and Glastonbury* (Leeds, 1981), pp 62–85; O'Keeffe, *Romanesque Ireland*, pp 152–65, 179–80.

crosses, but that the Christ figure should be modelled after larger wooden crucifixes is surely revealing, as life-size or large sculptures are frequently associated with miracles, due no doubt to their life-like qualities.[25] It is, however, very important to remember that in choosing a model for these new crosses, artists and patrons were deciding against the earlier native depictions of Christ's crucifixion on the tenth-century crosses. These had remained key monuments in the ecclesiastical landscape, and presumably continued to fulfil liturgical and devotional functions. This is evidenced by the fact that wealthy sites like Clonmacnoise, Co. Offaly, did not replace or add to their early crosses, although rebuilding their churches, while sites without early crosses did feel the need to commission analogues. By implication, a very deliberate artistic choice was being made in thus shifting the focus to Christ's body, the subtleties of which can only be understood by close examination of the sculpture itself.

The question we must ask, then, is how exactly this shift in focus is expressed artistically. In order to assess the nature of this change, it is necessary to examine in more detail some of the better preserved sculptures of the tenth century. The three crosses at Monasterboice, Co. Louth, are typical of this earlier tradition, even more than that at Moone.[26] On the cross of Muiredach (fig. 14.5), the crucifixion that occupies the centre of the cross head is placed within an ascending vertical axis of figural panels depicting related biblical scenes of the mocking of Christ, the raised Christ, the *traditio clavium*, and, above the crucifixion itself, the ascension.[27] On the horizontal axis, it is flanked by scenes that may show the denial of Peter and the resurrection. The composition is crowded with subsidiary figures: Stephaton, Longinus, angels and others that Peter Harbison has tentatively identified as Sol and Luna, Earth and Ocean.[28] While the figure of Christ is slightly larger, and is modelled with sensitivity and sophistication, it fails to dominate the cross. On the Tall Cross (fig. 14.6), Christ's crucifixion is similarly placed within an even more extended sculptural and scriptural sequence, albeit his larger scale vis-a-vis the cross, and his drooping head add a modicum of pathos.[29] Helen Roe's summation that 'On both crosses, the *Crucifixion*, the climax of the Passion, is displayed with outstanding elaboration and detail' is undoubtedly

25 Dodwell, *Anglo-Saxon art*, pp 118–19; see also Nees, 'On the image of Christ crucified', p. 355 for intentional ambiguities in manuscript images showing polychrome life-size sculpture. See also Bacci, this volume. **26** See, generally, Helen M. Roe, *Monasterboice and its monuments* (Dundalk, 1981). Moone is unusual in having what appear to be two crucifixion images, one on the base and one on the head. For an explication of this complex iconography, see Kees Veelenturf, *Dia brátha: eschatological theophanies and Irish high crosses* (Amsterdam, 1997), pp 132–3. **27** The identifications are those of Harbison, *The high crosses*, pp 143–4, who lists alternative possibilities given by other scholars. See also Stalley, 'European art and the Irish high crosses', 138–41 for discussion of the ascension image; for the most recent analysis of this cross, see Stalley, 'Artistic identity and the Irish scripture crosses'. **28** Harbison, *The high crosses*, p. 145; Veelenturf, *Dia brátha*, p. 137. **29** Harbison, *The high crosses*, pp 149–50; Roe, *Monasterboice and its monuments*, p. 46.

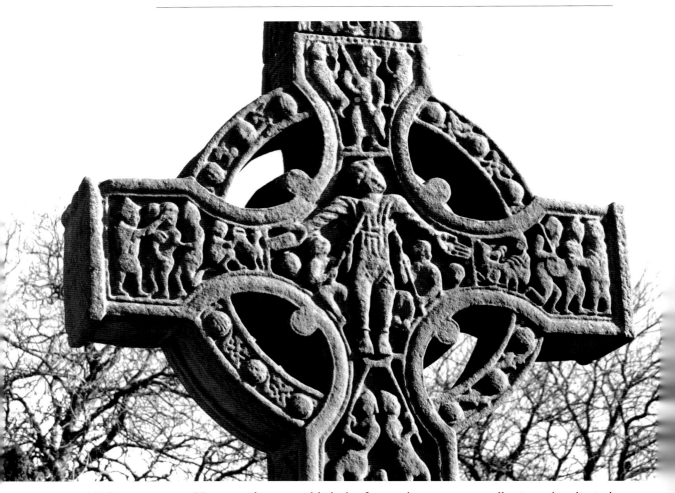

14.6 Tall Cross, Monasterboice: detail of crucifixion (photograph by the author).

true.[30] However, the noticeable lack of visceral impact, especially given the physical distance between the viewer and Christ, has never been commented upon and is perhaps more striking. Indeed, the same holds true for the north cross at Monasterboice, where the small scale of the figure, and its distance from the viewer, prevent affective interaction, even though in this instance the crucifixion is the only figural panel.[31]

PATRONAGE, REFORM AND NATIVE V. CONTINENTAL MODELS

There is, then, a decisive change between the tenth-century and twelfth-century crosses, from a placement of Christ within a scriptural and typological context, to a more direct confrontation with the viewer. Looking at the chronology, sites and

30 Roe, *Monasterboice and its monuments*, p. 19. **31** Harbison, *The high crosses*, p. 152.

patronage of such crosses suggests that the reform of the Irish Church was the factor behind the revival in stone cross carving, and thus must also have had a role in their changed appearances. The Irish Church was galvanized by important synods at Cashel in 1101 and Rathbreasail in 1111, both of these in Munster, and Kells-Mellifont in 1152, with the resulting division of the country into territorial dioceses of defined borders, with bishops and archbishops on the Roman model.[32] Ecclesiastics at Armagh and in Munster led this reform, and drew on the support and patronage of provincial kings whose influence is also reflected; thus the division of Ireland into two provinces at Rathbreasail matched the spheres of influence of Domnall Mac Lochlainn, king of Cenél nÉogain (d. 1121) and Muirchertach Ua Briain of Munster (d. 1119).[33] The twelfth-century crosses are largely found in Munster, and the first that can be dated with any certainty is the Cross of Cathasach at Inis Cealtra, Co. Clare, an island monastery in the Shannon with close connections to the Uí Briain.[34] This cross bears an inscription naming Cathasach, chief senior of Ireland, an Armagh cleric who retired to do penance and await death there, and whose obit is found in the Annals of Inisfallen under 1111.[35] This cross, unlike those that followed, does not depict Christ, but rather is covered in metalwork-derived interlace – nevertheless, it firmly situates the revived tradition within the artistically innovative sphere of Muirchertach Ua Briain. It was under Muirchertach's aegis that the churches of Glendalough were rebuilt c.1096–1111 as nave-and-chancel structures, including the vaulted church known as *cró Coemgen* (St Kevin's house); architectural developments were brought to Munster also with St Flannan's oratory in Killaloe, whose west doorway was, furthermore, ornamented with mouldings and capitals in the Romanesque style.[36] The key role that Muirchertach played in the synods of Cashel and Rathbreasail was part of his programme for political power, using religious authority to boost what might be regarded as historically dubious legitimacy. Likewise, Lebor na Cert (the Book of Rights), which he commissioned in 1101, draws on supposedly Patrician texts to justify the rights of the king of Munster to overkingship of Ireland.[37]

In this context, the possibility that the Market Cross of Glendalough (fig. 14.7) may have been commissioned as part of the rebuilding of Glendalough is highly

32 See, most recently, Flanagan, *The transformation of the Irish church*, pp 34–91. 33 Domnall Mac Lochlainn claimed kingship over the northern half of Ireland, Muirchertach Ua Briain over the southern half. 34 Liam de Paor, 'The history of the monastic site of Inis Cealtra, Co. Clare', *North Munster Antiquarian Journal*, 37 (1996), 21–32. 35 Françoise Henry, *Irish art in the Romanesque period, 1020–1170* (London, 1970), pp 123–4; Harbison, *The high crosses*, p. 98. 36 Ó Carragáin, *Churches in medieval Ireland*, pp 246–8, 258–62; Richard Gem, 'Saint Flannán's oratory at Killaloe: a Romanesque building of c.1100 and the patronage of King Muirchertach Ua Briain' in Damian Bracken and Dagmar Ó Riain-Raedel (eds), *Ireland and Europe in the twelfth century: reform and renewal* (Dublin, 2006), pp 74–105. 37 Anthony Candon, 'Barefaced effrontery: secular and ecclesiastical politics in early twelfth-century Ireland', *Seanchas Ardmhacha*, 14:2 (1991), 1–25 at 15–17.

significant.[38] This cross features a crowned Christ, clad in a perizoneum, his head drooping on his right shoulder, his feet almost touching the upright figure of cleric beneath.[39] The whole composition is framed by ornamental bosses, with interlace on the head, while on the base are two figures in high relief, now much worn. The east face of the cross is covered in low relief interlace and foliate ornament. Although its dating is controversial, it is likely to belong at least to the period before c.1127, as the more securely dated crosses at Tuam, Co. Galway, discussed below, show decided similarities, and are carved by a sculptor with a name relating his origin to Glendalough.[40] Raghnall Ó Floinn has recently suggested that the Glendalough figure of Christ may have been based on the now-lost 'speaking' crucifix from Christ Church Cathedral, Dublin.[41] The form of this lost cross is unknown, and Ó Floinn has proposed two alternative types; a large wooden cross, similar to the Cross of Gero, Cologne (965), or a smaller jewelled cross like the altar crosses at Essen.[42] His suggestion that Dúnán may have acquired it in Cologne c.1030 and brought it to Dublin at the same time as the foundation relics of the cathedral is both alluring and convincing.[43]

Evidence for the appearance of the Dublin cross is more certain than Ó Floinn allows.[44] The image (pl. 26) that illustrates Gerald of Wales' account of one of its miracles in the British Library manuscript of his *Topographia* (Royal MS 13.B.viii) suggests that it must have been a large, polychrome wooden image of *Volto Santo* type, rather than a smaller metalwork affair.[45] This illustration deserves to be taken seriously for its evidential value if Michelle Brown is correct, as I believe she is, in attributing a significant role to Gerald himself in the formulation of the illustrations.[46] This holds true particularly in the case of the Dublin cross, which Gerald had himself seen. Bearing in mind Gerald's noted sensibility to artistic affectiveness, as witnessed by his reaction to the gospel book of Kildare, it is improbable that this illustration should directly contradict the image type that he had seen.[47]

Gerald was not alone in recording the miracles of this crucifix, and a compelling piece of evidence regarding its appearance is Roger of Howden's description of its 'clamor' or ritual humiliation in 1197:

38 Ó Carragáin, *Churches in medieval Ireland*, pp 251–2. **39** Harbison, *The high crosses*, p. 95. **40** Henry, *Irish art in the Romanesque period*, p. 143. **41** Ó Floinn, 'The late medieval relics', p. 389. His arguments will be set out in 'The "Market Cross" at Glendalough and the "Speaking Crucifix" of Dublin', forthcoming. **42** Ó Floinn, 'The late medieval relics', p. 379; idem, 'Innovation and conservatism', p. 265. **43** Ó Floinn, 'The late medieval relics', p. 379. **44** Ibid., pp 376–7 states that 'unfortunately, no clear description of the cross exists, its size or the materials of which it was made – whether wood, stone, precious metals or of wood covered in metal plates and encrusted with gems.' **45** For a detailed discussion of the *Volto Santo*, see Bacci, this volume. **46** Michelle Brown, 'Marvels of the West: Giraldus Cambrensis and the role of the author in the development of marginal illustration' in A.S.G. Edwards (ed.), *English manuscript studies, 1100–1700, vol. 10: decoration and illustration in medieval manuscripts* (London, 2002), pp 34–59. **47** Most

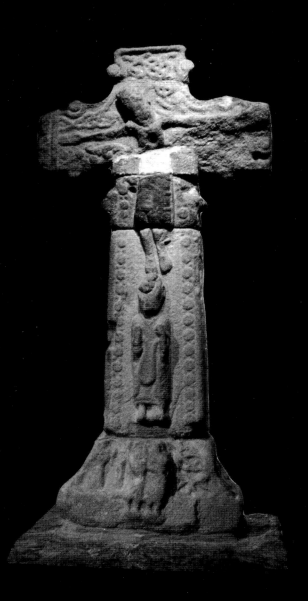
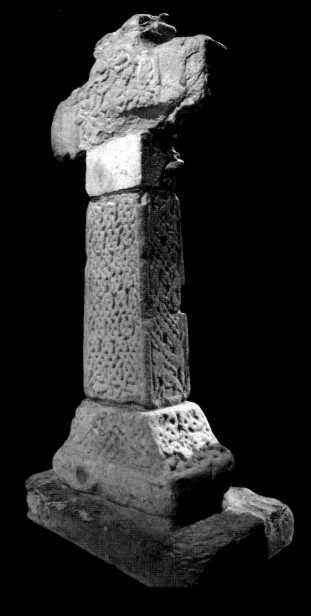

14.7a, b Market Cross,
Glendalough,
Co. Wicklow
(photographs by
the author).

There was in the cathedral church of Dublin a certain cross on which a rather expressive figure of Christ was carved: all the Irish, and other people as well, held this cross in the greatest veneration. Now, while this image of the crucified one lay prostrate on the floor surrounded by thorns, it went into agony on the sixth day. Its face reddened vehemently as if it were close to a roaring fire, and it perspired freely. Drops fell from its eyes as if it were weeping ...[48]

Two key elements of the description, from our point of view, are his emphasis on the expressiveness of the figure, and on its blushes. Quite simply, comparisons between metalwork and wooden sculptures reveal that from *c.950* to *c.1150* at least, wooden sculpture in general lends itself towards a more naturalistic and empathic modelling, a tendency that is, in any case, generally enhanced by the larger scale of the objects themselves.[49] That it was not covered in sheet gold but was polychromed in a naturalistic manner, unlike some other large wooden crucifix figures (such as, for instance, the twelfth-century crucifix of St Sernin, Toulouse) is implied by the sculpture's change of complexion.

OTTONIAN METALWORK AND THE PROBLEM OF THE 'BISHOP'S FIGURE' REVISITED

If it is the case that the Dublin crucifix was a large, wooden figure wearing a long robe, this precludes its use as a model for the Glendalough cross, although it raises the possibility that the cross at Monaincha, and indeed that at Cashel, may have drawn on it as a model. This does not, however, rule out a possible connection with Ottonian metalwork kept perhaps at Christ Church and acquired at the same time as the relics and large crucifix. Indeed, the evidence that the Glendalough cross was based on an Ottonian metalwork cross is exceptionally strong. Looking to European exemplars, the Herimann Cross of *c.*1049 (fig. 14.8) represents a

fully discussed by T.A. Heslop, 'Late twelfth-century writing about art, and aesthetic relativity' in Gale R. Owen-Crocker and Timothy Graham (eds), *Medieval art: recent perspectives. A memorial tribute to C.R. Dodwell* (Manchester and New York, 1998), pp 129–41 at pp 132–5. **48** Marie Therese Flanagan, 'Devotional images and their uses in the twelfth-century Irish church' in Howard B. Clarke and J.R.S. Phillips (eds), *Ireland, England and the Continent in the Middle Ages and beyond* (Dublin, 2006), pp 67–87. Roger Howden is cited at p. 69. **49** Such visual differences are difficult to appreciate in comparative catalogues or through photographic reproductions, where scale is figured out of the equation. Despite the inherent subjectivity of the experience, the display of large wooden crucifixes including the Crucifix of St Sernin of Toulouse, the Battló Majestat and the slightly smaller Organyà Majestat in the Museu Nacional d'Art de Catalunya's 2008 exhibition produced, for the author, the most powerful argument for the affective qualities of such sculpture. See Manuel Castiñeiras and Jordi Camps, *El románico y el Mediterráneo: Cataluña, Toulouse y Pisa, 1120–1180* (Barcelona, 2008), pp 400–13.

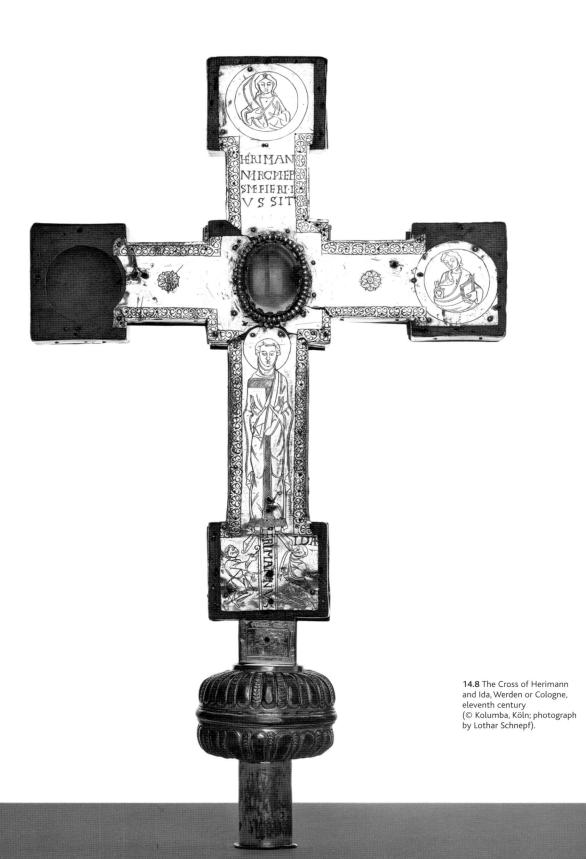

14.8 The Cross of Herimann and Ida, Werden or Cologne, eleventh century
(© Kolumba, Köln; photograph by Lothar Schnepf).

striking analogy to the composition found first at Glendalough, and in slightly different reworking, elsewhere.[50] The composition I allude to is the pairing of the crucified Christ with what appears to be an ecclesiastic, and occasionally, as at Glendalough, with two smaller figures below.[51] If Glendalough is the first in the sequence of figured twelfth-century crosses, we should expect that it would correspond most closely with its model, and this does indeed appear to be the case. On the Herimann Cross, the crucified Christ is shown on one side, on the other, the Virgin on the shaft of the cross acts as intercessor for the two patrons on the base, one of whom grasps her foot in supplication. While of course it is impossible to be sure that exactly such a model would have been available to Irish patrons, the connections cited above, along with continuing interactions with the Schotten-klöster in Germany, make it very likely.[52] It is clearly not Mary, however, who forms this intercessionary focus on the Irish crosses. And indeed, there has been much speculation as to who it is, whether Christ as abbot of the world, St Peter in his role of pope, with reference to reform, or, also with this in mind, embodiments of the newly born episcopacy, or the early patron saints.[53]

It is this latter suggestion that is the most convincing, for two reasons. Firstly, the positioning of the figure of Mary on the Herimann Cross suggests intercession with Christ, petitioned for by the patrons; we therefore might expect that a similar role might be played by the figures on the Irish crosses. The hagiographical evidence is unequivocal in assigning this role to the Irish saints, especially in interceding for those buried with them in their relic cemeteries at the time of the Last Judgment.[54] Indeed, given the placement of these ecclesiastics, often sharing the head of the cross with Christ (as at Roscrea, Co. Tipperary, and Tuam, Co. Galway) – but on the side associated elsewhere with *parousia* and Judgment – these cannot be contemporary figures, but must in some manner merit an equation with Christ, whose cross they so emphatically share.[55] Irish saints are repeatedly equated with Christ in their hagiographies, and in very unambivalent ways. To give just one example, in the life of St Colum of Terryglass, he foresaw

50 Ulrike Surmann, 'Cruz de Herimann, Köln/Herimann-Kreuz' in César García de Castro Valdés (ed.), *Signum salutis: cruces de Orfebrería de los Siglos V al XII* (Oviedo, 2008), pp 250–4. **51** It is possible that the current assemblage of the Herimann Cross is not its original one, and that the famous crucifixion with the reused Roman female head does not belong with the inscribed reverse. Despite this, it is likely that if not this crucifixion, then another one was paired with the Virgin and donor scene discussed here. For a historiography of this cross, see Dale Kinney, 'Ancient gems in the Middle Ages: riches and ready-mades' in Richard Brilliant and Dale Kinney (eds), *Reuse value: Spolia and appropriation in art and architecture from Constantine to Sherrie Levine* (Farnham, 2011), pp 97–120. **52** Dagmar Ó Riain-Raedel, 'Cashel and Germany: the documentary evidence' in Bracken and Ó Riain-Raedel, *Ireland and Europe in the twelfth century*, pp 176–217. **53** Henry, *Irish art in the Romanesque period*, pp 139–40; Harbison, 'The otherness of Irish art', pp 111–12. **54** See, for instance, the Middle Irish *Betha Phatraic*, ed. Whitley Stokes, accessed online at www.ucc.ie/celt/published/T201009/index.html (accessed 5 Jan. 2011). **55** I am grateful to Dr David Woods for first drawing my attention to the peculiarity of their placement.

his death, and offered one of his disciples the chance to share, first a bath, and then his death, with him. His disciple declined, but an unlettered pagan took up his offer. In far off Iona, Colum Cille witnessed the event and declared:

> Brothers, pray, because my colleague Colum has done a great thing: he has brought a barbarous heathen with him to heaven, without the work of penance, on the model of Christ and his thief.[56]

The fact that these figures hold staffs has sometimes been cited against their being the founding saints, as many of these did not have episcopal rank. However, the carrying of a crozier is not indicative of strictly episcopal authority: in the Book of MacDurnan of *c*.900, the evangelists Matthew and Luke are shown carrying them.[57]

Secondly, the material evidence suggests a similar interpretation, albeit by implication. On the West Cross at Kilfenora, Co. Clare, there is a rough, uncarved triangular area at the base. Fergus O'Farrell argued that this area was covered by a reliquary sarcophagus, citing the Romanesque 'sarcophagus' at Clones, Co. Monaghan, as a possible example of the type of structure that this might have been.[58] Similar slab shrines of an earlier period, but no doubt still venerated in the twelfth century, are found at the nearby Romanesque church of Temple Cronan, and lend credence to this argument. If this was the case, it is worth re-examining the iconography of the sarcophagus for what this could imply. On the Clones sarcophagus, which is not indeed a true sarcophagus, but rather, would have been placed above the grave of the saint, thus monumentalizing it, there is on the end or façade a bishop's figure, which, in this case, must represent the saint beneath.

To return to the 'Market Cross' at Glendalough, its significance can be summarized as follows. It appears to be the first of the series of figured twelfth-century crosses, and the one to set the iconographic mould for those that follow. This iconography probably derives from Ottonian metalwork crosses, perhaps some housed in Christ Church Cathedral, Dublin. The availability of such a model is explicable by reason of the close ties between Dublin and Glendalough at this period, while the decision to use it may rest with its closer intersection to theological preoccupations, perhaps because the original was an altar cross, but coupled, probably with the more compelling representation it offered of Christ. Although difficult to date with precision, it seems to this author likely to fall

56 'Vita S. Columbae abbatis de Tír da Glas' in *Vitae Sanctorum Hiberniae*, ed. W.W. Heist (Brussels, 1965). 57 London, Lambeth Palace, MS 1370, associated with Maelbrigt Macdurnan, abbot of Armagh from *c*.888 to 927. See Peter Harbison, *The golden age of Irish art* (London, 1999), p. 212, pls 136, 137. 58 Fergus O'Farrell, '"The cross in the field", Kilfenora: part of a "founder's tomb?"', *North Munster Antiquarian Journal*, 26 (1984), 8–13; Peter Harbison, 'The Clones Sarcophagus: a unique Romanesque-style monument', *Archaeology Ireland*, 13:3 (autumn 1999), 12–16.

within Muirchertach Ua Briain's lifetime, as the association with him and his bishop Máel Muire Ua Dúnáin, suggested by Tomás Ó Carragáin in the context of Muirchertach's building programme at Glendalough, is to some extent strengthened by the fact that the only cross certainly datable to this period is located at the Uí Briain foundation of Inis Cealtra. That Christ is shown crowned may also be significant.[59] The choices made at Glendalough – of an emotive figure of Christ; of an intercessionary ecclesiastic; of a reference to *parousia* implied through ornament rather than through figural sculpture – were to set the trend for high cross production throughout the century.

EXPRESSIVE CRUCIFIXIONS AFTER GLENDALOUGH AND DUBLIN: TUAM, CASHEL, DYSERT O'DEA AND INIS CEALTRA

This progress may be traced initially through the patronage of Toirrdelbach Ua Conchobair, whose well-documented interest in the cross as a means of copper-fastening his imperialistic claims to high-kingship may further support the idea that the Glendalough 'Market' Cross was directly patronized by Muirchertach. In 1123, the Annals of Tigernach record:

> Christ's cross in Ireland this year, and a great circuit was given to it by the king of Ireland, i.e. by Toirrdelbach Ua Conchobair, and he asked for some of it to remain in Ireland, and it was granted to him, and he had it enshrined in Roscommon.[60]

This is the famous Cross of Cong, whose inscriptions commemorate its patrons and craftsmen, as well as emphasizing its reliquary role: 'This cross is the cross on which the creator of the world suffered'.[61] Toirrdelbach, by his enshrinement of this cross, was attempting to draw on Constantinian authority in creating a new vision of triumphant Christian kingship within twelfth-century Ireland.[62]

Toirrdelbach did not proclaim his kingship from the cross by means of this inscription alone, but also from at least two of the high stone crosses that he erected in his caput of Tuam, which he further ensured became an archiepiscopal

59 I am grateful to Prof. Marie-Therese Flanagan for drawing to my attention the significance of the crowned Christ on these crosses in the context of twelfth-century Irish kingship and its regalia; this issue will be further dealt with in *The transfixed gaze* (forthcoming). **60** *The Annals of Tigernach*, ed. and trans. Whitley Stokes (2 vols, Lampeter, 1993), *s.a.* 1123. **61** Pádraig Ó Riain and Griffin Murray, 'The Cross of Cong: some recent discoveries', *Archaeology Ireland*, 19:1 (spring 2005), 18–21; Griffin Murray, 'The Cross of Cong and some aspects of goldsmithing in pre-Norman Ireland', *Historical Metallurgy*, 40:1 (2006), 49–67. **62** Jenifer Ní Ghrádaigh, 'Style over substance: architectural fashion and identity building in medieval Ireland' in Jenifer Ní Ghrádaigh and Emmett O'Byrne (eds), *The March in the islands of the medieval West* (Leiden, 2012), pp 97–138 at pp 120–5.

see.[63] On a shaft, now in the cathedral, Toirrdelbach's name is inscribed, along with that of the artisan; on the base of the Market Cross, the record of his patronage is joined with that of the 'successor of Jarlath', the patron saint of Tuam – and two figures are represented on each side of the base.[64] These two figures immediately recall not just those on the base of the Market Cross, Glendalough, but also those on the base of the shaft of the Cross of the Scriptures, Clonmacnoise, of 909. This was erected by Flann, high-king of Ireland, after his defeat of Munster rivals in the Battle of Belach Mugna – a decisive victory that allowed him to proclaim himself 'king of Ireland'.[65] There, the two figures have been identified as either Flann and the contemporary abbot, Colman, or their ancestors, Diarmait and the contemporary saint, Ciarán. It may have been read as both.[66] In any case, a reference back to this earlier monument to high-kingship is no doubt intentional; if, as has been argued above, the Glendalough Cross was also playing with such ideas, it is likely that both referenced Clonmacnoise and with the same intent.

But if at Tuam, kingship and cross are palpably linked, an examination of distribution reinforces the idea of crosses elsewhere as indicative of church reform: at Cashel, Monaincha and, arguably, Dysert O'Dea, Co. Clare. Diocesan pretensions, a key part and parcel of church reform, may also have played a role, as at Kilfenora, Co. Clare, with its six crosses. At Cashel, site of the 1101 synod, is the vestige of a once-spectacular cross. The question here is whether this cross may be associated with Muirchertach Ua Briain, and the synod of 1101, or whether it is so distinct from Glendalough and Tuam as to suggest that it may have been commissioned not by Muirchertach, but by Cormac MacCarthaig, at the same time as he built 'Teampull Cormac'/Cormac's Chapel, on the Rock, 1127–34. This cross is complex in form, and now has lost additional parts, in particular, some pieces on upper arms, which, by analogy with crucifixion plaques, might have included angels as on the mid-twelfth-century Romanesque lintel at Raphoe, Co. Donegal, or even the two thieves, as on the contemporary lintel at Maghera, Co. Derry.[67] Formally, the figure of Christ is of the *Volto Santo* type, with a long, belted robe. The maze on the cross base may perhaps confirm some engagement with Lucca itself, but is it possible that this cross replicated the famous 'speaking' crucifix from Dublin instead? If so, it would be an effective argument for Muirchertach's patronage. The key feature of the Dublin Christ was his expressive

63 Colmán Etchingham, 'Episcopal hierarchy in Connacht and Tairdelbach Ua Conchobair', *Journal of the Galway Archaeological and Historical Society*, 52 (2000), 13–29. 64 Harbison, *The high crosses*, pp 175–8, 365–6; Stalley, 'The Romanesque sculpture of Tuam'. 65 Conleth Manning, 'Clonmacnoise Cathedral' in Heather A. King (ed.), *Clonmacnoise Studies*, I (Dublin, 1998), pp 57–86 at pp 72–5; Harbison, *The high crosses*, pp 355–7. 66 Stalley, 'European art and the Irish high crosses', 156–7. 67 Peter Harbison, 'A labyrinth on the twelfth-century high cross base on the Rock of Cashel, Co. Tipperary', *JRSAI*, 128 (1998), 107–11; H.G. Leask, 'St Patrick's Cross, Cashel, Co. Tipperary: an enquiry into its original form', *JRSAI*, 81 (1951), 14–18.

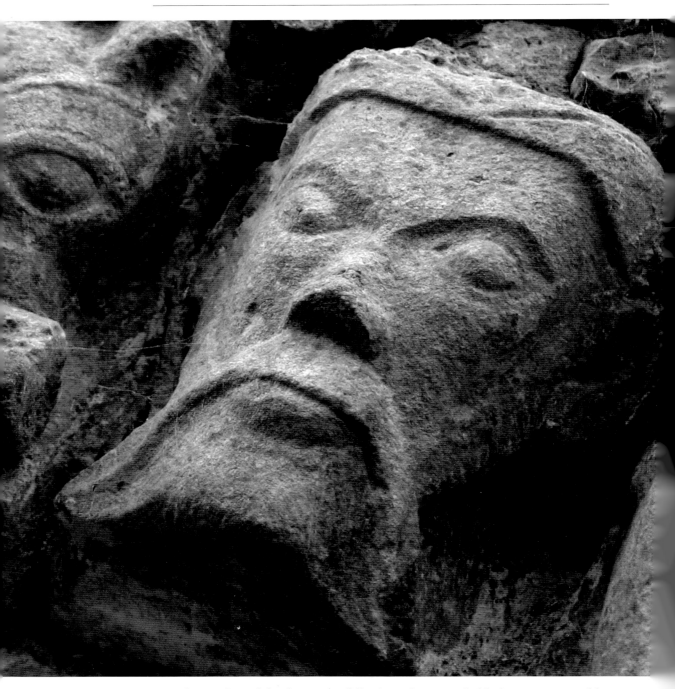

14.9 Voussoir, Dysert O'Dea, Co. Clare (photograph by the author).

appeal, one that, if the figure was fully draped, was probably best transmitted by his facial features. But at Cashel, Christ's head is now lost, which leaves the question of emotional or affective appeal rather open. Can we supply this loss through comparison with other crosses?

Two other sites suggest that we might indeed be able to posit a very expressive head of Christ at Cashel. The first of these is Dysert O'Dea, Co. Clare, and I have argued elsewhere that the church and cross there are certainly of the same period, of *c.*1140, and that the church and to an extent the cross, are modelled on Cashel and share stylistic traits.[68] The head of Christ currently on the Dysert Cross is a later replacement, the original one being removable, as, for greater depth of relief, it was carved on a separate block and inserted into the cross head. But Françoise Henry suggested that one of the heads now reused as a voussoir (fig. 14.9) is the lost original.[69] Her suggestion, although impossible to prove without disassembling the doorway, is certainly backed up by the distinctive modelling of the moulding around the forehead of the face on this 'voussoir', which could indicate that it was intended to be seen in the round; added to which its extremely striking features have the same solemnity, the same intensity of stare and the same hairstyle as *Volto Santo* types such as the Battló Majestat.[70] The second site is yet more intriguing; this is Inis Cealtra, already mentioned as a key Ua Briain foundation, and site of the first datable cross of the twelfth century, the Cross of Cathasach. A head of Christ recovered here in excavation in 1970 is of most expressive form (fig. 14.10).[71] Whether this was part of a cross, or indeed, part of a façade design, like the standing figure at Roscrea, is unfortunately impossible to determine now. One thing is clear: like the voussoir at Dysert, it presents a very close comparison with the most expressive wooden sculptures surviving from Continental contexts. An association with Muirchertach Ua Briain cannot be ruled out, nor indeed the possibility of the Christ Church crucifix as a possible model.

The fragmentary nature of the evidence at Cashel, Dysert O'Dea and Inis Cealtra precludes the possibility of connecting any of these with specific moments or people of the church reform. The discovery in 2004 of a shaft with crucified Christ above and two figures below at Aghalurcher, Co. Fermanagh, a site whose history at this time is utterly obscure, is more problematic yet. The uncarved reverse of this shaft suggests a placement next to a wall, if not indeed that it formed part of an architectural ensemble. Here too, Christ crucified is paired with standing authority figures, and Roger Stalley has suggested a compositional parallel with the Cross of Glendalough.[72] Even if the precise context of these pieces is impossible to assess, there seems little doubt that the idea of the high cross was

68 Jenifer Ní Ghrádaigh, 'Mouthing obscenities, Christological typologies?' I am no longer convinced that the analogy of Dysert is compelling evidence that the Cashel cross dates to 1127–34; firstly, because Ó Carragáin's suggestion of the connection between the Market Cross, Glendalough, and Muirchertach Ua Briain makes an earlier date a possibility; and secondly, because Muirchertach's possible building involvement at Cashel is unknown. **69** Henry, *Irish art in the Romanesque period*, p. 131, n.3, 'One may wonder, however, if the present head is the original one. If the back of the Mongolian-looking head with long moustaches on the portal was examined it might be found to have been the original head.' **70** For the Battló Majestat, see Camps, this volume. **71** Harbison, *The high crosses*, p. 99. **72** Roger Stalley, 'In search of medieval sculpture: rockeries, walls and

revived in the artistic maelstrom about Muirchertach Ua Briain in the later eleventh and early twelfth centuries, and that it was developed in the context of reform. Taking a reform context as a basis, the expressive quality of the sculpture at Dysert and Inis Cealtra raises the issue of audience, and audience response, touched on at the beginning of this essay. The question of direct, emotional appeal is emphatically embodied not just at Dysert and Inis Cealtra, but also in the cross at Roscrea, Co. Tipperary, where the head is now badly worn, but the torso is sculpted with subtle pathos. This idea of a direct appeal to the senses may be related to an increased interest in the response of the laity, expressed elsewhere in the push for parish structure, and an increased emphasis on the importance of the sacraments, and of preaching.[73]

The twelfth-century crosses do express complex ideas, but they are also far more instantly understandable as crucifixes than their elaborate, beautiful, but difficult, tenth-century prototypes. The idea of free-standing stone crosses certainly takes as its reference earlier native models, specifically perhaps the complex at Clonmacnoise, Co. Offaly. By drawing on Ottonian crosses for sculptural models, artists and patrons were choosing verisimilitude and visceral impact over abstruse exegesis; they were intentionally choosing popular, even cult models. It is illuminating to finish with Gerald of Wales, and his description of the Dublin cross:

> There is in Dublin in the church of the Holy Trinity a cross of most wonderful power. It bears the figure of the Crucified. Not many years before the coming of the English, and during the time of the Ostmen, it opened its hallowed mouth and uttered some words …[74]

This encapsulates the twelfth-century depiction of Christ in an Irish context: conceived of as a lifelike, embodied and even speaking likeness.

gateposts' in Joe Fenwick (ed.), *Lost and Found*, II (Bray, 2009), pp 179–87 at p. 183. **73** For preaching in early medieval Ireland, see Mullins, this volume. **74** Gerald of Wales, *History and topography*, p. 85.

Irish crucifixion plaques: a reassessment

GRIFFIN MURRAY

INTRODUCTION

There exists a corpus of small copper-alloy plaques from Ireland, all of which depict the crucified Christ accompanied by the soldiers, Longinus and Stephaton, and two attendant angels. There are currently a total of eight of these plaques known from the country, which together form a distinct group, on the basis of their size, manufacturing techniques and iconography (figs 15.5–12). Each of the plaques was cast as one piece, feature original fixing holes, and measure approximately 7 or 8cm square. With the exception of one example, which was cast as a solid piece, they are all in openwork and have a frame or border. None of the plaques features evidence for gilding or tinning and in only one or two cases is there any evidence of an inlay. Apart from one, which is now lost, the plaques are all now in public museums, with the majority being held in the National Museum of Ireland (NMI).

Although, they are only a small group, the plaques are particularly important as they span a period of time that saw momentous changes in the Irish church. Indeed, while the group shares similarities with Irish crucifixion iconography dating from the ninth and tenth centuries, some of the plaques may be compared with representations of the crucified Christ that were finding favour in Ireland during the twelfth century. While individual plaques were published over the years, it was Peter Harbison who first treated them as a group in an important paper published in 1980.[1] At that time, only six plaques were known, and since Harbison's publication further information on the provenance of three of these has

1 Peter Harbison, 'A lost crucifixion plaque of Clonmacnoise type found in County Mayo' in H. Murtagh (ed.), *Irish midland studies: essays in commemoration of N.W. English* (Athlone, 1980), pp 24–38.

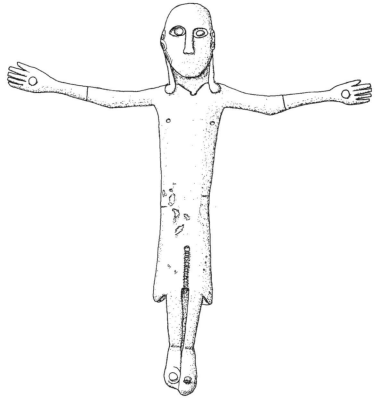

15.1 Crucifix figure, St Mel's diocesan collection (drawing by the author, 2005).

been revealed, while two further plaques, previously unknown, have been discovered. Harbison divided the plaques into two groups and argued that, given their similarity, they were probably all produced in Clonmacnoise, near which one of them is said to have been found.

As a result of the additional evidence that has come to light since then, this essay reassesses Harbison's groupings and presents a new scheme. Furthermore, the author argues that some of these new groupings are geographically distinct, indicating the possible location of different workshops, thus challenging Harbison's original theory of a single production centre. The author also presents an argument on the possible function of the plaques, new research on the provenance of individual plaques and the results of x-ray fluorescence (xrf) analysis carried out on six examples.[2]

2 The xrf analysis was carried out by Dr Paul Mullarkey of the NMI and Dr Quanyu Wang of the British Museum: see tables 15.2–5.

DATING

All of the plaques were apparently casual isolated finds and so the only means of dating them is through stylistic comparison with other material. As a result, various dates have been suggested for individual plaques and for the group generally, ranging from the late ninth/early tenth century to the twelfth century, with the majority of scholars favouring an eleventh- or twelfth-century date.[3] The variety in dating by scholars has been independently reviewed by both Harbison and Ruth Johnson and space does not permit for a restating of the arguments here.[4] It must suffice to state that, on the basis of style, this author believes that the group as a whole can be confidently dated to between the years 1000 and 1150, while some individual plaques may be attributed a narrower date range within this period. A longer time frame for the group is favoured here, in contrast to Harbison, Johnson and Cormac Bourke, all of whom argue that the similarity between the plaques indicates a tight date bracket.[5] Despite their general similarities, there is actually great variation among the plaques in terms of style, artistic skill and casting ability. An argument for a short time-frame for the group based on uniformity alone cannot be substantiated, given that the early medieval Irish church was very traditional, as demonstrated by its churches, round towers, reliquaries and croziers, all of which were extremely conservative in their form during the period in question.[6] Indeed, the longer time span for the plaques proposed here makes more sense, as it accommodates most of the dating arguments advanced so far.

FUNCTION

In the same way that scholars have suggested various dates for these plaques, they have also suggested various uses. All of the plaques exhibit original fixing holes,

3 Joseph Raftery, *Christian art in ancient Ireland*, II (Dublin, 1941), p. 152; Maire MacDermott, 'An openwork crucifixion plaque from Clonmacnoise', *JRSAI*, 84 (1954), 36–40; Françoise Henry, *Irish art during the Viking invasions (800–1020AD)* (New York, 1967), pp 122–3; A.T. Lucas, *Treasures of Ireland: Irish pagan and early Christian art* (Dublin, 1973), pp 119–20; Maire dePaor [neé MacDermott], 'Bronze crucifixion plaque' in Polly Cone (ed.), *Treasures of early Irish art, 1500BC to 1500AD* (New York, 1977), p. 181; Harbison, 'Crucifixion plaque'; Raghnall Ó Floinn, 'Bronze crucifixion plaque' in Michael Ryan (ed.), *Treasures of Ireland: Irish art, 3000BC–1500AD* (Dublin, 1983), pp 166–7; Cormac Bourke, 'The chronology of Irish crucifixion plaques' in R.M. Spearman and J. Higgitt (eds), *The age of migrating ideas: early medieval art in northern Britain and Ireland* (Edinburgh, 1993), pp 175–81; Ruth Johnson, 'Irish crucifixion plaques: Viking Age or Romanesque?', *JRSAI*, 128 (1998), 95–106; Peter Harbison, *The golden age of Irish art: the medieval achievement, 600–1200* (London, 1999), p. 297. **4** Harbison, 'Crucifixion plaque', p. 34; Johnson, 'Crucifixion plaques', 99–102. **5** Harbison, 'Crucifixion plaque'; Harbison, *Golden age*, p. 297; Bourke, 'Chronology'; Johnson, 'Crucifixion plaques'. **6** See, for example, Griffin Murray, 'Insular-

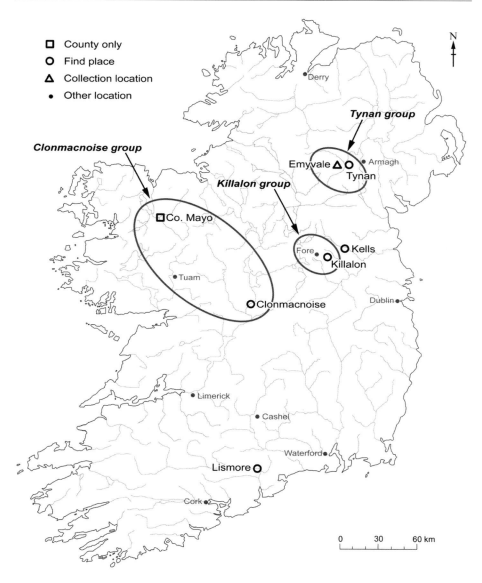

15.2 Map of Ireland indicating known find places of crucifixion plaques, as well as the geographically and stylistically distinct groupings presented here (map by Hugh Kavanagh).

meaning that they were all attached to something and thus originally belonged to composite objects. Both Harbison and Raghnall Ó Floinn suggested that they might have originally adorned altar-frontals.[7] However, of the eight stone altars known from this period in Ireland, all were approximately 1m in height and

type crosiers: their construction and characteristics' in Rachel Moss (ed.), *Making and meaning in Insular art* (Dublin, 2007), pp 79–94; Tomás Ó Carragáin, *Churches in early medieval Ireland: architecture, ritual and memory* (New Haven, CT, and London, 2010), pp 143–65. **7** Harbison, 'Crucifixion plaque', p. 26; Raghnall Ó Floinn, 'Clonmacnoise: art and patronage in the early medieval period' in Cormac Bourke (ed.), *From the isles of the North: early medieval art in Ireland and*

around 2m in width, suggesting that if contemporary wooden altars existed, they were of a similar size.[8] If this were the case, it seems very unlikely that the crucifixion plaques were set centrally on altar frontals as they are far too small.

Joseph Raftery suggested that they functioned as pax-plates, but this theory has found little favour.[9] Indeed, there is no supporting evidence known to the author that indicates the use of the pax during Mass in early medieval Ireland and it appears mainly to be a development of the later medieval church. Françoise Henry suggested that the plaques may have adorned book covers, in the same manner as ivory crucifixion plaques on Carolingian bindings.[10] However, while elaborate book covers do not survive from early medieval Ireland, eight book-shrines do, none of which, however, features crucifixion plaques or comparable crucifixion iconography.[11] One would expect that the decoration of book-shrines reflected the decoration of book covers and so, while the book cover theory may be appealing, there is no Irish evidence at present to support it.

A more plausible context for the plaques is on large metal crosses with wooden cores, as has been suggested by both Bourke and Johnson.[12] A belief in the existence of such crosses in the early medieval period has been expressed by a number of scholars over the years when looking at some of the stone sculpted high crosses of Ireland, particularly those at Ahenny, Co. Tipperary, the decoration of which, it has been argued, was influenced by their metal and wooden counterparts.[13] This has been most comprehensively argued by Dorothy Kelly, who also argued that the crucifixion panels on the south cross at Clonmacnoise and the tower cross at Kells are based on crucifixion plaques on such crosses.[14] Proof in the existence of these crosses came with the discovery in 1986 of a large metal cross with an oak core, of eighth or ninth century date, in Tully Lough, a lake in Co. Roscommon (fig. 15.3).[15] That large wood and metal crosses, like the

Britain (Belfast, 1995), pp 251–60 at p. 257. **8** Griffin Murray, 'Altars in Ireland, 1050–1200: a survey', *Journal of Irish Archaeology*, 19 (2010), 71–82. See also Ó Carragáin, *Churches in early medieval Ireland*, pp 187, 196, pls 190, 198 for other possible contemporary examples. **9** Raftery, *Christian art in ancient Ireland*, pp 105, 152. Harbison, 'Crucifixion plaque', pp 25–6, cites the worn face of Christ on some of the plaques as supporting evidence, but Christ's head in all examples stands proudest and so is most exposed to general wear. **10** Henry, *Irish art during the Viking invasions*, pp 122–3. **11** See Paul Mullarkey, 'The figural iconography of the Soiscéal Molaise and Stowe Missal Book Shrines' in Moss (ed.), *Making and Meaning*, pp 50–69 at p. 50, n. 1; Colum Hourihane, *Gothic art in Ireland, 1169–1550: enduring vitality* (New Haven, CT, and London, 2003), pp 114–37; Adolf Mahr, *Christian art in ancient Ireland: selected objects illustrated and described*, I (Dublin, 1932), pls 57, 65–6; Raftery, *Christian art in ancient Ireland*, pls 101–2, 113, 122, 126, 128. **12** Bourke, 'Chronology', p. 178; Johnson, 'Crucifixion plaques', p. 98. **13** For example, see Máire de Paor and Liam de Paor, *Early Christian Ireland* (London, 1964), pp 124–6; Françoise Henry, *Irish art in the early Christian period (to 800AD)* (New York, 1965), p. 140; Peter Harbison, *Irish high crosses: with the figure sculptures explained* (Drogheda, 1994), p. 11 **14** Dorothy Kelly, 'The heart of the matter: models for Irish high crosses', *JRSAI*, 121 (1991), 105–45; idem, 'Crucifixion plaques', *Irish Arts Review Yearbook, 1990–1*, 204–9. **15** Eamonn P. Kelly, 'Recovered Celtic treasure', *Irish Arts Review*, 20:3 (2003), 108–9; idem, 'The Tully Lough Cross', *Archaeology Ireland*, 17:2 (summer 2003),

Tully Lough Cross, influenced the design of sculpted stone high crosses, now seems certain. The large scale of the Tully Lough Cross indicates that it principally functioned as an altar cross. Taking into account that parts of it are missing, as well as the fact that it has been reconstructed, its current measurements of 127cm high, 43.8cm wide, and 3.4cm thick may be taken as approximate. It must have been held in position by a stand or socket, either built into the altar table itself, which seem to have been predominantly, if not exclusively, made of wood in Ireland before around 1050,[16] or constructed separately behind it. Such an arrangement is depicted in a rough carving from Drom West near Mount Brandon, Co. Kerry.[17] Indeed, such crosses must have been major foci for devotion within Irish churches.

While early sixteenth century in date, the so-called Clogher cross from Slawin, Co. Fermanagh,[18] appears to be a later medieval copy of an early medieval altar cross. Indeed, its form, decoration and dimensions all recall the Tully Lough example.[19] Fragments of other large altar crosses of early medieval date from Ireland are probably still awaiting formal identification in Irish, British and Scandinavian museums.[20] The Antrim Cross in the Hunt Museum, Limerick, may be one of these, as may mounts from the Chapman

9–10. **16** Murray, 'Altars'; Ó Carragáin, *Churches in early medieval Ireland*, p. 185. **17** Ó Carragáin, *Churches in early medieval Ireland*, pp 175–6, pl. 178. **18** See Cormac Bourke, 'Medieval ecclesiastical metalwork from the diocese of Clogher' in H.A. Jefferies (ed.), *History of the diocese of Clogher* (Dublin, 2005), pp 25–40 at p. 38; J.E. MacKenna, 'The Clogher Cross', *Ulster Journal of Archaeology*, 7 (1901), 113–18. **19** It is approximately 85cm high, 41cm wide and 4cm thick. MacKenna, 'Clogher Cross', 14. **20** Kelly, 'Tully Lough', 9; Kelly, 'Celtic treasure', 108.

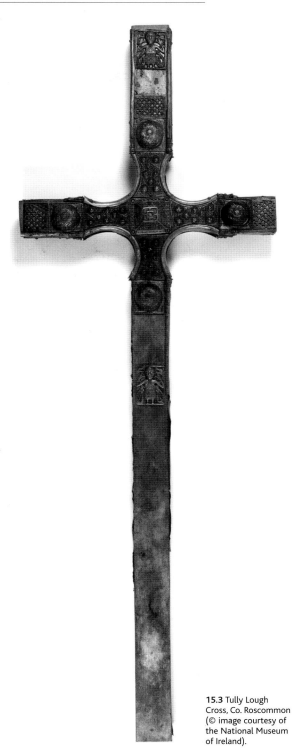

15.3 Tully Lough Cross, Co. Roscommon (© image courtesy of the National Museum of Ireland).

and Bell collections, which are now in the National Museum of Ireland and National Museums of Scotland respectively.[21] That this form of cross was common in Ireland is implied not only by these fragments, but by the survival of a contemporary Anglo-Saxon cross in Salzburg, Austria and the fragments of another from Dumfriesshire, Scotland. It is of note that the late eighth-century Austrian cross is contemporary with the bishopric of Virgil of Salzburg, an Irish man.[22]

The Tully Lough Cross features two near identical openwork figurative plaques, which probably represent Christ between two beasts (fig. 15.4).[23] These measure 7.3cm high and 5.1cm wide and 6.8cm high and 5.1cm wide respectively. Similar iconography can be seen on the lowest knop of the much later Lismore Crozier, dating from sometime before 1113.[24] However, the closest parallels in terms of the technique, dimensions (table 15.1), and general appearance of the plaques on the Tully Lough Cross, are the series of Irish crucifixion plaques under discussion. Thus, it is argued here that the crucifixion plaques were originally attached to large wood and metal altar crosses that were made in Ireland during the eleventh and early twelfth century. The reason behind the more subtle iconography of the earlier Tully Lough Cross is an area of research that requires detailed attention.

Clonmacnoise Group	Height	Width
Mayo Plaque (1)	8.5	unknown
Clonmacnoise Plaque (2)	8.4	7.25
Tynan Group		
Tynan Plaque (5)	8.2	8.6
Anketell Plaque (6)	8.0	8.0
Killalon Group		
Academy Plaque (4)	7.2	7.7
Killalon Plaque (3)	6.7	6.5

Table 15.1. Dimensions of plaques in the groups (measurements are in centimetres).

BACKGROUND

The plaques are the products of a long tradition of crucifixion iconography, which can be seen in Insular manuscripts and on Irish stone sculpture dating from the

21 Peter Harbison, 'The Antrim Cross in the Hunt Museum', *North Munster Antiquarian Journal*, 20 (1978), 17–40. Mahr, *Christian art in Ancient Ireland*, pp viii, ix, pls 18.6, 31.6. 22 Leslie Webster and Janet Backhouse, *The making of England: Anglo-Saxon art and culture, AD600–900* (London, 1991), pp 170–5. 23 Kelly, 'Celtic treasure', 109, pls 1, 3, 4; Kelly, 'Tully Lough', 10. 24 Françoise Henry, *Irish art in the Romanesque period* (London, 1970), pl. 26.

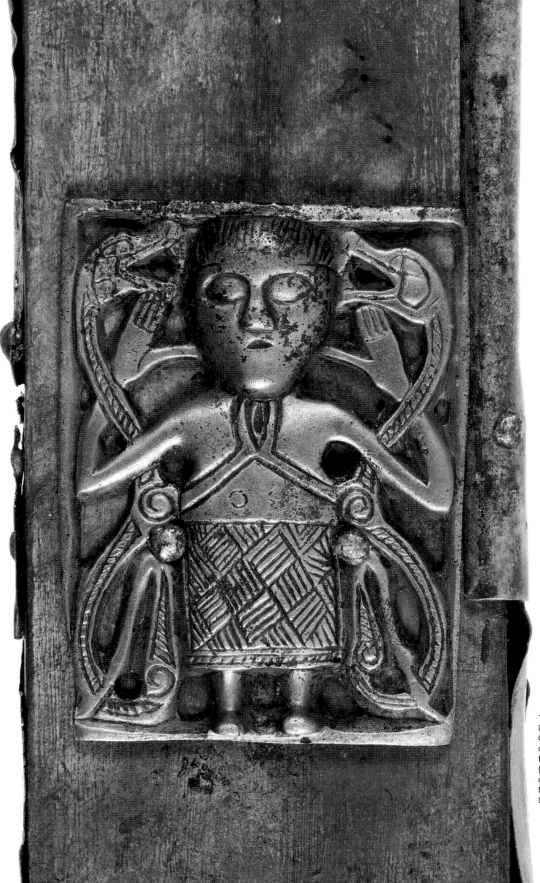

15.4 Tully Lough Cross, Co. Roscommon: openwork figurative plaque (© image courtesy of the National Museum of Ireland).

eighth to the tenth century.[25] Although part of the same tradition, a ninth-century copper-alloy crucifixion plaque from St John's, Rinnagan, Co. Roscommon, can be separated from the later plaques on the basis of style, manufacturing techniques, size and date.[26] This plaque is nearly three times the height of the later plaques and therefore would have been more appropriate in scale for attachment to an altar frontal. The figurative openwork plaques on the sides of the shrine of the Lorrha (Stowe) Missal, dated by its inscription to between 1026 and 1033, are also in the same tradition and are closely comparable stylistically to the crucifixion plaques.[27] A crucifix figure from Ballybrolly, Co. Armagh, probably eleventh century in date, is also closely related to the plaques and may similarly be from a large altar cross.[28]

Coinciding with the introduction of the ecclesiastical reforms in Ireland in the early twelfth century were changes in the physical aspects of the Irish Church, including its church architecture and religious metalwork. Most notable, in relation to churches and the liturgy, were the changes around the altar, with the development of chancels and the placing of altars against the eastern wall of the church.[29] In line with this, the massive altar crosses of the preceding centuries, which the crucifixion plaques appear to derive from, were supplanted by more modest examples, featuring independently cast figures of Christ in the Romanesque style, as a result of English and European influence. As the altars were increasingly being made of stone in this period and situated against the east wall, usually underneath the window, the smaller altar crosses were more practical for this new arrangement. Furthermore, in contrast to their predecessors in Ireland, the smaller size of these crosses meant that they could more easily be employed for use in processions. Some of the earliest examples in Ireland in the new Romanesque style include a detached crucifix figure in the St Mel's diocesan collection (fig. 15.1) and a cross featuring the outline of a figure in the NMI, which may be late eleventh or early twelfth century.[30] A well preserved example of a processional/altar cross from Mahoonagh, Co. Limerick, can also be stylistically dated to the early twelfth century.[31] Even the magnificent Cross of Cong, which,

25 Dom Louis Gougaud, 'The earliest Irish representations of the crucifixion', *JRSAI*, 10 (1920), 128–39. **26** Peter Harbison, 'The bronze crucifixion plaque said to be from St John's (Rinnagan), near Athlone', *Journal of Irish Archaeology*, 2 (1984), 1–17. **27** Harbison, 'Crucifixion plaque', p. 35, pl. 9; Padraig Ó Riain, 'The shrine of the Stowe Missal redated', *PRIA*, 91C (1991), 285–95. Mullarkey, 'The figural iconography', pl. 6. **28** Cormac Bourke, 'A medieval bronze cross from Ballybrolly, Co. Armagh' in M. Meek (ed.), *The modern traveller to our past: essays in honour of Ann Hamlin* (Dublin, 2006), pp 186–91. **29** Murray, 'Altars'; Ó Carragáin, *Churches in early medieval Ireland*, p. 192; see also Ní Ghrádaigh, this volume, pp 262–85. **30** Raghnall Ó Floinn, 'Irish Romanesque crucifix figures' in Etienne Rynne (ed.), *Figures from the past: studies on figurative art in Christian Ireland in honour of Helen M. Roe* (Dun Laoghaire, 1987), pp 168–88 at pp 169, 184–5, pls 10:1, 20. The St Mel's figure was badly damaged in the fire in St Mel's Cathedral on Christmas Day 2009. **31** NMI, 2009:26. Max. 28.15cm high, 15.3cm wide and 4.4cm thick.

as a major reliquary, was made to impress, is a lot smaller than the Tully Lough Cross, it too having been designed for procession.[32]

GROUPINGS

Peter Harbison divided the six plaques known at the time into two groups on the basis of differences in iconography.[33] Fundamentally, his Clonmacnoise Group (for example, fig. 15.5) is defined by the fact that both the angels and the soldiers on these plaques are standing upright, which distinguishes them from his Dungannon Group (for example, fig. 15.9), where they are depicted crouched, or hovering in the case of the angels. The provenances of only three of the plaques were known at the time, a lost example was said to have been found in Co. Mayo, another was found near Clonmacnoise, Co. Offaly, while a third was attributed to Dungannon, Co. Tyrone. Thus, Harbison named his groups the Clonmacnoise and Dungannon groups.

Since Harbison's paper was published, it has been revealed that the so-called Dungannon Plaque was found at College Hall/Marrassit near Tynan, Co. Armagh (fig. 15.9),[34] it is proven here that another plaque originally belonged to Major Matthew John Anketell of Emyvale, Co. Monaghan (fig. 15.10),[35] and, more recently, it has been discovered that another was originally found at Lismore, Co. Waterford (fig. 15.12).[36] Also since then, two additional crucifixion plaques have come to light. One of these was bought by the British Museum in 1983, and while published as being of unknown provenance,[37] it is demonstrated here that it was found near Kells, Co. Meath, in the late nineteenth century (fig. 15.11).[38] The other plaque was discovered around 1983 and while previously published as being found on the border between Cos Meath and Westmeath,[39] its precise find spot has now been established, which was in the townland of Rathbrack near Killalon, Co. Meath (fig. 15.8).[40] It now seems unlikely that all of the plaques were produced at Clonmacnoise, as Harbison originally suggested and the additional evidence has allowed for a regrouping.

While Harbison's Clonmacnoise and 'Dungannon' (or what we may now call Tynan) groups are retained here, they are in a modified form. In addition, a third group, labelled the Killalon Group, has been created. In this scheme, the plaque

32 Griffin Murray, *The Cross of Cong: a masterpiece of medieval Irish art from the twelfth century* (Dublin, forthcoming). Max. 76cm high, 48cm wide and 3.5cm thick. See also Ní Ghrádaigh, this volume, p. 280. **33** Harbison, 'Crucifixion plaque'. **34** Ann Hamlin and Richard G. Haworth, 'A crucifixion plaque reprovenanced', *JRSAI*, 112 (1982), 112–16. **35** See cat. no. 6. **36** See cat. no. 8. **37** Bourke, 'Chronology', p. 180. Johnson, 'Crucifixion plaques', 95. **38** See cat. no. 7. **39** Gerald Rice, 'An addition to the corpus of bronze open work plaques emanating from a Clonmacnoise workshop in the twelfth century', *Riocht Na Midhe*, 8:3 (1991), 114–17. **40** See cat. no. 3.

from near Kells and the Lismore Plaque (cat. nos 7, 8), are not included in any group (figs 15.11, 15.12). The correlation of the plaques in each group is not just a stylistic one; there is also a similarity in their size, particularly in relation to their height. Table 15.1 shows that the plaques in the Killalon Group are the smallest, with those in the Tynan Group coming next in height, and the Clonmacnoise Group plaques being the tallest.

Clonmacnoise Group (Clonmacnoise and Mayo plaques, cat. nos 1, 2; figs 15.5, 15.6)

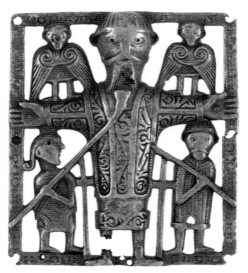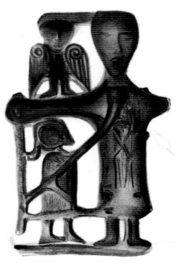

15.5 Clonmacnoise Plaque, cat. no. 2 (© image courtesy of the National Museum of Ireland).

15.6 Mayo Plaque, cat. no. 1, from a watercolour (© image courtesy of the National Library of Ireland).

This group is defined by the fact that Christ wears a full-length garment and holds his arms straight out from his shoulders. It is also defined by the fact that Longinus is on Christ's left, while Stephaton is on his right, contrary to all of the other surviving plaques. Inlays and settings were also used on these plaques, with the eyes of Christ and the soldiers on the Clonmacnoise Plaque having been probably originally inlaid with glass, while the Mayo Plaque was described as being inlaid with silver. All of the figures are depicted standing in this group.

Killalon Group (Killalon and Academy plaques, cat. nos 3, 4; figs 15.7, 15.8)
While these plaques are similar to the Clonmacnoise Group, in that the figures are depicted standing, there are a number of features that distinguish them from it and justify a separate grouping. Christ is bare-chested and wears a skirt-like loincloth, while his arms dip along their length. His hair is also treated differently; it is parted in the middle and falls in strands upon the shoulders of the flanking angels. Each angel carries a floriated staff at an angle to his body, and their wings are not pointed at the end like those in the Clonmacnoise Group. Furthermore, the soldiers in this group are depicted on opposite sides and there are two straps of

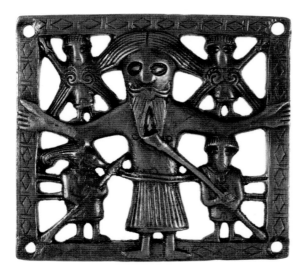

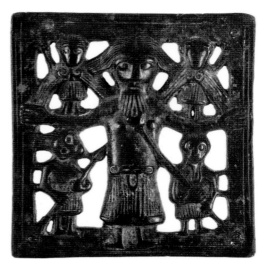

metal that connect each of them to the side of the frame. The Instruments of the Passion are also aligned with the angel's wings and the staffs that they hold so that a saltire cross is formed by the alignment. There are four fixing holes in these plaques, one at each of the corners.

15.7 Academy Plaque, cat. no. 4 (© image courtesy of the National Museum of Ireland).

15.8 Killalon Plaque, cat. no. 3 (© image courtesy of the National Museum of Ireland).

Tynan Group (Tynan and Anketell plaques, cat. nos 5, 6; figs 15.9, 15.10)

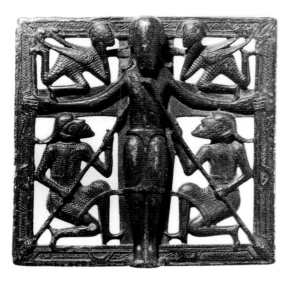

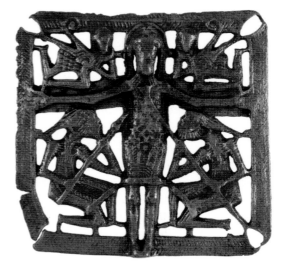

The angels in this group are depicted hovering or in motion, while the soldiers are both shown crouched, with the hems of their garments touching and forming an arc with the hem of Christ's loincloth. Christ's head and body are long and narrow, the loincloth is short and tight fitting, and the cross onto which Christ is nailed is represented. In contrast to all of the other surviving examples that feature fixing

15.9 Tynan Plaque, cat. no. 5 (© image courtesy of the National Museums of Scotland).

15.10 Anketell Plaque, cat. no. 6 (© image courtesy of the National Museum of Ireland).

holes around their edges, the plaques in this group were both originally attached using four projecting perforated tabs on their reverse.

Kells Plaque (cat. no. 7; fig. 15.11)

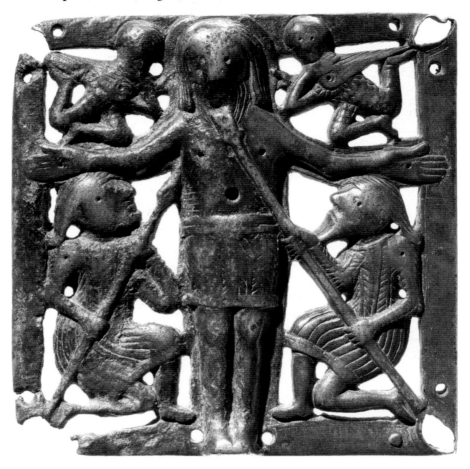

This plaque cannot be fitted into any of the groups defined above. While it is similar to those in the Tynan Group, there are a number of differences: Christ's head is slightly tilted to his right and his head and body are broader; he features a prominently marked navel and nipples; the hem of the loincloth does not touch, nor form an arc, with those of the soldiers; the angels have only one wing depicted; and Stephaton has a long pointed beard. Furthermore, this plaque was originally attached through fixing holes in its frame.

Lismore Plaque (cat. no. 8; fig. 15.12)
This plaque has also been separated from the others because, while it shares features with both the Clonmacnoise and Tynan groups, it does not sit

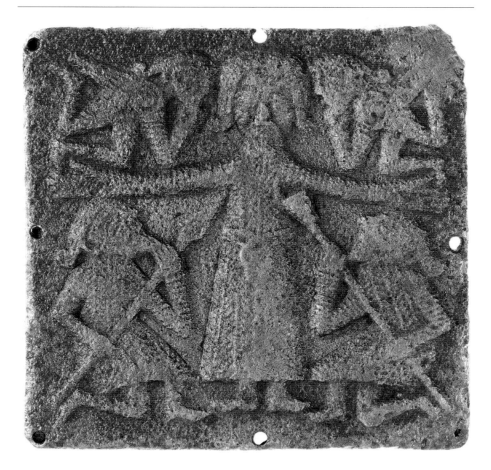

15.12 Lismore Plaque, cat. no. 8 (© image courtesy of the National Museum of Ireland).

comfortably with either group. It is also the only plaque that does not feature a frame and is cast as a solid piece, making it the heaviest of all of the plaques that have been weighed. Probably because of its weight, it features eight substantial fixing holes around its edge. It is also different from all of the other plaques in that the Instruments of the Passion are held underneath Christ's armpits.

WORKSHOPS

The three groups defined above appear to be geographically distinct from one another and it seems most likely that each group was the product of a different workshop. Indeed, it is now well recognized that geographically distinct workshops existed in Ireland during the eleventh and twelfth centuries and it has been argued by this author that these appear to have been aligned with the different regional kingdoms of the time.[41] The Clonmacnoise Group plaques were probably both produced at Clonmacnoise (fig. 15.2). There was certainly a workshop there

during the eleventh and early twelfth century, which was responsible for the shrine of the Lorrha (Stowe) Missal, with which the crucifixion plaques have already been compared.[42] Indeed, Ó Floinn has compared the decorative border on the frame of the Clonmacnoise Plaque with the decoration on a fragment of a motif-piece found in the new graveyard there.[43] Clonmacnoise was aligned politically with the west of the country in the late eleventh and early twelfth century, through the patronage of the O'Connors, kings of Connacht, which may explain the presence of the other plaque in Co. Mayo (fig. 15.2).

The Tynan Group plaques were probably produced by a workshop at Armagh. Tynan itself is very close to the ecclesiastical capital, while the Anketell Plaque came from a collection located at Emyvale, Co. Monaghan, which is only around ten kilometers west of Tynan, implying that it may have been found locally (fig. 15.2). Chronologically, they are probably the latest of the plaques, as the figures of Christ on them may be compared with the St Mel's crucifix figure (fig. 15.1) and the outline of the figure on the NMI cross.[44] This could be significant, in that it implies that Armagh was still producing large altar crosses in a period when the smaller Romanesque style crosses had won favour elsewhere in the country. This corresponds with what is known about the reform movement, the development of chancels and the introduction of Romanesque architecture in Ireland, all of which started in Munster, in the south of the country. The find of the early twelfth-century Romanesque style cross from Mahoonagh, Co. Limerick, emphasizes this.

The Killalon Group, consisting of one plaque from Killalon, Co. Meath, and an example of unknown provenance, may well have been produced by a workshop somewhere in the kingdom of Mide, perhaps at Fore (fig. 15.2). The plaque from near Kells, also in the kingdom of Mide, was probably produced at Kells itself, where a workshop is known to have existed in the eleventh century, which appears to have produced the shrine of the Cathach.[45] Finally, a workshop may have also existed at Lismore, as the Lismore Plaque shares a number of stylistic details with the figures depicted on the Lismore Crozier.[46]

CONCLUSION

It is argued here that the series of eight crucifixion plaques from Ireland were originally attached to large metal altar crosses with wooden cores, similar to that from Tully Lough, Co. Roscommon. Furthermore, it is suggested that these large

41 Murray, 'Insular-type crosiers', p. 91; Raghnall Ó Floinn, 'Schools of metalworking in eleventh- and twelfth-century Ireland' in Michael Ryan (ed.), *Ireland and Insular art* (Dublin, 1987), pp 179–87. 42 Griffin Murray, *The Cross of Cong* (forthcoming). 43 Raghnall Ó Floinn, 'Stray finds from Clonmacnoise', paper delivered at Clonmacnoise Studies: Seminar 3, 3 Oct. 2009. 44 Ó Floinn, 'Irish Romanesque crucifix figures', pp 178–9, 185. 45 Henry, *Irish art in the Romanesque period*, p. 89. 46 Raghnall Ó Floinn, 'The Lismore Crozier' in Ryan (ed.), *Treasures of*

altar crosses became redundant during the course of the late eleventh and early twelfth century with changes in liturgical practices and through the introduction of smaller altar/processional crosses of Continental form. Finally, it is argued that the plaques were produced by five distinct regional workshops, with the examples made at Clonmacnoise and Armagh being particularly accomplished, demonstrating the metalworking skill available at those important ecclesiastical sites.[47]

Name	Cat. no.	Cu	Sn	Zn	Pb	Ag	Metal
Clonmacnoise	2	74.12	_	23.60	1.19	0.08	brass
Killalon	3	74.49	8.75	5.68	8.91	0.16	leaded gunmetal
Academy	4	85.04	_	12.64	1.09	0.12	brass
Anketell	6	87.76	3.00	7.43	0.67	0.10	gunmetal
Kells	7	78.5	2.6	17.0	1.6	<0.1	brass
Lismore	8	79.54	3.26	15.87	0.39	0.08	brass

Table 15.2. xrf analysis percentages, median results.

CATALOGUE

No. 1: Mayo Plaque (fig. 15.6)
Provenance: Co. Mayo
Location: unknown
Dimensions: H. 85mm

DESCRIPTION

The whereabouts of this crucifixion plaque are unknown and the only evidence of its existence is a watercolour in a nineteenth-century antiquarian album. The illustration shows the plaque to be incomplete, consisting of only three figures. Christ is shown fully clothed in a long garment to well below the knees. The

Ireland, pp 170–1; Henry, *Irish art in the Romanesque period*, pp 97–100, pl. 26. **47** This essay is based, in part, on a section of my doctoral thesis for which I received a scholarship from the Irish Research Council for the Humanities and Social Sciences. I would particularly like to thank my doctoral supervisor, John Sheehan of the Department of Archaeology, University College Cork, who first recognized the new groupings presented here. I am also very grateful to Paul Mullarkey of the Conservation Department, NMI, for weighing and analysing the plaques in that museum for this essay, as well as for his comments and discussion. I would like to thank Quanyu Wang of the Department of Conservation and Scientific Research, British Museum, for weighing and analysing the Kells plaque. Eamonn Kelly, Rolly Read, Maeve Sikora, Andy Halpin, Raghnall Ó Floinn, Mary Cahill, Margaret Lanin, Cormac Bourke, Aideen Ireland, Alison Sheridan, David Clarke, Leslie Webster, Sonja Marzinzik, Susan La Niece, Virginia Smithson, Hugh Kavanagh and Frank Mockler are also to be thanked for their help and assistance during the study of this material. Furthermore, I am very grateful to Philip McEvansoneya for allowing me to refer to his discovery of the provenance of the Lismore plaque in advance of his own publication.

garment is decorated with a number of lines, including two long irregular vertical examples. These lines are connected to each other by a saltire cross in the middle and towards the bottom of the garment there are a number of short horizontal or near horizontal strokes. Christ's arms are held out horizontally, although his left arm is broken off just beyond the shoulder. The details of his right hand are not shown, except for the presence of a nail head in the palm. His legs are positioned apart and his feet point out to either side. Christ is shown beardless, and apparently with short hair, and his eyes, nose and mouth are depicted. There are two small projections from Christ's garment on his left hand side. One of these is located on the shoulder while the other is located below the arm and these are presumably where the missing angel's wing and the tip of Longinus' spear engaged Christ.

Stephaton can be seen below Christ's right arm. He is shown in profile and is dressed to below the knees in a long garment decorated with vertical lines. His legs are held apart and his feet point toward Christ. Only one arm is depicted, angled awkwardly backwards, which holds a long pole with a cup at the upper curving end of it. The lower end of the pole touches the side of the frame, while the cup at the upper end is held below Christ's chin. Stephaton's head is set at an angle, as if he were looking up at Christ; his chin is pointed and his hair sweeps back in a curl behind his head and touches the frame. No details of the face are shown, although there seems to be a raised line around the top, bottom and back of the head. A line extends from the hem of his garment to connect with the frame and with the hem of Christ's garment.

Above Christ's right arm and perched upon it is an angel. He stands with his legs held apart and his feet pointing outward on either side in the same manner as Christ. His wings fall downward and are decorated with parallel lines, and the points where they meet the body are marked with spirals. The body and the head are squat and his eyes and nose are represented. The surviving section of the frame is shown to be undecorated and there are two breaks or gaps in it. The upper and lower sections of the frame are wider than the remaining section on the side. Christ's head overlaps the upper part of the frame, while his right hand projects out over the side section.

HISTORY

This plaque is only known from a watercolour in a volume of antiquarian drawings in the National Library of Ireland (MS 4458, p. 74). It was published by Harbison, who suggested that the manuscript may have originally belonged to Sir William Betham and dates from the 1830s.[48] The illustration is captioned: 'This is a remnant of a singular brazen representation of the crucifixion it is inlaid with silver and was found in the county of Mayo.'

48 Harbison, 'Crucifixion plaque', p. 24.

COMMENTS

Harbison argues that the watercolour is full scale and therefore concludes that the plaque was 85mm high, while one cannot be sure of its original width. From the evidence of the other plaques, it appears that both an angel and Longinus have been lost, while the points where the missing angel's wing and the tip of the spear touched Christ are still discernable on the illustration.[49] While the general features of this plaque, as depicted, are in accordance with the others, one needs to be careful about accepting all of the details of the watercolour. For instance, Harbison argues that the details of the face of Christ were probably restored by the artist in the watercolour. Christ's garment may have been inlaid with silver, as this technique is mentioned in the caption, while Harbison further argues that the eyes of the angel may have been inlaid with glass.

————

No. 2: Clonmacnoise Plaque (fig. 15.5)
Provenance: near Clonmacnoise, Co. Offaly
Location: NMI (1935:506)
Dimensions: H. 84mm; W. 72.5mm
Weight: 99.71g
Material: brass[50]

DESCRIPTION

This plaque is a particularly fine casting, despite the fact that much of its fine detail is now worn. All of the figures on this openwork plaque are in relief and are hollow at the back. Christ has a large head with short hair, a forked beard and a moustache that curls up at the ends. He has small, rounded, projecting ears on either side of his head, oval eyes with round empty sockets, which presumably

49 Ibid., pp 24–5. **50** See table 15.2. The plaques in the NMI were analysed using a Spectro Midex EDXRF (energy dispersive x-ray fluorescence) spectrometer using a Molybdenum anode. The diameter of the tube collimator and the measurement spot size is 0.7 mm, and the distance from the sample surface varies from 2mm to 5mm. The operating conditions for the X-ray tube were 45kV and 0.6mA at normal air pressure. Sample counting time was 180 seconds livetime. The principal elements analysed were copper, tin, zinc, lead, silver, arsenic and antimony. There was no sample preparation, such as polishing or abrasion of the surface, as it would have resulted in unacceptable damage. Four of the plaques were chemically treated sometime in the 1960s or 1970s, while the Killalon Plaque has not been conserved, meaning that there are contaminants, surface dirt and corrosion products present. Other factors affecting the results are the surface depletion and enrichment of copper, tin and lead, due to corrosion mechanisms during burial. Only the major elements are listed in the tables presented here.

once contained glass studs, and a slightly upward curving mouth. His arms are outstretched and the hands, which overlap the frame, are perforated and have separately made nails of gunmetal in the palms (table 15.3). The top of his head and his feet also overlap the frame. The arms are covered, as is most of his body, with a robe that ends well below his knees. The garment is divided into eight panels decorated with paired half-palmette ornament. Three vertical panels of this ornament can be seen on the body, while both of the arms are divided into two horizontal panels. At the end of the vertical panels is a plain band, which may have originally held a decorative strip, and below that there is a raised hem bearing a horizontal panel of half-palmettes forming an S-scroll. The ends of the sleeves are milled, as is part of either side of the garment. His feet are turned outwards to either side and part of his right foot is damaged/broken off above the ankle.

Beneath Christ's right arm is a figure of Stephaton in profile wearing a long garment that curves in on either side, ending in a horizontal milled hem beneath his knees, and which is decorated with bands of herringbone motifs. Both his head and feet face towards Christ and his hair flows back from his forehead in strands that end in a single curl. He has a stubby nose, a slight mouth and a pointed chin. An oval eye is represented, with a rounded socket for a now-missing glass stud within it, and an ear. Only one of his arms is depicted, which is angled awkwardly backwards across his chest, and this holds a long pole that is curved at the top, where it expands into a cup below Christ's beard. The end of the pole overlaps the frame of the plaque and both it and Longinus' spear are in relief.

Below Christ's left arm is the figure of Longinus, who is seen frontally. He has short hair and small projecting ears. He has oval eyes with rounded empty sockets, which would have formerly held glass studs, a slight mouth and a moustache. His feet face outwards to either side and he wears a garment that falls to below his knees. This is mainly decorated with vertical bands of herringbone decoration, but also features a plain central band, and has a triangular perforation above a milled hem. Again, only his right arm is shown and this is also positioned at an awkward angle. It holds a spear that pierces Christ's left side, the butt of which overlaps the frame. On either side of Christ, and between him and the two Roman soldiers, is a slender cross. The tops of the crosses touch the Instruments of the Passion, while below they seem to rest on Christ's feet. Standing on Christ's arms are two angels that are frontally disposed. Their wings and short bodies are diagonally hatched and there is a spiral where each wing meets the body. A line joins the spirals to each other across the angels' bodies that form a pelta in each case. The angels' feet are turned outwards to either side and their faces are now very worn. The hairstyle of the angels is similar to that of Longinus and they have similar projecting ears.

The border is ornamented in false relief with a band of lozenge-and-slash decoration. There are six perforations in the frame, all approximately 2.5mm in

diameter. There is one hole in each of the four corners, three of which have been broken through, and one at the mid-point of each of the two vertical sides. At the point of the perforation below Christ's left hand, the frame has broken, while the hole below Christ's right hand contains the remains of an iron nail. There are a further four perforations 1mm in diameter in the frame. Two of these are on the outer side of the angels' heads, while the other two are below the outer of the soldiers' feet. They all contain the remains of copper-alloy nails, except the one below Stephaton's foot, which is empty. That above the angel on Christ's right is of gunmetal, while that below Longinus' foot is of brass (table 15.3). There are a further two holes 1mm in diameter between Christ's feet, one of which is broken through.

There are four minor casting flaws in this plaque, three of which have been repaired with brass that is of a different alloy, with a higher copper content than that used for the plaque (table 15.3). Both of the angels feature a repair patch, in the middle of the face of the angel on Christ's right and in the body of that to his left. The third repair patch is in the body of Stephaton, while the flaw underneath Christ's chin was apparently not filled.

HISTORY

The first known record of this plaque is in the minute book of the Committee of Antiquities and Polite Literature in the RIA (vol. viii, p. 286) under a meeting held on Wednesday 1 June 1932:

> Dr Mahr exhibited an early plaque, depicting the crucifixion, said to have been found at Clonmacnois [sic]. This object was not offered for sale.

Its exhibition at the meeting in Dublin was at the time of the Eucharistic Congress and, while it did not form part of the special loan exhibition of medieval ecclesiastical objects in the NMI at the time, it was most likely within this context that it came to the attention of Adolf Mahr. Indeed, it was probably the intermediaries responsible for lending St Caillin's book shrine from St Patrick's College in Thurles to the museum who brought the plaque to Dublin.[51] It was eventually acquired by the museum in 1935 and the file relating to it records:

> Said to have been found near Clonmacnoise. The property of the late Mr Frank Mockler, Grange, Thurles, Co. Tipperary. Deposited on his behalf by Rev. Richard Devane, St Patrick's College, Thurles, Co. Tipperary, through Rev. Thomas J. O'Connor, same address.

51 Mahr, *Christian art in ancient Ireland*, p. xiv.

Frank Mockler was a farmer at Grange, which is around 2km from Thurles.[52] He is said to have died around 1933 or 1934 and one of his sons studied for the priesthood at St Patrick's College, which probably explains the connection with that institution. How Frank Mockler came into possession of this plaque, which is recorded as being found near Clonmacnoise, approximately 85km from his farm and in a different county, remains unknown. However, in addition to being a farmer, Frank Mockler was also a water-diviner, which caused him to travel on occasion. While he did not have a car, he could have travelled to the area around Clonmacnoise by railway and it is conceivable that he found the plaque in the course of water divination.

Table 15.3. xrf analysis percentage results for secondary copper-alloy fixings to Clonmacnoise Plaque (cat. no. 2).

Feature	Cu	Sn	Zn	Pb	Ag	Metal
Repair patch 1	80.21	0.39	16.86	1.24	0.14	brass
Repair patch 2	80.91	0.87	15.50	0.47	0.46	brass
Nail frame top	83.20	5.02	8.59	1.32	0.46	gunmetal
Nail frame bottom	73.32	0.45	24.31	0.53	0.13	brass
Nail right hand	84.84	4.31	9.10	0.36	0.28	gunmetal
Nail left hand	84.21	4.686	8.956	0.54	0.33	gunmetal

No. 3: Killalon Plaque (fig. 15.8)

Provenance: Rathbrack, Killalon, Co. Meath
Location: NMI (1000:798)
Dimensions: H. 67mm; W. 65mm
Weight: 119.52g
Material: leaded gunmetal[53]

DESCRIPTION

Being the most recent find, this openwork plaque has not been treated or conserved and features an even green patina. It is executed in relief and is hollow at the back. It features a bare-chested Christ, who wears a long skirt-like loincloth featuring vertical grooves and a plain horizontal hem, which is tied with a belt in a large knot. Christ's arms fall slightly from the shoulders and are bent at the elbows so that the forearms are marginally raised. His legs are held apart and the feet are turned out to either side. The nipples stand out from his chest and his

52 I am sincerely grateful to his grandson of the same name for information about him. 53 See table 15.2.

hands and feet overlap the surrounding frame. Christ has large eyes with incised pupils, a broad nose and a horizontal mouth. His hair is parted in the middle and flows down and outward on either side of his head to touch the angel's shoulders. He also has a long beard that splits in two at the chin.

Longinus is seen frontally below Christ's right arm. He holds a spear diagonally across his body, the butt of which touches the corner of the frame and the tip of which touches Christ's side. He appears to be bare-chested and wears a skirt to the knees, decorated with vertical grooves and with a plain horizontal hem. His legs are positioned apart and his feet are turned towards Christ. His head is turned at an awkward unnatural angle as if to give the impression that he is looking up at Christ. Although his face is worn, his oval eyes and his nose can be seen. He has projecting ears, a pointed chin and hair standing straight up from the top of his head. Two bridging pieces attach him to the side of the frame. Stephaton stands on the other side of Christ below his left arm. He is also seen frontally, although his head is not turned like that of Longinus. He holds the pole diagonally across his body. The butt of it rests in the corner of the frame, while the cup itself is held beneath Christ's beard. He wears a long garment with a U-shaped opening at the neck. The lower part is decorated with vertical grooves, while parts of the upper sections are decorated with hatching. His hair is short and is represented by vertical strands. He has rounded eyes and an upturned mouth.

Two angels stand on top of Christ's arms, one on either side. They are also seen frontally. The joints of their wings are marked with spirals and the grooved wings fall down on either side and touch one of Christ's shoulders and hands respectively. They both wear a garment to below the knees that is decorated with vertical grooves. Their legs are held apart and their feet are turned out on either side. Even though the angels' faces are worn smooth, one can make out their oval eyes and see their projecting ears. Their hair, like Christ's, is also parted in the middle. A crude, floriated, staff rises from one of their shoulders in each case, expanding slightly at the top, before merging with the frame at the top corners.

The frame itself is decorated with a double-line border and is pierced at its four corners. The remnants of four iron nails are still fixed in these holes.

HISTORY

This crucifixion plaque was found around 1983 by a treasure hunter, using a metal detector. It was later sold to Fr Gerard Rice and was published by him in 1991, when he stated that it had been found on the border between Cos Meath and Westmeath.[54] It is now in the NMI and Eamonn Kelly, the keeper of Irish antiquities, subsequently interviewed the original finder of the plaque and visited the find location with him, which was in the townland of Rathbrack, near Killalon

54 Rice, 'An addition to the corpus', 115.

in Co. Meath, not far from the Westmeath border. The plaque was found near a mass path and adjacent to a field boundary 600m west/north-west of St Bartholomew's Roman Catholic church.

—————

No. 4: Academy Plaque (fig. 15.7)

Provenance: unknown
Location: NMI (R.2917)
Dimensions: H. 72mm; W. 77mm
Weight: 148.56g
Material: brass[55]

DESCRIPTION

This openwork crucifixion plaque depicts Christ in relief. His arms fall from the shoulders and are bent at the elbows so that his forearms are raised slightly. His hands in relief overlap the frame, the thumbs of which are larger in scale than the fingers. He is bare-chested and wears a long skirt-like loincloth to below the knees. This is decorated with vertical grooves and features a plain horizontal hem. A double-ribbed band runs across the waist of the loincloth and extends from Christ's body on either side to touch the Instruments of the Passion. The nipples and navel are both indicated by small circles. His legs, which overlap the frame, are held apart and his feet point outwards to either side. He has a large head with a long forked beard and an upward curling moustache. His hair is parted in the middle and runs down either side of his head where it extends to touch the angels' shoulders. He has oval eyes, a large nose and a small mouth.

Longinus, seen frontally, stands below Christ's right arm. He wears a garment to below his knees that has a slit at the neck and in the centre of the hem. Two grooves on the clothing emphasize the shape of the neck and the hemlines. His legs are held apart and his feet point outwards to either side. He holds a spear with both hands diagonally across his body. The butt of the spear touches the corner of the frame, while the tip touches Christ's right side. His head is unnaturally tilted, as if he were looking up towards Christ, and the hair sweeps back off the head from the forehead, narrows and then widens again where it ends in one large curl that touches the frame. Although his face is much worn, it is possible to make out his eyes and mouth and he has a pointed chin or beard. Two double-ribbed bands connect Longinus to the frame at the side. Stephaton stands below Christ's left

55 See table 15.2.

hand and his dress and posture are much the same as Longinus'. Similarly, he holds the pole diagonally across his body. The butt of the pole touches the corner of the frame, while the cup is held below Christ's beard. His head is held upright and he looks straight at the viewer, unlike his partner. Also, his hair is short and is represented by a number of vertical strands and he has slightly projecting ears. While his face is very worn, it is possible to see his oval eyes and his nose. Again, like Longinus, he is connected to the side of the frame by two double-ribbed bands.

An angel, depicted frontally, is perched on each of Christ's arms. They are wearing similar clothing to the two soldiers, consisting of a long garment with a slit at the centre of the hem. There is no slit in the neck as the spiral joints of the wings, which are milled at the top, conceal the upper part of the body. The legs are held apart and the feet are turned outwards like all of the other figures on the plaque. The wings fall diagonally downwards to touch Christ's arms and are grooved. Their hair consists of a series of vertical strands like Stephaton's, only that the central strands have herringbone decoration and they also have a horizontal fringe line. They have oval eyes and small projecting ears and, while other details of their faces are much worn, it is possible to make out their noses and mouths. Extending from one of the shoulders of each of the angels are crude represent-ations of floriated staffs that touch the respective upper corners of the frame. These expand at their upper ends where they split into three, with a main central section and two smaller short offshoots.

The frame is wide and is decorated with a running band of lozenge-and-slash decoration. There are also four large fixing holes, one at each of the four corners of the frame.

HISTORY

All that is known about this plaque is that it was an early acquisition by the RIA and had entered their collection by 1868 when J.O. Westwood illustrated it.[56] It was also recorded by William Wilde (d. 1876) in an unfinished catalogue of ecclesiastical antiquities in the RIA (W.92). It may be the 'brass figure of crucifixion' that was bought from William Edwards for £3 on 16 March 1853.[57]

———

56 J.O. Westwood, *Fac-similes of miniatures and ornaments in Anglo-Saxon and Irish manuscripts* (London, 1868), p. 151, pl. 51:7. 57 *PRIA*, 5 (1853), 398.

No. 5: Tynan Plaque (fig. 15.9)

Provenance: College Hall/Marrassit, Tynan, Co. Armagh
Location: National Museums of Scotland (KF13), on loan to Ulster Museum
Dimensions: H. 82mm; W. 86mm

DESCRIPTION

This plaque is also a particularly fine casting. Christ is depicted in high relief on a broad flat cross within a rectangular frame. His head, hands and feet project over this frame. He is bare-chested with the ribs clearly visible at the sides. He wears a loincloth that has a raised waistband and hem that are joined by a vertical band that reduces in width towards the centre. This separates a rounded panel on each thigh, the edges of which are decorated with hatching. The sides of these panels are decorated with a herringbone pattern. Christ's face is much worn, although the nose and ears are discernable. The top of his head is rounded and he has a long narrow face and an angular beard. His hair falls on his shoulders where it ends in a curl on each side of his head. Christ's legs are held close together, with the feet, which rest on a *suppedaneum*, pointing outwards. Christ's arms fall from the shoulders and are bent at the elbows so that the forearms are held horizontally.

Longinus, who is in a crouched position, is on Christ's right hand side. His right leg is tucked in behind his left and with both hands he clutches a spear that is held diagonally across his body and touches against Christ's right side. Stephaton, who is on Christ's left, is poised in a similar way, also with a pole held diagonally across his body. This pole ends in a cup held under Christ's chin. The butt of the spear and pole engage with the lower corners of the frame and end in what seem to be animal heads. Both of the soldiers' faces are seen in profile; they are bearded and their hair flows from their foreheads back onto their shoulders to engage with the frame. They are fully clothed to the knees in garments decorated with bands of herringbone. In each case, these have a slit at the neck, a raised waistband and a raised milled hem that engages with the hem of Christ's loincloth forming an arc. The bands of herringbone on Longinus' garment are divided by vertical milling, while those on Stephaton's garment are divided by grooves.

An angel is positioned on either side of Christ's head, where they appear to hover. Their bodies are crosshatched to the knees; there is a spiral at the point where their wings meet their bodies and the wings themselves are decorated with grooves that end in curls that overlap the frame. One of their hands rests against their face, while the other reaches out towards Christ's head. Their legs are thrown back behind them and, in each case, one foot engages with the frame while the other foot touches Christ's arm. The angels' faces, which are much worn, are not seen completely in profile, but are angled out towards the viewer. Like Christ, the tops of their heads overlap the frame and, with difficulty, two eyes may be seen, as well as a nose and a mouth.

The frame is elaborately decorated and each side is divided into three panels by semi-circular arches. The arches on the top of the frame surround the tops of the angels' heads, while the upper arch on either side of the frame surrounds Christ's hands. The remaining arches are decorated with incised concentric semi-circles. The panels at Christ's head, at his feet and below his right hand are decorated with half-palmette patterns. The outer two panels on the top of the frame are decorated with a zigzagging band on a hatched background, while those on the bottom of the frame have crosshatching. The remaining panels are decorated with a herringbone pattern. The top corners of the frame contain ovals, the centres of which are hatched. All of the panels and arches on the frame are encased in grooves running along the inside and outside edges of the frame. At the back of the plaque at the four corners are four projecting perforated tabs that protrude at right angles to a maximum of 6mm from the back of the frame. The figures in relief are hollow at the back.

HISTORY

This crucifixion plaque was found in 1844 in the townland of College Hall/Marrassit near Tynan by a person digging for potatoes.[58] John Bell, the Dungannon-based collector, had certainly acquired it by 1852, when he exhibited it to the British Association in Belfast.[59] It was acquired with the rest of the Bell collection, consisting of approximately 1,400 objects of mostly Irish provenance, by the National Museum of Scotland in 1868 and is currently on loan to the Ulster Museum.[60]

———

No. 6: Anketell Plaque (fig. 15.10)
Provenance: unknown
Location: NMI (R.2918)
Dimensions: H. 80mm; W. 80mm
Weight: 81.43g
Material: gunmetal[61]

58 Hamlin and Haworth, 'Crucifixion plaque reprovenanced', 112. **59** *Descriptive catalogue of the collection of antiquities, and other objects, illustrative of Irish history, exhibited in the museum, Belfast, on the occasion of the twenty-second meeting of the British Association for the advancement of science, September 1852* (Belfast, 1852), p. 5, cat. no. 40. **60** R.B.K. Stevenson, 'The museum: its beginnings and its development, part II: the National Museum to 1954' in A.S. Bell (ed.), *The Scottish antiquarian tradition: essays to mark the bicentenary of the Society of Antiquaries of Scotland and its museum, 1780–1980* (Edinburgh, 1981), pp 142–211 at p. 153. **61** See table 15.2.

DESCRIPTION

This openwork square crucifixion plaque depicts Christ wearing a loincloth. It is executed in relief and has a hollow back. Christ's outstretched arms fall slightly from the shoulders to the elbows, while the forearms are held horizontally. The irregularly shaped arms of the cross can be seen behind Christ and only a short section of the shaft is depicted. The shaft does not run behind his head or below the hem of the loincloth. There is, however, a nimbus depicted around his head, which the angels appear to hold. The loincloth extends to above the knees and is tied by a double-stranded belt in a large interlaced knot at the waist. From the knot hang two of the strands that end in out-turned lobes. The loincloth is decorated with herringbone and concave ribbing and it has a plain raised hemline. The legs are held slightly apart, the knees are depicted, and the feet are shown frontally and come together at the toes. Christ's head is long and narrow and he has long hair that falls to the shoulders, and a beard, the strands of which can be seen below the chin. His eyes are large and circular and his nose and mouth are just discernable on his much-worn face. His head, feet and hands all overlap the frame surrounding the scene.

Below Christ's right arm is Longinus, in profile in a crouched position with one leg kneeling and tucked behind the other. A vertical band runs down both legs. He holds a spear in his two hands, which are some distance apart on the shaft. The upper hand holds the shaft of the spear to his own chin, while the tip of the spear touches Christ's right side. The end of the shaft has been broken away. He is clothed in a garment that falls down to his knees. It is divided into two by a plain horizontal band at the midriff. It has a V-shaped slit at the neck that is defined by a raised out-turned collar. The arms are decorated with horizontal ribbing, while the body of the top section is decorated with vertical ribbing. The lower part of the garment is decorated with bands of vertical herringbone and has a raised plain hem. His hair sweeps back off the back of the head and ends in an upward turning curl that touches the edge of the frame. Although the face is worn, it is possible to see his oval eye and his nose, mouth and beard. On the other side of Christ, below his left arm, is Stephaton, who is almost identical, except that he holds a pole rather than a spear. The pole is curved at the top and the cup is held below Christ's chin, while the butt of the pole merges with the lower left corner of the plaque. Stephaton's face is much worn and, like his partner, appears to be looking up towards Christ.

Above Christ's arms on either side is a hovering angel in profile. They rest their chins on one hand and hold on to Christ's nimbus with the other. The details of their faces have been completely worn away and, while they appear to look out towards the viewer, the sides of their faces seem to be ribbed. Their wings are attached to their shoulders by a lobed spiral, with one narrow wing merging with

the corner and the other ending in a spiral that overlaps the top of the frame. Their bodies are decorated with a scale or pellet decoration that gives the impression of feathers. Their legs also feature a band, in the same way as the soldiers, and are thrown behind them. One foot touches Christ's arm and the other touches the side of the frame.

The frame itself is decorated with herringbone and features oval perforations at its four corners. All of the corners have been damaged, particularly the lower left where the frame has been broken through. The frame is also badly cracked at a point further up on the left side. At the back of the plaque at three of the corners, damaged, projecting, perforated tabs survive.

HISTORY

This plaque was originally in the collection of Major M.J. Anketell (1812–70) of Emyvale, Co. Monaghan.[62] He exhibited it with other material from his collection at the meeting of the British Association in Belfast in 1852[63] and again at the Dublin Exhibition in 1853,[64] where it was described as 'a representation of the crucifixion in copper'. The RIA acquired the plaque following the exhibition and the minute book of the committee of antiquities records on 21 November 1853

> That Mr Clibborn be authorized to communicate to Mr Anketell, that the committee will advise the council to recommend to the academy to take his antique representation of the crucifixion and an enamelled ball [bell?] in exchange for an ivory crucifix which formed part of the collection of the late dean of St Patrick's.

Furthermore, the proceedings record on 8 January 1855

> That permission be given to the council to exchange with Mr Anketell a modern representation of the crucifixion, made of ivory, and not Irish, now in the academy's collection, for one made of copper-alloy, and probably of great antiquity, and of native manufacture.[65]

While its find circumstances remain unknown, judging from what is known of the composition of the Anketell collection, it seems likely that the plaque was found in Ulster, perhaps somewhere around Emyvale itself.

———

62 Westwood, *Fac-similies of miniatures and ornaments*, p. 151, pl. 51:8. 63 *Descriptive catalogue of the collection of antiquities*, p. 9, cat. no. 41; Bourke, 'Medieval ecclesiastical metalwork', p. 39, n. 98. 64 Anonymous, *Official catalogue of the Great Industrial Exhibition (in connection with the Royal Dublin Society)* (Dublin, 1853), p. 149. 65 *PRIA*, 6 (1857), 155.

No. 7: Kells Plaque (fig. 15.11)

Provenance: near Kells, Co. Meath
Location: British Museum (1983,0701.1)
Dimensions: H. 82mm; W. 80mm
Weight: 185.8g
Material: brass[66]

DESCRIPTION

This rectangular openwork plaque is in worn and damaged condition, the left side especially so. Christ and the other figures are executed in relief and are hollow at the back of the plaque. Christ is depicted bare-chested and wearing a loincloth to above his knees. His head, hands and feet all overlap the frame. He is set on a plain background that outlines the shape of his body and that is continuous with the frame at the point of his hands and feet, but is distinct from the frame at his head where it forms a nimbus. The loincloth has vertical bands of herringbone decoration and features a double raised waistband and a horizontal hem with a step pattern. The nipples and navel are represented by circular depressions and the ribs are indicated by parallel grooves. The arms fall from the shoulders and are bent at the elbows so that the forearms are held horizontally and the nails in the palms are also represented by circular depressions. The legs are held close together and the feet point outwards. Christ's head is inclined slightly to his right, his hair is shoulder length and he is also bearded. The eyes are represented by circular depressions, the nose is worn, but discernable, and the mouth is slight.

On Christ's right is Longinus, who is in a crouched position with his right leg tucked in behind his left. His head is seen in profile, his eye is represented by a circular depression and his hair sweeps back from his forehead to end in a curl on his shoulder. His torso is clothed in a garment decorated with a herringbone pattern, while he wears a pleated skirt with a hem. He holds a spear with both hands diagonally across his body, which touches Christ's right side. Stephaton, on Christ's left, is similarly poised and dressed, with the exception that he has a long pointed beard and holds a pole with a cup at the end of it. There is a projection on the pole below the cup, which is held below Christ's chin. The details of Stephaton's garment are better preserved than the details of his partner's. The lower half of it is decorated with vertical grooves, while the hem is decorated with a step pattern. The upper half is decorated with vertical bands of herringbone and has a V-neck at the collar.

66 See table 15.2. The surface analysis was carried out on a few areas using an Artax μXRF spectrometer with a molybdenum target X-ray tube rated up to 40W and operated at 50k V and 800 μA with a counting time of 200 seconds. The diameter of the tube collimator used in the measurements is 0.65mm. There was no sample preparation, such as polishing or abrasion of the surface, as none was carried out on the pieces from the NMI with which these analyses are to be compared.

An angel is depicted at either side of Christ's head and, although their bodies are in profile, their faces are shown frontally. They both hold one hand to their chins, while the other clutches the nimbus around Christ's head. They have short hair, parted in the middle, and two small circular depressions for eyes. In each case, a single wing is depicted decorated with grooves, which has a spiral at the point where it meets the body. Their legs are thrown behind them, one foot held above Christ's arm and the other pointing towards one of the top corners. The angel on Christ's right is extremely worn and many of its details have been obliterated. The other one is better preserved and its body is decorated with a criss-cross pattern that probably represents feathers. It also has a slight down-turned mouth and the remnants of a nose.

At each corner of the frame there was originally an oval perforation. On either side of these there was a small round fixing hole. The examples on one side of the plaque are in good preservation and are further demarcated by lines bordering them, while those on the other are severely damaged. There are a further two fixing holes in the frame, one on either side of Christ's feet. One of the fixing holes in the bottom right corner retains part of a brass nail (table 15.4). A lightly incised vertical line is discernable on the inside of the frame on the right. There is a set of three, lightly incised, short, parallel lines on the right side of the top and bottom sections of the frame, as well as below Christ's left hand on the right of the frame. There are a further two short parallel lines lower down on the right side of the frame.

HISTORY

This plaque was formerly in the possession of the earl of Carrick, whose family lived on the Mount Juliet estate in Co. Kilkenny from 1857 to 1914. It is recorded in the file on it in the British Museum that it was brought to England with the family effects in the 1920s. It was bought by a private individual who later sold it to the British Museum through an agent, Kenelm Digby-Jones, in 1983. A handwritten note in the British Museum files annotated by Leslie Webster, 'Earl of Carrick's note on the plaque's provenance 12/4/89', records: 'Copper-alloy plaque found by a workman nr Kells and given to my father Thomas Rothwell'. Thomas Rothwell of Rockfield House, Kells, Co. Meath, was a collector of antiquities in the nineteenth century. He sold a significant portion of his collection to the RIA in 1897, which consisted principally of Bronze Age material, but also included stone age, medieval and early modern artefacts.[67] Two important objects from Lagore crannog, a Bronze Age dagger of Continental form and an unusual early medieval bronze pin, were previously donated to the academy by Mrs Rothwell of Rockfield, Co. Meath, sometime before 1861.[68] The donation of a decorated bronze ringed-pin by Miss H. Rothwell, Rockfield, Kells, Co. Meath, as

67 *PRIA*, 4 (1896–98), 279; NMI 1897:29–84. 68 W.R. Wilde, *A descriptive catalogue of the*

late as 1931 indicates that the Rothwell collection had not been completely dispersed by Thomas Rothwell himself.[69] This is also indicated by the wording of the note on the plaque in the British Museum, which implies that it had been acquired by the earl of Carrick from one of Thomas Rothwell's children, presumably sometime after their father's death.

Table 15.4. xrf analysis percentage results for the brass nail on the Kells Plaque (cat. no. 7).

Feature	Cu	Sn	Zn	Pb	Ag
Nail right bottom	80.3	3.0	14.6	1.9	<0.1

———

No. 8: Lismore Plaque (fig. 15.12)
Provenance: Lismore, Co. Waterford
Location: NMI (R.2916)
Dimensions: H. 76.5mm; W. 78mm
Weight: 311.10g
Material: brass[70]

DESCRIPTION

This is a solid brass crucifixion plaque depicting Christ wearing a long robe. This garment covers his arms and body and falls to above the ankles. The lower part of the garment is decorated with vertical bands of herringbone, it has ribbed sleeves, and is tied at the waist with a double-stranded belt in a large interlaced knot. Christ's arms are outstretched and are almost horizontal, although they do fall slightly from the shoulders. His legs are held slightly apart and the feet are turned outwards to either side. Christ's face is rounded and is in relative proportion to the rest of his body. He has long hair that falls to either side of his face and ends in an outward turning curl. He has oval eyes, a long thin nose, a slight mouth and a beard that splits into two outward curls.

Beneath Christ's right arm, Longinus is seen in profile in a crouched position, with his right leg tucked behind his left. He holds a spear diagonally across his body with his two hands, which are some distance apart on the shaft. The tip of the spear is held beneath Christ's armpit, while the butt of the spear ends near the bottom corner of the plaque. He is clad in a long robe to the knees, with vertical bands of herringbone decoration. His head is angled so that he is looking up

antiquities of animal materials and bronze in the museum of the Royal Irish Academy (Dublin, 1861), pp 466, 560–1, figs 353 and 457, nos 167 and 420. **69** *PRIA*, 39 (1931), 1–26 (p. 9); NMI, 1931:75 **70** See table 15.2.

towards Christ and his hair sweeps back from his forehead to end in a curl at his shoulder, with one strand curling in at the nape of his neck. An eye, nose and mouth are visible and he is also apparently bearded. Stephaton is beneath Christ's left arm and is in a similar position to Longinus. He is similarly clothed and has a similar hairstyle. He holds a cup on the end of a pole beneath Christ's armpit. The details of his face have been largely obliterated, although a nose and a pointed chin can be discerned. The hemlines of the two soldiers are in line with Christ's, although their feet are placed lower than his on the plaque.

Above Christ's arms on either side is a hovering angel. These are also seen in profile, each with its chin resting on one of its hands. This, the only arm represented, is, like Christ's arms, decorated with a ribbed effect. The details of their faces have been largely obliterated, although one can make out the noses in profile. They have long hair that sweeps back behind their heads and ends in a curl. Only one of their wings is depicted, which is pointed back and upwards at 45 degrees and is connected to their bodies by a spiral joint. Their legs are thrown behind them with one leg, in each case, touching Christ's hand and the other close to their wing.

There are four fixing holes at the cardinal points, one directly above and one directly below Christ and a further one on either side below his hands. The upper one is broken through. In addition, there are the remains of three copper nails in three smaller fixing holes, which are at three of the corners (table 15.5). The fourth corner, the top right one, has been damaged and so none survives here.

Feature	Cu	Sn	Zn	Pb	Ag
Nail right bottom	97.15	–	0.17	0.84	0.37
Nail left bottom	96.88	–	0.44	1.12	0.25
Nail left middle	97.03	–	0.20	0.89	0.36

Table 15.5. xrf analysis percentage results of copper nails on the Lismore Plaque (cat. no. 8).

HISTORY

Philip McEvansoneya recently discovered the provenance of this plaque while studying the Margaret Stokes papers preserved in the Royal College of Physicians of Ireland. There, he found a letter from John Underwood dated 14 August 1855 with a rubbing of the plaque stating that it had been 'recently discovered on the duke of Devonshire's estate at Lismore'.[71] This is undoubtedly the 'ancient casting in copper alloy, representing the crucifixion' that was bought by the RIA from John Underwood for £4 on 15 March 1856.[72]

71 Philip McEvansoneya, 'The provenance of a crucifixion plaque and a shrine figure', *Archaeology Ireland*, 27:2 (summer 2013), in press. 72 *PRIA*, 6 (1857), 314.

The cross at the heart of the Trinity: an Anglo-Norman development in art and theology

JOHN MUNNS

The representation of the Holy Trinity in the form of the *Gnadenstuhl* presiding over the Last Judgment in St Mary's Church at Houghton-on-the-Hill in Norfolk, where one would normally expect to find an image of Christ in majesty, is otherwise unknown (pls 27, 28).[1] In the later Middle Ages, the *Gnadenstuhl* image flourished to such an extent that Wolfgang Braunfels considered it to be *the* medieval form of the Trinity.[2] Prior to its discovery at Houghton in 1992, however, the *Gnadenstuhl* image was absent from extant English art before the thirteenth century, and unknown anywhere before the first quarter of the twelfth.[3] Since their discovery and restoration, opinions as to the age of both the lowest level of wall paintings at Houghton and the church they adorn have varied considerably. The most common estimate dates both the main building and the original scheme of paintings to the last quarter of the eleventh century, but the date is not universally accepted.[4] The difficulties of dating the work on the evidence of both the church's architecture and the paintings' style are outlined in the first part of this essay. As will be seen in the second part of the essay, however, the argument that the

1 See Tobit Curteis, 'St Mary's Church, Houghton on the Hill, Norfolk: conservation of the wall paintings' (unpublished report: Tobit Curteis Associates, 2006). I am grateful to Tobit Curteis for his assistance in sourcing the images in this essay. **2** W. Braunfels, *Die heilige Dreifaltigkeit* (Düsseldorf, 1954), pp xxxv–xxxviii. **3** *Lexikon der Christlichen Ikonographie*, ed. E. Kirschbaum et al. (8 vols, Freiburg, 1968–76), i, col. 535. **4** H.M. Taylor and J. Taylor, *Anglo-Saxon architecture* (2 vols, Cambridge, 1965), i, pp 325–6, suggest 1050–1100; N. Batcock, *The ruined and disused churches of Norfolk* (Norwich, 1991), suggests 1050–60; S. Heywood, 'The round towers of East Anglia' in J. Blair (ed.), *Minsters and parish churches: the local church in transition* (Oxford, 1988), pp 169–78 at pp 169–73, insists on a post-Conquest date; his conclusions are followed by the authors of the official guide to the church. R. Gem, 'The English parish church in the 11th and early 12th centuries: a great rebuilding?' in Blair (ed.), *Minsters and parish churches*, pp 21–30 at pp 22–5, outlines the dangers inherent in attempting to date minor churches on the basis of their style.

paintings should be assigned to the last decade of the eleventh century (or possibly the first decade of the twelfth) is given considerable weight by the scheme's unusual iconography. The final part of the essay shows how the appearance of an image of the *Gnadenstuhl* at Houghton in or around the late 1090s would relate to contemporary theological developments centred in the Anglo-Norman world.

I

The date of the church building at Houghton remains sufficiently ambiguous to be of limited use as a guide to the date of its earliest decoration. Stephen Heywood's contention is that the building of stone churches in East Anglia was a Norman introduction, and that no flint church should therefore be dated before the Conquest.[5] But while the predominant local tradition was indeed to build with timber as a result of the scarcity of local building stone, Heywood's use of Bury St Edmunds Abbey and North Elmham Cathedral to rule out the use of stone entirely by the Anglo-Saxons is far from conclusive: in an area where building stone is scarce, it would seem reasonable to assume that the larger the building project the less likely it would have been considered feasible to build in stone. The difficulty of constructing corners with flint, the only stone in ready supply, is then given as the reason for the regional preponderance of round towers (archaeological evidence shows that Houghton was originally one such round-towered church) – but no such difficulty seems to have prevented the construction of square-cornered naves.[6] A substantial scheme of church building across England was almost certainly underway before 1050 and if all the eleventh-century stone churches in East Anglia were built after 1066 the scale of the project was almost unfeasibly vast.[7] So, the possibility that the distinctive local tradition of stone churches with round towers may have begun well before the Conquest, even as early as the tenth century, must remain. With long-and-short work on the nave, Houghton also shows clear evidence of Anglo-Saxon building techniques. Yet, this cannot be taken as conclusive proof of age either: considering the scale of their projects, Norman patrons must have made use of native workmen. While it remains entirely possible, even probable, that Houghton dates from the late eleventh century, the possibility that more modest buildings, such as that at Houghton, were stone-built prior to the Conquest should not be too readily discounted.

If the architectural evidence remains inconclusive, the artistic is more so. Although the subject of the painting – the doom – on the east wall is exactly what would be expected, the details are unusual. Chief among the anomalies is the

5 Heywood, 'Round towers', pp 169–73. **6** K. Penn, *Reports on an archaeological evaluation at St Mary's Church, Houghton-on-the-Hill, North Pickenham, Norfolk* (Norwich, 2000 and 2001). **7** Gem, 'English parish church', p. 21.

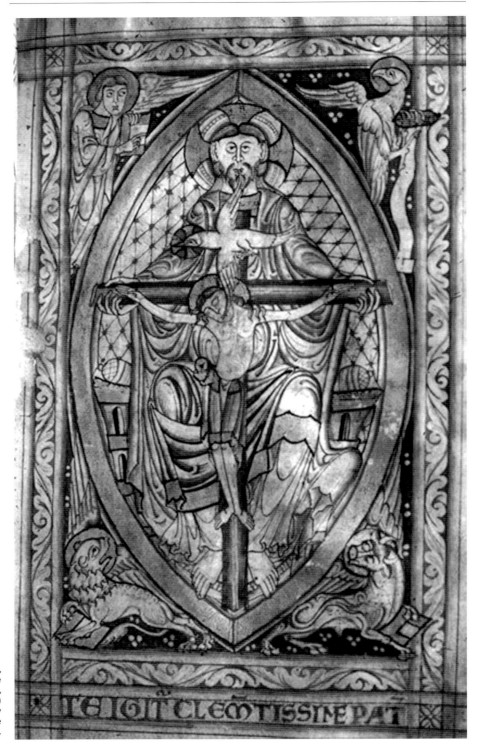

16.1 *Gnadenstuhl*, Cambrai, Bibliothèque Municipale, MS 234, fo. 2 (*c*.1125) (© image courtesy of Bibliothèque Municipale, Cambrai).

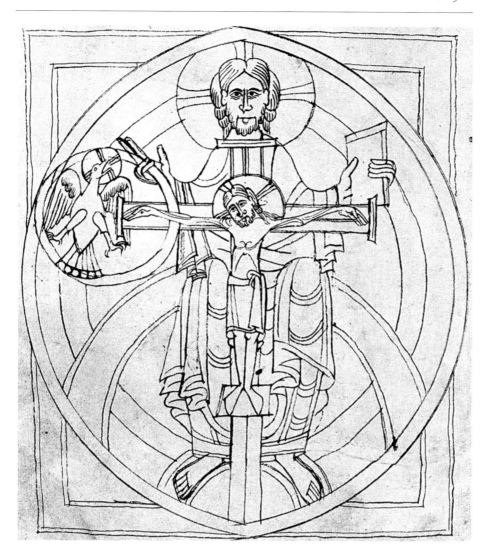

16.2 *Gnadenstuhl*, Perpignan, Bibliothèque Municipale, MS 1, fo. 2v (c.1125) (© image courtesy of Bibliothèque Municipale, Perpignan).

presiding *Gnadenstuhl*. Until the discoveries at Houghton, the earliest images of the *Gnadenstuhl* type were to be found in two manuscripts, the Cambrai Missal (fig. 16.1) and the so-called Perpignan Gospels (fig. 16.2) (both dated *c.*1125),[8] and fashioned in gilded copper plates to adorn a porphyry superaltar that probably originates from Hildesheim before 1132.[9] Of the three images, intriguingly, the

8 Cambrai, Bibliothèque Municipale, MS 234, fo. 2; Perpignan, Bibliothèque Municipale, MS 1, fo. 2v.
9 London, Victoria and Albert Museum, no. 10–1873; W.L. Hildburgh, 'A mediaeval bronze pectoral cross: contributions to the study of the iconography of the Holy Trinity and the cross', *Art Bulletin*, 14:2 (1932), 79–102, fig. 6. The superaltar is of particular interest, not only as the earliest example from Germany, but also in that the Son is alive and devoid of nails or wounds and that it appears to show all three persons of the Trinity on the cross, with the Father supporting the body of the Son, rather than the cross. Hildburgh suggests that it may represent an important stage in a

16.3 Detail of the Houghton *Gnadenstuhl*, showing the Holy Spirit in the form of a dove (image courtesy of Tobit Curteis Associates LLP).

Perpignan manuscript (which may originate from the Catalan abbey of Saint-Michel de Cuxa) most resembles that at Houghton in that the dove representing the Holy Spirit flies above the Father's right hand (fig. 16.3), whereas both the Cambrai Missal and the Hildesheim superaltar depict the dove between the heads

probably German development of Trinitarian crucifixion imagery culminating in the *Gnadenstuhl* – but then has difficulty accounting for its appearance in the Perpignan Gospels by the 1120s. He was writing, of course, long before the discovery of the wall paintings at Houghton.

16.4 Detail of the east wall of St Mary's Church, Houghton-on-the-Hill, showing the company of heaven surrounding the *Gnadenstuhl* (image courtesy of Tobit Curteis Associates LLP).

of the Father and Son, connecting their lips. The Houghton image is depicted within a triple mandorla amid a sea of adoring heads, all nimbed (fig. 16.4). Across the centre of the image there is a scroll but, like the scrolls held by other figures, it appears never to have contained a text. Much of the scheme is obscured and vague, but the large Trinity seems to be flanked by two ranks of full-length figures in niches, probably three per rank on either side. Below, a band of twelve roundels display half-length figures holding scrolls: seemingly Christ and five saints to the north and six demons to the south. Below this, angels announce and witness the general resurrection to the north of the chancel arch, and it can be assumed that the descent to hell would have been portrayed opposite it on the south. There is clear evidence of an Anglo-Saxon hand, most obviously in the quatrefoil on the Father's knee, but also in the long almost flipper-like hands of many of the figures that recall, for example, the sculptured feet of Christ preserved on a stone *suppedaneum* at Muchelney in Somerset.[10] Yet the paintings are hardly reminiscent of the sketchy, linear late Anglo-Saxon style common in eleventh-century manuscript illumination, instead finding their closest stylistic relative in the Athelstan Psalter of the second quarter of the tenth century (fig. 16.5).[11] It seems almost unthinkable that the Houghton images could be so early, but the parallels are

10 *Corpus of Anglo-Saxon stone sculpture, VII: south-west England*, ed. Rosemary Cramp, John Higgitt, B. Worssam and R. Bristow (Oxford, 2006), pp 171–2; E. Coatsworth, 'Late pre-Conquest sculptures with the crucifixion' in Barbara Yorke (ed.), *Bishop Æthelwold: his career and influence* (Woodbridge, 1988), pp 161–93 at p. 175, pl. IVd. 11 London, BL, MS Cotton Galba A.XVIII, fo. 21r.

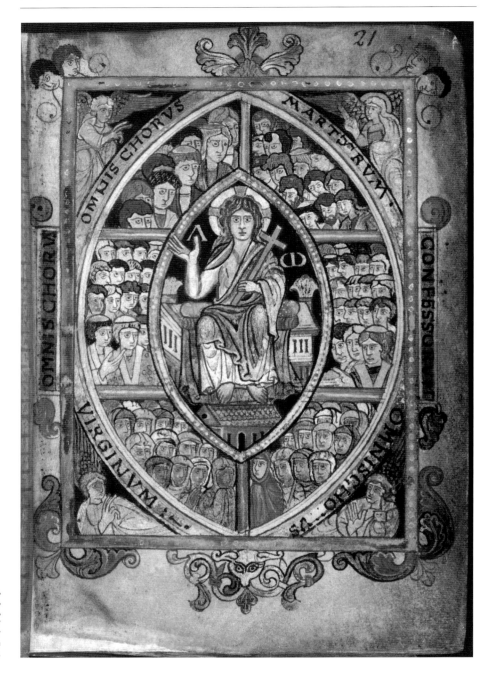

16.5 Christ in Judgment, London, British Library, Cotton MS, Galba A.XVIII, fo. 21r (© image courtesy of the British Library Board, Cotton MS, Galba A.XVIII, fo. 21r).

striking. Almost all the figures are beardless; their faces are round and full with thick, neat heads of hair formed from blocks of colour. Noses and eyes are drawn simply with single lines; mouths are turned down, sombre and dignified. Most strikingly of all, in both cases the central mandorla floats on a sea of holy faces, a

feature that was not to reappear more generally until the mid-1100s.[12] The Houghton faces are also similar in style to perhaps the only example of English wall painting agreed to have survived from the first half of the tenth century: the fragment of a face discovered in Winchester in 1966.[13]

Many of these features, however, may as easily derive from the influence of Ottonian art as the court of Athelstan. The cross on which Christ hangs has distinctive splayed ends that might readily be compared to those of the magnificent Ottonian metalwork crosses of the late tenth century, such as the Lothar Cross in Aachen Cathedral Treasury (pl. 25a, b).[14] Furthermore, where Athelstan shows Christ in majesty, Houghton has the Throne of Grace, and where Athelstan has a single mandorla with pointed ends common to the Anglo-Saxons, Houghton substitutes the rounded triple mandorla, more readily associated with Romanesque art. The eyes of the figures both in Athelstan and at Winchester have staring, centrally placed pupils, whereas in those at Houghton the pupils touch the top line of the eye giving a slightly hooded effect, again more reminiscent of later work. While the sketchier, linear, windswept style had come to dominate Anglo-Saxon manuscript illumination by the eleventh century, there is considerable evidence that the creators of wall paintings, for which the sketchier style was perhaps less appropriate,[15] continued to reflect Ottonian influence into the twelfth, as evidenced, for example, in elements of the substantial schemes remaining at Clayton in Sussex, of around 1100, and, to a lesser extent, Kempley in Gloucestershire, c.1130–40.[16] Yet, even here there is some room for debate. C.R. Dodwell and David Park both emphasize the Anglo-Saxon influence in the 'Lewes Group' of wall paintings to which Clayton belongs (the others being Hardham, Coombs, Westmeston and Plumpton), with Dodwell explicitly comparing the Christ in Judgment at Clayton with that of the Athelstan Psalter.[17] While

12 Admittedly, such a 'sea of faces' itself proves little, also appearing, for example, *inter alia* and in a rather different style, in the crucifixion scene in London, BL, MS Cotton Nero C. IV (Winchester Psalter), fo. 22. **13** R. Rosewell, *Medieval wall paintings in English and Welsh churches* (Woodbridge, 2008), p. 8, fig. 6. **14** These splayed cross ends can be seen in two Anglo-Saxon manuscript illuminations from the end of the tenth century: Paris, BN, MS lat.943 (Sherborne Pontifical), fo. 4v, and New York, Morgan Library, MS 869 (Arenberg Gospels), fo. 9v. These too have been linked to contemporary Ottonian metalwork, offering a possible route for the form of the Houghton cross: Barbara C. Raw, *Anglo-Saxon crucifixion iconography and the art of the monastic revival* (Cambridge, 1991), p. 113. The style continues into the eleventh century, appearing in London, BL, MS Stowe 944 (New Minster *Liber Vitae*) and on the Brussels Cross; J. Backhouse, D.H. Turner and L. Webster, *The golden age of Anglo-Saxon art, 966–1066* (London, 1984), nos 62, 75. **15** For an example of where it has survived in wall painting, however, see the angels at Nether Wallop of c.1000; Rosewell, *Medieval wall paintings*, fig. 8. **16** The scheme in the chancel at Kempley bears comparison with that over the chancel arch at Houghton. Kempley has roundels similar to those at Houghton, although much larger, above the altar and comparable full-length figures in niches on the north and south walls of the chancel. Christ sits in majesty in the centre of the chancel ceiling within a triple mandorla. The style of the images at Kempley, however, is unambiguously Romanesque. **17** C.R. Dodwell, *The pictorial arts of the West, 800–1200* (New Haven, CT, 1993), p. 324; D. Park,

conceding Ottonian influence in some of the iconography, he describes the paintings at Hardham as 'simply Norman'. Dodwell's observations notwithstanding, it seems to me that stylistic similarities between the monumental schemes at Clayton and German schemes, particularly those of the Reichenau school at, for example, Oberzell St Georg (tenth/eleventh century) and Niederzell SS Peter and Paul (early twelfth century), cannot be ignored.[18] The debate, meanwhile, only serves to highlight the difficulties of delineating the strands of influence at work in the artistic productions of Anglo-Norman England.

Despite the temptation to claim an earlier date, therefore, and the recognition that it remains a possibility, the balance of the evidence, architectural, iconographical and stylistic, suggests that Houghton-on-the-Hill represents the collaboration of Anglo-Saxon and Norman craftsmen sometime in the last two decades of the eleventh century, producing early evidence of an emerging 'Anglo-Norman' style. The fact that it appears in Houghton, not a place of great significance even in the eleventh century, would suggest that it was well established in eastern England by that time, regardless of its context.[19] The fact, however – unique as far as surviving English art is concerned – that it replaces Christ in majesty at the centre of the Last Judgment might point to a further significance still.[20]

II

Around the same time as Houghton Church was probably being built, the new Norman bishop of East Anglia, Herbert de Losinga (d. 1119), moved his see from Thetford to Norwich and, in either 1094 or 1095, founded Norwich Cathedral Priory, for which he chose the site of the Church of the Holy Trinity.[21] The

'Anglo-Saxon or Anglo-Norman? Wall paintings at Wareham and other sites in southern England' in Sharon Cather, David Park and Paul Williamson (eds), *Early medieval wall painting and painted sculpture in England* (Oxford, 1990), pp 225–47. **18** Dodwell, *Pictorial arts*, pls 117, 296. **19** The Domesday Book entry for Houghton-on-the-Hill is extremely brief; *Little Domesday*, fo. 232r. It was leased by one Herluin from Reynold, son of Ivo and supported just one free man. The leased land covered sixteen acres and was worth 16*d*. One Wihenoc then appropriated it from its pre-Conquest owners. Herluin [also FitzIvo] was probably Reynold's brother and Wihenoc [of Burley] Reynold's maternal grandfather, through whom Reynold inherited the manor of Houghton: see K.S.B. Keats-Rohan, 'Some corrigenda', http://users.ox.ac.uk/~prosop/domesday-people-corrigenda.pdf (accessed 18 Aug. 2008). **20** The *Gnadenstuhl* appears 'in majesty' in the apse in Danish church art from the mid-twelfth century. Examples survive at Fjelie (1150–75), Bjäresjö (1200–25) and Östra Hoby (1250–1300), all in the diocese of Lund (now Sweden but then part of Denmark), but none of these is a Last Judgment scene. **21** B. Dodwell, 'Herbert de Losinga and the foundation' in I. Atherton (ed.), *Norwich Cathedral: church, city and diocese, 1096–1996* (London, 1996), pp 36–44 at p. 41; E. Fernie, *An architectural history of Norwich Cathedral* (Oxford, 1993), p. 22. Francis Blomefield attributes the addition of the Holy Trinity to the Marian dedication of the church at Thetford to Herbert's predecessor Arfast, but provides no evidence and his account contains so many errors that this can probably be safely discounted: F. Blomefield, *An essay towards a topographical history of the*

dedication was transferred to the new cathedral, the foundation stone of which Herbert inscribed *In nomine patris et filii et spiritus sancti amen. Ego Herbitus episcopus apposui istum lapidem.*[22] It is also worth recalling that Norwich had close connections to the abbey of Fécamp in Normandy.[23] Herbert was probably schooled at Fécamp and rose to become prior there before moving to England to accept the abbacy of Ramsey, and then the see of Thetford. His abiding affection for his Norman abbey is revealed in the letters of his later years and his new cathedral priory was to use Fécamp's liturgy.[24] The relationship was still strong as late as the 1170s when a relic of the Holy Blood was sent to Norwich from Fécamp.[25] Fécamp also played an important role in William the Conqueror's propaganda war surrounding his invasion of England. The manor of Steyning in Sussex had been given to Fécamp by Edward the Confessor, but was subsequently seized by King Harold. Before setting sail for Hastings, Duke William confirmed Edward's grant and vowed to make it good in the forthcoming invasion, swearing his oath on a knife.[26] The abbey at Fécamp, a symbol of God's favour for the Norman invasion and at which the first bishop of Norwich had been prior, was also dedicated to the Holy Trinity. The Trinitarian dedications of the two churches most closely associated with Herbert might well have provided the motive for the privileging of Trinitarian imagery in the ecclesiastical refurnishing of his diocese, an undertaking described by one commentator as having the character of 'episcopal imperialism'.[27] The suggestion here is that Herbert's ecclesiastical refurnishing provides the most likely context for the replacement in the Last Judgment scene at Houghton of the usual image of the enthroned Christ Judge with an innovative image of the Holy Trinity. If accurate, this would push the date of the Houghton paintings towards the end of the century, at least to post-date Herbert's consecration in 1090 or 1091 and, more probably, that of the cathedral's foundation in 1094 or 1095.

If so, it may be that Fécamp played a central role in the dissemination, if not the development, of the *Gnadenstuhl* image. At the turn of the eleventh century, the Abbaye de la Trinité de Fécamp had been the site of the rejuvenation of Norman manuscript illumination after the Gregorian Reform movement arrived there with the appointment of William of Volpiano as abbot in 1001. Subsequently,

county of Norfolk (2nd ed., London, 1805).　**22** O.E. Saunders, *A history of English art in the Middle Ages* (Oxford, 1932), p. 50; B. Dodwell, 'The foundation of Norwich Cathedral', *Transactions of the Royal Historical Society*, 5:7 (1957), 1–18; on the foundation of the cathedral, see also Dodwell, 'Herbert de Losinga and the foundation'.　**23** N. Vincent, *The Holy Blood: King Henry III and the Westminster blood relic* (Cambridge, 2001), p. 70, n. 129.　**24** Herbert of Losinga, *Life, letters and sermons*, trans. E.M. Goulbern and H. Symonds (2 vols, London and Oxford, 1878), i, pp 64–6; D. Wollaston, 'Herbert de Losinga' in Atherton (ed.), *Norwich Cathedral*, pp 22–35 at p. 23; Dodwell, 'The foundation of Norwich Cathedral', 8.　**25** Vincent, *The Holy Blood*, p. 70.　**26** *Regesta Regum Anglo-Normannorum, 1066–1154*, ed. H.W.C. Davis (Oxford, 1913), i, p. 1.　**27** N. Batcock, 'The parish church in Norfolk in the eleventh and twelfth centuries' in Blair (ed.), *Minsters and parish*

it was the scriptorium at Fécamp that first absorbed both Anglo-Saxon and Ottonian influences into what had been left of the 'crumbs from the table of Carolingian art'.[28] The genesis of the *Gnadenstuhl* has been traced to the Ottonian court, and to the reverse of the Lothar Cross of *c*.980–1000, the similarity of whose shape to the cross at Houghton has already been mentioned, and on which a beautiful crucifixion is engraved in silver-gilt.[29] Above the low-hung, slightly twisted body of Christ reaches down the *manus dei*, but instead of blessing, the hand is holding a laurel wreath, in the centre of which is the Holy Ghost in the form of a dove.[30] The crucifixion image is explicitly Trinitarian. We remain in the realm of speculation, but one possibility is that the *Gnadenstuhl* image can be traced from Houghton, through bishop Herbert of Norwich, to the stylistic melting-pot at the abbey of the Holy Trinity at Fécamp, at which it had been adopted, either fully developed or in its infancy, from late tenth-century artistic developments in the Ottonian court. There is, however, a second possibility. The precise elements of the Lothar Cross crucifixion image – the crucified Christ, the *manus dei* and the dove with laurel wreath – have already appeared in the *Te igitur* initial of a mid-eleventh-century English missal from Sherborne Abbey (pl. 29).[31] The existence of the Sherborne miniature attests to the presence of such explicitly Trinitarian crucifixion imagery, almost certainly of the same Ottonian derivation, in England before the Conquest and raises the possibility that its development into the *Gnadenstuhl* came from native inspiration.

Among the many uncertainties, some safe conclusions can be drawn. The *Gnadenstuhl* image on the east wall of Houghton Church is the earliest extant example of the type, and its appearance there is entirely compatible with its long-assumed origin as a derivation of Ottonian iconography, mixed with Carolingian and Anglo-Saxon traditions in either northern France or southern England over

churches, pp 179–90 at p. 188. **28** Dodwell, *The pictorial arts*, p. 191. **29** *Lexikon der Christlichen Ikonographie*, i, col. 353. **30** Other examples of Trinitarian crucifixion imagery from Germany in the last quarter of the tenth century include the Psalter of Elizabeth of Hungary and a bronze pectoral cross in the Victoria and Albert Museum: see Hildburgh, 'A medieval bronze pectoral cross', pp 83–4. **31** Cambridge, Corpus Christi College, MS 422, p. 53; E. Temple, *Anglo-Saxon manuscripts, 900–1066* (London, 1976), no. 104; Rebecca Rushforth, *St Margaret's Gospel Book: the favorite book of an eleventh-century Queen of Scots* (Oxford, 2007), p. 53. The unusual sprouting tau-cross in the image finds models in both Carolingian and Ottonian art, an ivory plaque in the Walters Art Gallery (no. 71.142) being an example of the former and Munich, Bayerische Staatsbibliothek, Clm. 6421, fo. 33v, containing an example of the latter. It is also worth noting the early appearance in England of a type of Trinitarian image that may not be entirely unconnected from the *Gnadenstuhl* and that is otherwise not found until German and Byzantine examples from the late twelfth century, in which the enthroned Father holds the Son in his lap – but the Christ child rather than the crucified. The Holy Spirit is present in the form of the dove as in the *Gnadenstuhl*. The image appears in the full page miniature of fo. 1 of the Harley Psalter (London, BL, MS Harley 603) and then again, in modified form, in Vienna, Nationalbibliothek, Supp gr.52, fo. 1v; New York, Morgan Library, MS Pierpont 711, fo. 136r; and Fulda, Landesbibliothek, MS A.a.32, fo. 170r.

the previous decades and intensified in East Anglia after 1066. From close to the date of its development, the *Gnadenstuhl* image of the Trinity, with the crucifixion at its heart, was familiar if not to the people of England as a whole, then at least to those of her wealthiest and most densely populated county. Too often there is a desire to ascribe work of the late eleventh century to the hands of either Anglo-Saxons or Normans. In truth, patronage and the making of manners lay in Norman hands; the majority of the available artisan workforce must have been native Anglo-Saxons, employed, perhaps, under the watchful eye of an immigrant master. By the 1090s, young artists could have grown up familiar with both traditions, and Anglo-Saxon pupils may well have served as a Norman master's apprentice. The result, as evidenced at Houghton-on-the-Hill, is a style in which elements of both traditions remain. In time, in England as elsewhere, late eleventh-century style would evolve into a more recognizable Romanesque; at this point, however, there seems none more properly deserving of the name Anglo-Norman.

After Houghton, the *Gnadenstuhl* image disappears from English artistic record until the early thirteenth century, when we find it in a glossed psalter now in Liverpool and, in an adapted and unusual form, in a psalter now belonging to Trinity College, Cambridge.[32] The intervening century or more, however, attests to images that may relate to the *Gnadenstuhl*. In one, the cross appears to be depicted alongside images of the sun and a dove in an unusual Trinitarian image above the south door at Beckford Church in Gloucestershire. A second, which appears in Germany at the end of the eleventh century and is known in English manuscript illumination by the middle of the twelfth, is that of the cross being presented to Christ in Judgment in a formal arrangement strikingly reminiscent of the Throne of Grace. Such an image can be found in both the Pembroke Gospels and the Winchester Psalter, as well as in the Last Judgment scene of a French Christ-cycle probably made in the region of Corbie around 1175 and now in the Morgan Library in New York (pl. 30).[33] In this last image, which contains no accompanying text, Christ's torso is bare and his five wounds flow with blood. Around the enthroned figure is a sea of faces, the pupils of their eyes made by a single dot touching the line of the upper lid; above and below, angels announce

32 Liverpool, City Libraries, MS f.091.PSA, fo. 192b; N.J. Morgan, *Early Gothic manuscripts (I)*, *1190–1250*, A survey of manuscripts illuminated in the British Isles, 4 (London, 1982), no. 25. Cambridge, Trinity College, MS B.11.4, fo. 172 depicts the *Gnadenstuhl* but with the face of the Father obscured by a quatrefoil and with enemies prostrate below his feet in reference to the text of Psalm 109, to which the miniature refers. Writing before the discovery of Houghton-on-the-Hill, George Henderson tentatively identifies this as the earliest English example of the *Gnadenstuhl* image; G. Henderson, *Studies in English Bible illustration* (London, 1999), ii, pp 29–30 (the essay was first published in A. O'Connor and D.V. Clarke (eds), *From the Stone Age to the 'Forty-Five': studies presented to R.B.K. Stevenson* (Edinburgh, 1983)). **33** Cambridge, Pembroke College, MS 120, fo. 6v; London, BL, MS Cotton Nero C.IV, fo. 22; New York, Morgan Library, MS M.44, fo. 15.

the Judgment with trumpets; the centrally placed cross has splayed ends. The point should not be made strongly – there are many stylistic differences as well as perhaps a century of time to separate them – but there are elements of the Morgan image that recall elements of that at Houghton. The Last Judgment is not the only miniature to contain unusual iconography in the Morgan manuscript, and the scope of the cycle would seem to be unparalleled in France, causing Walter Cahn to relate it explicitly to the English cycles of the St Alban's Psalter and the Pembroke Gospels, and their Ottonian antecedents.[34] Such images can then be related to other depictions of Christ in majesty in which the empty cross is present, especially those, such as in the Winchester Bible or on an Anglo-Saxon ivory plaque in Cambridge,[35] in which the cross is presented by angels below the mandorla of the enthroned Christ and those, such as on the tympanum at the cathedral at Conques, where the angels seem to be lowering the cross into position behind the throne. None of these images is Trinitarian; rather, all depict Christ in Judgment, but it is precisely in the position in which we would expect to find a depiction of Christ in Judgment that the *Gnadenstuhl* image first appears, at Houghton. All these images contain the common elements of an enthroned divine figure, judgment and the centrally placed and presented cross.

An early common ancestor may be found in Rome, in the apse mosaic of the church of Santa Pudenziana. Here, an enthroned divine figure sits in judgment, flanked by the apostles; behind his throne a massive bejewelled cross stands on top of a hill, recalling that set up by Constantine (*c*.272–337) on the alleged site of Golgotha.[36] This is one of the earliest surviving images of the cross in Western art, dating to the end of the fourth or beginning of the fifth century and, for its age, the most magnificent.[37] The lowest section of the mosaic was removed during alterations to the building in 1711, but it is preserved in a sketch by Ciacconio of 1595 that shows it to have depicted the Agnus Dei and the dove of the Holy Ghost.[38] As it survives, the Santa Pudenziana mosaic appears, at first sight, to be an image of Christ in Judgment, but Frederic Schlatter has made a convincing case for it representing instead the Trinity in the heavenly Jerusalem.[39] The case still stands even if, as is probable, the now-destroyed lower images were not part of the original scheme, but a later amplification of the original Trinitarian intention by means of more familiar iconography. Dated by Schlatter to 410–17, and by others

34 W. Cahn, *Romanesque manuscripts: the twelfth century* (2 vols, London, 1996), ii, pp 157–8.
35 Winchester Cathedral Library, MS 1, fo. 1; for the ivory, which is housed in the University of Cambridge's Museum of Archaeology and Anthropology, see J. Beckwith, *Ivory carvings in early medieval England* (London, 1972), no. 18. **36** Egeria, *The diary of a pilgrimage*, ed. and trans. G. Gingras (Mahwah, 1970), p. 110. **37** Although for extant evidence of crucifixion images as early as the third century, see Harley McGowan, this volume, esp. n. 19. **38** F.W. Schlatter, 'Interpreting the mosaic of Santa Pudenziana', *Vigiliae Christianae*, 46:3 (1992), 276–95 at 286.
39 Ibid., 286–91.

as early as 390, the image's Trinitarian subject matter can be seen to reflect the recent dogmatic statements of the Council of Constantinople of 381.[40] Santa Pudenziana, then, provides an early Roman authority for the iconographic triumvirate of enthroned figure, cross and dove as representative of the Holy Trinity that, by the late eleventh century appear in the *Gnadenstuhl* image on the east wall of a small Norfolk parish church. This is not to suggest a direct connection; merely to make the point that the essential elements of a cross-bearing Trinitarian image that seems to appear from obscurity in eleventh-century England have a long and authoritative history, as do those featuring the cross beside the throne of Judgment.

By the middle years of the twelfth century, the *Gnadenstuhl* was appearing at the great abbey of Saint-Denis in Paris in various adapted forms.[41] An image that depicts the crucified Son held by the enthroned Father, but omits reference to the Holy Spirit, appears in one of Abbot Suger's windows; and a version of the *Gnadenstuhl* in which the place of the crucified Christ is taken by the image of the Lamb of God presides over the portico of the main west door. This latter image is reflective of a tension that seems to run through the Christological iconography of the period in England as well as France. For, although the image of the crucified Christ increasingly dominates the religious imagination, the image of the Lamb of God – an image which manages to refer simultaneously to sacrifice and resurrection – continues to provide a popular alternative. In both the iconography of the apse mosaic of Santa Pudenziana and the related scheme in the basilica at Fundi, the Lamb appears alongside the empty cross in a double reference to the Son, as though for the early Church even the image of the empty cross was not sufficiently victorious to represent the risen Christ alone.[42] For much of the twelfth century, the transition from the resurrection to the crucifixion as the site of salvation and the focus of the story of redemption remained incomplete, and the remaining tensions are reflected in the art. As will be seen in the final section of this essay, however, the emergence of the *Gnadenstuhl* image, and the theological insights it presupposes, attest to an early stage of that transition belonging to the religious imaginations of the artists and churchmen of the Anglo-Norman realm.

40 Ibid., 286. **41** On the iconography of Saint-Denis, especially the importance of Trinitarian imagery (among which we might tentatively include the three-nail crucifix), see L. Grodecki, 'Les Vitraux allégoriques de Saint-Denis', *Art de France*, 1 (1961), 19–46; P.L. Gerson, 'Suger as iconographer: the central portal of the west façade of Saint-Denis' in P.L. Gerson (ed.), *Abbot Suger and Saint-Denis: a symposium* (New York, 1986), pp 183–98; P. Binski, *Becket's crown: art and imagination in Gothic England, 1170–1300* (New Haven, CT, and London, 2004), p. 20. **42** Fundi is modern-day Fondi, in Lazio. The mosaic no longer exists but can be reconstructed from a description by Paulinus of Nola (Ep. 32); see G. Hellemo, *Adventus Domini: eschatological thought in fourth-century apses and catecheses* (Leiden, 1989), pp 90–7; Schlatter, 'Interpreting the mosaic', 278,

III

Theologically, the implication of the *Gnadenstuhl* is that the sacrificial death of the Son of God lies at the heart of the divine life, not merely as an event in time but, in some mysterious way, as an eternal reality. Such a suggestion is far from obvious, and the seemingly slow progress of the *Gnadenstuhl*'s growth in popularity might reflect a reticence in some quarters to embrace its implications, as might the lethargic acceptance of the theological vision of St Anselm of Canterbury (1033–1109), to which it can be seen to relate. Anselm's Trinitarian theology was for the most part a recapitulation of St Augustine's, with distinction arising largely from Anselm's need to incorporate the theory of the atonement in his seminal treatise *Cur deus homo*. He does this precisely by positing the death of the Son of God as inevitable in the sense that, from all eternity, the Son, sharing the Father's immutable will for the salvation of humanity by just means, willed to die.

Anselm's theory, as presented in *Cur deus homo*, was the first systematic attempt to explain *how*, rather than *that* the death of Christ brought humanity to atonement with God.[43] The first Christian millennium offered no such attempt. Based on passages such as Mk 10:45,[44] earlier theologians had posited a theory that the death of Christ constituted some sort of ransom payment for the wages of sin (usually considered, problematically, to be a payment due to the devil rather than God); but none had sought to work this through in detail.[45] Neither had any attempt been made to establish this or any other theory in dogmatic terms. Anselm's dialogue, crucially, addressed and so brought to the fore an important question that was beginning to trouble the minds of believers.[46] Put all-too-briefly, Anselm argued that in order for God to be perfectly just, he could not simply write off the affront to his goodness that was human sin: the crime demands

287, n. 40. **43** D.W. Brown, 'Anselm on atonement' in B. Davies and B. Leftow (eds), *The Cambridge companion to Anselm* (Cambridge, 2004), pp 279–302 at p. 280. An influential history of the doctrine of the atonement is F.W. Dillistone, *The Christian understanding of atonement* (Philadelphia, 1968). **44** 'For the Son of Man came not to be served but to serve, and to give his life a ransom for many'. **45** See, for example, Gregory of Nyssa's *Oratio catechetica*, in which he develops ideas found in Origen and Irenaeus. The idea of Christ acting in a substitutionary (but not penal substitutionary) way is not entirely new either, it too stretches back through the Fathers to the Bible (for example, Is 53:10) but it was never previously worked through. For a different view that considers Anselm to have radically misunderstood the ransom theory (which on his view is more appropriately called 'Christus victor'), see G. Aulén, *Christus victor: an historical study of three main types of the idea of atonement*, trans. A.G. Hebert (London, 1931). **46** That *Cur deus homo* was written in response to concerns raised by others, notably Anselm's student Boso (d. 1136), who gives his name to Anselm's interlocutor in the dialogue, is made explicit. Increased contact with Jewish and Islamic critics of Christian doctrine, especially of the idea of the death of the Son of God, should be seen as contributing to the concern and they, rather than proto-atheists, can be assumed to be the 'unbelievers' to whom Anselm's work is addressed.

satisfaction. But there are two problems. One is that as well as being perfectly just, God is also perfectly merciful and perfectly loving. The second is that even if the perpetrators (humanity) were to attempt to right the wrong, their inherent imperfection would make it impossible for them to atone for their rejection of God's perfect gift; any attempt at restitution by sinful humanity would, by definition, be imperfect, and so inadequate to the task. So, God's justice demands satisfaction from humanity but his mercy, and their sinfulness, makes that satisfaction impossible for them to offer. The solution, as Anselm sees it, is that God becomes incarnate and sacrifices himself (as the fully incarnate, but still sinless Son) to himself (as the perfectly just Father), so to speak. Thus, the defining moment in the economy of salvation takes place not in the tomb, when the dead Son is raised again to life, but on the cross, when the sinless Son is offered as an atoning sacrifice to the Father.

Anselm describes his treatise as a response to the horror of non-believers (*infideles*) at notions or images of this incarnate and suffering God. Such notions, Anselm has Boso contend, are 'beautiful ... and should be seen like pictures', leading one commentator to note that *Cur deus homo* is essentially a treatise about 'images and their rationale'.[47] Anselm's essentially teleological argument revolves around the issue of beauty, which he considers to be the same as the issue of necessity: that which is necessary is that which is beautiful.[48] A useful alternative, following David Brown, is to talk about that which is 'fitting'.[49] Jesus' death, Anselm contends, was impossible for him not to will, not because of any external constraint, but because God's just and loving nature makes it necessary (fitting) that he would freely will to make such a sacrifice, which was necessary (fitting) in turn in order for God's mercy to accord with his justice.[50] The crucifixion, no matter how horrific, thereby becomes a thing of beauty; and its image something of a sacrament of the transfiguration of the bad by the Good. According to this theory, the foreknowledge of the necessity of the Son's sacrifice, and the will to make it, if not the death itself (this point remains ambiguous in Anselm), are present eternally and immutably in the divine Trinitarian life.[51]

Cur deus homo itself was not completed until the turn of the twelfth century, but Anselm had been teaching and discussing it for some time. A number of its

47 *Cur deus homo*, 1.4; M.B. Pranger, 'The mirror of dialectics: naked images in Anselm of Canterbury and Bernard of Clairvaux' in D.E. Luscombe and G.R. Evans (eds), *Anselm: Aosta, Bec and Canterbury* (Sheffield, 1996), pp 136–47 at p. 136. 48 Although Anselm's concept of necessity with regard to God absolutely rules out any hint of external constraint, so he prefers to talk of God's own 'eternal constancy'; *Cur deus homo*, 2:10; see Brown, 'Anselm on atonement', p. 284. 49 Brown suggests, characteristically, what might be termed 'aesthetic considerations', which he traces both to Plato (through Augustine) and, more ingeniously, to Paul (Rom 5:19); Brown, 'Anselm on atonement', p. 285. 50 *Cur deus homo*, ii, pp 16–17; see also J. Hopkins, *A companion to the study of St Anselm* (Minneapolis, MN, 1972), pp 162–4. 51 Further clarified by Anselm in his final work, *De Concordia*, 2.2, in which, following Boethius, he argues that God's foreknowledge is not

ideas are anticipated by Goscelin of Saint-Bertin as early as the 1080s and again by
Gilbert Crispin, abbot of Westminster, in 1092 or 1093.[52] It is possible that
Goscelin, and certain that Gilbert, had discussed the ideas contained in the treatise
with Anselm a decade or two before he wrote them down. By the time of the
development of the *Gnadenstuhl* image, and its production in East Anglia, it is
entirely likely that Anselm's theory was well known, at least among the Anglo-
Norman clerical elite. The sacrifice of the cross, for Anselm, indeed lies at the heart
of the Trinity, and something of this vision of the God who, for his own sake,
could not but sacrifice his incarnate Son, is encapsulated artistically above the
chancel arch of the little Norfolk church at Houghton-on-the-Hill. As Anselm's
theological vision gained ground over the century after his death so, it would seem,
did the artistic images for which it might provide a theological rationale.

I want to end with a footnote. By the beginning of the thirteenth century, the
English artistic milieu had produced another Trinitarian image that, like the
Gnadenstuhl, would become increasingly popular in English (and to a lesser extent,
French) art during the later Middle Ages. The *scutum fidei*, or Shield of Faith,
probably developed from early twelfth-century attempts to represent complex
theological notions diagrammatically.[53] Its invention has been credited by some to
Robert Grosseteste (*c*.1175–1253), due to its appearance in a manuscript of his
dicta written shortly before 1231.[54] In fact, by then it was probably well estab-
lished: a fully formed version in an English copy of Peter of Poitiers' *Compendium*
can be dated to between 1208 and 1216 (pl. 31).[55] On either account, the earliest

really foreknowledge as it stands outside time (and is thereby compatible with human free will).
52 Goscelin of Saint Bertin, *The book of encouragement and consolation [Liber confortatorius]*, trans.
Monika Otter (Woodbridge, 2004), pp 57–60; see also, Raw, *Anglo-Saxon crucifixion iconography*, p.
171. In 1079, Anselm first visited Canterbury, the same year that Goscelin was forced to leave
Sherborne and 'wander the land for a long time', during which he stayed at a variety of Benedictine
monasteries (Goscelin, *The book of encouragement*, p. 26). Anselm was heavily involved in a dispute
about the veneration of Anglo-Saxon saints, a subject on which Goscelin was a leading authority; it
is tempting to speculate as to whether they met at this point. Later, during Anselm's archiepiscopate,
Goscelin lived in Canterbury and was to dedicate one of his last works to Anselm. Gillian Evans has
also observed that elements of his theory had been in the air for some time; G.R. Evans, *Anselm and
a new generation* (Oxford, 1980), pp 140–1. **53** See, for example, Cambridge, St John's College,
MSS E.4, fo. 153v (twelfth century) and D.11, fo. 38v (early thirteenth century), copies of the
Dialogi of Petrus Alfonsi (*fl.* 1106–26). Petrus, a Spaniard, lived in England *c*.1112–20.
54 Durham Cathedral, MS A.III, fo. 14v; S. Lewis, *The art of Matthew Paris in the* Chronica majora
(Aldershot, 1987), p. 195; Binski, *Beckett's crown*, p. 182. **55** London, BL, Cotton MS, Faustina
B.VII, fo. 43v. This section of the composite manuscript can be dated with some certainty to before
the death of Innocent III in 1216; Morgan, *Gothic manuscripts*, no. 43(b); W.H. Monroe, 'A roll-
manuscript of Peter of Poitiers' *Compendium*', *Bulletin of the Cleveland Museum of Art*, 65 (1978),
92–107 at 97. Lewis implies in her main text that Grosseteste's image is the original, but then
acknowledges the existence of this earlier example, without further comment, in a note; Lewis, *The
art of Matthew Paris*, pp 195, 494, n. 118. The earlier example shows a three-nail crucifix; whereas
the later illustration by John of Wallingford (who should not be confused with the earlier abbot of
St Albans of the same name), which like the text of the manuscript is probably by John's own hand,

extant examples of the *scutum fidei*, as with the *Gnadenstuhl*, are English. By the mid-thirteenth century, the shield appears again in a manuscript by John of Wallingford (d. 1258) and again in Matthew Paris' *Chronica Majora*, where it is given as the arms of God.[56] In later medieval reproductions of the shield, the Son is placed in the upper right corner, with the Holy Spirit ('proceeding from both the Father and the Son') at the bottom. These earlier English examples, however, all place the Son at the base, to emphasize his descent to earth, and three of them insert an image of the crucifixion (or, in the case of Matthew Paris, a plain cross) in the lower part of the shield between the words *filius* and *deus*. While the crucified Christ then disappears from subsequent versions, it seems worthy of note that for about a half-century from the latter years of our period of study, the symmetry of a peculiarly English Trinitarian image was interrupted in order to insert a representation of the death of the Son of God into its midst.

shows four.　**56** London, BL, Cotton MS, Julius D.VII, fo. 3v; Cambridge, Corpus Christi College, MS 16II, fo. 49v.

Antelami's Deposition at Parma: a liturgical reading

ELIZABETH C. PARKER

The complexity of the symbolism of Benedetto Antelami's Deposition is unmatched in any surviving representation of the subject in the twelfth century (fig. 17.1). This marble relief measures 110 by 230 by 7cm (c.43 by 90 by 3 in.) and is now lodged at eye level in the west wall of the south transept of the cathedral of Santa Maria Assunta in Parma. An inscription above the cross arm gives us a date of 1178 and the name of the sculptor 'who completed the work'.[1] The relief's original location, as one of several elements on a pulpit and/or a choir screen, has been hotly debated.[2]

[1] To the left are two rather cramped verses: *Anno milleno centeno septvageno octavo scvltor patravit mense secvndo*; to the right is the concluding hexameter: *Antelami dictvs scvltor fvit hic benedictvs*. Giuseppa Z. Zanichelli, cat. no. 16, in *Benedetto Antelami*, Catalogo delle opere, ed. Arturo Carlo Quintavalle, Arturo Calzona, and Guiseppa Zanichelli (Milan, 1990), pp 349–52. For translations of the inscription, see also Gianni Capelli, *La 'Deposizione' di Benedetto Antelami con Breve Guida Fotografica del Duomo de Parma* (Parma, 1980), pp 13–14; Moritz Woelk, *Benedetto Antelami: Die Werke in Parma und Fidenza* (Münster, 1995), pp 57–8, n. 153. For their substantial help with this study, I thank Madeline Caviness, Dorothy F. Glass, Charles T. Little, Katharina Schüppel, Maria Wenglinsky and Giuseppa Z. Zanichelli, as well as Nathan Bahny of Fordham University's Quinn Library, Linda Seckelson and Meg Black of the Metropolitan Museum of Art's Watson and Lehman Libraries. [2] For a damaged Majesty relief, three of four capitals, and four lions as column bases, see Zanichelli, cat. nos 17, 18a–c and 19a–d, in *Benedetto Antelami*, ed. A.C. Quintavalle, A. Calzona and G. Zanichelli, pp 352–5; Woelk, *Benedetto Antelami*, pp 80–94. For a history of the debate over the relief's location, see Zanichelli, cat. no. 16, pp 349–52. See further Woelk, *Benedetto Antelami*, pp 94–98, n. 286; Arturo Calzona, 'Lo spazio presbiteriale dal tempo dell'Antelami fino al 1417' in *Basilica Cattedrale di Parma: Novecento anni di arte, storia, fede*, I, ed. Arturo Carlo Quintavalle (Parma, 2005), pp 185–209; Fabrizio Tonelli, 'Architettura e spazio liturgico nella cattedrale di Parma da Benedetto Antelami alla fine del medioevo' in *Vivere il Medioevo: Parma al tempo della Cattedrale*, ed. Ivana Di Stefano (Milan, 2006), pp 52–70; Manfred Luchterhandt, *Die Kathedrale von Parma: Architektur und Skulptur im Zeitalter von Reichskirche und Kommunebildung* (Munich, 2009), pp 49–55.

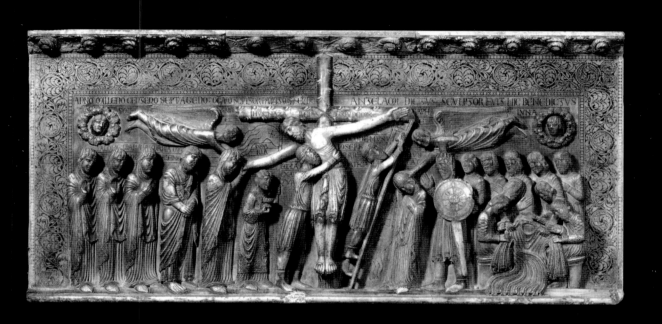

17.1 The Deposition. Benedetto Antelami (fl. 1150–1230), Duomo, Parma, Italy (image courtesy of Scala/Art Resource, New York).

As is frequently noted, but not really explained, the Parma relief includes not only elements typically drawn from crucifixion iconography in a representation of the Descent from the Cross, but also distinctive features that are unique to this representation. Joseph of Arimathea not only embraces Jesus' body, he kisses it. Mirroring Joseph in costume and headgear, as well as the direction of his sloping stance, Nicodemus mounts the second step of a ladder to remove with a now-missing implement the nail from Jesus' left hand that is still attached to the cross arm. Its truncated branches signify that the cross is characterized as the Tree of Life. Along the cross arm, rather than on a titulus, is the inscription *Iesus Nazarenum Rex Iudaeorum*. Carved inscriptions abound, identifying nearly all the figures. In clipeate wreathes, in the upper corners, are the heads of the sun and moon. John the Evangelist, noticeably barefoot, stands to the left behind Mary. The presence of the mourning figures of Mary and John is standard for evolving representations of the Descent from the Cross as they were developed in the West from Byzantine models beginning in the Carolingian period, although John is more typically positioned to the right of the cross.[3] There are many elements that

3 For analysis of deposition types, see Gertrud Schiller, *Iconography of Christian art*, trans. Janet Seligman (2 vols, Greenwich, 1971), ii, pp 164–8, figs 543–58; Bernd Schälicke, 'Die Ikonographie

go beyond this basic formulation, however. While angels are not unknown to either the deposition or the crucifixion, unique to this composition are the actions of the archangels, identified as Gabriel and Raphael. Here, Gabriel flies down to place Christ's freed right hand gently against Mary's cheek. The downward slope of Gabriel's right arm links him visually to the smaller scale figure of Ecclesia standing before Mary. Personifications of Ecclesia and Synagogue are frequent in crucifixion images since the Carolingian period, but here Ecclesia, holding a chalice in her right hand and in her left a banner etched in the background, wears liturgical garb and is not crowned. Her triumph – *Ecclesia exaltatur* – counters the defeated Synagogue with her broken banner etched in, standing to the right. Synagogue holds her right hand to her crowned head, which is pushed down toward the cross – *Sinagoga deponitur* – by the archangel Raphael. Byzantine crucifixions sometimes show this motif, but the angel is usually a half figure who pushes Synagogue away from the cross not toward it.[4]

Gabriel floats horizontally above Mary, John and the first of the three veiled female figures standing behind John. Mary Magdalen with 'Salome' and 'Maria Jacobi' are not out of place in a crucifixion or a deposition, but they mainly appear in the resurrection image of their Easter encounter with the angel at the empty tomb. Behind Synagogue stands a bearded soldier holding a sheathed sword projecting down from a shield, around the central boss of which is inscribed *centurio*. The centurion's raised right hand indicates his words, inscribed to the left of Raphael's extended right arm: *Vere iste filius Dei erat* (Mt 27:54). Five unidentified witnesses stand behind him and behind four seated soldiers depicted as gambling for Christ's seamless tunic that lavishly spills onto the lower frame. This scene of the gambling for the cloak, unusual even in crucifixions in Italian art, occupies fully one quarter of the foreground space. The other three sides of the relief are framed by lush foliate designs that amplify the life-giving sense of the Tree of Life cross, the only element to penetrate any part of this border.[5] This feature of foliate patterning, made to look like niello work and framed by a beaded border, together with the engraved banners of Ecclesia and Synagogue, add a component of metalwork to the composition, which is unusual, even for Antelami.[6]

der monumentalen Kreuzabnamegruppen des Mittelalters in Spanien' (PhD, Berlin, 1975), pp 61–97; Elizabeth C. Parker, *The descent from the cross: its relation to the extra-liturgical 'depositio' drama* (New York, 1978), pp 1–42. **4** Bianca Kühnel, 'The personifications of Church and Synagogue in Byzantine art: towards a history of the motif', *Jewish Art*, 19–20 (1993–4), 112–25; Mary-Louise Thérel, 'L'origine de la thème de la Synagogue rèpudiée', *Scriptorium*, 25 (1975), 285–92. See also Nina Rowe, *The Jew, the cathedral and the medieval city: Synagoga and Ecclesia in the thirteenth Century* (Cambridge, 2011), ch. 2, esp. pp 74–6, fig. 16 (Synagoga pushed by angel at Saint-Gilles du Gard). **5** Willibald Sauerländer, 'Benedetto Antelami: Per un bilanco critico' in *Benedetto Antelami e il Battistero di Parma*, ed. Chiara Frugoni (Turin, 1950), p. 15. For the meaning of foliate design, see Kirk Ambrose, 'Ornament as history' in *The nave sculpture of Vézelay: the art of monastic viewing* (Toronto, 2006), pp 60–5. **6** Sauerländer, 'Benedetto Antelami', pp 14–15. For the foliate

The projecting cornice along the top is decorated with fourteen three-dimensional rosettes, the middle section of four clearly more worn with signs of having been broken off.

Theologically, Antelami's choice of a deposition over a crucifixion emphasizes the *Christus patiens*.[7] Tied to the evolving Eucharistic doctrine of the Real Presence of Christ, the source of the image in the West lay in the liturgical reform movement in the imperial court of Charlemagne, and the theological debates in the writings of Paschasius Radbertus and Ratramnus, monks at the monastery of Corbie. Paschasius' 'identification of the human, physical body of Christ with the body in the Eucharist' would become institutionalized in the dogma of Transubstantiation at the Fourth Lateran Council in 1215.[8] The arresting physicality of Christ's body, and Joseph's embrace, are reflective of the increasingly emotional intensity of the Christocentric piety that developed in the course of the eleventh and twelfth centuries.[9] Chief among the early proponents of this approach in Italy was Peter Damian, schooled in Parma, renowned ascetic, and later a strong voice for reform in the papal courts from 1049 to 1072, at the time of the renewed debate over the meaning of the Eucharist between Berengar of Tours and Lanfranc of Bec.[10] The distinctive shift in style seen in Antelami's remarkably sensitive

border on a metalwork portable altar, see *Matilde e il tesoro dei Canossa tra castelli, monasteri e città*, ed. Arturo Calzona (Milan, 2008), cat. no. 22 (Michele Luigi Vescovi), pp 426–7. **7** Schälicke, 'Die Ikonographie', pp 77–97, traces this theme in the development of the deposition in the West and post-iconoclastic East from the ninth century. For the theme in crucifixion imagery, see Celia Chazelle, *The crucified God in the Carolingian era: theology and art of Christ's Passion* (Cambridge, 2001), pp 239–99. **8** Jaroslav Pelikan, *The Christian tradition: a history of the development of doctrine*, 3: *The growth of medieval theology (600–1300)* (Chicago, 1978), pp 184–204; Chazelle, *The crucified God*, pp 209–38. For the dogma of Transubstantiation proclaimed at Lateran IV in 1215, see Norman P. Tanner, *Decrees of the ecumenical councils* (London, 1990), i, p. 230. For discussion of the theology of the Real Presence in an Irish context, see Boyle, this volume. **9** Michal Kobialka, *This is my body: representational practices in the early Middle Ages* (Ann Arbor, MI, 1999; repr. 2002), pp 101–45; Sandro Sticca, 'The literary genesis of the Latin Passion play and the *Planctus Mariae*: a new Christocentric and Marian theology' in *The medieval drama*, ed. Sandro Sticca (New York, 1972), pp 39–67. For the relationship of Paschasius' theory of Real Presence and the Gero Cross, see Annika Elisabeth Fisher, 'Cross altar and crucifix in Ottonian Cologne: past narrative, present ritual, future resurrection' in *Decorating the Lord's Table: on the dynamics between image and altar in the Middle Ages*, ed. Søren Kaspersen and Erik Thunø (Copenhagen, 2006), pp 43–62. For an eleventh-century instance of personal piety, see Jane E. Rosenthal, 'An unprecedented image of love and devotion: the crucifixion in Judith of Flanders' Gospel Book', *Tributes to Lucy Freeman Sandler: studies in illuminated manuscripts*, ed. Kathryn A. Smith and Carol H. Krinsky (London, 2007), pp 21–36. For discussion of the physicality of Christ's body in a late antique context, see Harley McGowan, this volume. **10** Rachel Fulton, *From Judgment to Passion: devotion to Christ and the Virgin Mary, 800–1200* (New York, 2002), pp 89–106; Carla Bino, *Dal trionfo al pianto: la fondazione del teatro della misericordia nella Medioevo (V–XIII secolo)* (Milan, 2008), pp 151–61 (Peter Damian). For the eleventh-century controversy between Berengar of Tours and Lanfranc of Bec, see Pelikan, *The Christian tradition*, 3, pp 184–204, and Margaret T. Gibson, *Lanfranc of Bec* (Oxford, 1978), pp 63–97. See also Dorothy F. Glass, *The sculpture of reform in north Italy, c.1095–1130:*

rendering of Christ's body in its human corporeality represents the artistic response to the evolving Eucharistic devotion that developed in the 'long' twelfth century.[11] In considering the importance of Antelami's Deposition, it is worth noting the comparative novelty of the theme in twelfth-century Italy, especially in monumental form.[12] Antelami's depiction of the *Christus patiens* not only fulfils a singular expressive need in this composition, but it also relates on a deeper level to contemporary theological issues.

Antelami's relief thus begs other fundamental questions as to the nature of this image: does its monumentality serve a particular devotional and sacramental context here?[13] Can a Eucharistic context explain the superposition of the deposition on a crucifixion image? The deposition in itself would allow a focus on the Good Friday liturgy, but the incorporation of elements of a crucifixion image require the more encompassing sacramental context of the Mass within the rituals publicly performed in Holy Week.[14] While the composition as a whole defies a single explanation, the liturgical context is certainly the primary one.

What signals a sacramental context in the first place is its distinctly ceremonial cast: the figures of the Marys and John aligned behind the Virgin to Christ's right and the anonymous witnesses behind the centurion to his left. Their solemn, focused presence suggests their participation in a public liturgical performance, removed from a narrative representation of the event. Indeed, the distinctly ceremonial cast suggests the individual roles assigned to various members of the clergy and the laity in the allegorical interpretation that dominated the understanding of

history and patronage of Romanesque façades (Farnham, 2010), pp 91–3, n. 34. For Anselm of Canterbury in relation to the deposition on the mid-twelfth-century English Cloisters Cross, see Elizabeth C. Parker and Charles T. Little, *The Cloisters Cross: its art and meaning* (New York, 1994), pp 176–84. **11** See Lawrence Nees, 'On the image of Christ crucified in early medieval art' in Michele Camillo Ferrari and Andreas Meyer (eds), *Il Volto Santo in Europa: Culto e immagini del Crocifisso nel Medioevo. Atti del Convegno internazionale di Engelberg (13–16 settembre 2000)* (Lucca, 2005), pp 345–83; Gerhard Lutz, *Das Bild der Gekreuzigten im Wandel: Die sächsischen und westfälischen Kruzifixe der ersten Hälfte der 13. Jahrhunderts* (Petersberg, 2004), pp 29–39. It is hoped that Thomas E. Dale's stimulating discussion of this point in a talk at Columbia University in February 2009, 'Romanesque sculpture and the multi-sensory experience of the sacred', will soon be published. I thank him for letting me read his text. The increased naturalism is frequently attributed to Antelami's having seen the west portal sculpture at Chartres: Arturo Carlo Quintavalle, 'Ile de France, Provenza, Antico: Benedetto a Parma, Anselmo a Modena' in *Benedetto Antelami*, ed. A.C. Quintavalle, A. Calzona and G. Zanichelli, pp 47–82. **12** For a twelfth-century corpus from the Pisa Duomo, the earliest of the wood deposition figures from central Italy, see Antonio Caleca, 'I gruppi toscani' in *La Deposizione lignea in Europa: L'immagine, il culto, la forma*, ed. Giovanni Sapori and Bruno Toscano (Milan, 2004), pp 325–37, fig. 1. For an eleventh-century one, see Robert Didier, 'Une descente de croix sculptée mosane du XIe siècle: a propos du Christ de l'ancienne "Curva Crux de Louvain"' in ibid., pp 423–48. For twelfth-century Spain, see Schälicke, 'Die Ikonographie' and *Romanesque Art in the MNAC Collections*, ed. Manuel Castiñeiras and Jordi Camps, with Joan Duran-Porta (Barcelona, 2008), figs 103, 104, 106, 108, 111. **13** For detailed discussion of the importance of a sculptural image for devotional impact, see Bacci, this volume. **14** For analysis of the earliest evidence of the Good Friday liturgy, see Van Tongeren, this volume.

the medieval Mass.[15] The origin of this systematic interpretation is in Book Three of the *De officiis ecclesiasticis*, a treatise written by Bishop Amalarius of Metz for Louis the Pious in the early 820s.[16] In casting the Mass as a 'rememorative allegory […] depicting the life, ministry, crucifixion and resurrection of Christ', Amalarius' treatise, a synthesis of learned commentaries of both the Eastern and Western traditions, was the model for subsequent interpretations into the twelfth century and later.[17] A close reading of Antelami's image against Amalarius' text is fundamental to an understanding of much of what the sculptor has chosen to include in his composition. It provides, in particular, an explanation for the Deposition in a Eucharistic context, and for certain elements unique to his composition: the role of Ecclesia, the presence of the Marys, the position of John, and Joseph's kiss of Christ's body.

Antelami's image focuses on the prayer following the consecration that begins *Nobis quoque peccatoribus*, when, according to Amalarius, Christ, 'the second Adam', already crucified, is 'sleeping with his head inclined on the cross'.[18] At this moment, Amalarius explains, the celebrant assumes the role of the centurion who bears witness to Christ's divinity on seeing the blood and water flow from his side: 'Indeed, this was the Son of God.'[19] At the prayer's concluding words, *Per omnia seculorum*, the celebrant, now in the role of Nicodemus, elevates the host and then, together with the archdeacon, as Joseph of Arimathea, elevates the chalice. Rather than the crucifixion, that action, which became known as the 'little elevation', represents the Descent from the Cross, as O.B. Hardison explained.[20] By the

15 Josef A. Jungmann SJ, *The Mass of the Roman rite: its origins and development (Missarum Sollemnia)*, trans. Francis A Brunner (2 vols, New York, 1950), i, pp 86–118; O.B. Hardison Jr, *Christian rite and Christian drama in the Middle Ages: essays in the origin of modern drama* (Baltimore, MD, 1969), pp 36–41. **16** Allen Cabaniss, *Amalarius of Metz* (Amsterdam, 1954), pp 50–2. *Amalarii Episcopi Opera liturgica omnia*, ed. Jean-Michel Hanssens (3 vols, Rome, 1948–50). **17** Hardison, *Christian rite and Christian drama*, p. 44. For Amalarius' sources, see especially Hardison, *Christian rite and Christian drama*, p. 36, n. 5, p. 43, n. 21; Jungmann, *The Mass*, i, pp 87–8. It is not without interest that Abbot Peter of Nonantola accompanied Amalarius on his visit to Constantinople in 813: Cabaniss, *Amalarius of Metz*, pp 33, 112. Schälicke ('Die Ikonographie', pp 107–9) traces the various allegorical interpretations based on Amalarius from the ninth to the twelfth century. **18** *De his sacramentis dicit Agustinus in sermone LXV super Iohannem: […] 'Hic secundus Adam, inclinato capite, in cruce dormivit, ut inde formaretur ei coniux, quod de latere dormientis defluxit'* (Hanssens, *Amalarii*, ii, p. 344). Indeed, 'sleeping', more than 'suffering', best describes the face of Antelami's Christ. **19** *Coniux ista illum centurionem signat, de quo narratur in evangelio: **Videns autem centurio quod factum erat, glorificavit Deum dicens: Vere hic homo iustus erat** [Luke 23, 47]. Nisi futurum esset ut sacramento sanguinis et aquae inficeretur gentilitas, non ilico se centurio mutaret ad tantam compunctionem, ut aperte clamaret ex intimo cordis affectu: Vere hic homo iustus erat. Hanc mutationem designat sacerdos per mutationem vocis, quando exaltat vocem, dicendo: 'Nobis quoque peccatoribus'* (Hanssens, *Amalarii*, ii, pp 344–5). **20** Hardison, *Christian rite and Christian drama*, p. 70. *Hunc Ioseph ad memoriam ducit archidiaconus, qui levat calicem de altari, et involvit sudario, scilicet ab aure calicis usque ad aurem. Sicut ille diaconus primatum tenet inter ceteros diaconos, qui levat calicem cum sacerdote, ita iste Ioseph tenuit inter ceteros discipulos, qui meruit corpus Domini de cruce deponere, et sepelire in monumento suo; […] Sacerdos qui elevat oblatam, praesentat*

beginning of the thirteenth century, this liturgical moment would be eclipsed by the introduction of the Elevation of the Host at the consecration in the later medieval Mass.[21] But for Amalarius, and ostensibly for Antelami, the 'little elevation' was still the preeminent one.[22] As Antelami has depicted it, the centurion as celebrant bears witness to the source of the sacraments. Nicodemus holding up Christ's left arm is the celebrant when he elevates the host.[23] Joseph of Arimathea and Nicodemus removing Christ's body from the cross together represent the deacon and the celebrant at the elevation of the chalice. That Antelami's Ecclesia, holding a chalice, wears a dalmatic suggests that she participates in this liturgical moment.[24] According to Amalarius, the replacement of the chalice on the altar represents the entombment: the subdeacons, who accompany the archdeacon and the celebrant, take the part of the holy women who assist at the burial. He specifies, however, that since it is Joseph who actually takes the body of the Lord from the cross, it is the deacon, and not the subdeacons, who takes the chalice from the altar.[25]

Bishop Sicard of Cremona, an interpreter of the Mass more contemporary to Antelami, describes the 'little elevation' in his *Mitralis de officiis* of *c.*1200 in terms very similar to Amalarius. '*Per omnia sęcula sęculorum* is said in a loud voice', he explains,

Nichodemum, de quo narrat Iohannes [19.39–40 ...] Christi depositionem de cruce monstrat elevatio sacerdotis et diaconi (Hanssens, *Amalarii*, ii, pp 346–7). For the 'little elevation', see also Jungmann, *The Mass*, ii, pp 265–72; Thomas Drury, *Elevation in the Eucharist: its history and rationale* (Cambridge, 1907). I thank Fr Allan Fitzgerald of Villanova University for this reference. For his linking of the Deposition to Amalarius' interpretation of the Mass and the 'little elevation', see Schälicke, 'Die Ikonographie', pp 106–13. **21** Hardison, *Christian rite and Christian drama*, pp 64–5, Jungmann, *The Mass*, i, pp 118–21; ii, pp 207–12. Schälicke ('Die Ikonographie', p. 114) associates the introduction of the 'great elevation' with Bishop Maurice de Sully of Paris (1196–1208). See 'The elevation' in *Catholic Encyclopedia* (www.newadvent.org/cathen, accessed 22 Aug. 2010). Édouard Dumoutet, *Le désir de voir l'hostie: les origins de la devotion au Saint-Sacrement* (Paris, 1926), pp 49–53. **22** Schälicke, 'Die Ikonographie', pp 110–15. Schälicke ('Die Ikonographie', p. 117) suggests that the emphasis on the living Christ in the Eucharist caused the decline in the use of the deposition in this context, especially after the transition to the 'great elevation' where the deposition had no symbolic role. For the idea that the more expressive panel paintings forced the obsolescence of the wood groups, see Pietro Scarpellini, 'Le Deposizione dalla croce lignee nell'Italia centrale: osservazioni e ipotesi' in *La Deposizione lignea*, ed. Sapori and Toscano, pp 353–4. On the representation of *Christus patiens* as both living and dead, see Nees, 'On the image of Christ crucified', pp 355–9; see Woelk, *Benedetto Antelami*, pp 65–6. **23** Although in the visual tradition Nicodemus is the secondary figure, for Amalarius, who identifies him as 'he who at first came to Jesus by night' (Jn 19:39: a reference to Jn 3:1–2), Nicodemus is the celebrant. Antelami makes him identical to Joseph, only slightly smaller. **24** For Ecclesia's dalmatic, see the thirteenth-century image of St Eugenius in the treasury of Sant'Eustorgio in Milan, and Joseph Braun, *Die liturgische Gewandung im Occident und Orient* (Freiburg-im-Breisgau, 1907), pp 261–70, fig. 123: thirteenth-century seal in the cathedral treasury at Mainz; *Dictionnaire d'Archéologie chrétienne et de liturgie* (Paris, 1907–53), 4:1, pp 111–19 (Henri Leclerq). **25** *Tamen ipsae non susceperunt corpus Domini de cruce, sed Ioseph: sicut nec subdiaconi, sed diaconi, suscipiunt calicem de altari* (Hanssens, *Amalarii*, ii, p. 353). Amalarius, citing Matthew 27:55–6, names those whom Antelami depicts: Mary

as when the Lord gave up his spirit in a loud voice, and when the centurion cried out, *Vere Filius Dei erat iste*, and when the women, weeping, mourned their Lord. [...] At the words *Per omnia sęcula sęculorum*, the deacon, who lifts up the chalice and then puts it down on the altar, represents Joseph of Arimathea, who received the body of the Lord from the cross. The priest who elevates the host represents Nicodemus.

Sicard goes on to say that 'the deacon who kisses the priest's shoulder hints at the fact that Joseph in putting down the body, kissed it [...] The priest also kisses the host, meaning that Nicodemus did what Joseph did, and that through the Passion of the Lord, our reconciliation was made'.[26] In Antelami's relief, Joseph's kiss is a potent sign of the assurance of reconciliation for the believing viewer

Shifting from the Mass performance in general to the particular context for Antelami's Deposition, Maundy Thursday's Mass commemorating the Last Supper is arguably a primary context for the relief. Bernd Schälicke pointed to the special relevance of the deposition allegory and the 'little elevation' for Maundy Thursday's Mass, the climax of the liturgy of reconciliation for the day that marks the end of Lent.[27] All that we know of Parma's liturgy comes from the *Ordinarium Ecclesiae Parmensis* of 1417.[28] What specifically applied to Parma liturgically in 1178 has to be extracted from this early fifteenth-century document when set beside the twelfth-century Roman pontifical, along with contemporaneous liturgical commentaries in the tradition of Amalarius, such as Sicard of Cremona's *Mitralis*, often cited by the *Ordinarium*'s nineteenth-century editor, Luigi Barbieri.[29]

Parma's *Ordinarium* provides few details of Lenten liturgies, but capitals associated with Antelami's relief depicting the Fall of Adam and Eve and their

Magdalene, Mary mother of James ('the less' and Joseph), and Salome, the mother of the sons of Zebedee (James 'the great' and John). See also Mk 15:40, 47; Mk 16:1. **26** See n. 25, above. Sicard of Cremona, *Mitralis de officiis* (Turnhout, 2008), iii, 6, pp 198–9: *Per omnia sęcula sęculorum, alta voce tradidit spiritum, tum quia centurio clamavit:* **Vere filius Dei erat iste**; *tum quia mulieres lamentabantur flentes Dominum (759–63) [...] Per omnia sęcula sęculorum, diaconus calicem sublevat (769); [...] et post in altari deponit [...] significans Joseph ab Arimathia, qui corpus Domini de cruce suscepit (770) [...] Sacerdos qui oblatam elevat Nichodemum repręsentat, et hęc eleuatio Christi depositionem de cruce, depositio uero collocationem in sepulchro demonstrat. Diaconus, qui sacerdotis humerum osculator, innuit, quod Joseph deponens corpus ipsum fuerit osclatus (773–7) [...] Sacerdos etiam hostiam osculatur, innuens quod Nichodemus idem fecerit quod Joseph, uel potius per Domini passionem factam esse nostram reconsiliationem (779–82).* I thank Maria Wenglinsky for help with this and other Latin translations. See also Schälicke, 'Die Ikonographie', pp 108–9. **27** Schälicke, 'Die Ikonographie', pp 122–3, 128–9. **28** *Ordinarium Ecclesiae Parmensis e vetustioribus excerptum reformatum anno MCCCCXVII*, ed. L. Barbieri (Parma, 1866). **29** Michel Andrieu, *Le pontifical romain au moyen âge*, I: *Le pontifical romain du xii siècle* (Vatican City, 1938), pp 3–19 (his essay, 'Les origines du pontifical romain'); *Le pontifical romano-germanique du dixième siècle* (le texte avec utilization des collations laissées par M. Andrieu), ed. Cyrille Vogel and Reinhard Elze (Vatican City, 1963–72). As he does frequently throughout the *Ordinarium*, Barbieri (for example, p. 128, n. 3) cites Amalarius and Sicard of Cremona, as well as later Mass commentaries, including Guillelmus

expulsion from Paradise capture the traditional themes of alienation and penance related to Ash Wednesday.[30] By the twelfth century, the dispensation of ashes tended to be publicly administered to the congregation as a whole, a demonstration of growing ecclesiastical authority over the sacrament of penance at that time.[31] The *Ordinarium* gives a rather full account of the reconciliation rites in the Maundy Thursday ceremonies, allowing us to try to visualize aspects, important to the relief, of the ritual space within Parma's cathedral, which has been vastly altered since Antelami's time.[32] Early in the day, the bishop leads a procession of all the clergy to the door of the cathedral. There, he blesses the penitents, who prostrate themselves at his feet. The clergy, together with the penitents, then process to mid-nave, where, after a sermon by the bishop, the again-prostrate penitents are censed with holy water. The procession continues to the choir, where the bishop begins the Mass at the high altar and then assumes his seat in the middle of the choir.[33] Parma's one Mass for the day includes the blessing of three holy oils placed in the chapel of St Agatha, and the reservation of two consecrated hosts, placed in the sacristy.[34] For the community of penitents, however, the high

Durandus' *Rationale divinorum officiorum*. **30** *Ordinarium*, pp 124–8. For Adam and Eve capitals, see Zanichelli, cat. no. 18a, b in *Benedetto Antelami*, ed. Quintavalle, Calzona and Zanichelli, p. 353. Hardison, *Christian rite and Christian drama*, pp 97–109; on the liturgy of Ash Wednesday, see *Dictionnaire de théologie Catholique*, 12:1 (Paris, 1933), cols 904–6 (Émile Amann). **31** For the practice of general dispensation of ashes, see Pierre Gy, 'L'histoire liturgique du sacrement de penitence', *La Maison Dieu*, 56 (1958), 7–21 (pp 16–18). Compare O.K. Werckmeister, 'The lintel fragment of Eve at Saint-Lazare, Autun', *JWCI*, 35 (1972), 1–30 (pp 17–21). See also André Vauchez, 'Pénitents' in *Dictionnaire de Spiritualité ascétique e mystique, doctrine et histoire*, ed. Marcel Viller (Paris, 1984), xii, cols 1011–14; Paul Anciaux, *The sacrament of penance* (Worcester, 1962), pp 74–87; Schälicke, 'Die Ikonographie', pp 134–7; Kobialka, *This is my body*, pp 180–3. **32** *Ordinarium*, pp 128–37; Andrieu, *Le pontifical romain*, pp 214–26. For analyses of the choir area described in the *Ordinarium*, see n. 2, above, and especially Arturo Carlo Quintavalle, 'Per un pulpito di Benedetto Antelami' in *La Cattedrale di Parma e il romanico europeo*, I. *Il Romanico Padano* (Parma, 1974), pp 345–51; Calzona, 'Lo spazio presbiteriale', pp 185–209; Tonelli, 'Architettura e spazio', pp 52–70; Luchterhandt, *Die Kathedrale von Parma*, pp 52–3, nn 82–93. **33** *Ordinarium*, pp 131–2. The phrase *et sedet ante litterile in medio chori, ubi sit paratus papilio* appears to refer to the wooden chair placed near the high altar when the bishop officiated: see Tonelli, 'Architettura e spazio', p. 56. The marble cathedra installed in the centre of the apse (Tonelli, fig. 4.I (a) and Luchterhandt, *Die Kathedrale von Parma*, fig. 34) is dated 1210–20: see Zanichelli, cat. no. 31 in *Benedetto Antelami*, ed. Quintavalle, Calzona and Zanichelli, p. 370. **34** *Ordinarium*, pp 132–4. For three Masses originally on Maundy Thursday (the Mass of Remission, the *Missa chrismalis* and a third for the reservation of the Host), see Hardison, *Christian rite and Christian drama*, pp 118–27. At Parma, two hosts were reserved (and the kiss of peace prohibited): *Ordinarium*, p. 134. Each of the oils – for the sick, for the catechumens and for the chrism – was carried in separate processions to the independent chapel of St Agatha on the south side of the cathedral. For the door leading to it in the sixth bay of the south aisle, see Luchterhandt, *Die Kathedrale von Parma*, p. 375, fig. 334; compare Tonelli, 'Architettura e spazio', pp 59, 66, figs 8(1), 19; and Massimo Fava, 'Il complesso episcopale parmense tra tarda antichità e medioevo: dalla basilica paelocristiana alla cattedrale romanica' in *Vivere Il Medioevo*, pp 71–88 (p. 79, fig. 7): door in sixth bay of south aisle. The sacristy, in which the reserved hosts were kept, Tonelli ('Architettura e spazio', p. 56, fig. 4.I A) locates south

point is the bishop's granting of general absolution.[35] Ecclesia's appearance in clerical robes, holding up the chalice, in Antelami's relief would seem to emphasize the strengthened ecclesiastical authority of the Church, and therefore of the bishop, through the sacrament of the Eucharist.[36] The officiating bishop in 1178 was Bernardo II, who surely had a strong hand in the relief's commission.[37]

The unique depiction of Gabriel gently placing Christ's blessing right hand on the Virgin's cheek was singled out by Bernd Schälicke as demonstrating her role as participant in the work of redemption and, through her powerful example of devotion to Christ, her role as mediator for penitents.[38] By the intimate linking of Gabriel to the Virgin here, Antelami at the same time juxtaposes the idea of her being chosen to open the way for redemption at the Annunciation.[39]

The decision to show the interaction of Gabriel and the Virgin affirms the liturgical importance of the feast of the Annunciation, which was celebrated in Parma on 25 March and thus usually fell within the Lenten season. This date not only marked the beginning of the calendar year but also the anniversary of Christ's crucifixion; occasionally the movable feast of Good Friday would coincide.[40] As famously performed in Parma's cathedral in the fifteenth century, the *Ordinarium*

of the apse, but notes that the first mention of it was in 1226. See also Giuseppa Z. Zanichelli, 'Le cappelle Rusconi e Ravacaldi e le Sagrestie della Cattedrale di Parma nel XIV e XV secolo', *Aurea Parma*, 78:1 (1994), 3–25. **35** *Ordinarium*, p. 132; Hardison, *Christian rite and Christian drama*, pp 118–19; Andrieu, *Le pontifical romain*, i, pp 215–20. **36** See n. 24, above. For a discussion of the twin phenomena of the twelfth century (the Church's institutionalization of the reception of the Eucharist and the sacrament of penance to which it is tied), see Emile Amann, 'Pénitence', *Dictionnaire de Spiritualité*, xii, cols 970–4; Kobialka, *This is my body*, pp 197–216. For the reformulation of the idea of the primacy of the Roman Church in the eleventh century, see J.T. Gilchrist, 'Humbert of Silva-Candida and the political concept of *Ecclesia* in the eleventh-century reform movement' *Journal of Religious History*, 2 (1962), 13–28. **37** P. Bertolini, 'Bernardo', *Dizionario Biografico degli Italiani*, 9 (Rome, 1967), pp 250–4. Along with Antelami's Deposition relief and other elements connected with the pulpit, Bernardo also commissioned, in the 1180s, the reliquary that stood directly behind the high altar: Giuseppa Z. Zanichelli, 'L'Arca dei santi Abdon e Sennen nella cattedrale di Parma', *PO: Quaderni di cultura padana*, 7 (1997), 5–16. The *arca* also contained the relics of St Nicomede, sometimes mistaken for Nicodemus: Arthur Kingsley Porter, *Lombard architecture* (New Haven, CT, 1917), iii, pp 162–3. For the proportionate relationship between the dimensions of Bernardo II's new wing of the bishop's palace and the cathedral it faced, see Maureen Miller, *The bishop's palace: architecture and authority in medieval Italy* (New York, 2000), pp 175–7. For the current understanding that the presbytery was substantially achieved under the direction of Bernardo I, see Fava, 'Il complessso episcopale', pp 71–88 at pp 78–87. **38** Schälicke, 'Die Ikonographie', pp 129–31. He cites the Offertory anthem for Maundy Thursday, Psalm 117:16, as the source for Mary's holding Christ's right hand: 'The right hand of the Lord hath wrought strength; the right hand of the Lord hath exalted me'. Difficult to observe in the present condition of the relief is the tear on the Virgin's nose: Lara Vinca Masini, *L'Antelami a Parma* (Florence, 1965), fig. 1. **39** For Mary's compassion and intercession, see Schälicke, 'Die Ikonographie', pp 148–50; Fulton, *From Judgment to Passion*, pp 232–40. **40** Éamonn Ó Carragáin, 'The cross and the Eucharist on the high crosses at Ruthwell (in Northumbria) and at Kells (in Ireland)' in *La Croce: Iconografia e interpretatzione (secoli I –inizio XVI)*, ed. Boris Ullanich (3 vols, Naples, 2007), iii, pp 127–41 at pp 129–36. For the celebration in Advent, see Karl Young, *The drama of the medieval*

describes the representation of the Angel Gabriel descending on a wire from a window in the nave vaults to an image of the Virgin accompanied by prophet figures located in the *pulpitum*.[41] The rationale for the play's performance is spelled out in the *Ordinarium*:

> to lead the people of Parma to contrition, and to strengthen them in their devotion to the Virgin Mary, who certainly will protect from all dangers any who invoke her. In this church the *repraesentatio* can and should occur, since the church of Parma has been dedicated in the name of the Virgin herself and she is also the Patroness of the city and people of Parma.[42]

The reference to the dedication of the cathedral, in 1106, to Santa Maria Assunta asserts the early prominence of the Virgin in the life of Parma that continued to grow as her cult of compassion and intercession expanded.[43] The sophisticated form of enactment described in the *Ordinarium* is no doubt of a later date, but even if it is too early for some version with wood figures to have been used for an Annunciation performance in 1178, it is safe to assume that the feast itself was observed.[44]

church (2 vols, Oxford, 1967), ii, p. 245. **41** *Ordinarium*, pp 120–3 (calendar for March): *a fenestris volatarum dictae ecclesiae, versus santam Agatham, per funes Angelum transmittendo, usque per directum pulpiti super quo evangelium cantatur in quo fit reverenter et decenter repraesentatio virginis Mariae, ipsam angelica salutatione devote annunciaturum cum Prophetis et aliis solemnitatibus opportunis.* For the setting, Barbieri, *Ordinarium*, p. 122, n. 2; Quintavalle, 'Per un pulpito', p. 346; Tonelli, 'Architettura e spazio', p. 62. For twelfth-century portal sculpture of the Annunciation with prophets at Ferrara and Piacenza associated with Advent, see Dorothy F. Glass, 'Otage de l'historiographie. *L'ordo prophetarum* en Italie', *Cahiers de civilization médiévale*, 44 (2001), 328–38. **42** *Ordinarium*, pp 120–1: *In Annunciatione virginis Mariae cuius annunciationis repraesentatio in dicta ecclesia parmensi annuatim, solemnius et devotius quam fieri possit, celebretur, ad inducendum populum Parmae ad contritionem, et confirmandum ipsum in devotione ipsius virginis Mariae, quae quoscumque eam devote invocantes a periculis omnibus indubie tuetur; in qua ecclesia et merito fieri potest et debet, cum ecclesia parmensis in nomine ipsius Virginis dedicata fuerit, et ipsa etiam sit Patrona civitatis et populi Parmae.* **43** Giuseppa Z. Zanichelli, 'Strategie comunicative nelle cattedrali riformate: analisi di alcune scelte iconografiche' in *Medioevo: l'Europa delle cattedrali*. Atti del Convegno internazionale di studi, Parma, 19–23 Settembre 2006, ed. Arturo Carlo Quintavalle (Milan, 2007), pp 414–23; Donizone Presbyterio, *Vita Mathildis*, ed. Luigi Simeoni (Turin, 1973), II, XIV, vv 967–9: *Tunc celebrabatur, quo festo Parma beatur./ Maius ibi templum Mariae nomine fertur,/ In quo plebs tota Christum Parmensis adorat*; Fava, 'Il complesso episcopale', p. 78 (Feast of 26 Sept.: *Dedicatio ecclesie beatae Marie*). Reinhold Schumann, *Authority and the Commune, Parma, 833–1133 [Impero e comune, Parma, 833–1133]* (Parma, 1973), p. 153: he cites a charter of 1092, which refers to the 'Church of the Holy Mother of God and Virgin Mary [...] which holds the *principatum* of the whole diocese [*episcopium*] of Parma'. See also Sandro Sticca, 'The literary genesis of the Latin Passion play' in *The medieval drama*, ed. Sandro Sticca (Albany, NY, 1972), pp 53–63; Eric Palazzo and Ann-Katrin Johansson, 'Jalons liturgiques pour une histoire du culte de la Vierge' in *Marie: le culte de la Vierge dans la société médiévale*, ed. Dominique Iogna-Prat, Eric Palazzo and Daniel Russo (Paris, 1996), pp 14–44. **44** Schälicke, 'Die Ikonographie', pp 48–9, figs 39, 40: the Catalan Virgin with raised hand from San

Efforts to elicit contrition from the congregation increased from the mid-twelfth century onwards. This same impulse, to concretize, to enhance the experience of the Eucharistic event, also informed the performance of the Good Friday liturgy at Parma. It included moments that Amalarius had dramatized in his interpretation of the Mass, as well as later embellishments, including one that became the extra-liturgical *Depositio* drama, counterpart to the Easter *Visitatio Sepulchri*.[45] Parma's *Ordinarium* singles out an unusual moment early on Good Friday, when the deacon effects an enactment of the Descent from the Cross. In a solemn procession of the clergy, he carries the host from the sacristy – where it had been placed on Maundy Thursday – to the chapel of St Agatha.[46] Although the *Ordinarium* does not mention it, during the Gospel reading that follows (Jn 18–19), at the words *Partiti sunt vestimenta mea sibi: et in vestem meam miserunt sortem* (Jn 19:24), the twelfth-century Roman pontifical calls for two deacons to remove, 'in a furtive manner', the cloth on the altar under the gospel book.[47] While the scene of the soldiers gambling for the cloak, depicted in the lower right corner of Antelami's relief, might be seen to allude to this covert action, the group is so separate from the main composition that I now see it as having more of a political than a liturgical reference.[48]

The high point of the liturgy for Good Friday is the venerable rite of the *Adoratio Crucis*.[49] At Parma, after leading the congregation in a series of prayers for the Church, the *Orationes sollemnes*, the bishop proceeds to the altar of St Sebastian in the south aisle, on which a cross is wrapped in a shroud. Having taken the cross from his assistants, he begins the gradual unveiling of it, standing at the top of the stairs that lead from the nave to the door of the choir.[50] Then, having

Clemente de Tahull, in Fogg Art Museum in Cambridge, may be from an Annunciation group. **45** Young, *The drama of the medieval church*, i, pp 112–48 (also includes the *Elevatio*, privately performed before Easter Matins); 201–410. For the burial of the cross and/or the host in the *Depositio*, see Parker, *Descent from the cross*, pp 82–98. **46** *Ordinarium*, p. 138 (and n. 1): [During the singing of the *tractus*] *Quo incepto, iuxta morem dictae ecclesiae, accedat Diaconus ad sacrarium deputatum, duobus cerofarariis et totidem thuriferariis praecedentibus, et deinde Corpus Christi, sindone munda involutum, in gremioque casulae impositum, reverenter et devote accipiat, et id solemnius, quam fieri posit, ad cappellam sanctae agathae deferat*. For the location of the sacristy and of the separate chapel of St Agatha south of the cathedral, see n. 32. For St Agatha, see Ireneo Affò, *Storia della città di Parma* (4 vols, Parma, 1793, repr. 1956), ii, pp 66–7. **47** Andrieu, *Le pontifical romain*, i, pp 234–5: Hardison, *Christian rite and Christian drama*, p. 130 (eighth-century origin). The antiphon, *Diviserunt sibi vestimenta mea, et super vestem meam miserunt sortem*, was standard for Good Friday Nocturns: *Corpus Antiphonalium Officii*, ed. René Jean Hesbert (6 vols, Rome, 1963–79), iii, p. 154, no. 2260 (Feria VI in Parasceve); i, p. 172 (Nocturn). For its use at the Stripping of the Altars at the conclusion of Maundy Thursday ceremonies as well, see Hardison, *Christian rite and Christian drama*, p. 126, n. 100; Schälicke, 'Die Ikonographie', p. 131. **48** An article devoted to the meaning of the tunic in Antelami's relief is in preparation. I have revised my earlier thinking on this point: see Parker, *Descent from the cross*, pp 183–99 at pp 194–6. **49** For the rite and its early history, see Young, *The drama of the medieval church*, i, pp 118–20; Parker, *Descent from the cross*, pp 99–104. See also Van Tongeren, this volume. **50** *Ordinarium*, pp 138–9: *Completis Orationibus,*

placed the unveiled cross on a clean cloth before the high altar, the bishop, now barefoot, leads the clergy in genuflecting and kissing the cross. The ritual ends back at the altar of St Sebastian. There, those laymen, as well as all women, not allowed in the presbytery area where the high altar is located, are able to follow the bishop's example in venerating the cross: the bare feet of John in Antelami's relief may also signal this particular moment.[51] After the sacristan has returned the cross to 'its customary place', the bishop then celebrates the Mass of the Presanctified – using the second host reserved in the sacristy from Maundy Thursday's Mass.[52]

Parma's Good Friday service concludes with the extra-liturgical *Depositio Hostiae*.[53] The bishop leads the canons and clergy in a solemn procession to the chapel of St Agatha, from which he takes up the host that had been brought there by the deacon in the procession that began the day. The bishop himself, having now assumed the role of Joseph of Arimathea, then carries the host to an area behind the high altar, called *Paradisus*, where he reverently places it 'as in a sepulchre', thereby representing the entombment of Christ. Finally, kneeling at the door of the *Paradisus*, where lights are kept burning throughout the night, the

Episcopus, deposita casula, ad altare Sancti Sebastiani, super quo est Crux panno cooperta, procedit, quam a ministris accipit, et, reversa facie ad chorum, a summitate parum discooperit ipsam, incipiens solus antiphonam: **Ecce Lignum crucis***, ut ei respondeatur ut in Missali continetur.'* Andrieu, *Le pontifical romain*, i, pp 235–7. For *Orationes*, see Amalarius, *PL*, 105, 1027CD (Hanssens, *Amalarii*, ii, p. 98). The phrase *a summitate* appears to refer to the top of the stairs in what Tonelli ('Architettura e spazio', pp 61–2, figs 4.I, 7, 8) calls the *avancoro*, the substantial area between the choir and the pulpit. The phrase recurs in the description of the liturgy for Corpus Christi, when, *existente a summitate scalae*, the bishop gives the pontifical blessing: *Ordinarium*, p. 175. The size of the cross is not clear. For processional crosses in Maundy Thursday procession to the chapel of St Agatha, see *Ordinarium*, pp 132–3. For a larger wood crucifix mounted above the entrance to the choir enclosure in Tonelli's reconstruction of the presbytery area by the second half of the thirteenth century, see his figs 6, 7, 10, 11, 15; Fava, 'Il complesso episcopale', p. 86, figs 20 (end twelfth-century plan), 21. For the liturgical use of monumental crosses, see Lutz, pp 23–6, 40–2 (second half twelfth century); Fisher, 'Cross altar and crucifix', pp 43–63 (late tenth). **51** *Ordinarium*, pp 139–40: *Postea deponitur Crux tota discooperta ante altare maius super panno mundo; quam illico dominus Episcopus, depositis calceamentis, procedit ad adorandum, ter genibus flexis, ante deosculationem Crucis. Quo facto, ad sedem suam revertit, et ibi reassumit calceamenta deposita, et casulam induit. Postmodum dicti Canonici, et Beneficiati, atque ministri altaris et demum tota plebs, ter genuflexi, ut dictum est, Crucem adorant; et interim Improperia cantantur et alia, ut in Missali; deinde deportatur inferius, ut reliquus populus atque mulieres adorent et osculentur [...].* Luchterhandt, *Die Kathedrale von Parma* (fig. 334, p. 375) locates the altar of St Sebastian (and St Fabian) in the middle of the south aisle, in the fourth bay **52** For the reservation of the host, see Young, *The drama of the medieval church*, i, pp 114–15. For the Mass of the Presanctified, see Hardison, *Christian rite and Christian drama*, pp 123–4, 134, 196 (not for the laity); Jungmann, *The Mass*, ii, p. 409. There is no mention of the Marian lament, the *planctus*: Young, *The drama of the medieval church*, i, p. 503; Sandro Sticca, *The Planctus Mariae in the dramatic tradition of the Middle Ages*, trans. Joseph R. Berrigan (Athens, 1988). **53** The ritual was first reported for St Ulrich, bishop of Augsburg in the mid-tenth century: Hardison, *Christian rite and Christian drama*, p. 136; Young, *The drama of the medieval church*, i, pp 553, and 115, for Roman use in the eleventh or twelfth century. It is not mentioned in Andrieu, *Pontifical Romain*.

bishop and clergy say Vespers.[54] The prominence of Joseph of Arimathea's embracing Christ in Antelami's relief suggests that the two-part enactment of the *Depositio Hostiae* that uniquely frames the devotional liturgy of the *Adoratio Crucis* at Parma was in effect at that time.

Antelami's unusual grouping of John together with the holy women suggests that the variant of the *Visitatio Sepulchri*, described in the Parma *Ordinarium* as taking place before the beginning of Easter Matins, was also already known in 1178. According to the *Ordinarium*, instead of just three, representing the Marys, four members of the choir enter the *sepulchrum domini* with thuribles and candles. They seek the body of Christ placed there by the bishop at the *Depositio Hostiae* (which the sacristan had surreptitiously removed). Gently shaking the clean cloth in which the host had previously been wrapped, they return with it to the door of the sepulchre. One of two groups of clerics positioned on either side of the high altar initiate the angel's famous Easter dialogue: *Quem quaeritis*, to which a second group responds: *Iesum Nazarenum*. When the first group then says: *Non est hic; surrexit, sicut dixit et cetera*, the four choir members emerge from the sepulchre holding their candles. They face the congregation to sing the antiphon: *Surrexit Christus, iam non moritur*. Then, the 'most important of these four', a *guardachorius* representing John, approaches the bishop to proclaim the resurrection and to give him the kiss of peace.[55] The bishop responds: *Deo gratias*. The bishop initiates

54 *Ordinarium*, pp 140–2: *Finita dicta Missa, descendant dominus Episcopus cum Canonicis et toto clero ad capellam sanctae Agathae, et Corpus Christi, quod est ibi reconditum, cum ea processione, modo et forma et solemnitate quibus portatum fuit, inde devote accipiatur, et reportetur, et in* **Paradiso**, *post altare maius, reverenter recondatur, ut in sepulcro [ibi dimisso lumine copioso per totam noctem duraturo], Clericis cantantibus responsorium:* **Sepulto Domino**, *et cetera. Quo finito, dicuntur Vesperi ante ostium Paradisi a domino Episcopo et Clericis suis genuflexis* [...] The disposition in Antelami's time is not clear. The phrase 'ante ostium *Paradisi*' (*Ordinarium*, p. 140, n. 2) seems to suggest at least a semipermanent structure: Young, *The drama of the medieval church*, i, p. 125, n. 5; pp 300–1. Calzona ('Lo spazio presbiteriale', p. 191) thinks the sepulchre was in the crypt before 1417. Tonelli ('Architettura e spazio', pp 55–8, fig. 5[8]) indicates that the gate to the *Paradisus* in the area east of the high altar was post-medieval. For the term '*Paradiso*' for the burial site before the chapel of St Agatha at the south door of the cathedral, see Quintavalle, 'Per un pulpito', p. 351. See also *The Chronicle of Salimbene de Adam*, trans. Joseph L. Baird (Binghamton, 1986), p. 11. **55** *Ordinarium*, pp 148–9: *Ante inchoationem Matutini duo Guardachorii et duo Cantores cum pivialibus* **Sepulchrum Domini** *reverenter intrant cum thuribulis et incenso, cereis ante* **Sepulchri** *ostium duobus positis. Et, incensantes* **Sepulchro**, *quaerunt de Corpore Christi [quod ante hunc actum Sacrista pervigil inde abstulisse debuit, et in sacrario deputato reverenter recondidisse], et palpant linteamina munda, quibus id erat involutum. Quod non invenientes, revertuntur ad ostium* **Sepulchri**, *foris tamen non euntes sed, versus altare maius, iuxta quod sint aliqui Clerici, dicentes:* **Quem Quaeritis**? *Qui Clerici respondentes dicant:* **Iesum Nazarenum**. *Quibus primi respondeant:* **Non est hic; surrexit, sicut dixit** *et cetera. Postea egrediuntur* **Sepulchrum** *isti quatuor, praeviis dictis cereis, et dicunt, versus populum, antiphonam:* **Surrexit Christus, iam non moritur**. *Qua finita, maior illorum quatuor ad Episcopum accedit sine lumine, et ei dicit plane:* **Surrexit Dominus**, *et osculatur eum.* Young, *The drama of the medieval church*, i, pp 300–1. The *Ordinarium* (*De officio Guardachoratus*, p. 66) explains that there are four in number to signify the evangelists. The 'most important' *Guardachorus*, therefore, would be John.

Matins, after which a bell tolls for the *missa populi*, in which the congregation was able to participate.[56] The function of the altar of St Sebastian in the Good Friday rites suggests that it also served as the lay altar for the Easter Mass.[57]

The holy women also play a pivotal part in the drama of the Easter Mass at the beginning of Communion. Their discovery of the empty tomb signals the moment in the interpretation of Amalarius of Metz when the subdeacons, whom the Marys represent, come to the altar to receive the *Corpus domini*.[58] As O.B. Hardison explained, the subdeacons' wait for the celebrant to place the host on the paten represented for Amalarius the climactic moment of the Mass, the turning point from the sorrow of the Passion to the joy of the resurrection, 'when the prayers of the women were fulfilled'.[59] The raised hands of the two women in Antelami's Deposition, in contrast to the clasped hands of the Magdalen, appear to allude to their double role as both mourners of Christ's death and witnesses to his resurrection. For Amalarius, the holy women are particular devotional role models for those who participate in this 'sacrifice of Penance'.[60]

Antelami's complex Deposition resonates with multiple liturgical moments during the course of Holy Week, such that they successively draw out new meanings for the attentive viewer as the liturgy unfolds. It particularly seems to emphasize the act of witnessing. Not only the centurion, but also John in his testimony (Jn 19:34–5), bear witness to the sacramental blood and water that flowed from Christ's side. With Ecclesia, the Virgin, John and the holy women stand as sanctified witnesses, participants in the event. With Synagogue, stand the centurion and five secular witnesses behind him. Having followed Synagogue in

Elsewhere in the Easter rites (see next note) and at Christmas (p. 106), six are mentioned. **56** *Ordinarium*, p. 149: *Et Episcopus dicit:* **Deo Gratias**. *Qui Episcopus alta voce deinde dicit:* **Te Deum Laudamus**, *et incensat altare, dictis dupleriis ardentibus; et dum dicitur* **Te Deum Laudamus**, *ille, qui nuntiavit domino Episcopo Christum resurrexisse, similiter nuntiet dominis Canonicis. Finito* **Te Deum Laudamus**, *incipit dominus Episcopus:* **Domine, Labia mea aperies**, *et cetera. Cui Matutino intersint Magister scholarum et sex Guardachorii, omnes pivialibus solemnibus vestiti; et procedatur in ipso, ut in Nativitate. Quo finito, pulsetur Baoionus pro Missa populi.* **57** See nn 32, 49, 52, above. The altar of St Sebastian would thus have served as the cross altar: see Joseph Braun, *Der christliche Altar in seiner geschichtlichen Entwicklung* (Munich, 1924), i, pp 401–6. For the Mass of the Dead at the same altar, see Günther Bandmann, 'Früh-und Hochmittelalterliche Altarordnung als Darstellung' in *Das Erste Jahrtausend: Kultur und Kunst im werdenden Abendland an Rhein und Ruhr* (Dusseldorf, 1962), ii, pp 371–411 at p. 399. See also Quintavalle, 'Per un pulpito', p. 361, for burials near St Agatha **58** Hardison, *Christian rite and Christian drama*, p. 72; *PL*, 105, 1151A: *Praesentantibus se sanctis mulieribus ad sepulchrum Domini, inveniunt spiritum redisse ad corpus, et angelorum visionem circa sepulchrum, ac adnuntiant apostolis quae viderant* (Hanssens, *Amalarii*, ii, p. 359). **59** Hardison, *Christian rite and Christian drama*, pp 72–3; *PL*, 105, 1151D: *Postquam enim Christus sua salutatione laetificavit corda discipulorum, vota feminarum completa sunt percepto gaudio resurrectionis* (Hanssens, *Amalarii*, ii, p. 361). **60** Hardison, *Christian rite and Christian drama*, p. 69; *PL*, 105, 1146B: *Moraliter. Possumus subdiaconos nos peccatores intelligere, qui faciem, id est conscientiam peccatorum nostrorum, sacerdoti ostendimus, ut nostram confessionem offerat Deo. Quo*

her submission to the cross, they are thus drawn into Ecclesia's fold. In order for the viewer, too, to be drawn into the very heart of this representation, its original placement must have allowed for direct observation of it, similar to what is permissible today.[61]

peracto, [...] fervore crescente Spiritus Sancti, dilatantur corda nostra, quasi patena, ad suscipienda sacramenta ecclesiae (Hanssens, Amalarii, ii, p. 350). **61** The original location for Antelami's Deposition cannot be secured by the existing documentary and archeological evidence. The arguments for a pontile, alone or with a pulpit attached to it, have recently been challenged by Tonelli, 'Architettura e spazio', pp 60–6. He proposes a three-sided choir enclosure under the cupola. The pulpit was separate, accessible by stairs from the avancoro. Projecting beyond the seventh bay of the nave, the pulpit stood to the left of the central staircase leading from the nave to the avancoro and the central door of the choir enclosure (figs 4, 5, 8, 9, 15, 19). See also Luchterhandt, Die Kathedrale von Parma, pp 52–3, n. 82, for his support of Tonelli's proposal. Many scholars follow Quintavalle's reconstruction of the pulpit with the Majesty in front, and the Deposition on the south side, 'Per un pulpito', pp 349–50, pls xxxvii, xxxviii; 'I magistri dell'officina nicolesca e l'arredo della Cattedrale di Parma' in Benedetto ed. Quintavalle, Calzona and Zanichelli, pp 34–41. For evidence of a lectern's having been on the Deposition relief, see Gottfried Kerscher, Benedictus Antelami oder das Baptisterium von Parma: Kunst und kommunales Selbstverständnis (Munich, 1986), p. 77. For a pulpit with two lecterns, see Woelk, Benedetto Antelami, p. 96. For the Deposition on the west and the Majesty on the south side, see Tonelli, 'Architettura e spazio', p. 64, figs 6, 16; Fava, 'Il complesso episcopale', p. 86, fig. 20. Compare Luchterhandt, Die Kathedrale von Parma, fig. 334 (13). See also Nestore Pelicelli, 'Il pulpito di Benedetto Antelami', 1, Aemilia (1929), 39–45 at 39: his reconstruction (without lectern) with the Deposition on the front is in the Diocesan Museum in Parma. The reconstructions of Pelicelli, Tonelli and Fava support my belief that the liturgical context of the Deposition argues for a frontal view of the relief, allowing for maximum visibility by the congregation.

Index